THE PAINTING AND
DRAWING COURSE

THE PAINTING AND DRAWING COURSE

PORTLAND HOUSE
— New York —

A QUINTET BOOK

This 1988 edition published by Portland
House, a division of dilithium Press, Ltd.,
distributed by Crown Publishers, Inc.,
225 Park Avenue South
New York, New York 10003

h g f e d c b a

ISBN 0-517-66303-1

This book was designed and produced by
Quintet Publishing Limited
6 Blundell Street
London N7 9BH

Designer: Phil Mitton
Editors: Hazel Harrison, Sheila Buff,
Robert Stewart, Judith Simons

Typeset in Great Britain by
Comproom Ltd, London
Manufactured in Hong Kong by Regent
Publishing Services Limited
Printed in Hong Kong by South Sea
Int'l Press Ltd.

DRAWING AND
PAINTING
THE FIGURE

STAN SMITH AND LINDA WHEELER

THE FIGURE IN ART

The tradition of drawing and painting the figure, which has existed for thousands of years, is still firmly established today. The figure provides an absorbing study for both the experienced and inexperienced artist, and, as well as being a readily accessible subject, offers an infinite variety of shapes and forms. Within the discipline of painting or drawing the human figure, the principles of anatomical structure, perspective and form, together with the problems and potentialities of tone and color, can be studied.

The social and moral attitudes of different civilizations can be measured and understood to some extent by their architecture, sculpture and painting. Attitudes to the human body and to representing it in art have varied through the centuries, and may be considered to epitomize the different societies' attitudes and ideologies. This is partly because the individual body and each body's death is a great source of puzzlement. A society's general view of man's position in the universe in relation to God or nature is often recognizable in how the figure is shown in art and how realistically. How man regards himself in this position, whether he feels proud, humble, or simply confused, is similarly discernible.

Since the birth of the classical ideal some 25 centuries ago, artists have been influenced to a greater or lesser degree by the philosophy which was then expounded. A belief in the intrinsic beauty of the human body and its proportions, which was expressed in the art of Ancient Greece, later became one of the motivating factors for the artists of fifteenth-century Italy. This revival of interest in the human figure, which coincided with the existence of some of the greatest artists the world has ever known, led to that era being known as the Age of Humanism, or as it is more commonly recognized, the Renaissance.

Artists since then have worked in many widely differing styles, but their debt to the Renaissance remains clear. The understanding of perspective and anatomy taken for granted today is an heirloom from these earlier times. It is with good reason that these are still considered to be important areas of study for the artist: being able to represent the figure realistically, which has become increasingly possible with the growth of scientific knowledge, has always been one of the most important initial aims for the figure

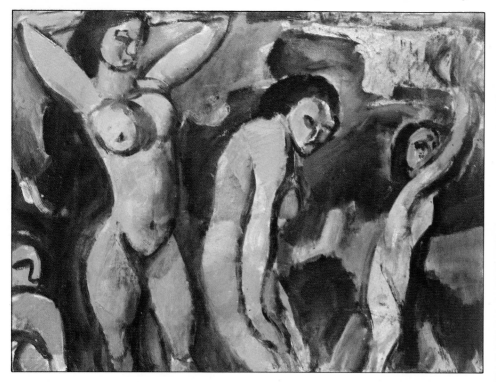

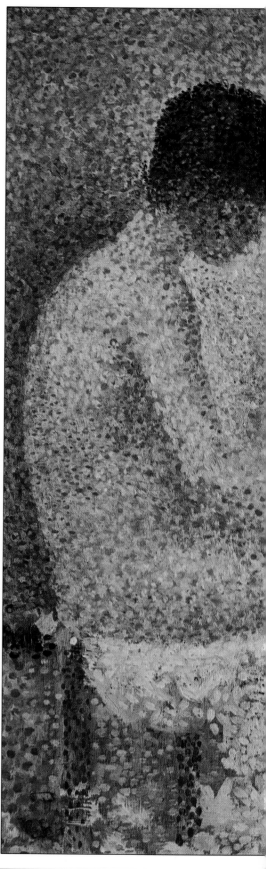

Above *The Bathers*, Georges Rouault. Rouault's apprenticeship to a stained-glass window maker was to have an effect on his art for the rest of his life. The rich, powerful colors and strong black outlines derived from medieval glass appear often in his work, together with simplified, elemental forms drawn in a bold, curving line, creating a lively sense of movement.
Right *Sitter in Profile* (1887), Georges Seurat. Primarily concerned with scientific theories of color vision and color combinations, Seurat's figure style was influenced by Puvis de Chavannes (1824-98), himself much impressed by Classical art. This oil sketch is typical of the way Seurat built up his monumental and simplified forms with an elegant and sensitive Pointillist technique.

CONTENTS

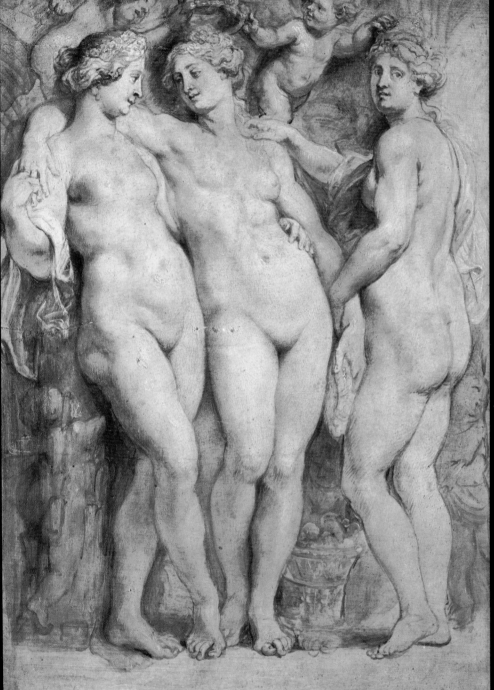

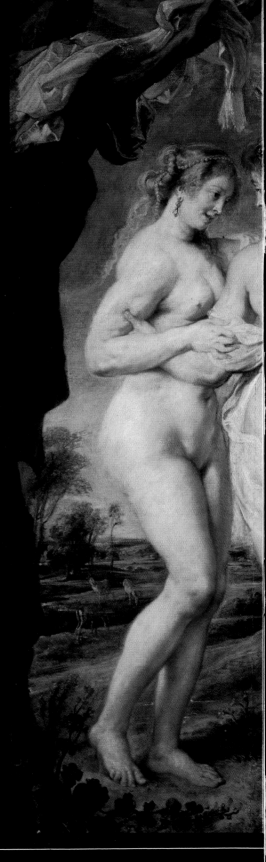

Above *Three Graces*, Sir Peter Paul Rubens. One of the greatest painters of his time, Rubens spent four years in Italy where he was able to study Classical sculpture, and Italian art, and copy Michelangelo's sculpture and frescoes. Draftsmanship was the basis of his genius, and this sepia sketch of typically Rubensian women demonstrates his ability to convey his ideal of beauty in the solidity and fleshiness of the marvellously voluptuous female forms.
Right *Three Graces*, Sir Peter Paul Rubens. Modern taste tends to prefer Rubens' sketches to his finished oil paintings, but the absolute mastery with which the paint is handled, brushed onto the canvas in rapid strokes of opulent, rich color, brings the forms into palpitating life.
Far right *Harmony of the Graces*, Hans Baldung Grien. A fine draftsman and colorist, Grien may have trained in Dürer's workshop and was also influenced by Mathias Grünewald (1460-1528). His favorite theme was the female nude, often depicted in macabre allegories in a mannered, linear style and exuding a coolness and asceticism typical of Northern art.

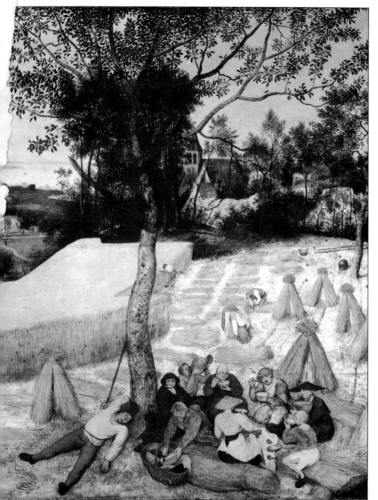

Left *The Corn Harvest* (*c* 1565), Pieter Bruegel. Bruegel devoted the last ten years of his life to painting genre scenes and religious subjects set in vast landscapes. Nicknamed "Peasant Bruegel" after the subjects he painted, he was one of the most important Netherlandish satirists, showing a genuine interest in rural life, combined with a satirical attitude toward vice. The naturalistically rendered landscape is peopled with little figures all busy at their labors. Color is an adjunct to form the bright, strong hues of the peasants' clothes standing out against the gold corn and the shapes of the shocks echoing the women's conical hats.

Below *The Pond*, L.S. Lowry. Lowry sets his brightly dressed stick figures in an industrial landscape, walking in horizontal processions which repeat the strong horizontals created by the streets, the edges of the pond and the viaduct. The figures, pushing babies, pulling dogs and children, echo the verticals of factory buildings, chimneys and smoke; they are submerged by their industrial surroundings.

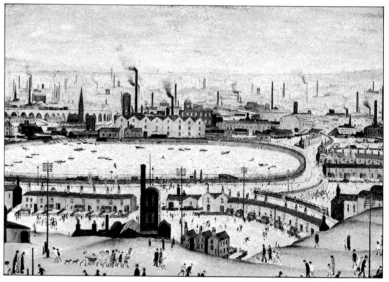

the scaling of one figure in relation to another is not. Instead, the most important people are shown as the largest, which allows easy recognition of the central characters in each painting. The owner of the tomb was usually many sizes larger than the rest of the family. Social rank was demonstrated by the way in which figures related to one another. For instance, if a man and woman were shown seated together then the man would be in front of the woman so that his body was unobstructed. She would be seated to his left, as this was the "inferior" side, in keeping with woman's place in Egyptian society.

The timeless sense of order and calm is often considered an attractive aspect of Egyptian painting for the modern viewer. Everything has its correct place and everyone their position. Symbolism was of paramount importance in these paintings and little was included that did not have some religious significance.

In contrast to the Egyptians, whose sights were set on the hereafter, the Ancient Greeks were concerned with the here-and-now. The Egyptians made no attempt to represent man as he really was; this would not have served their purpose. Man was represented by his most obvious features to make recognition by the gods and acceptance into the afterlife inevitable. The Greeks, however, did not share the Egyptians' conviction that there was better to come in the afterlife. Their gods were not always hard to please and, in fact, suffered from recognizable human weaknesses. The Greeks made their gods and goddesses in their own image.

The Greek interest in the human physique and their conviction in its inherent beauty led to their desire to represent it in art in the most vibrant, lifelike manner imaginable. It is possible to gain an idea of how Greek figure painting developed by looking at their pots and vases, a substantial number of which have survived to the present. The Greeks had perfected techniques of production and a characteristic style of decoration which transformed their pots from mere utilitarian objects to works of art in their own right. Until the fifth century BC the figures on these vases remained stylized. Work dated before this time is usually known as "black figure pottery" because the figures, which tend to be of a geometric design, are silhouettes filled in with either dark brown or black. This contrasts well against the background, which is usually the natural red of the pot but sometimes lighter in tone or gilded.

Around 500 BC this decorative scheme was reversed and the figures were picked out of the red against a black background. This was an important change as it meant that the figures could be elaborated using black lines to describe the form, giving a feeling of solidity. Later there were indications that artists were grappling with the problems of foreshortening and perspective, although in a simple way. Depth was indicated by placing a larger figure in front of a smaller one, and sometimes a few drawn lines hint at a receding plane. Suddenly the drawings on these vases appear much more realistic and "modern."

Greek artists were not content to remain anonymous, and often signed their paintings and sculptures. Many of their names have survived by repute although their work has long since been lost. Sculpture was a popular Classical art form and fortunately a certain

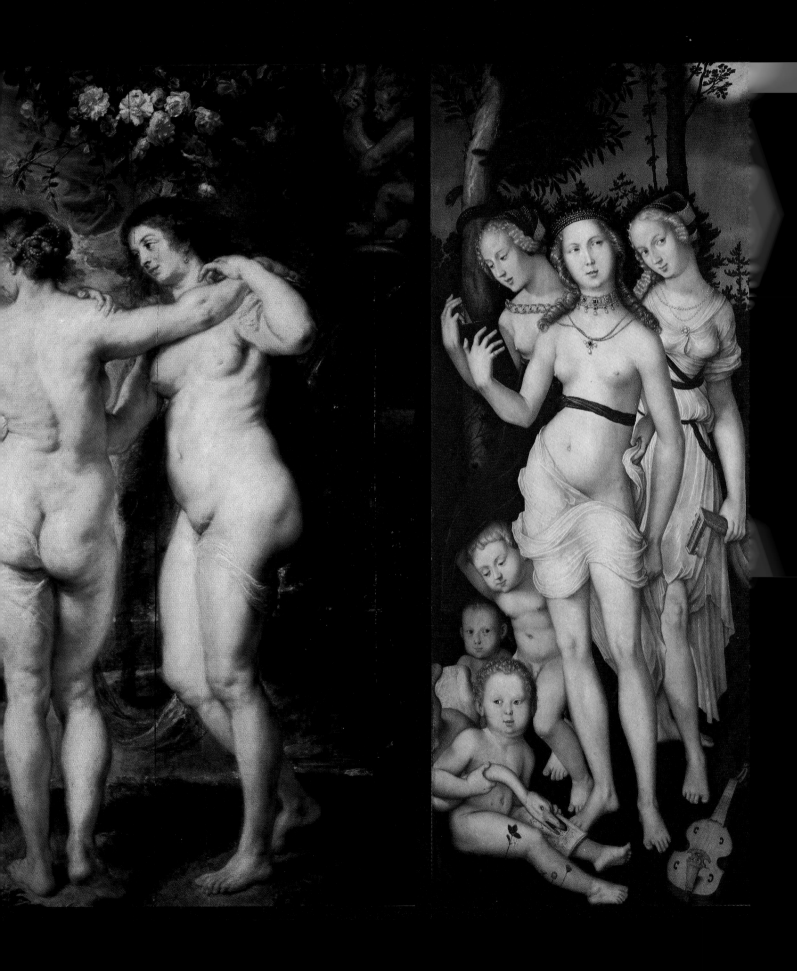

Right *The Charioteer of Delphi*. This beautiful bronze statue formed part of a group dedicted at Delphi by Polyzalus of Gela to commemorate his victory at the Games in 474 BC. Archaic sculpture had depicted the figure in rigidly frontal poses, the male naked and the female draped, called *kuoros* and *kore* respectively. Although in the sixth century BC there is greater understanding of the human, particularly male, anatomy, interest lies more in the folds and elaborate coiffure rather than in the underlying structure of the body. By the fifth century, the figure becomes more relaxed by shifting the axes of the hips and shoulders and the position of the head. The Classical sculpture from this period, of which the Charioteer is a prime example, developed a greater variety of poses and freedom in the treatment of hair and drapery. The columnar fluting of the Charioteer's *peplos* hangs naturally, acknowledging the body beneath.

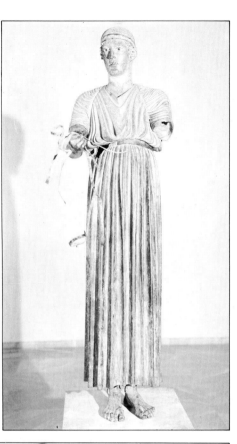

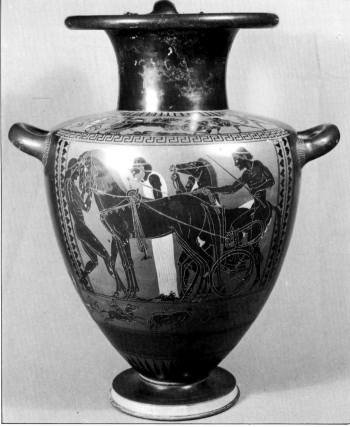

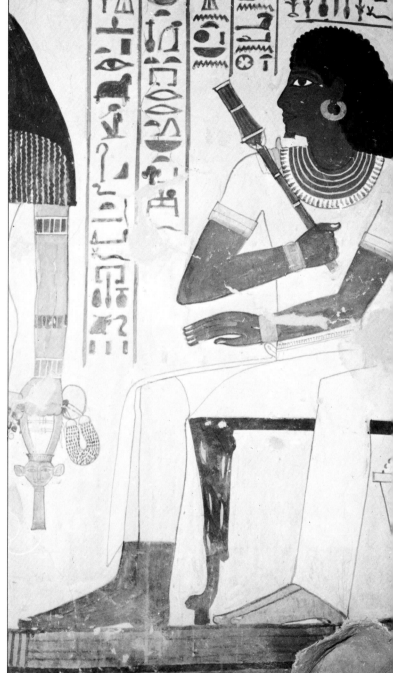

Left Early Greek vases were decorated with geometrical designs set in friezes round the vase. Figural compositions appeared in the seventh century BC with the strictly frontal view or profile being the rule. This silhouette style became inadequate for depicting movement and a new technique was invented where figures were drawn in silhouette with the details incised to show the clay beneath in thin lines. This encouraged a greater realism, further enhanced by the addition of red and white paint to pick out features such as hair, eyes and ribs. In this sixth-century vase, the little figures, hardly more than 1 inch (2.5 cm) high, are rendered in a lively manner, with the forms filled out and muscles bulging giving an impression of energy.

Above *Sennufer and his Wife*. The Egyptians believed that by recreating living creatures and objects they ensured their continued existence. A picture of a ruler enjoying life with his possessions around him meant that he would go on in the same way in the next life. It was a descriptive art, expressing a rational, objective truth which was unrelated to time and space.

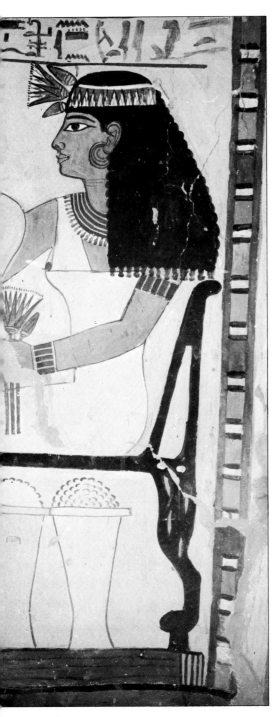

Three-dimensional perspective was unknown. Objects are shown from their most characteristic view with all the essential features visible. As these portraits from the tomb of Sennufer at Thebes demonstrate, the ideal human figure was shown with its head in profile but with the eye almost frontal, the shoulders face on, chest in profile and lower half in three-quarters profile. Men are generally depicted in their virile prime, their skins painted in red ocher; women are ever-youthful with taut and graceful bodies, their skins a paler color than the men's. Heads were carefully modelled with emphasis on the eyes.

amount has survived, mostly the Roman copies of the Greek originals. Where the copies and originals both remain it can often be seen that much of the character was lost by the imitator, but even so, such copies make it possible to trace the development of Greek art where there would otherwise be gaps in the knowledge of this subject today.

As with painting, sculpture before the fifth century BC remained archaic and stylized, and lacked movement. The sculptor had not yet mastered his material and pieces from earlier than this period retain much of the original character of the block of stone from which they were fashioned. Poses were staid and upright, and not fully considered as three-dimensional forms. However, *The Charioteer of Delphi,* a bronze sculpture made in 475 BC, represents the beginnings of a move toward a greater naturalism. The sculpture displays a tendency toward stylization, and the pose is stiff, but there are realistic sinews standing out on his arms and his feet are braced against the chariot to hold his balance.

A sculptor who enjoyed much acclaim among his contemporaries was Polyclitus, who lived in the fifth century BC. This recognition was partly due to his system of measuring human proportion according to an arithmetical formula. His careful calculations led him to suggest that the head should fit seven and a half times into the overall height of the body; the length of the foot should measure three times the palm of the hand; the length between the foot and the knee should measure six times the palm of the hand, as should the distance from the knee to the center of the abdomen. Although Polyclitus' demonstration model *Doryphoros,* or *The Javelin Carrier,* has not survived, several Roman copies show a much more fluid figure than had previously been achieved. All the weight is carried on one leg, while the other is more relaxed and bent slightly behind as though the figure is walking. The hips are tilted and, to compensate for this movement, and to regain a balance and harmony in the composition, the shoulders swing slightly out of alignment with the torso. The effect is of a young man who, though poised for movement, is balanced and at ease. It is an interesting pose as it is neither static, as a figure standing squarely on both legs would be, nor does it have the unnatural theatricality of a figure involved in violent movement.

That the Romans were impressed by the art of Greece is obvious not only from the numerous copies which they made but also from the number of complimentary references made to it by the Latin writers. They did more than simply admire from afar; in the same way that young artists made their way to Paris in the late nineteenth and early twentieth centuries to complete their art education, so the Romans went to Greece. Many were trained in Greece, or had Greek tutors. Also, much of the work produced as Roman art was in fact made by imported Greek artists. Even as Rome was becoming mistress of a great, expanding empire she looked to Greece for guidance in matters of aesthetics and art.

However, the Romans were of a different psychological make-up, and this soon began to show in their painting and sculpture. Certain aspect of Greek and Roman art share a common purpose: both races applauded acts of daring and fortitude and their art abounds with triumphant heroes. But, whereas the Greeks molded their young heroes into the perfect shape, the Romans were concerned to portray realistic likenesses. The Greek passion for ideals obliterated personality; a man who is truly perfect loses those characteristics which make him an individual. The young gods and heroes of the best of Greek art do not look capable of anger or sorrow, elation or exultation; occasionally they were allowed detached and condescending half-smiles. Not so with the Romans. Their realism was often unflattering and sometimes brutal despite the fact that the subjects were usually the ones to pay the artists' bills.

Many Roman wall paintings were executed in fresco which continued as a popular and durable method until, and after, the Renaissance. This involved the careful preparation of small areas of wall, onto which pigment was directly applied to wet plaster, so, rather than lying on the surface and later flaking off, the paint bonded into the wall as it dried. Tempera paint was used, this being a mixture of finely ground pigment and egg yolk or white; sometimes wax was mixed with the colors thus making it possible to paint onto marble or wooden panels. The Romans used a wider range of colors than the Greeks, including clear blues and vivid greens and reds, as a result of which some of their paintings are highly naturalistic, even impressionistic in style.

Another insight into Roman painting can be arrived at by reading the work of Vitruvius, a Roman architect. Toward the end of the first century BC he wrote *De Architectura,* a manual outlining the rules which should be applied to architecture; this influenced artists in all fields for many centuries. He was an exponent of the Greek philosophy that "man is the measure of all things," and suggested, in his list of rules for the guidance of architects, that buildings should conform to the same proportions as humans beings. The strong link between mathematics and art probably led Vitruvius to reflect that a man with his arms and legs extended could be contained within the square and the circle, both shapes being considered to represent aesthetic perfection. Of the many examples of men so depicted,

perhaps the best known is that by Leonardo da Vinci (1452 – 1519), drawn over 1,500 years after the death of its innovator.

There was a continuing interest in works of art which retold stories from mythology, but these existed alongside pieces of historical documentation. One of the murals in Pompeii illustrates a riot which took place in the amphitheater between the locals and a visiting town. It is interesting because of the subject matter, which seems to have a modern relevance, and also because of the treatment of the many tiny figures, scurrying about and fighting. These are sketched in with vivacity and a discerning disregard for detail. Because the artists of this period had only a limited grasp of the rules of perspective, the amphitheater is tipped at an angle to show the inside as well as the outside, and the figures in the foreground are more or less the same size as those further away. In spite of this, the overall mood has the immediacy of the work of a good, modern caricaturist.

Arguably some of the best portraiture ever produced is from this period. These were mostly pieces of sculpture, but there were also portrait paintings, a sufficient number of which survive to indicate their similarly high standard. Another example of wall painting in Pompeii from the first century AD is a double portrait of the lawyer Terentius Meo and his wife. The artist made realistic use of tone, highlighting, and naturalistic colors to enhance their forms and create a sensitive and expressive piece of work.

This era saw the emergence of the female nude as an interesting subject, as long as she was held within the framework of mythology. The Greeks had shown little interest in the female figure until late; the male Greek attitude to their womankind demanded modesty, despite the fact that it was acceptable for the young men to cavort in near nudity, and paintings of female nudes from the Greek period are often coy. Roman paintings of the subject display a certain eroticism, however. The Venus who appears on the wall of the House of Venus Marina in Pompeii, although painted around AD 10, still obeys certain Greek conventions: she is stocky, with a narrow torso, and has no pubic hair. Nevertheless her pose is inviting and the overall composition of Venus floating on a large sea-shell flanked by cupids is light-hearted. The Romans continued to paint the female nude, sometimes in an openly provocative manner, for two or three centuries, after which time it disappeared as a subject until the Renaissance.

In AD 311, the Roman Emperor Constantine I (d AD 337) proclaimed Christianity the official religion of his state; this had a profound effect on the art of the Western world. Christian dogma commanded that there should be no graven images and sculpture, an art form that had risen to heights of excellence during the preceding centuries, was disallowed. Fortunately, painting was considered to be important in educating the newly converted masses, despite a minority who believed that images of any sort were irreligious. Their consciences were salved

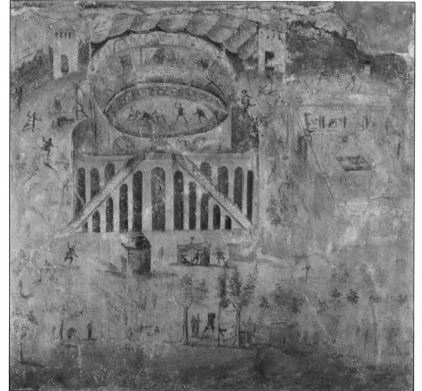

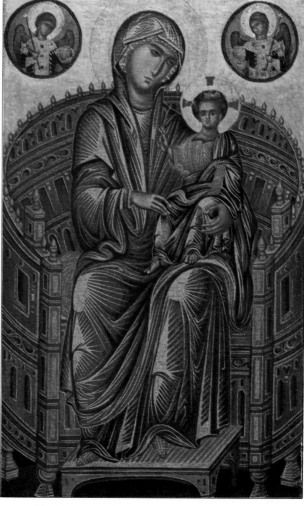

Above *The Riot in the Amphitheater.* The murals at Pompeii were executed from the end of the second century BC until AD 79 when Vesuvius erupted. Painted as interior decorations, they consist of perspective friezes, landscapes and figural scenes. A single vanishing point perspective and uniform light system had not yet been mastered by the Romans so that a somewhat "plunging" effect was the result, with the amphitheater tipped up and the figures all on the same scale.
Right *Enthroned Madonna and Child.* An imperial art glorifying Byzantium's greatness, Byzantine art was also a theological art, voicing the dogma of the day, and as such was stylized and opposed to Greek naturalism. Enclosed in a throne in which an attempt to create space and depth has been made, the Madonna and Child gaze out, the stylized folds of the robe creating rhythmic lines to form her shape;

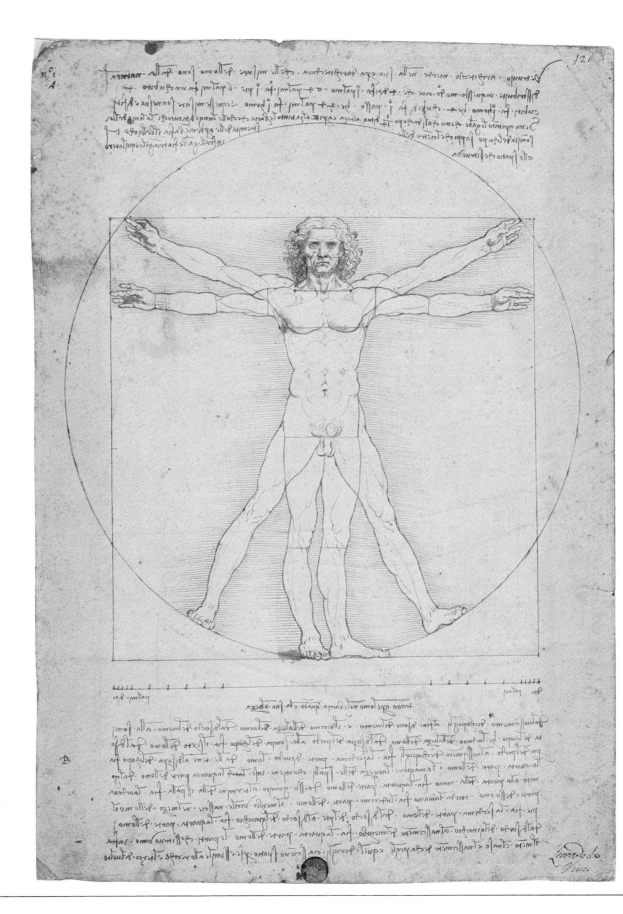

Left *Sketch of the Proportions of the Human Body from* De Architectura *by Vitruvius.* Leonardo da Vinci. The treatise of the Roman architect Vitruvius is the only handbook of its kind to survive from antiquity. In it he expounded on architecture and building, from the construction of theaters, temples and villas to town planning and hydraulics. The origin of these ideas came from Greek theories, but were not fully explained or understood by Vitruvius and left much scope for speculation and interpretation. The Greek idea that "man is the measure of all things" provided a useful doctrine of proportion on which later architects, particularly in the Renaissance, were able to base their own work. Leonardo's drawing shows his age's concern to determine systems of proportion, and the attempt by the architect Alberti (1404-72) to assert a link between primary geometric forms and those of the human body derived ultimately from Plato's statement in the *Timaeus* that the universe was built up from geometric solids. By containing the human body within a circle, Vitruvius was also affirming its divine proportions, the circle being the symbol of divinity or perfection.

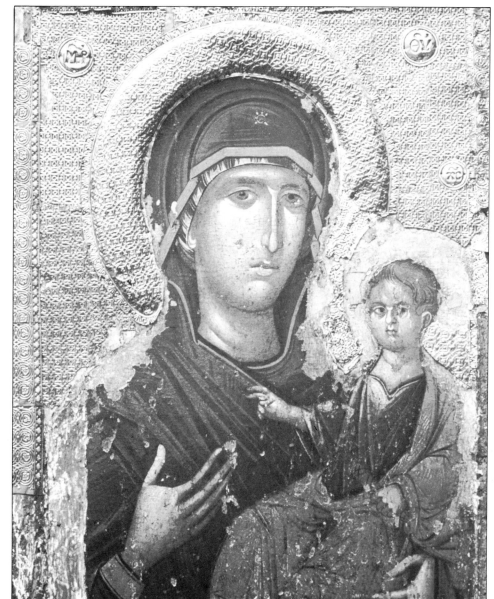

Right *Madonna and Child.* This Byzantine Madonna is of the *Hodegetria* type or "She who points the Way," introducing the spectator to her Son. Both faces are strongly modelled, with light and shades stylized into sharp patterns. An attempt to create plasticity has been made with the schematic comb patterning on the Madonna's shoulder.

toward the end of the sixth century when Pope Gregory the Great pronounced that, for those who could not read, illustrations of scenes from the Bible were an acceptable, even desirable, way of conveying information.

Paintings of illustrative figures were therefore encouraged, but the artist was never allowed to lose sight of the divine purpose of his work. Only what was thought to be absolutely essential to the religious message could be included in a picture. Shapes became stylized again, and lost their dependence on direct observation. There is evidence in paintings from this period that a limited knowledge of perspective, anatomy and foreshortening existed below the surface, but it was, simply, unimportant. With the demise of realism came a return of symbolism,

particularly in the use of color. Figures were set against areas of flat color, often gold or blue, or sometimes a richly elaborated pattern of jewel-like shapes.

In Byzantium, the capital of what had been the Eastern or Greek-speaking part of the Roman Empire, pictures which represented Christ, his mother Mary or the saints, came to be considered holy in themselves. Artists were strictly required to paint within traditionally acceptable guidelines; only certain ways of depicting the figure, facial expressions and gestures were permitted. A typical Byzantine altar painting, *Enthroned Madonna and Child,* demonstrates both the restrictions imposed by the Church and a touch of the realism from earlier times. The figure is seated on a throne placed against a flat, gold background.

Right *Madonna and Child Enthroned with Saints Theodore and George and Two Angels.* The production of icons or painted panels was important from very early on. Contemporaneous with the rise of Constantinople, other Near Eastern cities became important, notably Alexandria and Antioch in Syria. Alexandrian art had a Hellenistic elegance until the sixth century when the coarser Coptic style was adopted throughout northern Egypt. This sixth-century icon, found at St Catherine's monastery, Sinai, shows the still frontal, hieratic poses which came to Egypt from Syria.

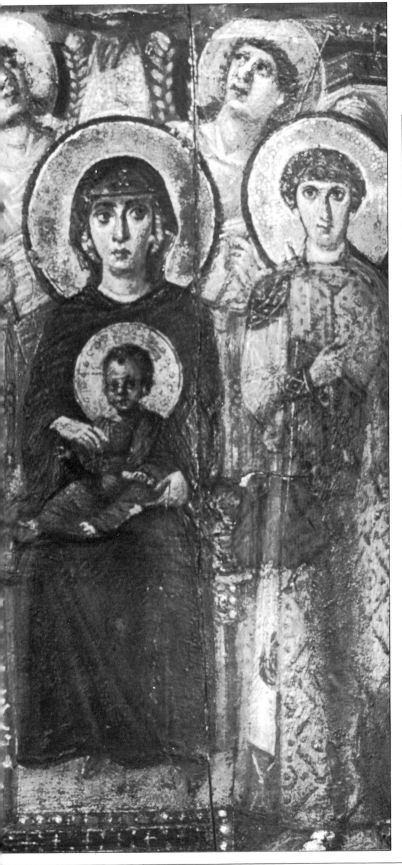

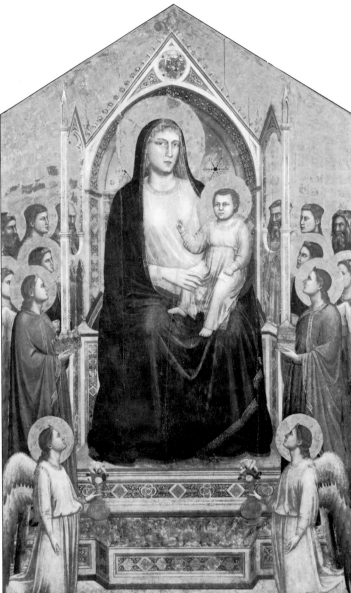

Above *Madonna Enthroned*, Giotto. Rejecting the stylized art of Byzantine and contemporary Sienese painters, Giotto attempted to render a more naturalistic world and is thus regarded as a founder of modern painting. By simplifying the drapery, he makes the figure stand out as a solid mass, and by using green pigment as an undercoat, achieves relief on the two-dimensional plane. Although posed similarly to the Byzantine Madonna, the solid, massive frame of Giotto's sculptural Madonna has a humanity and naturalism which was the major part of Giotto's contribution to art.

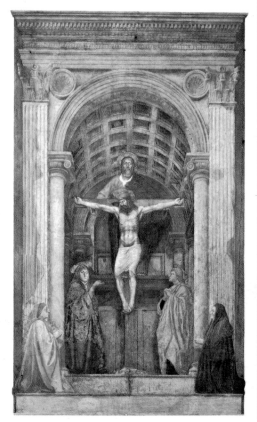

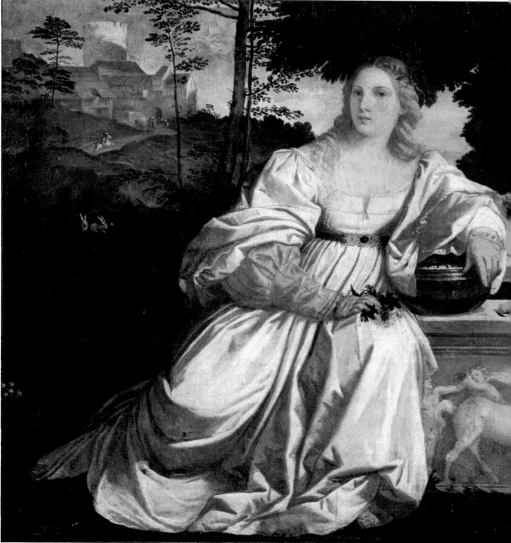

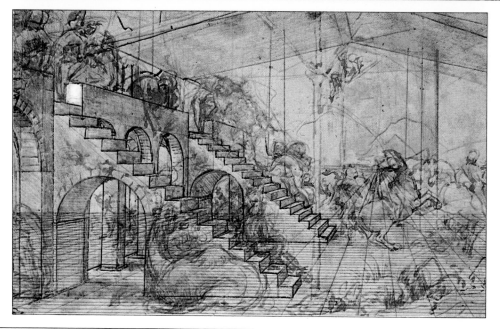

Above *The Trinity* (c1426), Masaccio. Masaccio's style is akin to Giotto's in its realism, narrative power and the way in which he creates space, light and solidity of form. His naturalism owes much to the architect Brunelleschi, the pioneer of the central perspective system and is shown clearly in this fresco in Santa Maria Novella, in Florence. Concerned more with the underlying structure of objects than with surface decoration, Masaccio uses light to define the construction of a body and its draperies. Set within a perspectively created space, which gives the impression of actually being a chapel extension, the figures stand with the light falling on their volumetric drapery assuring the solidity of their forms.

Above right *Sacred and Profane Love* (c1516). Titian. Painted to celebrate the marriage of Niccolò Aurelio, a Venetian humanist and collector, the subject of the painting was chosen from neo-Platonic writings. The nude figure, unashamedly displaying her beautiful, voluptuous body, represents the principle of universal and eternal love while the richly dressed figure, possibly a portrait of the bride, stands for natural love. Titian uses large planes of brilliant blue, red, rose and green to set off the sculptural forms whose warm flesh tones and generous proportions contrast with the hard outlines of the sarcophagus, making them two of the most beautiful female figures in Renaissance art.

Right *Perspective study* (c1480), Leonardo da Vinci. In this pen and ink preparatory study simply for the background of his *Adoration of the Magi*, Leonardo has used the central point perspective propounded by Brunelleschi. Perspective plots a stage in which to place figures in correct spatial relationships but also has a dynamic quality – note the vanishing point is to the right of center, matching the vigor of the figural movements. The rearing horsemen announce Leonardo's lifelong interest in this extremely difficult anatomical subject.

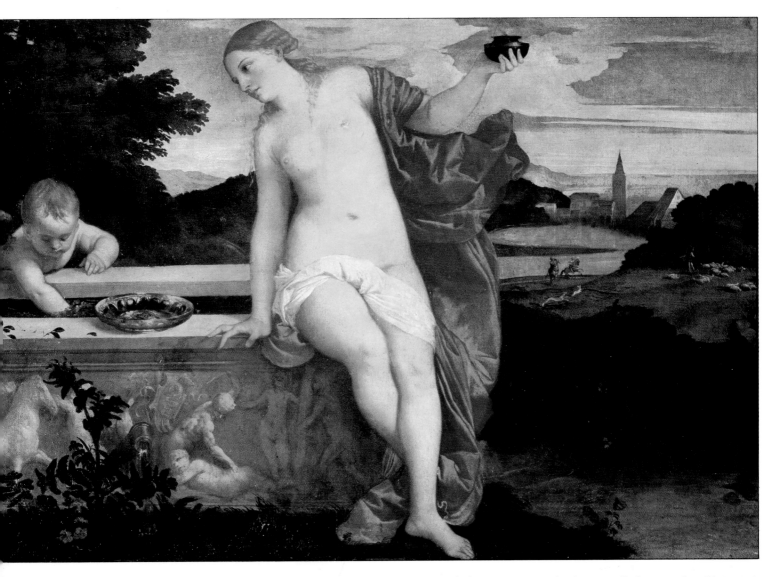

Although the composition has an abstract quality and is treated as a pattern of flat shapes, the line representing the back of the throne which encircles the Madonna nevertheless implies an enclosed space and therefore depth. Again, the folds of the Madonna's robes are highly stylized in the way they fall from her shoulders, around her arms and over her knees, but they give a good impression of the shape underneath, including a foreshortening of the upper legs. The expression on the face of both mother and child is serene, though solemn, a reminder of the religious fervor that permeates Byzantine art. The human figure was always portrayed in certain rigid poses which the artists learned as apprentices. Anything not included in this repertoire would have been difficult to represent as no one ever drew directly from the figure – there seems to have been neither the demand or the need.

Nearly all the surviving paintings from this time are of religious scenes, but this does not necessarily imply that no other paintings were produced. Private homes, castles and palaces probably contained nonreligious paintings, but these were vulnerable to the whims of private owners whereas paintings in churches were revered and protected. It is difficult to judge whether artists obeyed the same set of rules when producing secular pieces but it seems probable. The artist had again become an artisan, trained in a skilled craft but not expected to be innovative. Painting was often considered an adjunct to architecture at this time. Even when a painting was not made directly on the wall of a church or cathedral, its size was designed specifically for the proposed location, so imposing further constraints on an already rigidly ordered style of painting.

The work of Giotto di Bondone, (c 1267 – 1337) is generally recognized to have been a major turning point. His paintings may still appear static to modern eyes, but when compared with the work of his contemporaries it can easily be seen that Giotto was breaking the pattern. His treatment of form has a monumental quality not apparent in other paintings of the time, in spite of the backgrounds which at first remained flat, in the current style. The Ognissanti *Madonna*, painted by Giotto in about 1308, still retains much of the Gothic mood; it has a typically symmetrical composition with the Madonna seated centrally on a throne, surrounded by saints and angels. However, the figures, especially those of Mary and Jesus, appear sculptured because the artist made effective use of tone. Mother and child are posed in almost exactly the same way as the Byzantine *Enthroned Madonna,* but the folds of drapery which had, until then, been set into a standardized pattern are transformed by Giotto into rich flowing lines. The faces, though still serene, look capable of changing their expressions, and the babe's proportions are less like those of a miniature adult.

Giotto's work was obviously considered

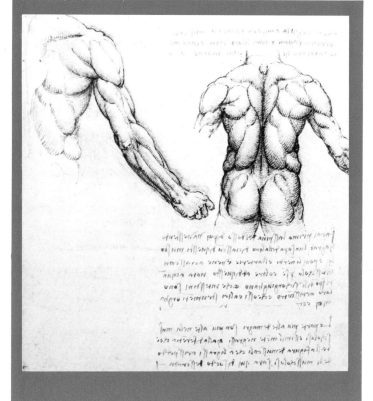

Above *Study of a Male Torso,* Leonardo da Vinci. Leonardo's notebooks were filled with studies of birds, cloud formations, water effects, skeletons, flowers and children in the womb. These minutely detailed sketches show his preoccupation with a scientific rendition of musculature, utilized in his interest in displaying the figure in movement.

valuable and unusual during his lifetime. It is known that he was greatly admired by Dante. Some of Giotto's finest work is contained within the Arena Chapel at Padua in northern Italy. This is an architecturally undistinguished chapel which was, unusually, built specifically to house these 36 fresco paintings, illustrating the lives of Christ and the Virgin. Giotto was painting not simply events, but moods, feelings and emotions; it is this which marks him out as an innovator.

It took some time for these new ideas to have any effect. The next half-century saw a general loosening of style, with artists increasingly interested in the use of light and shade and beginning, like Giotto, to represent their figures as human beings with human emotions. Coming at the tail end of an era which had devoted much of its creative spirit to religious fervor, these awakening techniques and the idea that artistic subjects could be other than divine, were revelations to artists and philosophers alike. The emphasis in figure painting was changing from religion toward realism, from the artist as instrument to the artist as creator. Available materials and pigments were simultaneously improving, and canvas was introduced as a support, releasing artists from medieval conventions into a greater freedom.

In the early fifteenth century, a discovery was made by a young architect which was to

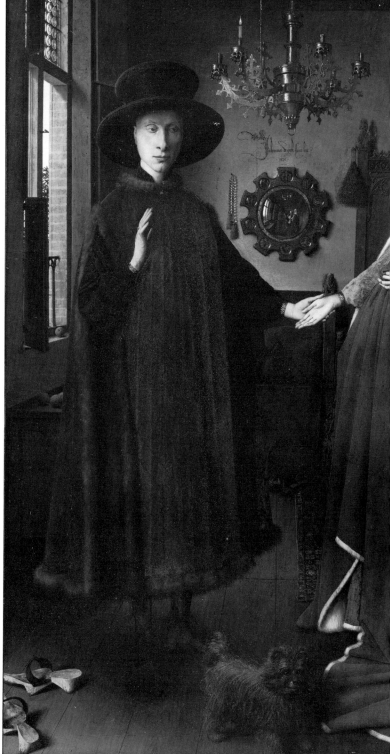

Above *Arnolfini and His Wife.* (1434), Jan van Eyck, Van Eyck is the major artist of the Early Netherlandish school. Among his achievements was the perfection of an oil medium and varnish fluid enough for him to obtain extremely subtle light effects and minute detail. This enabled him to create an extraordinary realism through the depiction of contrasting textures, space and light. Although the pose of Arnolfini and his wife is still medieval, the shadow on the

somber faces, the attention to detail in the rich furs and materials, and the light coming in from the window belong to the scientific age.

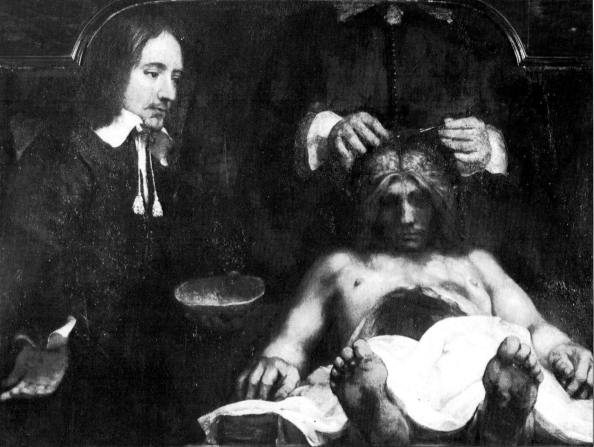

prove an inspiration to contemporaries and to succeeding generations. Filippo Brunelleschi (1377 - 1446) revealed what is now known as "the single vanishing point." The Romans had been aware of perspective and had made use of it in a limited way, but they had never understood the principles. Having established that there must be a fixed eye level, Brunelleschi found that lines running away from the viewer into the picture, although they are parallel, appear to converge to a single vanishing point on the eye level. Geometrical harmony and mathematics, so beloved by Classical artists, were to come into their own once more, to create the illusion of depth.

Masaccio (1401 – 28) was one of the first to realize the extent to which perspective could be used to imply space and depth. He used architectural detailing in his painting of *The Trinity* to place the figures within an alcove in the wall. A later artist, Uccello (1397 – 1475), was so excited by perspective that he worked ceaselessly in his experiments to establish the principles and mathematical rules by which it worked. His famous *Battle of San Romano* consists of three panels in which he has constructed a grid made up of fallen lances

and figures to create an illusion of depth within the picture plane. In spite of his vigorous application of the rules which he had worked out, Uccello made mistakes. A fallen figure in the foreground, although painstakingly foreshortened, is out of scale with its surroundings and the overall effect of the painting is unreal and disjointed. Piero della Francesca (1410/20 – 1492), who was slightly younger than Uccello, had a better grasp of the atmospheric quality of perspective and was able to suggest depth not just by diminishing size but by decreasing tonal contrast. Whereas Uccello's figures are like well-made models in a stage setting, Piero's are real people in real locations. Often they were modelled on local dignitaries who were flattered to have their portraits included in religious paintings.

The Renaissance was a period of upheaval because it marked a change from the common belief in a divine order to a greater understanding of the scientific rules which govern the universe. Principles about proportion and the anatomy, solid form, space and depth, initially made by the Greeks, were rediscovered. These new lines of thought are nowhere more evident than in the visual arts.

Above *The Anatomy Lesson* (1656), Rembrandt van Rijn. Rembrandt first made his name with a painting of *The Anatomy Lesson of Doctor Tulp* in 1632. This painting was also commissioned for the anatomical theater of Amsterdam and depicts its lecturer Doctor Deyman, dissecting the brain. It is a calculated design, the central figure which is nude and frontal, and steeply foreshortened, harking back to the perspective of Renaissance art theory. Rembrandt may have been influenced by Mantegna's *Dead Christ*. The strong *chiaroscuro* emphasizes the pathos of the scene, and illuminates the gory brain area and excavated stomach; the assistant on the left holds the removed skull. The painting illustrates the seventeenth-century fascination with science and medicine and Rembrandt's own particular interest in anatomy. Operations like this were often carried out on executed men.

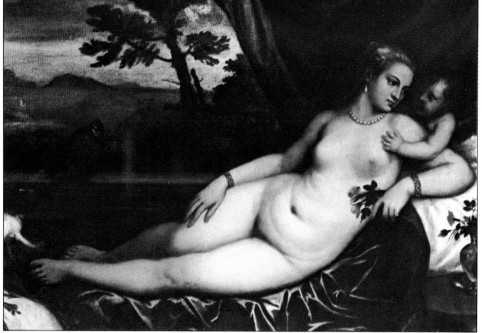

However, they were not without opposition. Savonarola (1452 – 1498), a fanatical preacher of doom in the fifteenth century who feared the moral results of scientific progress, persuaded Sandro Botticelli (1445 – 1510) to burn bundles of his drawings, many of which demonstrated the new learning.

During the Renaissance, artists became less dependent upon the Church for patronage because of the rise of rich families who were able to encourage the arts and, incidentally, record their ascent to power. There was a reemergence of portrait painting which was to surpass even the achievements of the Roman period. Giovanni di Arrigo Arnolfini was an Italian merchant based in Bruges who wished to document his marriage to Jeanne de Chenany, set in a comfortable, affluent background which epitomized contemporary bourgeois luxury. The double portrait of *Arnolfini and his Wife* by Jan van Eyck (c 1370 – 1441) who painted it for their marriage in 1434, is an excellent example of the way in which secular painting still retained much of the influence of medieval symbolism, while utilizing recent discoveries and innovations. The artist was aware of the rules of perspective recently discovered and utilized in

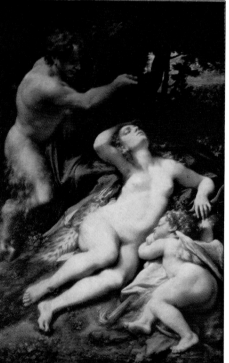

Top *Venus and Cupid* (c 1560), Titian. The Holy Roman Emperor, Charles V, was one of Titian's most eager patrons, commissioning paintings on religious and imperial themes, and a series of erotic subjects, known as *poesie*, mythological in title and

blatantly erotic in content.
Above *Jupiter and Antiope* (c 1532), Correggio. Correggio painted several pictures for private patrons with classical subject matter having strongly erotic overtones. One of four compositions depicting Jupiter's armour, this scene shows Antiope's

marvellously soft, languorous body, its soft warm tones set against the dark greens and browns as Jupiter takes her by surprise.
Right *L'Odalisca*, François Boucher. Correggio's sensual compositions look forward to Boucher's Rococo style. Boucher painted numerous

mythological pictures in which the subject was transformed into wittily indelicate *scènes galantes*, full of light-hearted voluptuousness.

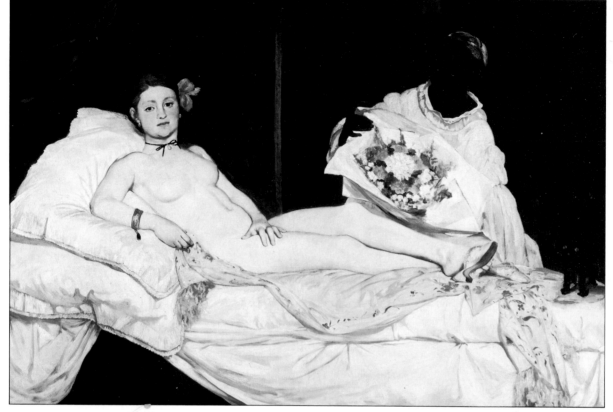

Above *Olympia* (1863), Edouard Manet. Rebelling against the academic history painting prevalent in France in his youth, Manet created a new style based on Velasquez, Goya and Ribera (1591-1652) in which he used the opposition of light and shadow with very little half-tone, a restricted palette with an emphasis on black, and painted directly from the model. His paintings caused much indignation, particularly the *Déjeuner sur l'Herbe* which closed the 1863 Salon and *Olympia*, exhibited in 1865. A Realist painter, he portrayed the world around him, sometimes with surprising touches. By placing the bed and body against a dark background, and throwing direct light with very little shadow on the forms, Olympia's cool sexuality directly addresses the spectator, her carefully placed hand drawing attention to what it pretends to hide.

Italy, and his painting is a good demonstration of how quickly new thinking was spread through the civilized world.

Released from the strict confines of religious painting, artists were free to use a wider range of subjects and there was a resurgence of interest in mythological themes. Also, the study of anatomy, abandoned for centuries, was resumed with vigor, leading to a mastery of nude painting in this period. Once the rules of perspective had paved the way to a greater realism, it was natural that artists should become interested not just in the outward appearances of the human body but also in its underlying structure. The sketchbooks of Leonardo da Vinci show that he had made a study of anatomy, including a careful dissection of corpses, which was considered almost blasphemous at the time. His exploratory drawings include the investigation of the growth of a child in the womb and numerous annotated studies of parts of the body.

The Renaissance curiosity was not confined to the visual arts but was also concerned with philosophy and science. The body was studied for its own sake, not just for the sake of realism in art. Artists were required to record facts and results; their role changed in this sphere, by necessity. Leonardo recorded his own discoveries; Rembrandt (1606-69), in 1632, recorded the mood of scientific curiosity

in his first major group portrait, *The Anatomy Lesson of Dr. Tulp*. He returned to this theme in 1656, when he painted *The Anatomical Lesson of Dr. Joan Deyman*, which depicts the dissection of the human brain.

With the growing interest in and understanding of the naked body, combined with fewer moral constraints, asceticism gave way to sensuality, at first tentatively, and later with wholehearted delight. Patrons encouraged artists to produce works with only a thinly veiled erotic content. The paintings of Titian (c1487-1576), Correggio (c1489-1534), Rubens and Boucher (1703-70) are examples of a frank enjoyment of voluptuous female flesh. Oil paint came to be increasingly widely used, and the laying of transparent glazes, one on top of the other, allowed artists to paint with a transparency and luminosity that lent itself well to a sympathetic rendering of flesh, and, at the same time, to blend tones which created a great vitality.

A fascination with the texture and elasticity of skin and its light-reflecting qualities was constant through the next few centuries. The eighteenth and nineteenth centuries saw some of the most sensitive and sensual painting of the female nude, but there was a danger of the subject becoming stifled by the classical tradition many artists sought to emulate. There was a strange double standard which accepted paintings of nude figures in a

Left *Diana,* Auguste Renoir. A French Impressionist painter, Renoir's paintings have elements of the decorative techniques of the eighteenth century and Boucher's pretty color, He introduced the "rainbow palette" into the Impressionist technique which was restricted to pure tone and eliminated black. The human figure, especially female, formed a more important part of his art than in that of his fellow painters, and there are many studies of charming women, young girls, flowers and pretty scenes. His late works are mainly nudes, fleshy and voluptuous, the warm, pink skin tones enabling him to use his favorite color scheme of pinks and reds. "It is necessary," he said "to be able to actually *feel* the buttocks and breasts."

classical mold as respectable but cried out in horror at work which simply presented the body as a thing of beauty, worth revealing simply for its own sake. It is ironic that this same attitude was the basis of most of the work produced in Ancient Rome, when female nudes were presented in mythological settings. The attitude was pinpointed by Pierre Auguste Renoir (1841-1919), when he described a nude painting "which was considered pretty improper, so I put a bow in her hand and a deer at her feet. I added the skin of an animal to make her nakedness less blatant – and the picture became a Diana."

It was no doubt this sort of hypocrisy which prompted Edouard Manet (1832-83) to paint his notorious *Déjeuner sur l'Herbe,* which, despite being based on *The Judgement of Paris* by Raphael (1483-1520), caused a huge public outcry when it was exhibited because of the juxtaposition of the naked woman with the fully clothed men. The fact that the nude is relaxed in the woodland scene and the men seem like intruders in spite of their obvious pleasure, enchances the absurdity of convention. Two years later, in 1865, Manet painted *Olympia* which was received with shock and outrage. In this painting the viewer finds his gaze returned with disconcerting candor by a nude who is reclining on a bed draped with splendidly decadent silks and tassels.

Toward the end of the nineteenth century, artists began to create works in which the nude figure is painted performing everyday tasks. Edgar Degas (1834-1917) and Pierre Bonnard (1867-1947) both produced a number of pictures of women in the bathtub, combing their hair and so on, which are like intimate glimpses into the subject's private life. At the same time as the content was becoming less important in the new freedom, the way it was treated was gaining importance. The Impressionists, for instance, were preoccupied with light and color being reflected or partially absorbed by objects and wanted to convey the effects of light in the paint. The Fauves were concerned to portray emotion using particularly strong and often violently contrasting colors.

The choice of subject matter in painting is now relatively free of convention, if not of inhibition. It is interesting, however, that representing the male nude is still frowned on, although it is legally and morally permissable. Artists can today concentrate on the methods and techniques of representing the human figure, with a firm backup of scientific knowledge, and need not be concerned about society's reaction.

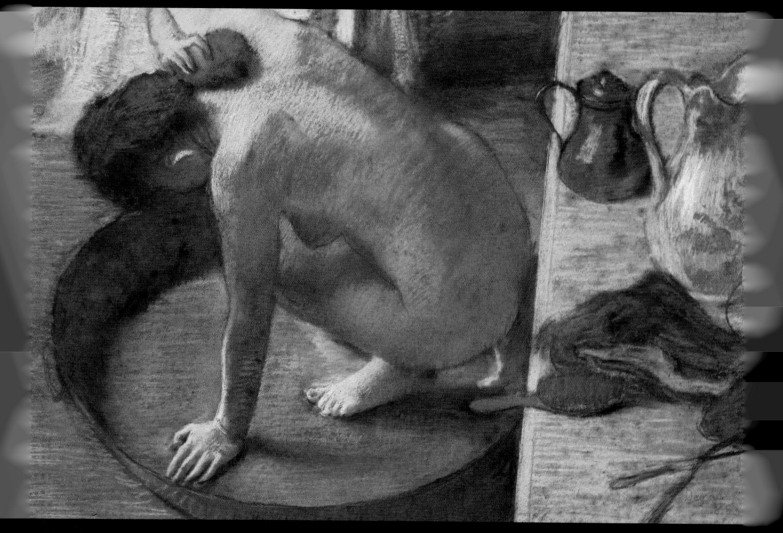

Above *The Tub* Edgar Degas.
Degas has used pure pastel,
strong color and a simple
composition for this drawing.
The strokes sometimes move
across the body and
sometimes with it, a
technique which imbues the
work with life.
Far left *La Gommeuse et les
Cercleux,* Jean Louis Forain
(1852-1939). Form and mood
is brilliantly suggested by
light falling on the men's
faces and shirt-fronts and
highlighting the scantily
dressed girl.
Left *The Night* (1918-19),
Max Beckmann (1884-1950).
A leading German
Expressionist, Beckmann
painted several allegories
reflecting the human
condition.
Right *The Kiss,* Gustav Klimt.
Klimt has created one body
out of two, swathing the two
lovers in a stylized cloak, and
achieving a highly decorative
effect.

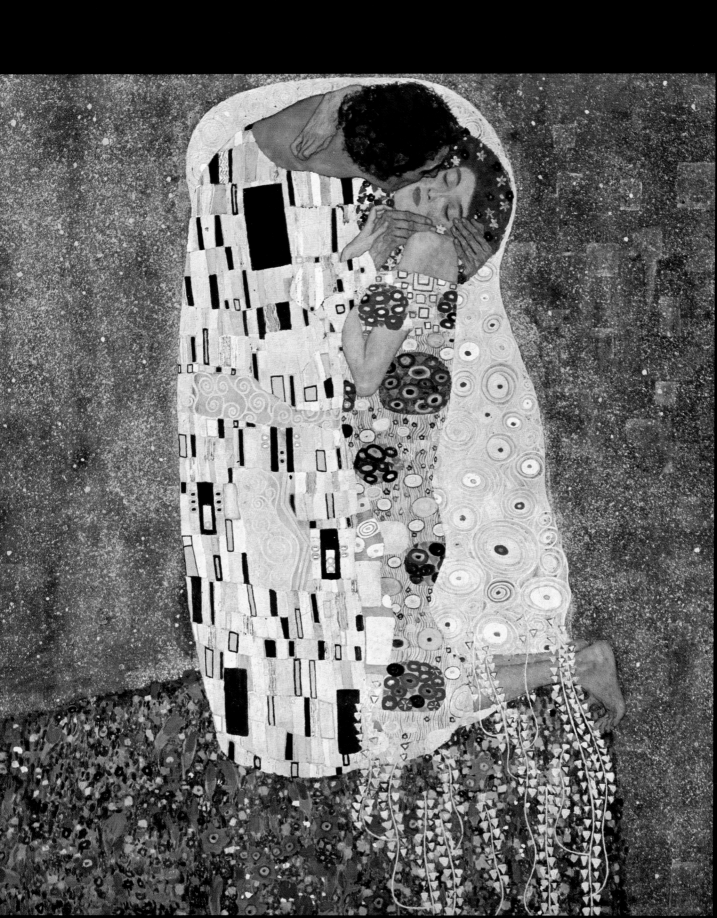

THE HUMAN BODY

For anyone attempting to portray the human body realistically, including the way the various muscles and joints interact in movement, some knowledge of anatomy is very helpful. We have only to compare the rather flat and stylized paintings of pre-Renaissance times with those done later, in the light of subsequent anatomical research, to understand the value of the study. Knowledge of man's internal structure was evident before the Renaissance but it had not been documented visually with the kind of accuracy that can be seen in the work of Leonardo da Vinci, who was working in the fifteenth century. Curiosity, coupled with a desire to draw and paint a convincing representation of a human being, resulted in Leonardo's remarkable exploration into the mechanics of the human body. The

knowledge of anatomy acquired by artists of Leonardo's generation resulted in remarkably accurate depictions of the human body. The artist's skills in draftsmanship were essential as a means of recording anatomical complexity, and medical knowledge was closely aligned to artistic endeavor at that time. During the twentieth century the use of photography has enabled medical science to dispense with artistic skills, and although diagrams are still vital, artists are no longer needed to make intense observational drawings in the manner that was previously necessary. The vast array of modern medical textbooks enables anyone to study the mechanism of the human form, and the present attitude in art school no longer attaches such importance to the first-hand knowledge that was considered essential. It is

ironic that Leonardo da Vinci knew more about the working of the human body than most twentieth-century artists.

Understanding the human anatomy involves the study of a complex structure of living organisms. The aims of the artist are, however, understandably different from those of a medical student and it is more useful in this book to consider the fundamental mechanics of the human frame rather than analyze the body from a clinical or biological point of view. The artist is primarily concerned with the aspects of anatomy which directly relate to what is visible to the naked eye. Because the shape of the human form is conditioned by the internal structure, it is necessary to consider the bones and muscles which in turn affect and dictate the surface shape.

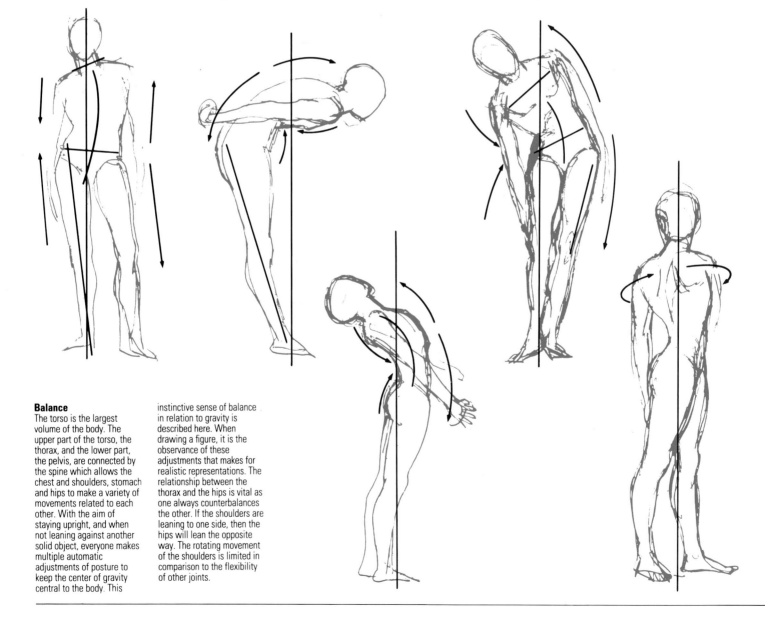

Balance

The torso is the largest volume of the body. The upper part of the torso, the thorax, and the lower part, the pelvis, are connected by the spine which allows the chest and shoulders, stomach and hips to make a variety of movements related to each other. With the aim of staying upright, and when not leaning against another solid object, everyone makes multiple automatic adjustments of posture to keep the center of gravity central to the body. This

instinctive sense of balance in relation to gravity is described here. When drawing a figure, it is the observance of these adjustments that makes for realistic representations. The relationship between the thorax and the hips is vital as one always counterbalances the other. If the shoulders are leaning to one side, then the hips will lean the opposite way. The rotating movement of the shoulders is limited in comparison to the flexibility of other joints.

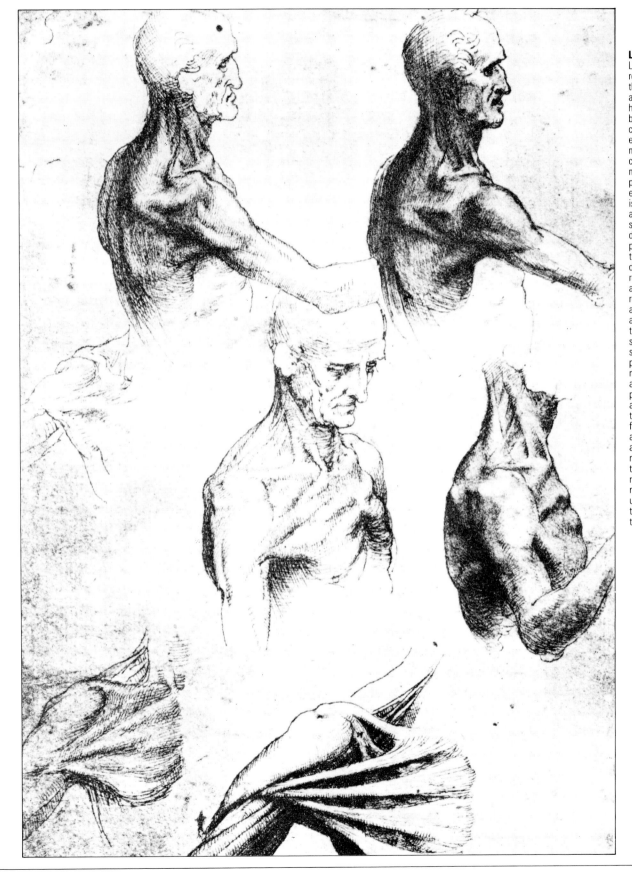

Left *Sketchbook drawings,* Leonardo da Vinci. The relationship of the head to the chest is just as important as that of the chest to the hips because all parts of the body, unless supported, are continuously balanced with each other. The directions of movement always flow, as can be seen when any movement is captured on paper or canvas, and an extended limb or a bent torso is always counterbalanced by an adjustment of weight somewhere else. When drawing or painting a portrait, it is vital to consider these relationships. Leonardo da Vinci made extensive researches into the human anatomy and his confident, realistic studies remain both anatomically and aesthetically interesting for the twentieth-century student. The head of the subject portrayed here is well placed on the shoulders. The most visible of the shoulder and chest muscles is the pectoralis major which is attached to the clavicle and the sternum and looks like a fan, when outstretched. It attaches at the other end to a point beneath the deltoid muscle on the arm. The trapezius is the muscle that runs down the back of the neck and attaches to the upper spine at the back and to the clavicle at the front of the torso.

The relevance of anatomical knowledge for the figurative artist is directly related to its application; consequently, an understanding of the nature of form is only of use if it is considered from a sculptural point of view with an emphasis on three dimensions. Every object can be described in terms of its internal structure. In most instances this is immediately apparent but occasionally, as in the case of the human form, it may be disguised by the nature of the surface covering, the skin. Gravity determines how the structure of an inanimate object rests on a surface and all geometric objects except those with curved surfaces – the sphere, the cone and the cylinder – will always remain static unless affected by some external force. However, the human form cannot be so easily understood: it must be considered anatomically as well as in relation to the force of gravity. Even if a figure appears static, it will only remain so if it supports itself by a balanced distribution of load or if its weight is acting against some other support.

If the skin, muscles and organs are removed from a body, the skeleton can only reveal the relative size and proportion of its constituent parts. It does not enable the artist to consider how the figure balances on the ground or how the movement of one part of the body results in a redistribution of weight in order to accommodate that move without loss of balance. When a particular part of the figure is moved it is the result of the muscles of the body affecting the skeletal joints in the way that a pulley provides the link between the otherwise static parts of a machine. If a person stands still for any length of time it is unlikely that he or she would choose a stiff symmetrical posture. Instead, the body is able to shift the weight from one side to another and at any given time one leg may be taking more weight than the other. This distribution of weight affects every other part of the figure, and unless the figure is affected by an external force it usually retains an instinctive balance.

THE SKELETON

Apart from providing protection for the internal organs of the body, the skeleton provides shape and support for the figure as a whole. The word "skeleton" is derived from the Greek word meaning "dried up" and the properties of flexibility in the bone structure of a human being are quite different from those found in a living skeleton. While it is part of a living being, bone is constantly renewing itself. The unique structure of the human skeleton comprises 206 bones fitting together at joints which allow freedom and versatility of movement and yet still provide a strong and rigid framework for the body as a whole. A baby is born with 350 bones; many of these fuse together, and by the end of the

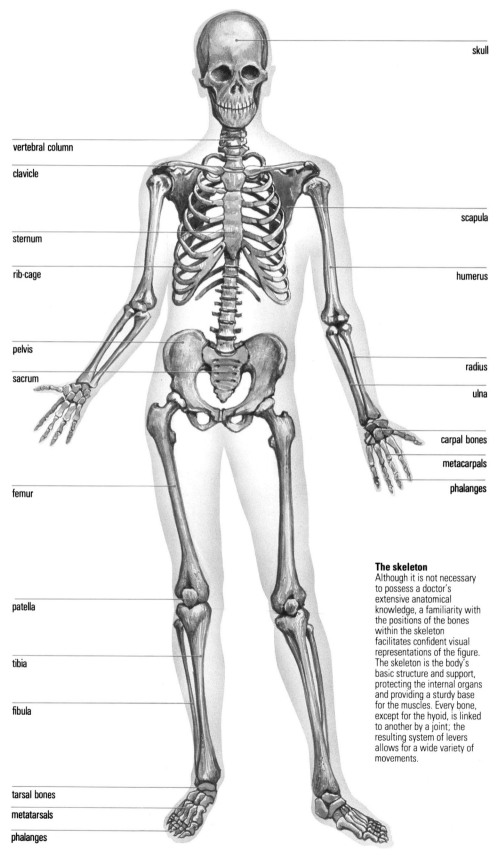

skull

vertebral column

clavicle

scapula

sternum

humerus

rib-cage

pelvis

radius

sacrum

ulna

carpal bones

metacarpals

phalanges

femur

patella

tibia

fibula

tarsal bones

metatarsals

phalanges

The skeleton
Although it is not necessary to possess a doctor's extensive anatomical knowledge, a familiarity with the positions of the bones within the skeleton facilitates confident visual representations of the figure. The skeleton is the body's basic structure and support, protecting the internal organs and providing a sturdy base for the muscles. Every bone, except for the hyoid, is linked to another by a joint; the resulting system of levers allows for a wide variety of movements.

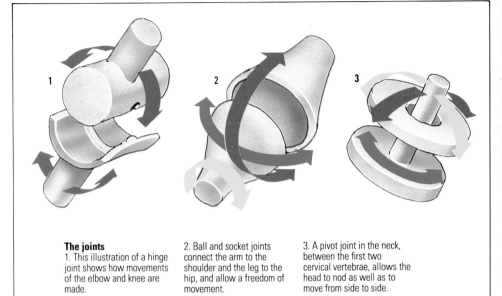

The joints
1. This illustration of a hinge joint shows how movements of the elbow and knee are made.

2. Ball and socket joints connect the arm to the shoulder and the leg to the hip, and allow a freedom of movement.

3. A pivot joint in the neck, between the first two cervical vertebrae, allows the head to nod as well as to move from side to side.

growth period (at the age of 25 in men, younger in women) all bone fusion is complete and the skeleton assumes a reasonably permanent shape.

The human skeleton can be subdivided into two main areas known as the axial skeleton and the appendicular skeleton. The axial skeleton comprises the central axis of the figure and includes the bones of the cranium and face, the spinal column, the ribs and sternum. From these bones is attached the appendicular skeleton comprising the shoulder girdle, the arms and hands, and the pelvic girdle, the legs and feet.

Although the portraitist need not be concerned with the individual names of each bone it is useful to consider the individual characteristics of the various bone groupings. The spinal or vertebral column has a remarkable combination of properties and provides support for the weight of the torso and at the same time enables flexibility and considerable movement in many directions. In the fetus, the vertebral column can be seen as a single C-shaped curve of bone and yet after birth the raising of the head creates the beginning of the more complex curvature of the neck. Later the movement involved in standing and walking creates the beginning of a similar curve in the lower or lumbar regions. The curvature of the spine should never be underestimated in drawing, and a simple acknowledgement of its shape enables the artist to understand the main rhythms of a pose. Unless affected by injury, disease or poor body posture, the spine will always involve a subtle S-shape that is apparent when looking at x rays or medical diagrams.

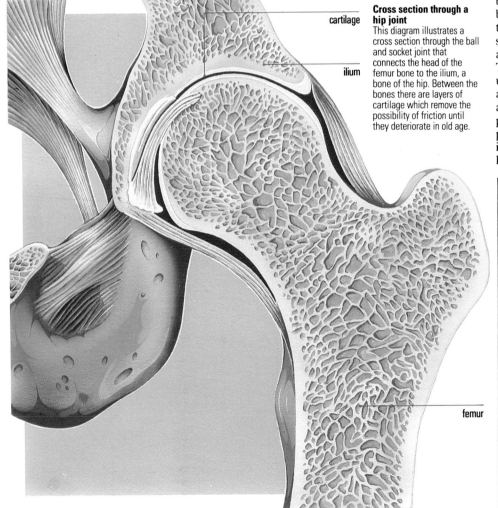

cartilage

ilium

Cross section through a hip joint
This diagram illustrates a cross section through the ball and socket joint that connects the head of the femur bone to the ilium, a bone of the hip. Between the bones there are layers of cartilage which remove the possibility of friction until they deteriorate in old age.

femur

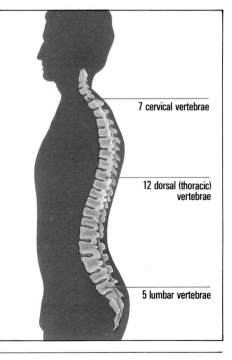

7 cervical vertebrae

12 dorsal (thoracic) vertebrae

5 lumbar vertebrae

Right *Sketchbook drawings,* Leonardo da Vinci. This extraordinary artist and scientist filled a great number of notebooks with observations and drawings of the human anatomy, sometimes carrying out dissections to increase his knowledge. The precise drawings on this page describe the bones and joints of the human arm from both sides. The shoulder blade, or scapula, and shoulder are attached to the humerus of the upper arm by a ball and socket joint; the humerus attaches to the bones of the lower arm, the radius and ulna, with a hinge joint which allows great flexibility. The carpal bones of the palm of the hand are jointed to the lower arm and extend into the metacarpals and phalanges of the fingers. All Leonardo's observations are supported by notes in his curious mirror handwriting.

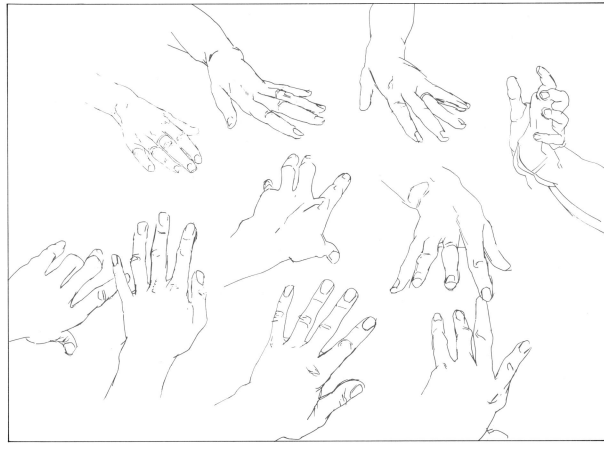

The hand
A complex series of joints in the hand make many combinations of movements possible. The flexible fingers of a healthy adult are capable of bending back some way over the top of the hand or of stretching across more than eight notes on a piano, while the other hand can simultaneously hold thin, fragile or moving objects of almost any shape, although there are limits as to size. When painting or drawing a figure, the artist soon becomes aware that hands are one of the most expressive features; Leonardo da Vinci was one of the first to notice and utilize this in his work. It is worth sketching them in different positions and from different angles to become familiar with the general form before incorporating them in paintings.

The bones of the lower extremities can be separated into three groupings involving the pelvic girdle, the bones of the legs, and the bones of the ankle and foot. The pelvic girdle supports the trunk and provides the casing in which the leg bones are attached. The adult pelvis consists of three separate bones fused together; the male pelvis is slightly bigger but generally narrower in its overall structure.

The femur or thigh bone is the largest and heaviest single bone in the body and it is important to realize that it is not in a vertical line with the axis of the erect body but is positioned at an angle. From a frontal view of the skeleton, the two femurs form a V-shape and because of the female's greater pelvic breadth the angle of inclination is greater than in the male. The patella or kneecap is a small flat bone lying in front of the knee joint and enveloped within the tendon that attaches to the large muscle of the upper leg. The tibia or shinbone is the larger of the two bones forming the lower leg, and the fibula or calf bone lies parallel with it on the outside of the figure. The ankle and foot are composed of the tarsal and metatarsal bones, and the toes are made up of bones known as phalanges. The general structure of the foot is similar to that of the hand, and yet the configuration of bones does not allow for the wide repertoire

of movements associated with the hand.

The bones of the upper extremities of the figure can also be grouped into three units comprising the shoulder girdle, the bones of the arm and the bones of the wrist and hand. The pectoral or shoulder girdle is made up of two bones: the collarbone or clavicle and the shoulder blade or scapula. They are important to the artist inasmuch as their movement visibly affects the horizontal axis of the shoulders and determines the position of the arms. The bones of the arms include one large bone from shoulder to elbow known as the humerus, and two thinner bones in the forearm known as the radius and the ulna. The construction of the arm is thus similar to the leg. The bones of the wrist are called carpals and the palm of the hand consists of five metacarpals which radiate from the wrist and connect to the phalanges of the fingers.

With the exception of the hyoid bone in the neck, to which the tongue is attached, every bone in the human form articulates with at least one other bone. The joints may be distinguished by putting them into three groups based on the amount of movement possible at the point of articulation. The least movable joints are called "fixed joints," which category includes bones fusing together as they do in the cranium to create a suture. The

next category includes joints which allow slight movement, such as between the radius and the ulna in the forearm. Freely moving joints, the third category, provide considerable freedom in different ways and these have more importance for the artist in that they determine the degree to which the body makes perceptible changes of position. Within this last category are other distinctions. A pivot joint connects the spine to the skull, whereas a ball and socket joint connects the femur to the pelvic girdle. These allow for considerable movement both sideways and vertically, whereas the hinge joint, as in the knee, is more limiting. Each joint is directly related to the kind of movement commonly made: the motion of walking or running is performed by strongly jointed bones able to carry weight whereas the joints of the wrist allow complex and delicate twists and turns which relate to the activities of the arm, hand and fingers.

At this point it is worth considering perhaps the most important part of the anatomy for the artist, namely the hand. The activity of drawing is made physically possible by the mechanism of this complex series of joints. In both structure and nervous connections, it is more highly advanced than in any other creature. It is simultaneously possible to hold

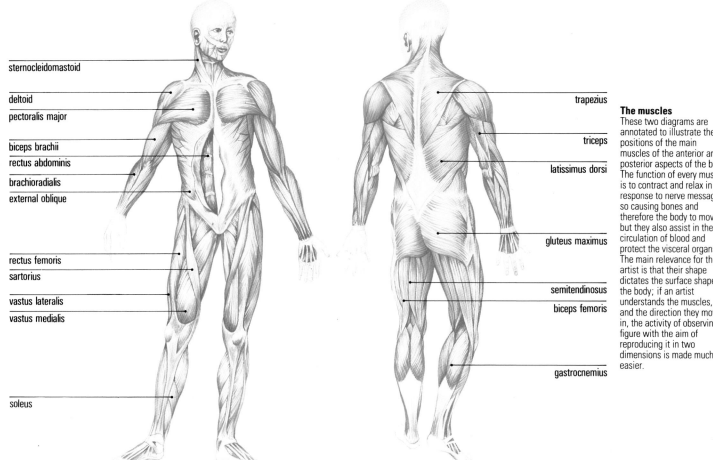

sternocleidomastoid

deltoid

pectoralis major

biceps brachii

rectus abdominis

brachioradialis

external oblique

rectus femoris

sartorius

vastus lateralis

vastus medialis

soleus

trapezius

triceps

latissimus dorsi

gluteus maximus

semitendinosus

biceps femoris

gastrocnemius

The muscles
These two diagrams are annotated to illustrate the positions of the main muscles of the anterior and posterior aspects of the body. The function of every muscle is to contract and relax in response to nerve messages, so causing bones and therefore the body to move, but they also assist in the circulation of blood and protect the visceral organs. The main relevance for the artist is that their shape dictates the surface shape of the body; if an artist understands the muscles, and the direction they move in, the activity of observing a figure with the aim of reproducing it in two dimensions is made much easier.

a pencil between thumb and forefinger and yet at the same time grip an object with the palm and other fingers quite independently. Although the potential movements of the hand are complex, they are taken for granted. Even the simplest daily operations would be inconceivable without the use of this remarkable apparatus, which can touch every other part of the body. The hand has played an integral part in man's development. The activity of drawing and painting involves the coordination of hand and brain, and although the hand itself can only produce the physical results of observation, its versatility enables an artist to convey with remarkable subtlety the intention of the mind.

THE MUSCLES AND SKIN
Linking the skeletal structure and the activity of movement is the function of the muscular system. All bodily movement is caused by the contraction or relaxation of some muscle group, and muscles can only work by pulling, and not by pushing. The engineering of the human body is such that in the physical activity of pushing against an object the muscles are in fact pulling against the joints.

Rather than consider the names of each muscular group, it is more important for the artist to recognize visually that they exist. As Jean August Dominique Ingres pointed out: "Muscles I know; they are my friends, but I have forgotten their names."

Most skeletal muscles are attached to two bones with the muscles spanning the joint in between; one bone usually moves more easily than the other. They are sometimes categorized according to the type of action they perform; for instance, muscles that bend a limb are called flexors and those which straighten a limb are called extensors. When considering the muscular structure of a figure it is important to remember that muscles are more evident if the figure is performing some activity, and in the many instances when a seated figure is observed, the bulk of the muscles will be relaxed. Strength is the result of the expansion of muscle fiber and not the addition to it; a strong person has the same number of fibers as a weaker person, and a person's complement of muscle fiber is determined at infancy and is consistent through life.

An important point in relation to the age of the sitter is perhaps best explained by one of the many observations made by Leonardo da Vinci in his study of anatomy: "I remind you to pay great attention in making the limbs of your figures, so that they may not merely appear to harmonize with the size of the body but also with its age. So the limbs of youths should have few muscles and veins, and have a soft surface and be rounded and pleasing in color; in men they should be sinewy and full of muscles; in old people the surface should be wrinkled, and rough and covered with veins,

and with the sinews greatly protruding."

It is interesting that Leonardo considers the muscular structure in relation to the skin, and in reality our awareness of muscle is to some extent conditioned by the skin which reveals and conceals it. Taken as a whole, the human skin is the largest single organ of the body and is also the only unprotected tissue of the body which intervenes between the internal organs and the outside world. Its versatility matches that of the skeleton, it enables the body to retain fluid and it protects the body against contact with harmful rays while at the same time regulating blood pressure and body temperature. It constantly and efficiently renews itself and, more obviously, contributes toward forming the particular shape and color of an individual. The color of skin is affected by a dark pigment substance called melanin, the amount of which increases with exposure to strong ultraviolet light. Skin of whatever color presents fascinating problems.

The skin is composed of two distinct kinds of tissue. The outer surface, visible to the eye, is known as the epidermis and consists of several layers of tissue that are continually being replaced by the innermost cells of this layer. The tissue beneath this is known as the dermis and consists of hundreds of nerve endings, sweat glands and hair roots. About one-third of the body's blood flows through this layer, and heat or motion affects the surface of the skin's color by reddening its

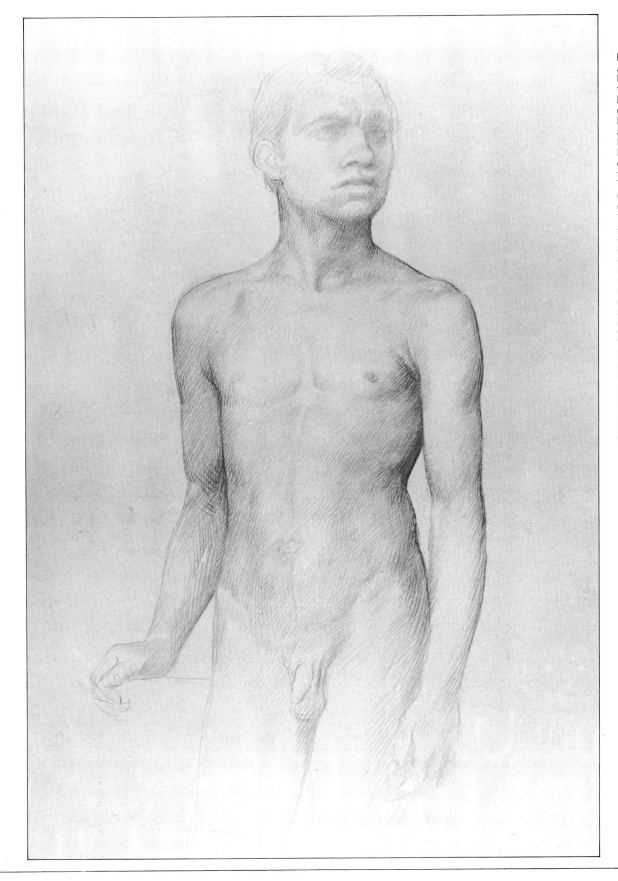

Left *Nude Male Youth*
Alphonse Legros (1837-1911).
Born in France, Legros moved
to England in 1863 and
bacame a naturalized British
citizen in 1881. He was well
known for his engravings,
and was made Professor of
Etching at the Slade School,
London in 1876. This etching
displays his familiarity with
the shapes beneath the skin.
The neck and upper torso are
drawn using hatching and
crosshatching to describe the
firm musculature. The
sternocleidomastoid muscle
attaches to the clavical from
above, while the trapezius
and deltoid muscles of the
neck and upper shoulders
merge with the pectoralis
major muscle across the
chest. The latter attach to the
sternum in the center of the
chest to form a thin, flat
valley between the nipples.
The rectus abdominis
muscles, which run down the
central panel of the torso
below the chest, are
separated by cartilage, so
horizontal ridges are visible
beneath the skin. The head
and hips are faint by
comparison with the detail of
the torso.

Right *Studies for Libyan Sybil*, Michelangelo Buonarroti. Drawn in red chalk, the main sketch describes the main contours of a youthful back, with the bulged muscles left white to indicate highlights and broad and smudged lines worked in the shadows. The trapezius muscles down the back of the neck to the shoulder and center back, the biceps and brachioradialis of the arm, the deltoid muscles of the upper shoulder and the slanting latissimus dorsi are all visible. The large gluteus maximus muscles curve away in relief. The bones of the spine and the rib cage are also visible because of the stretching position of the arms. Brief sketches of toes, a hand and the shoulder help the artist to come to terms with the desired image in his mind.

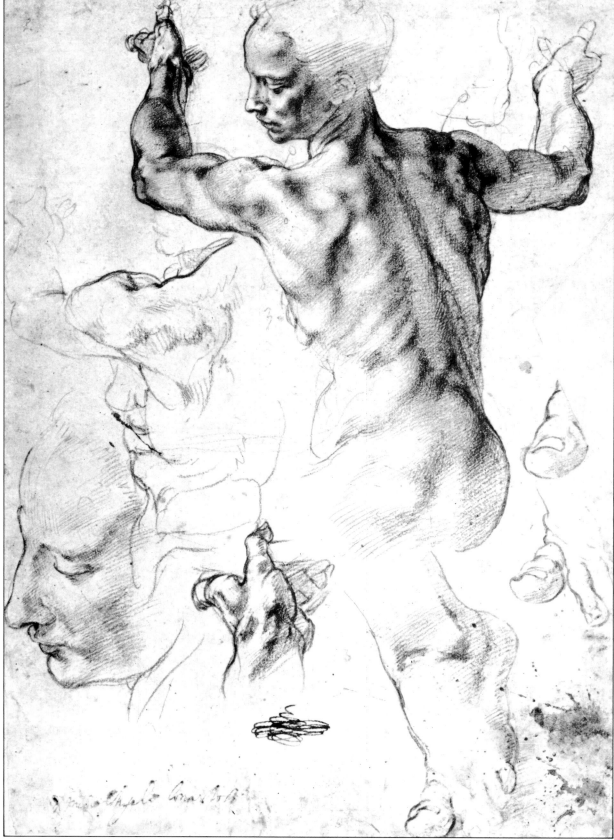

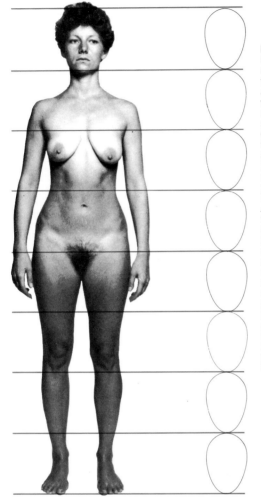

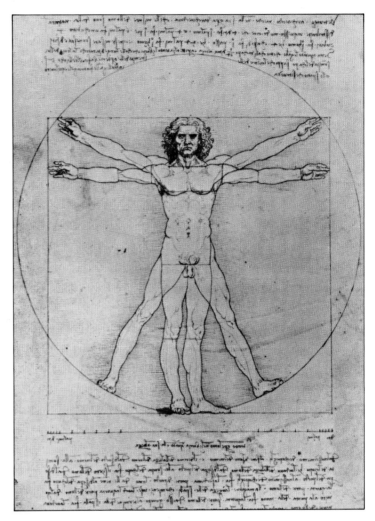

Proportion
It is useful to examine the relevant size of the parts of the figure because scale and a sense of coherence are vital to a lifelike representation. It can be seen from the row of heads **(left)** that eight constitute the height of the standing adult. Leonardo's sketch, *Vitruvian Man* **(right)** demonstrates proportion in universal, geometric terms. The idea was taken from *De Architectura* by Vitruvius, which, expounding theories about the relation of man to his surroundings, principally architecture, is the only book of its kind to survive from the age of antiquity. Leonardo displays the Renaissance concern to establish systems of scale and harmony similar to those of the Greeks, and places the image of a man within a circle and a square to illustrate the unique proportions of the human figure.

appearance. The entire body, with the exception of the palms of the hands, the soles of the feet and certain portions of the genitalia, is covered with hair, and even though this may not be always visible it is always affected by the muscular activity beneath the skin.

LIFE DRAWING
During this century the activity of drawing the nude figure, known as "life drawing," has not involved much anatomical theory and there is a tendency to try to understand the figure as if it were simply a geometric object. During and after the Renaissance, artists equipped with anatomical knowledge were able to compose figures realistically from a preconceived repertoire, often using statues for models. Michelangelo had an extensive knowledge of anatomy, but this led him to draw figures in which the muscles were exaggerated to a degree unattainable in reality. In other words, each part of the figure was presented as though performing some activity requiring muscular force. Although Leonardo da Vinci

realized that this was false, it become common practice for artists to depict muscular structure without any indication of muscular activity. Gradually, it has become common practice to draw figures using the experience gained through observation combined with a certain amount of preconceived knowledge.

The twentieth-century penchant for non-figurative art is mainly due to the influence of the Impressionist painters, in particular Paul Cézanne. Although Cézanne's training almost certainly included some direct anatomical research, his experiments with painterly problems of color and form resulted in his indicating volume with planes, which indicate changes in surface direction. In this sense, Cézanne would consider the torso of a figure as a solid volume comprised of a surface structure of many different flat planes rather than as a ribcage with muscle and skin stretched over it. Although this is an over-simplification, there is no doubt that Cézanne's attitude toward the depiction of the human figure was quite different in concept from that of prevous artists.

An awareness of the anatomy may be most useful when considering a figure disguised by clothing. The portrait painter, in particular, will often be confronted with a figure in which the only evidence of observable anatomical structure is in the hands and head, It is, however, often necessary to decipher how the structure of the body is situated beneath the clothing as it is then easier to imply the solidity of the figure.

At this point it is worth examining the relative size of the parts of the figure so that they can be presented in scale and with coherence. Any guidelines relating to human proportion are necessarily theoretical inasmuch as nature's peculiarities can never be accommodated by man's attempts to categorize them. A further reason for not dwelling on what is ultimately an idealized view of the human being is the fact that portraiture involves an awareness of an individual and as such is at odds with a preconceived notion that the size of the human body can be understood in identikit terms. The most useful reason for studying the

norm, however, is that it makes noticing the differences and the peculiarities, if they exist, easier.

The Ancient Greek and the Italian Renaissance artists favored the use of the head as a unit of measurement; this was related to the rest of the figure is such a way that it occupied one-eighth of the total height of the figure. The sixteenth-century Mannerist painters preferred a more elongated figure which was sometimes more than nine head lengths to the total figure; however, the average is much nearer to eight head lengths. For reasons of convenience the head is often used in this way; once its size has been stated on the paper the approximate size of the rest of the figure may be realized quickly.

One of the most well-known examples of theoretical human proportion is evident in Leonardo's drawing based on the ideas of Vitruvius. Entitled *Vitruvian Man*, the drawing is concerned with the way in which the outstretched limbs of a man may be related to the perimeter of the geometric forms of the circle and square. The revival of the classical ideals of human proportion emerged with the Renaissance preoccupation with man's relationship to the world. By relating the organic structure of the body to the manmade structures in architecture and painting, the artist was able to consider size, scale and proportion with reference to the needs and requirements of the human being.

In practical terms the male adult is generally larger than the female and the muscles are more developed. The shoulders of the male are broad in comparison with the hips and the reverse is true in the female. Although the size of both males and females differs considerably, the proportions across the body are usually consistent with this general physical comparison. When the artist is confronted by a model it is helpful to consider how the internal proportions of the limbs are related, and although there are always exceptions to the rule it will generally be found that a tall thin person will have a consistent thinness of proportion through the trunk, neck and limbs, whereas a short stocky person will have a consistent thickness throughout.

When the theoretical unit measurement of the head is related to the figure it is assumed that the figure is standing in an alert posture, whereas in reality the effect of tiredness often results in the weight compressing the figures in such a way that the spine bends and the head sinks. When drawing a standing figure it should be apparent that the weight of the figure is taken by the legs and that the feet are firmly flattened on the floor. In an adult the hips are midway between the top of the head and the feet. If the head is then used as a measure of length it will be found that there is

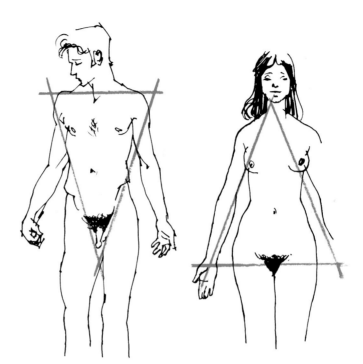

Male and female form
It is interesting to see how the male and female forms differ in these generalized sketches. Taking only the torso into account and ignoring the legs, the broad shoulders and thin hips of the idealized male figure form an inverted triangle, while the wide shallow pelvis and narrow sloping shoulders of the female can be seen as a pyramid shape. There is generally more fat in this area of the female, which accentuates the shape of the bones beneath. It would be ridiculous, however, to assume that all male and all female figures conform to a standard shape. The value of diagrams such as these is in prompting an awareness of general shapes which, in turn make it easier to spot the peculiarities of individual figures.

a similar distance from the bottom of the chin to the nipples. From the nipples to the hips will be two head lengths and again from hip to knee and knee to foot. The arms may also be considered in this way: shoulder to elbow will be one and a half heads and elbow to wrist one and a quarter heads. Although it must be emphasized that this is only an approximation, the relative proportions of arms and legs is usually the same in most people.

When the artist is confronted with a subject it is not usual to be concerned with reasons for certain aspects of growth, but it may be useful to consider that from a resulting drawing or painting the spectator will be expecting certain clues relating to the age of the model. Although the face reveals most of the information, the posture and activity of the body generally contributes to the feeling and mood that the drawing conveys. It should also be remembered that all human beings are at all times growing and changing and this aspect of life cannot be ignored.

During the first 18 years of a human being's life the rate of growth may appear to be considerable, but gain in weight is much slower than in most other animals. Even during adolescence the increase in appetite results in a relatively low increase in weight and a gain of 12 pounds or so per year is average. The normal height increase for boys is about three and half inches a year, and about two and a half inches for girls. The development of the skeleton is complex and corresponds to the growth and functions of the internal organs of the body. At birth the bones are soft, comprised of connective tissue which becomes cartilage and finally bone

tissue. The top of the skull is soft and pliable at birth and any effects of distortion during birth disappears shortly afterward. The most noticeable change in skeletal structure occurs as the bodily functions develop. At birth the neck is short, the shoulders are high and the chest is round. Gradually the neck lengthens and the shoulders and chest lower themselves as the ribs slope downward. Pubescent developments cause a boy's shoulders and chest to strengthen and a girl's hips to widen. A "shrinking" often occurs in old age, but this is not due to the bones decreasing in size.

Leonardo da Vinci was aware that apart from the physical signs of age manifesting themselves in anatomical structure, body language, indicated by different technical methods on paper or canvas, could also convey the age of the sitter. He wrote in *Treatise on Painting*: "Little children when sitting should be represented with quick, irregular movements, and when they stand up, with timid and fearful movements." These varying techniques would reflect the mood or action of the subject. In its most extreme form, body language may convey emotion in the same way as facial expression. The posture of an adult will be understandably different from that of an old or very young person and for the portrait painter the selection of posture will be partly out of choice and partly necessity. The position of the body and the mood conveyed in it are important aspects of portraiture, enhancing the emotions contained within the picture and making the portrayal more convincing.

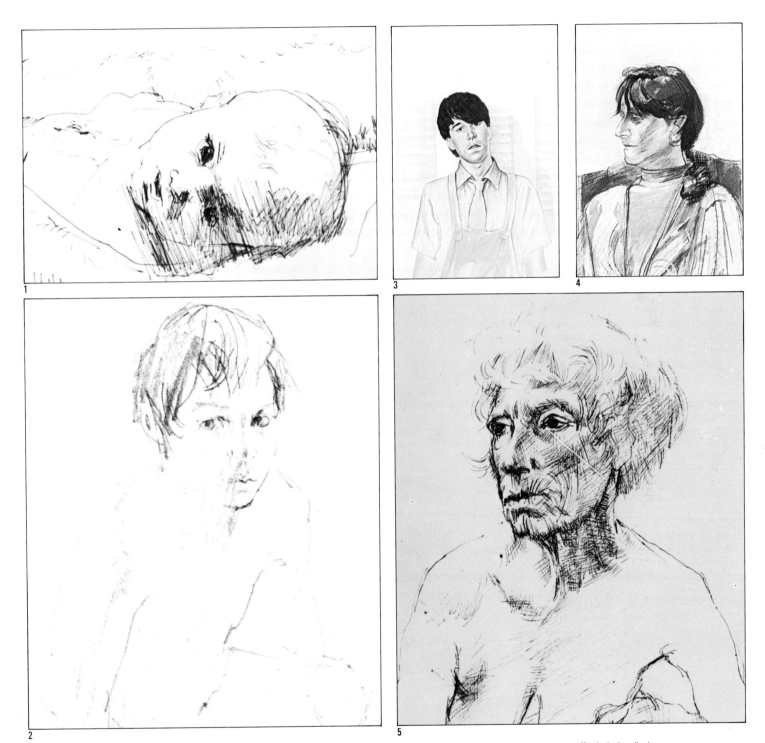

1

2

3

4

5

The effects of age
The artist should consider the medium, the composition and the pose carefully before making a life drawing. Each of these components have decisive effects on the look of the resulting picture.
1. *Saskia* is a quick, impromptu sketch of a small baby with alert, staring eyes,

drawn in ballpoint pen on thin notepaper. The brevity of the sketch and the scribbles match the jerky, uncontrolled action of a baby moving, while the dark pupils are the focal point of the portrait.
2. *Crouching Boy* is a similarly brief sketch drawn in soft pencils. The contours of his limbs positioned

askew, reflect the extraordinary agility of young children.
3. *Man in Blue Shirt* is more solid because the forms are filled in watercolor. A number of different tones, laid separately, give an impression of smooth, unlined skin by marking simple highlights and

shadows.
4. *Seated Woman*, by comparison, displays a skin just beginning to lose its elasticity. The area of the face is interestingly filled with a whole range of tones, and lines under the eye and round the mouth are highlighted and shaded. In pastels the artist was able to

effectively describe her pose and the texture of her skin.
5. This shows a detail from *Old Woman* which was drawn using a technical pen. The fine lines are exploited to portray a wrinkled skin, while the woman's position and sloping shoulders illustrate tired muscles.

THE CLOTHED AND NUDE FIGURE

Representative figure drawing depends upon the ability of the artist to see what is actually there, rather than what is thought to be there. Training the eye to discern the subject's true characteristics is of greater value than manual dexterity. When preparing to draw the figure, it is important to be aware of the qualities of the body's natural clothing, the skin, and of the drapes or clothes covering the body, at the same time as understanding the anatomy.

On healthy bodies the skin usually fits snugly, naturally keeping pace with increasing or decreasing size. Although on the very old or on people who have suffered a sudden weight loss, the skin tends to sag and hang loosely about the body, it is by nature elastic and resilient. However, at the back of the knee and the elbow and in the groin, where the joints under the skin allow movement of the individual sections of the limbs so the skin is constantly being pulled and relaxed, permanent creases can be seen on most people. These creases are useful points of reference; when making figure drawings many artists begin by mapping out their relative positions.

The quality and texture of skin varies from person to person, and this causes its appearance to differ. If skin is not protected from the elements by clothing, the style of which is often dictated by fashion or climate, it tends to lose its naturally soft texture. When compared with the soft, new skin of a baby, for example, a sailor's weather-beaten face seems almost leathery. Areas usually exposed to sun and wind are naturally darker and often coarser than areas which are usually covered; skin will adapt and form protective layers when necessary. The dark skin of races from countries where the sun shines powerfully and more consistently has evolved to form a permanent protection against harmful rays.

Skin's texture also varies over different parts of the body. The facial skin of a lady from the last century, for example, who never allowed herself to sit in direct sunlight because beauty was partly measured by the fairness of skin, may even have been given translucent qualities by an artist who wanted to give depth to a painting. The palms of her hands could not have been treated in the same way, their skin probably being a little tougher and more textured. It is interesting that, probably as a reflection of the fashion for fair skin, conventions from the past have stipulated that a lady's skin should always be painted a paler color than a man's.

The color of flesh is, however, subtle and infinitely variable. Each person has an individual skin coloring, which itself varies from one part of the body to another. Over the years, many different formulas have been suggested for the mixing and underpainting of skin color to allow just the right hue to shine

Right *Victorious Amor,* Michelangelo Merisi da Caravaggio. The outrage felt by some contemporaries at Caravaggio's worldliness and lifestyle must have been tempered by admiration for his outlandish skills as an artist. The enthusiasm he felt for life is reflected in the warm tones and extensive use of contrast and light and shade to create full-bodied figures and rich backgrounds. It is significant that Caravaggio worked directly onto the canvas from nature, using live models for his figures, rather than making the extensive preparations and revisions which were considered necessary at the time. With a well-controlled and detailed use of color and tone, Caravaggio has achieved a lifelike and realistic representation of a young boy.

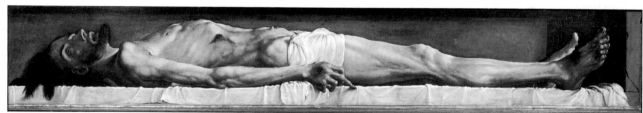

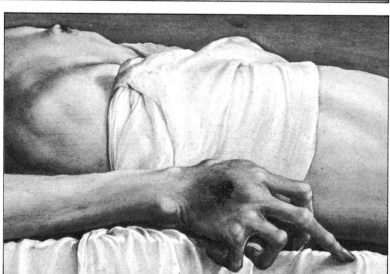

The Dead Christ or *Christ in the Tomb* (1521) by Hans Holbein. Holbein was already a prominent painter in Basel when he left for England in search of more work. He is most famous for his portraits, richly colored character studies of such figures as Erasmus, Thomas Cromwell, Thomas More, and Henry VIII together with some of his wives. This painting dates from an earlier period than his English court portraits, however, and is a fine example of his religious painting, a theme he was later forced to abandon when religious works were banned in Basel as an effect of the Reformation. In this study, Holbein used a narrow range of colors – chiefly cool tints of green and white – to reinforce his somber theme. Horrifyingly realistic, these subdued shades also serve to draw attention to the only warm color in the painting – the red of Christ's wounds. The detail shows Holbein's skilful draping of the loincloth and the precision of the anatomical detail. The colors, stark pose and masterly *chiaroscuro* combine to suggest the penetrating chill of the tomb – its confines dramatically reinforced by the unusual format. The painting is a good example of how the figure can be a vehicle for expressing universal themes.

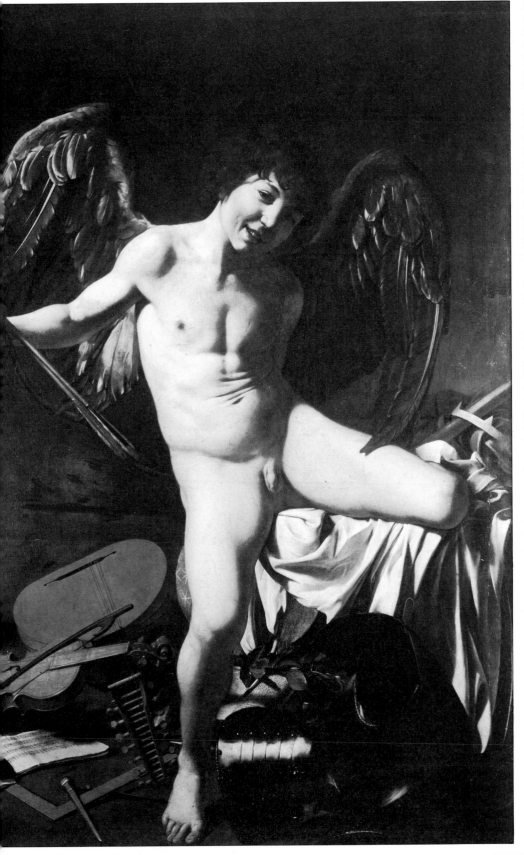

through subsequent glazes. Before painting, variations in color and tone across the body must be carefully observed. Changes may occur depending on whether the bodily temperatures or emotional mood of the model changes, or if he or she has recently been engaged in strenuous exercise.

An artist will often find that the surroundings also influence the color of flesh. Because of the reflective quality of skin, the nude figure picks up color from objects around it which in turn greatly affect the mood of the painting. By surrounding the model with a deliberately chosen range of colors, the atmosphere can be altered and controlled. Painters sometimes compare colors which they are mixing with white, a piece of white paper for instance. This makes it easier to judge tone and make adjustments until the color is satisfactory.

An interesting example of the way in which color can be used in emotional terms to convey a particular mood is the painting of *The Dead Christ* by Hans Holbein (1497/8-1543). Holbein placed the figure against a background of cool greens and whites which are reflected in the face and hand. This contrasts with the treatment of the rest of the body, which in the shadows retains some of the warmer tones associated with living flesh. The stark and uncompromising pose and careful attention to anatomical detail combine with the deliberately simple and somber color to convey a horrifying image of death.

Victorious Amor, painted by the Italian Caravaggio (1573-1610) almost 100 years later, demonstrates an entirely different handling of the male nude. This figure is a lusty, golden boy whose glowing flesh reflects the warmth of the surroundings. The composition is more complex in both tonal and linear terms, although, like Holbein, Caravaggio chose to use a narrow color range to emphasize mood.

THE CLOTHED FIGURE

The use of drapery or clothing on the figure is, at its simplest, an extension of the skin and can be treated in a similar way. Just as with the nude there are certain bones and muscles which determine the surface form, so these continue to dominate the shape of the clothed body. Even when the figure is draped in an all-enveloping costume, the solidity of form can be retained by finding clues to the structure and concentrating on them more fully. Folds and creases often give an idea of the underlying structure.

Manet's *Young Woman in an Oriental Costume,* painted toward the end of the nineteenth century, shows how, by adroit use of only a few simple folds, it is possible to imply the body underneath. The artist chose to paint this model in a costume which leaves

only the head and forearms uncovered but is flimsy enough to allow tantalizing glimpses of the body beneath. The use of this sort of costume is a popular device because it allows the subject of the painting to retain a certain decency, while at the same time giving emphasis to the very parts which are concealed. A clothed or partly clothed figure may be more erotic than one which is totally nude, and especially so if the quality of the cloth itself is sensuous.

Just as the use of certain colors can evoke particular moods, so the choice of material clothing the figure can bring about differing emotional responses in the viewer. Some kinds of cloth are more clinging than others. The qualities of silk and satin are, for instance, not at all the same as those of wool or linen. The former are flimsy lightweight materials which serve to cover the flesh while revealing the form, whereas the latter are thicker and retain much of their own character, being less affected by the shape of the body underneath. The more tactile silks and satins are a popular choice when the female body is being represented as an object

of desire.

The more robust types of cloth often reduce the figure to a simple outline which, depending on the purpose of the painting, can be satisfactory. Simplifying by a process of selection is common practice in all visual representation and made easier if the form is not complicated by elaborate, creasing clothes. Using large areas of flat color can give greater impact to the parts of the picture which are worked in more detail.

Where portraits have been commissioned the artist will often have been required to paint the sitter in some kind of formal dress, and this will necessarily have become an important element within the picture. Some of the most sumptuous and elegant portrait paintings show the subject displaying various signs of wealth and status. It is not surprising, after all, that the sitter should wish to be viewed by posterity looking at his or her best. In this type of work, the costume can dominate the painting, making a rich and intricate pattern of folds and pleats in a variety of textures and colors.

A typical example of highly elaborate

Right *Girl with Shuttlecock*, Jean-Baptiste-Siméon Chardin (1699-1779). Chardin has provided much inspiration for many artists of the twentieth century in his natural handling of ordinary realistic forms. Apart from his stature as one of the greatest still-life artists, he is also famous for his treatment of modest, middle-class subjects. This reversed study of a young woman owes its charm to his skilful use of white, the simple, formal drapery complementing the cool, settled pose.
Above right *Mealtime of the Officers of St. Jorisdoelen*, Frans Hals. One of the great Dutch masters, Hals is primarily known as a portraitist. This group picture of civic guards is one of five he painted between 1620 and 1630, at the peak of his popularity. Hals is renowned for his ability to capture fleeting expressions; this group portrait suggests in its composition the ease and camaraderie of the guards. The drapery and clothing are an important part of this effect, the overall rhythm aided by the crisp angles of the starched ruffs, the texture and weight of the costly materials and the creases and directionals of the hanging cloth behind the figures.

Cloth studies
These details of cloth from Hals' *Mealtime of the Officers of St. Jorisdoelen, Haarlem* illustrate the artist's mastery of paint. The rich heaviness of the furled silk banner, the almost transparent quality and delicacy of the two ruffs, their contrasting shapes emphasizing the artist's proficient handling of detail, the texture of the suede with its brilliant gold-embroidered decoration, and finally the luxurious sheen of the thick sash, are carefully evoked with tiny, almost invisible brush-strokes.

costume is the portrait of Louis XIV by Rigaud (1649-1743), painted in 1701-2. The mood of artificiality in this painting is due partly to the obvious posing of the Sun King and partly to the overwhelmingly rich and heavy garments he is wearing. The painting is a flamboyant gesture, not only of the wealth and power of the subject of the painting, but also of the virtuosity of the artist. He shows his skill in representing fur, velvet and lace with great conviction and careful attention to minute detail. Although it was intended as a gift for his grandson, the King of Spain, Louis was so delighted with this image of himself that he decided to keep it.

Because of the constant changes in the world of fashion, paintings which portray clothes in the style of the time are important pieces of historical documentation. From this point of view, "genre" paintings, which show ordinary people doing everyday tasks, are even more valuable sources of information since they are not dependent upon the approval of the person paying. The artist has complete freedom to show reality even in its less attractive aspects. Hals (1581/5-1666), whose ability to produce elaborately detailed and highly finished paintings shows in such works as *Nurse and Child,* was probably at his best when producing genre paintings, when the freedom of his brushwork and masterly use of paint rival the Impressionists of two centuries later. In his painting *Malle Babbe,* Hals indicated the subject's clothing using broad strokes of color which suggest the form without describing it in detail. Her white cap and ruff are painted in high contrast to the dress which, like the rest of the painting, is dark and somber. This throws the head of the figure into sharp relief and gives emphasis to the almost maniacal expresson on her face. The artist's use of white paint to pick out the highlights in energetic and jerky brushstrokes seems very much in keeping with this study of drunkenness and vulgarity.

It has been common practice for centuries to paint figures in contemporary costume in order to update old stories, so making them more relevant to the ordinary man or woman. Pre-Renaissance and Renaissance artists employed this device in their religious frescoes which helped to carry the message across to the illiterate faithful, showing characters from the Bible as ordinary people such as they might meet any day. This meant that the farmers, artisans and shopkeepers of the time could identify more easily with their Biblical counterparts and recognize them as mortals rather than saints. It also meant that local dignitaries could increase their self-importance by modelling for the more illustrious characters represented.

Often, however, costume portrayed little contemporary or historical accuracy and was

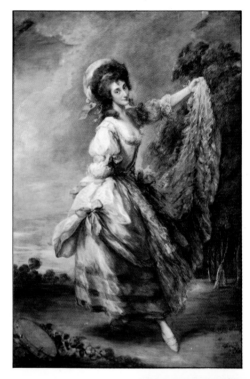

used simply as a means of giving structure and unity to a complicated composition. Mannerist painters from late sixteeth-century Italy, for instance, used swirls of drapery to give dramatic emphasis to the movement and gestures of their figures, filling the picture plane with activity. They included trailing swaths of cloth as an important element within the composition, rather than an accurate rendering of a garment which could actually be worn. These large and energetic paintings full of tumbling figures rely upon their curving masses of drapery to hold them together and, incidentally, to fill gaps which would otherwise reveal miles of landscape. The conviction with which the artists represented cloth hanging or billowing in the breeze is often countered by an air of unreality because of the bright, even brash, colors and the overwhelming grandeur of the scenes.

To draw or paint the figure with conviction requires a sound working knowledge of its anatomy; similarly, the artist must investigate and become familiar with the anatomy of cloth to be able to make full use of the way its folds can emphasize or conceal. Artists' preliminary drawings often include careful

studies of pieces of drapery. Numerous investigative sketches of this sort will encourage increasingly confident representations of a variety of textures and qualities. By noting how sharp creases give way to soft folds and by observing the differences between the character of freehanging material and that which is draped over a solid object, the artist acquires a repertoire of visual language which can be used to inform paintings of the clothed figure.

An interesting experiment in drawing, and one that is frequently given to students in art schools, is to set up a still-life group using objects that have a clearly defined shape, such as boxes or bottles, and then to cover it with a plain piece of cloth. By softening the outlines the artist is forced to give greater consideration to tonal qualities and to treat the group of objects as a single, solid form in space. Individual details will be lost but a unity and monumentality will compensate. A very ordinary collection of objects can become mysterious and interesting when presented in this way. In the visual, as in other fields of art, the statement is often given greater potency by that which is left unstated.

Repeating this experiment but using, instead of the plain piece of cloth, a number of different, coloured pieces, preferably with very positive surface patterning, will demonstrate how the entire effect can be changed although there is no alteration in the structure of the group itself. The character of the objects underneath will be dominated by the noisy chatter on the surface. By emphasizing the decorative quality of the cloth, the volume and solidity which were so positive in the previous group become far less apparent, and sometimes unrecognizable. It is easy, at this point, to move away from objective realism into the realms of abstract painting. Paint applied as flat areas of bright color will tend to destroy any illusion of depth. Using color and tone skilfully, an artist can control the level of abstraction. Many painters employ a system of simplifying and flattening shapes to arrive at pictures which, although figurative at the outset, no longer have any apparent link with the reality. Some find this a fascinating area for study and have devoted a great deal of time and energy expanding on this theme.

These same experiments can be tried using people instead of objects underneath the drapes, and similar effects can be observed. A model posed in a reclining position will take on new dimensions when entirely covered by a large sheet. The interpretation of reality can become much more personal when the immediately recognizable aspects of the figure are hidden. Having learned how to represent the figures as a working machine, the artist is free to focus attention on particular areas

Above *Giovanna Baccelli* (1782), Thomas Gainsborough (1727-88). In this full-length portrait, the clothing is an important part of the composition, helping to convey a sense of movement and vitality. The pose, visible brushstrokes and blending of the figure into its landscape setting all increase the sensation of spontaneity and gaiety. In later life Gainsborough often painted his models using an unusual method – he placed his canvas the same distance away as his model, to form an angle of 90° between sitter, painter and canvas. Using a pair of fire tongs to hold his brush at arm's length he would then make marks on the canvas. The purpose of this technique was to lessen control over the brushmarks and to force himself to see the portrait in the same way as he saw the person posing in front of him. Gainsborough's understanding of character and anatomy was as profound as his love of landscape.

Right *The Clown Don Sebastian de Morra*, Velazquez. The unusual and direct pose of this dwarf, a jester from the Spanish court, reveals the strong human understanding and sympathy Velazquez brought to the art of portraiture.

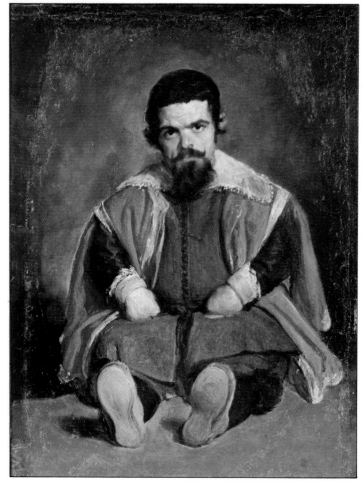

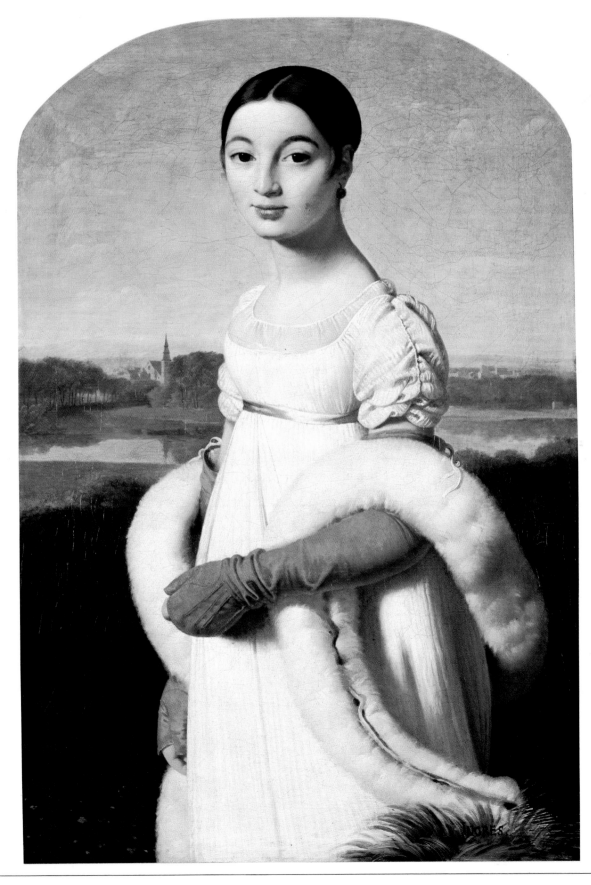

Left *Mademoiselle Rivière* (1805), Jean Auguste Dominique Ingres. Typical of many portraits Ingres made of well-to-do sitters, this painting shows a sensitive treatment of the contours of the body, with the lines of the figure accentuated by the folds in the thin material of the dress. The angle of the elegant, long neck and uncovered chest, with the face turned toward the viewer, invites an inquisitiveness into the quality of her skin, the texture of which is made to contrast with the luxurious textures of the fur and satin. The curve of the fur reinforces the form of the face and shoulders, its delicate softness juxtaposed sensuously against the wrinkled gloves and the sheen of the satin ribbon.

which can be distorted or disguised at will; the figure can be used as a starting point only, before moving on to highly subjective and fantastic images. The parallel between the draped figure and a gently rolling landscape has been exploited by a number of artists, some of whom have chosen to use this as a deliberate visual metaphor. When the viewer is forced to see the human figure from a new angle, its very familiarity makes it exciting.

Again, with a figure instead of a still life, the disintegration of form which is caused by the imposition of a highly decorative covering can be used as an area for exploration and discovery. The ambiguity of solid form combined with flat pattern has stimulated the interest of many and prompted artists such as Pierre Bonnard (1867-1947), Paul Gauguin (1848-1903) and Henri Matisse (1869-1954) to make paintings which investigate the various possibilities. The strong influence of Orientalism which pervaded art of the nineteenth and early twentieth centuries is at its most apparent here. The emphasis is decorative and calligraphic and the figure becomes merely incidental. Gauguin considered a sense of mystery and decorative design to be two of the most important elements in art, and felt these aspects were being left behind by an age which was becoming increasingly mechanized and over-sophisticated. The scientific approach that had so excited the Impressionists had become, for Gauguin, a mere copying of nature, simple statements of fact which left little room for the imagination. He used the system of simplifying forms and colors until they made a decorative pattern in their own right and himself termed it "abstraction."

Gauguin's sojourn in the South Pacific was to have a profound effect on his work, bringing out essentially intuitive responses to what he saw. Guided by his respect for non-European art, he broke with the traditions laid down by the artists of the Renaissance and started the movement toward Expressionism and Surrealism. The paintings which he made during his time among the people of Tahiti, where he lived for some years between 1891 and his death, are concerned with creating a symbolic atmosphere without providing a logical explanation. He painted figures whose brightly patterned native dress argues with the exotic landscape in which they are set. The distinction between figures and background is minimal since Gauguin's love of strong colors and simple shapes makes for some paradoxical tonal and spatial relationships. His admiration of the savagery of primitive art forms combined with his passion for harmony and simplicity led him to make paintings which were lyrical and moody and yet hinted at religious and superstitious beliefs. His contemporaries found these results difficult to accept. During his lifetime he remained largely misunderstood and it was not until after his death that Gauguin's contribution came to be fully recognized and admired.

Gauguin died in 1903. His influence became apparent within a few years when a number of young French painters, including Matisse, Derain (1880-1954), Vlaminck (1876-1958) and Rouault (1871-1958), became known as the Fauves or "wild beasts" because of the intense savagery of their colors and images. In Germany, a group of Expressionist painters called *Die Brücke* aimed to create a new and

Right This cheerful study by Goya captures the subject arrested in the course of her movement. The treatment of costume here provides a vehicle for exploiting the contrast of light and dark, an interest Goya derived from his two greatest influences, Velazquez and Rembrandt. The straightened back and happy pose are emphasized by the hang of the clothes.
Center *Autoritratto* (1910), Egon Schiele (1890-1918). The artist was 20 when this drawing was made; only 28 when he died. At this point, his style is characterized by an Expressionist concern for emotional content. The clothing in this example is used to delineate the form beneath, the distortion and emaciation of the figure given added poignancy by the way the material gathers about the body.

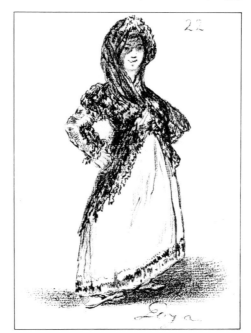

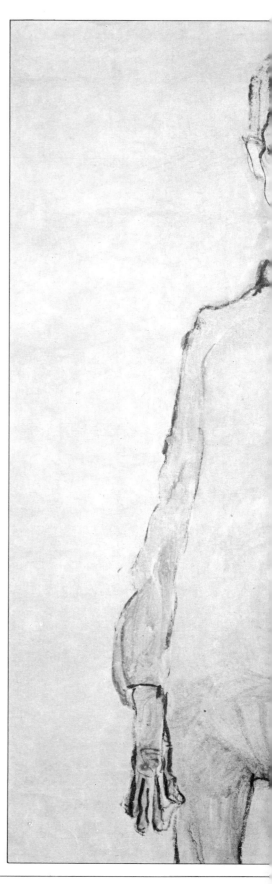

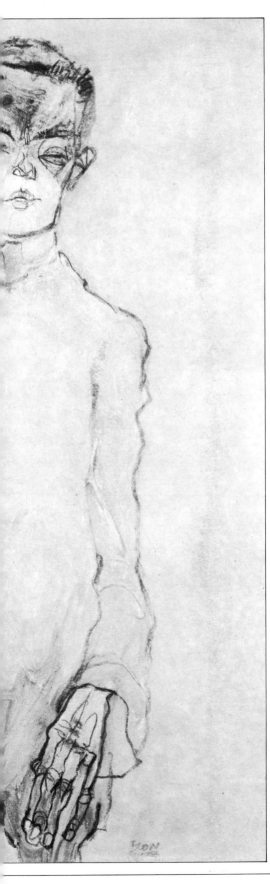

antinaturalistic form of painting. They represented the human figure in a deliberately brutal way using costume to slash in areas of color.

Matisse was the most important and influential painter among the Fauves and had a more deliberate and less spontaneous approach to painting than the Germans. Even so, his work, being fundamentally intuitive, fell within the Expressionist ideal. Like Gauguin, Matisse had a high regard for Oriental art and was concerned with the concept of simplicity. He painted his figures in simple lines and flat colors, often using a single color to give a great intensity of mood. He saw costume as a way of introducing ornamental pattern, although his aim was not simply to decorate but to express life itself.

In his later paintings he became almost obsessed by the nude figure, although he retained the individual decorative quality of his paintings by setting them against brightly colored backgrounds. His *Pink Nude*, which was painted in 1935, moved close to total abstraction: the figure itself is a stylized outline, filled in with a hot pink with only arbitrary variations in hue. This is set against a large geometric area of brilliant blue and white checks, with further decorative elements being introduced by a strip of red and pink, a blob of bright yellow and more checks in green and white, all occupying the top third of the painting. Matisse said that his paintings used "beautiful blues, red, yellows, matter to stir the sensual depths in men."

Matisse and those who followed him became increasingly excited by the abstract qualities in their work and for a time figurative art was not a popular element in modern painting. However, having taken abstraction to its logical conclusion, many artists have found it to be too limiting and have returned to figurative representations.

CHOOSING A COSTUME

How the artist chooses to dress a model today will be dictated to a large extent by the sort of painting he or she intends to produce. If it is with the human body itself that the artist is primarily concerned, then simple drapes will probably be preferred. This will allow a study of the way in which form is revealed by the

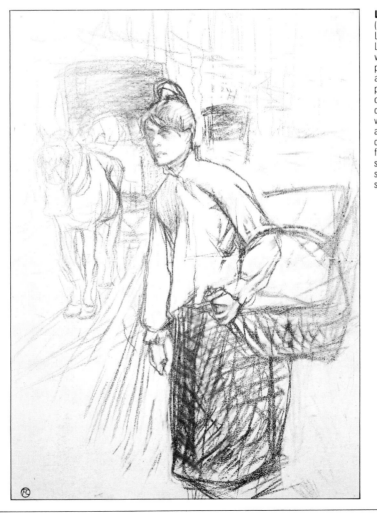

Left *The Washerwoman* (1888), Henri de Toulouse-Lautrec. Around 1888, Lautrec became fascinated with portraying the ordinary people of the cafés, streets and theaters of Paris. The flat patterns and strong outlines of Japanese prints in this charcoal drawing of a washerwoman display another interest he developed at this time. The figure is treated almost as a silhouette, with the clothes serving to outline the overall shape and express character.

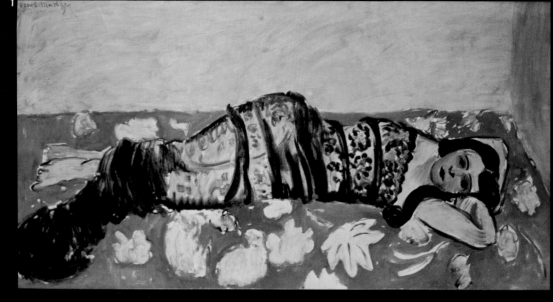

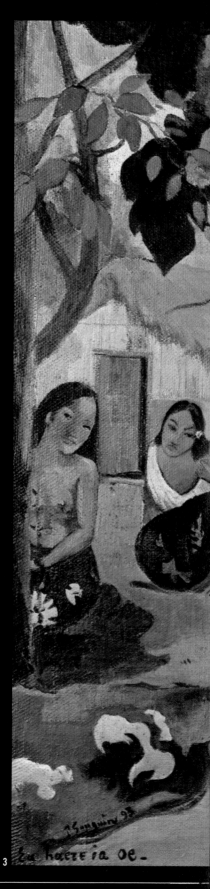

1. *Lorette VII (L'Echarpe Noire),* Henri Matisse. The suggestive pose of this model is given added piquancy by the clinging, transparent material covering her body. Throughout his life, Matisse was particularly interested in the decorative aspects of pattern and color.

2. *Seated Woman in a Chemise* (1923), Pablo Picasso. The monumentality and calm grandeur of this figure almost gives it the appearance of classical sculpture. The angle of view helps to produce this effect as does the relative distortion of the hands and head. Another equally important element is the clothing, nominally a chemise, the thin drapery is arranged and depicted in such a way as to bring to mind the thin coverings of classical figures.

3. *Ea Haere la Oe* (1893), Paul Gaugin. Gaugin produced his finest work during his sojourns in the South Sea island of Tahiti. Here the costumes worn by the native women are derived from the real world, rather than the artist's imagination, the patterns on the material reflecting the natural surroundings, leaves, fruit and flowers. The painting gains its symbolic and emotional power through the tension which exists between the real activity portrayed by the artists and the action on the flat surface of the canvas – the way the colors, shapes and patterns work together.

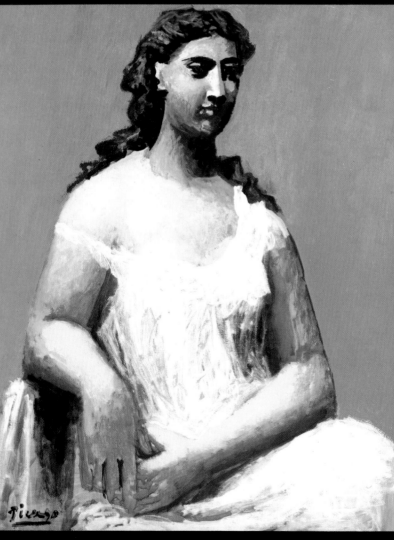

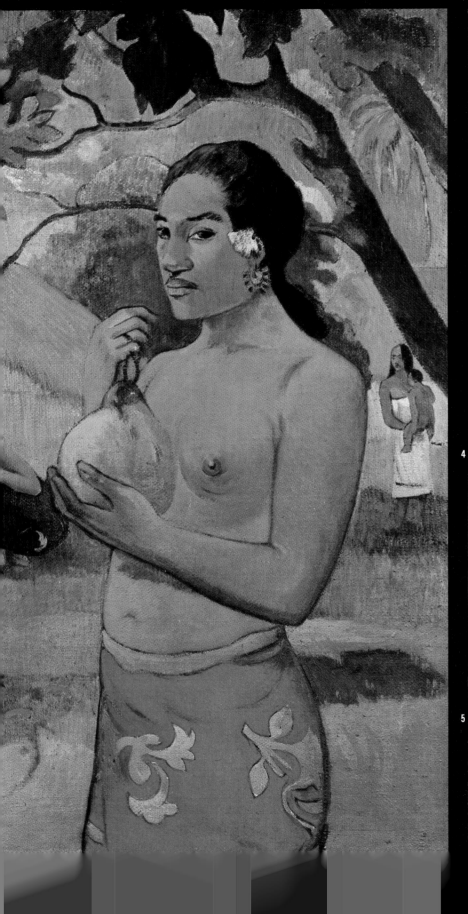

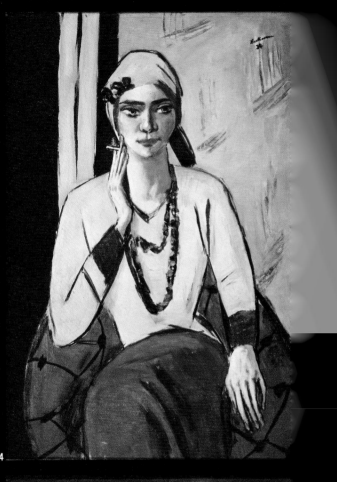

4

5

4. *Quappi in Rosa* (1932), Max Beckmann. This portrait owes much of its power to the full integration of tone, color, composition and brushwork. Although the woman is in 1930s dress, this does not detract from the strong emotion or timeless quality of the painting.

5. *The Travelling Companions,* Augustus Egg (1816-1863). An outstanding feature of this painting is the delight with which the artist has observed the dresses. The composition is a subtle play on a mirror image, the eye being led from figure to figure to spot the small differences.

rhythms of the cloth and the ways in which the figure exists as a solid object in space. To emphasize the bulk and volume of the figure, a single light source can be used which will reveal the model as a mass sculptured by light and tone.

It may be that the artist is interested by particular types of dress. Pablo Picasso (1881-1973) was fascinated by the theatricality of costume, especially in the early years of his painting career. He made paintings of Pierrots and Harlequins, often contrasting the gaiety of dress with the apparent melancholy of the model: the sad clown image. Edgar Degas (1834-1917) was another painter who was interested by theatrical dress. He made numerous studies of ballet dancers, which exploited his skill as a draftsman, and also visited the racetrack where he became engrossed in the multicolored jockeys set against the green of the turf. Henri de Toulouse-Lautrec (1864-1901) frequented the circus where the combination of bright lights and garish costumes became a source for several of his paintings. Athletes, ballplayers, fighters and sportsmen are a favorite choice of subject matter, both because of their decorative attire and because they show the

Right *Three Figures in an Attic.* In this modern oil painting of three figures in a garret room, the artist has created a still, cool atmosphere by establishing a single light source which bathes the models. Their stillness is further emphasized by the plain cut and somber colors of their clothing set against the steeply receding patterned carpet and bed, which isolate the figures from each other. The light-colored clothes of the man on the left emphasize his height, complementing the strong horizontals of the walls and door and the steeply angled diagonal over his head. A divorce is created between the standing figure and the two on the bed, not only through the positions and expressions on the faces but also through the contrast between the light- and dark-colored clothing, and the fact that the light falls most strongly on the standing figure.

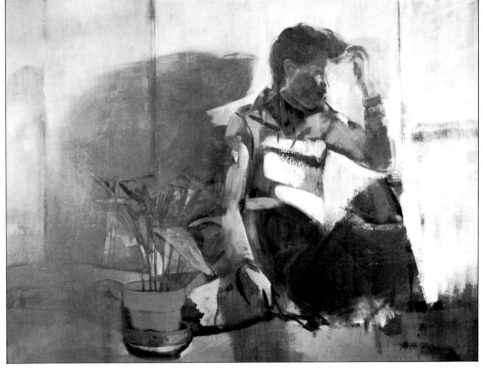

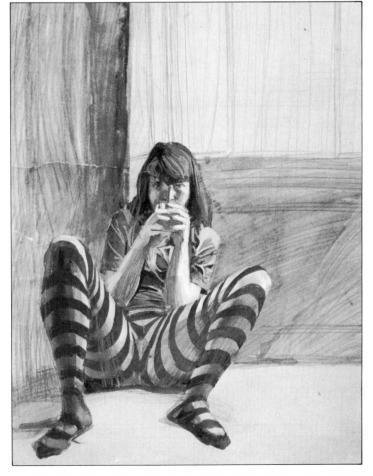

human body in action and, usually, in the peak of condition.

An interest in modern costume would obviously prompt the artist to find a model whose style of dress was up-to-date. Fashions are always changing and, to a certain extent, everyone is influenced by the mood of the moment. It is, however, the way in which individuals adapt current trends which gives the clue to personality. The artist who wishes to present a modern image would need to paint from a model whose dress sense is naturally lively and modish. This kind of painting can be both a portrait of the person and of the age.

The one constant element in all these approaches to painting a clothed model, regardless of whether the artist intends to emphasize decorative, tonal or linear qualities, is that the underlying structure is the human body. Even though deliberate distortion, using as a basis a sound knowledge of anatomy, has frequently been used by highly skilled and experienced painters to develop a particular idea or theme, anatomical mistakes as a result of ignorance, even where it is not part of the artist's intention to give an accurate rendering of the figure, will almost inevitably jar. Painting is a form of communication and has its own visual language. To make a visual statement with authority requires a thorough knowledge of the way in which this language works. There are no short cuts: the rules have first to be learned before they can be broken.

Above left *Seated Girl.* The model in this oil painting is wearing a loose sweater over a red shirt and jeans. Light comes from the upper left illuminating the sitter's reflective expression and strongly modelled features, and the red jeans throw her arms and clasped hands into relief. The casual clothes create a sense of naturalness and informality.
Above *Figure in a Courtyard.* The artist has placed his model in the strong shimmering light of day, and a hot, dazzling effect has been achieved with the light reflecting off the white background. Form is dissolved in light, the broken outlines emphasizing the glare and the broad stripes across the sitter's chest contrasting with his darker clothes. Although the sitter's face is obscured, his hair and shirt with upturned collar denote his youthful, trendy dressing.
Left *Girl in Striped Tights.* This watercolor and gouache painting is strongly dominated by the bold, curving lines of the zebra tights which the sitter is wearing. These demonstrate the artist's desire to delineate the volume and structure of the figure and its muscle formation in an unusual way.

GIRL IN VEST AND BOOTS
mixed media on paper 15×10 inches (38×25 cm)

A rich sense of pattern and an extravagant concern to wear a variety of materials were the obvious characteristics of this model's dress sense. When interpreting a strong arrangement of colors and textures, care should be taken not to let such things dominate the personality of the model, unless a sense of decoration or ambiguity is the artist's intention. The various textures of mixed media are used here to reflect the variety of clothes, while, at the same time, the clothes enhance the model's personality, which included feelings of delight, indulgence and nonchalance.

The personality is also brought out in the way the model is posed. The positions of her arms are contrasted: one is relaxed along the arm of the chair, the other raised. The legs are crossed so as to bring both shoes in view at an interesting conjunction. The shoes are given due exaggeration to stress their uniqueness. Contemporary dress is often as bizarre as dress from previous historical periods and thus provides an interesting area for exploitation.

Using pencil on drawing paper, the model's eyes are drawn in some detail, the rest of her face and shoulders following (2). The eyes act as an anchorage while drawing a point of reference for the relation of the other details of the face, also the jewelry, sunglasses and the shape of the vest lapels. A thin black watercolor wash is laid for initial shadows, the black being mixed with a minute amount of Indian red to give it some warmth. With delicate washes of yellow ocher, warm green and burnt sienna, color is applied to the clothes, and when dry a more complex sense of form and texture is achieved with touches of darker tones and further black delineation. A flat wash is laid for the shadowed areas of the legs, the spontaneous brushmarks describing the tension along the thigh (3). Outlines of the arms, hands and trousers are pencilled in and blatantly corrected, and details such as the watch, bracelet and cushion are solidly described (4).

The model is viewed from above in order to emphasize the angles of the arms which create a tension across the main diagonal of the body. The slanting view also enables emphasis to be given in the finished picture to the shape of the boots, the sharp corners of their heels and cuffs echoing the elbows and, together with the angles of the knees, forming a pleasing compositional structure (1).

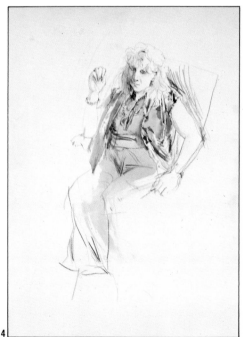

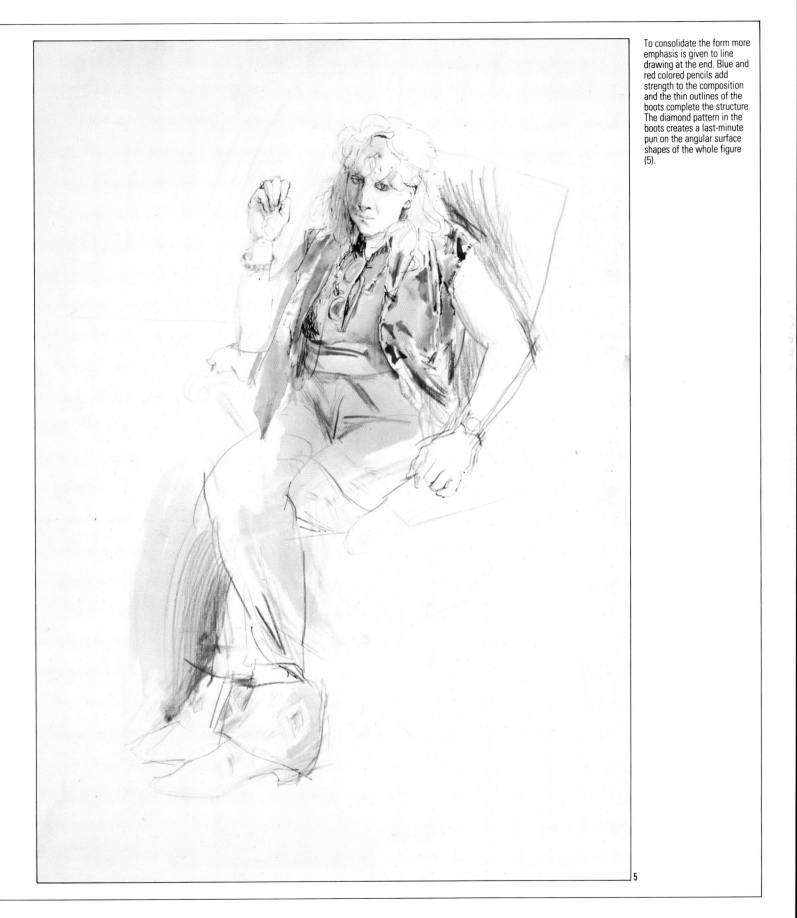

To consolidate the form more emphasis is given to line drawing at the end. Blue and red colored pencils add strength to the composition and the thin outlines of the boots complete the structure. The diamond pattern in the boots creates a last-minute pun on the angular surface shapes of the whole figure (5).

5

GIRL IN FEATHERED JACKET
pastel on paper 23×32 inches (58×81 cm)

The richness and subtlety of the pastel medium enables the artist to work with freedom, making a variety of marks at the same time as maintaining and reinforcing the initial drawing. It is possible to establish a wide range of shades and tones using different techniques, including hatching and cross-hatching, and overlaying and blending colors. Otherwise, if a multitoned effect is not required, a large number of different colors and shades are readily available at art suppliers. The real beauty of the pastel medium is its purity. It is one of the most direct ways of applying pigment to a surface, being only lightly bound in gum. The resulting brilliance of each color and the way pastels allow artists to work directly in blocks of color or with a linear approach are the most obvious reasons for the popularity of the medium. Its disadvantage is that pastel tends to crumble easily, and needs delicate treatment and frequent fixing at all stages.

Ascertaining a subject's tonal values is important in any medium, particularly with pastels because it is worth taking advantage of the wide range of colors and tones available. Viewing a subject with half-closed eyes cuts out a certain amount of detail and allows tones in the subject to be matched and contrasted with greatly increased clarity. The main problem in this drawing involved relating the predominating areas of mid-tones – the skin, jacket and background all being of a similar intensity.

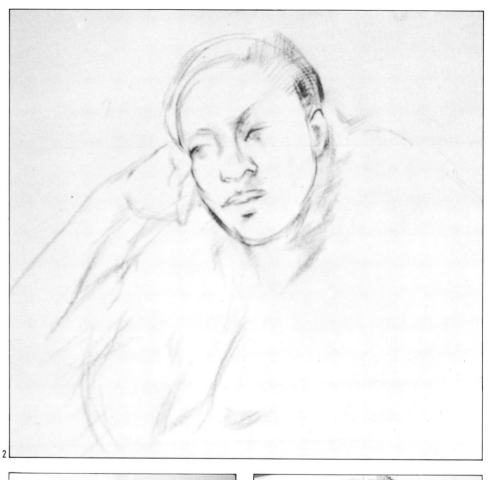

The model is in a relaxed and comfortable pose, semi-reclined on cushions, her head resting easily on a crooked arm and her legs pulled up toward her. The artist chooses to view the subject by placing himself to one side, so that the model's left shoulder gains prominence. The structure of the composition is nicely balanced, with the crooked arm and the bent leg almost creating a vertical symmetry (1). The focal point of the composition is the slightly angled head, and the artist establishes this area by drawing quickly in soft, brown pastel. Outlines are drawn first, but the artist fills in the face in considerable detail to get a feeling for this crucial area of the composition (2). This linear approach allows the relationship between the model's face, fingers and the open neck of the feathered jacket to be built up spontaneously.

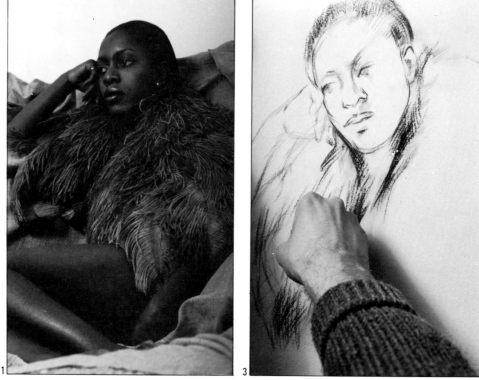

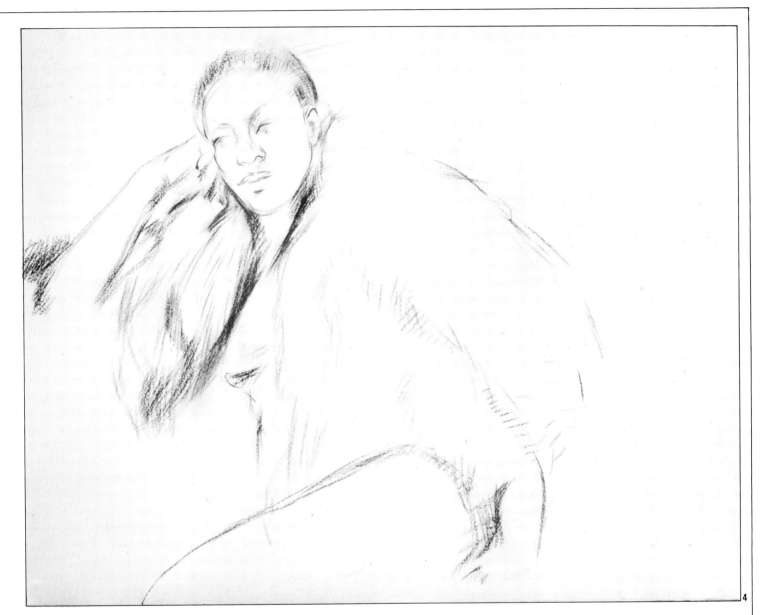

This gives the drawing a liveliness and depth and helps to establish a wider tonal range. The rough texture of the paper shows through, also giving an added sparkle and vivacity (3). With the key section of the drawing firmly described, the next stage is to block in the rest of the form. The importance of the line of the crooked arm, which leads the eye to the subject's face, is reinforced by the line of the bent leg, giving an overall harmony to the composition. Even at this early point in the work, the quality of space is well defined, the positive and negative shapes having equal importance. The lines describe not only the form of the figures, but make the undrawn areas on the paper work as well (4). The problems of successfully rendering form with light and shade are acute whatever the color of the skin. At this point the artist is concerned with developing tonal qualities and bringing out the contrast between the smooth flesh of the model and the interesting texture of the feathered jacket. The dark areas of the hair and neckline are reinforced. The subject is sitting in natural light, which is coming from the lefthand side (5).

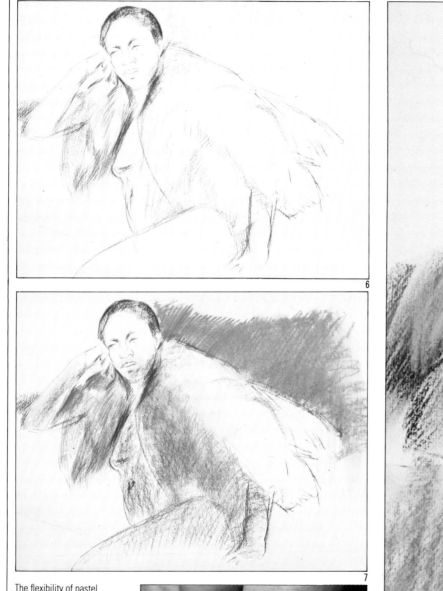

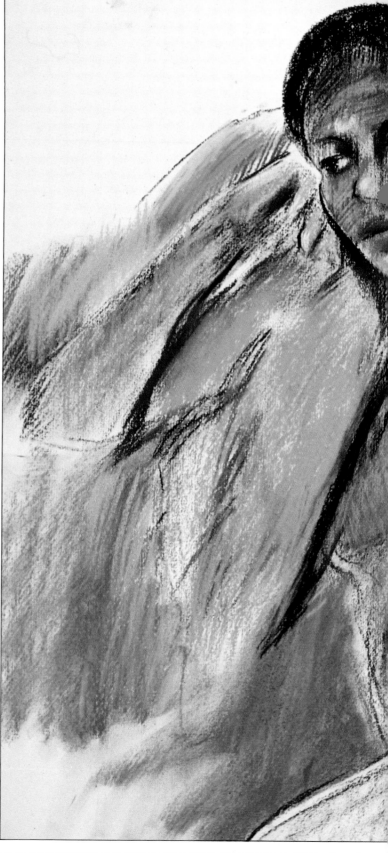

The flexibility of pastel means that the artist can alternately delineate and shade. Here loose strokes of light mauve suggest the softness and bulk of the jacket, while areas of hatching bring out the shadows (6). A vivid, blue-green background is added, the shade being echoed on one side of the jacket. Other colors are introduced and the basic flesh tone laid (7). Toward the final stage of the drawing, light hatching is overlaid on areas of blocked-in color to make accents and highlights (8). In the finished drawing, all areas are firmly established, while the spontaneity of the original sketch is retained (9).

SEATED NUDE BY WINDOW
pastel and chalk on paper 20×15 inches (51×38 cm)

Pastel is a delicate medium, providing a range of brilliant colors and the possibility of working one over others until the result almost looks white. Chalks are more incisive, harder and produce fine lines, allowing the artist to draw with a vigor impossible in pastel. Both these media allow the artist to work light over dark and make changes or adjustments while work is in progress. Models are likely to move, however subconsciously or surreptitiously, while they are posing, and in order to keep the picture alive, the artist must be able to respond to these changes. Often, a particular pose will not suit a model and he or she will move to a more natural, comfortable position. This encourages the creation of more natural and lively drawing. Such changes need not totally obliterate the original work.

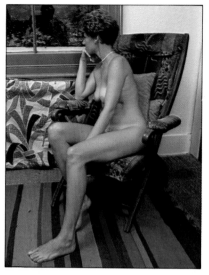

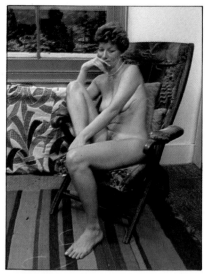

1

2

The model's first pose, with both feet touching the floor and her head twisted to look out of the window, proves uncomfortable, and despite the initial drawing already being established, the model moves to a position in which she can relax. The two strong lines of her back and her left leg need only slight readjustment and the positions of her neck, head, arms and right leg are changed, although the points of reference remain constant. The first sketches are made in blue pastel, the artist feeling for the pose and quickly relating angles and positions (1,2). With some solid work in shades of blue and red, areas of the figure are shaded and the form fills out.

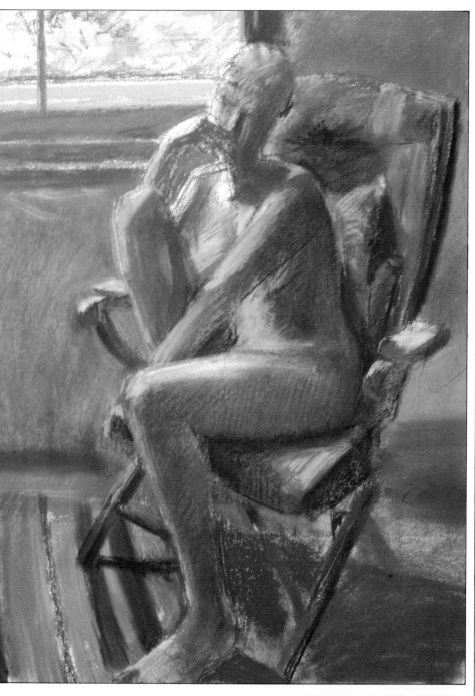

The whole picture is worked using a complex system of laying and overlaying colors in different combinations, so that the underlayers show through. The result is an overall sense of unity and a subtle feeling for form. Positive background shapes are laid in blocks of color (3). The patterns of the background cloth are ignored and a single color is implied, with brighter pastels used nearer the light source. Using the heavier chalks, earth reds and browns are added to bring out the form of the figure, and build up the arm of the chair over the background blue (4). Chalks and pastels combine for the bold stripes of the carpet, which provide a tension with the diagonal of the chair. White and yellow highlights in both pastel and chalk, which is illustrated in this close-up (5), give a strong impression of the indirect sunlight falling into the room. Some of these are blended and smudged into the colors beneath, with further lights added in the final stage. Hatching with contrasting pastels over the already blended and fixed colors creates final subtle shading. Indigos and blues are used over the left thigh, and pinks over the chest and left arm (6).

THE FIGURE SEEN IN CONTEXT

The context of a painting is, in a pure sense, any suggestion of a background or setting which locates the figure in space. It is possible to represent the figure without indicating surroundings, but when it comes to finished works, particularly paintings, artists are inevitably involved with some notion of context. The background may be abstract, even of a totally plain color; more usually, the artist places the figure in a setting which gives an idea, sometimes very precise, of the world the figure inhabits. The details of the setting may also imply the world the artist inhabits, as they often provide essential clues to man's self-image at any one time, revealing certain moral and ideological preoccupations. In the West, in an age of relatively free expression, they tend to reveal the artist's personal viewpoint.

Artists have not always had the freedom to present the figure in any chosen manner, as is generally considered possible now. Social and moral constraints have at times proved too powerful to be ignored, and have often prevented artists from being honest or explicit. The artist of the Middle Ages was little more than the humble bearer of God's word. Since then, classical notions of beauty and the purity of the human form, derived from Greek representations of the body, have provided both an enduring artistic ideal and a convenient excuse for portraying the naked form during the periods when such exposure was frowned upon. In the same way, religious, mythological or historical themes could be called upon to furnish safe backdrops for artists to display their primary interest.

In the Renaissance, the beauty of the human figure was openly appreciated as it had been in Greek and Roman times, although it was still felt that the themes of paintings, whether they included nude figures or not, had to be based in either myth or religion. Carrying this tradition into the nineteenth century, Jacques-Louis David (1748-1825) painted the nude figure with the notion that it was justifiable if the figure "represented the customs of antiquity with such an exactitude that the Greeks and Romans, had they seen the work, would not have found me a stranger to their customs." Under the patronage of Napoleon, the politically motivated work of this artist came to be highly influential, reflecting the new cult of devotion to duty and austerity in France at the time.

Another French painter in this classical mold was Ingres (1780-1867), who studied in David's studio. Despite the apparently detached quality of his work, he was an emotional and imaginative artist and came to be accepted as the champion of a classical idealism, completing works with titles such as *The Triumph of Romulus over Acron* (1812) and *Apotheosis of Napoleon* (1853).

Two centuries earlier, in mid-seventeenth-century Spain, the great Velazquez painted his only nude, the *Rokeby Venus*. Spain was particularly slow in relaxing the strict moral code of the Middle Ages, and the work must have been considered severely shocking. In spite of its classical disguise, which led Velazquez to add, as an apparent after-thought, a cupid holding up a mirror into which the reclining nude is looking, there is a freshness and lack of idealization in the painting. This is partly due to the unusual pose, with the figure seen from behind, which allowed her a freedom from coyness because the viewer is unapprehended. Mirrors are often considered useful props; they allow the viewer to glimpse the subject from another angle, so reinforcing the three-dimensional sense of space.

By contrast, in the mid-eighteenth-century French court of Louis XV, blatantly erotic nudity was accepted and encouraged. Works by François Boucher and Jean Fragonard, for example, show little attempt to render the indecent decent in mythological disguise; even the pretence of classical respectability was abandoned. These paintings reflect the taste for frivolity and exaggerated gallantry prevalent in the French court at that time.

In northern Europe the desire to be rid of pretence and disguise manifested itself in a different way, and led to a fashion in genre painting exemplified by such Dutch works as *Boy Removing Fleas from his Dog* by Ter Borch (1617-81) and *A Woman and her Maid in a Courtyard* by de Hooch (1629-83). The paintings of Jan Vermeer of Delft (1632-75) are in a similar style although they demonstrate his particular mastery of color and the effects of light falling into a room. He often chose everyday, domestic scenes for subject matter, such as *Maid Servant Pouring Milk* or *Music Lesson*.

A similar authenticism was propounded by

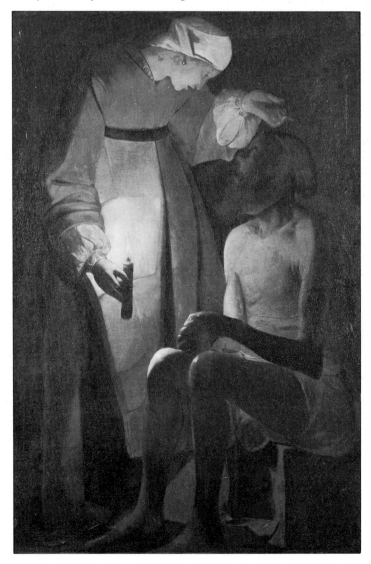

Left *Job Mocked by his Wife,* Georges de la Tour. The subject of this painting is not the figures, which would have little interest taken separately out of context, but the emotion expressed between them. This is emphasized by the single candle, its light creating a world for them and cutting out the background. Sympathy for Job's vulnerability is evoked by his wife's overbearing attitude and the gesture of her hand as well as his nakedness and low position. The simplified forms of this painting give it a deceptively modern appearance; in fact they are often considered to reflect a revival of interest in the Franciscan way of life which took place in Lorraine, where de La Tour worked, in the early seventeenth century.

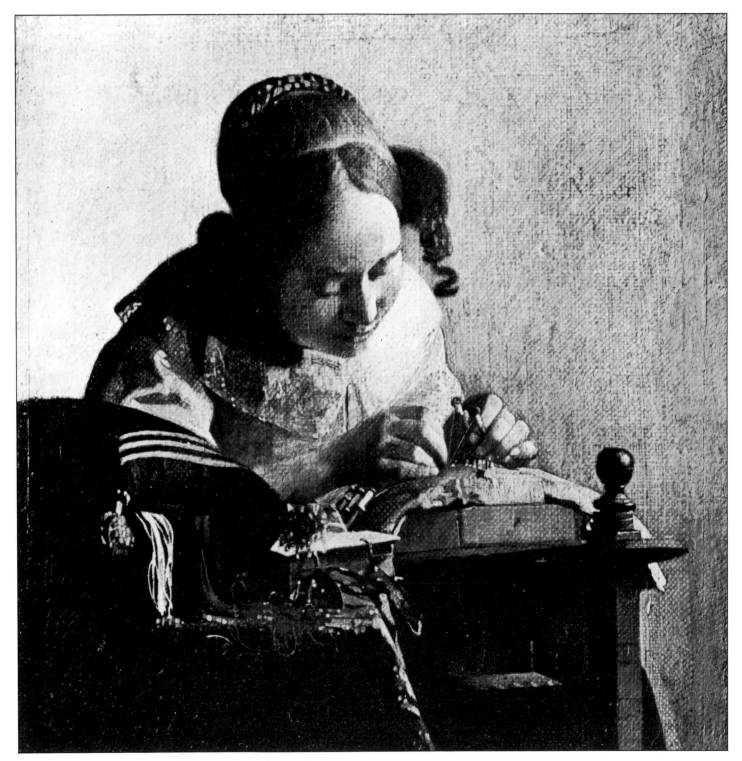

Above *The Lacemaker*, Jan Vermeer of Delft. The context of this genre painting is domestic, and the scene is informal and unpretentious, with the lacemaker's accoutrements scattered in seemingly haphazard disarray. The composition is, however, beautifully designed: the strong lines of her hair, collar and arms, of the cushion and the edge of her worktable are all directed toward her hands, to the action she is making, so allowing the viewer to share her concentration, as if sitting just in front of her. The portrait is charming and intimate because the subject and the setting are natural; it is a simple comment on the everyday life of a young girl.

the self-named pre-Raphaelite Brotherhood painters in Victorian England. The founding members of this group, Dante Gabriel Rossetti (1828-82), Holman Hunt (1827-1910) and John Everett Millais (1829-96), stated their aim as a desire to return to a more natural life than the new enthusiasm for machinery allowed; their inspiration was the world of medieval romance. In their determination to present verity they worked a great deal from life and included careful detail in their paintings. Hunt, in particular, produced work of great seriousness and historical accuracy, even travelling to Palestine in order to give his pictures an authentic flavor.

Working at the same time in France was Gustave Courbet. He began painting in the age-old classical tradition that, in the shadow of David and Ingres, was still prevalent in early nineteenth-century France, but soon began to develop the individual style that was to cause an uproar among contemporary art critics. The classical tradition had grown stale, and much painting could be classified as either pedantically academic or sweetly sentimental; in reaction to this, Courbet set himself up as the leader of the Realist school of painting. He chose subjects from contemporary life, not excluding what was usually considered ugly or vulgar. He deliberately rejected the intellectual and premeditated approach to painting, preferring instead to react instinctively to the power of nature. He made numerous paintings on the themes of woman as an organic earth-mother figure, of the sea and of the fruitfulness of nature shown best by mighty trees at harvest time. He was a great believer in the joy and glory of life. However, by highlighting the plight of the ordinary working man and giving significance to mundane activities, Courbet was as good as asking for the inevitable abuse which continued unabated through much of his life.

Another painter whose work could be classed as Realism in a similar vein was Honoré Daumier (1810-79), although he was more politically motivated than Courbet. He used his paintings and caricatures to bring the plight of the poor into public consciousness, vesting the humblest of themes and the meanest of situations with weight and dignity.

The nineteenth century was a time of upheaval in Europe, mostly due to social and economic changes. Reflecting the turbulence, some artists assumed a similar role to that of modern photojournalists, deeming that art should mirror all aspects of life. Goya (1746-1828), a Spanish painter, produced the dramatic *Shooting of the Rebels on May Third 1808* inspired by his resistance to French military rule which existed under Joseph Bonaparte between 1808 and 1814, and also produced 65 brutally savage etchings entitled

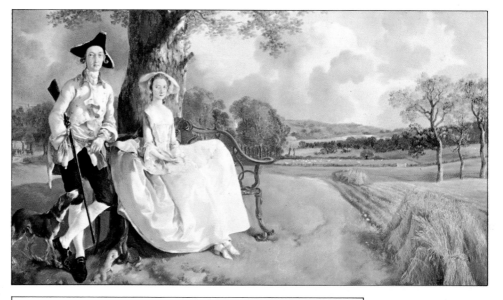

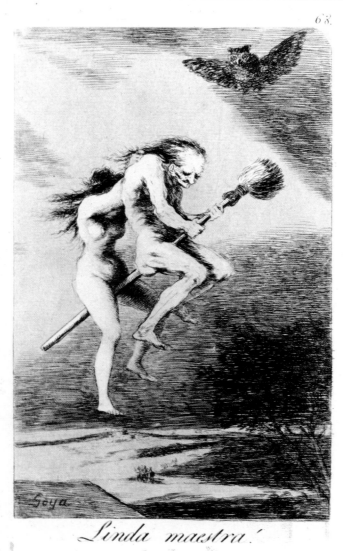

Linda maestra!

Above *Mr. and Mrs. Andrews*, Thomas Gainsborough. This painting of local gentry in a landscape setting has an elegant and carefree atmosphere. The richness of the countryside and the play of light over the grass enhance the context, and perfectly match the mood of the couple. Gainsborough's style was well suited to the pastoral fashions and tastes of the eighteenth century, and his artistry was much in demand.
Left *Linda Maestra*, Goya. The eerie, night setting of this bizarre etching provides an evocative background for an unusual subject. The coarse wispiness produced by the etching technique reinforces the texture of the witches' hair and the twigs in the broomstick. Despite a lack of detail, the weird and macabre impression is powerful.
Right *The Awakening Conscience* (1853), Holman Hunt. The Victorian setting of this picture is rich and colorful, full of strong, mixed patterns and ornate detail. Hunt's portrayal may be viewed as a realistic representation of a middle-class interior; however, the lavish detail may also be seen to make a mockery of the girl's position as the man's mistress, over emphasizing her material gain at the moment that she realizes her folly. There is a strong moral emphasis in this pre-Raphaelite painting.

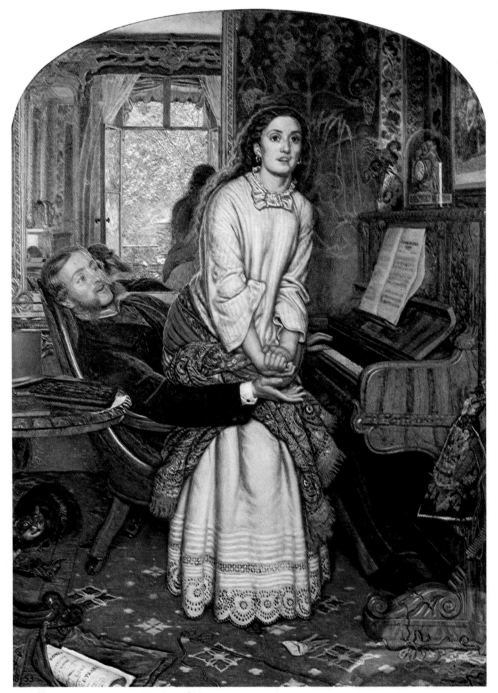

their technique. It had become known that all color and form is perceived as a series of patterns on the retina, and the eye does its own color mixing. Their aim was to recreate the brilliance of sunlight and the effects of light on local color. The intensity of their color harmonies was due to the use of complementary colors in the shadows. If the light part of an object was green, for instance, then the darker areas would display red. They expelled black from their palettes.

The direct and painterly way in which the Impressionists expressed their ideas and the vitality and freshness of their work created a new mood in painting. They were concerned with "truth," but they shifted the emphasis away from content. They wanted to take no moral or religious stand; it was therefore important to paint people or things where no meaning other than the purely visual impact was implied.

Because the eye can only focus on a relatively small area at one time, these painters were obliged to dispense with fine detailing in order to convey the general impression. Some of the Impressionists, Monet in particular, became so involved in the pursuit of the ephemeral effects of light that solid form became dissolved in the total atmosphere of his paintings.

Often the Impressionists' paintings of the nude figure are sensual but unerotic. This is largely because the quality of sensuality is as much to do with the handling of the paint and the artist's obvious joy in the effects of light as it is to do with the represented nature of the model. Even so, the sunlight dappling across female flesh in some of Renoir's paintings, and the delicate backlighting behind the nudes by Bonnard, provide effects that are more tactile than intellectual.

Seurat (1859-91) took the Impressionist ideas to their logical extension – Pointillism. In some of his paintings, including *The Bathers*, he totally abandoned the use of colors mixed on the palette, covering his canvas instead with tiny dots of primary color in varying combinations, leaving the eye of the viewer to mix them optically. He was also aware of the phenomenon of "irradiation," of any color in nature being surrounded by its complementary color, and used this theory in his pictures.

Seurat's "divisionist" technique involved calculating the quantities of various colors present and placing them as separate dots on the canvas. The picture so produced had then to be viewed from the correct distance, when the dots would appear to mix and blend, achieving greater luminosity than would be possible had the colors been mixed on the palette.

Although Impressionism began as a lively and forward-looking movement, it quickly

The Disasters of War. David, who was in active sympathy with the French Revolution, painted three portraits of the martyrs of the Revolution – Marat, Lepeletier and Bara. These and other paintings are visual documentation of political events. Goya and David took Realism to an extreme, intending to record and shock.

With Courbet painting scenes from everyday life, and great scientific progress being made through the nineteenth century, the path was paved for the Impressionist painters such as Monet (1840-1926), Renoir, Manet and Pissarro (1830-1903). Their struggle against classicism is evident in Renoir's *Diana* and Manet's *Olympia;* however, the most important aspect of their painting was their use of light and color. This was a revolutionary, scientific approach to painting. They became famous for representing scenes of everyday life in cafés, restaurants, on the street, by rivers, in bedrooms, bathrooms, and dining rooms, and recent developments in photography led them to compose their pictures in a spontaneous and inconsequential manner reminiscent of the snapshot. Figures were often presented half out of the picture. But more important than the content was

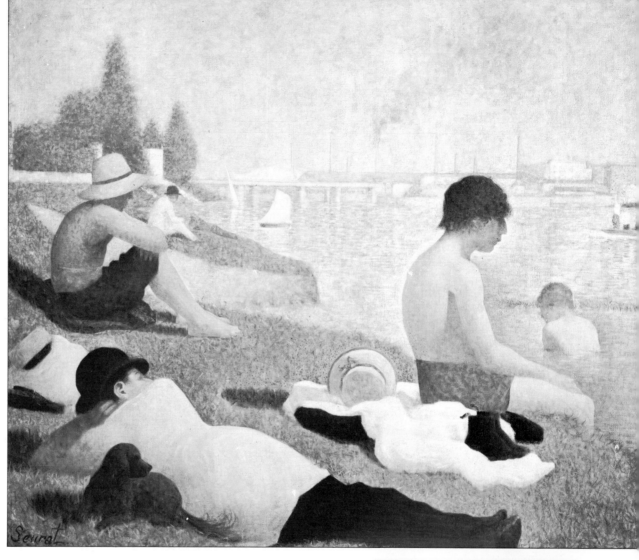

Right *The Bathers,* Georges Seurat. Partly as a result of reading Chevreul's book on color theory (first published 1839) and Charles Henry's observations on the aesthetics of light, Seurat evolved his "Divisionist" technique. He built up the figures in his paintings with a great number of dots or strokes of local color combined with the colors from the sky and surrounding objects; in shadows he included the complementary colors of proximate areas of light.

Far right An illustration for *The Rape of the Lock,* Aubrey Beardsley. Recognizably in Beardsley's linear style, this black-and-white drawing displays some exemplary eighteenth-century details, such as the decorations on the table and the style of the wall moldings, to place the figure in the context of the poem by Alexander Pope. The almost abstracted area of the gown, stippled with a floral pattern, makes a strong, flat contrast against the blocked-in floor.

Below right *The Restaurant Entrance,* Jean Louis Forain. Much in the style of Honoré Daumier, Forain delighted in making satirical comments on society in his paintings and drawings. Strong emotions are expressed in a few simple lines and washes in this watercolor painting.

staled. The artists involved had so whittled down scientific naturalism to a purely optical matter that there was no further progress to be made. By the end of the nineteenth century, influenced by the real threat of the camera, there was a strong reaction against the idea that the artist is a copier of nature, and instead there was a feeling that the artist should use paint as a means of self-expression.

The paintings of Vincent van Gogh were dedicated to making people think and to bring them to understand the comfort and warmth of love. He wanted to express through his paintings the universal power of light. He learned from the Old Masters and from the Impressionists but eventually developed his own style, working from the observation of real things and real people, in a highly subjective manner. He simplified form and exaggerated the drawing and the color. His real sympathy for the peasants who had to

scratch a living from the land is apparent in the way he emphasized the squareness and solidity of a workman in order to give expression to the idea of hard labor. The warmth of his emotions and his reaction to the wonders of nature are expressed by his vibrant use of orange to represent sunlight. Like the Impressionists, he was fond of using complementary colors and found that he could set one off against the other to further intensify the emotional content. By working in this purely subjective way, he found that his use of drawing and color was becoming more symbolic and that this in turn was leading to a flattening of the picture plane.

Van Gogh's treatment of the human figure was one of sympathy and passion. His own anguish and suffering, which led to his eventual suicide, were expressed in his paintings as a feeling of isolation. He often painted single, stolid figures which seemed to

suggest that they were more at home with the soil than with one another. The autobiographical element is strong in his paintings. He felt that what he had to say would only have significance if it was born of his own experience. It was this which led him to abandon ambitious themes such as *Christ's Agony in the Garden* and replace them with more personally relevant ones. His emphasis on personal feeling marked him out as one of the forerunners of Expressionism.

Gauguin, also working expressively, did not use color as a purely visual record of the effects of light. He was more interested in the way that color can be used to evoke mood and emotion. Working with large areas of flat, unbroken color, his pictures became mysterious and decorative designs. His paintings of the figure demonstrate an authority in drawing which was subjugated by his feeling for pattern and color. The inherent

savagery which is present in all his paintings, particularly his self-portraits, prepared the way for the Fauves.

However, the most influential post-Impressionist was Paul Cézanne (1839-1906), who believed that personality could only be developed to the full when in close contact with nature. Although Cézanne is remembered for his sensitive treatment of landscape, in his early years as a painter he was indifferent to this subject, and produced large figurative works. Throughout his life he was obsessed by the theme of bathers. His early studies, which he made directly from the model, were coarse and frequently erotic. He attacked the canvas with great ferocity, laying on the paint in thick slashes with a pallete knife. His unconventional approach to drawing prevented him from ever fulfilling his ambition to paint more academic nudes after the fashion of Delacroix. In his old age he

painted distorted and stylized figures from photographs or from the imagination. His simplifications of the female nude, which often seem less than human, nevertheless conform to classical compositional devices. His large painting *The Bathers,* which he was working on in the years leading up to his death, has a triangular composition into which are fitted apparently clumsy and shapeless female figures. Cézanne defined form and structure by an infinite variation of tone, and space by the use of well-regulated receding planes. If the underlying geometric structure sometimes makes his work appear severe, then the subtle variation of line and tone lends it a lyricism which has been admired and emulated ever since.

The Fauves, a group of French painters working at the beginning of the twentieth century, were so called because their treatment of day-to-day scenes was considered wild and animalistic. In their use of rhythmic line the influence of Cézanne can be discerned, but their use of bright color and pattern was more cheerful and decorative. Their paintings of the figure were energetic and uninhibited. The aim was to produce compositions which were expressive as a whole without relying on details.

At the same time Georges Rouault was painting more violently Expressionist pictures than other French artists. He was a religious artist who is best known for the stained-glass effect of his paintings with bright colors outlined heavily in black. Between 1904 and 1910 he painted brutal pictures of prostitutes, corrupt judges and so on, using sour, dirty colors and shockingly incorrect drawing.

The development of graphic art has greatly influenced painting in this century. At the end of the nineteenth century, there was less of a distinction between "fine art" and "graphic art." Many important artists of this time were not only painters but also poster designers. The flat pattern quality which had been such a feature of the work of Gauguin and was being exploited so well by Matisse, Kandinsky (1866-1944) and Rouault, was particularly suitable for printed designs. Printed techniques, in turn, played an important part in the final decision to reject perspective in favor of surface shapes; this led inevitably toward total abstraction of form. Artists such as Henri de Toulouse-Lautrec and Aubrey Beardsley (1872-98) were primarily interested in the figure but represented it in a way which was already halfway toward the abstract. Beardsley's black and white drawings used elongated and attenuated forms and contrast large and simple shapes with areas of fine detail. Toulouse-Lautrec dispensed with modelling in depth in favor of emphasizing the surface plane. His use of the calligraphic line and bright splashes of color produced images

Above *Mr. and Mrs. Clark and Percy* (1970), David Hockney. All the objects depicted in this scene are naturalistically represented to give a subtle impression of their volumes and their positions in space. There is a fine, lyrical quality to the white lilies. However, the lack of surface detail seems to imply that Hockney deliberately abstracted the forms, choosing certain features specifically and leaving others out, also that the objects themselves were deliberately chosen. The result is an inconsistent view of reality, an example of the artist's Expressionist style of painting. The Clarks were painted in their home, in a sunny and relaxed setting, with the viewer in the position of a guest.

Far left *Nevermore*, Paul Gauguin. With great sympathy for the subject, Gauguin painted this intimate portrait of a young girl asleep. All the paintings of his later life have an extreme individuality of style, partly because the subjects and landscapes are those of the South Sea islands where he lived, which, being so different from his native France, greatly influenced him. He painted the people and the landscapes not just for the sake of recording them, however, but also to record his reactions to the primitive lifestyle. He was sensitive to the tropical colors and unusual patterns and forms and incorporated them to create powerful images of natural innocence and simplicity

Left *Harlem* (1934), Edward Burra (1905-1976). The city context of this watercolor painting was inspired by a visit that Burra made to New York in 1934. The vivid impression of the lifestyle of the black New Yorkers is conjured up by the brittleness of the medium and the juxtaposition of harsh and soft textures. The brick, asphalt, pavement and iron contrast with the clothes, the blue jacket, pink shirt and green Homburg hat, and also with the fur. Simplified forms and a peculiar perspective which almost implies that the upper windows are stuck to the wall instead of being a part of it, are all part of the disjointed atmosphere.

Right *Shelter Scene*, Henry Moore (1898-1986). The dreariness of waiting out the air raids in shelters and subway stations during the Second World War is emphasized by the somber coloring of this drawing. Despite the monumentality with which Moore characteristically imbues his figures, the setting is crowded and a feeling of claustrophobia is implied by the heavy, overlaid lines.

Far right *The Call of Night*, Paul Delvaux (b 1897). The dreamlike quality of this painting by the Belgian artist, who was influenced by de Chirico and Magritte, is typically Surrealist in style. The references within the picture, despite being meticulously painted, are denied any consistency and therefore coherence. The picture describes a totally unrealistic and contrary scene, for example, the trees are bare while the nudes are growing long bushes of leaves from their heads. The viewer is mystified and prompted to question reasons for the existence of the objects and the relationships between them.

which are both decorative and sensitive descriptions of the human figure.

As artists experimented with new and exciting media the distinction between painting and sculpture became less obvious. Cubism, developed at the beginning of the century by Pablo Picasso and Georges Braque (1882-1963), became, in its final stage, a mixture of drawing, painting and collage. The Cubist method of treating the composition as an arrangement of geometrically shaped planes related to the rectangular plane of the picture was a clear influence on abstract art, but however abstracted their work became during certain periods, Picasso and Braque never lost interest in the human figure as a source of inspiration.

Picasso treated the backgrounds of his Cubist paintings in the same way as the figures. The form is fragmented and so is the space, making it difficult to translate. But Picasso does provide visual clues which help the viewer to recognize his familiar environment in the painting. In *Les Demoiselles d'Avignon* the figures are surrounded by what, at first, seem to be incomprehensible shapes. Then at the bottom of the canvas is a small still life of fruit: a melon, pears and grapes. Suddenly the figures seem to be enclosed by folds of drapery, which are perhaps curtains.

The eye and brain demand meaning from the visual work and where something is not fully explained, the imagination takes over.

The abstraction of some of Henri Matisse's paintings often does little more than give an implication of surroundings. In *The Dance*, for instance, there is no more than a simple division of the canvas into two shapes. In the lower half is a mound-like form which can be seen as a grassy hillock, although the only real basis for presuming as much is that it is colored green. Similarly the rest of the canvas is a deep and intense blue, which may be the sky. The conventions of childhood insist that grass is green and sky is blue and the instinctive reaction to these colors being used in conjunction with the figure is to interpret them accordingly.

Some painters choose to keep the background simple but to include certain selected items almost in the way that a stage director uses props to set the scene for a play. Otto Dix (1891-1969), whose work is particularly interesting because he used mixed media including egg tempera, employed this contextual device. He painted figures against a background flooded with almost flat color, and then included a small number of pertinent details: a carefully painted marble table top, a cocktail glass, a box of matches, a packet of cigarettes. All the details are rendered with precision and are chosen because they are immediately evocative of a particular atmosphere.

Cézanne and Matisse were both fascinated by bathing figures, and the backgrounds they included often gave only minimal information. An indication of a tree or a suggestion of figures dressing or undressing are sufficient to suggest the subject matter. David Hockney (b 1937) has continued this

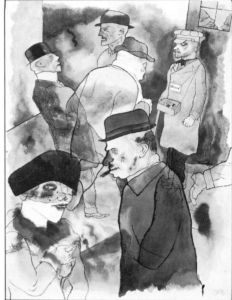

Above *Dammerung 22,*
George Grosz. Strong
reactions to Germany's social
corruption prompted Grosz to
draw brutal caricatures;
society reacted by
persecuting him with some
frequency for insulting public
morals. This watercolored
drawing ironically juxtaposes
two people of questionable
character conversing in the
foreground with a veteran
who is forced to sell matches
for a living.

Some artists are aware of the need to place
figures against a truly contemporary back-
ground. This idea directly opposes the idea
behind abstract paintings which contain no
particular reference, so implying a universal
context. The problem of creating
contemporary settings is much greater now
than ever before, as objects and styles become
dated and tend to look old-fashioned
increasingly quickly against the pace of
progress. By including a symbol of the
modern age such as a television, which was
used by Richard Hamilton (b 1922), a modern
atmosphere can be conveyed. However,
changing styles of interior decoration make it
easy to date a television from the 1960s, and a
painting becomes emphatically out-of-date
because of the very techniques used to create
the opposite effect.

One solution to this problem, which might
be considered a gimmick, was found by the
artist Michelangelo Pistoletto (b 1933), whose
pictures of life-size figures are painted onto a
mirrored surface which reflects the
surrounding space. In this way the figures are
always in a contemporary context.

technique using Beverley Hills swimming
pools as the background for a number of his
paintings. Again, there is not a great deal of
visual information. He fills his canvas with
large areas of blue and white, finding hard-
edged shapes in the ripples and splashes of
water.

Surrealist painters, by contrast, used
deliberately complex backgrounds to suggest
eerie and mysterious atmospheres with no
firm and comprehensible linking references.

De Chirico (1888-1978) produced strange
effects using strong tonal contrasts and several
eye levels. *Secret and Melancholy of a Street*
shows a solitary girl playing in an empty
street, but at the far end an unseen figure casts
a long shadow across her path. Painters such
as Magritte (1898-1967) placed their figures in
incongruous situations to create similar
feelings of discomfort.

Artists reflect their personal vision in
paintings, but also the age in which they live.

THE FIGURE IN MOTION

Another kind of context in which the figure is commonly seen is that of activity, whether it be hoeing a field, running, riding, dancing or enjoying some other kind of sport or pastime. The moving figure presents an exciting challenge to artists, and they have tried to represent it in a variety of ways. The element of realism in a picture of figures, for example, gives an impression of motion by inference; if the figure seems real then the observer will attribute human qualities to it, including the fact that a body is never absolutely still. Similarly, if a body is represented in an attitude which a body would not take if it were asleep or dead then the observer will assume that the subject was moving both before and after the depicted split-second. Some artists in this century have expressed motion in an abstract way, the movement itself being more important than the figure.

A convincing portrayal of the figure in motion is based on the artist understanding the still figure, its anatomy and its potential movements. But it is not only the principles that are important: an artist with a personal view to express in paint probably needs the confidence that only drawing practice can give. Drawing can be seen in relation to painting as grammar is to a language; confidence with the basic skills leads to a fluency in handling the figure and an ability to produce the desired result, an individual vision. The fact that fluidity of line and vitality are more easily expressed in paint if they have been rehearsed in drawing does not mean that a painting should necessarily be composed in pencil first. It is simply that drawing is a good way of loosening up and it is a cumulative process.

The greatest innovating artists of the past had all mastered the techniques of previous artists before giving work their individual interpretations. Studying the great masters and learning from their work is a valuable way of understanding how different approaches and techniques are successful in different ways.

The great revolution in art which culminated in the Renaissance brought with it a thirst for understanding and a desire to represent objects realistically. New-found knowledge of anatomy and perspective freed artists from the restrictions and conventions of the Dark Ages; the flat, static quality that had characterized medieval painting gave way to breathtaking demonstrations of virtuosity in the rendering of form and space. But the artists of the early Renaissance still had not overcome the problem of how, convincingly, to represent the idea of movement within their pictures. For all the painstaking accuracy of their portrayal of anatomical and architectural detail, there is an air of unreality about these paintings.

Uccello's *Rout of San Romano* is an ideal illustration of the Renaissance position. The artist spent long hours grappling with the problems of foreshortening, drawing the figure from angles which, to other artists of the time, must have seemed very difficult. This picture, painted between 1454 and 1457, illustrates a battle which took place some 20 years earlier between the people of Florence and of the neighboring state of Siena. It is one of three panels, and assiduously accurate in every detail. Each element of the painting is considered separately and constructed with mathematical precision, while the composition of spears, lances and trumpets is used to emphasize the receding planes. Even so, the unreal and wooden quality persists, particularly visible in what critics have labelled the "rocking horses." This is partly because of the theatricality of the color which is reminiscent of medieval pageantry, and partly because of the ways the figures and animals fail to interact with one another. Uccello exploited linear perspective fully, but made little concession to atmospheric perspective and the way in which tone and color are diminished by distance. Also, his white horses do not reflect the color which their proximity to flags, banners and other horses suggests they should. His figures bear themselves with the calm dignity of a military procession rather than the passionate agitation of a real battle. There is, of course, no suggestion that Uccello intended it to be other than a highly decorative expression of his own frequently voiced feeling: "How sweet a thing perspective is!"

As the secrets of anatomy gradually unfolded and artists became familiar with the way the body works, so their rendering of the human figure became less stiff and more human, a quality in painting which implies continuous movement. *Primavera*, by Sandro Botticelli, which was finished in 1478, shows how concerned the artist was to portray his figures as living, moving beings, despite the highly decorative and tapestry-like background. The artist's use of subtle colors and sinuous lines in waving hair and drapery suggest a fluidity not apparent in the work of previous artists. Although the subject matter of this painting is allegorical and the setting owes much to fantasy, the figures, especially the Three Graces, have taken on a new, fleshy quality.

It is worth remembering that Botticelli worked in tempera, which is an exacting and difficult medium to control and tends to give a dry and brittle finish. It was Leonardo who, experimenting with the more elastic oil paint, which was already being widely used by artists in northern Europe, invented a technique called "sfumato." This literally meant a

smoking, or blurring, of the edges which imbues form with mystery and contrives to suggest that the figures have been caught between one movement and the next. By blending one form into another and breaking up the severe outlines which had featured in Uccello's paintings, Leonardo was able to give the impression of light and air around his figures. The softening effect of these hazier outlines conveys the transitory quality of light and implies movement and the passage of time. This invention was quickly seized upon by other painters of the time and was used to great effect by Raphael, Giorgione (1475-1510) and Michelangelo.

Titian, working later than Leonardo, developed his individual wide-ranging styles with an innovative mastery of color. He used color and light to restore unity to paintings in which his contemporaries considered him to have broken all the rules of composition. The paintings are lively because, although he was intensely concerned by the internal structure, they are not symmetrical, as was normal at the

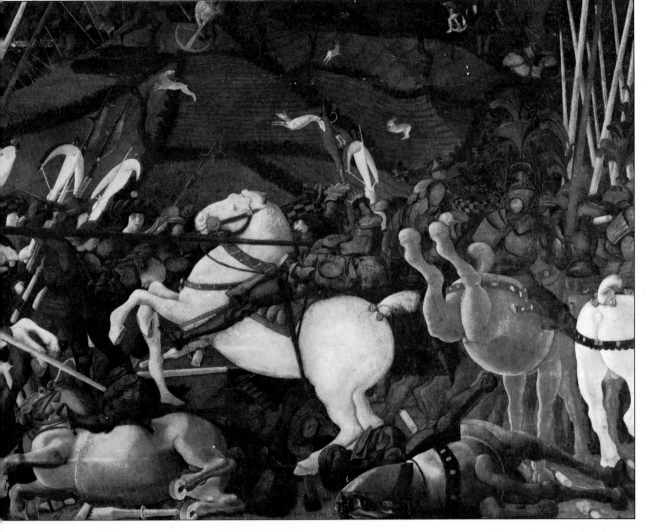

Left *Rout of San Romano* (1454-57), Paolo Uccello. Uccello's experiments with perspective rendered him one of the great names of the Italian Renaissance. Together with Brunelleschi, Donatello and Masaccio, he pioneered the use of a geometrically calculated space to create the illusion of movement and depth on the flat picture plane. Lances bring the spectator's eye into the picture; dead horses litter the foreground; behind, carefully placed figures and an oddly fore-shortened bucking horse lead the eye back into space. Abstract patterning combined with geometrical construction lends a strangely suspended and unreal air to the decorative scene.

Below left *Archers Shooting at a Mark*, Michelangelo Buonarotti. A sculptor, painter, architect and poet, Michelangelo was one of the greatest artists of the Renaissance. This red chalk drawing shows his mastery of anatomy and although realism is disregarded in the overall design, each figure is meticulously observed, its powerful muscles and curves redolent of violent movement. The artist has fully exploited the medium in line and tone.

time, and the characters portrayed are inter-related while not being in their expected positions. His control of color and composition and portrayal of complicated groups of figures in action are well illustrated by his painting of *Bacchus and Ariadne*, painted in the early 1520s.

Caravaggio, with less regard for grand schemes and structures, took the use of light to a harsh extreme. He used flickering light and extreme tonal contrasts, often with strong shadows throwing up selected shapes into clear relief against the hidden light source, to give his paintings an unnerving and uncompromising intensity and reality. The life within these paintings exists in the subject matter, where light is a vital element making the characters live and move. It also exists in the fact that Caravaggio modelled the people, and more importantly the saints and other religious figures, from less than perfect human beings – a scandal at a time when the Church was trying to impose a tighter morality on society.

Above *The Raft of Medusa* (1817), Théodore Géricault. This painting caused a storm when it was exhibited at the Paris *Salon* of 1819 because of its political overtones and realistic treatment of its macabre subject. Having studied in Italy, Géricault was much impressed by Michelangelo and the Baroque, elements of which can be seen in the drawing of the bodies and the extremes of human emotion. The complex figure composition, based on a double triangle with lines sweeping across, ensures a sense of constant, swirling movement as the eye is guided around the picture.

Right *Primavera*, Sandro Botticelli. One of a group of late fifteenth-century Florentine painters who rejected the naturalism of Masaccio's art in favor of a more linear and ornamental style, Botticelli relied, solely it appears at times, upon line to express emotion and graceful movement in a deliberately archaic manner. In this painting, hair and drapery flow, with outline and color conveying a fluid and rhythmic sense of movement.

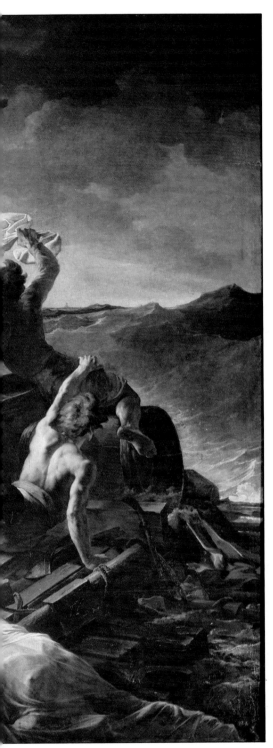

The influence of Caravaggio can be seen in the paintings of Rembrandt, Velazquez (1599-1660), de la Tour (1593-1652) and Le Nain (c1593-1648). The great Baroque sculptor Bernini (1598-1680), whose medium was marble, also represented the human figure with enormous vigor. Like Caravaggio, his influence was strong and his vision new. The figures he molded are expressive and dramatically conceived, flowing within their self-imposed structures.

It may generally be seen that, until the nineteenth century, figures successfully represented in motion are made to look lively and realistic by the artists using perspective, color and light, and sometimes by depicting them in active positions. Michelangelo's figures display the artist's mastery of the human anatomy, and often seem taut with imminent action and latent energy. The action of the figure on its own, however, is not enough to create an overall impression of energy. The surface structure needs to be similarly tense; the stresses within the composition, created by line and by the juxtaposition of color, can be used to relate the space and the activity and create a larger atmosphere of movement and vitality. Michelangelo's *Archers Shooting at a Mark* demonstrates the importance of structure; each figure separately possesses a minute amount of the whole sense of movement.

The Mannerists were a group of painters, including Bronzino (1503-72) and Vasari (1511-74), who followed in the wake of the High Renaissance. They turned their backs on the classical ideals of balance, harmony and perspective and concentrated on the grand gesture. The results are huge, flamboyant compositions portraying scenes of drama and turbulence. The surface structures of these compositions are vital to the movement and spirited liveliness in these paintings, and are emphasized by vibrant, often brash colors. To further exaggerate the flow of movement within the picture plane, the Mannerists were prepared to contort the form of the human body and often echoed these shapes in clouds, trees or drapery. The twisted, writhing figures are typical of this period of painting.

The Raft of Medusa by Théodore Géricault (1791-1824) is a fine example of the importance of composition. The painting has a strong surface structure, based on a double triangle with crossing rhythms. Shapes are repeated; for example, the billowing sail is echoed in the restless waves and clouds. The force of the wind and the forward motion of the boat are matched in the hope created for the survivors by the sighting of a distant ship, all stressed by a strong, curving diagonal. The vitality of this painting was inspired by the artist's feelings of outrage against the naval authorities, whose incompetence he blamed for the shipwrecked *Medusa.*

A painting technique which has been used to emphasize dynamism is the "gestural brushstroke," where the action of the artist actually laying paint on the canvas remains visible. Fragonard (1732-1806), painting in a light-hearted manner, used broad though well-controlled brushstrokes to give an impression of spontaneity and movement. Some of the paintings by van Gogh (1853-90) display similar energy with strong brushstrokes describing the forces at work in nature in, for example, *Landscape with Cypresses*. In a different medium, Matisse used scissors to cut out paper for his collage compositions. Each cut was final and vital to the whole and may be

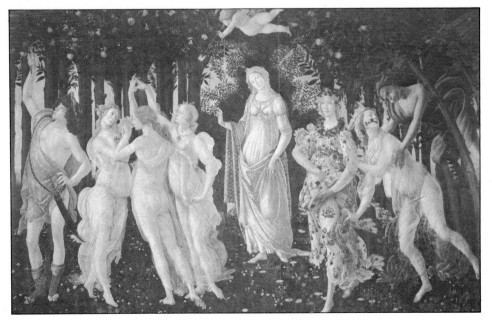

similarly considered as having been made in "moments of creativity." The figures in *The Swimming Pool,* for example, despite being abstract, could not be doing anything but moving in the peculiar, frantic manner of swimmers delighting in their surroundings.

The invention of the photograph was one of the most important innovations for artists of the nineteenth century. Photographs could be used as a valuable aid to composition, giving detailed impressions of possible surface structures and the relation of forms and could also be used to assess tonal values. The *camera obscura* – a rectangular box with a lens at one end and a reflector placed at an angle of 45° to direct the image received through the lens onto a plate of ground glass which could be traced over – had been used by artists for similar reasons since its invention in the sixteenth century. Artists' reactions to using the *camera obscura* as an aid to drawing and painting had, however, always been divided. Hogarth (1697-1794), for example, felt that the animation of reality was lost with the artist copying no more than a lifeless imitation of the original scene. Others criticized the way the image was too intense in color and tone, and therefore false. The same arguments were propounded against the use of the photograph, which was considered by some a more dangerous invention as it was capable of fixing the image, freezing the lifeless imitation. There were, at the same time, fears that photography would become a substitute for painting.

It cannot be denied that the first photograph brought a new perspective to the art of capturing scenes from life on a flat surface. In some ways, photographs seem to portray a greater degree of reality than paintings. Whether they were capable of capturing movements and liveliness in the same way as paintings was the subject for some intense debating.

Eugène Delacroix (1798-1863), despite being enthusiastic about the invention, was aware of its limitations for the artist. He presented two angles of the debate in 1850: "The study of the daguerreotype if it is well understood can itself alone fill the gaps in the instruction of the artist; but to use it properly one needs much experience. A daguerreotype is more than a tracing, it is the mirror of the object. Certain details almost always neglected in drawing from nature, there – in the daguerreotype – characteristically take on a great importance – and thus bring the artist into a full understanding of the construction. There, passages of light and shade show their true qualities, that is to say they appear with the precise degree of solidity or softness – a very delicate distinction without which there can be no suggestion of relief. However, one should not lose sight of the fact that the

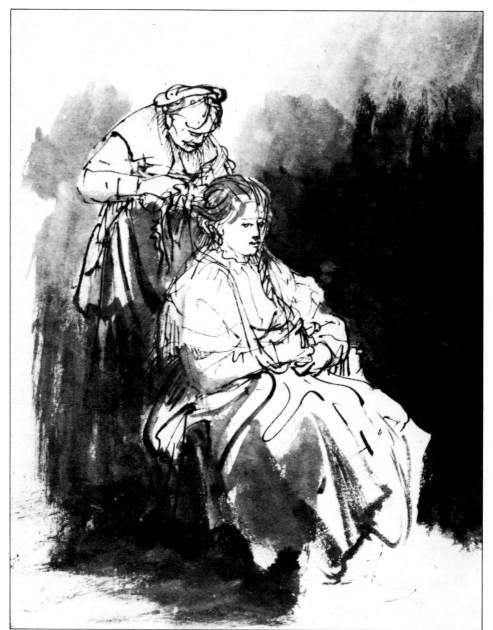

daguerreotype should be seen as a translator commissioned to initiate us further into the secrets of nature; because in spite of its astonishing reality in certain aspects, it is still only a reflection of the real, only a copy, in some ways false just because it is so exact . . . The eye corrects, without our being conscious of it. The unfortunate discrepancies of literally true perspective are immediately corrected by the eye of the intelligent artist; in painting it is soul which speaks to soul, and not science to science."

Auguste Rodin (1840-1917), commenting on the ability of painting and sculpture to present an original approach, presented a similar point of view when he said: "It is the artist who is truthful and it is photography which lies, for in reality time does not stop and if the artist succeeds in producing the impression of a movement which takes several moments for accomplishment, his work is certainly much less conventional than the scientific image, where time is abruptly suspended."

With these arguments in mind, it is easy to understand why Gustave Courbet (1819-77) and other Realists were dependent on photography to some extent. They sought to escape from the artificiality of classicism and romanticism by representing scenes from everyday life with a total frankness and objectivity of vision. Ironically, Courbet's *Return from the*

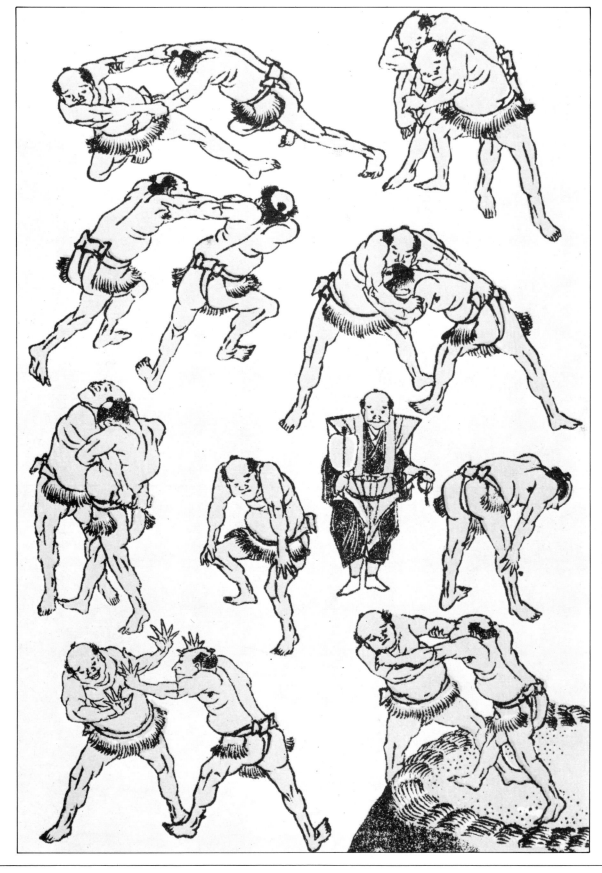

Far left *Saskia at her Toilette*, Rembrandt van Rijn. Rembrandt was the acknowledged master of *chiaroscuro*, or the depiction of light and dark to create dramatic effects, a method derived from Caravaggio. Almost 2,000 drawings and many jottings of precious, intimate thoughts exist in his hand, many of them of his first wife Saskia, who died in 1642. His marks are scratchy and economical but convey a wealth of movement and emotion in their rapid, broken lines. In this sketch, light comes from the upper left, highlighting the maid's intent expression, her hand braiding Saskia's hair, and Saskia's patient face as she glances toward the artist. The figures emerge from the shadow created by washes of tone. Although generally on a small scale, Rembrandt's work always has a sense of grandeur.

Left *Japanese Wrestlers*, Hokusai (1760-1849). One of the great masters of the *ukiyo-e* or Japanese color print, Hokusai was also a book illustrator, painter and print designer. His vigorous drawing and strikingly original use of color vividly convey bustling Japanese city life. Combined with these is a strong sense of humor, evident in this sheet from a sketchbook. The simplified forms are endowed with power and movement rarely equalled in art; the line has many functions, moving rapidly across the paper to enchant and engage while describing the action of the wrestlers.

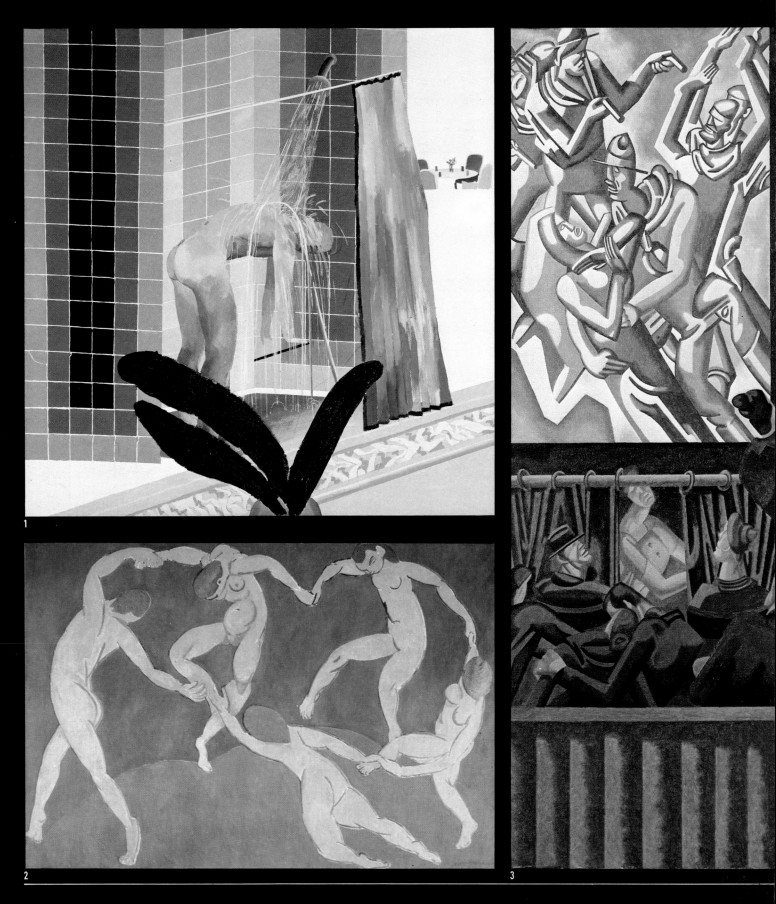

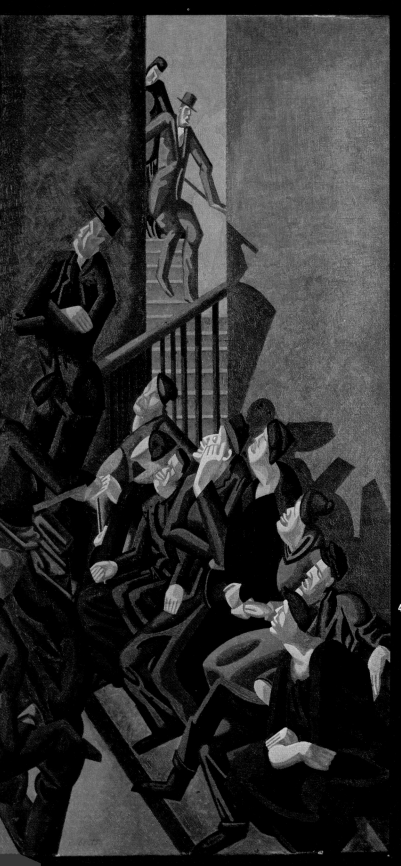

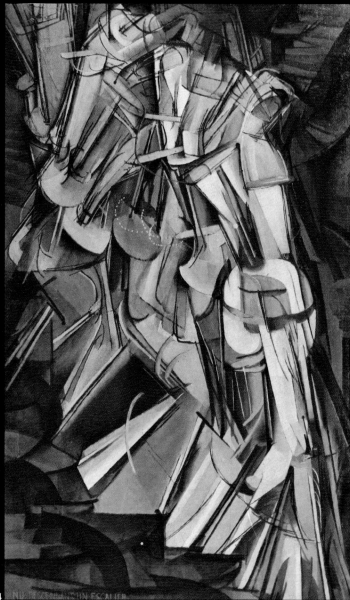

4

1. *Man Taking a Shower in Beverly Hills, May '80*, David Hockney. Hockney is a representational artist and uses strong, light colors, generally in flat acrylic paints. Fascinated by the play of light on reflective surfaces, Hockney paints interiors which are always light and sun-drenched. The body is strongly silhouetted against the tiles and the slashes of water are a lively quotation from comic book convention.
2. *The Dance*, Henri Matisse. Matisse was the foremost artist of the Fauves group of painters whose works were executed in strong violent colors, flat patterns and distorted forms. For him, color, drawing and composition were inextricably linked and could be used to express emotion.
3. *The Cinema* (1920), William Roberts (1895-1980). Roberts was a member of the Vorticist group, the name of which was taken from Boccioni's statement that artistic creation had to originate in a state of emotional vortex. Roberts sets his figures in a series of diagonals, horizontals and verticals, to convey a zigzag movement which is emphasised by placing strong colors against each other. The angular machine-like forms of the audience are emphasized by their violently stupid expressions as they watch the Western, a monochrome version of themselves.
4. *Nude Descending a Staircase*, Marcel Duchamp. A combination of Cubism and Futurism, this painting shows the influence of the chronophotographical experiments of Marey and Muybridge. The color range is severely restricted to blacks and browns, and the segmented figure reduced to simple geometric and semi-mechanical forms. The subject is fused with the surroundings, and multiplied and elaborated to suggest the spiralling movement of the figure.

Fair was dismissed by a public used to the graceful, impressive academic art of the time as "a banal scene worthy only of the daguerreotype." Another of his paintings was described as one which could be "mistaken for a faulty daguerreotype." This was only the reaction of outrage: Courbet's paintings are sincere and powerful expressions of reality as he saw it. Photographs of similar scenes might have recorded the details more scientifically, but would almost certainly not have had the same feeling.

The camera was not able to take the place of the brush, but photographs have proved a valuable aid to painting. Walter Sickert (1860-1942), for example, dismissed as "sheer sadism" the idea of demanding more than one sitting for a portrait when a good photograph of the face sufficed. During the next few years, improving photographic techniques made it possible to capture moving as well as still images. The instantaneous image, available from about 1860, revolutionized the way in which human and animal figures in motion were represented by artists and also the way in which ordinary people recognized what they saw.

In many ways, painting had become stylized in its depiction of movement. Certain conventions had grown up, a good example of which is the way that horses were shown moving at a gallop. Géricault's painting *Horse Racing at Epsom* (1820) demonstrates how the misconception about the way that horses move had become accepted; in fact, when Degas began to paint them as they really move, his new images were rejected as unnatural and unrealistic.

The photographer who drew attention to these and other discrepancies was Eadweard Muybridge (1830-1904). He had become interested in the continuing debate about whether all the legs of a horse come off the ground together at any point during galloping. Muybridge set out to make photographic proof of the locomotion of a galloping horse and his astonishing results were published in 1878 and 1879. In a series of consecutive photographs it was demonstrated that all the horse's legs were in the air at once but that, instead of being extended, after the manner of Géricault's painting, they were drawn up beneath the body of the horse. What the human eye is not quick enough to perceive was irrefutably proved by the camera. As the photographer himself observed about the image: "We have become so accustomed to see it in art that it has imperceptibly dominated our understanding and we think the representation to be unimpeachable, until we throw all our preconceived impressions on one side, and seek the truth by independent observation from Nature herself."

Muybridge went on to further investigation

and later published *Animal Locomotion* which was an impressive study of the movement of humans and animals. This collection of photographic sequences shows people and animals involved in a variety of everyday activities and continues to provide an excellent source of reference on movement for artists.

The French photographer Etienne Marey (1830-1904) also assisted artists toward an understanding of movement. He developed the technique of chronophotography – a system of producing multiple images on a single plate so it was possible to record the second-by-second movements of a bird in flight, of a man walking or a child jumping. Marey drew graphs from his chronophotographs tracing the patterns and rhythms of movement, and these became a source of inspiration for a number of artists, the most notable of whom was probably Marcel Duchamp (1887-1968).

Early in the twentieth century, Duchamp had become fascinated by the idea of simultaneous representations which made it possible to give the impression not just of movement within a given space, but also of the passage of time. He made no secret of the fact that Marey's chronophotographs and diagrams provided the initial impetus for the paintings he produced on this theme. The studies of *Nude Descending a Staircase,* painted in 1911 and 1912, are clearly derived from the work of Marey although the influence of Cubism is also apparent. The geometrical treatment of the fragmented figure which spirals diagonally across the canvas is a highly successful representation of movement, however much it shocked orthodox opinion at the time.

While Duchamp's nude is still recognizably human, the repetition of the partially abstracted form gives the painting a mechanical feeling which heralds the reverence that the Futurists felt for machines and their function. Formed in Italy in 1909, the short-lived and ultimately not very influential Futurist movement was expressed by the painters Umberto Boccioni (1882-1916), Giacomo Balla (1871-1958) and Gino Severini (1883-1966), among others. They believed the solid materiality of objects to be diffused by movement and light, and felt that movement could be more realistically represented by presenting successive aspects of forms in motion simultaneously on canvas. The resulting sense of motion in some of their paintings is unique.

In almost every field novel techniques meet with resistance and it should be remembered that not everyone welcomed the arrival of photography with enthusiasm. There were many artists who chose either to ignore it or to work in conscious opposition to the ideal of

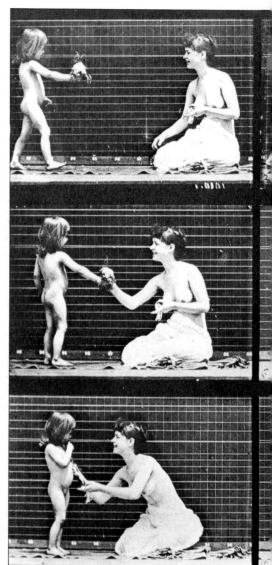

photographic realism. The work which Henri Matisse was producing around the same time as Duchamp was painting makes an interesting comparison. Both artists were concerned to represent movement, energy and vitality; both artists chose to work in a manner that would not be considered realistic in the normal sense of the word. But whereas Duchamp communicated his ideas in an intellectual and scientific way, the paintings of Matisse are expressive of almost pure emotion. *The Dance,* painted in 1909, is an ecstatically vibrant representation of movement. The intense, pure colors, the quality of line and simplicity of form are expressive of great excitement and vitality. Years later, Matisse is recorded to have said that he painted "to translate my emotions, my feelings and the reactions of my sensibility into color and design, something that neither the most perfect camera, even in colors, nor

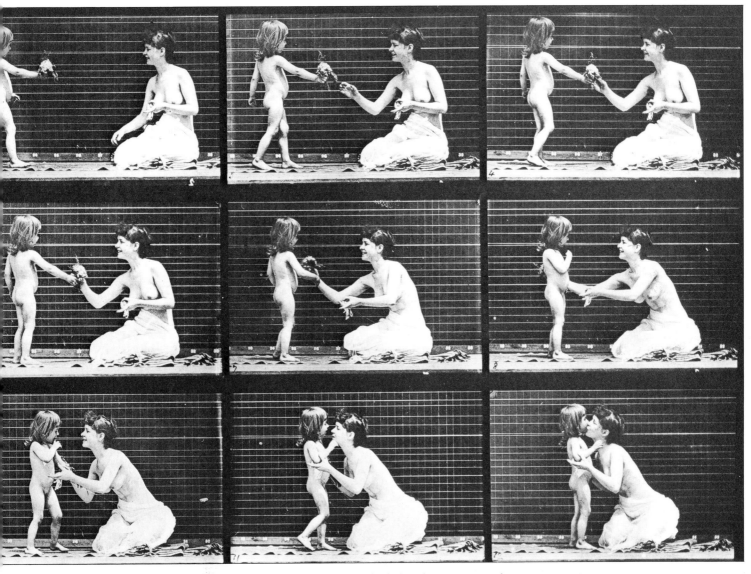

the cinema can do."

Studying the variety of approaches to the problem of successfully suggesting movement is instructive for artists today. A great number of effects are possible with different techniques, which, once mastered, can be manipulated to suit the individual artist. Presenting the figure is partly a question of the artist being fluent with the chosen media; but it is also a question of understanding the anatomy, the movement of the body and the principles of perspective.

Representing movement is also a question of the composition. One of the most important elements to consider is the surface structure of the work. The figures and objects should interact and flow, and if the sense of movement is to be emphasized then the composition should always take the eye in one main direction. If a composition is too formal, however, the figures will stiffen.

The use of color is vital to the structure and the mood of a painting. Colors can be subtle, with graduating or contrasting tones an important element, suggesting changing light; or they can be bold and solid which often gives a more vibrant impression. "Sfumato" – fusing the outlines – is one of the many varied techniques which can be efficiently used to suggest figures in motion.

To capture movement by drawing or painting requires constant practice. It is worth watching people move and noting positions of tension, which would, on paper, best illustrate a certain action. Capturing the split second position is not simply a matter of seeing and presenting that particular position on paper or canvas; just as the model must have moved to it and out of it again, so the artist must understand and imply the whole motion.

Above *Child Bringing a Bouquet to a Woman* (1885). Eadweard Muybridge. Muybridge was one of the first men in the nineteenth century to successfully analyze movement in photography. Preferring not to photograph artists' models as "their movements are not graceful," he managed with difficulty to persuade non-professionals to pose nude or nearly nude. These beautiful photographs are in fact of the wife and daughter of the Principal of the Philadelphia School of Industrial Art, and were taken with a special camera with 12 lenses, each of which made a separate image on a glass plate so that it was possible to photograph 12 stages of a particular sequence with one camera.

NUDE WITH CIGAR
oil on hardboard 48×36inches (122×91 cm)

The technique of painting in oils has been practiced for so many hundreds of years that there is a tendency to think it straightforward. In fact, the principles are fairly simple to grasp, but with the benefit of a little experience, the artist discovers a number of rich possibilities which can be adapted to help develop and enhance his or her style of painting. First, the choice of support, whether it is canvas, plywood, masonite or wood, influences the types of size and primer to use. For use on ready-sized supports, emulsion primers are relatively porous in comparison with gesso grounds, which are made without oil and zinc oxide and dry hard and smooth. Both white and colored oil-based or acrylic-based primers can be bought or prepared at home.

A tinted ground will allow the artist to work both down to the darks and up to the lights, and can prove very useful as long as the chosen tone is of a neutral cast and is sympathetic to the overall mood of the work. A raw sienna, for example, can be used for a nude figure painting. White priming allows warm shadows to be laid in to contrast with cool lights and highlights; darks can be painted in several layers and lights can be left as a thin staining with the white showing through subsequent glazes. The resulting luminosity adds an authentic sense of light to this picture, which includes a large window.

1

The process of making a picture inevitably includes a great number of decisions followed by revisions, then further changes of mind and readjustments. Oil paint is well suited to accommodating these changes without necessarily clouding or muddying except where desired.
Some areas of the gesso ground are carefully left uncovered and the rest washed with a mixture of Payne's gray and turpentine. The figure, whose white outline describes the light coming through the window, is worked in dark browns, terre verte and yellow ocher, and background details carefully delineated and filled. The use of ultramarine gives the interior space a coolness and haziness (1).

Next, a smoky white glaze is worked over the floor and the figure given stronger white and yellow highlights. The focal point is shifted to the mirrored reflection, where a crisscross pattern echoes the structure of the window frame (2). Another change of mind causes the form of the body to be reinforced with some darker greens and browns. Masking tape prepares for precise lines to be added to the window frame, and the towel gains highlights (3).

The woman's fingers catch direct sunlight, and the towel becomes flatter in tone with decorative red stripes. The most important change, however, is in the basic construction of the picture. Right at the end, the ceiling is heightened and the top of the window straightened to increase the spaciousness of the room (4).

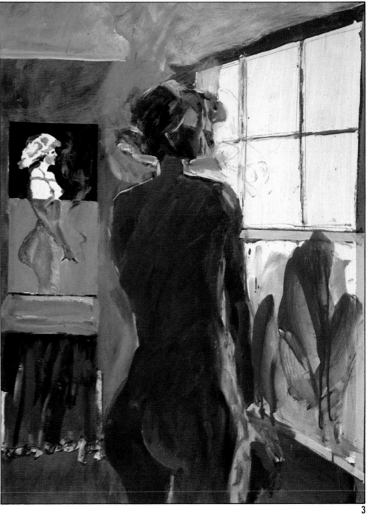

4

3

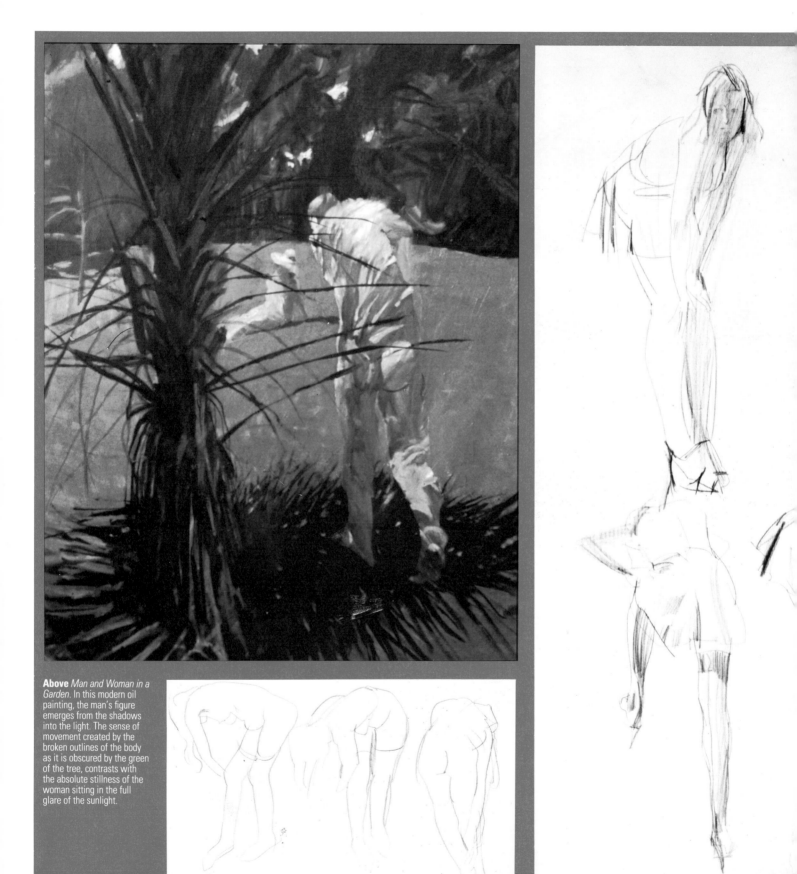

Above *Man and Woman in a Garden*. In this modern oil painting, the man's figure emerges from the shadows into the light. The sense of movement created by the broken outlines of the body as it is obscured by the green of the tree, contrasts with the absolute stillness of the woman sitting in the full glare of the sunlight.

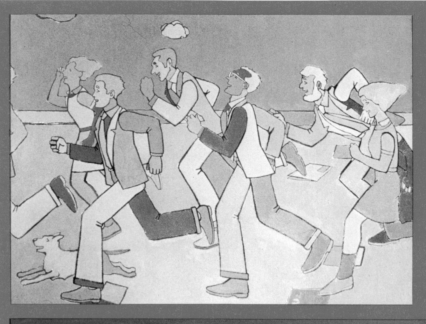

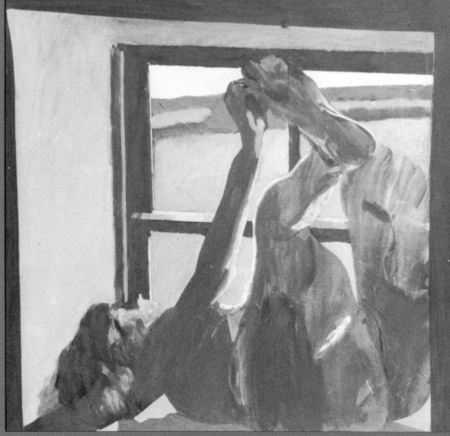

Left *Runners on the Beach (No 2).* The movement of these cardboard cut-out figures, deliberately depicted in a naive, semi-geometric style, is achieved by the several figures, all in obvious running positions, being crowded together, and by the juxtaposition of the colors.

Far left These three thirty-second pencil sketches of a girl taking off her stockings demonstrate how a few simple lines can give the impression of movement. Short poses are good practice, teaching the artist the ability to react quickly to small movements and forcing the description of instantaneous impressions while walking around the figure.

Left These rapid sketches show how the artist has captured the essence of the movement of the figure in simple lines.

Above *Girl Lying in a Window.* The artist has brilliantly captured the sense of the model rolling over, ecstatically kicking up her legs. The figure is placed within the yellow embrasure of a window, its darkish form outlined against the window and the gold of the cornfield, with the light falling on its contours. This painting, the result of much overpainting as the model's position changed, demonstrates the liveliness of the oil medium.

NUDE BY BALCONY
oil on hardboard 36×54 inches (91×137 cm)

A board or wood support is solid enough to take a hard gesso primer without fear of the primer cracking as it would on canvas. The gesso ground, a mixture of whiting and size, is applied thickly in four layers, each layer being rubbed smooth before the next is added. Beneath this, rabbit-skin glue size is applied in two coats and left to dry. In this particular work, the first laying in of color was in oil paint, diluted with genuine spirit of turpentine. When dry, the surface was developed by overpainting with a little more linseed oil added to the turpentine at each stage. The artist took care to leave certain designated areas, parts of the floor for example, completely white. The process of building up the color, and elaborating and enriching using increasingly thick paint on subsequent layers, can be taken further by using stand oil instead of linseed in the later stages. If it is felt that some parts of a work are inconsistent with others because the color seems to be "sinking in," then retouching varnish applied with an atomizer will bring any color back to its true liveliness. This very diluted varnish can also be obtained in aerosol spray cans. It does not leave a harsh, shining surface to make overpainting difficult and is a useful aid when a picture has been left between stages for some time. This picture took some extensive compositional changes, making overpainting essential.

The initial oil painting is made with a limited range of colors. Cobalt blue and Payne's gray are used for the background, while shades of green and yellow are used for the figure and the main areas of shadow. A large proportion of the painting is left white to suggest the strong sunlight streaming through the open door. All the main shapes and relationships are established at this stage, but there is considerable scope for change (1).

Details are built up in all the background areas of the painting. A lace curtain is added at the window to the left of the picture; the artist is here experimenting with ways of balancing the strong diagonal created by the left arm as it slopes down to the floor. A vivid pattern is overpainted on the bed and a large pillow added behind the figure's head, easing the conjunction with the wall. These decorative details serve to create a surface interest on the blocks of color (2).

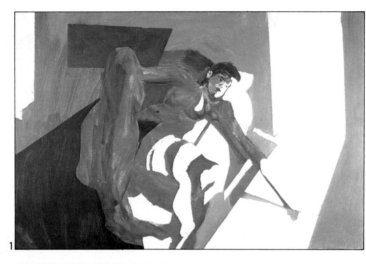

1

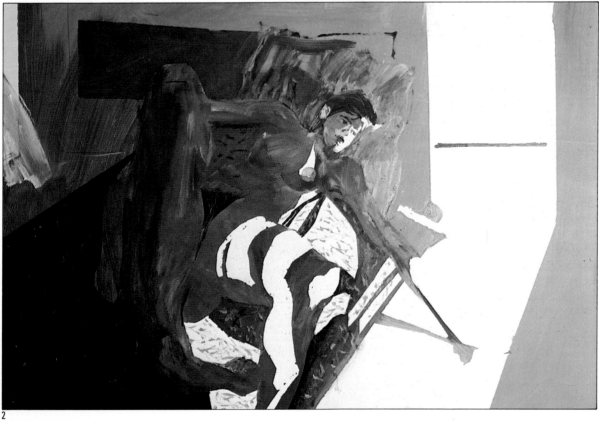

4

2

86

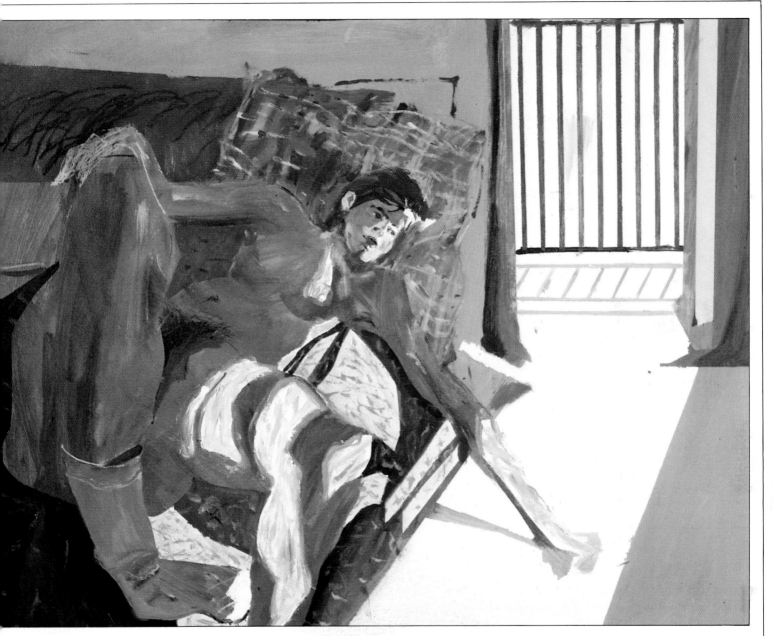

More detail is built up in the background of the picture. Strong vertical lines indicate the balcony railings; these are painted with the use of masking tape to ensure straight edges. Curtains elaborate the door frame and the lace curtain is extended up into the window area. The areas of white in the painting are almost entirely constituted of untouched, gesso-primed board; they maintain the high contrasts (3). The next stage of the painting begins to show evidence of a change in the artist's basic intentions. The red and yellow added to the highlight area on the left leg

and arm suggests a later time of day in that the intensity of the light has modified. The introduction of these colors alter the overall mood of the painting, softening it. The artist decides to remove the lace curtain and strengthen the window area to match the severity of the door frame. A hint of green in the view from the door suggests that further interest will develop here. The figure, too, is in the process of readjustment, with an attempt being made to interrelate arms and legs more closely. Such changes have a surprisingly dramatic effect on the overall

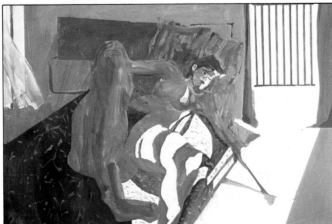

atmosphere of the painting. Although the basic shapes have remained constant, additions to the color range have altered our perception of the monumental form of the figure and the shape of the highlights and shadows. The decorative details have also added a new dimension. One great advantage of painting in oils is that it allows for such major changes in emphasis; considerable experiment can be accommodated within one painting (4).

3

GIRL BY WINDOW WITH BLINDS
watercolor and gouache on paper 18×28 inches (46×71 cm)

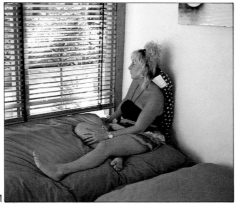

This is an example of watercolor being used mostly in its pure form, to describe the effects of light in a bright and airy room. The white of the paper shines through the thin washes giving the painting a luminosity which also existed in reality.

Attention is divided between the window and the figure, both potentially being the subject. Light sources are often more difficult to control inside the picture than outside when the effect of light can be exploited without including a dominating rectangle of light. However, including a window or open door presents the artist and the viewer a large number of challenging compositional structures and effects.

Here, the artist holds the shape of the window by enclosing it in darker tones, the window itself being mainly represented by the untouched white of the support. The strength of this image and the shimmery effect of the blinds provided a strong basis, allowing the painter to present a sympathetic interpretation of the seated girl in the interior.

The pose is arranged to obtain a quick study of light quality. The upper part of the model, leaning against a cushion, is silhouetted against a white wall. The hard lines of the Venetian blind form diagonals and contrast with the softer shapes of the bed and the figure of the model (1). The first ideas of the compositions are mapped out lightly in watercolor on Strathmore paper stretched out on a board with paper tape (2). The green sap of the trees is painted over the broken brown lines which show through the watery green wash, emphasizing the dissolution of forms in light (3).

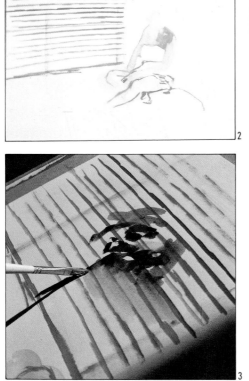

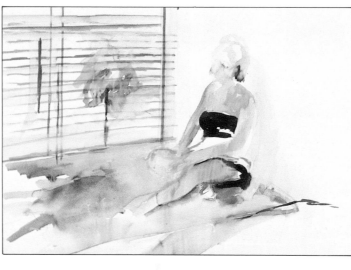

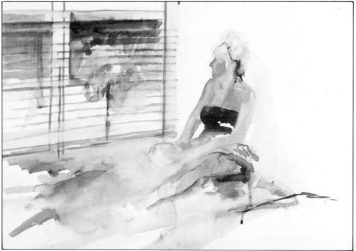

The two basic themes, the shimmering effect of light on the trees through the blinds and the light on the bed and the model, are elaborated by building up thin washes of blue and flesh tones. Verticals are added to create space and structure (4). A strong slate blue wash is painted in at the top of the blind with lighter diagonals below, forcing the light through the lower half of the window. Broad areas of cadmium orange are applied to establish the body and the vermilion skirt begins to appear (5).

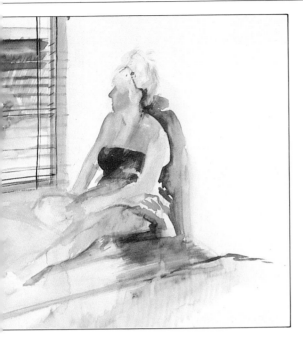

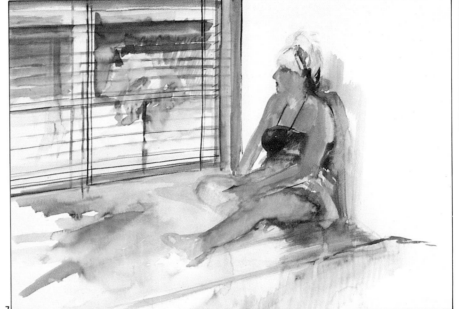

7

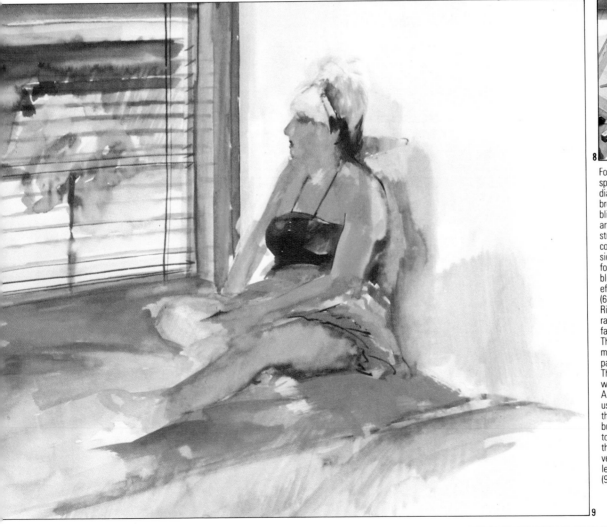

8

Forms are made solid in space. Thin black vertical and diagonal lines and a stronger brown one are added to the blind. The profile and upper arm are accentuated and a strong line traces the contours of the model's left side. A slate blue wash forms her shadow while a blue wash with a striped effect gives the bed height (6).

Rich strong flesh tones in raw sienna, plus white in the face, are applied to the body. The outstretched leg is modelled, the white of the paper giving luminosity (7). The artist adds gouache white for highlights (8).

A strong blue gouache wash used with white establishes the bed. Further shadow is built up and deep pink flesh tones added to strengthen the body's modelling. More vermilion and a streak of lemon are added to the skirt (9).

9

DRAWING THE FIGURE

CHARACTERISTICS OF DRAWING

The dictionary defines drawing as the art of making pictures with pencil or pen and ink. This is a perfectly adequate explanation, but drawing can be both much simpler and much more complicated than that. Any mark, made deliberately onto a flat surface, even if it is only a line drawn into sand with the finger, can be described as drawing. At the same time, the distinction between drawing and painting is not always clear. As a general guide, drawing can be distinguished from painting because the former is primarily concerned with line while the latter has more to do with tone and color, even though many drawings contain elements of all three. A painting, however, often makes use of tone, color and form to create a total illusion; to make the viewer believe, momentarily, that the frame of the painting is a window through which the painted scene can be observed as if it existed in reality. A drawing is much more a statement about reality than it is an attempt to copy it. Although an artist may represent three dimensions in a drawing by using solid modelling, many drawings are nothing more than a simple outline which separates one area of the paper from the next. The space defined and enclosed by line in some mysterious way takes on a dynamism of its own, existing in a self-imposed context.

While it is this linear quality which helps to distinguish drawing from painting, the line also distinguishes drawing from reality. In real life nothing has a line drawn around it. Things can be perceived because they are made up of solid, light-reflecting masses. Their apparent outlines change as either they, or the viewer, move from place to place. The drawn line is a visual symbol, standing for the difference between a solid shape and the space surrounding it. It is not the line which receives attention, but the shape of the space or mass which it implies. Even so, the line does have a quality of its own and this inevitably influences the feeling of the drawing. Paul Klee (1879-1940) talked of "taking a line for a walk" and was very aware of its intrinsic energy. By experimenting with different drawing media it can soon be seen that even an abstract line has a character of its own. A line drawn with a stick of charcoal will have a vigor and urgency that cannot be suggested by a delicate pencil.

Most people see drawing as a form of visual record or a type of documentary. This categorization encompasses everything from the briefest of sketches, intended only to note an idea for later development, to finished studies. Michelangelo made hundreds of drawings to investigate the figure in different positions and from different angles. Despite the fact that these drawings were part of the process of painting and sculpting, they are also works of art in themselves. Similarly, Rembrandt, Rubens, Raphael, and many others made numerous studies of the head. While these may have been made with particular paintings in mind, the studies demonstrate powerful artistic curiosity. This type of drawing is a way of finding things out, of seeing how they look, of discovering how the quality and intensity of a line can be used to interpret the texture of surfaces.

However, in order to understand more about the nature and power of the line, it is worth examining different types of drawing where the line takes on a special significance beyond its capacity to define forms in space. Cave drawings, picture languages and the stylized drawing of children all help to demonstrate the more expressive aspects of the line.

The oldest works of art which survive are drawings. Examples in France and Spain, dating back to the paleolithic period, include animal figures drawn onto the walls of caves. These drawings were probably made with lumps of earth or clay which may have contained traces of minerals such as iron oxide or may have been burned to enrich the color. The exact purpose of these drawings is not known, but it is assumed that they were part of the ritual of the hunt and it has been suggested that by marking the image of a creature on the wall, primitive people felt that they had gained power over the beast or tamed it in some way.

Drawing has also played a large part in the development of the written language. Some scripts today, such as Chinese, still retain a pictorial quality. Early writings, such as Ancient Egyptian hieroglyphics, closely resemble strip cartoons. The Egyptians made little distinction between their paintings, which were really colored drawings, and writing. The purpose of their tomb paintings was to convey information, not to create the illusion of reality. Egyptian sculpture and some of the less formal paintings show that they were quite capable of imitating real life but this was not their principal intention.

In the light of these "primitive" examples, it is interesting to trace the development of drawing ability in children. When infants first begin to express themselves using paper and pencil there are certain typical stages through which they pass. The basic urge to draw appears to be instinctive; children with no paper or pencil will use sticks and stones to scratch marks on the ground. Not until they are much older does it occur to them that the marks they make should bear any resemblance to reality; a young child draws simply to make a statement. Nevertheless, children are selective and everything that is represented has a special significance.

Many studies have been made of the early years of a child's development and it has been suggested that the first thing a child learns to distinguish is the face of its mother. Later, the overwhelming fascination of this face is represented in simple terms when the child begins to draw. First pictures of "Mother" often consist of a large circle containing smaller circles indicating eyes and mouth.

The power of this image is such that, at this

Right The earliest surviving works of art are pictorial. These Ice Age paintings were found in the caves at Lascaux in southern France. Many of the figures are grouped and the scenes are apparently anecdotal in character. Hunters and bisons, drawn in a strong curvilinear style, move across the wall in a mysterious ritual, their execution both artistically and technically of an extremely high standard.

Children's drawings
Drawing is the child's first artistic creation and is his instinctive response to the visual world. His first visual reality will therefore be his mother's face, and as this two-year-old's drawing shows, the eyes and nose are of particular significance. Single lines are used to represent the legs and feet (1).

As the child's visual and mental perception develops, so does his ability to note down what he sees. This drawing by a five-year-old includes more details. Note the preoccupation with the hands, particularly the differentiation between the thumb and fingers (2). The awareness of his hands is probably due to the fact that children of this age learn many new manual skills, particularly writing.

1

2

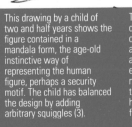

3

4

This drawing by a child of two and half years shows the figure contained in a mandala form, the age-old instinctive way of representing the human figure, perhaps a security motif. The child has balanced the design by adding arbitrary squiggles (3).

The more developed drawing, by a thirteen-year-old, shows a strong awareness of composition, and an acute observation of everyday things, such as the necklace, lamp and bottom of the table. A good attempt has been made to depict the fingers realistically (4).

stage, the child will often make no attempt to include the body.

The next typical stage is the drawing of the figure where arms and legs are shown radiating from a circular head. Again, the elements which are included reflect their importance at this point in the child's development. Someone who has only recently learned to walk will be very aware of the function of the legs. The child records this milestone in his development by acknowledging limbs on paper usually with a single pencil line, but often culminating in big feet. Similarly the hands, over which the child has only imperfect control, may be disproprotionately large in his or her drawings.

Like paleolithic man making cave pictures of animals in order to assume control over them, children attempt to reinforce their identities through drawing; in this way, they can exercise control over the environment in the act of recreating it. As children become more aware of surroundings, other elements begin to appear in the drawings. Sky and ground are often represented by two lines, one above and one below the figure. Sometimes a single line is used which completely encloses the figure in a secure mandala, a feature which has been observed in the drawings of children of all races, both primitive and civilized. The implications are fairly obvious; the child is using the line drawn around the figure as a symbol for security, a protection against the unknown.

The way in which children draw figures in action is often interesting. A running figure may be drawn with legs which are no different to those of a standing figure, except for the fact that they are twice the size. In a manner reminiscent of medieval painting, the child is drawing attention to the function of the legs by enlarging them out of proportion to the rest of the body.

It is not always easy to interpret children's drawings except by being present while they are being made. Children usually draw attention to the significance of marks they make, although they may later forget what the marks were supposed to represent. Usually they do not take more than a few minutes to complete each drawing and once it is finished it will be set aside and forgotten. It seems as though the actual process is of far greater importance than the result.

It is only as the child grows older that he begins to want to make drawings which are less subjective and more a literal imitation of the visual world. This comes partly as a result of observations of other people's drawings and paintings. It is also at least partly due to the expectations of adults who will ask, "What is it meant to be?" and will even call upon the child to justify the contents of a picture. It is then that it becomes important that it should fall within the conventions accepted by the adult world. A child who has quite happily portrayed "Mother" with a frizz of red hair when really it is straight and dark will suddenly see the drawing as "wrong." At this stage, the naiveté of the child's drawing begins to be replaced by sophistication, but many artists of the twentieth century have tried to recover the naive quality of children's drawing in their own work.

Just as when children draw they are not seeking to imitate reality but to say something about it, so artists may choose to concentrate upon a particular aspect of their subject matter. If they are interested in facial expressions then their drawings will not be the same as if they were interested in investigating anatomical features. At its most extreme, this preoccupation leads to exaggerated, caricature.

The drawings of George Grosz (1893-1959) are sensitive and emotionaly charged representations of some of the less desirable human characteristics. Nobody would suggest that his drawings attempt to portray these qualities through lifelike imagery. The manic

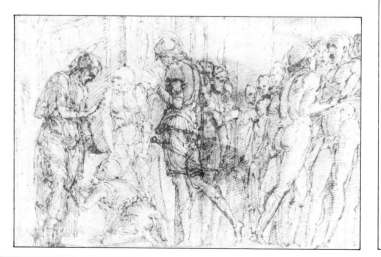

Right *St. James Led to His Execution*, Andrea Mantegna (1431-1506). Mantegna first worked in Padua, the center of Humanism in north Italy, which helped to determine his style. His knowledge of classical archaeology led him to depict the human body on a monumental scale, sculpturally modelled with archaeological precision. In this sketch for the destroyed fresco in Padua, the figures are well placed in relation to each other, showing Mantegna's preoccupation with design, and movement is rendered by the strong verticals and diagonals.

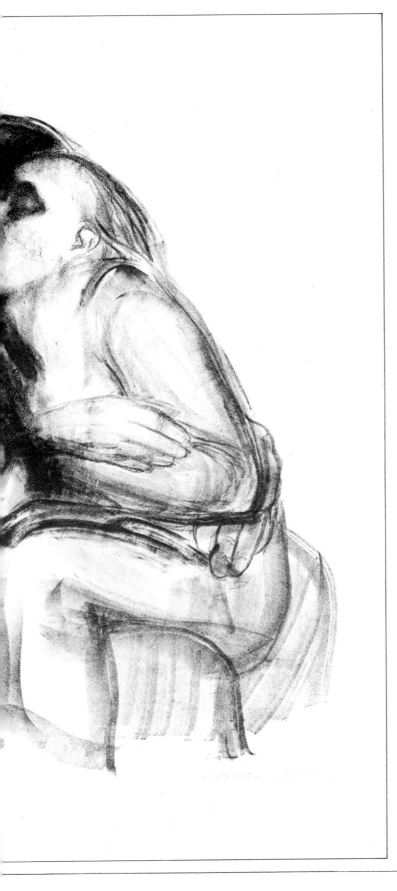

and savage expressions of his characters are conveyed almost entirely by line, the occasional suggestion of tone being incidental to the linear quality. The variety and intensity of the line makes his work very expressive. Grosz's paintings characteristically display people who are animalistic in their desires and fears, both of which emotions are nakedly apparent on their faces. Although his drawings are humorous in tone, Grosz illustrates the human condition in a peculiarly realistic way. The fact that this "realism" is not photographic does not in any way detract from the significance of the drawing. In fact, the language chosen to convey this particular message is exact, apt and evocative of the seedy world his characters inhabit.

Drawing is a highly subjective activity; the way in which different people draw is as recognizable as their handwriting. The finished work is partly an objective record of what artists see and partly a record of how they feel about what they saw. This instinctive response to the visual world is as different and various as there are individuals; this is one reason why there is always something new to draw.

Left *Death Cycle: Death Holding a Girl in his Lap* (1934-35). Käthe Kollwitz (1867-1945.) In this lithograph, the artist has achieved a marvellous marriage between subject and technique, the sweeps of expressive line and areas of dark, heavy tone creating a strong sense of pathos and compassion. A graphic artistic and sculpture, Kollowitz lived in the slums of Berlin and her work displays her concern in emotive line.
Above *Face of a Man*, George Grosz. The apparently simple, fluid lines of this caricature display a consummate knowledge of draftsmanship. Each line is made up of short, broken strokes which imbue the well-observed portrait with energy, and exude Grosz's hatred of the bourgeoisie.

PAPER

The choice of drawing materials available to the artist is very wide and an enormous range of effects can be achieved. The first consideration must be the sort of ground which is to be used. Since the time of the first drawings, executed on the walls of caves, man's ingenuity has brought all sorts of improbable surfaces into use. Clay pots, notably those from ancient Greece and Rome, were a favorite recipient for the drawn mark and today provide evidence of the life of those civilizations. Wood, bark, leaves, papyrus, silk, vellum and parchment were all used as drawing surfaces by primitive peoples. Precious metals, stone, shell and wax tablets all have had designs engraved upon them.

Paper, however, remains the most common choice. It provides a good and regular surface for drawing, is relatively cheap and readily available, and is convenient and easy to transport. Although most drawings are done using a dark line on white or light-colored paper, there is no reason to abide by this convention. It is also possible to make drawings onto dark paper using a variety of implements, such as light-colored pencils, pastels, chalks, crayons or pens with white ink.

Paper has not always been the inexpensive and easily available commodity it is today. The first known use of paper was in China as long ago as the second century AD. Its use gradually spread through Islam and Byzantium until, by the thirteenth and fourteenth centuries, it was available in certain parts of Europe.

Papermaking was a skilled craft which involved pulping fibers of vegetable origin in water, which was sometimes mixed with some form of adhesive binder. The fibers were collected on a perforated frame and then allowed to dry. It is only comparatively recently that wood pulp has replaced other vegetable fibers to become the most commonly used ingredient in papermaking. More expensive paper is still manufactured from fine linen or cotton rag, and silk and rice paper continue to be made, mostly in Japan and China.

Paper is available from stationers and art suppliers in standardized sizes and a variety of weights and surface textures. The different sizes are known by their traditional old names, including Crown (17 × 22 inches), Double Crown (19 × 22 inches), Quad Crown (19 × 24 inches), Double Quad Crown (24 × 38 inches), Post (24 × 38 inches), Double Large Post (26 × 29 inches), Demy (28 × 42 inches), Double Demy (28 × 44 inches), Quad Demy (29 × 52 inches), Music Demy (32 × 44 inches), Medium (34 × 44 inches), Royal (35 × 45 inches), Super Royal (36 × 48 inches), Elephant (38 × 50 inches), and Imperial (41 × 54 inches). Large pieces of expensive paper can usually be purchased in single sheets. There is no reason for the artist to accept these standard sizes and formats as they are. It may be that a particular subject would be better drawn on a piece of paper that was more square in proportion or more oblong. Large sheets of paper can easily be cut down into a number of smaller ones offering a variety of formats.

The three most commonly available paper surfaces are: Hot Pressed or HP, which is smooth and shiny; Cold Pressed or Not (meaning *not* Hot Pressed) which has a medium smooth texture; and Rough, which is often handmade and preserves the natural granular surface. Today, paper is usually bleached or artificially colored and fillers such as chalk are used to improve the surface. Hot Pressed paper is ideal for drawing in pen and ink because its smooth surface allows the pen strokes to move across the paper without impediment. For pencil work, the slightly rougher texture of Cold Pressed paper is usually considered to be preferable, while the surface of Rough paper is at its best when used for the broader strokes of chalk or charcoal.

Although paper is fairly cheap material, particularly in relation to the other types of surface, the price and quality can vary a good deal. Cheaper paper is perfectly acceptable for everyday use, but bears no relation to the quality of good handmade paper, which is naturally much more expensive. Many qualities of paper come in a choice of shade and color, with quite a wide range available. The choice will depend very much upon the sort of drawing to be done. A drawing which emphasizes linear aspects or dwells upon detail would be better on a white or pale neutral paper. Tinted papers are best used for tonal drawings as this will allow both the light and dark areas to be positively defined against the mid-tone of the paper. Some draftsmen respond better to one type of paper than another. Experimenting with different types of paper is well worth the effort and time.

For a pen and wash or a watercolor drawing it is often better to stretch the paper. This is done by soaking the paper for a short time in cold water and then attaching it to a drawing board with drawing pins or gummed paper strips. As the paper dries it acquires a taut, drum-like surface which is pleasant for drawing on and does not wrinkle when wet paint or ink is applied.

MEDIA
Charcoal

One primitive drawing implement which is still popular today is charcoal. In earlier times, stubs of charred wood would have been used but today willow twigs are converted into charcoal in special ovens.

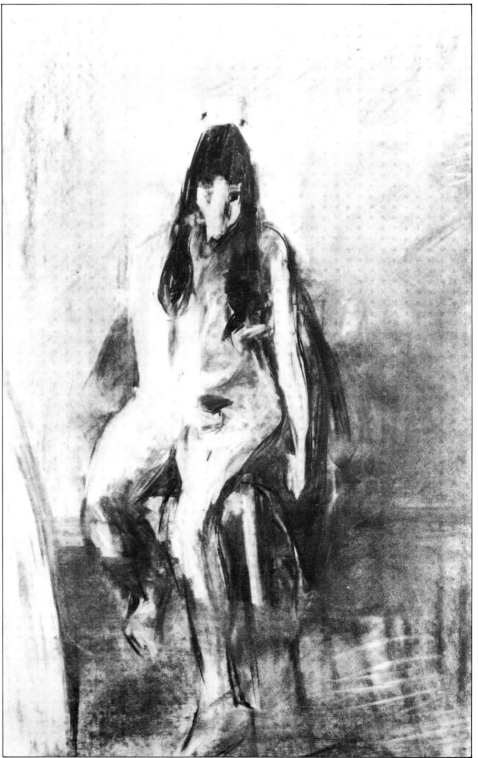

Papers, pastels, chalks and crayons
Several manufacturers produce good watercolor papers, examples of which are shown here. When buying paper, attention should be given to its weight, tone and texture. Although a good selection of tinted papers is available, tinted washes can be applied to white paper to obtain the exact color required. The amount of white required to show through the paint determines the texture and weight of the paper to be used. Paint easily covers smooth paper while heavily textured paper leaves small flecks of white.

A light, medium and dark graduation of each color will probably be enough for pastel drawing. Pastel pencils (2) are easy to blend, are non-toxic and do not fade. Oil pastels (3) can be mixed directly on the paper while wax pastels (4) have the added advantage of being usable on any surface; they are non-toxic and water- and light-resistant. Caran d'Ache (5) crayons range from medium to hard; Neopastels (6) are softer. Conté crayons (7) are similar to natural chalks and are available in a limited range of colors.

Top left *Woman Seated by a Dressing-Table*. This drawing on drawing paper illustrates the strong line and fine grduations of tone which can be achieved with black chalk. White chalk is used to create highlights and to show the fall of light.
Above left *Sleeping Mother and Child*. This sketch shows the subtle effects which can be achieved with pen and ink on Schoellershammer paper. A heavily loaded pen has been used to obtain the scratchy, straight lines to build up the mother's head, and less heavily loaded to draw the rounded contours of the baby.
Above *Seated Nude*. The expressive quality of charcoal is shown on a slightly grainy drawing paper where the mottled surface of the paper shows through the light application of the medium to create a textured background.

The advantage of charcoal as a drawing material is that it is soft, gives a sympathetic but positive line, and can be corrected easily if necessary. To exploit charcoal to the full, it should be used on a toned, slightly granular paper. This means that the black areas of tone will be broken up by the untouched cavities in the paper where the charcoal cannot reach; this gives a sparkle and spontaneity to the drawing.

As charcoal can only be used in a negative sense, to show where light is not falling, it is often very effective to use white chalk for highlights or to indicate where light is falling. On toned paper, this combination works particularly well. Charcoal is at its best when the subject calls for a forceful approach – broad and confident bands of tone with relatively little detail.

Chalk

Conté chalks are similar in effect to charcoal but they are much harder and therefore can be used for finer lines and greater detail. These little sticks are available in both black and white, and also come in the traditional terracotta red and dark brown. More recently, Conté has introduced a range of colored chalks which include strong primaries and soft pastels.

Like charcoal, these chalks show to their best when used on tinted paper with a fairly rough texture. The mood of the subject can be emphasized as much by the choice of paper color as by the drawing materials. Leonardo used red chalk, made from iron oxide, usually drawing onto a warm buff-colored paper. Later, from the mid-sixteenth century onward, the combination of black, white and red chalk was favored by many artists. Notable exponents of this style of drawing include Rubens and the Italian, Tiepolo (1696-1770).

Pastel

A softer and more luminous effect is given by the use of pastels, which were much beloved for their opalescent quality by the Impressionists. Pastels are composed of finely ground pigment, held together in sticks with gum. They are powdery and difficult to control, but can be used to produce drawings of great subtlety.

Like charcoal and chalk, pastels rub off rather easily and need to be fixed to the paper if the effect is to have any permanence. This is achieved by spraying the finished drawing with some sort of binding agent such as glue or resin. In the past, a variety of fixatives were used including beer, skimmed milk, egg white and gum arabic. Today synthetic resin is widely employed and is applied either with a spray applicator or an aerosol can, which is

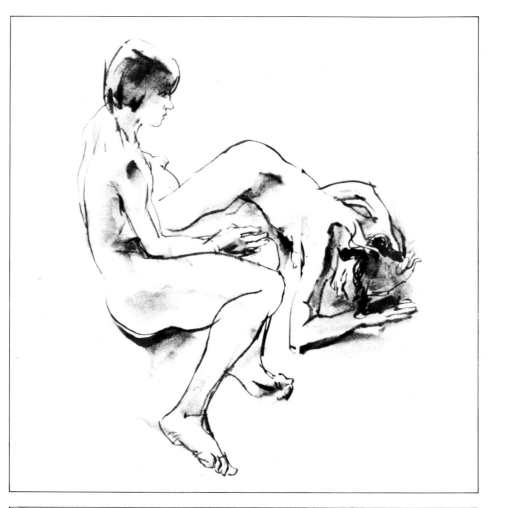

'My Father'
Richard Bellamy · 11/11/11

John Bellamy '82

more expensive but easier to use. Another way of fixing dry pigment is to impregnate it with a binding agent. Charcoal or pastels can be soaked in a drying oil immediately before they are used. The drawing should be completed before the oil has had time to dry.

Crayon

Wax crayons are an example of the way that dry pigment can be held together so that it does not smudge. Generally speaking, though, the quality of wax crayons is unsubtle and they are not particularly popular as a drawing material. They can, however, produce interesting effects when used as a mask before making a drawing in pen and wash. Because wax is water-resistant, lines drawn onto the paper will repel any water-based ink or paint which is subsequently laid over the top. This can produce exciting, though unpredictable effects.

Silverpoint

A drawing technique popular with artists of the Middle Ages and the Renaissance, though little used nowadays, is silverpoint. The drawing surface, most often paper or vellum, is given a coating of opaque white, and a sharp metal point, usually made of silver, is then used to scrape through this prepared surface. The metal point, which can also be made of gold, copper or lead, is secured in a wooden holder or leather casing in much the same way that modern graphite pencils are held in a wooden sleeve. The line produced by this method is very fine, which makes it most suitable for delicate and elaborately detailed drawings, such as portraits. Because it is such an exacting medium with little room for correction, the draftsman must make confident, disciplined strokes to achieve the best results.

Pencil

The use of graphite as a drawing medium was developed in sixteenth-century England; later, wooden sleeves, similar to those used in silverpoint, were added. The modern graphite pencil is manufactured in a range from very hard to very soft. The harder pencils (H to 6H) are more suitable for architects and technical draftsmen as they can be sharpened to a fine and durable point. The HB pencil is midway between the hard and soft and is good for everyday use. Most artists, however, prefer to draw with the range of softer pencils (B to 6B) which allows a greater intensity of effect to be achieved. Carbon pencils are a mixture of clay and carbon and can be used to produce a savage black line.

Working in pencil allows for an infinite amount of elaboration and corrections are easy to make. Although pencil smudges less than chalk, pastel or charcoal, it is still a good

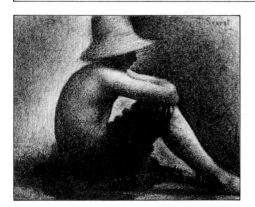

Above left *Two Nudes*. This charcoal sketch illustrates how the medium can be used to give an impression almost like ink on very smooth paper.
Far left *Study for Pink Nude* (1935), Henri Matisse. This charcoal sketch demonstrates Matisse's marvellous sense of rhythmic line and form.
Left *Seated Boy with Straw Hat*, Georges Seurat. The founder of Neo-Impressionism, Seurat developed the Pointillist technique, used here to great effect in this monumentally conceived drawing, strong static luminosity is conveyed through large areas of tone.
Above *My Father, Richard Bellamy* (1982), John Bellamy. This charcoal portrait shows how much can be conveyed with a few economical lines and squiggles. The features are dominated by the piercing glance from eyes which are the only heavily worked area of the picture.

Far left *Nude in Chair*. This effective study, done with a soft B pencil, consists of a few flowing lines to suggest the body while the stronger outlines of the head have been obtained by firmer application.
Left *Seated Man*. Here the artist has used graphite pencil to draw this pensive-looking figure. The combination of clay and graphite makes a harder medium than charcoal which can be used to make strong, vigorous, linear marks. These lines have the effect of drawing the figure in visually, complementing the mental withdrawal in the strong V-shape.
Right *Crouching Boy*. This sketch shows the flexibility of the softer range of B pencils. The thick, lighter line and shadow is achieved by using the pencil on its side.

idea to spray all drawings with fixative.

There are many brands of colored pencils which are available in a variety of qualities and every conceivable color. Some are also water-soluble and a wash effect can be produced by going over the drawing with a wet brush. These pencils are a relatively new development, and, although interesting results can be accomplished, the possibilities have not yet been fully explored.

Ink

A drawing medium which can produce a mark of authority, but also allows for a fine degree of subtlety, is ink. This was popular with many artists, including Rubens and Michelangelo, and, in the hands of a penman such as Rembrandt, proved itself to be a technique of extreme versatility. The best ink has always been made in China, although, strangely, it became known in the West as Indian ink, acquiring this misleading name because it was the East India Company which first introduced Chinese ink to Europe. The main ingredient of Indian ink is carbon, which is made by burning various resinous woods, such as pine. The soot is then collected on the underside of metal or stone slabs and combined with glue or resin. In the East, ink is molded into cakes or sticks which are rubbed against abrasive stones before use and mixed with water. In the West, Indian ink is usually sold already mixed into a liquid.

True sepia comes from the ink sacs of the octopus. It gives a fairly permanent color, ranging from nearly black in its undiluted state to a pale yellowish brown with the addition of water. Bistre is a cheaper substitute for sepia and is made from charred wood. It is less satisfactory, however, as the color is less intense and less permanent. Another alternative to real sepia is oak-gall ink, which has been in use since the eleventh century. Concentrated water which has been used to boil oak-galls renders a brown fluid which is very similar in effect to sepia. Unfortunately, its rather acid content tends to burn paper and it bleaches rapidly if it is exposed to direct light.

Apart from these traditional inks it is possible to purchase a good range of colored inks, which are available in a transparent or opaque form. Although the transparency of ink is one of its more attractive qualities, it is sometimes useful to have opaque ink for use on dark paper. With opaque ink, white or light colors can also be used to draw in details over the top of darker areas of a drawing. In the past artists have often introduced small amounts of colored pigment to modify black ink slightly. Both vermilion and terre verte were commonly used in this way, the former to produce ink of a warmer, the latter, ink of a cooler character.

The main tools used for the application of ink are the pen and the brush. The pen has been in use since early Egyptian times, or longer. Ink pens can be made easily and cheaply, which accounts for their widespread popularity. In its simplest form, a stick with a slightly sharpened end can be dipped in ink, or any other colored liquid, and used to make a mark, but in order to control this mark properly it is better to make a slightly more sophisticated version. Reed or bamboo are often used to make ink pens because their hollow centers allow for a reservoir of ink to be retained. The ends are usually tapered either to a point or a blunt chisel-like shape. If the ends are also split then the artist can vary the width of the stroke by exerting a greater or a lesser pressure on the pen.

A favorite choice for drawing in ink has always been the quill pen. Any kind of feather can be used, but the best are the long wing feathers of swans or geese. These are sharpened and shaped in the same way as reed or bamboo pens and are springy and pleasant to use. The drawback with quill pens and others of this type is that they wear out

quickly so the quality of line can alter a great deal during the course of the drawing. This can be turned to good effect: many of Rembrandt's pen and ink drawings, acknowledged as being among the best of their kind, show evidence of his having used an increasingly worn nib, but with such empathy that the finished result is considered enhanced.

More durable, if slightly less sympathetic, are nibs made from different types of metal which fit into a shaft or holder. The best and most expensive metal nibs are made of gold, but silver, steel and chromium are all common and perfectly satisfactory. However, a metal-nibbed pen imposes a greater uniformity of drawing technique and many artists prefer the freshness and vitality of the reed or quill.

With such a variety of different drawing pens available it is best to experiment with as many as possible. A pen with a pointed or rounded end will give a line which varies only slightly in breadth but is excellent for free, expressive drawing. A sharper edge and greater variation in breadth of stroke can be achieved with a chisel-ended nib, the type designed for calligraphy, particularly italic writing. If the italic pen is held consistently at an angle of 45° then the line will alternately narrow and thicken as it describes a curve.

Possibly the most difficult tool for the draftsman to use, but certainly one which has enormous versatility, is the brush. To use it properly demands forethought and sureness of touch, but the flexibility of this implement allows for greater variety and beauty in the drawn line.

Originally brushes were probably no more than a twig or reed which had been hammered until the end was splayed out. Although drawings of some immediacy can be produced, this type of brush is clumsy and awkward to handle. Today, brushes are generally made of synthetic fibers or some sort of animal hair gathered then bound to a metal or wooden shaft. The hairs are so arranged that the brush is either round and tapers to a point, or is flat in section and has a chisel-shaped end. The natural ends of the animal hair should be left intact, as this not only improves the shape of the brush but also facilitates the flow of ink or paint. The hair most commonly used in the manufacture of brushes is hog bristle, which is stiff and coarse, ox or camel hair, which is slightly less stiff, and a variety of softer hairs, more usually either squirrel or sable. The most expensive of all these is sable, but it is well worth the extra cost as it is springy and resilient. With proper care, sable brushes should have a reasonably long life. Sable brushes should never be left standing in water; they should be washed in clean water and pulled back into shape.

In China and Japan, where the brush has always been a greatly favored implement, both for drawing and for writing, it is manufactured with meticulous care. The center of the brush is made up of a cone of stiffer hairs around which are assembled layers of longer and softer hair. This system of assembly allows a reservoir of ink to be held between the nucleus of stiff hair and the more pliable outer layers. The root of an Oriental brush is the thickest part and even a very large one will taper to a fine point. A skilled practitioner can produce drawings of extreme subtlety and sensitivity with this sort of brush, but it requires an entirely different technique, with the brush held vertically.

The effects which can be achieved with an ink-loaded brush are numerous. Broad washes of dilute ink can be contrasted with fine but strong lines of more concentrated color. Crosshatching, stippling, splattering and the sharp, freely drawn line can all be used. The drawing can be given a softly graded tonality or high contrast. Francisco Goya was fond of making direct brush drawings which have a very atmospheric quality. He sometimes introduced a color, such as red, in order to give a heightened effect. Certain European artists, such as Nicolas Poussin (1593/4-1665) and Claude (1600-82), used ready-mixed washes which gave three or four different grades of tone. This gave their drawings a distinctive quality because of the ordered tonality. William

Turner (1775-1851), who was a great admirer and imitator of Claude, nevertheless did not adopt this system of using a predetermined tonal scale. His drawings, which are in many respects similar to those of Claude, remain individual because of their more specific tonal effects.

Alternative Media

The drawing implements and media described here are those which have been in most common usage, throughout the ages and have retained their popularity up to the modern day. This should not deter the artist from experimenting and inventing different methods of drawing. Rags dipped in ink can be used to dab or smear expressive marks on paper. Fingers, hands, leaves, flowers and pieces of string can all be used to transfer color with excitingly unpredictable results. Smudges and blots used judiciously can give a drawing an air of immediacy; even accidental marks can be incorporated.

Certain types of pen not normally associated with fine art can nevertheless be employed in an interesting and creative way. A drawing in ballpoint pen can be rendered quite atmospheric by flooding it with oil or turpentine. Colored felt-tip pens are worth investigating; some of the newer brands come in colors which can be blended.

A sharp point or stylus can be used to scratch through a layer of opaque ink or paint, allowing the paper to sparkle through; in fact,

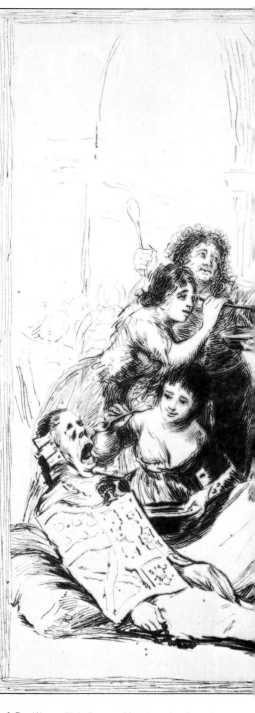

Left *Two Women, Nude.* Pen and ink have been used since about the twelfth century, although not generally by European artists until the Renaissance, when the reed pen was introduced. There is little or no margin for error when using the pen. Spatial relationships between subjects have therefore to be worked out as well as the placing of the composition on the paper. This sketch shows the care with which each mark has to be made and the way in which tone and texture can be implied with the medium.

several kinds of scratchboard, specially prepared to give precisely this effect, are commercially available. They have a black surface which can be drawn into with a sharp implement to allow the white underlayer to show through.

TECHNIQUES

Art schools have traditionally adhered strictly to an academic approach for teaching figure drawing. Until quite recent times, students

had to spend a considerable period making studies of antique plaster casts. Only after they were thought to have reached the necessary level of competence in this discipline were they allowed to draw from a live model. Although this may seem to be quaint and old-fashioned, there are certain points in favor of this approach. Plaster casts are naturally easier to draw because they do not move around. They are also more likely to represent the "ideal" human figure than a real

live model; beginning with a standard notion of proportion can help the artist to appreciate individual differences later. Modern art schools no longer put their students through this type of apprenticeship but there is nothing to stop anyone from adopting the same tactics as Auguste Renoir, who believed that his figure drawing was inadequate and inaccurate and drew literally hundreds of studies from plaster casts in order to improve. Whether this discipline is employed or not, **much useful**

Selecting your viewpoint

Before choosing a viewpoint, it is important to take time to study the exact position you wish to draw, the pose and its surroundings. This can be done by moving gradually around the model, which will show the different angles and play of light on the form. The body's main volumes are basically composed of cylinders, each having a central axis and linking up with the spine, as the superimposed lines over these photographs show. When starting a drawing, a useful method is to work out the volumes in terms of cylindrical shapes.

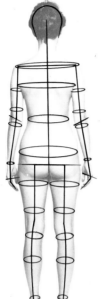
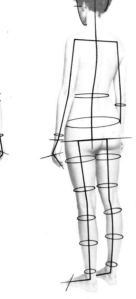
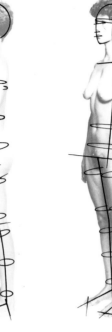
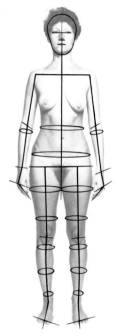

Limb movements

These poses show the arm's relation to the rest of the body and the effect of its movements on the contiguous muscles. By raising one arm, the whole of that side of the body is slightly raised; with both arms raised, the area above the waist is lifted and the muscles tightened. With the legs apart and arms down, the whole body has a more relaxed and heavier appearance, and the shoulders and chest muscles sag.

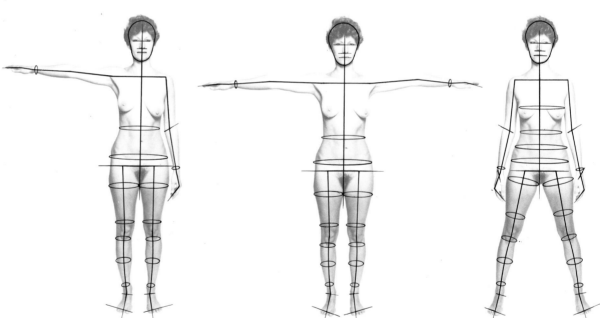

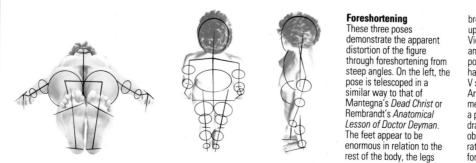

Foreshortening

These three poses demonstrate the apparent distortion of the figure through foreshortening from steep angles. On the left, the pose is telescoped in a similar way to that of Mantegna's *Dead Christ* or Rembrandt's *Anatomical Lesson of Doctor Deyman*. The feet appear to be enormous in relation to the rest of the body, the legs broad and short while the upper body is hardly visible. Viewed from above, the head and shoulders of the central pose dwarf the figure's lower half which diminishes into a V shape.

Artists should learn to measure by eye or by holding a pencil at arm's length, drawing entirely what they observe in front of them rather than relying on any foreknowledge.

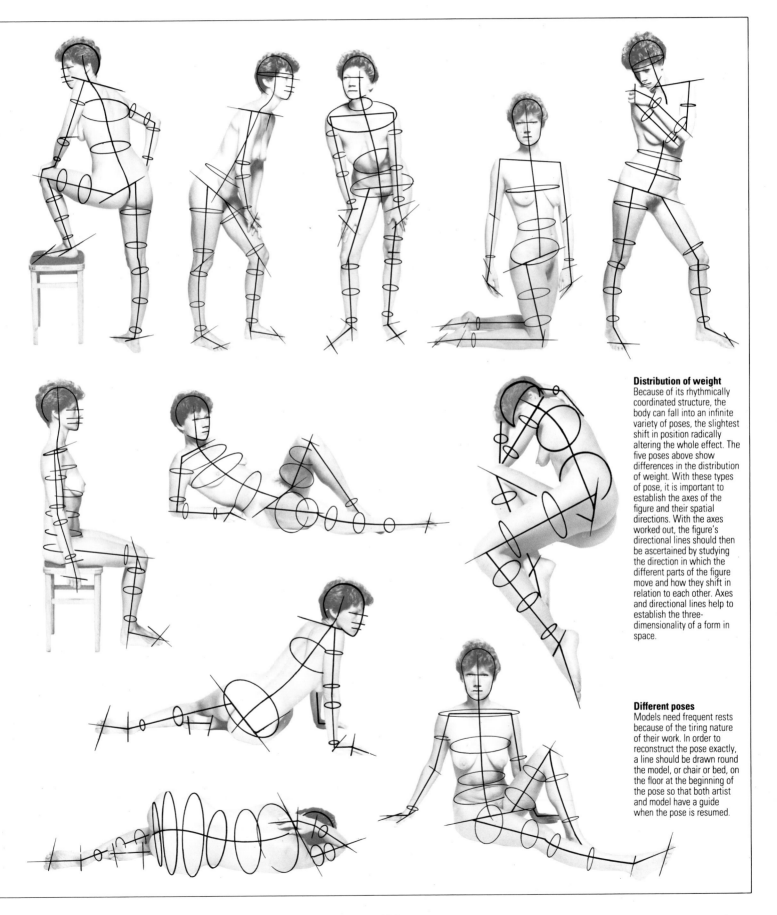

Distribution of weight

Because of its rhythmically coordinated structure, the body can fall into an infinite variety of poses, the slightest shift in position radically altering the whole effect. The five poses above show differences in the distribution of weight. With these types of pose, it is important to establish the axes of the figure and their spatial directions. With the axes worked out, the figure's directional lines should then be ascertained by studying the direction in which the different parts of the figure move and how they shift in relation to each other. Axes and directional lines help to establish the three-dimensionality of a form in space.

Different poses

Models need frequent rests because of the tiring nature of their work. In order to reconstruct the pose exactly, a line should be drawn round the model, or chair or bed, on the floor at the beginning of the pose so that both artist and model have a guide when the pose is resumed.

information can be gained by examining the way the great masters of the past have drawn the figure.

Methods of drawing differ from one artist to another and it would be ridiculous to suggest that there was a right or a wrong way. Even so, there are certain guidelines which can be useful to follow, especially for a straightforward study of the figure. The best advice of all is just to practise. Drawing has to do with training the eye as much as with a facility with pen or pencil; the actual technical skills, although important, are secondary to quality of vision. For this reason, the best way of starting a figure drawing, or any other sort of documentary drawing for that matter, is to spend some time analyzing the various shapes and relationships. Before starting to draw, the overall proportions of the figure should be considered and the correct format of paper selected. The height of the posed figure should be compared with the breadth by holding a pencil at arm's length and using the thumb as a sliding measure. It is often surprising to find that the width of the pose is greater than the height, in which case it is best to use the paper in a landscape (horizontal) format. By again holding up a pencil or any

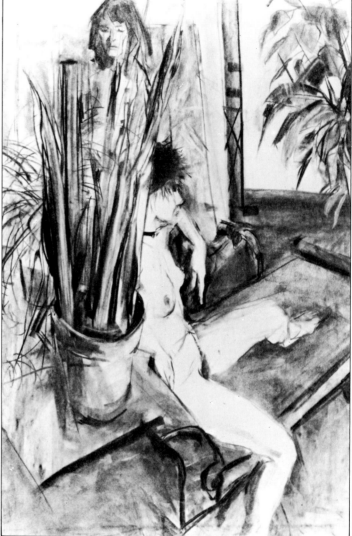

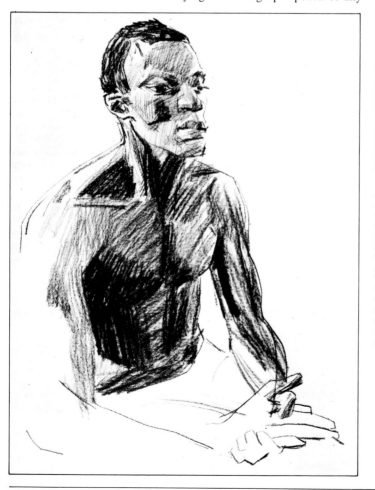

Below *Portrait of a Man*. This somewhat sculptural drawing, executed in graphite pencil, shows the planes and curves of the torso and head, and how the forms are built up through the contrast of the strong black hatching with the lighter diagonal lines.

Above *Plants and Two Nudes*. This atmospheric drawing in charcoal and 8B pencil has been done on drawing paper. The strong charcoal verticals and diagonals create the spatial dimensions in which the figures are placed while the figures are outlined in pencil, with a good deal of finger work to create the hazy shadows, and the highlights rubbed in with a kneaded rubber.

other straight edge, in a vertical position, the central axis of the pose can be determined. Judging the distribution of forms about the axis plays an important part in the dynamics of the drawing.

After checking the overall proportions and choosing the size and shape of the paper, the artist must decide how much space will be occupied by the drawn figure. The mood of the finished work will be influenced by how large the figure is in relation to its surroundings. Even if there is no indication of background at all, the position of the figure on the paper is important. Quite apart from making sure, before starting work, that the whole figure is going to fit, it is also important to avoid creating an uncomfortable feeling by siting the figure too close to the top or bottom. Some people like to make a series of little crosses or dots on their paper to mark points of reference before they actually begin to draw. The top of the head, the feet,

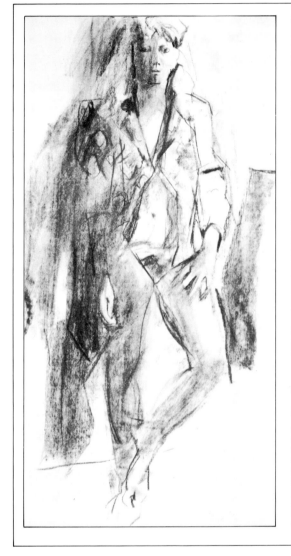

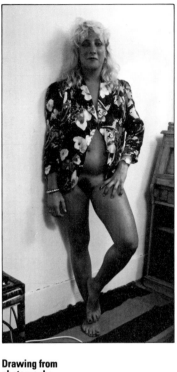

Drawing from photographs
The artist has used a photograph of a model for this charcoal with Conté crayon study drawn on good quality drawing paper. A comparison of the two demonstrates his use of artistic license: the casual appearance of the photographed model has been transformed into an impression of a figure moving out of darkness into light.

the framework it is easy to fill in the gaps and round off the corners in order to translate it back into living, moving flesh.

Sensitive handling of line can fill a drawing with energy and vitality. As discussed earlier, an important role of the line is to imply shape or mass, but sometimes the line must also indicate a meeting between two solid forms. This poses a very interesting problem. It is easy to see that certain drawing media have characteristics which make them more suitable to use for describing particular effects. But if a soft yielding form, such as the human body, is in contact with something hard and unyielding, such as stone, the line which separates them will have to imply the characteristics of both. In such a case the line must indicate the displacement of one form by another more dominant one, marking the point of contact and conflict.

A line need not always represent the "edge" of a shape. A drawing is usually made up of a mixture both of outlines and interior lines. Many of the interior lines discernible on a drawing of the nude show the interlocked and underlying structure of the body; here a knowledge of anatomy can be very useful. Emphasizing these lines of structure establishes the nude as a three-dimensional form in space. This feeling of solidity can be enhanced further if the artist imagines that lines are drawn around the body of the posed model. (A particularly cooperative model may allow real lines to be traced around his or her body, but this is not really necessary.) Two imaginary lines drawn one above and one below the waist would mark out a cross-section rather like a chunk out of the middle of a tree trunk. By putting a line around the model's middle the artist is obliged to consider and analyze this shape and to find a way of showing this. It is important to learn to use the line in an exploratory fashion and to feel a way around the form.

A drawing which sets out to express movement of the body needs to be treated in an entirely different way. Careful analysis and preliminary measurement depends upon the figure remaining still; even a slight alteration of pose sets up a whole new series of relationships. A drawing about movement cannot be as detailed as one from a posed, static figure, because there is only enough time to put down a minimum of information. However, a few rapid pencil lines are often enough to capture the spirit of a movement. Many artists find that the best way of recording the figure in motion is to make large numbers of quick drawings, spending no longer than a couple of minutes on each. By their very nature these fleeting glimpses are more likely to convey the impression of movement than more considered and finished work.

shoulders, knees and elbows can be plotted out in relation to one another and marked lightly on the paper.

This system of marking out points of reference can be taken much further. All the features of the figures can be translated into a series of interrelated marks on the paper, providing a good method of crosschecking. A dot on the paper which indicates the position that will be taken by the tip of the nose is related to a dot which marks the point of the chin and another which marks the ear lobe. This triangle can be related to the position of the other, larger triangle which is made up from the point of the knee, the ankle and the iliac crest. An elaborate network of tiny marks can be built up in this way, which can eventually be joined, after the fashion of children's dot-to-dot drawing games, to produce the image of the posed figure.

It must be remembered that the patterns built up from these measurements and comparisons are flat. They must be so because they are recorded on a surface which is two-dimensional, but what they represent are three-dimensional relationships occurring in reality. If these triangles were constructed as a piece of sculpture, their planes would all be facing in different directions; the artist has to be aware not just of how one area of the drawing relates to another but of a myriad of plane shapes which also have interrelation-ships within the space they occupy. This analytical approach has much in common with the ideas of the Cubists. Paul Cézanne believed that "one should try to see in nature the cylinder, the sphere, the cone, all put into perspective." In making a mental image of the figure as a construction built from familiar volumetric shapes, the artist is simplifying it into a series of forms easier to understand. If there are any flaws in the way that this basic construction hangs together then they can be readily seen and corrected. Having built up

RECLINING NUDE
pastel and charcoal on paper 32×20 inches (81×51 cm)

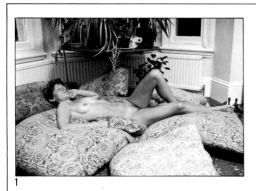

The reclining figure has always been a popular subject: the pose can suggest a sense of calmness and relaxation, or invite a frank observation or admiration of the naked body. The artist must pay careful attention to the way the body changes in a horizontal position – the rib cage may be more prominent, the flesh may slacken and the angle of the head can take on a particular importance. A bed or divan presents a fairly uniform surface, but cushions give a more undulating support, echoing the curves of the figure itself (1).

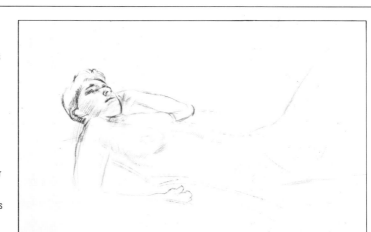

Working within a set period of time, an artist will always find certain areas of a drawing or painting taking precedence over others. In this pastel drawing, the head and face provided a focal point, and this resulted in a portrait study made at the expense of detail over the rest of the body. The study evolved by constantly relating all the points of the drawing with the head. By placing the figure in a diagonal position, the composition is given more interest.

Even when there is unlimited time, a certain amount of selection is inevitable and indeed preferable when confronted with the complexity of reality. Here, the model is reclining on a number of cushions, each of which is delicately patterned, and behind the figure is a table heaped with plants. Natural light coming from behind the figure provides a further complexity which was overcome by simplifying some areas and strengthening others. The greens reflected on the skin from the plants were given a new source: a simple, blocked-in background. The result shows how different the personal view of a drawing can look when compared with the relatively indiscriminate view through the camera lens.

The initial stage is a charcoal drawing. The artist begins by sketching the head in a relatively detailed fashion and then gradually works across the paper, delineating the rest of the figure. The figure is placed diagonally on the page, at a slightly different angle to the actual pose (2). The pose of the model changes slightly as she relaxes, the angle of her right arm becoming less acute and her hand moving further down the cushions. The artist takes account of this change and redraws the arm in the new position. Alterations of this nature need not be eradicated; the original lines are faint enough to be incorporated (3). The monochrome drawing is not yet complete, and the artist adopts a tonal approach to the work and covers most of the paper with charcoal. This creates shaded areas and areas of highlight (4).

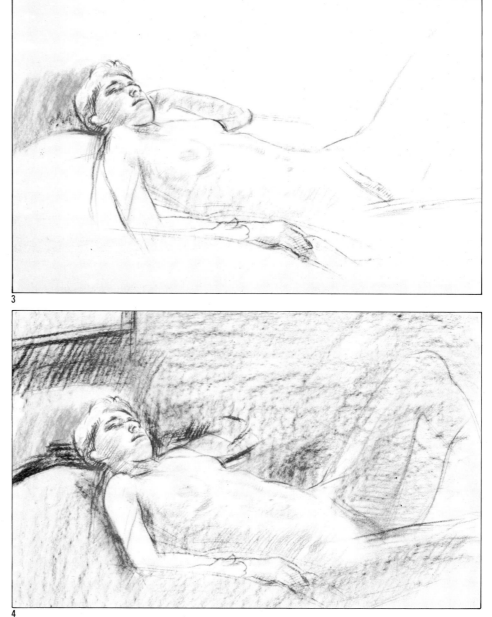

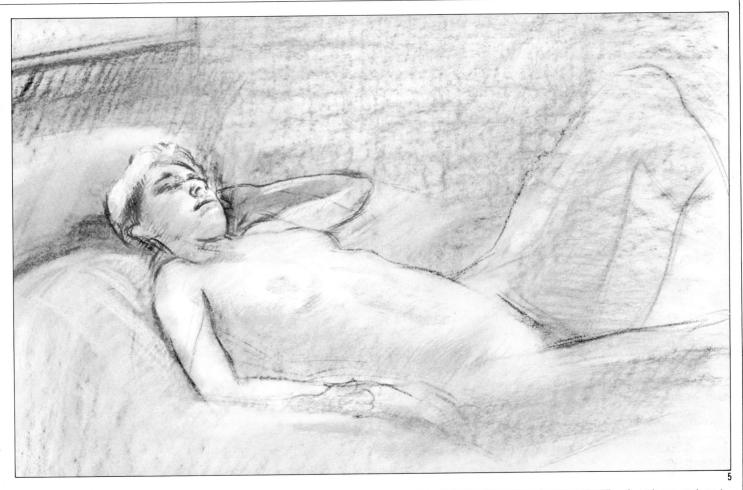

5

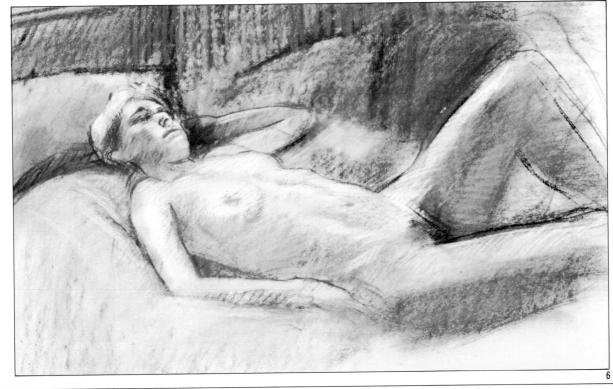

6

A certain amount of pastel has already been added to the basic charcoal drawing. More pastel is now incorporated, the artist restricting his choice to subdued hues in order to concentrate on the tonal qualities. At the same time as the tonal structure is being carefully built up, the detail is beginning to emerge, the figure being strengthened with firmer charcoal lines (5).

The drawing is now well established; further alterations would be difficult to make. The ligher areas of the figure are modelled and the artist sprays the picture with a commercial fixative, in effect creating a gray underpainting to which more vivid pastel colors can be added (6).

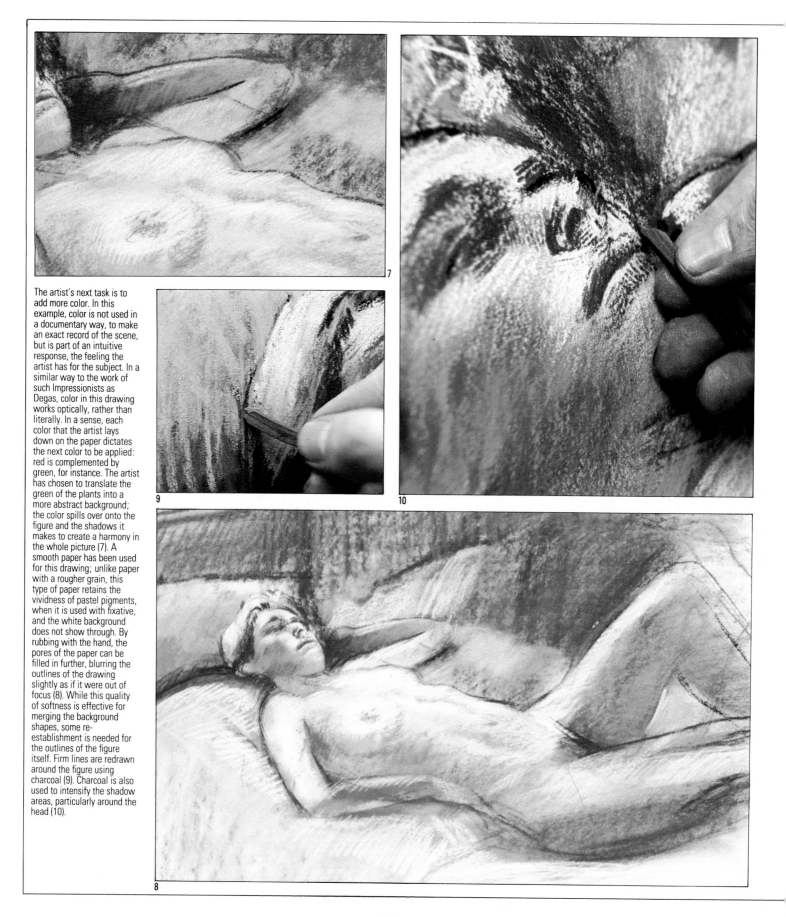

The artist's next task is to add more color. In this example, color is not used in a documentary way, to make an exact record of the scene, but is part of an intuitive response, the feeling the artist has for the subject. In a similar way to the work of such Impressionists as Degas, color in this drawing works optically, rather than literally. In a sense, each color that the artist lays down on the paper dictates the next color to be applied: red is complemented by green, for instance. The artist has chosen to translate the green of the plants into a more abstract background; the color spills over onto the figure and the shadows it makes to create a harmony in the whole picture (7). A smooth paper has been used for this drawing; unlike paper with a rougher grain, this type of paper retains the vividness of pastel pigments, when it is used with fixative, and the white background does not show through. By rubbing with the hand, the pores of the paper can be filled in further, blurring the outlines of the drawing slightly as if it were out of focus (8). While this quality of softness is effective for merging the background shapes, some re-establishment is needed for the outlines of the figure itself. Firm lines are redrawn around the figure using charcoal (9). Charcoal is also used to intensify the shadow areas, particularly around the head (10).

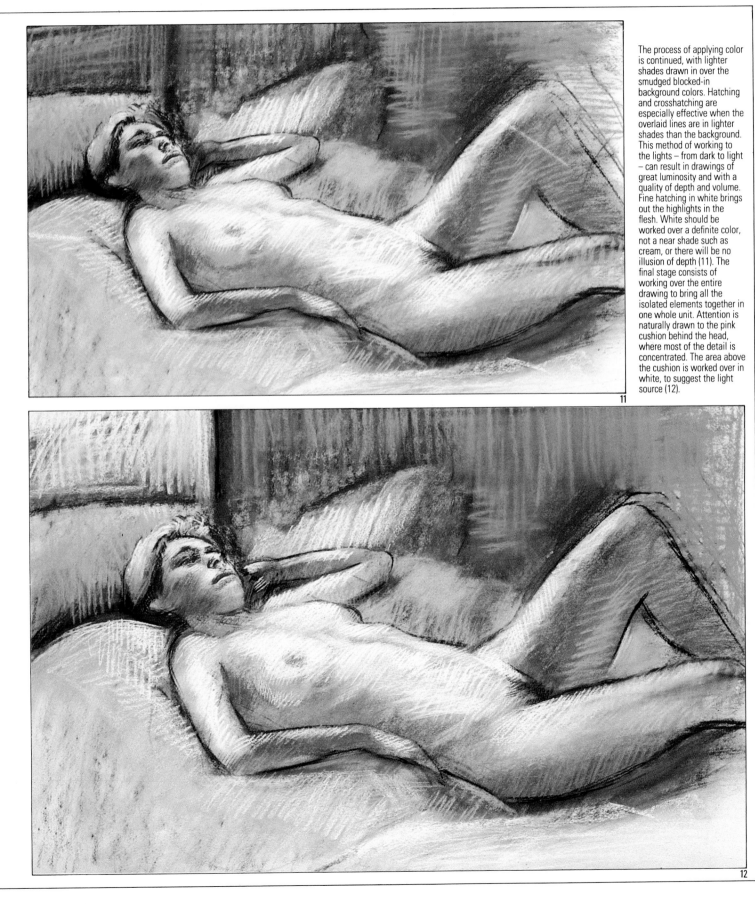

The process of applying color is continued, with lighter shades drawn in over the smudged blocked-in background colors. Hatching and crosshatching are especially effective when the overlaid lines are in lighter shades than the background. This method of working to the lights – from dark to light – can result in drawings of great luminosity and with a quality of depth and volume. Fine hatching in white brings out the highlights in the flesh. White should be worked over a definite color, not a near shade such as cream, or there will be no illusion of depth (11). The final stage consists of working over the entire drawing to bring all the isolated elements together in one whole unit. Attention is naturally drawn to the pink cushion behind the head, where most of the detail is concentrated. The area above the cushion is worked over in white, to suggest the light source (12).

11

12

SEATED MALE FIGURE
pen and ink wash on paper 20×15 inches (51×38 cm)

A monochrome wash together with line drawing is used in a lively and spirited way in this picture. Attempting to describe both color and tone with such a wash can be difficult because the two concepts sometimes become confused. In this case the color of the skin in a badly lit interior presents a problem for the artist, the skin tones being difficult to distinguish from shadows. However, with a single light source the resulting scene is challenging.

The artist chooses to use the washes to represent the dark side of solids. The principles of interpreting solids are used, with dark sides on paper, lights left white and the edges between lights and darks merging softly. Allowance is made for residual light, which is the light striking surfaces behind the form and reflecting back. This results in thin, soft edges along the darks. In energetic and successful drawing, such refinements are important.

The model is seated on the arm of the sofa, comfortable and relaxed with the weight of his body taken on his left arm and his right arm crossing to the left knee. The artist sits in front and just to one side of the model, so that the composition forms a strong diagonal, shaped by the side of the torso and the left calf. This is perfectly intersected by the symmetrical zigzag of the left elbow and right knee. Light coming through the window creates highlights on the top edges and the far side of the figure (1).

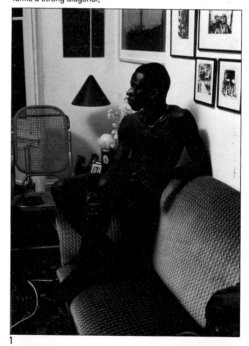

1

3

The first stage of the drawing process is achieved, working on a heavy, smooth Hot Pressed paper in pencil. The shape of the head is drawn and redrawn to establish its position in relation to the angles of the shoulders and arms. The initial stage inevitably involves some searching and experimenting before pleasing angles and proportions are established (2). With a fine reed pen and India ink, the outlines of the form are carefully delineated (3).

Single drawn lines provide a solid impression of the figure, and the drawing fills the paper. The lines are bold and energetic, showing a sound knowledge of the anatomy of the figure and the directions of tension. The shapes of muscles and bones are implied in the curves and corners and a three-dimensional effect is achieved in the fore-shortening which is particularly evident in the left thigh and right arm. The hands and feet are described in general outline, details such as fingers and toes being avoided at this stage (4).

2

4

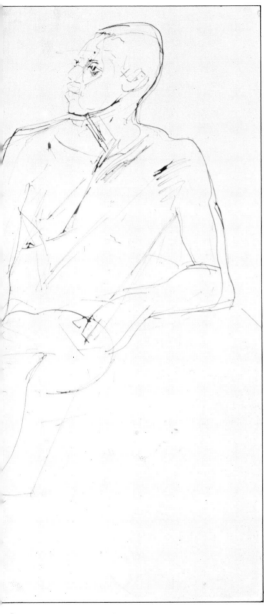

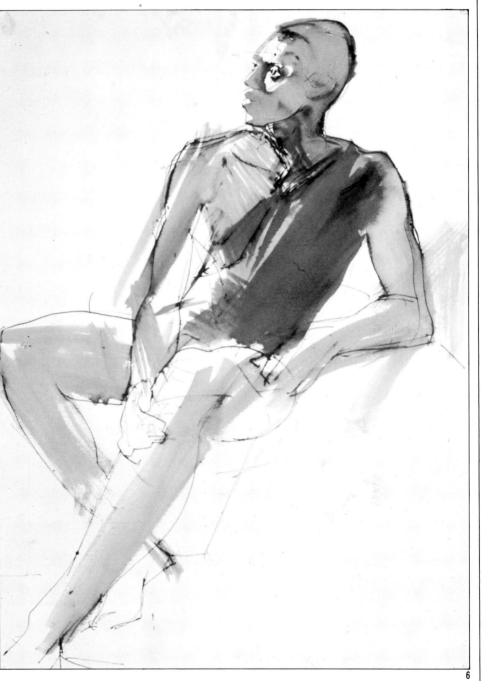

6

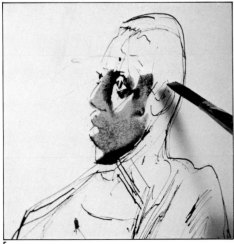

5

Using a small flat brush the first wash is laid over the face, carefully describing the shadowed parts and avoiding thin areas left white to bring out the volumes of the lips, chin and nose, and the circle of the eye-socket. It is possible to take out the intensity of a wash using a sponge to soak up excess ink. The artist leaves thin, dark areas under the brow, down the side of the nose and under the ear to describe shadow and form; the rest of the face is painted in a flat tone to give an impression of the color of the skin (5). Thin washes are laid over the whole figure to bring out the form almost in an abstract way. The shadowed parts of the body are filled in straight, flat stripes; the upper left arm, being in shadow, is completely blocked in. At the same time, the artist changes his position, moving further round to the front of the model. As a result, the position of the right arm is moved out from the body, the elbow creating more of an angle. The neck and collarbone are carefully detailed at this stage, with brushed ink describing the directions of the neck and chest muscles, and also describing the flesh wrinkling over the abdomen (6).

The artist's new position is further to the front of the model (7). The detail (8) shows the artist using a sponge to make wide, flat stripes in the thick ink wash to describe shadows on the figure and the sofa. The ink is well diluted but, despite this, the outline drawing beneath, which has previously soaked into the paper and dried, does not run.

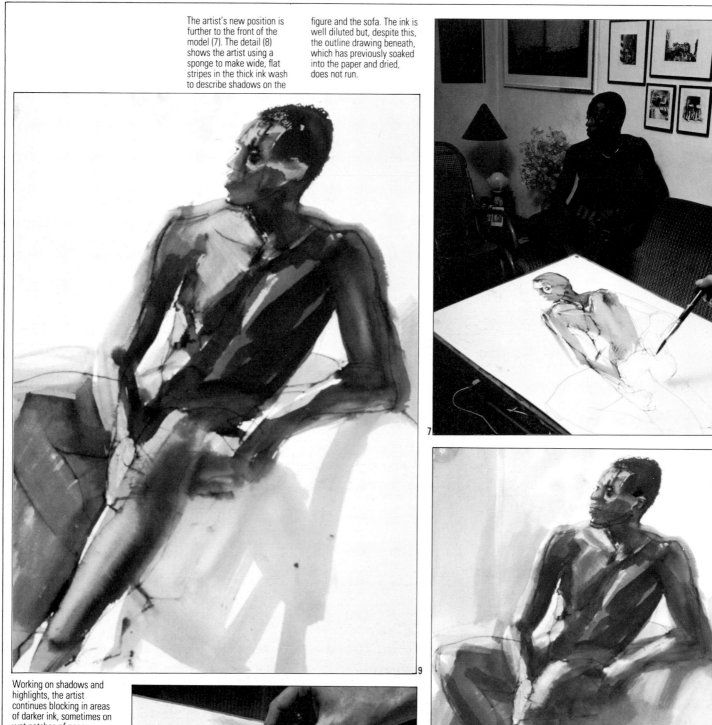

Working on shadows and highlights, the artist continues blocking in areas of darker ink, sometimes on wet patches of paper deliberately to cause the outlines to blur, then allows the washes to dry. The hair is carefully worked to look curly against the white background (9). Lights are emphasized by adding strong black areas of shadow in juxtaposition. The blurred outlines are firmed, details such as the ear added and the background filled in with thin washes (10).

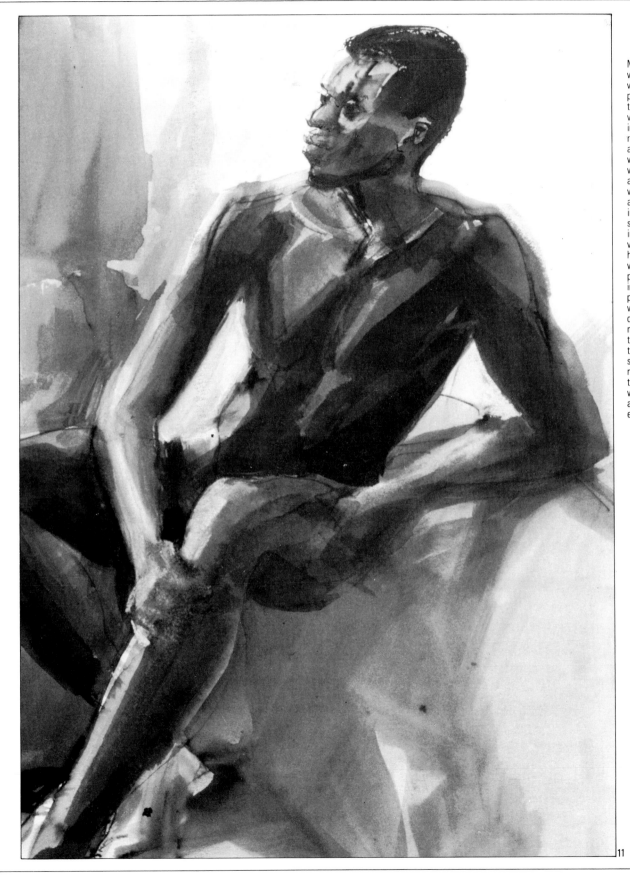

Making such a detailed and well-formed picture in ink washes is a slow-moving process, because of the need to wait for the ink to dry at various stages. The final image displays a depth and roundness which can only be achieved by the careful working and overlaying of washes. The figure is drawn and almost completely filled with various shades of gray and some black, which indicate the model's dark skin. The form of the figure is indicated by the intricate and varied shadows; the highlights, in thin tones which allow the white of the paper to show through, add interest and vitality to the picture. The technique works well, describing the directions and shapes of muscles, and directions of tension within the figure in the built-up tones, which seem to have been nonchalantly laid and match the mood of the subject, but which describe the figure accurately and with great energy (11).

11

GIRL IN VEST
monoprint and pastel on paper 25½×20 inches (65×51 cm)

Printmaking usually involves making an edition of near-identical images from one plate or block. The exception is the monoprint, which is a print in that the picture is made on another surface and transferred to the support, but it is a once-only image. It involves removing ink from an inked plate by drawing with a stick, a pen or a brush, and placing the paper to take the image over the top.

Monoprints are sometimes used as a basis over which elaborations of color or incised drawing can be added. Edgar Degas reinforced some of his with pastel drawing. Monoprinting is often considered the most immediate means of drawing, enabling the artist to work with the kind of freedom normally associated with oil paint, and the flexibility of the technique allows considerable alteration to be made while drawing is in progress. It is particularly suited to representing strong tonal contrasts.

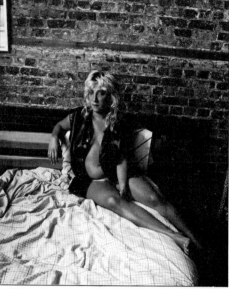

The model is seated at the end of a bed, with her legs stretched out to one side of her, down the side of the bed.
The lines of the pose are straightforward and uncomplicated; there are no overwhelming problems of foreshortening or complex anatomical demands. The model is well-built and fleshy; the curves of her stomach and thighs provide interesting volumes for the artist. The light is coming into the room from the model's righthand side, and highlights are clearly visible on her right hand, her stomach, right shin and over the thighs and the right side of her face. The leather vest also reflects streaks of light. The artist deliberately chooses an article which enables him to exploit the medium (1).

Linseed oil is added to some black lithographic ink to thin the ink and make it less sticky. Only a small amount of ink is required and it is mixed with the oil until the substance is creamy. The artist applies the ink to a sheet of formica using a roller. Sometimes glass or copper or zinc plates are used. The method works as long as the surface is smooth and completely non-absorbent (2).
The drawing process begins. A broad brush and a rag are used to remove ink from areas of the formica. A rag can be used to remove solid areas of ink, which will indicate whole areas of light. Starting with the head, the artist works over the whole area, indicating the basic position of the figure (3). A variety of brushes are employed, for marks of different sizes and shapes; these will give the impression of different textures.
If a mistake is made, it is possible to replace the ink and start again. Otherwise, ink can be removed in an area, then some can be brushed back to create marks within the highlight (4).

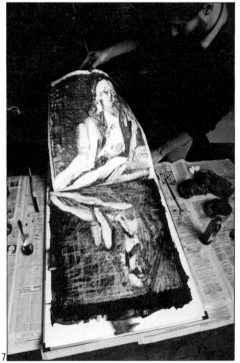

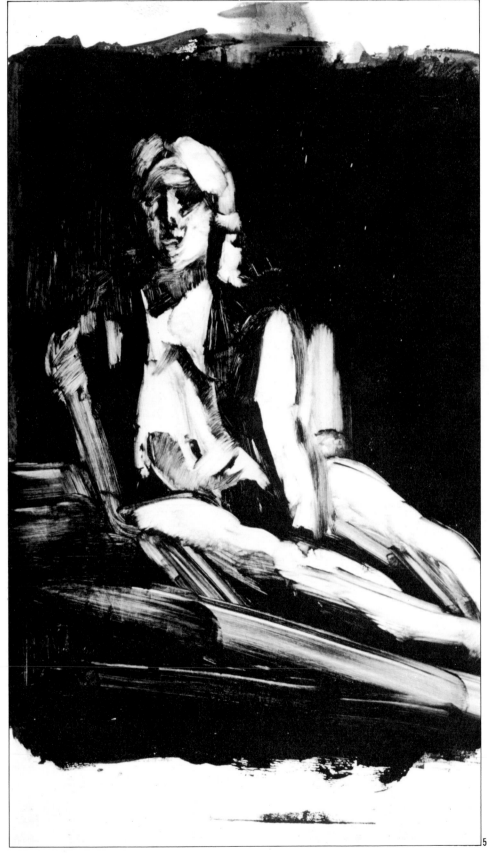

The basic drawing reaches a state of completion; the form of the figure is established and the background a uniform black. The highlights look overstated at this stage, but the artist is anticipating working over the print with pastels (5). The formica is placed flat on the floor and a piece of smooth drawing paper laid over the top. The image would emerge less distinctly if it were pressed to a coarse-grained paper. Using the back of the spoon (6) and the pressure of hands, ink is forced from the formica into the paper. The more pressure applied while burnishing, the denser the image. The small point of contact that a spoon makes creates a thin streakiness, as can be seen over the background. The artist chooses to work the spoon over the paper using a criss-cross pattern (7).

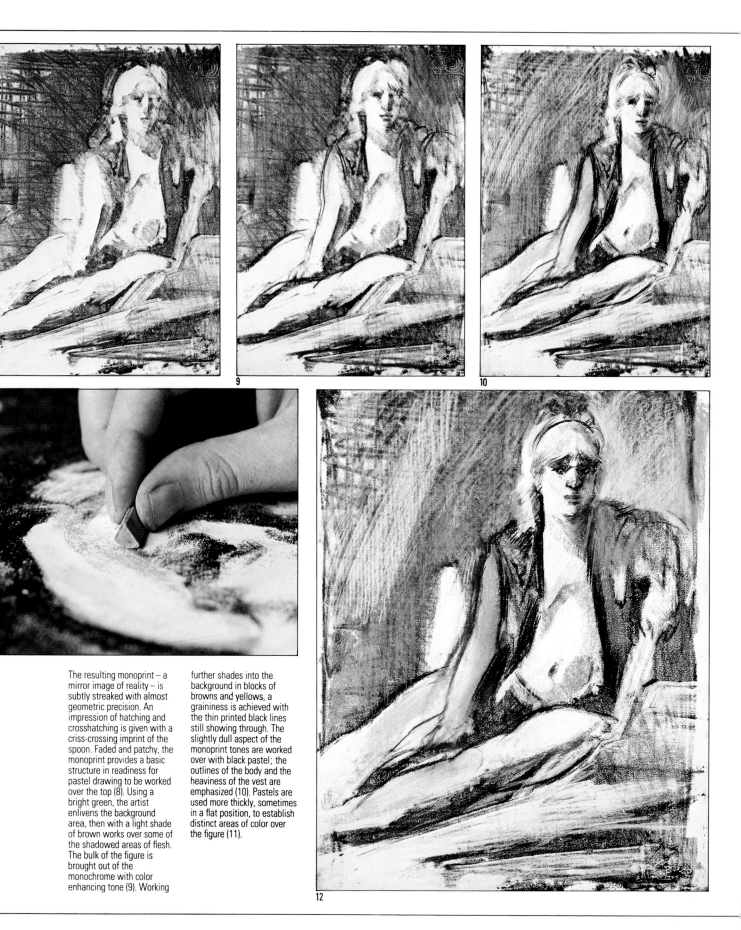

8

9

10

11

The resulting monoprint – a mirror image of reality – is subtly streaked with almost geometric precision. An impression of hatching and crosshatching is given with a criss-crossing imprint of the spoon. Faded and patchy, the monoprint provides a basic structure in readiness for pastel drawing to be worked over the top (8). Using a bright green, the artist enlivens the background area, then with a light shade of brown works over some of the shadowed areas of flesh. The bulk of the figure is brought out of the monochrome with color enhancing tone (9). Working further shades into the background in blocks of browns and yellows, a graininess is achieved with the thin printed black lines still showing through. The slightly dull aspect of the monoprint tones are worked over with black pastel; the outlines of the body and the heaviness of the vest are emphasized (10). Pastels are used more thickly, sometimes in a flat position, to establish distinct areas of color over the figure (11).

12

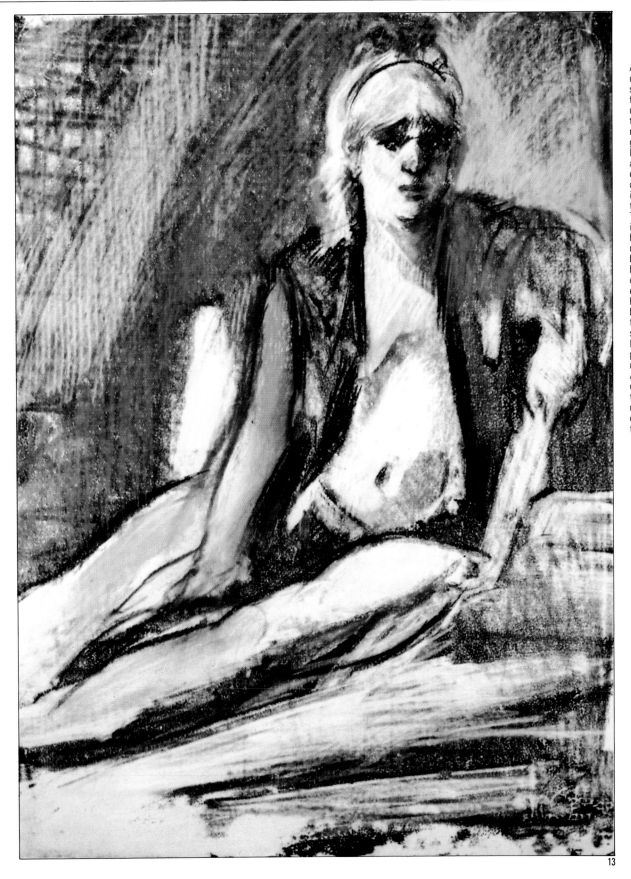

A strong rust-red pastel is used to block in areas of shadow and add some richer flesh tones. The white of the unprinted paper still shows through, but the effect is more solid than the graininess of the background. Detail is added to the face, and white highlights bring out the volume against the darks (12). The artist decides in this final stage to change the model's pose slightly. This last-minute decision illustrates the way pastel can be used as an opaque medium. To give some balance to the pose, and break the strong, curving diagonal of the body, the elbow is moved out using highlights to cover the shape beneath. The right hand and fingers are detailed over the strong lines of the model's left thigh, white and cream pastel covering the black, reds and browns underneath. Although pastel is generally considered to be a transparent, luminous medium, it also has a covering potential, which is fully exploited here (13).

13

PAINTING THE FIGURE

Painting, like drawing, is the enclosing of a view of three-dimensional reality in two dimensions. The difference between the two techniques is that drawing is concerned with the use of line to convey the solidity of form, whereas painting is generally more concerned with the use of tone and color to convey not only form but the qualities of light. Finished paintings are also more likely to give a complete picture, whether realistic or symbolic, because the whole surface is usually covered.

COLOR AND PIGMENT

An understanding of color and the effects of color in different combinations is important before an artist can hope to paint in the way he or she intends. Often this understanding is gained through experience in using pigments, but it is worth becoming familiar with basic color theory. Color can vary in three ways: there can be differences of tone, which is the lightness or darkness of a color; there can be differences in hue, which is the quality that distinguishes red from blue or green, for example; and there can be differences in intensity of color, which is the purity or saturation value of the hue. All these can be used with different effects in painting.

The three primary colors, red, blue and yellow, are the only colors that cannot be produced by blending and which, in various combinations, mix to form all the others. The complementary color of each primary is the secondary color made by mixing the other two primaries. So, green, which is made from a mixture of blue and yellow, is the complementary of red; purple is the complementary of yellow; orange is the complementary of blue. Tertiary colours are those which are arrived at by mixing a primary color with one

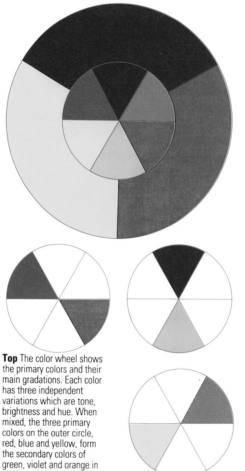

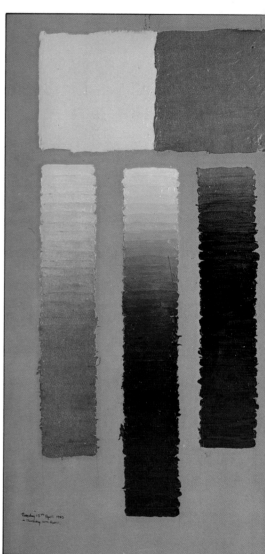

Top The color wheel shows the primary colors and their main gradations. Each color has three independent variations which are tone, brightness and hue. When mixed, the three primary colors on the outer circle, red, blue and yellow, form the secondary colors of green, violet and orange in the inner circle. In 1672, the English scientist, Sir Isaac Newton (1642-1727) discovered that a beam of white light could be split by a triangular prism into its component chromatic rays; he named the seven divisions of color red, orange, yellow, green, blue, indigo and violet. **Above** Complementary colors are those from opposite sides of the color wheel, and they have no primary colors in common.

Pigment sources
Artists' pigments were made from natural or readily accessible substances until the early nineteenth century when the rapidly developing chemical and dyeing industries led to a burst of brilliant new colors. Charcoal (1) yielded black, earth (2) produced various browns and Chalk (3) white. Cinnabar (4), realgar (5), malachite (6), orpiment (9), azurite (11). naturally occurring minerals ground into powder by the Bronze Age Egyptians, produced vermilion, orange, green, yellow and blue. The Romans developed Tyrian purple from whelks (7) and the blue-green colour known as verdigris from corroded copper (8). From lapis lazuli (10) came ultramarine,

Left Primary colors are so called as they cannot be made by mixing; however, all other colors can be produced by mixing them, either physically or optically. To experiment with the range of hues between the colors, is a useful exercise.
Above Secondary colors, orange, purple and green, produce grays when they are mixed together. By combining secondaries or complementaries a wide range of broken colors can be made; these tend to be closest to the colors of nature.

Above right This range of neutral grays gives an idea of how many hues are easily obtained.

of its own secondaries. Blue mixed with green gives turquoise, for example. A color wheel is simple to make and quickly gives information about complementaries, when required.

The Impressionist painters were particularly interested in the effects of light and color and were fascinated to find that the shadow of any given color produced its own complementary. They banished black from their palettes and concentrated on painting in a way which gave the impression of real light, hence their name. More recent artists have experimented with the optical effects of juxtaposing colors, which clash or argue with one another, as happens, for instance, with certain reds and greens. Medieval artists often used color symbolically. For instance, blue and gold were considered to be the colors of eternity. Color is usually used subjectively, and many artists are recognizable for the use of particular color ranges in their paintings.

The paints used by artists to convey color have two main ingredients: finely ground pigment and some form of binding medium. The chosen medium dictates the painting techniques to be used in applying the color to the surface. There is a very wide range of pigments available today; most of the paints and colored pencils or pastels in current use are made from pigments which have only been discovered within the last 200 years. This fact has been of considerable assistance when verifying the dates of paintings and drawings.

In the past, the range of pigments has been very limited. The roughly prepared earth pigment of cave paintings, for example, which were probably bound with some sort of animal glue, afforded the early artist a palette consisting of only browns and ochers. To this was added a black made from carbonized organic matter. Because of the conditions under which these paintings were executed, it is unlikely that any attempts were made to expand this color range.

By the time of the Egyptian civilization, there were several more pigments available to decorate the walls of the tombs. Their paintings include a delicate yellow which was

119

often used as a background color; this is probably the color we know as Naples yellow, made from lead antimonate. Terre verte, which literally means "green earth," and malachite, which is a natural, basic copper carbonate, provided them with a choice of greens. Their brown pigments include raw and burnt umber (iron hydroxide and manganese oxide) and manganese and Verona brown which are natural earth colors. Like the cave painters, the Egyptians used carbonized organic matter for black.

The range of pigments in use in the Middle Ages had extended to include burnt sienna, which is calcined iron and manganese oxide. Around AD 1400, flake white, or white lead, came into use and despite its disadvantages has been an important component in the artist's palette ever since. Besides being poisonous, this basic lead carbonate tends to darken when exposed to hydrogen sulfide. Many poisonous colors or fugitive colors used in earlier times, including verdigris, orpiment, realgar, massicot yellows, minium and several red lakes, have now become obsolete and have been replaced by more reliable modern pigments.

It is always worth ascertaining the qualities of each pigment before starting to paint; even now, relatively few pigments are fully permanent and safe to mix with all the others. A pigment's mixing capabilities, its transparency or brilliancy, its consistency when mixed and its drying time are all discovered by experience; whether it is "permanent" or "fugitive" and, if applicable, "toxic" is marked on the label by the maker. The latter description need not deter the artist; it is no more than a warning.

About 60 different pigments are readily available; a decision to limit the palette is important as a choice of too many colors can be confusing and will not lead to a full understanding of the potentialities of each pigment. An exception to this would be if an artist wishes to emphasize brilliance of color above everything else, because colors made by mixing are slightly denser. A simple palette of warm and cool permanent colors might consist of: flake or titanium white (not needed for watercolor), lemon yellow, yellow ocher, light red, Indian red, raw umber, terre verte, viridian and cobalt blue. Cadmium yellow could be used if a stronger yellow is required; cadmium red, vermilion or alizarin crimson if a brighter red is required. Raw and burnt sienna, French ultramarine and Hooker's green are also useful. These additions are all reasonably permanent if protected from a strong light. Instead of using black, which tends to make colors dull, it is usually better to mix dark colors using, for example, a blue with burnt sienna or raw umber; this principle inspires the artist to discover the true nature

of shadows. Endless color variations are possible with just a small selection of pigments, which, in any case, will demand extensive experimentation before the required color is achieved and the properties of each pigment are understood.

Pigments themselves were traditionally ground by the artist, which was a time-consuming and arduous occupation. Part of an artist's training in previous centuries involved learning how to prepare his own paints and materials; in the Renaissance workshops this job was given to the young apprentices. The more finely the pigment is ground, the better the finished product. The main reason for the disparity in price today between paints described as being for artists and those for students is that the former are more finely ground. Pigments which have not been properly ground produce paints which are patchy in color, particularly apparent in thin washes. Another reason for paints being expensive is costly raw materials; pure ultramarine, for example, is made from ground lapis lazuli.

MEDIA AND TECHNIQUES
In the past, the varied methods of using the pigments and the different techniques of application have been influenced by the

binding medium or vehicle with which they have been mixed. Egyptian and Assyrian painters mixed dry pigments with glue or gum to make paints which they used for decorating both the insides and outsides of their buildings. In the Orient, water-soluble gum or eggwhite was used for painting miniatures, and size, which is a thin liquid glue, for paintings on either paper or silk.

During the first few centuries AD the Egyptians, Greeks and Romans made use of beeswax as a medium for encaustic painting. This technique of painting involves fixing the colors by heat and the results are particularly durable. Great practical problems occurred in its application, however, because the paint only remained fluid enough to work for a short time, even when the palette was kept over a fire and the paint applied with warmed instruments. The technique did not lend itself readily to much elaboration or refinement. Surviving examples of the use of this technique in Egypt, mainly portraits in tombs, have a rough finish showing traces of the instruments used to apply the paint. Some of the wall paintings found in Pompeii and Herculaneum are also thought to be examples of the encaustic method although their surfaces are smooth.

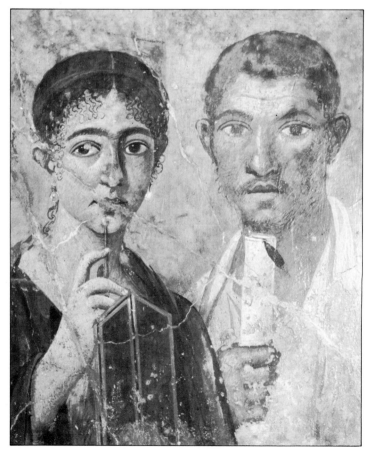

Left *Portrait of a man and Wife.* The idea of a portrait did not occur to the Greeks until the end of the fourth century BC. Sculptors had previously represented the ideal man, his face without a particular expression, but around the time of Alexander the Great, they began to invest their portraits with individual characterization. Pompeii, a Roman town, contained reflections of Hellenistic art; Greek artists were employed there, but it was the Roman and Italian painters who developed the Pompeian realistic genre. In this extremely expressive and true-to-life double funeral portrait, the colors are laid on flat within contours which have been well defined.

Palettes
Influenced by Velasquez's solid tonal paintings and Courbet's Realism, the art of Whistler (1834-1903) was delicate and low-toned. He spent much time mixing colors in advance in order to paint quickly. For portraits, he advised students to have oval palettes with white at the top in the center and to the left yellow ocher, raw sienna, raw umber, cobalt and mineral blue; to the right, vermilion, Venetian red, Indian red and black. Flesh tones were placed at the top near the center with a black strip curving downward to create shadows. Color was spread between lights and darks so that tonal changes could be made and a tonal picture built up; preparation for the background was made on the left. A modern palette might include white, lemon yellow, yellow ocher, light red or Indian red, terre verte, cobalt blue, raw umber, and crimson. Rembrandt's retangular palette of warm, strong colors consisted of white, black, burnt sienna, ocher, Vandyke brown, vermilion or medium red, Chinese yellow, cobalt blue, ultramarine and medium green.

Fresco

Fresco was the first important and popular technique used in applying paint to a background. Both Vitruvius and Pliny (CAD 23-79) make reference to it in their writings but it was not until the thirteenth century that it came to be widely used across Europe. It is the only method of painting which can truly be termed "watercolor" as it is the only one to use just water as the vehicle for the pigment. It is, however, called "fresco" painting because it involved the application of pigment to fresh plaster. As the plaster dried, the color was bonded into it and became a part of the wall, instead of lying separately on the surface. This made it a particularly durable method.

Because the paint had to be applied while the plaster was still wet, the design of the intended painting had to be planned in sections, each one representing a day's work, and carefully drawn out on paper beforehand. At the beginning of each day, exactly the right area of wall was covered in fresh plaster. Giorgio Vasari, the sixteenth-century artist, architect and biographer, gave fresco his highest accolade, describing it in *Lives of the Most Excellent Painters, Sculptors and Architects* (first published in 1550) as being "the most masterly and beautiful" of methods. He explained how the technique was employed: "It is worked on the plaster while it is fresh and must not be left until the day's portion is finished. The reason is that if there is any delay in painting, the plaster forms a certain slight crust whether from heat or cold or currents of air or frost, whereby the whole

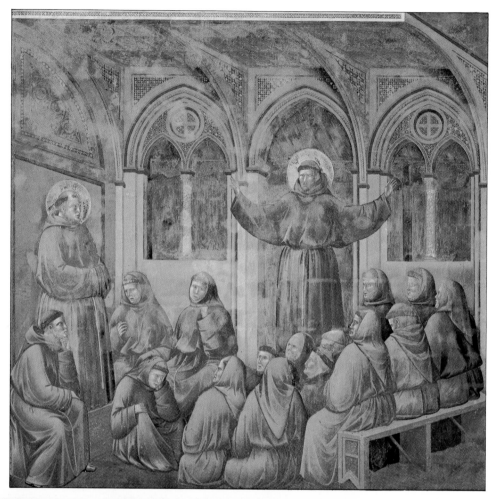

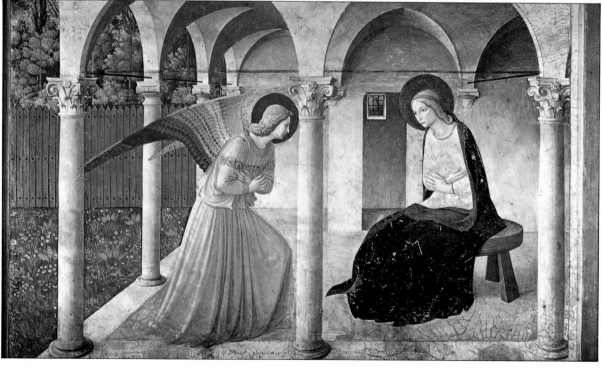

Above *St. Francis Preaching* (1297-*c*1305). Giotto. Giotto's ability to represent the human figure and emotions and to recreate the visible world on the two-dimensional plane is well demonstrated in this fresco scene.
Left *The Annunciation*, Fra Angelico (*c*1387-*c*1455). This fresco, with its perfect sense of color and composition, shows Angelico's interest in perspective to create a harmonious setting for his figures.
Right *Virgin Annunciate* (1527-8), Jacopo Pontormo (1494-1557). Pontormo's works are often exaggerated in form and emotional content
Far right *The Delphic Sybil* (detail), Michelangelo Buonarotti. Michelangelo worked on the Sistine ceiling between 1508 and 1512. The Sybil's head and eyes turn away from the movement of her arms, her strong body and face derived from classical sculpture.

work is stained and grows moldy. To prevent this, the wall that is to be painted must be kept continually moist, and the color employed thereon must all be of earths and not metallic and the white of calcined travertine. There is needed also a hand that is dextrous, resolute and rapid, but most of all a sound and perfect judgement; because while the wall is wet the colors show up in one fashion and afterward when dry they are no longer the same. Therefore in these works done in fresco it is necessary that the judgement of the painter should play a more important part than his drawing and that he should have for his guide the very greatest experience, it being supremely difficult to bring fresco work to perfection."

The colors used for fresco work were almost entirely earth colors, most vegetable and metallic pigments being chemically unsuitable. The "white of calcined travertine" to which Vasari refers, had to be used because the more usual lead white, "biacca," was incompatible. Travertine was a building material widely employed by the Romans, a notable example of its use being the Colosseum. By burning travertine, a white lime appears from which the fresco white "bianco Sangiovanni" was manufactured. As the surface of the painted plaster dried a chemical reaction caused a crystalline skin of carbonate of lime to form on the surface. This not only protects fresco paintings from damp and other atmospheric conditions but also lends them a metallic luster which is part of their unique appeal.

The limitations of this technique are paradoxically also the reasons for high standards being achieved in its use. The practitioners of fresco painting were obliged to give careful consideration to the planning of the composition, which gave an overall unity of style to each. Also, working against the clock, the frescoer was required to paint deftly and with a sureness of touch. There was no time for corrections, and although details could be added after the work was dry ("fresco-secco") this was not advocated by purists. Additions were sometimes made in tempera paint but this tended to darken quickly and spoil the fresco. Vasari pointed out that it was necessary to "work boldly in fresco and not retouch it in the dry because, besides being a very poor thing in itself, it renders the life of the picture short."

The most common method of transferring the design to the plaster on the wall involved preparing a full-sized cartoon on paper, then pricking tiny holes along the drawn lines on the cartoon. The paper was then held against the surface which was to be painted, and a muslin bag containing powdered charcoal was dabbed onto the cartoon so that the design showed up on the plaster as a series of black dots.

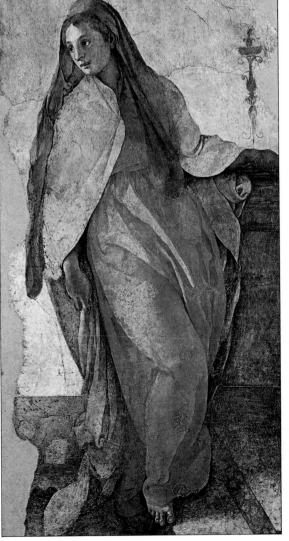

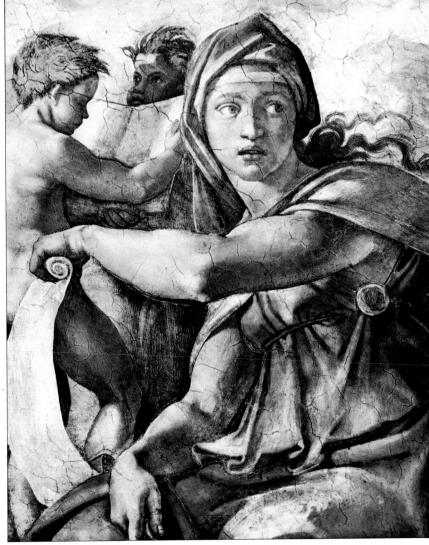

Right *The Boxers.* This modern painting shows the effectiveness of large blocks of tempera color combined with acrylic.
Below Looking from left to right, different consistencies can be seen. A directly applied and unworked pure egg tempera is similar to thickly laid watercolor. Painted in a similar way, an egg yolk, stand linseed oil and dammar varnish resemble a mixture of pure tempera and oil paint, resulting in very dense color. A whole egg mixed with dammar varnish and oil of cloves emulsion produces a flat, dense color.
Bottom These illustrations show various egg-oil emulsion mixtures which produce a glossier finish than pure tempera. Looking from left to right the mixtures are: one level teaspoon of linseed oil with one egg yolk; one yolk, one teaspoon of blended stand linseed oil and dammar varnish; the yolk and white of an egg blended with a teaspoon of linseed oil added drop by drop, and four drops of white vinegar, all strained; 20 drops of oil of cloves added to one egg and a quarter of the egg's volume of dammar varnish.

Tempera

Painting in the tempera medium has a longer history than fresco painting. The word "tempera" comes from the Latin verb "temperare" which means "to divide or proportion duly; to qualify by mixing; to regulate; to discipline." The literal translation seems appropriate; the mixture of pigment and medium is difficult, needing precision, and the method of applying tempera paint to a ground is itself a discipline. The method has been widely used both in the Orient and in Europe from the earliest times and was extremely popular through the Middle Ages to the fifteenth century, when it was superseded by oil painting. Occasional revivals of interest in this technique have kept it alive until the present day, although it is no longer widely popular.

The normal ground for tempera painting was a wooden panel which was occasionally covered with canvas. The choice of wood varied according to availability. In Italy, poplar was most commonly used, as recommended by the Italian artist and writer Cennini (born c1370); in central Europe the choice was pine, while in Flanders and northern Europe it was oak. Other woods, including larch, maple, box, linden, fir and willow were also used. The wood had to be well seasoned, planed and, if necessary, jointed. The practice of covering panels with canvas or linen was to prevent joints opening later and spoiling the picture. Next, several layers of gesso ground, the main ingredients of which were size and some form of whitening agent, usually plaster of Paris, were laid over the panel. The gesso was sanded down after it had dried to provide an even, smooth surface on which to work. Sometimes the gesso ground was toned by a coat of resin or size with an added coloring agent, although it was more usual to retain the white surface which reflected light back through the translucent paint, adding brilliance and depth to the color.

A number of different media are favored by different people as the best vehicle for the pigment in tempera painting. Vasari was

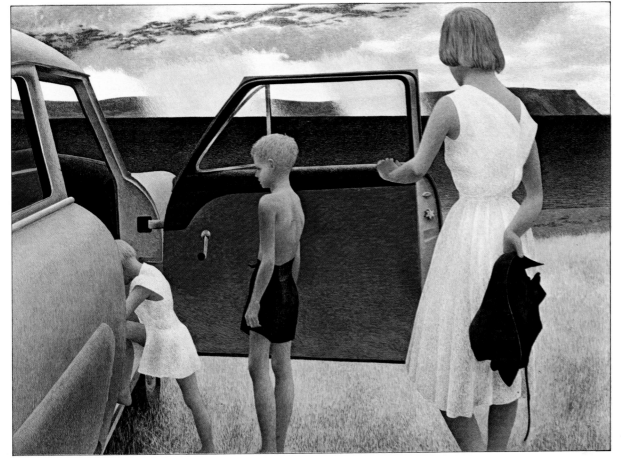

Left *Family and Rainstorm,* David Alexander Colville (b1920). This painting, on a board support and almost photographic in its treatment of the subject, demonstrates the versatility of tempera, one of the earliest types of paint media. The cool colors, gray, yellow and brown, have a smooth, opaque quality which help to create the sense of stillness and the monumentality of the figures.

firmly of the opinion that the yolk of an egg excelled all others. The following is his description of the way in which the Old Masters prepared tempera paint:

"They whisked up an egg and shredded it into a tender branch of a fig tree, in order that the milk of this with the egg should make the tempera of the colors, which after being mixed with this medium were ready for use. They chose for these panels mineral colors of which some are made by the chemists and some found in the mines. And for this kind of work all pigments are good, except the white used for work on walls made with lime, for that is too strong. In this manner their work and their pictures are executed and this they call coloring in tempera. But the blues are mixed with parchment size, because the yellow of the egg would turn them green, whereas size does not affect them, nor does gum."

Tempera paint has a number of advantages over fresco painting and many of the great exponents of the latter worked their smaller pieces in tempera. With its brilliant white gesso ground the paint has a greater luminosity than it was possible to achieve in fresco work, and also a slightly greater depth of tone. Because the paint could be laid in thicker layers, the light areas could be built up more strongly. It was also the practice of artists to create softer transitions of tone by "scumbling." This is the laying of semi-transparent light paint over darker areas, sometimes in an irregular way, to modify the paint beneath by creating areas of broken color. Tempera being flexible, artists were able to include areas of fine elaboration in their paintings.

Medieval artists were beginning to establish a method for painting the human figure. Areas which were to be flesh were given an underpainting, usually of terre verte. This subdued green complemented the pinkish color of the flesh and was allowed to shine through in areas of shadow to provide the half-tones. The green underpainting was sometimes heightened by the addition of white and occasionally greater depth was added by shading areas in transparent brown.

All this preparatory work was extremely important in helping to give tonal depth to the finished painting and was, interestingly, closer to the techniques of the Impressionists than to the practice of adding black to arrive at darker tones, which was more customary at the time.

After the underpainting, the artist mixed enough of each of the colors he intended to use, to avoid running out before completing a painting. As with fresco, tempera changes as it dries and the colors lighten by several shades. The experienced tempera painter would make allowances for this but it was always difficult to match a new batch of color with any that had already dried. The preparatory mixing partly accounts for the continuity of hue which is noticeable with this method of painting. Three main colors were mixed in order to paint the flesh. The artist began by laying in the main areas with a mid-tone, then worked over the top with the darker then the lighter tones. Later, a semi-transparent mixture of black and yellow ocher called "verdaccio" provided the deepest shadows.

When painting the clothed figure, the system used by medieval painters was almost the same as for flesh. The colors for the underpainting were carefully chosen to complement whatever colors were chosen to go over the top; red, for example, took a greenish-gray underpaint, and blue usually took a white-gray or occasionally a green. The top color was similarly painted in stages: the mid-tone first, then the darker and then the lighter areas.

Oil

The invention of oil painting is attributed, by Vasari, to Jan van Eyck who was working at the beginning of the fifteenth century. Although oil had been used as a vehicle for pigments by earlier artists, van Eyck was certainly the first artist to develop a recognizable technique of working with pigment suspended in oil. He was the first to exploit the way in which colors could be blended softly to achieve a more natural effect than was possible with tempera. He probably ground his pigments in some sort of refined oil, possibly linseed or walnut oil, which, according to Vasari, is less inclined to darken with age. Because oil paint alone would, it is believed, take about 400 years to dry, it was necessary to add an agent to accelerate this process. Van Eyck probably used turpentine which would have thinned the paint as well as helping it to dry.

The support which is most commonly associated with oil painting is canvas although artists continued to use wooden panels as well. These had originally been used because of their rigidity, which was an important consideration when working with a medium such as tempera. With its greater flexibility, oil paint could be applied to a less rigid support without the danger of its cracking. There are obvious advantages in using canvas. It is light, which makes it easier to transport than wood and also allows for larger paintings than had previously been practical. Canvas can be rolled when not in use which makes it economical of space, and it is also more economical to buy than large panels of wood.

The traditional method of preparing a canvas, and one which is popularly used today, is to stretch the canvas over a wooden frame and secure it with tacks. Wooden frames consist of "stretchers" which can be made at home but are also available at art suppliers. The stretchers are jointed at the corners in such a way that the tension of the canvas can be adjusted at a later stage by hammering in wooden pegs. Raw linen is the best material to use and it is easier to stretch if it is slightly dampened first. Once stretched, the surface of the canvas can be prepared for the oil paint. Some of the earlier users of oil paint continued to lay a ground of gesso, but this was not found to be entirely suitable as canvas tends to contract and expand with changing atmospheric conditions, which caused the rigid gesso to crack and flake off. Also, finished canvases were often rolled up for transportation, and a flexible grounding was obviously necessary. The usual method employed by artists today is to give the canvas several coats of size, the purpose of which is to fill the pores of the canvas and make it non-absorbent. There are various kinds of size available; rabbit-skin preparations are

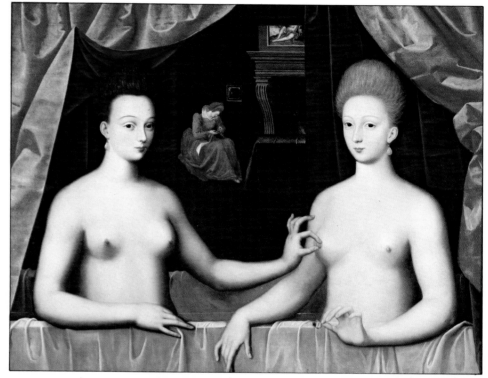

Above *Gabrielle d'Estrées and her Sister*, School of Fontainebleau. This double portrait in oils of the mistress of François I and her sister exemplifies the sensual and decorative style of painting which flourished in France between 1528 and 1558. The rich, glossy qualities of the medium complement the etiolated elegance of the subject.

Right Canvases are usually made from linen, cotton, a linen cotton mixture, or jute. Unbleached calico is a cheap cotton weave (1). A good cotton canvas is almost as good as linen provided that it has previously been primed (2). Jute is coarse and needs a good deal of priming (3) while linen (4 and 5) is the best and most expensive type of canvas coming in several weaves, the best of which are closely woven with the threads knot-free. Linen primed with acrylic is multipurpose (6).

Right Canvas is the most common support for oil paintings, and is extremely receptive to the paint when fixed to a stretcher. Wood for stretchers comes in many lengths, and pieces can be fitted together to make rectangles of all sizes.

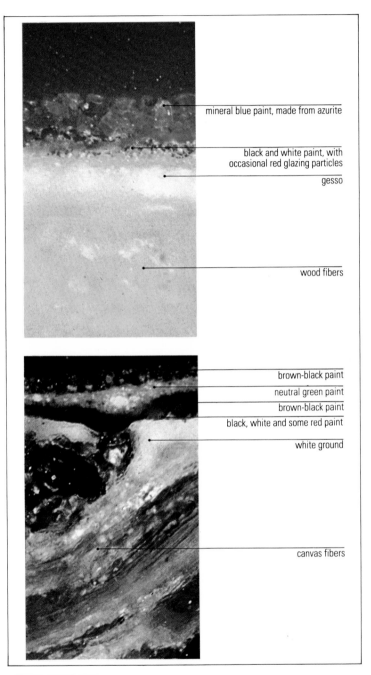

mineral blue paint, made from azurite

black and white paint, with occasional red glazing particles

gesso

wood fibers

brown-black paint
neutral green paint
brown-black paint
black, white and some red paint
white ground

canvas fibers

Left This cross-section of an early Flemish painting has been magnified 200 times. Wood was used as a support for easel paintings by the Egyptians, and again in medieval and early Renaissance art. This cross-section shows the gesso ground, made from plaster mixed with size, and layers of paint.
Below left This cross-section of an early painting by Titian has been magnified 100 times. It was one of the first paintings to be done on canvas. The white ground has penetrated the canvas fibers and the neutral green underpaint, terre verte, applied as a ground for flesh painting, is revealed.
Below *Portrait of a Woman with Gloves and Crossed Hands*, Frans Hals. Chiefly known as a portraitist, Hals was an extremely original artist with a unique directness of approach. Influenced by the Caravaggisti, he used *chiaroscuro* for dramatic effects in rendering instantaneous impressions. Bold brushstrokes and impasto build up textures, particularly evident in the hands.

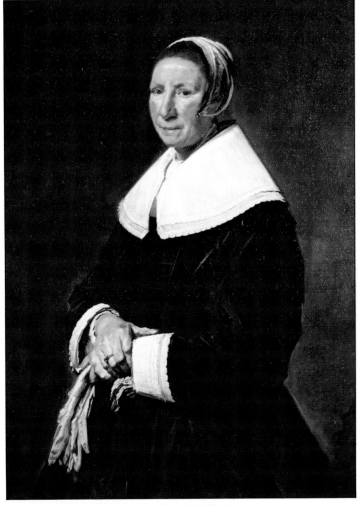

generally considered to be the best.

The next stage involves covering the surface of the canvas with a "primer" which is prepared from a number of ingredients. Vasari gives a recipe which consists of "a paste made of flour and walnut oil with two or three measures of white lead put into it." The following recipes for grounds are only guidelines and should not be considered as the only possible ones to use; grounds are very much a matter of individual preference.

A simple but efficient oil ground consists of six parts turpentine, one part linseed oil and some flake white. This should be applied to a dry surface which has already received two coats of size, applied when hot. The ground should be brushed on, and left to dry for 24 hours, and then a second coat applied and left for about a month before using. An emulsion ground might be mixed with one part whiting, one part glue size, one part zinc oxide and half part linseed oil. A simple gesso ground, for use on wood or masonite, might consist of one part whiting and one part size. The dry whiting should be sifted into some of the heated glue size until a smooth paste is achieved. The rest of the hot size should then be mixed in to give the gesso mixture the consistency of cream.

The addition of white clay gives greater body to the ground, while an acrylic medium, a synthetic resin, could be included for its elastic properties. It is a good idea to include an anti-fungus and anti-bacterial agent, which is often added into proprietary brands of glue size as a matter of course.

Several layers of primer should be laid. For the final coat, some artists prefer to add some coloring pigment, thus giving themselves a tinted ground on which to work. Some, preferring to give the surface of the canvas "teeth", dab the heel of the hand against the

wet primer. Applying the primer with a foam sponge roller gives a similar effect.

Many of the pigments used today are recent innovations. Artists from previous centuries had very few colors to choose from, but even so they often deliberately worked from a palette with further restrictions self-imposed. Now, with the large range of pigments available, it is more important than before to choose a palette of only a few colors, as this is more likely to result in a unity and harmony being achieved in a painting than when a confusing jumble of pigments is at hand. Also, it means that the artist becomes increasingly familiar with the few chosen colors, and can exploit them to the full.

Because the pigment is suspended in oil, which turns into a solid, transparent substance when dry, a number of glazes need to be laid, one over the other, to achieve the required shades and tones. The layers together combine to give depth to the colors, while they retain a brilliance in the transparency. These qualities are enchanced by the use of underpainting. Light reflects back through thin layers of paint from a white or pale underpainting, so giving work an extra luminosity.

The major advantage of oil paint is that it remains workable over a long time, allowing colors to be blended, modified or changed as the work progresses. The oil itself retards the drying time of the paint, while the addition of turpentine or varnish accelerates it. Each subsequent glaze should contain more oil than the previous layer; the last layers need to be well oiled so that progressive workings retain their elasticity. This means that artists,

working from dark to light, can blend highlights carefully and with as much detail as is required into the hard, dry underlayers without fear of the paints muddying.

The special qualities of oil paint are particularly evident in pictures of the human figure, when they can be exploited to make flesh appear almost translucent, and can be used to express the different textures of cloth very realistically. The medium is also suited to the rendering of mood and emotion, because the paint itself can be varied in texture. The painter can mix it thick or thin, dry or wet, and can either apply it smoothly so that there is no surface texture and no evidence of manipulation, or roughly, with brushstrokes a definite, stylistic feature. Scumbling, and the techniques of working wet paint into dry, and dry paint into wet are examples of further ways of achieving textured effects and tonal depth. This versatility allows artists to work fluently and expressively within the restrictions of the media, adding their own enthusiasm to the mood of a painting. The variety of techniques can be used in many ways to create vivid representations of nature.

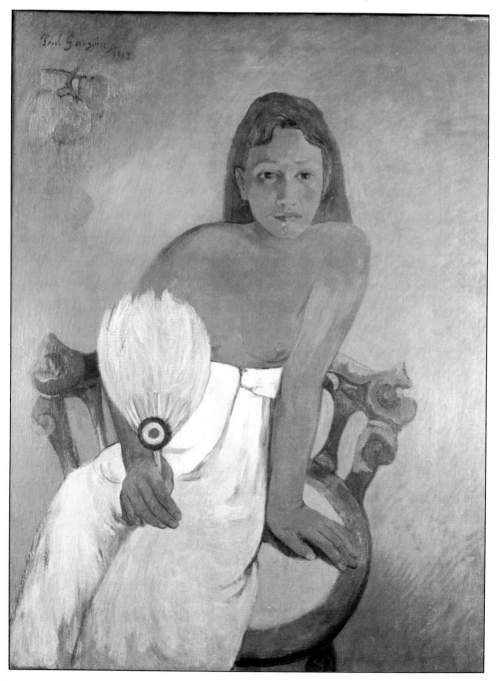

Right *Girl Holding a Fan* (1903), Paul Gaugin. One of the first to find inspiration in the arts of primitive civilizations, he rejected the representational function of color, using it in flat, contrasting areas which strengthened its emotional and decorative effect. He went "native," painting his finest pictures in Tahiti, fascinated by native sculpture and ritual. His forms became more simplified and his colors richer, in tune with his tropical surroundings. In this oil painting, the strangely represented right arm can be seen as an example of the primitive influence. Using almost flat areas of rich color within strong outlines to form rhythmic patterns, he creates a strong visual image redolent of the nostalgic nineteenth-century idea of the Noble Savage.

Watercolor

Watercolor painting, a method which has been particularly associated with British artists, is a more recent technique than oil painting, and has been popular since the eighteenth century. It is a difficult technique to master, because the paint is transparent and purists do not use white pigments to produce the lighter tones. Watercolor technique involves the artist working from the lightest through to the darkest tones by laying a series of colored washes. Paintings are usually executed on white paper, the color of the paper itself showing through to provide the light tones. If pure white areas are required, then the paper is left completely uncovered by paint. The pigments, which must be finely ground, are mixed with a water-soluble gum, gum arabic being the most usual. A small amount of added glycerine helps the paint to retain its solubility, even after it has dried.

The best watercolor paper is handmade and has a rough texture which causes tiny points of untouched white paper to sparkle through the washes, giving greater luminosity to the result. It is advisable to stretch watercolor paper before use, to prevent it from buckling and wrinkling as the water soaks in.

Gouache

If white body color is added to the pigment the technique is known as "gouache." The paint used for gouache is not transparent and it is possible to use lighter paint across areas of darker tone. This allows for greater elaboration when painting. It is a less exacting medium than watercolor, but the result is less luminous. An artist wishing to produce spontaneous paintings of figures can choose either of these media, but as watercolor demands a speed of working and its luminous effect implies the changing qualities of light, it seems particularly well suited to capturing the moving figure.

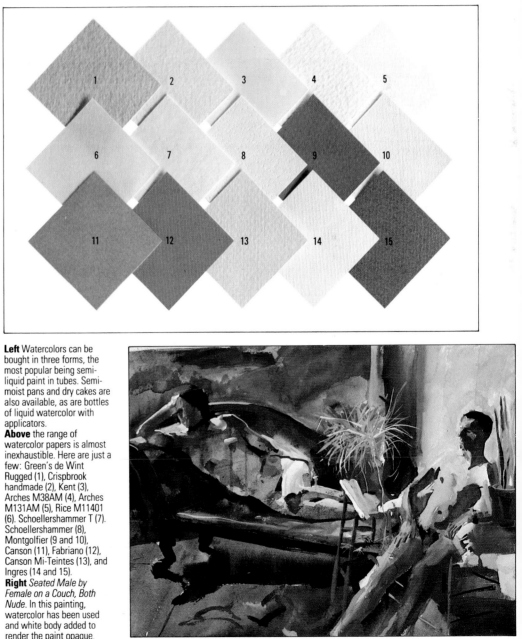

Left Watercolors can be bought in three forms, the most popular being semi-liquid paint in tubes. Semi-moist pans and dry cakes are also available, as are bottles of liquid watercolor with applicators.
Above the range of watercolor papers is almost inexhaustible. Here are just a few: Green's de Wint Rugged (1), Crispbrook handmade (2), Kent (3), Arches M38AM (4), Arches M131AM (5), Rice M11401 (6), Schoellershammer T (7), Schoellershammer (8), Montgolfier (9 and 10), Canson (11), Fabriano (12), Canson Mi-Teintes (13), and Ingres (14 and 15).
Right *Seated Male by Female on a Couch, Both Nude.* In this painting, watercolor has been used and white body added to render the paint opaque.

Artist's box
The Winsor and Newton box contains acrylic paints. A plastic emulsion, soluble in water, acrylic allows for thin washes, although not as thin as watercolor, as well as thick impasto. Its particular advantages are that it dries very quickly and is permanent.

Acrylics

Recently, the advances in technology have led to the development of a wide range of artificial pigments. Acrylic paints, which are bound in a synthetic resin, are a regular medium with many artists today. They have the advantage of being water-soluble while they are wet but are quick-drying and extremely durable. They are not to be confused with oil paints, however, and cannot be used to achieved such subtle effects, mostly because they are more opaque and do not allow the artist to build up tone and color in the same way.

Brushes and Palette Knives

For all the methods of painting described in this chapter, the most common instrument of application is the brush. Generally the stiffer bristle brushes are used for oil and acrylic painting. A long handle allows the artist to use the brush as an extension of the arm in large, sweeping strokes. For more detailed work and for watercolor, soft sable brushes are a usual choice, but the size, shape and texture of a brush is always a matter of individual

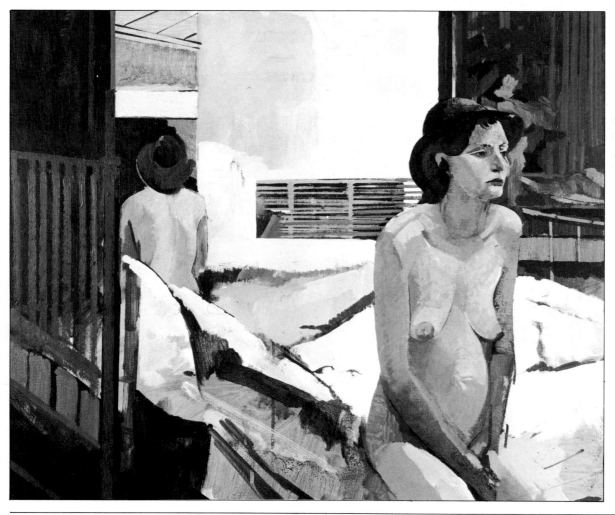

Left *Girl Sitting on a Bed.* This painting demonstrates the strong colors of acrylic and its covering power. The model is seated on a bed, her back reflected in the mirror. This device is used to extend the picture space and to lighten the background tones. The main color areas are first blocked in with opaque paint, and subsequent layers built up without the colors coming through. The figure is built up

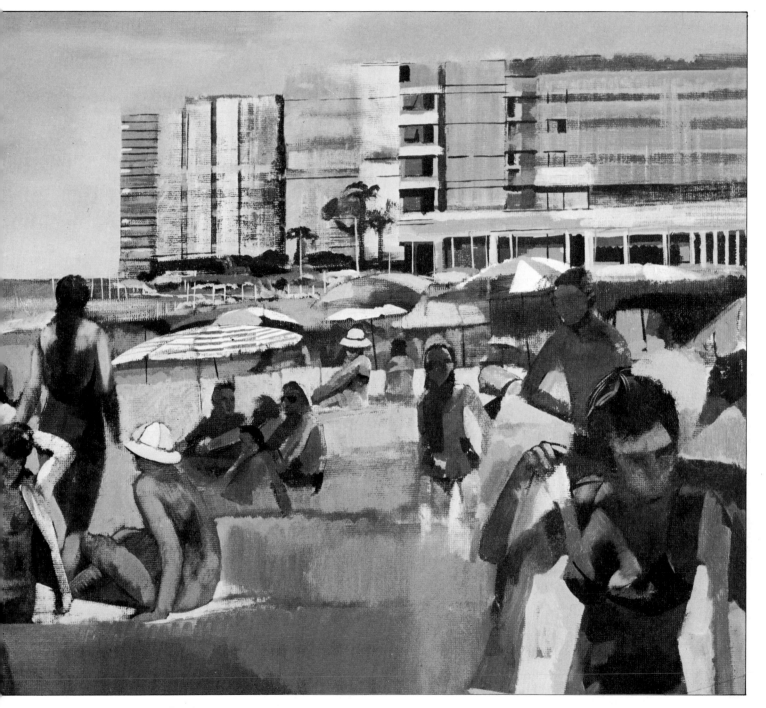

in thin washes and the outlines strengthened with black paint. Lights and darks are contrasted by showing the play of light on the forms. **Above** *Beach Scene*. This hot scene illustrates the strong contrasts obtainable from acrylic paints. Constructed from a series of photographs taken from different angles, it demonstrates the ''correctability'' of the

medium: the transparent yellow jacket in the right foreground is a late addition as are the buildings in the background, brought in to close off the picture space and to direct the spectator's eye to the figures. The sense of hazy heat is captured in the shimmery effect of the buildings and blurred outlines of the figures.

preference. There is no right or wrong tool for any particular painting technique. Many artists keep a selection of brushes; this would probably include round and flat brushes of varying sizes with handles of different lengths, some made of hog bristle, others of squirrel or sable.

The brush is not the only tool to be used in applying paint; palette knives are also used. Two notable exponents of this technique are Courbet and Vlaminck, who painted some of

their pictures entirely with this tool. Palette knives are designed for two distinct purposes: for mixing the paint and for scraping the palette clean. The former are designed in different shapes, usually either spatula- or trowel-shaped. They can be useful in conjunction with a brush for laying in the larger areas of paint. The textural effect given by a palette knife is very different from that of brushstrokes and it is often considered to be particularly suitable for impasto work.

SKETCHBOOK PREPARATION

Before embarking on a painting, it is worth being acquainted with some of the basic problems and possibilities inherent in the situation and the composition. By working on a small scale with an implement which lends itself to rapid notation it is possible to discuss the best way to approach the subject, working on angles, lines, tones and even colors until the essence of the desired effect is realized. Sketching works almost like a dialogue; suggestions arise, are discussed and then either discarded or accepted.

Some artists work better by attacking the support with fervor and directness, allowing the image to emerge spontaneously from a struggle carried out without any preparation.

For many, however, the advantages of sketching outweigh the benefits of a spontaneous method of painting. Certain types of work seem to demand a careful and considered approach, and the resulting sense of calm that can be brought into a picture is often important. As a compromise, and to ensure a continuing liveliness while painting, many artists use visual notes only as a general aid, and do not allow themselvs to be bound by the lines and spaces, rhythms and intervals of the sketches. The elaborating, changing process continues: angles and stresses may be changed and extraneous elements brought in to increase the atmosphere or add strength.

Above right and right
These two sketches offer the viewer intimate glimpses of a girl completely relaxed in her bath. A sense of movement and indulgence is achieved in their combination; separately they may be taken as useful preparatory studies, helping the artist to build up a store of visual information. The back view was established in a very short time, with verticals, including the hose and the girl's spine, creating a symmetry only upset by the glass balanced on a corner. Because the artist is looking down on the girl, a cramped sense of space is implied. Establishing the idea of a side view, the girl is again sketched briefly but with a little more care. Background details and a mirror reflection are included. The artist still stands above, so that the angles of the side of the bath are sharp, and the body foreshortened.

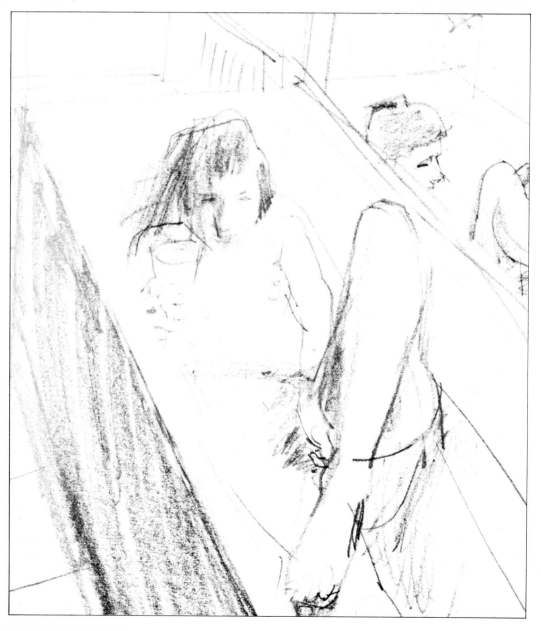

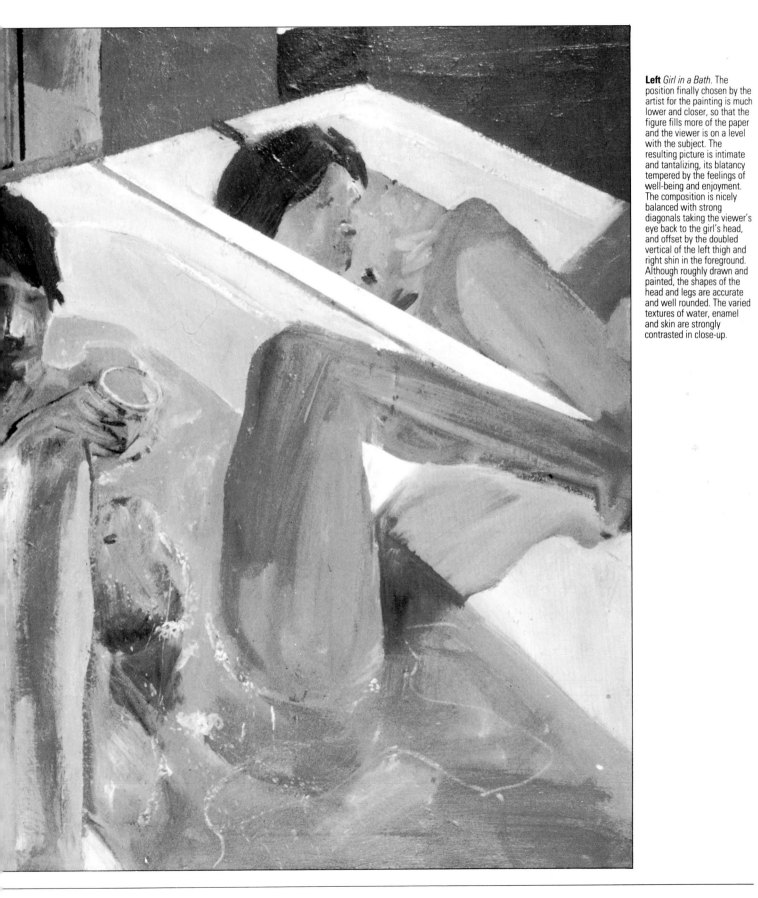

Left *Girl in a Bath*. The position finally chosen by the artist for the painting is much lower and closer, so that the figure fills more of the paper and the viewer is on a level with the subject. The resulting picture is intimate and tantalizing, its blatancy tempered by the feelings of well-being and enjoyment. The composition is nicely balanced with strong diagonals taking the viewer's eye back to the girl's head, and offset by the doubled vertical of the left thigh and right shin in the foreground. Although roughly drawn and painted, the shapes of the head and legs are accurate and well rounded. The varied textures of water, enamel and skin are strongly contrasted in close-up.

FIXED LIGHTING

Light is normally used in painting as an aid to the expression of form and color. The transience of natural light is used to express reality, to enhance feelings of movement and liveliness in pictures and to create the impression of three-dimensional form. Always changing, presenting different aspects of objects and altering local color, light is used to present an endless variety of moods.

To consider light as a constant, however, presents an entirely different world. When directly lit by a single, fixed source, the figure takes on a monumental, almost abstract quality, decorated with a surface pattern, which reveals form incidentally. To avoid abstracting the forms completely, figures need to be made to look realistic in other ways. In these pictures, the artist displays his comprehensive knowledge of anatomy and a proficient understanding of movement and foreshortening. In outlines, filled in with areas of flat, unbroken color in the two paintings, the artist describes movement and mood, despite each picture being dominated by the stripes of bright light striking the bodies through blinds. The results bring to mind the brilliance of a southern sun and create a strong sense of interior space.

Below Compiling a sketchbook of drawings in preparation for painting a series of figures in sunlight streaming through a window with blinds, the artist includes views of models from all angles. The form of the figure is more detailed in pencil than in the paintings because the artist is experimenting with the stripes. In the process of working out how the slanting lines fall across the body, it is essential to discover the precise forms and curves, so that the stripes can follow round them.

Bottom The back is not traditionally popular in figure painting because it is generally considered uninteresting. Sometimes, however, if some added interest is created by, for example, the head turning over the shoulder, then a back view can be intriguing. Character might be expressed by hair and a profile, by the set of the ear and the angle of the neck.

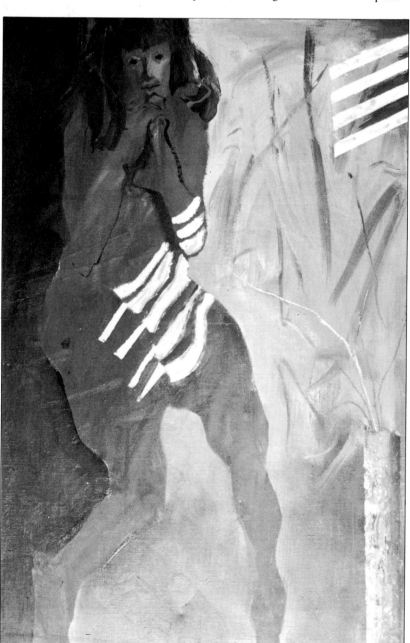

Left *Standing Girl in Sunlight.* The form of this figure is filled in almost uniform, flat color, to give an abstract impression of a girl. However, because of the powerfully representative position of her legs, the position of her hands folded in front of her and the wistful expression on her face, a great deal of feeling is evoked. The strong sunlight over the left arm and the torso gives the painting strength and vitality, and, crossing the picture at a slanting angle, creates a tension, being in conflict with the vertical position, self-protective pose and personality of the subject.

134

GIRL IN CHAIR
acrylic and gouache on paper 21×14 inches (53×36 cm)

The model is posed beside a window with bright sunlight slanting into the room, creating strong patterns of light and shade over the body (1). The artist chooses to ignore the stark contrasts of tone, concentrating instead on the general effects of light. It is interesting to compare the positions of the shadows in this photograph and in the final picture; in the latter a shadow is delineated over the right thigh in a different position. The picture takes some time to complete, and the artist is always aware of movement, accommodating his painting to it, rather than forcing a rigidity.

Glazing is a method of painting in which thin layers of paint suspended in the sort of medium which allows colors beneath to shine through are laid one over another. The system of underpainting a monochrome structure and glazing color over the top is part of a long painting tradition. In the past, the common medium for the underpainting was tempera and gouache was used for the glazings. Modern artists have adapted the tradition to accommodate recent developments in materials; acrylics are often used today for the underpainting and gouache mixed with casein for the glazes. If the underlayer of paint is white, and the glazes semi-transparent, a luminosity and vibrancy is achieved in the harnessing of the priming color; dark or mid-toned underlayers enhance a feeling of depth in the shadows.

The structure of the figure in this painting, which was emphasized by bright, afternoon sunlight, was delineated in firm monochrome strokes. Darks were toned and lights painted in white to give a strong impression of the form of the figure before the gouache was added.

1

2

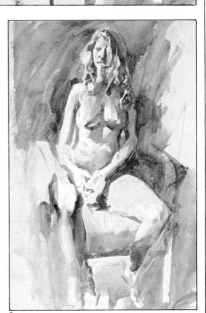

Almost like a sculptor coaxing form from a piece of stone, the artist brings the form of the figure out from the paper by careful modelling. The figure emerges in the building up of a series of monochrome washes in umber on tan-colored watercolor paper. The method is suited to representing subjects or scenes under direct light where volume is emphasized by extremes of light and dark (2 and 3). In the detail, highlights are added in blue and white to give a strong overall structure to the underpainting (4). The background is also laid and blurred streaks of white worked over the model's right shin in preparation for the dark shadows which are to be painted against the bright highlights of that area of the painting (5).

4

5

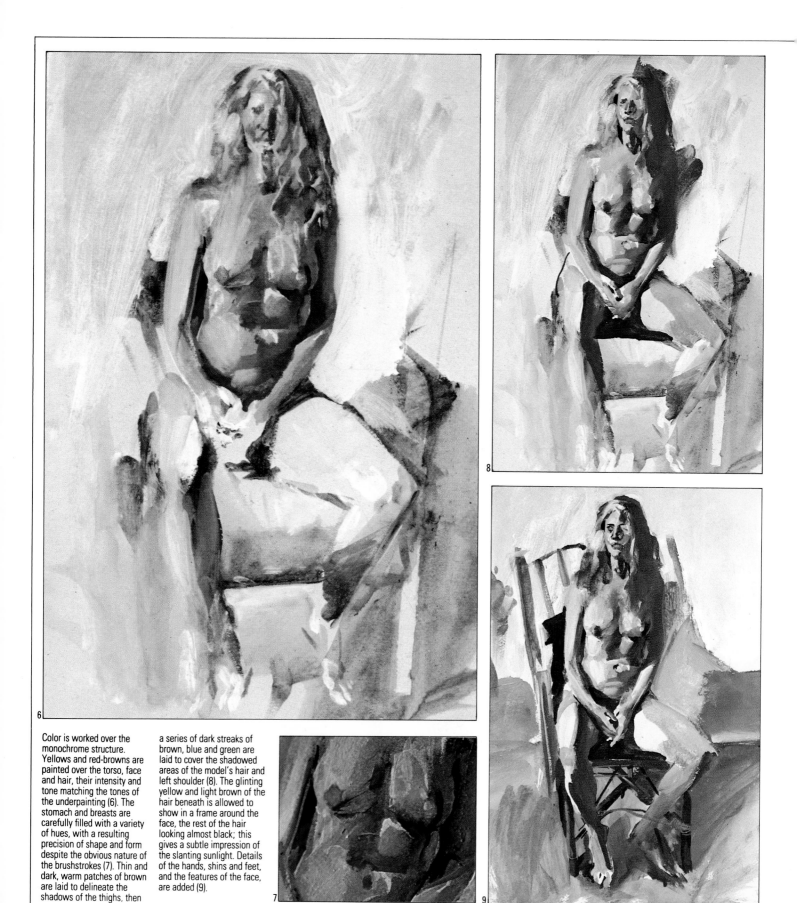

Color is worked over the monochrome structure. Yellows and red-browns are painted over the torso, face and hair, their intensity and tone matching the tones of the underpainting (6). The stomach and breasts are carefully filled with a variety of hues, with a resulting precision of shape and form despite the obvious nature of the brushstrokes (7). Thin and dark, warm patches of brown are laid to delineate the shadows of the thighs, then a series of dark streaks of brown, blue and green are laid to cover the shadowed areas of the model's hair and left shoulder (8). The glinting yellow and light brown of the hair beneath is allowed to show in a frame around the face, the rest of the hair looking almost black; this gives a subtle impression of the slanting sunlight. Details of the hands, shins and feet, and the features of the face, are added (9).

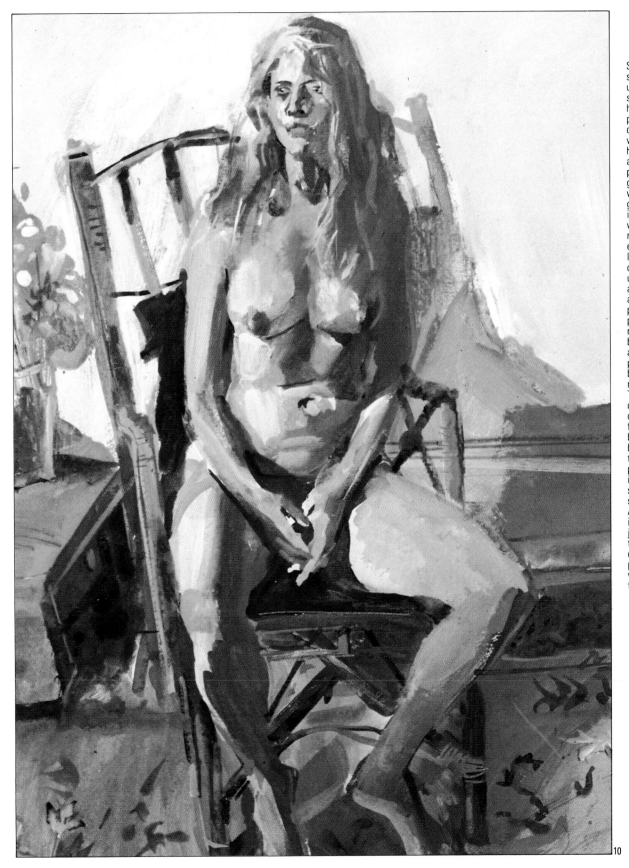

Some lights are added; some show through from the underpainting. Over the stomach, breasts, face and hair, extra highlights are painted where sunlight glints over the flesh; the rounded volumes of the figure, however, are mostly achieved in the actual process of underpainting and glazing. The casein medium with gouache allows for a great spontaneity because it is quick-drying and it covers well at the same time. Oil requires waiting because each glaze takes time to dry. It is an exciting technique, creating an opportunity to use a traditional method with a quick-thinking, modern approach. The covering power is visible in this painting in the way the dark, monochrome background becomes a cool, light blue, and also in the way yellow is painted over the very dark brown hair, and over the mauve of the carpet.

The artist changes the shape of the chair to suit the shape of the paper and of the figure. Instead of a rounded back he paints a square, barred back to give strength to the surface pattern of the painting, creating a diverse interest in the slightly slanting angle and its shadow on the wall behind. A sense of the room's space is implied by a line for the junction of wall and floor and the placing of the vase of dried leaves. The carpet pattern provides a delicate yet lively side interest to the finished painting (10).

10

WOMAN IN A GARDEN
mixed media on paper 21×14 inches (53×36 cm)

Mixing media is an interesting way of making pictures. Artists have always experimented with combinations of techniques to create a range of effects. Pastels worked into monoprints, and ink and pencil added to watercolors are just two examples. Oil paint, rubbed onto a support with a rag soaked in turpentine, will form a solid base capable of endless enrichment with pastels, inks or colored pencils. Paper, artboard, or stout, sealed cardboard are suitable supports for this kind of work.

The composition of this picture, painted in watercolor and gouache with pencil, ink and pastel elaboration, required thought because of the richness of the available subject matter. Planes were set in relation to the ground level and the table, and the figure was placed in the middle distance behind a large bush which was an atmospheric part of the garden and a contrasting foreground form. The various textures within the picture were of prime concern while working. The mixed media brings out a lively sense of the variety of shape, pattern and color in the garden scene, a variety it would be difficult to suggest in a single medium.

1

5

2

The relaxed, informal view of a woman sitting in a garden poses interesting problems of scale, texture and content. There is a danger, with such busy subjects, that the artist's eye may be overwhelmed and the result be unsatisfactory through attempting to achieve too much. To represent this scene, the artist has to act as a visual editor, selecting areas of prime concern from the mass of detail available. Although the figure is undeniably the main interest in the painting, it is not given a correspondingly prominent position, but assumes its importance through its location. Setting the figure in the middle distance, behind a large, flourishing bush, has the effect of leading the eye back to this point, rather as if the observer is walking down a garden path. The understated, reserved placing of the figure creates a sense of discovery (1).

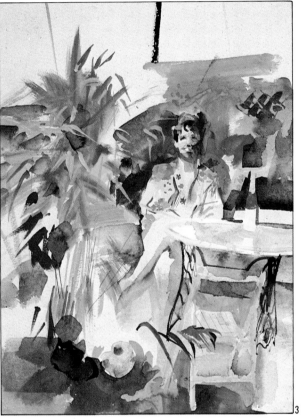

3

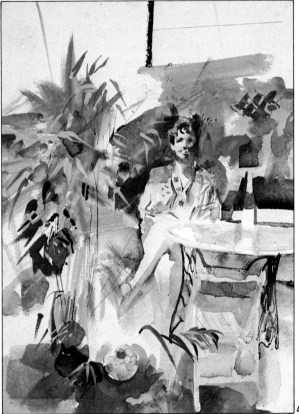

4

The initial preparations include stretching the paper, ready for painting in watercolor. A sheet of rough watercolor paper is soaked in water and taped right side up to a board, with paper tape. The two long sides of the paper are taped down first, then the two short sides. Using a large brush charged with pure watercolor, the foilage, table, chair and figure are quickly blocked in. This initial blocking in of the main forms is loose and suggestive, to allow room for subsequent alteration, while at the same time establishing the main relationships. The chair has shrunk in proportion to its actual size and a soccer ball has been added in the foreground. The ball establishes a ground level in the forefront of the picture and serves to carry the eye back to the figure's face, echoing the shape of the head (2). The watercolor painting is gradually built up, using a variety of shades of green to organize the variety of tones present in the foliage. More detail is added to the figure and a strong vertical established for the wire fence in the background (3). At this stage, the artist introduces a new medium – pen and ink – to add a further dimension to the work. The thin, spidery marks of the pen sharpen up the details and express the spindly stems and pointed leaves of the large foreground plant (4). Taking care to allow the painting to dry before applying the ink, the artist makes quick, light strokes with a dip pen over the painted areas and into the blank spaces (5).

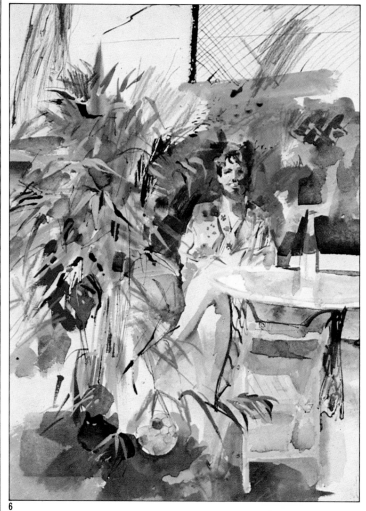

6

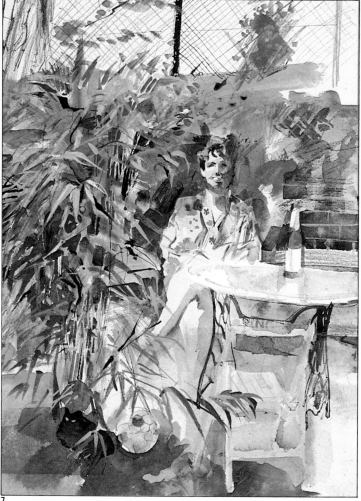

7

Further experiment is made with other materials and techniques. Pencil, colored pencil and water-soluble pencil are used to treat some of the background areas of the picture including the fine grid of the wire fence. The tree trunk is drawn boldly with colored pencil. Blots of ink give a depth to the foliage (6). Water-soluble colored pencils are a relatively new medium, combining the fine line possible with pencil with the translucency of water-color when water is applied to the drawing. They have many interesting possibilities for the artist. When dampened, the line produced by such a pencil floods the surrounding area with color, but remains visible under the wash (7). White is added to the pure watercolor, making a gouache. This serves to build up the solid areas of color and introduces new tones in the foliage (8).

8

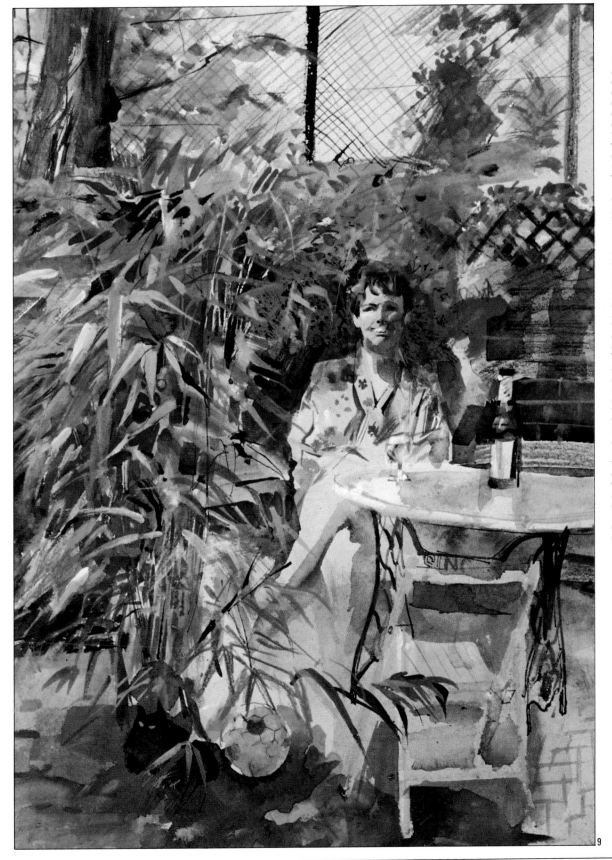

Mixing media is particularly appropriate when there are different textures and different levels of interest to consider in a picture. Simply combining media for the sake of it, or with no thought how the different materials will work together, will not guarantee a sensible result; materials must be chosen with definite effects in mind. Experiment is the best way of becoming aware of the potential of mixed media. In the finished work, the overall impression is one of liveliness, light and movement: this has not been achieved, however, by indiscriminate or haphazard use of media. An element of restraint and a constant awareness of how each addition will combine with the whole are crucial aspects of attempting complex, detailed subjects. Watercolor, gouache, pen and ink, pencil, colored pencil and, in the final stages, oil pastel are all used here; each has its part to play in the rendering of the various textures, tones and forms. Small busy areas are contrasted with large relatively blank spaces; touches of light and color create a vivid surface pattern which suggests movement and vitality. A wide range of colors have been used including a wide variety of greens, to give depth to the garden landscape (9).

9

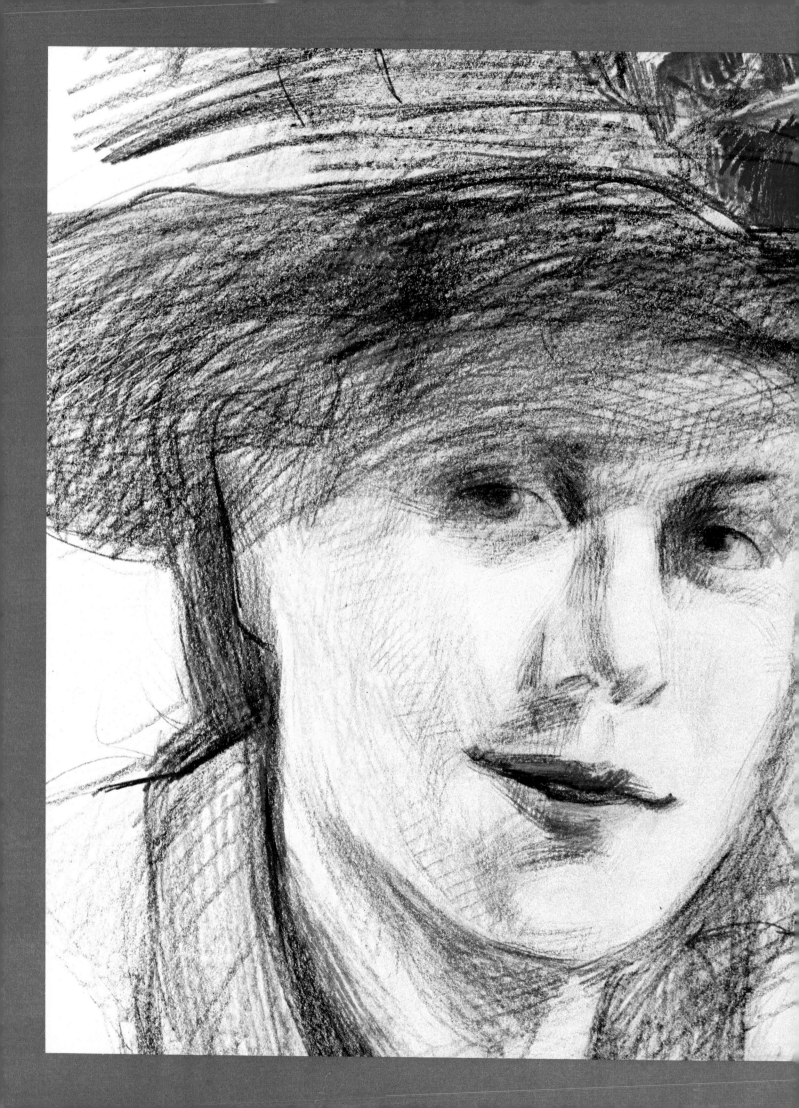

DRAWING AND
PAINTING
PORTRAITS

JOHN DEVANE

THE ART OF PORTRAITURE

The sheer number and variety of portraits drawn and painted over the centuries provides a fascinating source of imagery, lending insights into changing social conventions and tastes and bringing the past to life. They bear witness to artists' continuing attempts to depict the complexity and uniqueness of the human character and temperament. While portraits are intended to display specific features or reveal the character of an individual, they often, perhaps surprisingly, reveal as much about the artist and the artist's relationship with the subject. The conflict created between the intention, to depict an individual, and the result, which often implies a great deal more, is of lasting interest to artist and layman alike.

The existence of figurative sketches on cave walls drawn by the people of the Ice Age *c* 15,000 BC, suggests that it is almost instinctive for human beings to want to represent themselves. These drawings are not portraits but pictures of anonymous figures and animals illustrated in lively, stylized form. By comparison, portraits as they are understood today have existed as an art form for the relatively short period of about two and a half thousand years, and emerged in the type of civilization in which there was a need to celebrate or commemorate individuality.

Thus portraiture has passed in and out of favor. In the Middle Ages, for instance, portraiture hardly existed because works of art were created only for the glorification of God. The English *Wilton Diptych* includes a picture of King Richard II (1367-1400) kneeling before the Virgin; the King is only identifiable by the hart emblems on his cloak. Both before and after that, the intention of much portraiture in the Western world has been to present not individual character but a person in his or her social, political or religious role, so celebrating status or riches. Sometimes portraits have been, and are, set within mythological or historical compositions for similar reasons. However, it may be seen that during and since the Renaissance, two different and very general approaches to the art of portraiture have run parallel. The presentation of the actual personality of the subjects has been important for some artists, sometimes at the expense of their reputations and patrons' support in the form of commissions. Artists painting good likenesses of patrons for specific occasions or in robes of office have usually been able to earn a living, while artists painting for personal interest or in the pursuit of truth have not.

If a portrait is described as a "good likeness," the implication is that the sum of the features is instantly recognizable to anyone who has met or seen the subject, and it is generally assumed that all the greatest portrait painters were able to oblige their patrons with such a likeness. However, alone, the reproduction of features does not necessarily reveal a great deal about the subject, and certainly has nothing to do with the quality of the painting. The warm response of viewers looking at portraits by Old Masters – portraits of men and women unknown to them – is often provoked by the perception of a kind of sympathy or understanding existing between sitter and artist. Some great artists have been able to

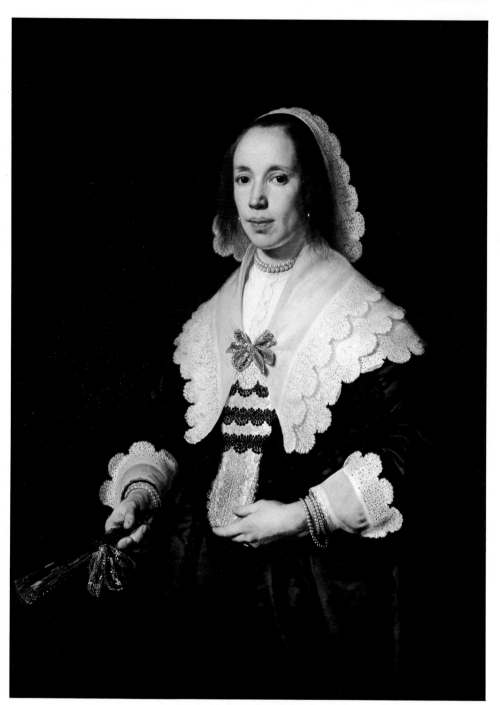

Above *Portrait of a Lady,* Bartholomeus van der Helst, (1613-70). This unusual portrait, with its black-on-black effect, was painted by Amsterdam's leading portrait painter of the mid-seventeenth century. He has ensured the unity of the painting by matching the lady's dark eyes and strong pale face to the starkly contrasting blacks and whites of the whole. The dress is in fact a dark blue-black, rich in both color and texture, while it is toned against a brown-black background. The lace and pearls are painted in intricate detail to indicate the subject's wealth, and their blue whites contrast with the warmer whites of her skin.

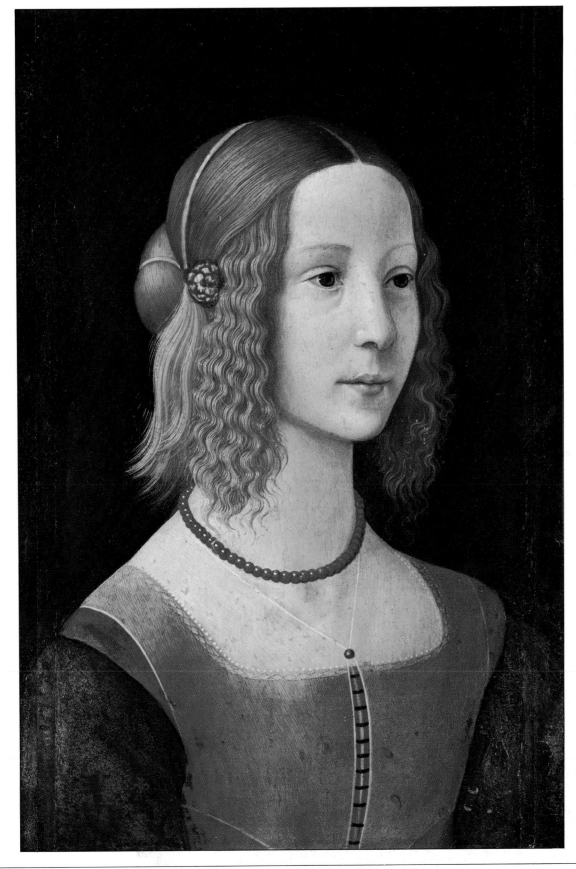

Left *Portrait of a Girl*, Domenico Ghirlandaio (*c*1448-94). This portrait has been attributed by some to the hand of Sebastiano Mainardi (active 1493-d 1513), who worked in the studio of Ghirlandaio, but the truth remains a mystery. Whoever the artist was, the quiet beauty of this portrait bears witness to a mastery of naturalistic paint effects. The picture is unified by the use of complementary greens and reds in the dress, the necklace, the hair decoration and the rosiness of the girl's lips. Her bearing, high forehead and flaxen hair, combined with her downcast eyes, make a subtle statement on the idealistic modesty of the young Renaissance woman.

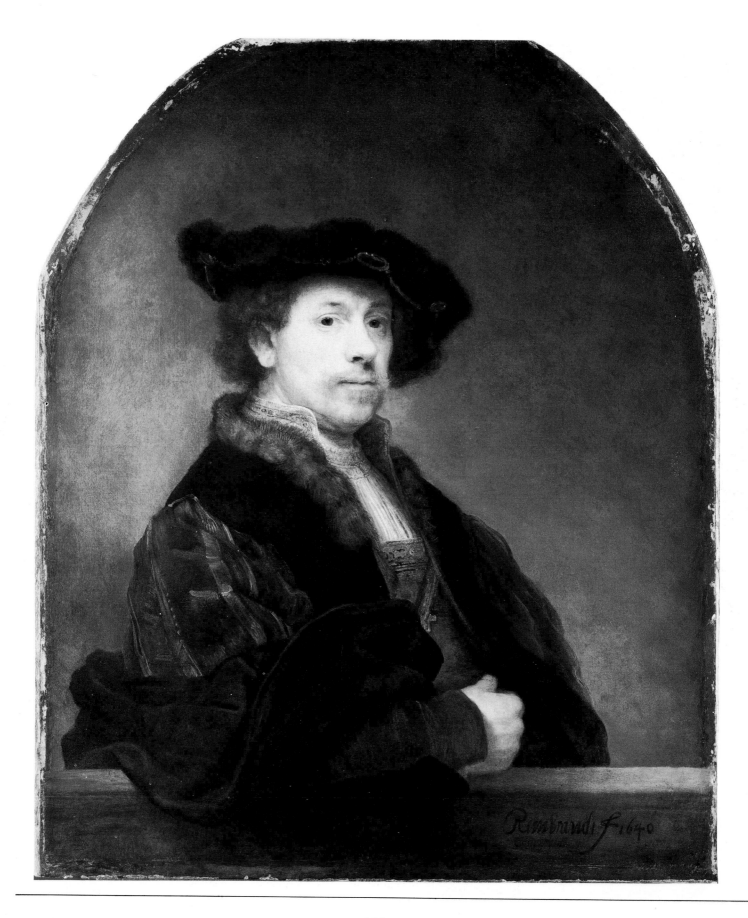

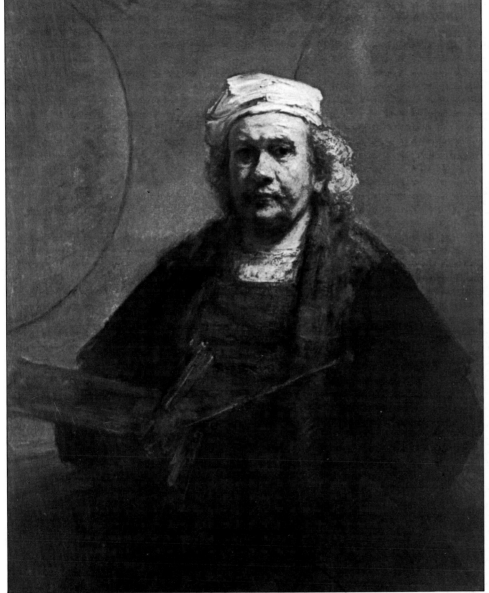

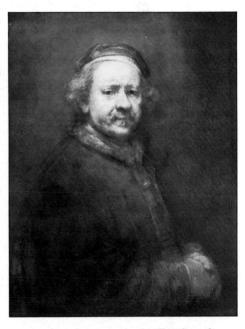

Self-portraits by Rembrandt In these self-portraits, just three of the dozens he painted, Rembrandt recorded his psychological and physical changes with a characteristic mastery of the medium combined with acute self-awareness. Self-portraits demand a peculiar twofold understanding. Using a mirror and painting the reflected image, the artist is treating his own face as if it belonged to another person; simultaneously he is privileged with a depth of self-knowledge. This conflict can cause ambiguity in the painting, certainly not aided by the difficulty of extricating mistaken preconceptions which would hinder a truthful picture. The character of the artist is revealed to an extent by the changing painting style. At ages 34, 53 and 63, these portraits show the development of Rembrandt's techniques while his face aged. In the first he is a successful young painter, much in demand. During the 1640s, in other works, he started concentrating on the inner character or spirituality of his subjects. By the time he was 53, his wife had died and he was bankrupt, and the sadness caused him to paint energetically for himself. The third portrait reveals the face of disillusion. The blurred paint betrays an acceptance of his life's tragedies.

reveal this kind of true feeling without losing the respect of their patrons.

Because portraits necessarily record how the artist sees the subject, they cannot be truly objective. In painting one face, the artist records a two-way reaction. Some portraits describe the sympathy between the painter and the person being painted; others, not necessarily less good, display a formality, and some a satirical or otherwise harsh response. Other reasons for the necessary subjectivity of a portrait exist. The artist may feel that the character of the subject could be enhanced by a certain background or the inclusion of objects, which would provide hints as to the situation or interests of the subject. A great deal of realism has been employed by many portraitists, others have presented their subjects within a disconnected or abstracted vision. These comparisons illustrate differences in artists' intentions, as prompted by the personality of the subject. They also illustrate how the background and character of the artist may to some extent be revealed.

In some portraits, the interaction between artist and sitter is displayed more overtly than in the implied mood or intention. In attempting to portray an individual realistically, some artists involuntarily include their own physical characteristics. As Leonardo da Vinci (1452-1519) wrote in his *Treatise on Painting*: "If you were ugly, you would select faces that are not beautiful and you would paint ugly faces, as do many painters, whose painted figures often resemble that of their master." It is interesting to compare the portraits by Rembrandt van Rijn (1606-69), for example, with his many self-portraits. Hardly a year went by when he did not commit his own features to canvas, and it becomes apparent that in many of his portraits of others there is a resemblance to his own features. These similarities cannot simply be accounted for by the use of immediate family as models. Often the resemblance is not only in the face but concerns the body as a whole.

In these terms, the most revealing type of portrait might be said to be the self-portrait, in which inner and outer characteristics can be portrayed without the inhibiting attempt to come to terms with the separateness of another person. Painting a self-portrait could be considered as the ultimate attempt to

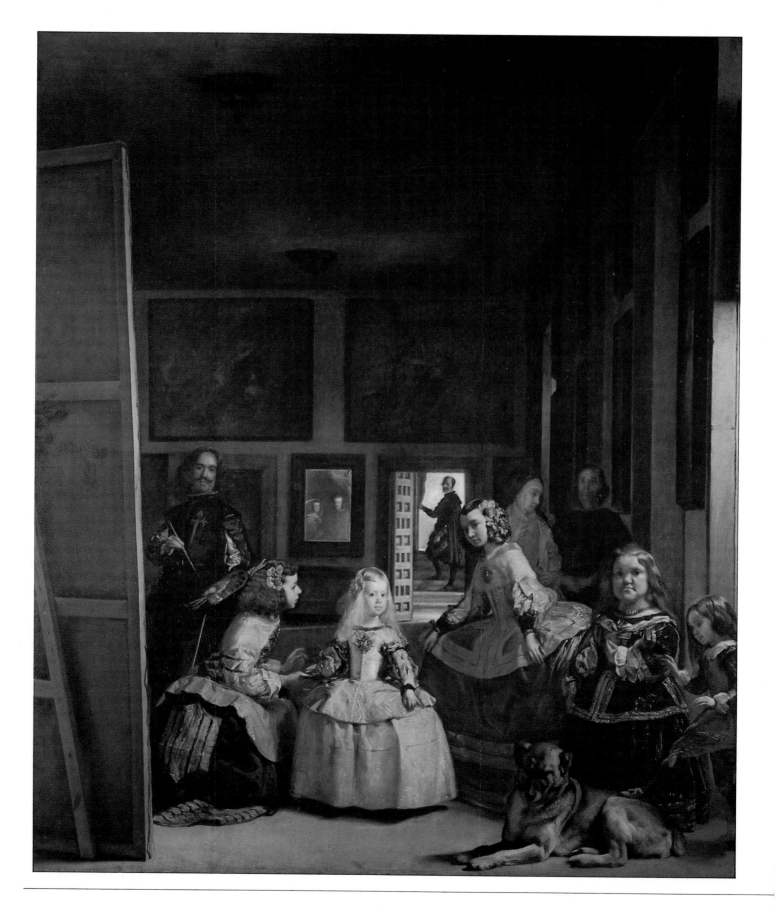

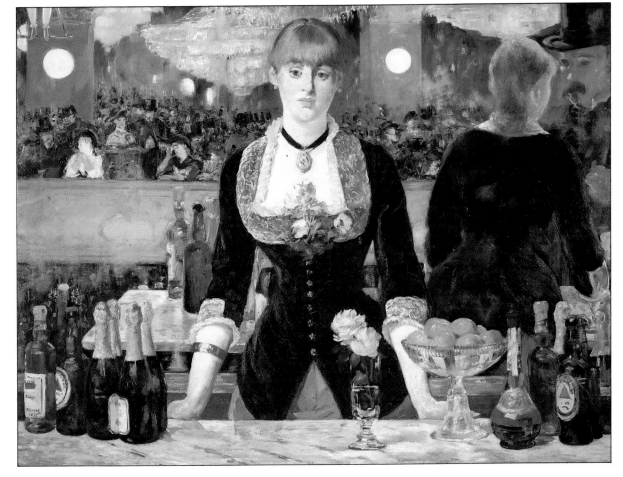

Far Left *Las Meninas (The Maids of Honor),* Diego Velasquez. The artist may have used a mirror to paint this group portrait, which includes himself, and painted the reflection, not reality. However, to be truthful to the mirror reflection, he would have had to paint the back views of the King and Queen of Spain (who appear in a mirror on the wall behind) and their bodies would have blocked almost everything else from view. In reality they probably did not stand in front of the group; in other words, in reality, the people at the center of the idea were not there.
Left *A Bar at the Folies Bergère,* Edouard Manet. From the mirror reflection it is evident that the girl is taking an order, perhaps from the artist. The implication of life connected with it but going on outside it brings the picture alive.
Below One of Kitagawa Utamaro's series of "Beauties making up." This wood block print exploits the mirror reflection to make a simple statement on the grace and beauty of a Japanese lady.

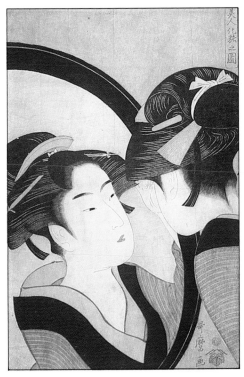

combine the inner and outer self. At the same time, the discipline enables the artist to become increasingly aware of the complexity involved in observing features and expressions and committing them to canvas or paper. Rembrandt's memorable self-portraits amount to a visual graph of the inevitable aging process.

The Spanish painter Velasquez (1599-1660), unlike his contemporary Rembrandt, did not display any desire to produce self-portraits except in *Las Meninas (The Maids of Honor)*, which he painted late in life. In this picture, he included a self-portrait which was in fact an image of the artist as seen by others. The painting is a comment about the painting of portraits. The actual subjects of the portrait within the whole group – the King and Queen of Spain – are not in the picture except in reflection. The viewer becomes the subject, standing in the imaginary position of the royal couple. In this visual paradox, Velasquez seems to be confronting the nature of reality, forcing the viewer to an awareness of the deception caused by an acceptance of illusion.

The use of realism in painting is an attempt to create an illusion. The artist is presenting a picture as if it is part of the actual world, as if the viewer were looking through a window onto the presented scene. Realism in painting may be described as the representation of the natural world in as generally recognizable a way as possible using perspective and tone and other painterly devices. As realism became accepted in the Western world, its aims became confused and this resulted in a common misconception that the sole purpose of painting was to mimic the natural world. The importance attached to this realism is essentially a Western dilemma. Eastern cultures have always remained aware of the distinction between the visual world and the world of artifice that includes the flat surface of a painting. The Eastern point of view is reinforced in the way that the Western vision of reality, as presented on canvas or paper, has changed over the centuries. This in itself is further proof of the impossibility of an objective portrait. Art is not life; the fascination of painting and drawing is in the revelation of personal visions.

Fifteenth-century technical innovations like the use of oil paint in some respects impinged on the subtlety with which earlier European artists combined an acute awareness of visual phenomena with an understanding of a

Giovanni Arnolfini and Giovanna Cenami, the children of wealthy Italian merchants established in Bruges, which was finished in 1434. The serene physiognomy exemplifies the style of northern European painting at that time, but despite the microscopic attention given to surfaces and the realistic feeling of light and space, the actual poses of the figures are rooted in earlier Gothic sculpture. The statuesque couple join hands with a ceremonial calmness and gaze out from their bedchamber while the spectactor replaces the original witnesses to the marriage vows.

Petrus Christus (active 1442?–d 1472/73) emerged as the major painter in Bruges after van Eyck's death. Although much of his work is derivative, *Portrait of a Girl*, generally considered to be Lady Talbot, is both beautiful and strikingly individual. The fascination that this tiny painting exerts is partly due to the expression on the child-like face. Because of the fashionably plucked eyebrows and high forehead, the oval purity of the face becomes apparent. The gentle facial contours are smooth, and yet any mask-like resemblance is relieved by the penetrating stare of the slightly slanting eyes.

By contrast, in many examples of Flemish portraiture the subject appears to be unaware of the artist's presence or self-absorbed and deep in prayer. The portraits by Rogier van der Weyden (*c* 1400-64) usually follow this pattern, and his *Portrait of a Lady*, although similar in posture and facial type, is quite different in feeling from the almost provocative countenance of the girl by Petrus Christus. The direct confrontation between Lady Talbot, if it is she, and the artist is apparent, despite the stiffly encased little body, and reveals a particular person with a credible human presence.

By comparing the works of Flemish and Italian painters during the fifteenth century it is possible to detect the overlap of influence that occurred. The lessons learned from van Eyck are evident in the work of Antonello da Messina (*c* 1430-79), who was probably the most important southern Italian painter at the time and certainly responsible for the Italian involvement with oil paint. Antonello adopted the Flemish love of detail but managed to incorporate it into a breadth and harmony of design that is purely Italian. His portraits probably influenced Giovanni Bellini (1430/40-1516) and many other painters who acquired a knowledge of Flemish paintings without actually seeing them.

As portraits became fashionable, artists were required to expand their formal repertoire. Hans Memling (1430/5-94), whose art is purely Netherlandish, found favor with Italian clients by combining portraiture with a glimpse of landscape. By comparison, the

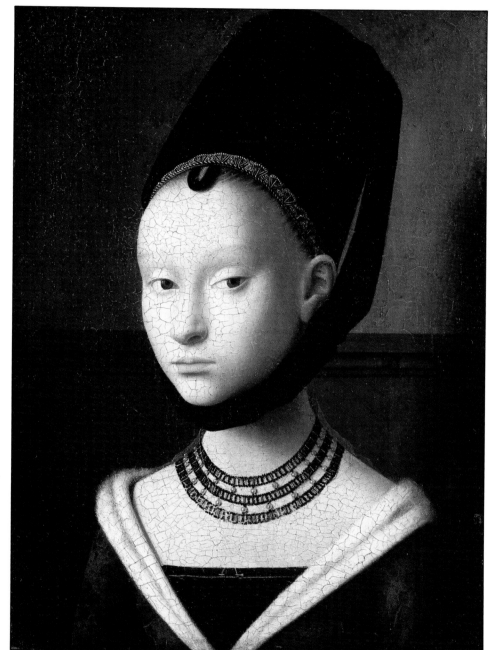

work of Piero della Francesca (1410/20-92) embodies all the Renaissance ideals: it combines realistic representation held in check by mathematical considerations of formal relationships. For Memling landscape provided an interesting foil to figures; Piero was fudamentally preoccupied with landscape as the space human beings occupy. "Renaissance man" is usually depicted as being at one with the natural world, and from Giotto onward most religious depictions occur in the open air, in contrast to the closeted world favored by the Flemish painters.

One of the most talented of early Flemish

Above *Portrait of a Girl*, Petrus Christus. The inquisitive yet wary air of this young girl has been captured by the Netherlandish artist to create a beautiful and, at the same time, disturbing portrait. Her shyness is endearing because her expression of self-assurance is an attempt to deny it. Christus' mastery of the oil medium allowed him to reveal a distinct personality behind the youthful gaze.

Right *Portrait of a Man*, Antonello da Messina. This confident work is traditionally considered to be a self-portrait, probably painted in 1475. Originally the eyes were painted looking the other way, but in the final version the subject is staring at the spectator, so forcing a direct confrontation and demanding a response. The Flemish style of the three-quarter view was to have an important influence.

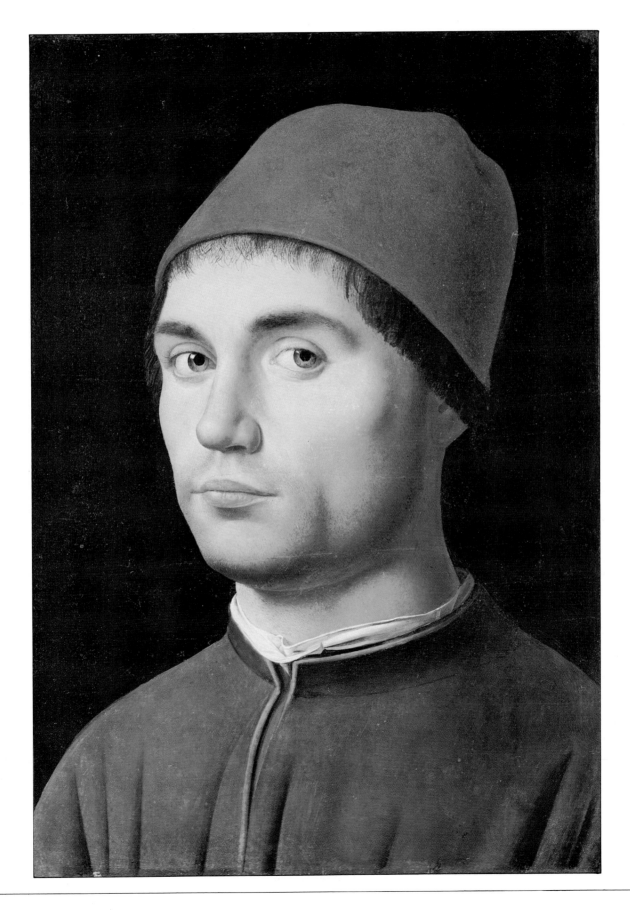

painters after van Eyck to influence Florentine painters was Hugo van der Goes (active *c* 1467-82). Tommaso Portinari, an agent for the House of Medici in Bruges, commissioned an altar painting by him which was sent to Florence on completion. This provided the Italians with a first-hand glimpse of a remarkable oil painting. Apart from the originality of its composition and large scale, which was unusual for a Flemish artist of this time, it illustrated a virtuoso performance of a complex religious scene with landscape in the background and life-size portraits of shepherds and children flanking the center picture. Although large-scale frescoes were commonplace, an oil painting of such complexity as *The Portinari Altarpiece* was a great achievement.

The leading French painter of the fifteenth century was Jean Fouquet (*c* 1420-*c* 1481). He was certainly influenced by the new Renaissance ideas, especially the desire to depict tangible volume. As with Hugo van der Goes, his most powerful picture is a strange diptych, the *Diptych of Melun*, combining a religious scene with portraiture. In the lefthand panel his patron Etienne Chevalier, Chancellor of France, is seen kneeling beside an enigmatic image of St. Stephen. A grasp of reality is confirmed by the implied weight of a book St. Stephen is holding; its volume is understood and it occupies a three-dimensional space. The slight tilt of St. Stephen's head and the fact that it is seen from below, contrasts and breaks the monotony of what might have been a repetition of the more upright posture of Chevalier. Despite St. Stephen's neatly trimmed hair, his wrinkled skin and expression are naturalistically represented. The opposite panel of the diptych is more overtly Gothic in appearance. Peculiar red cherubs surround the stiff Madonna figure, and the bizarre format of the picture is accentuated by speculation that the Madonna is also a portrait of Chevalier's mistress.

As Renaissance ideas evolved and spread through Europe, the importance of the artist as an individual became more apparent. With the passage of time, the myth surrounding an artist grows, and sometimes less attention is focused on the subject than on the painter. The name of Leonardo da Vinci resounds through history. Apart from epitomizing the Renaissance ideal, Leonardo's relatively small output of paintings seems to endorse the mystery of his genius. The *Mona Lisa*, perhaps the best-known portrait ever to be painted, is shrouded in mystery, partly because of the awe generated by the mastery of its creator and partly because so little is known about its origin. The wooden panel is unsigned and undated, and there are no records of payment, suggesting that it was not a commissioned work, nor any information that could

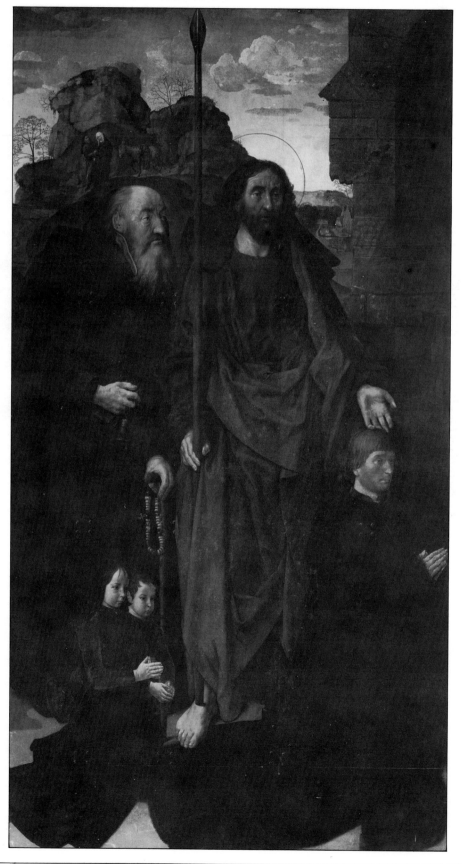

154

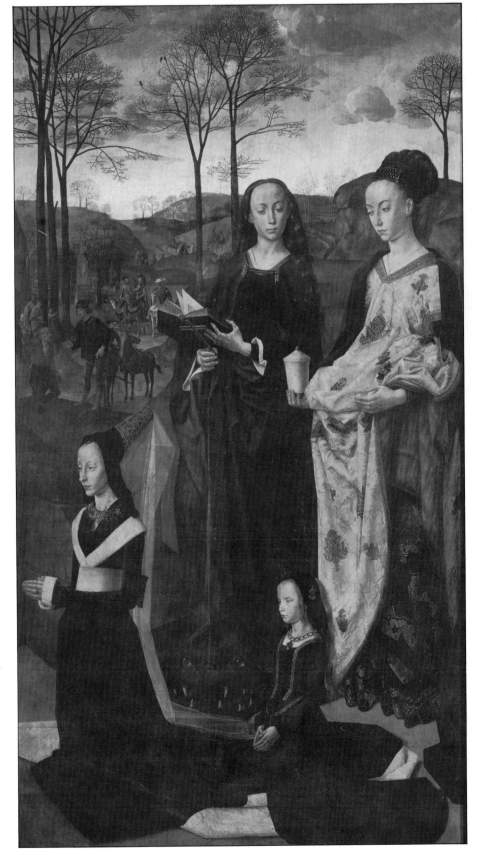

shed light on its intended owner. There are no drawings by Leonardo that could be interpreted as preparatory studies and there is some speculation about the actual identity of the subject.

The lack of information on the *Mona Lisa* is all the more surprising in the light of the visual clues given by Leonardo in the majority of his paintings. His iconographical references, which have been considered in depth by various critics, reveal specific information about the sitters. In the portrait *Ginevra de' Benci*, for instance, the foliage of juniper amid the surrounding landscape can be interpreted as a visual pun on the woman's name, *ginevra* meaning juniper in early Italian dialects. Another portrait entitled *Lady with an Ermine* represents Cecilia Gallerani, the mistress of Il Moro whose emblem included the ermine. The effects of juxtaposing the woman and the animal were certainly calculated by Leonardo, and even without knowledge of the emblematic association, the echoes provide a disturbing note to what might otherwise have been a traditional portrait. The unblinking stare of the ermine is matched by the sharp delineation of the woman's features, and the position of her beautifully drawn hand is repeated in the position of the animal's claw. Both these portraits differ considerably from the *Mona Lisa*. Not only do they definitely represent particular individuals, they also display hairstyles and clothing which were typical of contemporary fashion. By comparison, the *Mona Lisa*, devoid of jewellery and visual clues, seems timeless.

It has been suggested that the *Mona Lisa* is a composite portrait painted over a number of years and perhaps fusing together the images of more than one model. On a purely technical level, the paintwork has an organic quality achieved by imperceptible layers of transparent paint blended without a linear emphasis on contour. The early years of Leonardo's work on the *Mona Lisa* coincided with a period of anatomical study in Florence. Between 1503 and 1506 he lived in the Hospital of Santa Maria Nuova, and the

Far left and left *The Portinari Altarpiece,* Hugo van der Goes. The Flemish artist was commissioned by Tommaso Portinari, the Medici representative at Bruges, to paint a large-scale altarpiece for the church of the Hospital of Sta Maria Nuova in Florence. When displayed, in about 1476, the proficient handling of oil paint and mastery of design surprised and pleased the Italians, who adopted oil techniques later than the northern Europeans. These two side panels of the triptych show the donor and his family with their patron saints standing behind. The volumes and textures of the clothing are described richly yet delicately; similarly the women's jewelry and the hands of the children are painted in minute detail. The activity of the background figures adds life and vigor to these fine paintings.

subsequent knowledge gained must have affected the course of his painting. The degree of realism attained was the result of an increased awareness of the structures beneath the skin. Most medieval doctrines encouraged the belief that the universe could only be understood spiritually, but Leonardo believed knowledge to be based on an objective understanding of experiences combined with mathematical reasoning. In his own writings, he expressed contempt for the aristocracy of Florence who based their intellectual superiority on a tradition of acquired knowledge and relied on memory rather than natural intelligence.

Leonardo considered the *Mona Lisa* important enough to accompany him on his travels, and even in an unfinished state it exerted considerable influence over the fashion for single figure portraiture. It is almost certain that Raphael (1483-1520) saw the picture, and now, more than ever, the enigmatic presence of the *Mona Lisa* continues to attract speculation and admiration. Countless thousands of people file past its bulletproof case in the Louvre, and yet further along the same wall is another picture which, although not so popular, embodies many of the Renaissance ideals in portraiture.

Baldassare Castiglione by Raphael portrays a serene personification of the courtier as a gentleman. Castiglione was the author of *The Courtier*, a book that describes codes of behavior for the Renaissance man. It enjoyed vast success, not only in Italy but throughout other parts of Europe and Raphael provides a visual equivalent in the serene countenance of the portrait. The calm and dignified expression coupled with the eloquent yet restrained paint quality sets the precedent for centuries of single figure portraits.

Although Raphael and Leonardo differed as personalities, they were linked by a conception of the world that was quite different from the northern European view. The achievement of Albrecht Dürer (1471-1528) seems more deliberate and less fluent in comparison with Leonardo's work, and it is hard to think of the two artists as contemporaries. Dürer admired the Italians, but he felt that the secrets of their painting eluded him and in 1505 he went to Italy in the hope of discovering them for himself. Despite this pilgrimage and subsequent familiarity with work by Bellini and Leonardo, there exists in his work a conflict between the rational order of Italian Humanism and the disjointed, traditional aspects of the Gothic world. The paintings of Raphael and Leonardo exude technical confidence as well as a general sense of assurance between man and the world. The haunting presence of some of Dürer's images, his *Self-Portrait* for example, although in step with technical innovation, presents a

vulnerable and uncertain image of man.

This kind of conflict is not so apparent in the work of another German painter, the younger Hans Holbein (1497-1543), who was more cosmopolitan than Dürer and, through his travels, was able to reap the full benefits of Renaissance painting while maintaining his own individuality. During the disturbances of the Reformation, Holbein visited England, where he painted a remarkable portrait of Henry VIII.

Renaissance concepts found fruition in Holbein's vision of the world, and his depiction of philosophers and scholars as well as merchants and the aristocracy shows how he had developed despite the religious and artistic conflicts which occurred after the Reformation in the sixteenth century. The paintings of Dürer, Lucas Cranach (1472-1553) and Mathias Grünewald (c 1460-1528) include intensely personal characteristics that have since been thought to epitomize Germanic art. The restrained and detached vision of Holbein has less strictly Germanic

traits, and yet in the intimate portrait of his wife and children there is an almost cruel awareness of human imperfection that is suppressed in his more impassive descriptions of the aristocracy. In the allegorical portrait of Jean de Dinteville and Georges de Selve known as *The Ambassadors*, Holbein displays a virtuoso performance that typifies his ability to combine a commanding human presence with the attributes of status and success, and a visual acknowledgement of the intellectual and scientific progress of his day. The celebration of earthly success is amended by the introduction of a visual "memento mori" in the form of the distorted reflection of a skull in the mirror.

During the Renaissance in Italy, various developments took place in different regions and it was in Venice that the exploration of oil paint's potential found its outlet. As a rich and independent city it was open to distant commerce and the people were quick to exploit the commercial possibilities of such an advance. The arts flourished and the demand

Far left Detail of *Ginevra de 'Benci*, Leonardo da Vinci. This portrait is generally considered to be of Ginevra de 'Benci, painted between 1474 and 1478 to celebrate the occasion of her marriage although there has been some doubt. The theory is, however, supported by the existence of a prickly juniper tree in the background, framing the subject's face; *ginevra* or *ginepro* means "juniper" in Italian. This type of visual pun on names was common during the Renaissance and Leonardo made full use of it here, with the lady's pale skin looking almost translucent in front of the semi-opaque glazes of the evergreen.

Left *Mona Lisa*, Leonardo da Vinci. The model for this timeless portrait was Lisa Gheradini, the wife of Francesco di Zanobi del Giocondo. The enigmatic smile of the Gioconda has been spoken and written about since the painting was first displayed, and it is interesting that the way she seems to smile with only the left part of her mouth accords with a piece of advice given to Renaissance women by Agnolo Firenzuola in a book on beauty and etiquette. He suggested: "From time to time, to close the mouth at the right corner with a suave and nimble movement, and to open it at the left side, as if you were smiling secretly . . . this is not affectation, if it is done in a restrained and graceful manner and accompanied by innocent coquetry and by certain movements of the eyes . . ." Whether the *Mona Lisa* influenced this ideal or was influenced by it, it is certain that the picture, so different from others of the time, constitutes a landmark in the development of portraiture. The seated pose is relaxed, almost informal, and the mood of the subject enhanced by the mysterious landscape and somber coloring.

for pictures was so large that artistic factories developed out of what had been small family concerns. Giovanni Bellini was the most important influence on painters of his own and next generations. Jacopo Bellini (c 1400-1470), his father, was also a painter, as were his brother Gentile (c 1429-1507) and brother-in-law Andrea Mantegna (1421-1506); between them they produced hundreds of religious compositions and portraits.

Bellini was one of the first Italian artists to use oil paint as a medium in itself and quicky realized its potential, the results of which challenged the cool, dry Florentine style. Bellini's vision accommodated a tactile response to the visual world similar to that of the Flemish, yet at the same time a pictorial organization worthy of the best fifteenth-century Italians. One of his most striking portraits is *Doge Leonardo Loredano*. This elderly man swathed in robes has the monumental grandeur and solemnity of a marble statue. Despite the delicate quality of the skin, the bone structure is realized with authority; this is accentuated by the satin robe and intensely blue background.

Bellini's paint application is sober and restrained, yet painters ever since have tried in vain to understand how the richness

evolved. This achievement was remarkable considering the exploratory nature of what was then a relatively new medium. The passage of time has only added to the elusiveness of an explanation, the only certainty being that the application of transparent glazes of paint results in a translucent quality that cannot be equalled by the application of opaque paint. His paintings paved the way for the sumptuous paint qualities in the work of Titian (c 1487-1576) and Giorgione (1475-1510). At the same time, the clarity of Mantegna gave way to a softer, more organic feeling in which the effect of light on skin and drapery reached unknown heights.

The confidence with which Bellini's successors Titian and Giorgione painted skin resulted not only in realistic portraiture but extended to reveal the whole figure. The authority with which they dealt with the nude was unprecedented and unequalled in Europe. The frank sensuality, the opulent draperies and luscious landscapes were truly Venetian and quite opposed in spirit to the more overtly intellectual achievement in the rest of Italy. Despite similarities in Giorgione's work and Titian's early pictures, their contrasting temperaments eventually emerged. The graceful subtlety of Giorgione

is matched by the vigorous and dramatic aspects of Titian. The official portraits by Titian, including those of his patron Charles V and of Pope Paul II with his grandsons, have interested many portrait painters since, but the lasting effect of his work is due to the influence of the less formal portraits that with relaxed yet animated postures are remarkably modern in concept.

With few exceptions the artists of the sixteenth century were seemingly intimidated by the formidable artistic achievements made in the High Renaissance. It was not until the twentieth century that a recognizable difference between the Renaissance and the Baroque era was acknowledged. Michelangelo Buonarroti (1475-1564), who outlived both Raphael and Leonardo by more than 40 years, had a considerable influence on the next generations of Italian painters. His sculptural devotion to the male nude provided the inspiration for the frenzied schemes of willfully distorted groups of figures that are usually termed Mannerist and find their most overt realization in the work of Jacopo Pontormo (1494-1557) and Parmigianino (1503-40). The sober vision of Bronzino (1503-72), a pupil of Pontormo, reveals a remarkable penetration in the field of portraiture. The restrained color, which is untypical of Mannerist painting, emphasizes the icy grandeur of his aristocratic subjects, who in alert postures and with expressions of disdain, confront the world with an inscrutability that anticipates the portraits of Ingres (1780-1867). In Bronzino's portraits of children there is a more immediate human involvement yet even here an element of unease lurks behind the immaculate surface. In the portrait of Giovanni de Medici (1475), the young boy's gleeful expression is matched by the way he grasps the bird in a chubby hand. Within the limitations of what at first appear to be straightforward half-length portraits, Bronzino achieves subtlety as well as variety. The positioning of the hands is always crucial to the design of the painting and invariably draws attention to the pictorial accessories, competing with the head as an immediate focal point.

Bronzino's strength as a portrait painter is partly due to an ability to reconcile human imperfection with an abstract purity of design. In *Portrait of a Young Man* (c 1529) the sense of pictorial harmony might suggest a somewhat idealized vision of what has been considered a self-portrait. On closer inspection, the clean-shaven purity of the head belies a frank acknowledgement of imperfection in the divergent squint of the left eye. At the bottom edge of the painting, the gargoyle-like caricatures decorating the arm of the chair and the stone ledge contrast violently with the calm superiority of the portrait. It has been

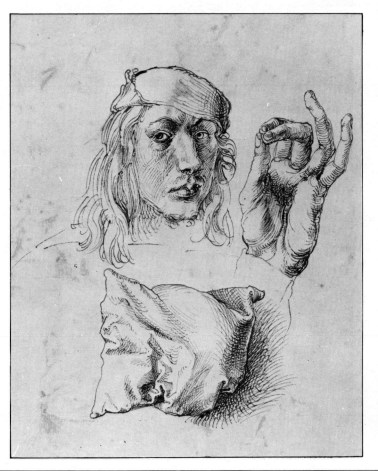

Left *Portrait of Erasmus* (1523), Hans Holbein. A powerful study in character, this portrait shows the humanist scholar at work in his study, his profile clearly etched against a curtain. Erasmus moved to Basel in 1521 where Holbein lived and worked; this picture was painted during the struggles for the Reformation. When the Reformation brought a decline in patronage, Erasmus gave Holbein an introduction to Sir Thomas More in England, where the artist went to look for commissions.
Right *Self-portrait*, Albrecht Dürer. Using pen and ink on paper, Dürer drew this self-portrait at the age of 22, having already developed an individual style. His use of hatching and crosshatching illustrate an assured grasp of form and volume, also visible in the hand and pillow sketches. The confident lines of the portrait display enquiring eyes and a slight, humored scepticism.

Above *The Ambassadors,* Hans Holbein. This famous double portrait was commissioned in 1533 and displays great detail and imaginative use of oil colors.

The objects ranged on the chest probably referred to the particular interest of the two men and emphasize Renaissance learning.

Right *Baldassare Castiglione,* Raphael. The piercing blue eyes of Count Castiglione confront the spectator with a demanding honesty, while his benignity

probably expresses the view of the man who was held by his peers to be an authority on etiquette. Raphael's fluid paint techniques suit the mood of contentment.

suggested that the sophistication of Mannerist imagery implied a similar sophistication on the part of the viewer. However, it was a violent rejection of this acquired attitude that marked the subtle vision of Caravaggio (1573-1610).

Few painters since Giotto have had such a fundamental impact on the course of Western painting as Caravaggio. The idea of the artist as a rebel is common to the twentieth century but at the end of a century that had paid homage to the achievements made during the Renaissance, it was an anathema. Caravaggio's early death added potency to a notorious reputation that had encompassed a personal and artistic confrontation with the established opinions. His career was violently criticized and there was controversy surrounding his religious works which were often rejected on the grounds of indecorum. However, his paintings were appreciated by astute collectors. The main reason for the conflict surrounding his work is not easily discernible in retrospect, but his delight in presenting solemn religious themes with a frank reality challenged the very foundations of pictorial convention in the sixteenth century. His intolerance of the repetition of forms in the style of Michelangelo and Raphael forced him to strike out alone and resulted in remarkable work, based on observation and not the precedents set by others. The main objection to Caravaggio's art resulted from his blatant acknowledgement of visual phenomena and an unwillingness to present the spiritual world in anything not visually tangible.

As modern x-ray evidence has shown, Caravaggio's painting method involved compositional changes being made while working; this would substantiate the argument that he did not rely on preparational studies and drawings. It also suggests that he worked directly from models, and by so doing he produced images with individual rather than preconceived characteristics. In this respect, Caravaggio's religious subjects can be interpreted as groups of portraits of people acting out religious roles. The theatrical metaphor is also appropriate considering that the space his figures occupy invariably takes the form of an enclosed box which eliminates the necessity of indicating landscape, the main province of previous Italian painting. He was fond of painting figures in contemporary dress and juxtaposing these with figures in robes that are often associated with allegorical or religious subjects. The sense of drama that pervades Caravaggio's work is enhanced by the implications of a powerful light source emphasizing the volumes of figures depicted; this does not attempt to convey the kind of spirituality apparent in the work of El Greco (1541-1614) or Tintoretto (1518-94).

Caravaggio's *Conversion of St. Paul* records the miraculous event with unprecedented honesty. *The Supper at Emmaus* displays a similar candor in the individual characterization of the figures, except for a slight concession to an idealized Christ figure. The man on the right, seen in profile, is anything but idealized, and it was this emphasis on human imperfection that confounded the expectations of his patrons. In most previous paintings, the sanctity of a religious personage was fully endorsed by a clean exterior that radiated an inner light. By comparison, Caravaggio's saints emerge as ordinary people straight from the streets of Rome or Naples complete with ragged clothes and dirty feet. Often they are projected in ungainly and contorted postures, providing an immediate, physical confrontation with the viewer that his contemporaries found objectionable.

Caravaggio's influence over artists extended well beyond previous geographical limitations. Although his revolutionary realism inspired imitators closer to home, his true legacy found fruition in the work of Diego Velasquez and Rembrandt van Rijn, and was to be resurrected in the nineteenth century by Gustave Courbet (1819-77) and the Realist movement.

In comparison with the turbulent life of Caravaggio, that of Velasquez, the Spaniard, was sedate. His confident artistic achievement as a court painter parallels that of his contemporary and friend, Sir Peter Paul Rubens (1577-1640). Both painters enjoyed early and lasting success at the courts of their respective patrons and yet their opposite temperaments resulted in a completely different artistic development. The grand schemes and painterly flourish of Rubens

.Left *Cardinal Don Fernando Niño de Guevara*, El Greco. Born in Crete, El Greco's real name was Domanikos Theotocopoulos, but he did not stay in his native country. Instead he studied painting in Venice, where the work of Tintoretto and Michelangelo had a great influence, and later in Rome before going on to work in Spain. He was a sculptor as well as a fine painter, mainly concentrating on religious subjects. His unusual style can be seen in this portrait of the Cardinal. El Greco often used bold lighting and the typically large, visible brushstrokes contribute to a feeling of liveliness. He manipulated the brush to create the different textures of silk and lace with great effect. At the same time, the stern aspect of the Cardinal and the way in which he looks down at the spectator create an impression of authority.
Right *Portrait of a Young Man*, Agnolo di Cosimo di Mariano Bronzino. The adopted son and pupil of Pontormo, Bronzino displays the Mannerist penchant for excellent and potentially vigorous physiques and exaggerated poses in this portrait, which has been thought to be of himself. The figure displays an aristocratic disdain and coolness, which is enhanced by the green hue of the plain unwelcoming background.

Above Detail of *The Supper at Emmaus*, Michelangelo Merisi de Caravaggio. The shadowy light of this imagined scene afforded Caravaggio an opportunity to exploit *chiaroscuro* techniques; using these the old man's profile has been most realistically represented. The stretching position of his arms adds enormous vitality and tension to his pose.

Right Detail of *The Topers*, Diego Velasquez. These cheery, drunken faces were painted from live models, probably people from the streets of Madrid, where Velasquez was working as court painter to Philip IV of Spain. Their expressions are utterly believable; apart from the style of dress, the men could easily be imagined on any city street today.

epitomize the Baroque tendency in painting, of which he is the most important northern exponent, and the sober vision of Velasquez emerges through the confrontation with a single figure and as such occupies a central position in the development of Western portraiture.

The influence of Caravaggio on Velasquez is apparent in many ways. His early work reveals a spontaneous naturalism, and he underplayed any overt expression in an attempt to convey the effect of light on tactile surfaces, using *chiaroscuro*. In the picture known as *The Topers* (c 1629), the mythological figures form a theatrical tableau and occupy the bulk of the pictorial space. Landscape exists as a backdrop to the human activity, but the lighting evokes an interior rather than exterior space. Although the three figures at the left of the picture could have emerged from one of many timeless evocations of this subject, the group at the right have a more earthy realism that may have been the result of painting from live models. They reveal a confrontation with the artist or viewer, and probably represent quite

accurate, informal portraits, although their identities are unknown.

A tension exists between the specific description of an individual model and the character that the model depicts. In other words, the figures in *The Topers* owe their credibility not to the fact that they are taking part in some mythological story or pagan rite but to the degree in which they are acting out their roles in a dramatic reconstruction. The figures are believable because they were probably posed in a studio and their individual characteristics acknowledged rather than underplayed.

Considering the ability with which Velasquez was able to characterize groups of figures, it is not surprising that when he was confronted by just one, he was able to convey a great intensity. As Velasquez matured, his technique became more sophisticated and the economic handling of paint enabled him to convey a solidity of form with atmospheric depth. Unlike Rubens, he had no need to display his virtuosity as a painter; instead, his disciplined vision evolved through an increasing subtlety. This is evident in the

remarkable portrait of Pope Innocent X. Previous pontiffs had been immortalized but Velasquez's work is different because it portrays the man inside the public image. Similarly, his portraits of Philip IV reveal an unsure man cloaked in the trappings of power, the grandeur of which belies a sense of innocence and vulnerability. By contrast, the portrait of Don Diego de Acedo, who was known as "El Primo," is presented with the attributes of administrative status. Although the physical burden accentuates the subject's tiny body, the facial expression reveals a thoughtful man whose burden is in fact the society that finds his disability a source of amusement. Portraits by Velasquez do not celebrate human imperfection; instead they acknowledge human individuality with compassion and understanding, and as such can be ranked among the highest achievements in European portraiture.

The culmination of Velasquez' work is a large group portrait entitled *Las Meninas (The Maids of Honor)*. The almost effortless depiction of reality evident in the compact compositional structure gives way to a para-

doxical interpretation that questions the fundamental nature of illusion. The self-portrait at the left of the picture implies that the picture could have been the view seen by Velasquez himself in a large mirror. If this logic is continued, then it could also be assumed that the reflection of the royal couple in a mirror behind Velasquez would imply their real position in front of and facing the main group of figures. If this were the case, the royal couple would also be visible with their backs reflected into the mirror that Velasquez would have used in order to paint the group in such a way. To further complicate any logical interpretation, he painted himself working on a large support that could be understood as the back of the completed painting in question. The visual paradox involved in this picture defies any rational explanation but it suggests a concern by the painter to stress the difference between the structure of a painting as a separate entity, and the deception caused by an acceptance of what purports to be real.

The careers of Velasquez and Rembrandt are interestingly contrasted. Both painters emerged from the influence of Caravaggio, and both display a constant preoccupation with portraiture, and yet the secluded, ordered world of the Spanish court could not be further removed from the conflicting political and religious concerns evident in the small Dutch nation. The Dutch won their independence from Spain by a 40-year truce in 1609 and then produced some of the most influential painters that Western culture has known. Unlike the aristocratic monarchies of England, France and Spain, social status was measured by acquired wealth and not hereditary circumstances. The art reflected the taste of the Protestant middle class and found fruition in the depiction of day-to-day life. Contemporary records substantiate the fact that pictures were bought by people from different social levels, and although there was little patronage for religious works, the domestic interior, the still life and the figure became the secular vehicles for both moral and religious concerns. The sumptuous still life paintings of Willem Heda (1593/4-1680/2) make reference to the vanity of earthly gratifications, Rembrandt's biblical themes emerge in domestic settings, and the pristine interiors of Vermeer (1632-75) reveal ideas that transcend the apparent concern with domesticity.

In Utrecht, the widespread interest in the work of Caravaggio emerged through the paintings of Hendrick Terbrugghen (1588-1629). One of his favorite images was the single figure *genre* subject that usually took the form of a solitary musician or singer isolated against a simple background. Even in his religious compositions Terbrugghen depicted the biblical personages with a down-to-earth realism, often stressing the irregularity of their features and making no concessions to the many idealized images of the past.

In Haarlem, Frans Hals (1581/5-1666) became the chief exponent of portraiture. The popularity of his paintings is partly due to the depiction of optimism and gaiety. The early paintings, particularly, convey with vitality expressions of laughter and happiness, and although they were often contained within a traditional format there is a liveliness that is seldom equalled by his contemporaries. As his reputation grew, he was able to secure important commissions that provided a rare opportunity in seventeenth-century Holland to paint large works for public display. They included six life-size portraits of militia groups, three group portraits of Regents, and four family groups. The two group portraits painted two years before his death are generally considered his most powerful works. They depict the male and female Regents of the Old Men's Home, and the economic paint handling combines solidity with strikingly individual portraits. Each head forms a focal point within the group and yet both paintings are unified by compositional strength and a simple tonal structure.

Left *Regents of the Old Men's Home,* Frans Hals. Painted only two years before his death, this group portrait of the female regents is typical of Hals' later style. The composition is simple but strong, and the monochromatic tones do not detract from the interest of the picture. Each face portrays great character; despite their individuality, however, the women seem united and contented in their shared vocation.
Right *Hendrijke Stoffels,* Rembrandt van Rijn. This portrait is of Rembrandt's devoted mistress who lived with him until she died in 1663. Her expression seems full of tenderness; similarly her image is painted with an unmistakable depth of feeling. The portrait is imbued with harmony, not only in the emotions portrayed but in the simplicity of composition, the relaxed and contented pose and the soft lighting which enhances the texture of her jacket and the gentleness of her face.

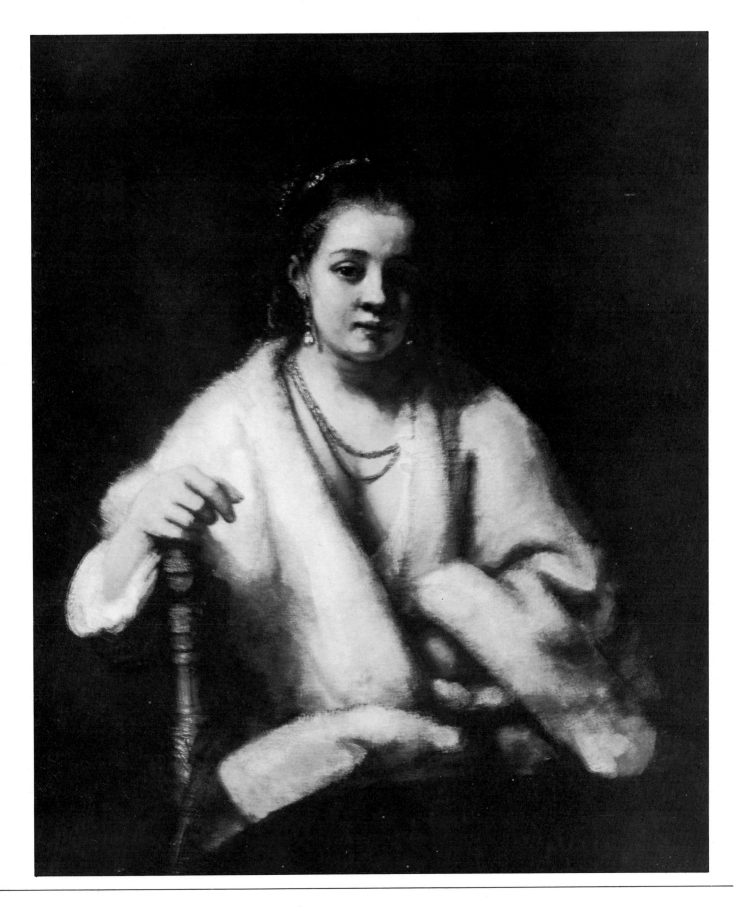

Although Hals was employed as a portrait painter for most of his life, other painterly styles became more fashionable during the seventeenth century. Rembrandt van Rijn is the name that remains synonymous with the golden age of Dutch painting. In terms of insight into human experience, Rembrandt has been universally acclaimed and seldom surpassed. However, there was always a conflict in his mind between the need to produce commissioned portraits and the desire to paint for personal reasons. Eventually the private obsession dominated, but earlier in his career he was able to satisfy the demands of his patrons with prodigious and innovative results.

Rembrandt's qualities as a portrait painter were apparent from the beginning of his career, and his early explorations in self-portraiture reveal a man whose original vision would not be suppressed by the outmoded conventions of many of his contemporaries. The beginning of his success unfolds with the innovative handling of *The Anatomy Lesson of Dr. Tulp*. The picture, compared with previous attempts at the same subject, is quite revolutionary in concept and was received enthusiastically. In seventeenth-century Holland the dissection of a corpse for anatomical study was a common event, and the popularity of such displays often resulted in the admission of the public with audiences of up to 300 people. The problem of combining a group of figures in such a way that each was recognizable yet contributed to a common activity, had resulted in artificial groupings in previous Dutch attempts. However, Rembrandt chose to depict a private group in which Dr. Tulp is performing surgery for the benefit of a group of students in natural poses, positioned so that, despite a similarity of dress, there is variety in posture. The simple white ruffs worn by the men become a strong compositional element and not just an excuse for repetition. The figure straining forward to see the corpse is an innovative introduction, providing a sense of animation that contrasts with the solidity of the surrounding figures.

Rembrandt made use of a similar device 30 years later in *The Board of the Clothmakers' Guild*, a group portrait of five corporation officials engaged in examining accounts. Once again the severity of the design is relieved by one of the figures who appears to be midway between sitting and standing. With the help of photography, the twentieth century is familiar with figures caught or frozen while moving, but in the seventeenth century, this novel approach ensured Rembrandt's reputation for originality. In both instances Rembrandt was able to comply with his clients' wishes while at the same time pursuing his own interests and inclinations. His own knowledge, and an awareness of Italian art, contributed considerably to the development of a personal vision that was considered unique even by his contemporaries.

As Rembrandt gained more independence as a painter, his attitude to his work changed and the youthful exuberance gave way to introspection, brought about by the tragedy of his wife's death a year after giving birth to their only surviving son. As van Dyck's paintings became more fashionable with the

Right *Girl with a Pearl Earring*, Jan Vermeer. It seems extraordinary that even toward the end of the last century Vermeer's pictures were hardly known; this portrait was bought in the early 1880s at a sale in The Hague for the sum of five shillings. It is a touching work and takes a closer view of its subject than Vermeer's *genre* pictures, which usually show the women involved in some kind of occupation, for example reading, needlework, carrying water or playing the virginal. This portrait is unusual because the girl is placed ambiguously against a darkened background, and has no specific pursuit. The only reference to her time is her clothing. However, although unnamed, the portrait was without doubt painted using a live model. Vermeer succeeded in capturing in solid form the mood of a moment.

Left *Susanna Lunden,* Sir Peter Paul Rubens. In opposition to his contemporary Nicolas Poussin, who believed in the absolute importance of design in painting, Rubens advocated the vitality of color, and his attitude is evident in this portrait. Susanna, later to become Rubens' sister-in-law, is depicted in splendid, sensuous reds and greens. The materials of her dress are as rich in texture as they are warm in tone. The luxurious plumage of her hat is matched by the heavy billowing clouds behind her. The focal point of the painting is her full bosom. Rubens has painted the flesh tones in layers of overlaid color, and the white highlights are almost opaque, The pinks and reds are offset by their complementary greens and the whole effect is lightened by the indigo blue sky. **Above** Rubens' techniques are visible in this detail of Susanna's right eye. The streaked grayish underpainting gives depth to the shadows under thin glazes, while pink and white paint highlights the forms of her nose and eye.

wealthy art circles in Amsterdam, Rembrandt's work became less popular. He abandoned many of his social contracts, consequently got into debt and turned inward in an attempt to alleviate his misery. Props were discarded in favor of simplicity. The single figure shrouded in darkness became the vehicle for his interest, and light, not on the face but within it, the central unifying force.

A pupil of Rembrandt and probably the teacher of Vermeer, Carel Fabritius (1622-54) encompasses the *chiaroscuro* of the former with a foretaste of the high-key palette of the latter in his work. With few exceptions, Rembrandt's pictures involve an illuminated figure set against a dark background; in Vermeer's pictures, the reverse is true with the exception of early work and one or two tiny portrait heads. Most of his figures occupy a defined space and are positioned against a brilliantly illuminated wall surface. In his self-portrait, the bold *chiaroscuro* of Rembrandt is combined with a background wall surface that is light in tone.

Vermeer's work is full of paradox. Although he is not considered a portrait painter in the accepted sense, his images of women in domestic interiors have a credibility that suggests the artist made studies of particular individuals. The fact that Vermeer often favored the use of profile is also surprising considering his apparent interest in optics and the degree to which the profile is usually associated with artifice. Perhaps the most disconcerting aspects of his output are the apparent lack of transition from early to later work, and his immaculate painting technique and smooth surfaces that accentuate the implied emotional distance between subject and artist or spectator. In many cases he emphasized the gap with furniture, curtains or an empty space in the foreground.

Vermeer's most famous single figure portrait is the *Girl with a Pearl Earring*, whose enigmatic presence has been compared with that of the *Mona Lisa*. The beautiful quality of understatement found in the simple oval head is echoed by the shape of the earring. As may be noticed in the almost imperceptible tonal transition from the nose to the light side of the cheek, Vermeer disregards the more generally accepted ways of describing volume. Similar examples of this technique occur throughout his work and suggest an awareness of the way in which the optical anomalies found in nature differ from the painterly devices used to imply solidity. Since the early Renaissance the solidity of a head had usually been described by a single light that emphasized volume in a pronounced way. If the girl's head in Vermeer's portrait had been lit from the right-hand side, the nose would have cast a shadow on the portion of the face furthest from the spectator, and the volume of the head would

have been evident in the conventional way. Vermeer, however, seems deliberately to have shunned such practice and yet achieves a sense of volume in an infinitely more subtle way. The way the girl is caught in the movement of glancing over her shoulder becomes timeless in his hands.

The political decline of the Italian states and the rising nationalism of both Protestant and Catholic countries in the seventeenth century resulted in Holland, Spain and Flanders nurturing artistic proficiency in a way that had previously only been encouraged within the religious orbit of the papacy. The careers of two artists of differing temperaments can be seen to represent the opposite poles of artistic concern at this time. The respective contributions of Sir Peter Paul Rubens and Nicolas Poussin (1593/4-1665) provided the springboard for a conflict that has occurred in varying guises ever since. Poussin is remembered essentially for his depictions of classical and mythological subjects rendered with an obsessive emphasis on geometric structure and organization. Although he did paint portraits, and had a considerable influence on Western painting, he was more concerned to represent idealized

human images. Philosophically his attitude represented the antithesis of Rubens' turbulent world.

With the election to the Academy of Rubens' biographer, the course of French painting in the eighteenth century was decided. Although classical subjects were preserved, they were deprived of their intellectual rigor and a frivolity and self-indulgence in paintings of the human form emerged. Francois Boucher (1703-70) was one of the chief exponents of female nude painting, the object of which can only be regarded as lascivious, and with the exception of a few striking pictures his *oeuvre* is characterized by a lack of regard for individuality, and a concern for the trivial. Jean-Baptiste Chardin (1699-1779) stands apart from the prevailing concerns of this style and has more in common with the example set in Holland during the previous century. His figures are generally incorporated into domestic interiors and with few exceptions they are depicted as though unaware of the artist's presence.

Except for isolated examples, painting in the eighteenth century cannot compete with the contemporary literary and musical achievements, and the course of French

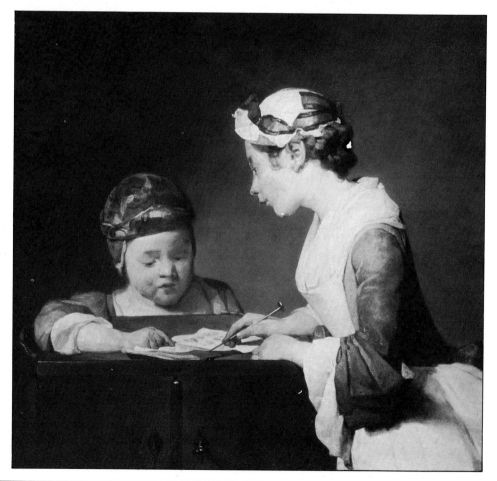

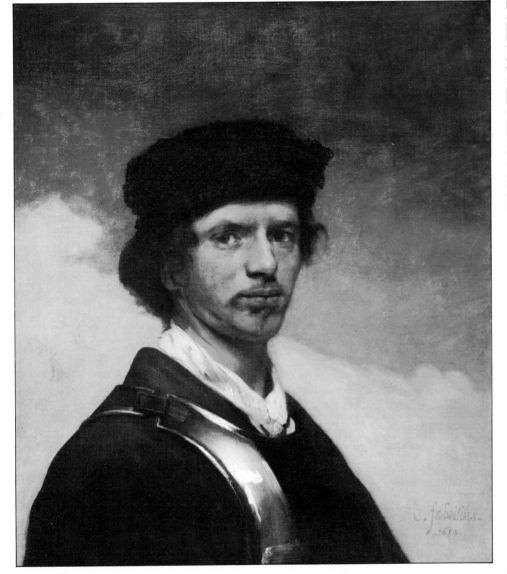

Far left *The Young Schoolmistress*, Jean-Baptiste Siméon Chardin. Running parallel to the fashionable Rococo style in eighteenth-century France was a simple naturalism similar to the Dutch *genre* pictures painted the century before. This picture is an example of Chardin's direct portrayal of everyday life.
Left *Self-portrait*, Carel Fabritius. It is probable that this is a portrait of the artist himself. Fabritius was a pupil of Rembrandt, and learned to use limited colors combined with subtle tonal contrasts for effective results.

Rococo eras were tempered by a return to sobriety in the form of neo-Classicism, no other single artist could compare with Goya. Like so many painters, he defies categorization. Despite his early sojourn into fashionable frivolity, his portraits of the Spanish royal family display an intense realism. In other later portraits, it is obvious that he had studied the effects of poses and expressions, and his strong individual vision revealed itself in a confident use of contrasting lights. He emerges as a painter who with prophetic insight anticipated the trauma of events of which the rest of Europe seemed unaware.

The storming of the Bastille in 1789 heralded a new era. Paris emerged as the center of a political and artistic revolution of international significance. The Revolution and Napoleon's rise to supreme power was celebrated by Jacques Louis David (1748-1825) whose passionate political involvement resulted in a series of paintings praising both classical and Republican virtues. The enormous *Coronation of Napoleon* involves over 100 portraits and demonstrates the degree to which David's fanaticism was apparent. A more modest yet probably more memorable piece of propaganda is evident in *The Death of Marat*, a powerful portrait of one of the Revolution's martyrs, depicted with the dramatic intensity usually reserved for religious personages. Baroque elegance is replaced by an uncompromising severity that epitomizes the neo-Classical concern with drawing. Marat's bath has been rightly compared to a tomb, and the use of a large empty space above the figure accentuates its stark simplicity.

painting in particular could not be further removed from the era of Rationalism which it parallels. Portraits continued to be painted although in most cases as a document of social standing. In England, however, portraiture emerged independently and, for the first time, did not rely on foreign influence. The achievements of Holbein, Lely (1618-80) and van Dyck (1599-1614) had previously been considered awesome, but by the eighteenth century the English could boast of native talent in the work of Sir Joshua Reynolds (1723-92), William Hogarth (1697-1764) and Thomas Gainsborough (1727-88). The contributions of these three were very individual. Reynolds was influenced by the high ideals of the Renaissance and ignored Dutch realism, as he was convinced that art should be respected as a form of ethical education. Hogarth, on the other hand, was determined

to expose the hypocrisy and immorality of society and concentrated on the portrayal of affectation and abuse in satirical pictures. The incisive and spontaneous qualities of his work are obvious in his sympathetic sketch, *A Shrimp Girl*. Gainsborough's portraits are painted in a distinctive, elegant style that reflects the preoccupations of the gentry and aristocracy in the eighteenth century.

Bartolomé Murillo (1617-82) lived in seventeenth-century Seville. Apart from his many fine religious and allegorical paintings, his portraits of children stand out with an unusual freshness. His pictures of street urchins are notably vivid, and he could be considered to have invented child portraiture. However, probably the most significant personality to emerge in Spain was Francisco de Lucientes Goya (1746-1828). Although in France the excesses of the Baroque and

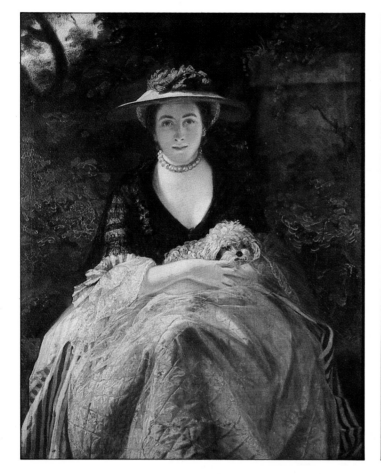

The disciplined vision of David inspired many imitators in the classical tradition. The apex of this pictorial ideology also provided the basis of a rebellion against the vigorous classical principles and became the Romantic movement. Although, paradoxically, both attitudes shared a dissatisfaction with government and culture, they provided the focal points of almost irreconcilable tendencies in painting. Prior to its effect on French painting, Romanticism had emerged in a literary form in England and Germany, and invariably conjured up a mood of fanciful escapism suggested by desolate ruins, murky forests and atmospheric landscapes. Although painters of both persuasions evolved a pictorial language that was specifically representational, the underlying concerns were quite different philosophically. Jean Auguste Dominique Ingres proved to be David's most original pupil and is generally accepted to be an important exponent of classical ideas, while his rival Eugène Delacroix (1798-1863) provided a formidable argument in favor of Romanticism. From a technical point of view the classical preference for linear structure opposes the more overtly emotional and expressive use of color in Romantic painting. However, this generaliza-

Above left *Nelly O'Brien*, Sir Joshua Reynolds. The first President of the Royal Academy, Reynolds was the most important and influential British artist of his day. Having travelled through Europe and studied the works of Italian Renaissance artists, he returned to London determined to educate young artists in the classical ideal, urging them to study the works of Michelangelo and Raphael. Portraiture, he held, should be considered in the grand manner, because the beauty of art consists in rising above "singular forms, local customs, particularities, and details of every kind." In consequence some portraits by Reynolds take on a rigidity of form and a detachment which belie his sensitivity. By contrast, this portrait, painted in 1763, indicates a vital interest in the individual and an acute response to the subject. The mood is comfortable and displays an intimacy between artist and subject. Nelly O'Brien is seated in a richly colored woodland scene; the paints

have been used to render dappled light and the textures of the clothing with great subtlety. Her blue eyes confront the spectator with a gentle honesty.

Above right *The Shrimp Girl*, William Hogarth. The individuality and precision of Hogarth's art lies in his acute awareness of the injustice and immorality buried within society. To bring these absurdities to the public eye, he satirized anecdotes in sequences of pictures both painted and engraved; famous examples are *A Rake's Progress* and *Marriage à la Mode*. When painting portraits he proved incapable of affectation and flattery, but was confident and displayed enormous common sense. *The Shrimp Girl* is a delightfully lively portrait, although a simple sketch. The colors are thin and the brushstrokes brief, except for the face which is illuminated in flushed pinks and highlights. Her expression could not be described as sophisticated; she illustrates the innocence

and courage of a girl likely to take advantage of whatever life offers.

Right *Monsieur Bertin*, Jean Auguste Dominique Ingres. The portrait is positioned within the shape of the canvas so that the picture is weighted in the lower half; this, combined with the precise delineation of the shape of the body, illustrates Ingres' concern with composition and the way it influences the mood of a portrait. The almost sculptured solidity of the figure is emphasized by the triangular surface structure combined with the somber colors, the graying hair and dark clothing. It is all painted in minute detail and with great realism. Bertin's hands are fleshy but firm; these and his face are the lightest and therefore most immediately noticed elements of the painting. The hands, however, are not relaxed but are flexed, as if he is almost resting his weight, but is in reality on the verge of moving. This aspect, combined with the

expression of his face which is kind in its severity and seems about to betray some emotion, gives a strong impression of impending movement. This creates a tension with the superficial sturdiness of the picture.

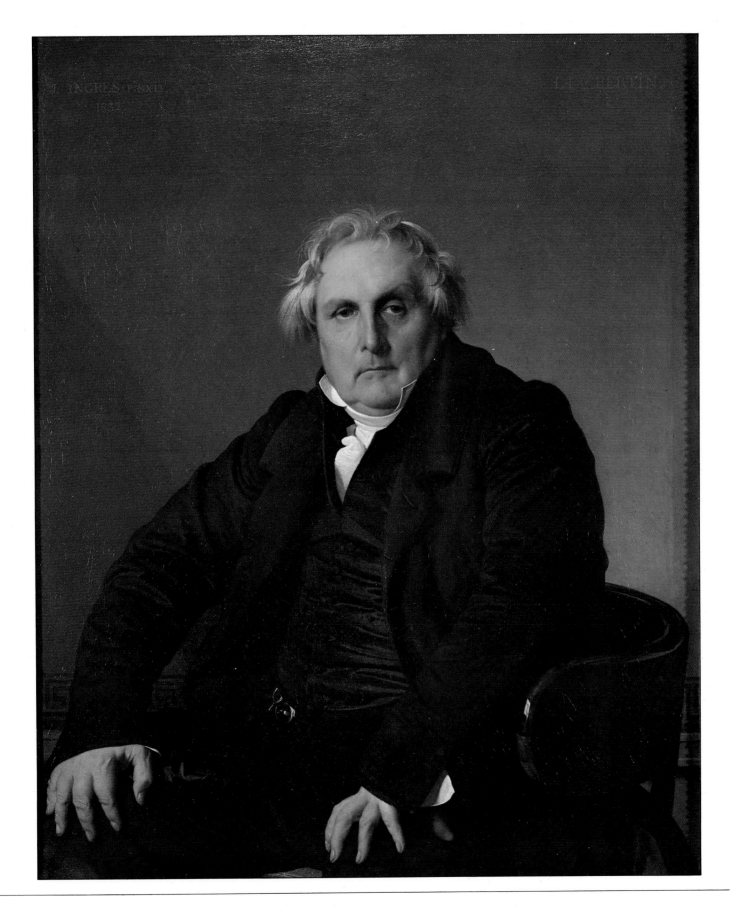

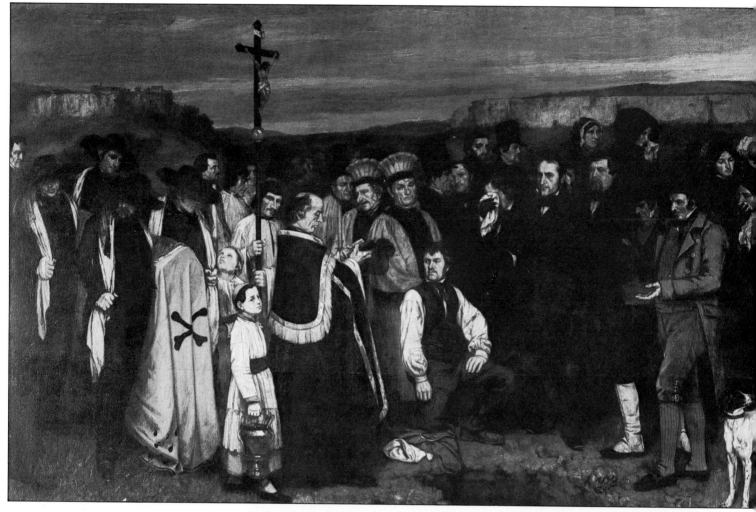

Above *The Burial at Ornans,* Gustave Courbet. The artist was 31 when this picture was exhibitied at the Paris Salon of 1850, attracting both the attention and the dismay of onlookers. The life-size display of the ordinary existence of ordinary people shocked the Romanticists and Classicists alike, because Courbet had removed the veils of illusion. Courbet said: "Painting is an art of sight and should therefore concern itself with things seen." The group portrait, including members of his family and some of his friends, is vividly drawn, with every character involved in some action. The gaping grave in the foreground unites the opposing groups of the churchmen and the mourners in an awareness of a common fate.

Right Detail of *The Bellelli Family,* Edgar Degas. In this portrait of Degas' aunt and her family, the artist has created a compositional structure that reveals the tensions known to exist within the family. Degas could not have failed to notice the problems during his nine-month stay with them in 1858 and 1859. The gloomy and impatient Baron is painted in shadow and slightly out of focus. His unusual positon with his back to the spectator is contrasted with his wife's sorrowful but upright stance. The sympathetic lighting bathing the daughters and the mother creates a unity between them which conflicts with the hunched and darkened form of the father. An emotional complexity is thus defined within the rectangle of the canvas.

tion cannot accommodate the anomalies that occur in the work of individual exponents.

The Romantic generation responded to the banality of everyday existence by travelling abroad, and much of the material used by Delacroix was the result of his exotic journey to Morocco in 1832. The complex allegorical and historical subjects of his paintings provided a form of political escapism and were intended to be, in his own words, "a feast for the eyes." His portraits included some intimate and revealing studies of friends, for example Chopin (1838), but his more expressive and exuberant nature enabled him to excel in large and complex compositions.

By comparison, Ingres provided an intellectual journey back through time in an attempt to recreate a view of antiquity through nineteenth-century eyes. The slow research and obsessive consideration for preparatory study hindered Ingres in his ambition to be a great history painter, and although he considered portraiture to be a less worthy occupation it proved to be his greatest

achievement. It could be argued that his portraits present the last significant examples of traditional Western portraits that acknowledge a social order behind the subject, but, at the same time, their fascination lies in the diversity of individual appearance trapped within a relatively orthodox format. Despite the fact that Ingres had neither the imagination nor the pictorial invention of Delacroix, his paintings present an authority which was the product of acute observation and an ability to transform his perception into something timeless. His male subjects confront the viewer with a relaxed confidence and aloofness, and occasionally, as in the portrait of Monsieur Bertin (1832), with a formidable presence that is accentuated by the imposing sculptural posture. By comparison, his female subjects, Madame de Senonnes for example, emerge as the embodiment of the decaying age of indolence.

Unlike many painters who in later life evolved a more spontaneous technique, Ingres obstinately persisted with his original style in spite of the radical developments being made around him. Few portrait painters since have immortalized their patrons with such skill and uncompromising clarity. However, the re-evaluation of the artist's position within an established order resulted in an increasing gulf between those who paint portraits on a commissioned basis and those who paint portraits for personal reasons. Gustave Courbet emerged at the forefront of the Realist movement in painting, intent on using the language of painting as a truthful reflection of contemporary life. Not only did he challenge the established extremes of Classicism and Romanticism, but he questioned the role of the artist in society to such a degree that the repercussions are still apparent.

By elevating an everyday occurrence to the level of importance usually reserved for a religious or historical subject, Courbet opened the way for an attitude that was to be reflected in literary as well as visual achievements. In *The Burial at Ornans*, exhibited in 1850, he presents a life-size description of the mourners at a funeral, all linked by the thought of a common fate regardless of their station in life. The figures are portraits of Courbet's friends and family standing in rows at the graveside. The impact of such a picture was unforgettable, and its apparent banality and lack of conventional drama confused many critics who considered it to be an outrageous joke, an irreverent evocation of a solemn event. The political implications of Courbet's visual democracy did not go unnoticed and became the object of ridicule.

Since Courbet, many artists have adopted the role of an outsider in society and have produced work regardless of the endorsement

or acknowledgement of that society. Consequently the portrait has become less evident in its traditional role, and as the mainstream of painting has veered further away from the established views, so the portrait has emerged as an informal depiction of an individual rather than a public display of status.

The advent of photography was another reason for the decline of traditional portraiture. Initially photographers sought to imitate the conventions of Western painting, and it was assumed that the new invention would make painting obsolete by providing a more immediate means of fixing human appearance. The experiments of Nicéphore Niépce (1765-1833) and Louis Daguerre (1789-1851) were successful, but although the French were quick to realize the potential of photography, other nations remained sceptical. An account from the *Leipzig City Advertiser* reveals how threatening the invention appeared to people in the nineteenth century: "To try to catch transient reflected images is not merely something that is impossible, but as thorough German investigation has shown, the very desire to do so is blasphemy. Man is created in the image of God, and God's image cannot be captured by an human machine. Only the divine artist, divinely inspired, may call on his genius to dare to reproduce the divine human features, but never by means of a mechanical aid."

Such wishful thinking may have reassured the flagging spirits of aspiring portrait painters, but some serious nineteenth-century artists, including Ingres, Delacroix and Courbet, were quick to exploit photography as an aid. A more significant awareness of its use, however, is to be found in the work of Edouard Manet (1832-83) and Edgar Degas (1834-1917). Although firmly rooted in their essentially conservative, bourgeois backgrounds and unimpressed by Courbet's socialist views, Manet and Degas were nevertheless affected by his visual authority and the unprecedented realism of his approach.

Normally associated with the Impressionist revolution of the mid-nineteenth century, Manet and Degas are in fact only tenuously linked by a rejection of the prevailing academicism. Ironically, Manet wanted public acceptance, yet his choice of subject provoked bitter criticism especially through his depiction of the nude figure. The frank realism of the painting entitled *Olympia* (1863) proved too much for contemporary morality, and although its historical precedent existed in the work of Titian and Giorgione, its blatant reliance on the depiction of a nude woman devoid of allegorical or classical attributes resulted in hostility. The fact that the woman acknowledges the presence of a spectator implied that its intention was provocative and

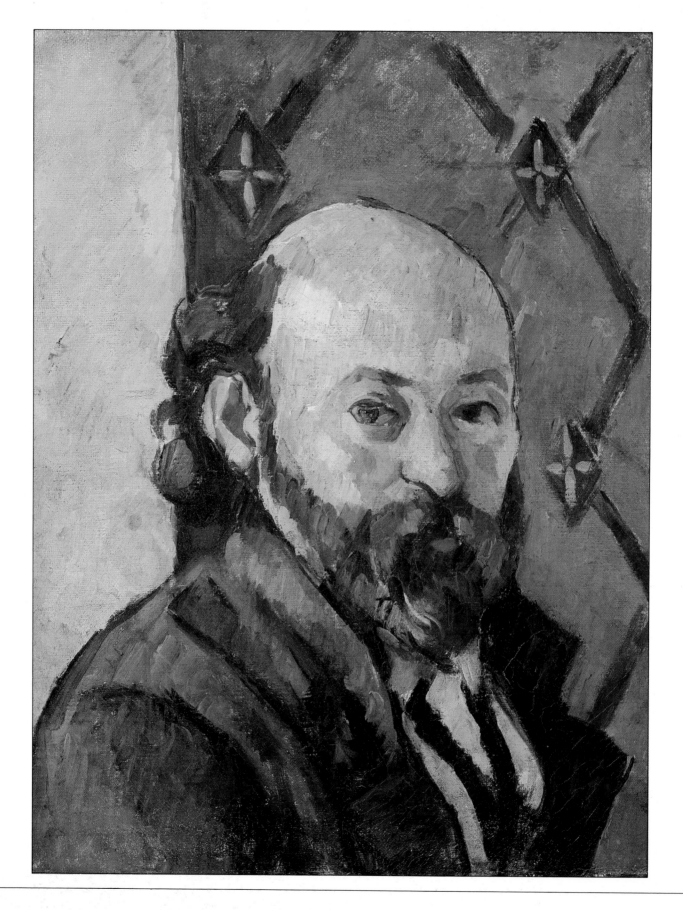

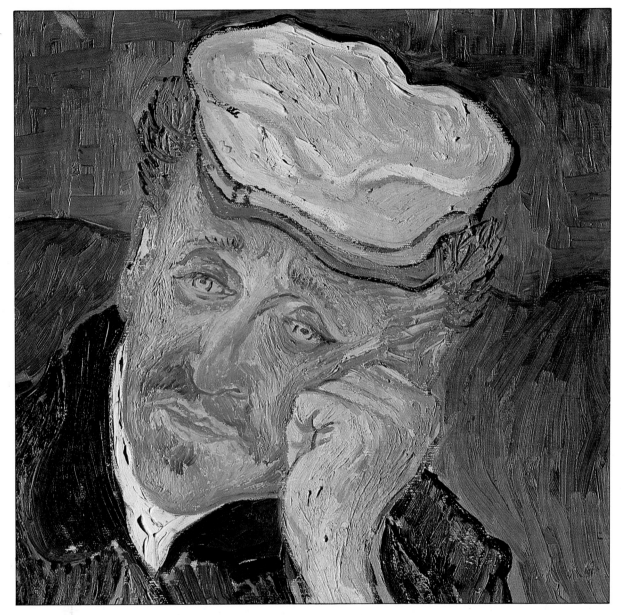

Left *Self-Portrait,* Paul Cézanne. From the artist's appearance, this self-portrait is thought to have been painted in about 1880, by which time he had developed an individual set of color theories and painting techniques. Cézanne carefully considered and monitored the layers of overlaid color and small, obvious brushstrokes used for large-scale hatching. Simultaneously, he calculated the juxtaposition of certain hues and tones above, below or beside others for precise effects. Here, reds, yellows, blues, greens, creams and grays are worked into the face, with the final effect of lights and shadows creating a dark and withdrawn portrait.

Right Detail of *Dr. Gachet,* Vincent van Gogh. The artist has exploited the descriptive character of his brushstrokes to emphasize the forms of the face, including the nose, cheekbones and eyebrows. The marks of the bristle brush are often apparent in the thick paint and give an actual raised texture to the painting. The lively techniques and van Gogh's particular vision combine to create this intelligent, bright-eyed portrait.

therefore challenged the normally accepted canons of pictorial decency.

Degas may be considered the most complex personality of the later part of the nineteenth century, and his connection with the Impressionists is paradoxical. Whereas Courbet openly rejected both Classicism and Romanticism and forged his own path through Realism, Degas attempted to reconcile these tendencies in his own work and always maintained strong respect for his predecessors, unlike many of his contemporaries. Also, during the middle of the nineteenth century there was a rediscovery of seventeenth-century painters and in particular the Dutch *genre* masters. The re-evaluation certainly affected Degas' progress. His involvement with photography and the influence of the

simple beauty of imported Japanese art combined to arm him with sufficient material to shape his own pictorial language. Degas portrayed people as though they were about to move or were in the process of some activity, and consequently revolutionized the concept of portraiture and brought it in step with other contemporary achievements.

Degas' portraits are essentially informal and intimate, and another aspect of his paradoxical nature emerges in his treatment of *genre* subjects. *The Absinthe Drinker* (c 1876) presents what appears to be a slice of contemporary life. However, the depiction of something that was apparently casual became a problem of theatrical deceit, because Degas manufactured a situation by employing professional models or friends to adopt the

roles required. As with *The Topers* by Velasquez, the painting purports to be something it is not; posing as a drinking scene, it is presented through the informal portraits of Marcellin Desboutin and Ellen André.

Degas' deliberate portraits were painted with striking originality. An example of this style is the portrait of Viscomte Ludovic Lepic and his daughters, known as *Place de la Concorde*. The apparently normal street scene does not offer any clues or reasons to explain its use as a setting for the portraits. Combined with this unusual aspect of the painting is the fact that Degas abhorred outdoor painting which he compared to fishing. When so many of his contemporaries advocated painting directly in front of the landscape, Degas pursued his experiments indoors regardless of

Right *Thomas Stearns Eliot,* Patrick Heron (b 1920). The preoccupations of the artist emerge as strongly as those of the famous poet and playwright in this portrait, which was painted in 1949. Using bold juxtaposition of warm and cool colors and of patterns, so exploiting the surface structure, the artist presents a double-angled view of Eliot. The slate-blue and green area of the face simultaneously forms a shadowed area of the frontal view and a strong profile. The result connects like a jigsaw, implying a disjointedness which is a reflection on the detachment of the poet's vision.

Far right *Gertrude Stein,* Pablo Picasso. This portrait of a renowned connoisseur of art and Picasso's early patron was painted when the artist was 25. It reveals a familiarity with the translation of volume into two dimensions, as evidenced by the economy and confidence of the strokes and the simplification of form, for example, the ear. The subject is portrayed in a relaxed pose with the weight of her body settled in the chair and the hands resting, but her intelligent dark eyes shine in a lively face. Despite her stillness, she seems totally aware of everything around her.

the innovations being made in the depiction of changing light and atmosphere.

Reality is implied in the subtlety of his compositional structure. Although an initial glimpse of *Place de la Concorde* suggests movement, the sense of animation is in fact conveyed by the repetition of similar poses and the tension this causes. The figure of Ludovic is seen as though he is striding across the picture, and his implied movement is accentuated in the position of a similar male figure at the left of the picture. The daughters provide implied movement in the opposite direction by the slight difference in their similar positions; they are dressed in the same way and could at first glance appear to depict the same girl as though seen through different frames of an animated film. The technique of the visual echo is a common occurence in Degas' work, and may be seen frequently in the compositions of ballet dancers. In effect, Degas manages to persuade the spectator that he is witnessing a fleeting glimpse of reality, and yet on closer inspection the illusion is the result of a sophisticated organization of space. Degas positioned the main point of interest at the side in many of his pictures and made use of empty spaces in such a way that they are just as important as the figures.

The need for portraiture emerged with the development of realism in the fifteenth century, and its continuation before this century mostly occurred in situations where that need combined with wealth and patronage. In the twentieth century, the existence of traditional portraiture has been overshadowed by radical departures of intention in art, and there has been a general decline of interest in figurative depiction. R.B. Kitaj (b 1932) observed in *The Artist's Eye* (1980): "The period that separates us from 1900, surely one of the most terrible histories of bad faith ever, should somehow conceive and

nourish a life of forms increasingly divorced from the illustration of human life which had been art's main province before."

However, despite the general dissatisfaction with representational art, few major late nineteenth- and early twentieth-century painters have refrained from painting portraits, Vincent van Gogh (1853-90) believed portraiture required serious consideration, and Henri Matisse (1869-1954) and Pablo Picasso (1881-1973), among many others, have used it to express their own visions. It is ironic that Paul Cézanne (1839-1906), whose work was inspired by the natural world of organic forms including the human body, should influence the development of abstract art forms which seem divorced from any kind of external reality. The common aim

of naturalistic representation disappeared with the Impressionists in the late nineteenth century, since which time portraits have been executed in individual and expressionist styles. The critic John Berger has suggested in his essay "No More Portraits" from *Arts in Society* (1977) that the demands of modern vision are no longer compatible with the singularity of viewpoint that is the prerequisite for any static painted likeness. However, despite the theoretical reason for its demise it continues to emerge.

Changes in the structure of society in the last 100 years have emphasized the importance of all individuals, not just the royal, rich and famous. With artists such as Max Beckman (1884-1950), Alberto Giacometti (1901-66), Francis Bacon (b 1910),

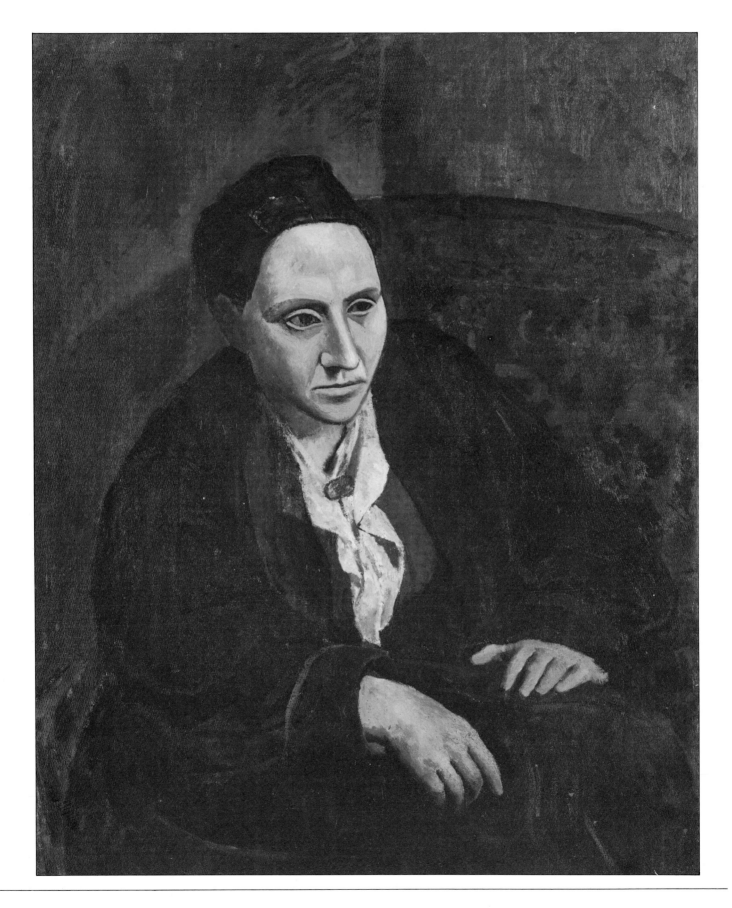

Lucian Freud (b 1922) and David Hockney (b 1937), the portrait as a private interest has developed with little concern for accepted or traditional ideas and has enabled the artists to focus their attention on individuals without the pressure of constraints of the official commission. Ironically, since the 1960s it has become a mark of status to be painted by well-known artists purely because of their reputations.

Although there are now considerably more people painting and drawing than ever before, the portrait continues to be the least common art form among amateurs and professionals alike. However, what is painted is honest, and also expressive of the artist's personality or intentions. Commissioned portraits are often recognizably different in intention; the need to satisfy the client is likely to influence the way the portrait is approached.

A witty comment on the traditional concept of the portrait as a measure of social stature is apparent in a painting by Peter Blake (b 1932) entitled *Self-Portrait with Badges*. The robes of office have been replaced by the contemporary uniform of blue denim and baseball shoes, and a metallic shield of buttons presents a compendium of references to popular culture. During the 1960s a number of artists, usually grouped as Pop artists, reacted against the mainstream development of painting since 1945 by celebrating the transience of contemporary culture. Appropriately, London and New York played prominent roles in its development and, because of its figurative orientation, an ironic return to an earlier conception of portraiture emerged. In contemporary culture the myth surrounding the early death of film stars has been perpetuated by the widespread familiarity of their images through photography. Andy Warhol (1930-87) is unique among contemporary painters in providing a kind of twentieth-century society portrait. Instead of popes or aristocrats, Warhol celebrated the contemporary heroes of stage and screen and became the chief exponent of the posthumous portrait, silkscreened in multiple groupings of repeated images. The banality of the image of Marilyn Monroe, for example, is alleviated by the addition of paint applied in a cosmetic manner, with no attempt to enhance the volume of the head. A swath of color across the mouth doubles as lipstick and also comments on the more liberal use of paint by his American predecessors. The resulting portraits have nothing to do with observing an individual, but instead they rely on the spectator's familiarity with the subject's face or public image. In this respect they compare with the images of Caesar Augustus as seen by the general public during the Roman era and return the history of portraiture to its beginnings two thousand years ago.

Right *Celia in Black Slip and Platform Shoes '73,* David Hockney. With a confident use of line and color, Hockney has portrayed his subject in an informal, reclining pose. She is probably not totally relaxed, and the artist has captured this transience briefly and precisely. It is amusing that under scrutiny the hair looks almost like a child's scribble.
Below *Marilyn,* Andy Warhol. Multiple images have been silk-screened to create this portrait. The simple, abstracted forms for Marilyn's mouth, nose, eyes and hair make no attempt to convey her character; however, when the shapes are mentally combined with the well-known public image of her vulnerable, glamorous beauty, the result is a twentieth-century icon.

Left *Self-Portrait with Badges,* Peter Blake. Painted in 1961, when the artist was 28, the portrait is iconographic with its multitude of references to Blake's life and influences and the 1960s. The collection of buttons in itself reflects Blake's preoccupation with collecting odd bits and pieces, what he called "durable expendables," including bus tickets and food packages, some of which he involved in other pictures of the period. He was an Elvis Presley fan, and the inclusion of the pop star's "photograph" indicates Blake's ability to represent precise likenesses and has the effect of dating the portrait. Blake became a leading figure of the Pop movement; he managed to sum it up in his work and simultaneously provide further inspiration for it.

THE HUMAN FACE

Although there are more than two million species of lifeforms on this planet, there is only one species of human being. Men and women are unique in the animal kingdom for many reasons, not least the ability to reveal a tremendous range of feeling and emotion by slight movements of facial muscle. Even without speech, people can communicate by almost imperceptible movements of the eyes, eyebrows, mouth or cheek.

From early childhood it is understood that certain states of feeling can be described through expressions. A picture of a person smiling or frowning usually involves an emphasis on the shape of the mouth with its upward or downward curve; the use of masks in the circus or theater provides an audience with a similar repertoire of facial conventions. In both children's drawings and masks the shape of the actual features of the face provides clues about expression. Although the portrait painter will not usually be concerned with such obvious extremes, it is useful to understand how the features are affected by what lies beneath the surface.

The structure of the human head is such that any movement of the eyebrows, eyes or mouth is the result of muscles pulling across the face in many directions. A movement of the eyebrows affects the skin of the forehead, and in a similar way, a movement of the mouth affects the skin around the nose and chin, and also pulls the skin tautly across the bone structure of the cheeks. A certain amount of time is required to draw or paint facial expressions, but the very nature of human expression involves constant movement. Few artists have been able to convey pronounced states of facial expression because of the difficulty involved in arresting movement, and consequently many portraits display a less overt expression which is not designed to show any specific emotion but is often interpreted as one of melancholy or seriousness, although this may not have been the artist's intention.

Among the many well-known portraits those by Frans Hals qualify as successful descriptions of facial expressions. Few paint-ers have been able to capture with such apparent effortlessness the elasticity of the animated expression. By comparison, the paintings by Jan Vermeer convey a somber view of reality, but on closer scrutiny also reveal a deep insight into the use of facial expression and an understanding of the almost imperceptible movements that imply life. The mouth, for instance, often looks moist and is usually slightly open as though in the process of drawing breath. The eyes also have a moistness which may sometimes reveal a quizzical expression simultaneously with a calm and reflective one. Within an apparently limited format Vermeer achieves a remarkable degree of subtlety, and any written description of the qualities of his paintings will be inadequate when faced with the work itself. Only the activity of observing and practising, combined with some anatomical knowledge, can provide the artist with the necessary understanding and skill to convey the complexity of human appearance with conviction.

ANATOMICAL FEATURES
The Skull

The skull can be divided into two main areas, consisting of the cranium and the facial bone structure that houses the cavities for the features of the face. The 28 bones which make up the human skull are all firmly connected with one another, with the exception of the mandible or jawbone. The hyoid bone is often described as being part of the skull, but in fact is the only bone in the body which is not attached to another. It is positioned in the upper neck.

At birth the head forms a much greater proportion of the total body length than in adults, and also the cranium occupies a larger proportion of the volume of the head than it does later. The cranium provides protection for the cavity that houses the brain and is comprised of thin curved plates of bone which in the newly born are separated by fibrous tissue at their edges. In the first year of life the bones grow and fuse together to form a rigid protective casing. The frontal bone of the cranium consists of a vertical section which forms the forehead, and a horizontal section which is divided in two and forms the roof of each eye cavity. Across the top of the head the frontal bone meets with the parietal bones, one each side, which in turn meet with the occipital bone at the rear of the skull. On each side of the skull there are two more plates of bone which are called the temporal and sphenoid bones. The two most prominent cavities of the face are the orbital, or eye, cavities. At birth they are proportionately much larger than in an adult, and from their upper border to the lower edge of the jaw is about a half of the total height of the skull. In an adult this measurement is about two-thirds of the total height because, as the teeth develop, the jawbone becomes more pronounced and the face becomes longer to match the cranium. The orbital cavities provide protection for the eyeballs; at their lower edge they are bordered by the zygomatic and maxilla bones which in turn provide the boundaries for the nasal cavity. Below the anterior nasal spine, the two maxillae meet and form the structure which contains the upper teeth.

All the bones in the face and cranium are firmly joined together with the exception of the mandible or jawbone, which is horseshoe-shaped. The jaw is attached to the cranium at a joint just in front of the ear. The ears do not contain bone and they are only evident in the skull as small holes behind the joint of the jaw. Of particular importance to the artist is the nodule of bone just behind and below this opening for the ear. This is called the mastoid process, and from this point the blatant sternocleidomastoid muscle of the neck emerges and runs diagonally down to the clavicle.

The position of the jaw in relation to the rest of the head is determined by the growth of the teeth and therefore also by the loss of teeth. In the mature adult the jaw is prominent and often in the male squarer and slightly larger, although it is dangerous to generalize. The ease with which a person's bone structure is visible is directly related to the age, sex and racial origin of that person.

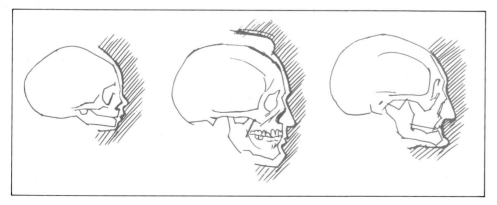

An aging face
An awareness of the bone structure beneath the skin is vital, and it is interesting to notice the changes that take place between infancy and old age. These changes can be generalized and applied to almost any face. Within the first year of life, the bones of the cranium, separate at first, grow and fuse together. In infancy the eye cavities are proportionately larger in the skull than later in life, while the jawbone is undeveloped because there are few teeth. When the teeth grow the jaw becomes more prominent, so lengthening the shape of the whole face. Although adult bones do not usually change shape, the way that they are related or connected may, as cartilage dries and does not restore itself in old age. This causes a "shrinking" effect. In the skull, tooth loss causes the jaw to recede.

1

5

9

2

6

10

3

7

11

4

8

12

A changing face

By tiny muscular movements in the face an enormous range of feelings can be expressed. Most of these movements are made involuntarily, to express emotions which often pass or fade as quickly as they come. Even extreme emotions such as joy, anger or pain, are expressed spontaneously, and it is difficult to fake them, as the pretence is also visible. Despite this, which is a problem for any actor, actress or model, these photographs illustrate with effective realism an interesting range of emotions.

The lefthand column displays a range between laughter and quiet amusement. When laughing, deep creases appear in the skin and the features are elongated, the eyes and mouth being pulled across the face (1). When the head is tilted back, bodily movement is implied while the facial muscles are less taut (2). Progressively more serious, the face loses its lines and the eyes become rounder (3 and 4).

In the center column, the expressions are subtle. An ambiguous lifting of the corner of the mouth could indicate a question but the eyes seem to show cynical amusement (5). The intense stare is due to the model staring into the camera; otherwise it is an unemotional expression (6). Downcast eyes seem to imply doubt or shyness (7) while the sideways angle and unequivocal stare are suspicious (8).

The last column illustrates the emotions of distrust (9), anger (10 and 11) and disgust (12). The angle of the head is important, as is the shape of the eyes, the size of the pupils, the placement of the pupils within the eye and the shape of the mouth. The way the skin is pulled over the cheekbones and creases beside the mouth is a good indicator of extremes of emotion, or of age.

Bones and muscles of the face

These artist's drawings describe how the bones and muscles work together beneath the skin to form the exterior of a face as it is generally recognized. It is interesting to see how the flesh sits over the bones of the cranium, and transforms the macabre aspect of the skull into familiar features (1). The repeated angle of the head and skull illustrates how the shape of the nose and the thickness of the flesh are the main reasons for the actual shape of a face being different from the structure beneath (2 and 3). It can be seen how the muscles affect the way the flesh moves. The frontalis muscle is the main reason for eyebrows moving up and down and creases appearing in the forehead. The mouth is capable of moving sideways as well as up and down, because of the buccinator and the muscles of the orbicularis oris, which includes the levator anguli oris and the depressor anguli oris. The sternocleido-mastoid, which attaches to the mastoid process behind the ear and to the clavicle or collarbone beneath platysma, is a vital link between the head and the body (4,5 and 6).

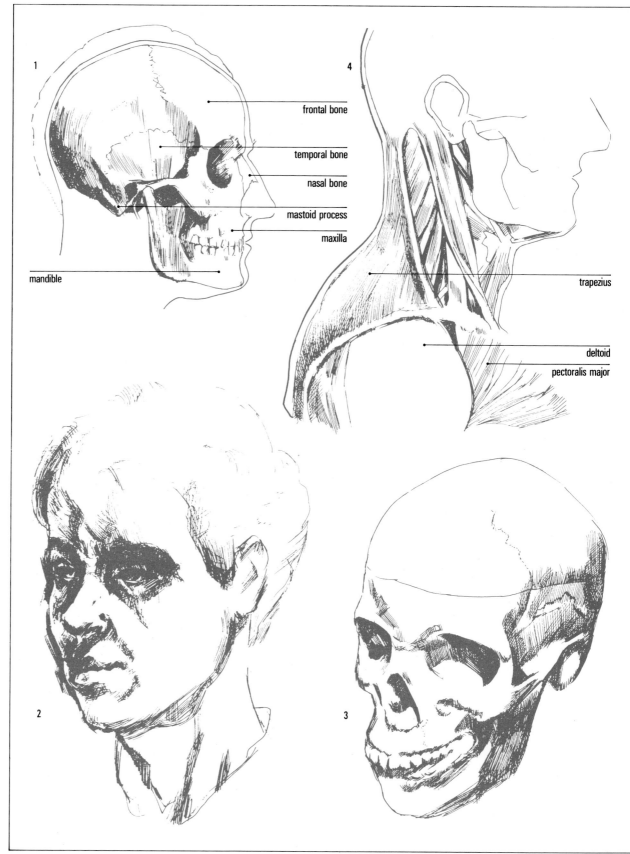

1

frontal bone

temporal bone

nasal bone

mastoid process

maxilla

mandible

4

trapezius

deltoid

pectoralis major

2

3

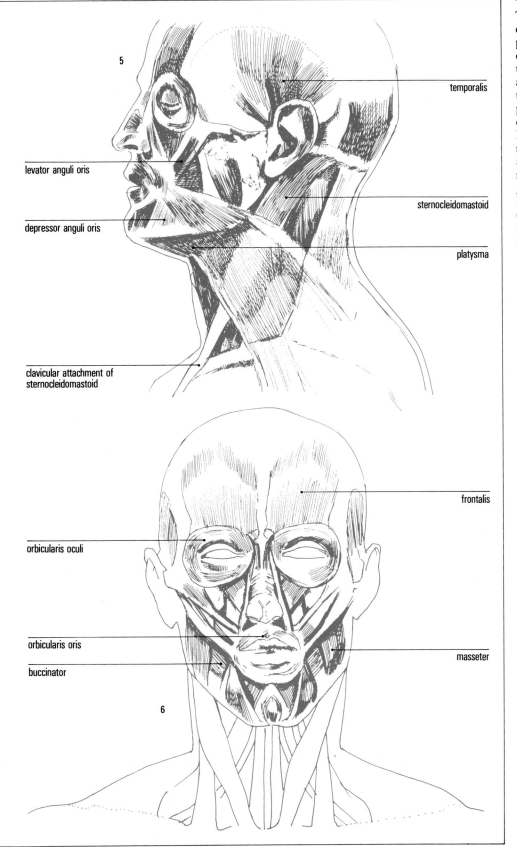

5

temporalis

levator anguli oris

sternocleidomastoid

depressor anguli oris

platysma

clavicular attachment of
sternocleidomastoid

frontalis

orbicularis oculi

orbicularis oris

masseter

buccinator

6

The Muscles

The portraitist is primarily concerned with conveying character through the human physiognomy, and although the skull determines an individual's physical shape, it is the movement of the parts of the face which affects an understanding of individuality and uniqueness. In the nineteenth century, Realist painters attempted to describe the physical characteristics of individuals in great detail. During their student days they followed a standard procedure which involved examining a range of human expressions by copying schematized heads which displayed the exaggerated facial movements inspired by laughter, pain, rage, or anger. The problem concerning the rendering of such feeling is that unlike the muscles of the body, facial muscles are usually only evident when they affect the features, but whenever the features move they do so in relation to certain other parts of the face.

The muscles which are used to create facial expressions are found under the skin of the face, under the scalp and in the front of the neck. They are directly related to the orifices in the skull and therefore center around the mouth, the nasal cavity, the eyes and the external ears. Many muscles are responsible for lip movements: the orbicularis oris muscle which surrounds the mouth consists of a number of muscles entering the upper and lower lips from above and below respectively. Muscles also pass into each lip horizontally, and the buccinator muscle passes from the side of the mouth and into the cheek. All the muscles that affect facial expression are related to, and owe their movement and normal symmetry and control to, the seventh cranial nerve.

The orbicularis oculi muscle surrounds the cavity of each eye and its fibers affect the eyelids and allow the eyes to close gently or tightly. The eyes may also move as a result of the muscles in the scalp stretching the forehead and also as a result of the nose moving. The muscles surrounding the mouth provide the most obvious facial movement; by using a mirror it is apparent that this movement is most evident around the jaw, cheeks and chin, as the skin is pulled taut over the bone.

When the artist is considering the head it is important to think about how the neck is attached and how its movement affects the positioning of the head. The most important muscle of the neck passes from behind the ear to the inner part of the clavicle and is called the sternocleidomastoid muscle. The two muscles, one on each side, together allow the neck and head to bend forward, and independently they allow the head to turn from left to right and the chin to tilt upward. The muscle on the right side turns the head to

the left and vice versa.

When faced with a living model, the artist's knowledge of the skull and muscles will only be of use if it can be given practical application. The human skull is easy to draw in the sense that it can be understood in terms of changes in structural planes and cavities. The head of a living person is less easily understood because of the addition of hair and features as well as the layers in between the skin and the bone. Although it is often tempting to start by drawing the lips or eyes, it is always wise to bear in mind the main structural parts of the cranium and face. By considering the form of the cranium rather than the hair, and the cheekbone and jawbone rather than the features, the artist should be able to compensate for the natural desire to underestimate these in relation to the size of the whole. If each component is considered separately, the result will be disjointed because the relationships are difficult to judge.

The Skin and Hair

One of the most difficult problems confronting the portrait painter involves reconciling the solidity and structure of the head with the softness and elasticity of skin. To assume that the head is sculpted in solid masses is to inherit the danger of the image being statuesque rather than human; however, if the reverse occurs the figure will lack structure. To achieve the balance required is difficult and paradoxical.

In Western painting over the centuries the quality of skin in paintings of both males and females has tended toward generalization. The female skin has almost always been pale and translucent, nearly white in comparison with the male skin. Painters often exaggerated this apparent difference until it became a pictorial convention. Fashions have also tended to accentuate this distinction. The high forehead and plucked eyebrows common in fifteenth- and sixteenth-century portraiture reinforced the idea that the female face is smoother and paler than the swarthy male's. In reality it may be true to say that the female skin is softer than the male, but, more importantly, the color of any fair skin alters due to the effects of temperature and physical well-being. Although this may not be so apparent in darker skins, an inability to recognize changes is the only reason.

Climatic change and exposure to the sun are the most obvious causes of changes in skin color and texture. The accumulative result of many years of exposure to the elements is evident in the dryness of an old person's skin. Lines and wrinkles around the features are more prominent with facial movement, but when they exist in a motionless face they allow the artist to map the structure of the head with a degree of ease.

A common error in attempting to paint the face arises through the assumption that the head stops where the forehead meets the scalp. Even with thin hair the forehead must be seen to move under the mass of hair rather than joining flush with it. Regardless of the angle of view, it is always the case that the shape of the skull dictates the way the hair grows.

Many people have been puzzled about how painters indicate hair, considering the apparent difficulty of describing with line and shape something which is comprised of many thousands of parts. Albrecht Dürer was once asked if he used a special brush made for the sole purpose of rendering hair; it is perhaps quite reasonable for people who are not familiar with painting to assume that the degree of realism often achieved could only

Far left Detail of *Grotesque Heads,* Leonardo da Vinci. These ink studies illustrate Leonardo's preoccupation with form and his masterful descriptive powers. In old faces skin loses its elasticity with the result that creases and wrinkles form; also, if the skin loses its fleshiness the underlying bone structure becomes increasingly visible. Such characteristics of age or personality add to the individuality of any portrait. These particular faces, however, are hideous in their realism, and lead to a supposition that they were fashioned in Leonardo's imagination. Whether this was the case or not, he was obviously aware that the size and angle of the neck, and the relationship of the head to the body, which includes the matching of skin thickness and bone size, are vital to the realism of any portrait.

Left *A Grotesque Old Woman,* probably after Quinten Massys (1465/6-1530). The exaggerated degree of ugliness in this portrait seems unbelievable. The deliberate hideousness of the woman's long, misshapen face is emphasized with cruel irony by the fashionable hat, and implies that the artist found an inherent fascination in the nature of the grotesque. It has been suggested that the picture is not an actual portrait but a piece of social satire, although it is thought by some that the sitter was Margaret, Duchess of Corinthia and Countess of Tyrol. It is not easy to understand why anyone with such features would wish to record them.

Right *Self-Portrait,* Sir Peter Paul Rubens. Like Rembrandt and many other artists, Rubens painted his own face frequently, as an exercise in capturing emotions and expressions. In this self-portrait, the face betrays no characteristics of age, rather a jauntiness and youthful humanity. His full moustache, small beard and wavy hair add a pattern of their own to the portrait which might otherwise have been bland, as his face is without wrinkles. The direct gaze and lifted mouth display an endearing honesty and liveliness.

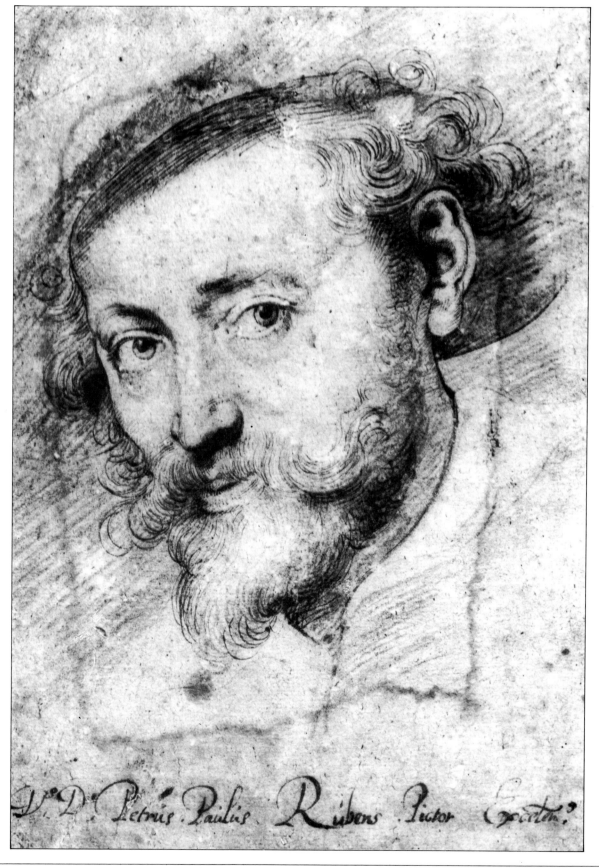

result from trickery. Dürer painted hair in much the same way as many other painters, by first considering the overall shape of the head of hair and then indicating the direction of growth. Although everyone knows that hair is not a solid, it is easier to consider it so while painting. If a sculptor were intending to carve from a piece of stone the head of a woman with long flowing hair, he would first need to consider the hair as a tangible volume rather than a collection of tiny stands. In much the same way, a painter must first simplify the overall mass, which reflects and shades light.

Although a mass of curly hair may not reveal such obvious changes of color in light as smooth, straight hair, it is always the case the more light is reflected on the top of the head if the figure is lit from above. If the hair stands away from the head as thick curly hair often does, the areas nearer the scalp will be denser and also darker, being shaded by the hair nearer the surface. Once the light source is established, changes in color and tone can be noted. Eventually the mass may be made to resemble hair in the method of paint application. With age and loss of hair, the scalp becomes more prominent.

The Eyes

Another difficult problem for the portrait painter involves the depiction of eyes. In many portraits they are the means by which an immediate confrontation with the spectator is made. Because of their obvious importance in any portrait, it is crucial that they do not become unrealistically prominent in relation to the rest of the face. It must be remembered that the eyeball is almost spherical and that the actual portion of its visible surface is small in relation to the area hidden by the eyelids and within the bony orbital cavity. The outer surface, or white of the eye, is called the sclera and consists of protective fibrous tissue. The front portion of the sclera is transparent and forms the cornea; this amounts to about one-sixth of the surface of the sphere. The curvature of the cornea is more convex than that of the sclera and might be considered as being a segment of a smaller sphere joined to the larger.

One of the most immediate characteristics of a person's face is the color of the eyes, and this pigmented part is called the iris. It is situated behind the cornea and is comprised of radially arranged fibers and circular muscular fibers which alter the size of the black pupil in much the same way as the aperture mechanism of a camera lens. The pupil is in fact a hole; in bright light it contracts and in darkness it expands to allow more light through to the lens within, which is suspended by ligaments and provides the crucial link with the light-sensitive part of the eye known as the retina. While seeing, images are focused on this inner surface, and depending on the distance involved the lens will alter its shape. When objects nearer than about 20ft (6m) are observed, the anterior surface of the lens bulges forward and becomes more convex, allowing those objects to be received by the retina. In normal vision the slightly different images of the two eyes are combined by the visual cortex to enable stereoscopic vision.

In the adult face the eyes are situated midway between the top of the head and the bottom of the chin, with a space equal to the width of one eye between them. Unless the eyelids are deliberately forced wide open, a small portion of the iris is hidden by them; when the head is vertical, the top lid covers the top portion of the iris.

It is almost inevitable that the portrait painter focuses on the eyes, and yet when any part of the face is given too much prominence there is a danger that the part will destroy the unity of the whole. When confronted by a portrait by Rembrandt the eyes, painted without undue emphasis, appear to be like visual magnets, demanding attention. The adage that the quality of a portrait depends on whether the eyes follow the spectator around the room almost achieved credibility with Rembrandt's self-portraits, in which the intense and penetrating stare is a reminder of the intensity involved in the activity of painting a human presence. Although Rembrandt painted eyes with remarkable accuracy, he always managed to situate them in such a way that the orbital cavities of the skull seem to enclose and protect them.

The white of the eye, as it is known, is something of a misnomer; in reality its appearance is dependent on the state of the

subject's health and on light, and often its moistness, indicated by highlights, will cause it to appear bluish-gray in color. A cast shadow caused by the effect of light on the forehead will often accentuate the depth of the eye sockets and, under close scrutiny, it becomes evident that the eyelids themselves have a thickness which casts a shadow onto the surface of the eyeball.

Racial Differences

Racial origin not only affects the skin pigmentation, but also the general shape of the body and face. Direct observation of particular individuals should dispel any notion that physical types can be easily categorized; within any one geographical location there are always infinitely diverse physical differences which defy generalization. However, because the shape of the overlying skin and muscle tissue in any face is dependent on the underlying bone structure, some racial differences are reasonably apparent. The shapes of skulls vary, for example.

The history of Western portraiture is inevitably dominated with images of white Europeans, and yet even within this limitation there is a range of facial types. In 1740, Carolus Linnaeus, the Swedish taxonomist, suggested that the species *Homo sapiens* could be considered in terms of five distinct variations: African, American, Asiatic, European and Indian. By 1900 the groupings had become more complex and the French anthropologist Joseph Deniker suggested that there were in fact six groups with 29 smaller subdivisions of those groups. By 1961 W.C. Boyd, an American professor of immuno-chemistry, reached the conclusion through the use of blood groupings that a total of 13 groups make up the one species.

The definition of any one grouping is difficult and there can be no specific characteristics that are particular to any one particular race. In North America there has been an attempt to define the characteristics of both black and white people, assuming for the sake of simplicity that the white people are of western European origin and the black people from the Gulf of Guinea. It was discovered that the North American Negro generally has a lower hairline on the forehead, a broader nose with a lower bridge, and a more pronounced jaw.

In the case of both white and black people being of similar stature, the Negro will be the heavier, with a shallower chest, narrower pelvis and longer legs. The obvious difference between people of different origin or race is the color of skin, and as there is no recipe for painting skin tones, the artist must rely on powers of observation in coming to terms with the particular characteristics of each individual sitter, whatever his or her race, age or sex.

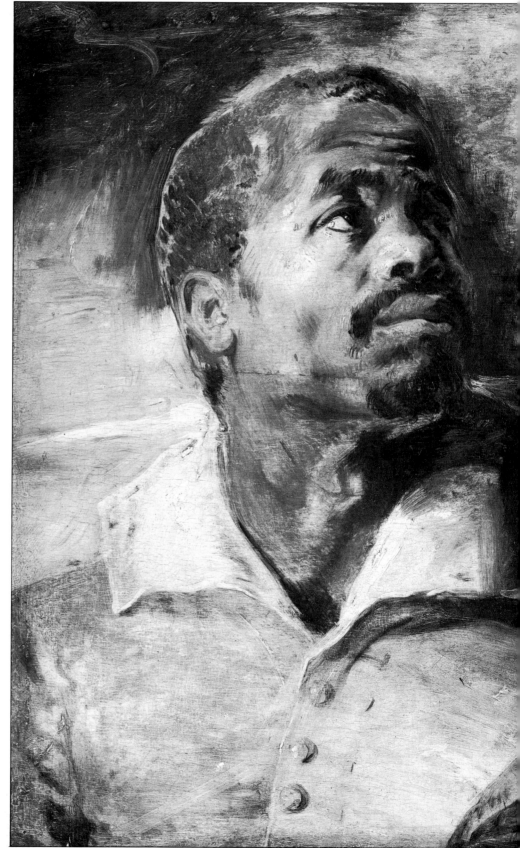

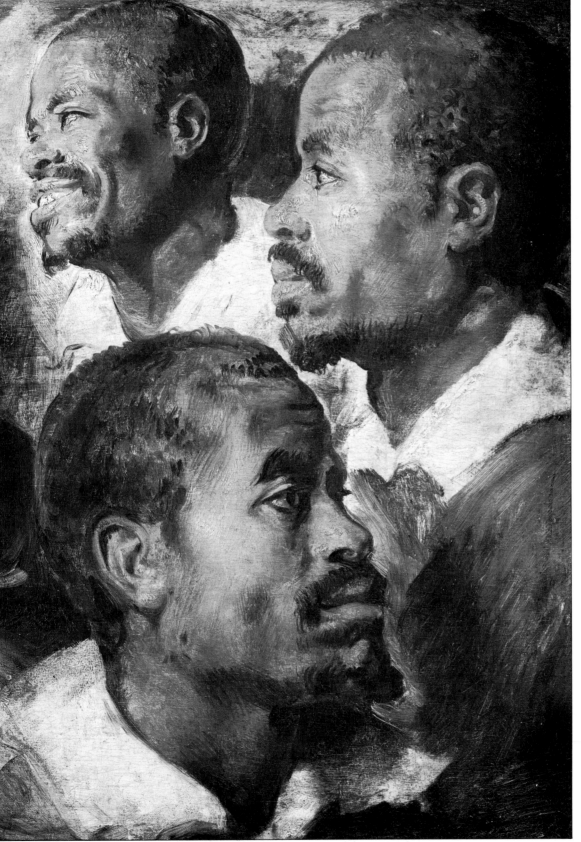

Left *Studies of a Negro Head,* Sir Peter Paul Rubens. This type of study – painting a number of different views of one face on the same canvas – was unusual for its time, and provides an animated composite portrait. It is interesting that not only do the views vary, but also the lighting and even the expressions differ for each of the four heads. The main study on the left is a three-quarter head-and-shoulders view but is made more unusual and dramatic because the subject is observed from a low position, the light coming up to illuminate the modelling on the side of the face, heightening the expression and the upward gaze. The topmost study is also a three-quarter view, but in this case the expression is more animated and the light is coming from the front, casting the back of the head into shadow.

The study which occupies the righthand corner is a classic profile view, the light being used to describe the contours and details of the face, rather than accentuate an expression. This provides a revealing contrast with the lower foreground study, where the lighting creates a more somber mood. The composition, with the heads arranged in a circle, brings the four separate studies into a unified whole.

USING LIGHT TO REVEAL FACIAL DIFFERENCES

The earlier part of this chapter was concerned with the anatomical construction of the skull, muscles and skin but to apply these facts practically, the artist is reliant on direct observation of what is, in fact, only the outer surface. The existence of light and shade is the artist's most useful aid for the application of knowledge about the human form.

In Western painting the description of volume has often been attained by acknowledging a light source above and to one side of the subject. Many painters realized that the light source in a painting is most effective in a realistic sense if it mimics the natural light of the sun. As Leonardo da Vinci directed in his *Treatise on Painting:* "Above all, see that the figures you paint are broadly lighted and from above . . . for you will see that all the people you meet out in the street are lighted from above, and you must know that if you saw your most intimate friend with a light from below you would find it difficult to recognize him."

In nearly all Leonardo da Vinci's portraits the light source is consistent with his observation of the effect of natural light. Shadows cast from a consistent light source help to indicate the changes in direction or plane across the form. After Leonardo it became common practice to indicate the shadows of the nose and brow to explain the volume of the head. In a similar way the chin would cast a shadow across the neck, and the cheekbone furthest from the light source would be bathed in shadow. Leonardo's advice about lighting was connected with his realization that the emotional content of the picture would be to some degree the result of it. If the lighting were directed from below the face, the effect would be quite different; some artists have used this quality to their advantage, creating unusual, theatrical or dreamlike results which automatically distance the spectator.

Edgar Degas was fascinated by the effects of artificial lighting and sometimes transferred the elements of theatricality into a portrait in a domestic interior. The following quotation, taken from *The Notebooks of Edgar Degas*, is an example of the advice he gave to others: "Work a great deal at evening effects, lamp light etc. The intriguing thing is not to show the source of light but the effect of the lighting." Degas realized that by not revealing the source of the light he could take more liberties with its effects. Many painters before Degas has used a single source of light; at first glance, a portrait by Rembrandt, for example, appears to present a figure bathed in light in much the same way that a figure might be observed in a darkened room with a shaft of

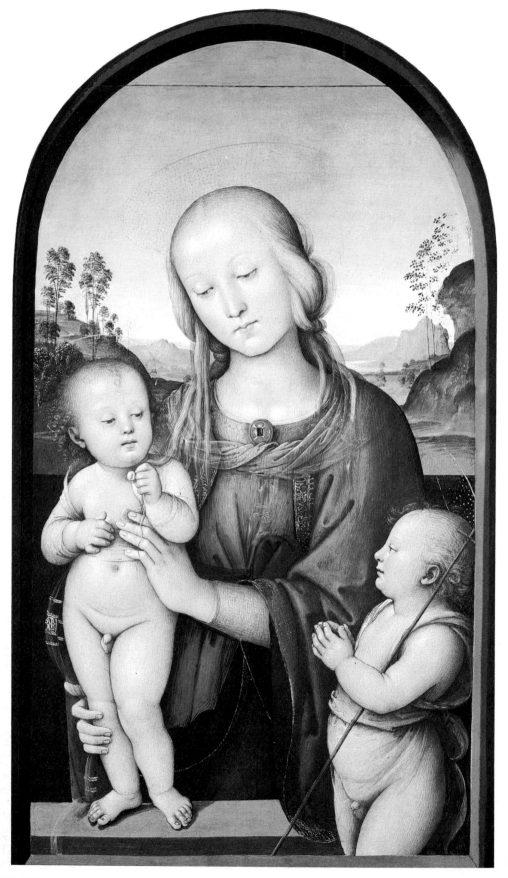

Far left *The Virgin and Child with St. John,* Pietro Perugino (active 1469-d 1523). Thought to have been a pupil of Piero della Francesca, Perugino was painting during the early Renaissance. This religious portrait displays some of the advancing ideas including the theory, later expounded by Leonardo da Vinci, that bodies should be lit uniformly from above. A diffused light bathes the three figures in their landscape setting, and soft shadows, particularly beneath the Virgin's chin, help to describe the volumes of the faces and the exact positions of the limbs.

Left *Portrait of a Woman,* Frans Hals. Painted *c* 1640, about 150 years after Perugino's portrait, this picture displays the use of interior lighting. There is one direct light source, which may have been artificial or from a window but has still been contrived to fall from above, in accordance with the convention that developed in the attempt to imitate nature. The light is deliberately strong and the women's face more dramatically modelled as a result.

Directional highlights on skin These images illustrate the effects of directed interior lighting on black and white skins, and should not be confused with the effects of daylight. The images are matched on the two pages. To begin with, a strong, narrow light was directed onto the necks of the models from behind them. It had the effect of whitening both skins where it shone, while it failed to provide any light to show the form of the rest of the head. The height of the sternocleidomastoid muscle created a shadow when a spot of light was caught on the jawbone (1).

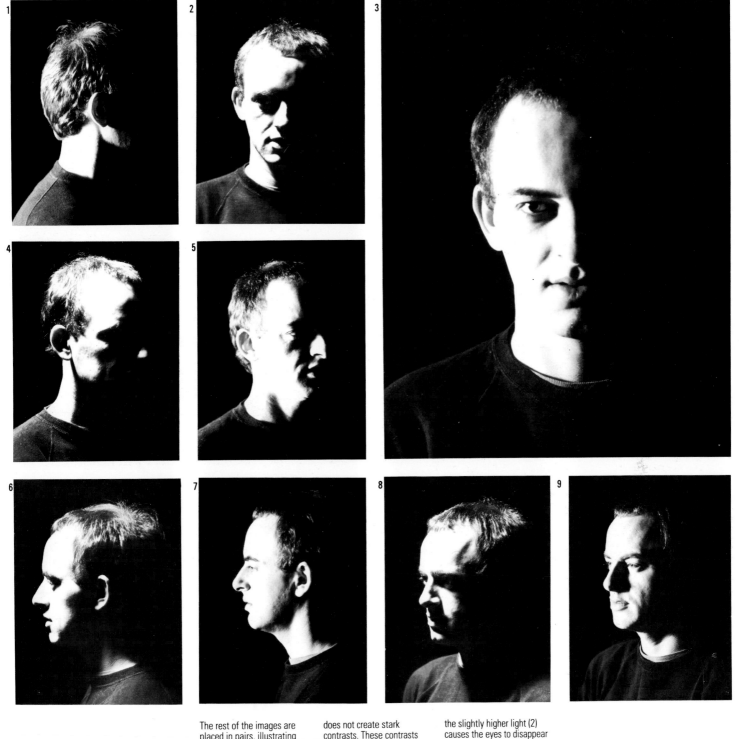

The rest of the images are placed in pairs, illustrating how two different strengths of light, shone from the same angle, pick out different facial contours and features. The softer, wider light source shown in one image of each pair, that is in (2), (4), (6) and (8) on both pages, allows the light to travel further and does not create stark contrasts. These contrasts are particularly evident, under the strong light, on white skin which reflects more light from its surface. The actual shape of the face seems to change in some pairs; for example the stronger sideways light (3) lengthens the features while the slightly higher light (2) causes the eyes to disappear and every contour of the face, every change of direction on the surface of the face to stand out.

Right *Self-Portrait,* Jean Millet (1814-75). The lack of facial detail does not mean that there is a subsequent lack of character in this portrait. The hat pulled down over the artist's ears, thick clothing and a rough beard and moustache give a vivid impression of the artist's temperament. Born in a French peasant family, Millet started to depict *genre* scenes and country people in conditions of hardship and poverty. Drawn on rough-grained paper, the technique of this down-to-earth self-portrait matches the content. There is a dark shadow beneath the peak of the artist's hat while the rugged features, the nose and cheekbone are highlighted for a solid, chiselled effect.

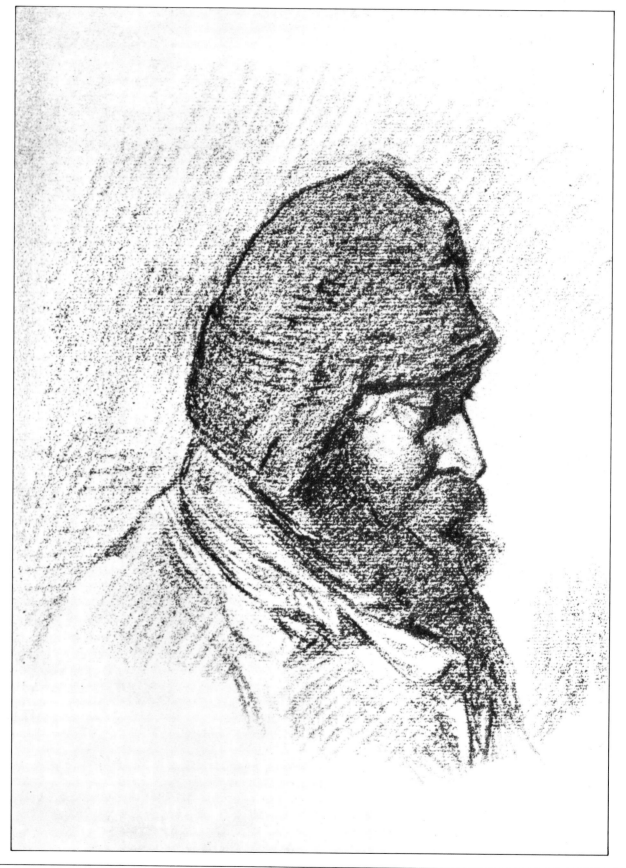

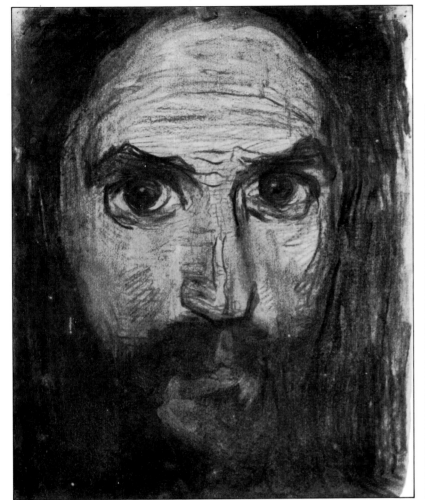

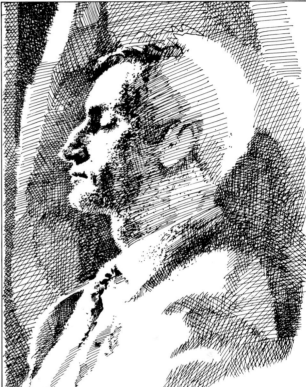

light falling on one side. On closer examination it is apparent that Rembrandt did not feel it necessary to observe the logic of natural light and although his paintings are deceptively real, the light is allowed more emphasis in certain places for dramatic pictorial purposes. In order to draw attention to the face and hands, Rembrandt would accentuate the lighting in certain places. The problem with a pictorial convention, however, is that once it becomes an acceptable means of describing volume it is in danger of becoming a cliché. In the hands of lesser painters, Rembrandt's dramatic lighting became an arbitrary means of describing form.

The academic painters of the nineteenth century were trained to observe the effects of light on the plaster cast of a face, and it became common practice for them to paint a real person with a preconceived notion of how light would affect the face. In many instances the adherence to a pictorial convention probably passed unnoticed, but when the artist attempted to paint a portrait in a landscape setting there would often be a discrepancy between the convention of lighting on the face and the apparently natural effect of light on the landscape. The Impressionist painters dispensed with many preconceptions and the accepted mode of lighting a face was the first to perish. Edouard Manet deliberately chose to light his figures from the front and was often criticized for his rejection of *chiaroscuro*. By using light in this way Manet was able to flatten faces and concentrate on the subtle internal volumes without the use of cast shadows. People found it hard, at first, to accept Manet's paintings of figures with their apparently shadowless faces; in fact they are not flat at all.

In everyday life our perception of a human face often involves many different light sources at the same time and, similarly, the portrait painter may be confronted by a subject in which the directions of the light sources are various. This will cause a plethora of cast shadows and may provide problems for the artist attempting to come to terms with the volumes of a particular face. The most straightforward way to begin portrait painting is to limit the light sources for reasons of convenience, and later to experiment by changing or strengthening them.

Artificial light has its advantages; not least is the fact that its strength and position do not change. It is now possible for the artist to select a light source regardless of the quality of natural light or the time of day. Natural light, which changes minute by minute, can prove annoying for the portraitist attempting to capture a face in a certain light with particular shadows. In these circumstances, it may be worth taking a photograph of the subject and working from this until a similarly lit opportunity arises. If a strong, harsh light is required, providing distinctive shadows and modelling, a powerful tungsten bulb can be used and produces a brighter constant light than sunlight.

By comparison with the light bulb, natural light is bluish in color. As an experiment, this difference can be observed while sitting in a subway train as it passes through a dark tunnel; the eyes become accustomed to the artificially lit environment and it is not until the train moves suddenly from the tunnel into daylight that the blueness of natural light is apparent.

DRAWING PORTRAITS

DRAWING AS DESIGN

The twentieth century has seen many changes in the teaching of drawing, especially in the rejection of the laborious academic methods advocated before and during the nineteenth century. Before a student at art school was allowed to draw a model he was obliged to spend many hours working from a plaster cast. The study of anatomy and an understanding of the effect of light and shade was supposed to be the best way to prepare an artist for the more advanced problems of drawing a real person. Many artists did not emerge from this difficult training without succumbing to the pitfalls of academicism, but those who did are remembered for the more personal language that developed in spite of it.

Jean Auguste Dominique Ingres is often quoted as having said, "Drawing is the probity of art," and yet the meaning of the word drawing in the English language cannot fully encompass its wider implications in other languages. In fact, in both French and Italian the word for drawing (*le dessein* and *il disegno*) also means "design." When Ingres was remarking on the importance of drawing he was not concerning himself with presenting visual facts in the form of a recognizable image, but was commenting on the necessity of organizing pictorial structures in such a way that the individual parts are considered in relation to the coherence and unity of the whole. The term drawing as understood in English does not fully accommodate this meaning; this might partly explain the blinkered assumption that drawing should be connected with the imitation of reality.

Before describing the techniques of drawing, it is worth considering the uses and purposes which will affect how these techniques develop. Drawing with a line is the most immediate and primitive method of making an image and lends itself to making quick sketches or notations, which might have symbolic meaning. In Eastern cultures the calligraphic nature of writing reveals how closely linked drawing and writing can be, and yet in the Western world the division is pronounced. If an artist decides to make a quick study of a particular face the use of line emerges as a kind of shorthand, but with more time a different kind of drawing might emerge as the result of a thorough exploration into the volume of the head. The quality of a drawing is not necessarily improved by more work and quite often a lengthy study results in a lifeless image whereas a quick study appears lively and spontaneous. Sometimes a drawing may be considered as a complete statement in a creative sense, sometimes as a means of preparing for a painting; equally a drawing may be the visual document of objective, perhaps scientific, research and as such not

relate at all to the procedure of painting.

Leonardo da Vinci provides evidence of the latter approach in his analytical studies of anatomical structure which were the visual results of tireless research. It would be a mistake to assume that the nature of direct observation precludes creativity, but the degree to which it imposes restraints on the artist will affect the resulting drawing. If, for example, a technical draftsman is required to draw the working components of an engine, the desire for clarity will take precedence over an artistic or creative use of line or shape. In this function the drawing is required as an acknowledgement of fact and as such will succeed or fail through the artist's visual

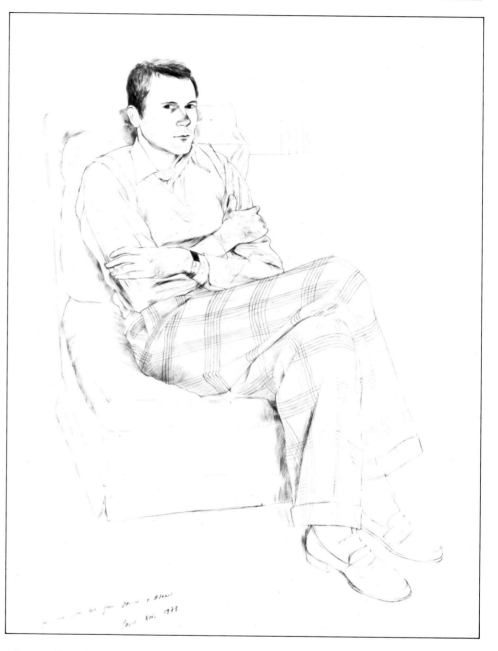

Above *Portrait of Jean Léger,* David Hockney. Executed in 1973, this pencil drawing shows a subtle combination of different types of mark, both linear and tonal. The basic structure of the portrait is linear, the lines being traced around the contours with precision and economy. A similar use of simple line in the gridded pattern on the trousers effectively suggests form. A restrained use of hatching provides tonal contrast but does not detract from the purity of the line. Darker shading on the nose serves to bring this feature forward in space; the darkest areas are the hair, eyes and watchstrap, balanced to give harmony. The result shows an interplay between the particularity of the subject and the volumes and depth of the figure.
Above right *Caravaggio,* Octavio Leoni. This drawing relies on tonal contrast rather than a linear construction. The rich intensity of the dark areas suggests the famous artist's violent life.

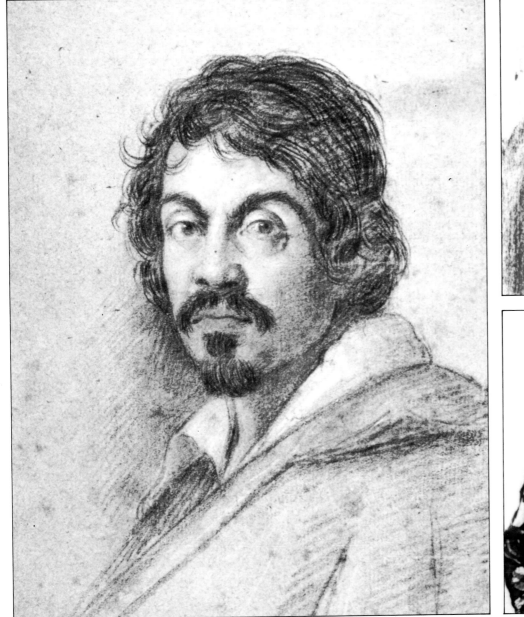

explanation of those facts. The drawing technique is irrelevant.

When attempting to draw the human figure, such rigorous objectivity is unnecessary; however, it is important first to understand the "components," as it were, of the figure in order to be able to express them competently with a degree of subjectivity later. Just as handwriting is expressive of personality, so is drawing. If several artists were to attempt to draw the same portrait, the results would be quite different. Even within the apparent limitations of one particular medium, the expressive nature of drawing is totally dependent on an individual's response to a given situation.

LEARNING TO OBSERVE

During the course of day-to-day living, an awareness of visual phenomena is restricted to the recognition of certain clues that distinguish one object from another. Most people would be able to describe with some accuracy the particular visual characteristics of another person. However, very few people would be able to translate that knowledge into a drawn image. When confronted with another person, an awareness of their appearance is to some extent due to the recognition of facial mannerisms or gestures, and attention is normally focused on the separate features. Consequently when first attempts are made to draw a figure, the features of the face are

Top and above This modern portrait sketch was drawn in charcoal and Conté crayon using a photograph as reference. A comparison of the two indicates that the artist's intention was not to reproduce a strict likeness, but to suggest certain qualities of light. One of the difficulties of working from photographs is that the drawing might turn out to be too static, but here the looseness and spontaneity of the charcoal medium confers a greater degree of liveliness than existed in the original photograph. Charcoal and crayon lend themselves well to the type of treatment where the accent is more on contrasts of light and shade than descriptive work.

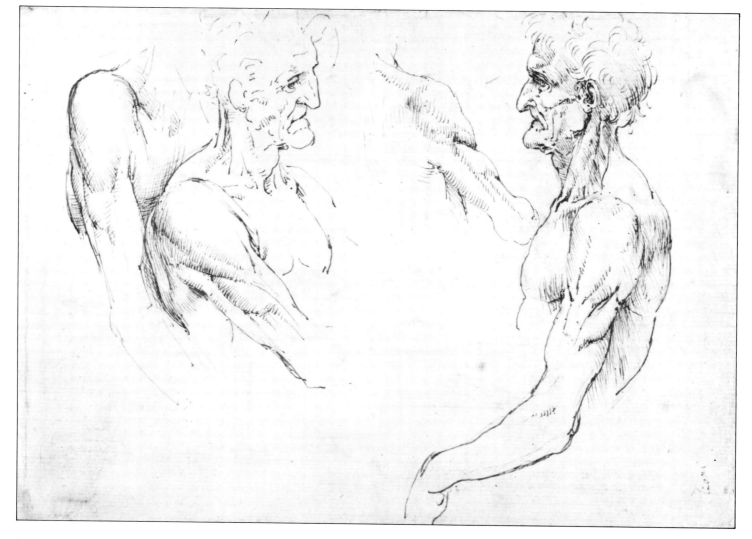

indicated and little or no attention is paid to the structure or complete form of the head.

One of the major problems encountered through drawing is thus connected with seeing. Children are usually curious about the visual world and the images they make represent an unconcious attempt to find a symbol or sign to remind them or a viewer about the real world of people and objects. Their drawings are not hindered by any preconceived notions about representation and do not conform to any pictorial conventions. As a child becomes older, the innocence of such drawings becomes equated with naiveté, and any art form that does not conform to a more realistic representation of the world is likely to be dismissed. It is a curious aspect of human development that drawing as a means of expression is common to children of all races and backgrounds, and yet with age this desire becomes replaced by the verbal and written language.

The activity of seeing and observing with the final aim of transferring the image is complex. Most people who do not need to translate their observations into any tangible equivalent will find considerable difficulty in selecting from reality the most vital shapes and forms that collectively suggest a coherent image. In a face, for example, it is not just the shape of the eyes and the mouth that are important, but the selected shape of the whole. Everybody who is gifted with sight will be able to distinguish a familiar face in a crowd, but few people would find it necessary to translate that image into another form, unless a verbal or written description of that person is required. when an artist attempts to describe a person visually he will need more information about that person and cannot rely solely on a familiarity with certain features.

Understanding the physical structure of bodies in space is the first problem of drawing; the second problem involves translating that understanding onto the two-dimensional surface of a sheet of paper. The third and perhaps most crucial factor in drawing involves getting rid of the common misconception that the merits of a particular drawing are somehow connected with the degree to which it imitates reality. Although this might seem to be a contradiction of intention, it is important that the artist's interpretation of reality is the product of a selective process and as such is directly related to the idea that a drawing will succeed or fail depending on the strength of its own internal structure of lines and shapes. A constant awareness or acceptance of images through photographic reproduction has imposed restrictions on our visual development to such a degree that most people usually consider the merits of a drawing in relation to photographs and do not acknowledge the fact that a drawing may be interesting because of its own self-sufficient structure. In this respect, a person who is not used to studying the structure of objects will probably find it difficult to recognize the visual structure of a drawing unless it appears to mimic reality and include the visual superficialities that are required in the casual recognition of objects in everyday life.

Far left *Head and Shoulders of a Man,* Leonardo da Vinci. Leonardo's drawings reveal a process of inquiry, both scientific and artistic; the outstanding beauty and precision of these works alone would qualify him as a great artist. Anatomy was a lifelong interest; his researches in this field led him to the brink of discovering, it is believed, the circulation of the blood. Leonardo pursued all of his studies determinedly, refusing to accept any fact or theory until it was substantiated by his own discoveries: in anatomy, for example, many of his detailed and annotated drawings were the result of his own observations of dissections. Leonardo drew in all media – red and black chalk, pen and ink, silverpoint – and accompanied his sketches, caricatures, plans and drawings with notes executed in mirror writing. After his death, the many notebooks containing his drawings passed into the hands of Pompeo Leoni who organized them into two volumes – one for science and one for art. In 1637 one of these volumes was given to the Biblioteca Ambrosiana in Milan; the other eventually became the property of the British Crown and is now in Windsor Castle. In the nineteenth century, 600 of these drawings were placed in separate mounts; the anatomical drawings were bound separately. Together these represent the most extensive documentation of Leonardo's extraordinary life of research and observation.
Left *Portrait of a Young Man,* Albrecht Dürer. This portrait was executed in charcoal and the crisp lines and subtle modelling display Dürer's skill as a draftsman and his control of the medium. Today charcoal is regarded more as a medium suitable for sketching but this drawing shows it can be used for very detailed, highly finished work.

ASPECTS OF DRAWING
Form and Line

The strength of a linear drawing depends on whether the internal volume of the figure or object is satisfactorily suggested by the line of its contour. In any linear drawing the surface area of white paper is considerably larger than the area of paper that is covered by the pencil and the linear description of form requires an awareness of what appear to be the empty spaces between the lines. These lines do not delineate actual forms; lines in a drawing represent artificial boundaries. If, for example, a hand is placed on a sheet of paper and the form is delineated with a crayon, the image on the paper will convey a hand, and yet the two-dimensional result will not describe the volume. It is recognizable due to its strength as a symbol. In order to move beyond a symbolic image it is necessary to consider how solid volumes are perceived and how the information gained can be translated into an image that conveys depth or solidity.

Many attempts have been made to equate the human form with simple, geometric or well-known forms: the head, for example, might be likened to a sphere or egg shape with cavities for eye sockets and additions for the nose, ears and neck. The problem with such simplifications is that they are essentially theoretical and in practice do not help with the complexity of drawing. On the other hand, any attempt to convey the contour of a head without first considering its three-dimensional structure will usually result in a two-dimensional image not unlike a child's. It is evident that a balance is required in which the simplification of volume may be acknowledged without over-simplifying the drawing itself.

Once the artist has established the fact that the apparent line around a living form is likely to change and move, he or she can then start to understand how the contour can explain the internal structure, that is, the solid form. The line that appears to separate one object from another in effect defines the point at which the solid volume curves away from view. In the same way, the horizon line at sea is an arbitrary limit – the point at which the actual curvature of the earth prevents a perception of the continuing curve. If the edge or contour of, for example, a globe is suggested by a single unbroken line, the drawing appears to represent a flat object and is therefore not sufficient to explain the volume. It should then be apparent that in order to make an image that does suggest form it will be necessary to reconsider the use of line, or alternatively involve the addition of tone.

By varying the pressure on the pencil, a line of different intensity will result, and by the addition of tone in relation to the effect of light and shade a more substantial indication of volume can be realized. Alternatively the contour may be broken or the directions of lines changed to indicate different places. In the case of describing a face, certain points around the contour may reveal the overlapping of one form over another. By careful observation it will become apparent that the line that appears to delineate the jaw or cheek actually moves in front of the contour of the neck and what at first appears to be a silhouette is actually a subtle interplay of contours that move backward and forward in space, not just two-dimensionally. In attempting to define the volume of the head it is helpful to consider how the pencil point would negotiate different changes in direction if it were to physically move across the actual object in question. Assuming that a head is being considered from a three-quarter view, the apparent contour of the nose would move from below the forehead and then appear to cut across in front of the cheekbone furthest from view. Both Picasso and Matisse used line with remarkable subtlety, and often indicated the volume of a figure by slight changes in contour without any addition of tone.

Another example of an indication of form by line is evident in the work of Alberto Giacometti (1901-66). In many of his early drawings the solid volume is implied by an awareness of the changes of plane that have been encountered while studying the form of an object. The cavity of an eye socket is explained without the cast shadow caused by

Far left *Two Nudes* (1956), John Golding (b 1929). This deceptively simple pen and ink drawing is a good example of how line can suggest volume.
Left *Caroline,* Alberto Giacometti. Giacometti combined an interest in spatial relationships with a highly personal view of the figure, capturing the isolation of modern life. This painting shows how Giacometti "drew" with paint, using line and hatching to convey both solid form and space.
Above This pencil drawing shows a high degree of control. The continuous line both evokes form and sets up rhythms.

light on the forehead: the depression in volume is evident by the indication of changes in plane. It is always tempting to underestimate these changes and concentrate on the superficial resemblance of the features. Although the various components of the eye, the iris and pupil, for example, might be clearly visible, a convincing indication of their relative positions cannot be provided if they are not represented resting deep within the eye socket. In portraiture the temptation to emphasize the features must be avoided so that the structure of the head is resolved in its entirety.

Perspective

Drawing need not be the result of clinical observation at the expense of expression, and it is worth considering how some artists have come to terms with methods of representing the visual world with some accuracy. The predominance of realism in Western art has hindered an appreciation of drawing as an art in itself; in Eastern cultures there has been less emphasis on the imitative quality of drawing and more appreciation of line and shape. However, developments that have been made with the aim of naturalism were inspired by a growing awareness of perspective. The use of perspective as an aid to figurative drawing reached its peak during the Italian Renaissance. By establishing a fixed viewpoint in relation to a given subject it was realized that an image could be drawn which suggests how an object is perceived in space. This contrasts with the image behaving as a symbol which describes an object's obvious two-dimensional qualities without implying its relative position to the spectator.

If an artist wants to draw a pair of scissors, the outline or silhouette is sufficient to strike a chord in the observer and the image will be instantly recognizable. If, however, the same object is seen from a viewpoint that is not symbolic, the problem of conveying its shape naturalistically is more complex. The same situation occurs when an artist is confronted with a model; the artist must acknowledge the difference between what he knows to be real and what he actually sees.

Before beginning a drawing it may be useful to indicate the eye level and establish an imaginary horizontal plane between the artist's eye and infinity which will dictate the height of the horizon. This level will rise or fall according to the position of the artist, and even though the drawing may proceed in an intuitive manner it is important that this level be related to the position of the model. In theory it is assumed that all parallel horizontal lines converge at a point known as the "vanishing point;" in practice this may be evident by standing in a street and noticing how the buildings appear to diminish in size

the further away they are. The parallel lines of the rooftops and pavements on either side would converge to a single point if the street were long enough. The vanishing point depends for its position on the viewer's eye level, which is a vital consideration in the composition of a picture.

Although it might be assumed that drawing a single figure would not involve perspective, it becomes apparent that the relative position of artist and subject will affect the drawing. If the artist is positioned at the same eye level as the subject and also very close, the subject's head will be seen at eye level but the whole body will be seen from above. If the model is seated on a chair and viewed from a close vantage point, the thighs will be seen from

Perspective Representing three-dimensional form on a flat surface has preoccupied artists and draftsmen for centuries. The notion of perspective, rediscovered in Western art during the Renaissance, enabled artists to attempt to come to terms with the difference between reality and what they actually saw in front of them. These examples show perspective applied to representations of the human figure. The drawing of the two figures and its schematic outline showing eye-level and vanishing points (**above** and **top right**) illustrate the rigorous planning necessary to express not only the volume of a form in space, but the relationship between the figures. The foreshortened reclining nude (**above right**) shows a figure in a horizontal plane. Because the body is composed of curves and not of straight lines, giving a convincing representation of recession involves keen observation rather than merely a systematic application of fixed rules.

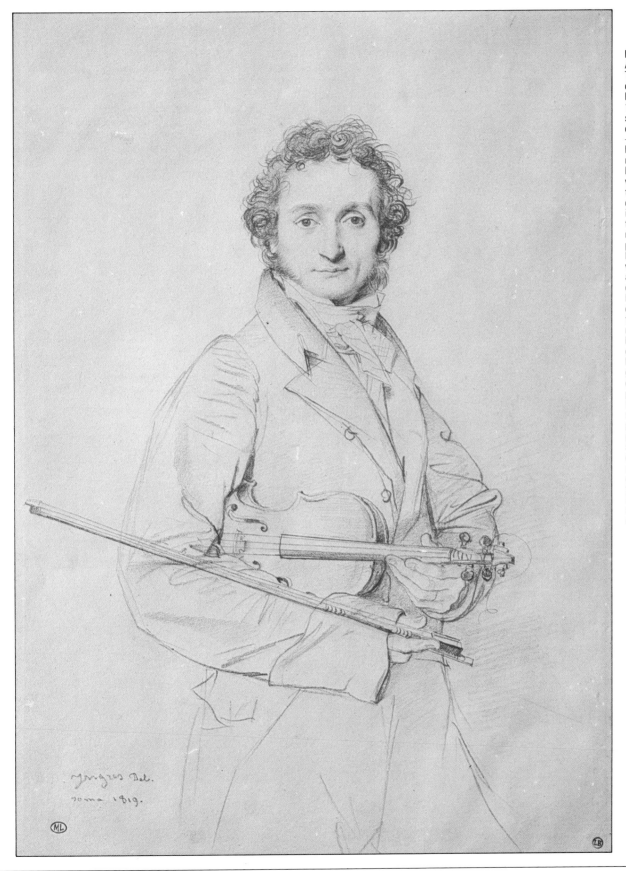

Left *Paganini* (1819), Jean Auguste Dominique Ingres. This portrait was drawn during the artist's stay in Rome, where he moved in 1807 after winning a scholarship. It may have been one of the portraits he made – chiefly in pencil – to earn his living after his prize money ran out. Ingres, who had studied in David's studio, went on to become one of the best-known French artists of his day and was firmly identified as an opponent of the new Romantic movement. At the time this portrait was executed, Niccolò Paganini (1782-1840) was on the brink of success as a virtuoso violinist and composer. It is ironic that Ingres should come to portray one of the most influential figures in the rise of romanticism in music. Paganini's life was as extravagant as his aesthetic; he was a womanizer, fond of gambling and noted for acts of extreme generosity. A popular idol in many European capitals, he revolutionized the art of playing the violin. This portrait shows Ingres' sensitive draftsmanship, yet displays a paradoxical realism. The entire figure is observed in detail, but the twisted pose and recession in space implies that the sitter is viewed from a distance.

above. If the artist moves further away, the thighs will appear to be foreshortened and the discrepancy of viewpoint will be less evident.

The complexity of many realist paintings provides a paradoxical result in the realization of this phenomenon. In the work of Jacques-Louis David and Ingres the clarity and detail evident in some portraits suggests that the subject was seen from a close vantage point, and yet the particular application of perspective contradicts this by implying that the whole figure was observed from some distance. More recently Euan Uglow (b 1932) had deliberately emphasized this visual distortion but many artists have compensated for it in an attempt to convey a more acceptable representation of reality.

As with any such theory, its practical application can only be more complicated. A simple acknowledgement of the relative eye levels of both artists and model at least provides a foundation for coming to terms with the representation of three-dimensional bodies on a two-dimensional surface.

Tone

The reason for so far considering drawing in linear terms is not to exclude other approaches but to establish an idea about the nature of perception without attaching too much importance to the effects of light and shade. The addition of tone should not be considered as an embellishment to line drawing, but its use is often the result of the desire to compensate for a lack of three-dimensional volume that probably arises from a misunderstanding of the nature of linear drawing.

A specific problem for the artist in the twentieth century is the acceptance of visual material in photographs. The photographic image is by its very nature reliant on light and shade; however, the tonal quality can provide a false yardstick for the artist and the pitfalls of imitating the apparent naturalism of photographs should be avoided. A photograph of someone's face in strong sunlight can result in an image that is predominantly dark or light and lacking in half-tones. If this effect is copied in a drawing, with dark patches acting

as approximations of shadow, the volume of the form, especially in the shaded areas, will be flattened. If a photographic use of tone in a drawing is falsely equated with realism, an understanding of the language of drawing will suffer; "dark patches" usually amount to a disappointing over-simplification of tone values. Tone in drawing can in fact be variously used for many purposes.

Before considering examples of tonal drawing it is worth examining its origin which was, interestingly, an extension of linear drawing. The use of tone as "conceptual shadow" emerged as a means of indicating

how the boundary of an object disappears from view as it turns around the contour. Byzantine artists made use of this method of indicating volume, and although the result adequately conveyed a form of relief it did not imply a source of light. During the Renaissance the use of tone in relation to an implied light source enabled artists to describe the volume of an object with a degree of realism. As artists became more aware of the optical effects of light they realized that shadow revealed the internal structure of the object and provided a means of creating a convincing three-dimensional space.

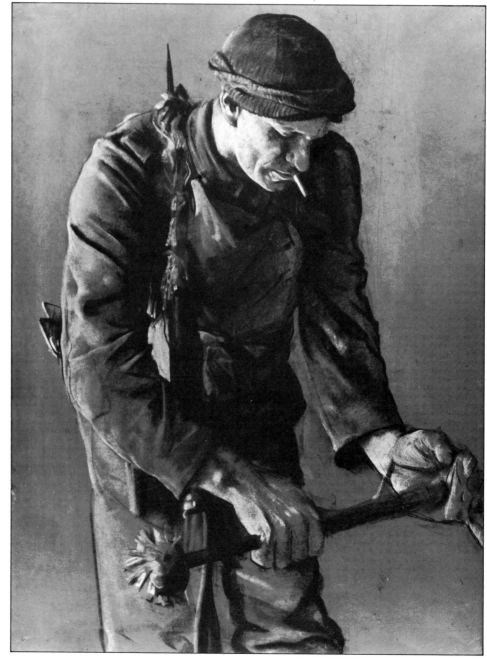

Right *Raider with a Cosh,* Eric Kennington (1888-1960). A combination of rough strokes and smooth blending in this pastel drawing conveys different textures as well as volume and depth. The strong light, coming from over the subject's right shoulder, illuminates the side of his face while throwing his body into deep shadow. This strong contrast gives the portrait a striking quality which is almost cinematic in effect.

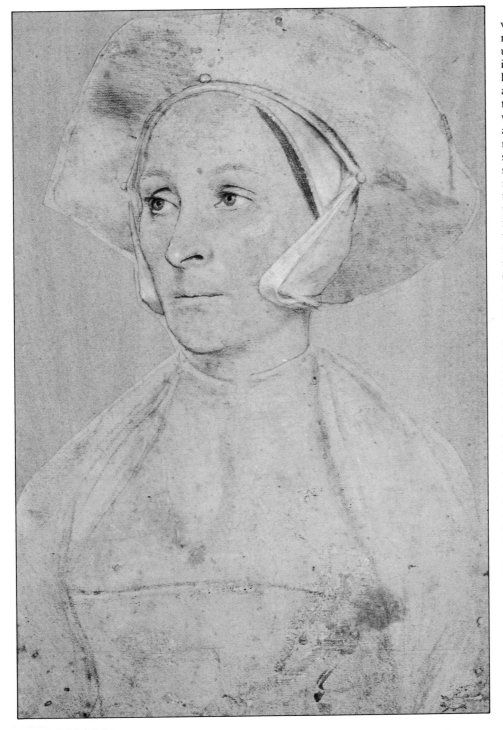

When attempting to draw a figure with a view to considering tonal structure, it is often rewarding to situate the model against a uniformly colored background. If, for instance, a white wall is chosen and a single light source from one side is used, it will be apparent that where the wall appears to meet the most illuminated side of the face, the wall will seem to be darker than the area that adjoins the shadowed side of the face. By moving the model near to the wall a cast shadow on the wall will be evident and the selection of the most important shadows will reveal the spatial connection of the figure to the background. It will also be evident that the use of a single unbroken contour will impinge on the degree of volume implied when using tone, and that the contour will need to be reconsidered if a convincing representation of volume is to be attained. By closely following the contour it will be evident that it almost disappears at certain points and the edge of the object is indisinguishable from the background.

As the form of an object moves into an area of shadow cast by another object its contour becomes less pronounced and, therefore, if a line of equal intensity describes the light and the dark side of an object the illusion of volume will be hindered. It is important that the tonal structure is considered with the initial structure if the drawing is to have consistency. As the human form is infinitely more complex than a regular geometric solid there can be no easy solution for its realization through drawing. Any attempt to separate by theory the various activities in drawing will not necessarily provide a solution, and the actual experience of drawing combining observation and a sensitive handling of the medium is the best way to learn.

MEDIA

For reasons of convenience the idea of drawing has not so far involved discussion of different techniques and drawing media but it should not simply be assumed that drawing necessitates the use of pencil on paper. The availability of colored drawing paper and the wide range of drawing implements extend the range of drawing techniques almost infinitely although the fundamental concerns of making a two-dimensional image are similar.

The common assumption that drawing involves making a dark image on a light surface can in fact be reversed, and the distinction between drawing and painting need not be so obvious. Edgar Degas is renowned for his use of pastels on tinted paper, and in many instances the result achieves the richness of color and breadth of design that is commonly associated with the use of oil paint and the process of working from dark to light. The art of the twentieth

Drawing children Making portraits of children involves a number of particular problems for the artist. Most children do not make ideal sitters; younger ones are usually fidgety and unable to hold a pose for long. While older children are often eager to cooperate, they probably lack the concentration necessary for a prolonged sitting. With patience and a degree of flexibility, however, it is still possible to draw a child from life. Practice making quick sketches will enable the artist to capture fleeting movements: these drawings can later be assembled to provide reference for a more finished work. For a formal pose, it may be possible to alternate short periods of drawing with rest breaks for the child. Even more crucial for children than for older models is the choice of a pose which is not only natural and characteristic, but comfortable as well. Children asleep or concentrating on their play, also provide good opportunities for making portraits. If other methods do not work, it is always possible to draw from a photograph, either carefully selected or specially taken for the purpose. In general, pay special attention to the differences in skin texture, proportion and anatomical structure between children and adults and choose a medium that will help to maintain a degree of lightness and vitality.

1. This group portrait is composed in the shape of a triangle, with the poses of the children suggesting a mixture of curiosity and shyness. It is executed in pen and ink, with light smudges to add areas of tone and texture. Since pen and ink does not allow much alteration, the compositional relationships must be carefully considered before beginning to draw. Work from top to bottom to avoid smudging the work.

2. This child was drawn quickly using a 2B pencil on plain white drawing paper to capture the pose before the boy moved. The hands were emphasized, almost to the point of distortion, to provide a foreground focal point and increase the sense of depth. Pencil marks have been used here not only to delineate the form but also to give overall tone.

3. Another way of introducing areas of tone in a drawing is to apply small patches of paint to counterpoint the line. Here ragged, sketchy lines applied with acrylic paint give an added dimension to the sensitive and careful pencil work of the drawing. The head and cuffs of the dress were emphasized to bring out the quality of the pose.

4. This detail of a drawing of a seated child, made in colored pencil on a page in a sketchbook, shows how a systematic build-up of lines can create the impression of tone and form. This technique is the opposite of using line to imply volume by tracing the contours of a shape. This approach works best using colored pencil.

century has resulted in a remarkably diverse attitude to pictorial language which has manifested itself in an equally diverse range of pictorial techniques.

The pencil has always been popular for its accuracy in portraiture. At its best it is simple, quick and effective and can be removed by an eraser if corrections are necessary. The effect of the pencil alters according to the quality of the paper, and a smooth white or off-white paper is often preferred for straightforward effects.

Before graphite was used in pencils, other methods of drawing with a pointed implement were common. During the Renaissance a method of drawing which relied on a confident and disciplined technique using a sharp metal point known as silverpoint was developed. This enabled artists to make delicate and elaborately detailed pictures, carefully drawn because this medium did not allow for any alteration or correction of the initial state-ment. Evidence of its beauty can be found in the work of Leonardo da Vinci and Albrecht Dürer.

Charcoal may be considered the most primitive drawing implement, yet it provides a more varied range of marks than pencil. Many artists have favored this medium as a means of exploring the possibilities of tonal relation-ships. It is usually applied to coarse-grained paper which enables its potential tonal range to be exploited more easily but, as with any medium, the result of trial and error may result in a personal preference for surface quality. Georges Seurat developed many ideas for paintings with charcoal studies of individual figures. He usually preferred a technique that dispensed with any overt use of line, and by establishing a theoretically consistent light source he was able to model each solid form in such a way that the contour combined perfectly with the internal model-ling of the form. Chalk has often been used in conjunction with charcoal, especially when off-white or colored paper is used. A strong feeling of volume can be achieved using mid-toned paper and subsequently adding charcoal for the shadow areas and chalk for the highlights. Many drawings by the Old Masters involve such a tonal range and provided a logical means of preparing to paint in monochrome.

Pastels and crayons are easily available in ready-made form and apart from their own individual properties may be used in conjunc-tion with charcoal and pencil respectively. Pastels are made of ground pigment mixed with a binding medium. The quality of mark can vary considerably due to the ease with which pastels crumble, and in order to keep the pigment on the paper it must be fixed by the application of synthetic resin available commercially in bottles or aerosol cans.

Left Detail of *Portrait of Duranty,* Edgar Degas. This portrait of an art critic and novelist shows Degas' preoccupation with draftsmanship and coloring. Here the two are combined: the basis of the work is distemper painted on unprimed canvas, with pastel overworked to heighten the color and add to the drawing on the figure itself. The surface pattern of the pastel strokes contrasts with the form.

Right *Sleepy Nicole,* Mary Cassatt (1845-1926). An American artist, Cassatt was influenced by the Impressionists, particularly Degas. The rather limited range of subjects in Cassatt's art, however, reflects her status as a woman artist – women were not even permitted to work from clothed male models or venture into the teaching studios. This tender portrait shows her characteristic device of making the figures large in scale, filling and dominating the frame.

Colored pencils have become popular quite recently with the precedent set by David Hockney. The obvious advantages of this medium are that it enables the artist to work with the accuracy of pencil and at the same time involve color. Although pencils are clean quick and portable, there are certain disad-vantages to this medium. The individual colors are available in varying degrees of intensity, but they are generally consistent in terms of softness and hardness. To make a comparison, the ordinary graphite pencil is available in a range from 6H (very hard) to 6B (very soft), and this enables the artist to select the best grade for each particular purpose. Generally speaking, the harder end of the scale is used by technical draftsmen, and artists normally use the range from B to 6B. The colored pencil, on the other hand, is generally available in only one grade for each color and this is roughly equivalent to a B pencil. Consequently it is difficult to cover a large area quickly with dense color and the drawings often involve a linear technique with areas of tone indicated by blocks of over-lapping colored lines.

Some colored pencils available are water-soluble and the incorporation of a brush dipped in water, used for blending areas together, can compensate for the linear quality if it is not the desired effect.

The use of drawing ink has always been popular as a medium and can be applied either with a pen or a brush or a combination of both. The quill pen has been associated with ink but there are now many commercial equivalents on sale. A pen holder with a choice of metal nibs provides the means of making a considerable variety of lines and marks, which, by applying diluted ink with a brush may be extended even further.

In the twentieth century, modern tech-nology has resulted in many "convenience" drawing media. From the ballpoint pen to the fiber-tip pen there are many alternatives to the more traditional approaches. The draftsman's line pen provides a consistent ink line that will not vary either by pressure or angle of drawing point. It is unsympathetic to the more creative uses of ink and its advantage is mainly of ease.

Choosing a Medium
The choice of a particular medium may be

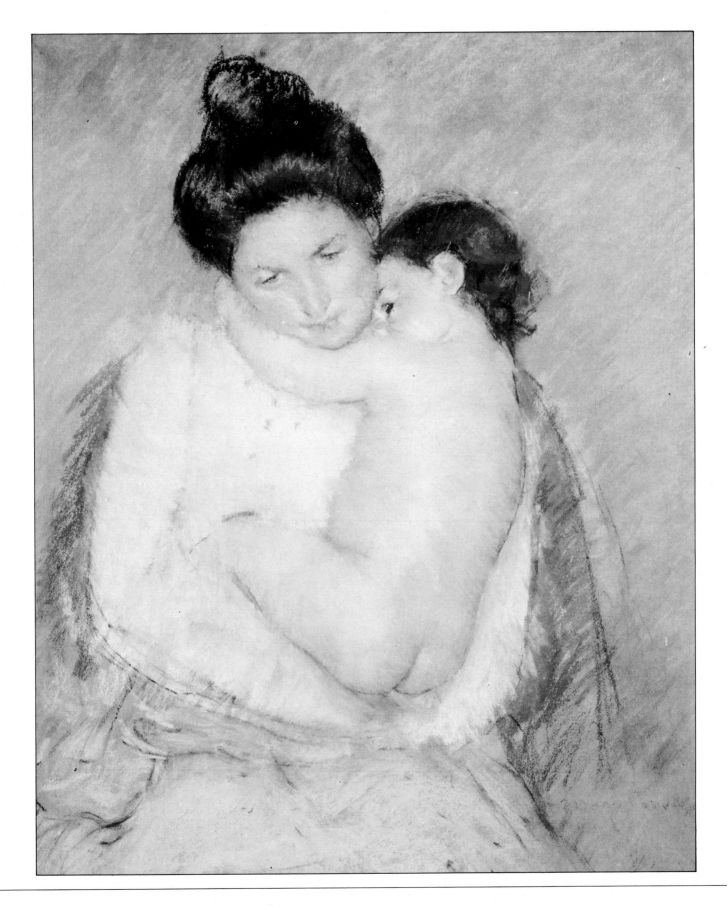

influenced either by personal preference or necessity. The distinction between drawing and painting is often based on technique and it is simultaneously assumed that while drawing is primarily concerned with line, painting is concerned with color. This over-simplification becomes meaningless when a number of individual artists are considered, and in some cases the division between painting and drawing is imperceptible.

By considering a few drawings by various artists it will be evident that the particular choice of medium enabled the artist to best convey his particular vision. Ingres used pencil on paper as a convenient way of recording an individual's facial characteristics and at the same time exploring the sinuous contours that could later be used in a painting. Sometimes he continued with a drawing so that it would be complete in itself, more often the drawing would be used to provide the

visual information for a later painting.

When Rembrandt van Rijn drew figures he often incorporated ink line and wash. The consideration of light was paramount and he sacrificed detailed description in favor of a dramatic summary of light and shade. The ease with which Rembrandt implied volume resulted in an expressive use of mark making which can be compared with the fluency of Chinese painting. Nothing could be further removed from the disciplined line of Ingres and yet both artists chose the medium which, apart from any reflection in temperament, best suited the problem.

Edgar Degas was an unusually inventive draftsman. He constantly experimented with combinations of drawing and painting media and sometimes used pastel in conjunction with thinned oil paint over the top of a monotype. His obsession with process is perhaps most evident in the large pastel drawings and yet his

recurrent use of this medium resulted from his attempt to combine the linear quality of Ingres with the spontaneous color of Delacroix. By literally drawing with color he was able to retain the precision of a linear statement and at the same time achieve the rich quality of layered colors. Each successive layer of pastel would be fixed and its application by hatching and crosshatching would allow the previous colors to show through. Degas had always been fascinated by the technical expertise of the Venetian masters, and by using pastel he sought to find a modern equivalent, creating optical mixtures.

David Hockney has often favored colored pencils for drawing portraits of friends and scenes while travelling. As a result, his choice of medium, whether intentional or not, provides a convenient method of recording accurate visual appearances. His ink portraits are also immediate and unique.

Kitaj 74

Far left *Christopher Isherwood and Don Bachardy* (1976), David Hockney. In 1969 Hockney made a portrait in acrylic of these two people in the same pose; both this earlier work and the lithograph shown here were inspired by a photograph Hockney took of the couple sitting in their home in Los Angeles. Lithography is an immediate and direct form of printmaking where drawings are made on prepared plates. This example was printed in gray and black on gray handmade paper; the soft, documentary line is characteristic of Hockney's draftsmanship.

Left *Study for Miss Brooke,* R.B. Kitaj. Like Hockney, who studied at London's Royal College of Art at much the same time, Kitaj is interested in figurative work. This pastel study shows a characteristic emphasis on contour – the profile of the sitter. Texture is brought out by working into the coarse paper and rubbing back.

Caricature Caricature is a type of visual shorthand designed to provoke, through exaggeration, some sort of response – recognition mixed with amusement at the very least, although social or political comment is often implied too. Like portraiture, the essential prerequisite is the ability to capture a likeness; the dividing line between portraits and caricatures is not always clearly defined. In general, however, caricaturists isolate and distort the characteristic features of their subject and are concerned not only with revealing personality but also with the social context. Many artists have shown a fascination with caricature: Leonardo, for example, made many drawings of distorted faces, revealing a preoccupation with oddity and disharmony almost as strong as his interest in perfection and beauty. True portrait caricature emerged in the late sixteenth century but not until the eighteenth century, with the work of James Gillray (1757-1815) and Thomes Rowlandson (1756-1827), was political caricature established as a *genre*. The French, caricaturist Honoré Daumier (1810-79) was one of the greatest exponents of this art form. Caricature is dependent to a large extent on line; this linear quality is particularly important for examples designed to be reproduced in newspapers and magazines.
1. *George Bernard Shaw* (1925), Sir Bernard Partridge. This watercolor caricature is a whimsical portrayal of the playwright, the emphasis being placed on the head, face and the aggressive, challenging pose.
2. *Sean Connery* (1974) Michael ffolkes. The humorous magazine *Punch* has featured the work of many cartoonists since its beginnings in the nineteenth century. This cartoon of Sean Connery is an example of the type of caricature which is funny and recognizable, but not savagely satirical.

1

3. *Salvador Dali* (1980), Richard Cole. Slightly more pointed in its humor, this pen and ink caricature of Dali incorporates Surrealist imagery from the artist's own work to make a striking comment.

4. *Thomas Augustine Arne,* (1710-78), in the style of Francesco Bartolozzi. This coloured etching shows Arne, a composer of music and song for theaters and pleasure gardens, in a humorous pose with his face caricatured. Arne composed the music for "Rule Britannia."

5. This modern illustration by Ian Pollock for a book jacket shows the use of watercolor to create a distorted, vaguely ominous figure.

JANE IN BLUE SHIRT
pastel on coloured paper

The choice of paper is the first consideration when beginning a drawing and will crucially affect the way that the work proceeds. When making a drawing on white paper, every mark, however dark or light, will be darker than the surface and will consequently imply contours or areas of shade. When working on darker paper, on the other hand, the addition of light marks will imply those areas of the subject that are affected by light.

Toned or colored paper is often a good choice of surface for a pastel drawing. If the paper is allowed to show through the drawn marks, it will work as a positive part of the drawing.

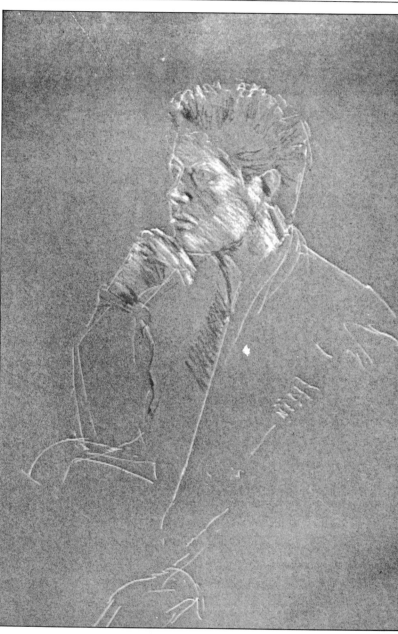

The model is seated in a fairly upright but comfortable pose, her head resting on one hand. From the artist's viewpoint, some distance away, the head is seen almost in profile, but a small portion of the other side of the face is visible (1 and 2). The drawing begins by establishing the position of the face and hand in white (3). Regular diagonal shading from left to right emphasizes the form of the head (4).

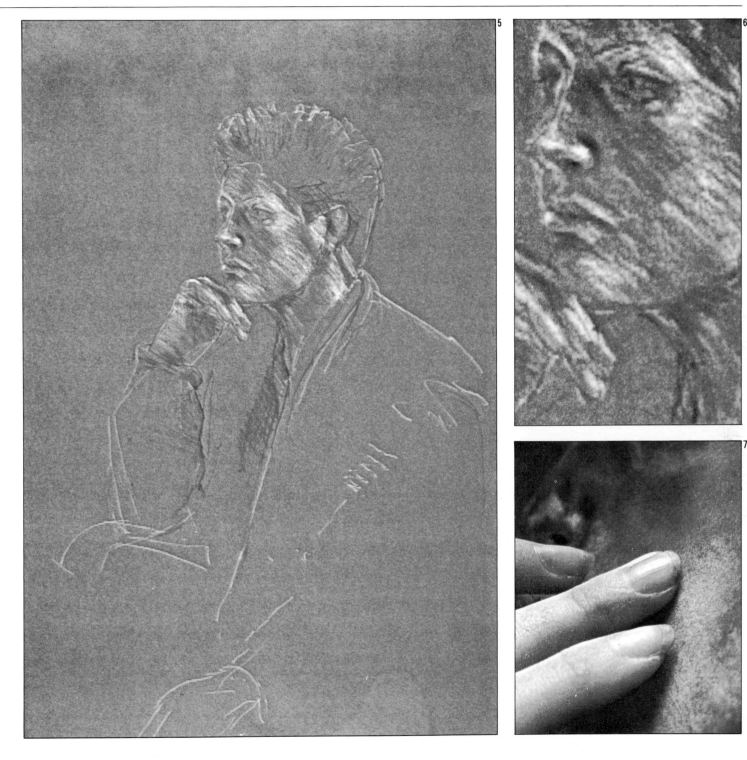

The artist continues to emphasize the dark tonality of the paper by overlaying different colors to build up the areas of the face and hands (5). On closer examination, it is possible to see that the range of marks includes dark strokes as well as the lighter flesh tints. At this stage work is concentrated on the most crucial part of the drawing; and background areas are only sketched (6). Areas on the throat and cheek are smoothed by smudging with the fingertips to create tones which contrast with the more precisely drawn contours. Care is taken not to disturb other parts of the drawing (7).

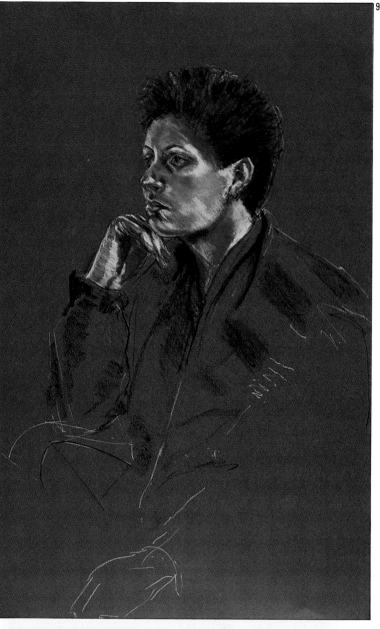

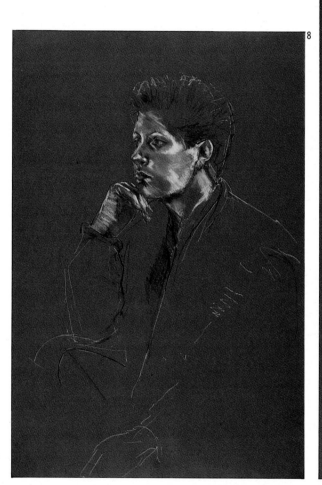

As the drawing nears completion, more emphasis is placed on the face and hand. The flesh tones become more substantial and a rich surface pattern is built up through the use of a variety of colors (8). The flexibility of pastels as a drawing medium means that they can be used alternately to delineate and shade. Here the bulk of the shoulders is suggested by the simple application of strokes of blue, with gaps left between them to reveal the color of the paper. At the same time, blue lines also serve to fix the contours of the figure (9). For finer detail, in the shadow areas under the eyes and around the mouth, the artist uses colored pencil. Rather than applying a range of neutral tones in these areas of shade, green and blue strokes are used which merge with the brown of the paper to create richness and add a sense of volume and depth (10).

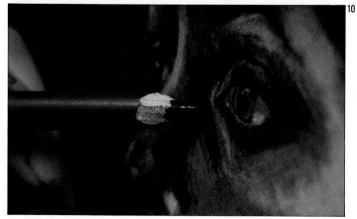

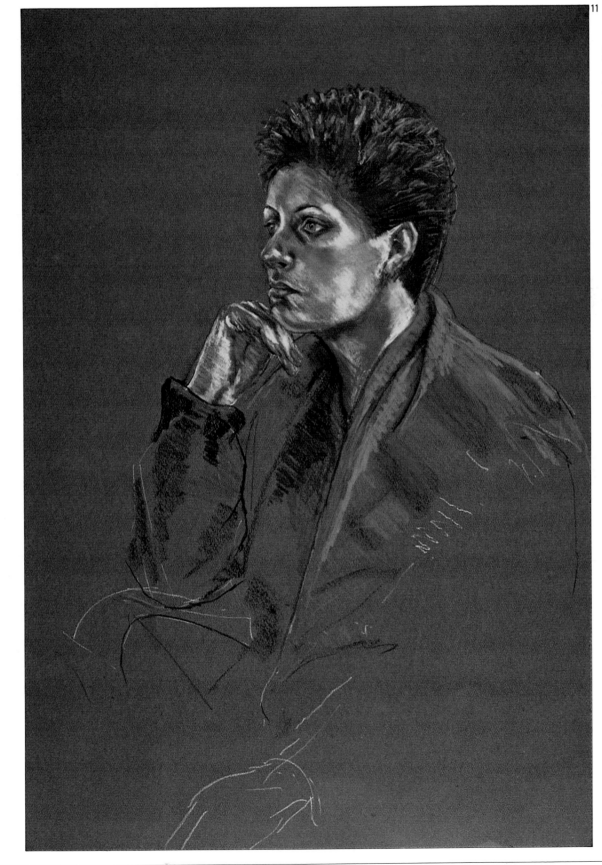

11

Pastel drawing is probably the most substantial way of applying pigment to a surface and the methods of application vary widely. Although it is generally assumed that pastel is best suited to a fairly broad treatment, considerable delicacy and precision of line are possible by taking care while drawing and spraying with fixative at regular intervals. By crosshatching or applying the strokes in different directions, an optical mixture will occur where one color overlaps another. When viewed at a distance the colors will appear to merge, giving a richness of quality that would not be so apparent with flat areas of color. In the finished drawing, the brown of the paper also contributes to the sense of depth, cohering the entire image (11).

Below Detail of *Virgin of the Rocks,* Leonardo da Vinci. Leonardo's technique involved a warm brownish underpainting, followed by the working of blues, purples and cool colors and finishing with warm glazes. This detail illustrates the bluish paint visible through the flesh tones on the Christ child's nose.
Right *Portrait of a Man,* Titian. Painted in a later style in oils on canvas, this is a striking portrait, sometimes thought to be of the young Titian himself. Textures are vividly represented, and the fluid paint handling shows a development from the opacity of Leonardo's layers.
Far right *A Woman and her Child,* Sir Anthony van Dyck. Famous chiefly for his portraits, this Flemish artist treated his subjects with an individual liveliness and confidence. Working a century later than Leonardo, the relaxed pose and happy atmosphere are a sign of an increasing informality in portraiture, balanced by an increasing ease with the medium.

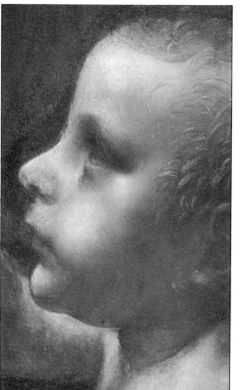

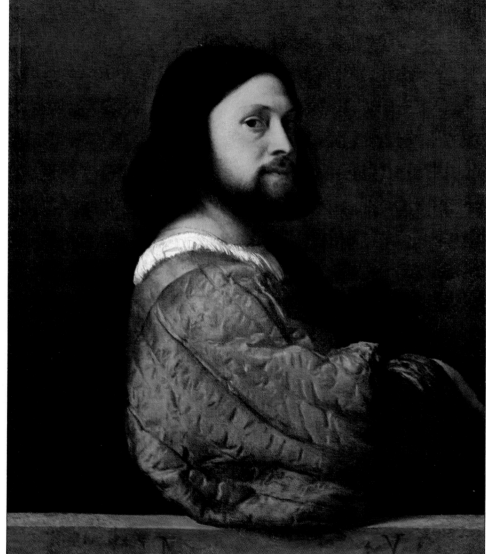

in a method of application that allowed for considerable change while painting, rather than the method favored by the Flemish painters which involved establishing the design with a pointed implement and adding paint afterward. Leonardo painted the preparatory areas by establishing tones rather than a linear structure – a method that was only worthwhile using semi-transparent paint. Although he succeeded in finding a clearer oil medium than had previously been used, it was still warm in tonality and not perfectly transparent. In order to compensate for this warm glaze, which he always knew would yellow with age, he began to paint preparatory stages, the main shapes and forms, in blue-purple tones. To deaden the effect of these colors, which would be too pronounced if set on a white priming, he first prepared the panel with a yellowish-brown ground. By following this procedure Leonardo started with a warm, mid-toned ground, painted in cool colors and finished by adding warm color again. Many of his contemporaries did not follow this method and preferred to work from a linear drawing and from a light ground into dark. The logic behind Leonardo's apparently complex procedure and much of his originality regarding technique was misunderstood.

A problem with Leonardo's theory was that a painting often arrived at a finishing stage before the complete procedure had taken place, and the final warm glazing, which all the previous applications had been anticipating, was unnecessary. Vasaris has stated that this happened to the *Mona Lisa*; although it progressed over a number of years the final glaze of color was dispensed with and the picture abandoned as unfinished.

Obviously, for a glaze to work it must be darker than the color to which it is being applied; in other words, the glaze will only provide the richness and depth anticipated if the underpainting or previous glazes have a lighter tonality. They work in the way that stained glass is only bright when the light outside shines through. Leonardo's obsession with creating a strong feeling of volume by emphasizing the darkness of shadow in the preliminary stages meant that the painting

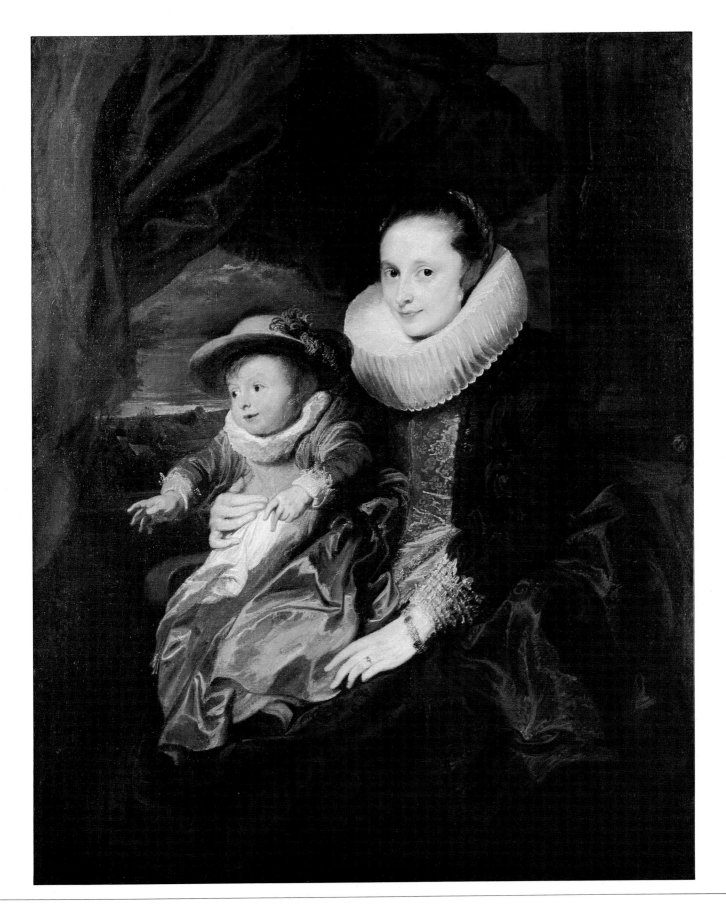

often reached a point where the shadows became unrealistically black, rendering useless any subsequent glazes. Shadows are not usually light in tone but in many instances, the shadow areas of Leonardo's paintings are completely opaque. Many painters after Leonardo tried to remedy this by understating the shadow darkness so that the final glaze of paint would be more effective.

The Venetian painters were quick to exploit the possibilities of oil paint and adopted many of the procedures tried by Leonardo. By subdividing the activity of painting, they were able to consider the initial stages of each picture tonally and only the finishing stages in terms of color. The use of *chiaroscuro* provided the tonal foundation for their application of countless transparent glazes of color. Whereas the Flemish paintings were distinct and detailed from early on, and Leonardo brought the early stages of his paintings near to completion monochromatically, the Venetians ignored the details and kept the shape of the painting as loose as possible until much later, to accommodate the subtleties of the final stage.

Because the final glaze relied for its effect on being darker than the preceding one, the Venetian painters deliberately understated the darkness by using reddish-brown rather than purplish-blue. The lightest areas of the painting, usually the skin, would be painted thickly over the mid-toned ground and would be almost white in the lightest part. If there was any clothing or drapery, this would be painted in the light tones of its local color, often over the top of a priming made in the complementary of the final color. Similarly, when painting a blue sky, warm cream or brown would first be underpainted to bring out the intensity of the blue before the final glaze. By making the shadows slightly lighter and by making the lights slightly lighter also, some areas being almost white, the whole picture would develop so that it was perfectly suited to the application of a final glaze of transparent color, which had the effect of permanently darkening and enriching the picture.

When painting flesh the Venetians were able to dispense with blue because the coolness resulted from the light flesh tones being placed over the darker underpainting. In comparison to Flemish painting, in which the color of skin often involved the addition of blue, the Venetian effect occurred through the optical mixture of pigment. Both techniques resulted in a pearly skin quality often found in reality.

The complete Venetian procedure was similar to the first and only stage of the Flemish technique. Venetian painting involved the use of a range of tones which, if considered as a line, could be seen to begin with dark transparent glazes, progress to semi-opaque mid-tones created using a little white, and end with thick, opaque white paint. This range is based on the way that, in reality, the shadows tend to sink into a scene whereas the highlighted areas are most readily seen. By carefully modulating the paint in this way the result often looks as though it was painted all at once.

This kind of painting procedure was adopted throughout Europe and it was generally considered that dark shadows should be transparent and light areas opaque with half-tones being formed by a mixture of both. In the hands of Rembrandt, Rubens and Velasquez this procedure resulted in powerful yet subtle effects of light and shade. With great experience gained through studying the early developments in oil painting the artists of the seventeenth century were able to take more liberties with the methods of application, and despite the similar use of the transparent shadows and opaque lights they developed a highly personal visual language.

An Increasing Spatial Awareness
When comparing a portrait by van Eyck with one by Velasquez it is apparent that apart from the technical differences there is a quite different feeling about the space conveyed through the paint. As artists became aware of the relationship between painting procedures and optical experience, certain changes occurred in the way in which the artist observed reality. Van Eyck's creative ability combined with a subtle use of oil paint enabled him to create a vast array of tactile and visual experiences. Coupled with an awareness of perspective, this technical breakthrough resulted in an art form that has enjoyed popularity because of its apparently imitative nature. However, to consider what actually happens while observing an object that is close at hand is to realize that van Eyck's illusion of reality is in fact paradoxical.

When van Eyck painted a face, the microscopic detail would suggest that he chose to observe his model from a close vantage point. It is fair to assume that, armed with a technique capable of rendering precise surface detail, van Eyck was intent on pushing it to the limits by focusing his attention on each hair and wrinkle in the hope of recreating the complexity of nature in paint. However, when considering the painting as a whole, the result is at odds with his intention. Although some objects are further away from the picture plane than others, they are all treated with the same degree of focus. In *The Marriage of Giovanni Arnolfini and Giovanna Cenami* (1434), all the objects behind and in front of the two figures are painted with the same degree of precision as the two figures. The chandelier, the mirror, the fruit and the sandals are all rendered with a remarkable degree of accuracy. Although each object is presented in its correct spatial position, its accuracy and sharpness would suggest that van Eyck painted each one from a close vantage point and then carefully positioned all of them in their respective positions in the painting.

Although this phenomenon is evident in Italian painting it is more pronounced in Flemish painting because of the tradition of depicting deep space. If an artist is painting a face by sitting very close to the subject, the area around will appear to be out of focus unless attention is deliberately shifted to what is behind the figure. If the same figure is seen from some distance the volume will be less distinct, and there will be less distinction between the figure and its surroundings. Because the flat surface of van Eyck's picture is an object, the spectator can see the face of the man and the chandelier behind quite clearly at the same time. In reality, however, the distance between the two would not allow a viewer to focus on both without either the face or the chandelier being more prominent. Although the composition of the picture is unified in terms of a balanced distribution of masses in space, the fact that each object is observed in isolation results in a disjointedness that is different from the effects achieved by Velasquez and many painters since.

When painters after Leonardo began to used a toned ground, the procedure of painting with transparent shadows and opaque lights ensued. The technical preference resulted from an awareness that objects and people must be affected by light in order to be visible at all. An object in shadow is less distinct and when painted it could be rendered effectively in transparent paint with blurred contours. Leonardo's painting is different from van Eyck's because the shadow areas of a figure or object are pushed back in the picture by transparent glazes. The Venetian painters Giorgione and Titian grasped this phenomenon and also realized that it was essential for the painting to have a convincing pictorial unity. In other words, it should represent a view that would be consistent with the artist looking at the whole scene at once. They retreated from the close vantage point of the Flemish masters in favor of a more distanced view.

The use of a colored or mid-toned ground for painting emerged through the desire to present the tonal gradations of light and dark by working from the tonal center outward, rather than from light to dark. This so-called *chiaroscuro* enabled the artist to unify the picture in terms of light and dark rather than in terms of individual objects. It could not be said that van Eyck was unaware of light, on

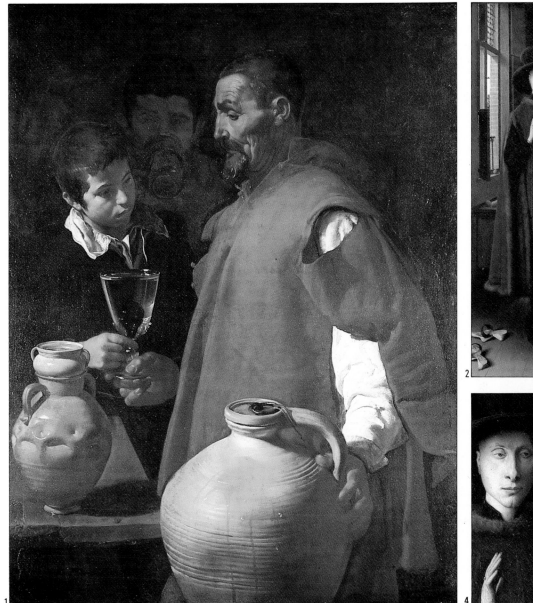

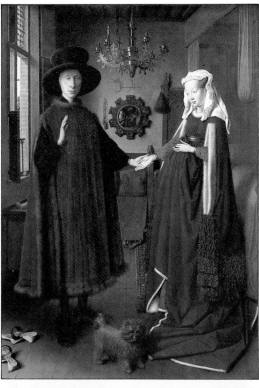

The increasing spatial awareness It is interesting to compare Velasquez' *Merchant of Seville* (1) with van Eyck's marriage portrait (2) when considering how artists' spatial awareness increased between the 1430s and the 1630s. This awareness reflected a growing understanding of the potential of oils and of the way light and color change throught space. Velasquez distanced the figure behind the merchant and the boy by darkening and blurring his face and his clothing. When compared with the almost tangible, stark realism of the merchant's face (3) and the ceramic jug, these techniques make the background figure less immediate within the picture; however, when noticed, he is equally lively and an integral part of the scene.

The room portrayed by van Eyck, working 200 years earlier, is bathed in a uniform light, and the objects in the background are as distinct as the faces. As can be seen in the detail (4), the chandelier and the mirror are painted as intricately as Arnolfini's face and hat, the only indication of space being the use of perspective. The result, despite the awesome realism of each section of the picture, is dislocated as each object demands equal amounts of the spectator's attention. By comparison with Velasquez' portrait, which gives an indication of a story, the marriage portrait is a simple statement of fact; the objects and people, observed in isolation, are not coherent enough to imply that the figures ever lived, or grew old.

Below *Don Andres del Peral*, Goya. The Spanish artist, painting at the turn of the nineteenth century, was profoundly influenced by Caravaggio and Velasquez. **Right** *Madame Moitessier Seated*, Ingres. This portrait, finished in 1856, displays the wealth of the subject, a member of the French bourgeoisie during the Second Empire. The blatant expense of the gown and luxury of the setting are represented in minute detail. **Far right** *Elena Carafa*, Edgar Degas. Painted 17 years later than *Madame Moitessier Seated,* this portrait displays different artistic aims. The colors, patterns and textures are briefly described and epitomize Degas' ability to sum up atmospheres economically.

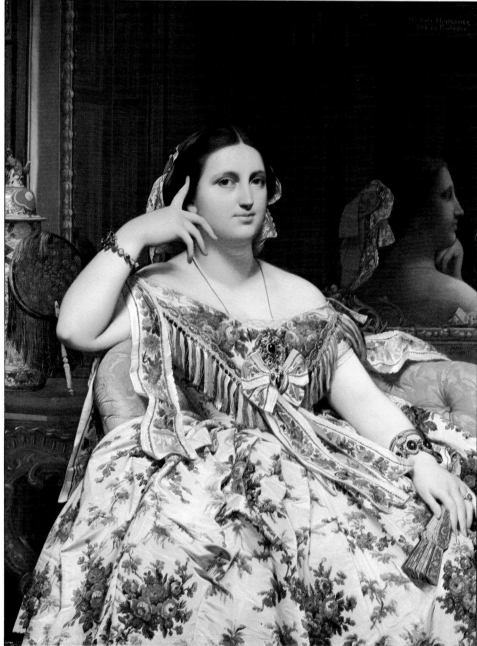

the contrary his objects would be invisible without it, but he did not consider it as a means of unifying the picture, only as a means of imitating reality. Through Venetian art and on to Velasquez, the idea of light and dark being used as a unifying factor becomes more apparent. In early Velasquez, objects still retain that bulbous reality associated with the close vantage point. The early portraits are so solid, it seems to be possible to reach out and tap the skulls. With experience, Velasquez played down such obvious illusion and by distancing his vision he sought to describe not just the faces and objects but the distances in between.

Although the difference between van Eyck and Velasquez may not seem important, the development from one to the other has left its indelible mark on the history of Western art. It is sometimes assumed that when an artist is composing a painting, the physical organization of objects and people in space is the main problem. When the portrait painter is confronted by a subject, the position of the figure in relation to any other objects in the room should, perhaps, be considered. Van Eyck, for example, positioned objects in the marriage portrait with considerable care in order to achieve some kind of balance. The equal distribution of possessions around the room accords with the overall symmetry of the design. The spatial organization of such a painting results in a distinct difference between foreground and background, and while the figures and the objects may be considered as positive, the space around and behind may be considered as negative.

By comparison, in *Las Meninas*, by Velasquez, there is less emphasis on such a distinction, and foreground and background are unified as the result of a different approach. When Velasquez prepared the composition, rather than move the objects he moved his own position; by forgetting about the individual characteristics of objects he considered the pictorial organization of his subject in terms of lines and shapes. He distanced himself from the subject and attempted to recreate in paint a momentary glimpse of reality. Although each area of the painting would have required individual attention during the physical act of painting, it would have been conceived as part of the whole. In this respect Velasquez looked at the distribution of light and dark rather than the distribution of people and objects.

Late nineteenth-century portraits

1. *Captain Frederick Burnaby,* James Tissot (1836-1902). This nonchalant pose epitomizes the ease and gallantry of a popularized nineteenth-century ideal: Captain Burnaby was a hero of his time. Reputed to be the strongest man in the British Army, he died from a spear wound in Khartoum in 1885.

2. *Cha-u-Kao, the Female Clown,* Henri de Toulouse-Lautrec (1864-1901). Breaking ground with his unusual viewpoints and compositions, Toulouse-Lautrec represented Parisian low life in his drawings, paintings and lithographs with enormous vigor and sympathy.

3. *Study for Madame Pierre Gautreau,* John Singer Sargent (1856-1925). The finished work for which this is a study caused a scandal when it was first exhibited in the Salon of 1884 because of the daring pose. The black dress is treated almost as a negative space, throwing the white flesh into relief, as if it were a portrait bust placed on a column.

4. *Self-Portrait,* Vincent van Gogh. The artist's many hundreds of pictures had a strong influence on abstract painters because his aim was not to use colors to reproduce visual appearances but to express, and cause, emotion. He suffered, particularly toward the end of his life, from depressions and hallucinations; the thick, swirling paint quality of this self-portrait expresses this mental anguish. Colors not usually associated with flesh are included, not just to complement the skin tones but as an integral part of the total impression.

5. *Woman in Black,* Mary Cassatt. This portrait, painted c 1882, is composed to boldly fill the canvas. The paint is loosely and thinly applied in large brushstrokes, but the outline of the dress is solid. The face and hands are well observed and painted with more opaque pinks and whites. To soften the outlines of the fingers, the paint was dragged, when wet, with a clean, dry brush. The result is lively and impressionistic.

The Impressionist painters were quick to identify with the apparent casualness of Velasquez' technique but they were not enamored with the use of *chiaroscuro*. The idea of considering light in terms of dark and light amounted to a kind of visual heresy. The colors in the spectrum produce white light so it was assumed that light in a painting could be created by the juxtaposition of colors rather than tones. The disintegration of the boundaries between foreground and background continued with the result that objects were deprived of their tangible volume and described in terms of light flickering across

their surfaces.

Although the liberation of color enabled the artist to dispense with the more laborious academic procedures involved in making paintings, it imposed certain limitations in terms of technique. By rejecting the tonal ground in favor of a white one, the Impressionist painters wanted to achieve luminosity and freshness, but this was at the expense of a richness and subtlety. In the same way that Velasquez translated the individual characteristics of a person or object into areas of tonal relationships, so the Impressionists translated and dissolved that

tonal structure into areas of color.

When confronted with a figure, the Impressionist painter would consider the shadow area of the face as a series of patches of color and reflected lights. The apparent blueness of a shadow would be simplified as a blue shape; if this shadow occured on the side of the nose then it would be considered with the same impartiality as the shadow on a vase. The fact that it was part of the nose would be almost irrelevant, and the main concern of the painter would be to forfeit anatomical integrity in favor of the pictorial organization of color. The problems of reconciling human

Above *Self-Portrait*. Gwen John (1876-1939). A women of independence and determination, the British artist Gwen John spent most of her life almost as a recluse and in great poverty, despite much hard work. The pose and mood of this self-portrait, painted in her mid-20s, exemplifies that of many of her portraits of others – pensive figures viewed frankly in half-length poses. Her subtle use of oils displays a control over the medium; she exploited many shades of similar colors, mostly browns and rusts, to create a warmth and uniformity.

Right *Interior near Paddington 1951*, Lucian Freud. The realism of this portrait lies in the meticulous observation of the room and the view through the window. However, this technique also creates confusion; like van Eyck, Freud disregards the way objects further away lose their clarity, and as a result there is an underlying sense of unreality. This, combined with the unrelenting brownness and the unspecific title, attempts to deny the individuality of the figure, who nevertheless possesses a unique face.

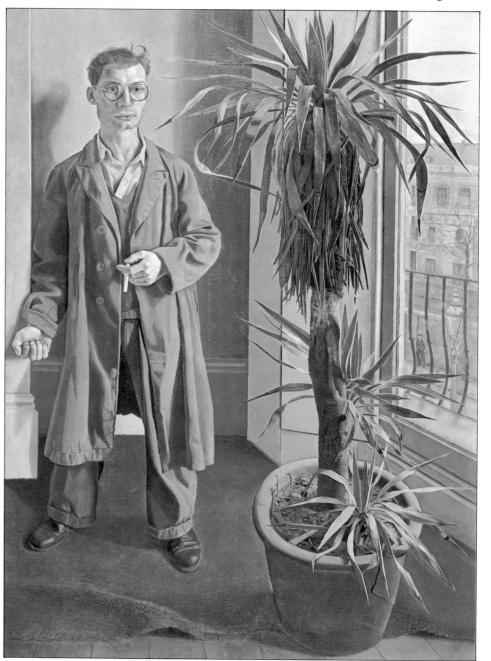

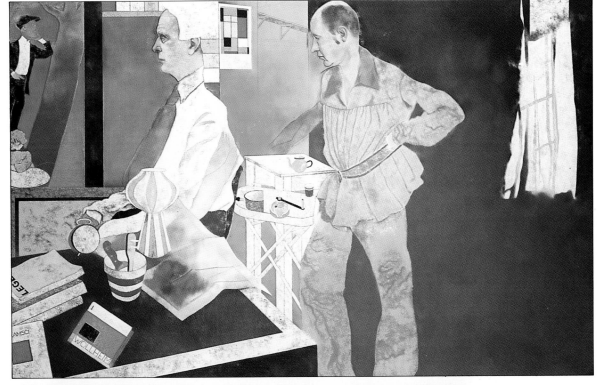

Left *From London (James Joll and John Golding)*, R.B. Kitaj. This double portrait, finished in 1976, gives a lively impression of the two men and their room with small details adding particular interest. However, unusual techniques create a disconnected vision. Bright colors are used for their inherent qualities and not because they imitate reality.
Below *Melanie and Me Swimming*, Michael Andrews (b 1928). Fully evocative of a watery scene, the clear colors and sharp outlines of this work are painted in acrylics on canvas. The blackness of the water seems transparent, partly by inference because the man's lower limbs are distorted through the ripples. The skin pinks and the whites of the splashes are shaped to give a strong sense of movement, while the mutual trust of the two is evident in the balance between them.

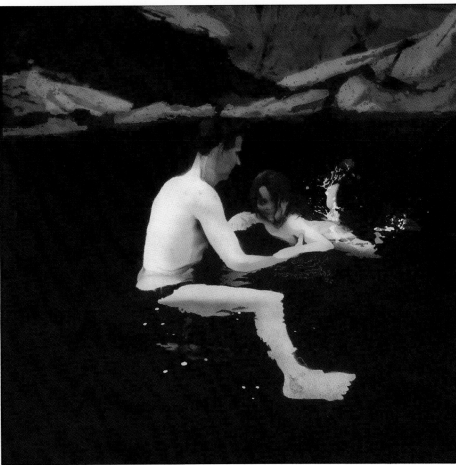

appearance and emphatic color perhaps accounts for the rift that occurred between those artists intent on exploring light and color and those intent on describing human appearance. The work of Edgar Degas provides the visual evidence of this dilemma. His transition from the early tonal portraits to the monumental figure studies of his maturity shows how his predeliction for describing the particular characteristics of his individual sitters gave way to the more universal images of his later nude figures.

Degas' attitude to painting portraits resulted from an empirical understanding of the work of the Old Masters. He was obsessed with trying to recreate the same subtlety that he admired in Venetian painting and yet ironically ignored all documentary evidence on the subject of technique and also the recent scientific experiments in the chemistry of painting. The problem with basing technical knowledge on direct observation of completed paintings arises because the surface denies any investigation of the preparatory stages. Although there is considerable written information relating to technical procedure, it cannot be assumed that painters did not deviate from accepted conventions, and certainly technical advances involved at least a partial rejection of what had gone before. The would-be portrait painter of the present is faced with an abundance of technical choices and historical precedents.

Painters have found more scope in the description of human appearance than in any

other visual phenomena. The twentieth-century has seen the portrait as a subject for dissection: Picasso delighted in rearranging the human face in a way that his predecessors would have found incomprehensible. In an effort to keep in step with the twentieth-century style, artists have subjected human appearance to a vast array of pictorial surgery, removing and isolating features and presenting different views of the same person in one pictorially unified image. More recently some artists have tried to reconcile twentieth-century ideas with the practices of the masters of the preceding centuries.

COLOR THEORIES

During this century there has been a pronounced interest in the use of pure color, and consequently an abundance of information relating to its theory. In many instances the use of color is considered in relation to the color wheel and the respective roles of primary and secondary colors. The theories themselves have existed for centuries, independent of verbal formulation. It is not necessary for artists to research the theories scientifically, but before starting to paint, it is worth understanding basic color relationships. The practical application of this understanding is, however, limited by the fact that painting does not always involve uncomplicated color combinations. A further problem is the fact that the very nature of paint necessitates some consideration of the color value of the prepared surface of the panel, paper or canvas.

The color wheel is a useful, quick guide to understanding simple color theories. The artist's three primary colors – red, yellow and blue – can be mixed in pairs to create three secondary colors – orange, green and indigo. The wheel illustrates these six hues merging to form a complete circle, each color being opposite its complementary. Red is opposite green, yellow opposite indigo and blue opposite orange. The complementary colors are mutually enhancing and have been juxtaposed in paintings to create extra intensity or emphasis throughout the centuries. They may also be painted in layers to give depth. For example, a warm cream of brown color may be painted beneath a blue sky and the result be close to the reality it attempts to represent. Similarly, a pink provides the muted complementary to green, The complementaries do not need to be of equal intensity to provide the required effect.

Any color can be varied in tone and in intensity. The tone of a color depends on its lightness or darkness against an imagined scale ranging from white to black. The intensity or chroma of a color depends on how much color there seems to be when, for example, an object is seen through the

atmosphere, or when pigment is mixed in water or some other transparent medium. For instance, the local green color of a tree will gain a bluish tinge at a distance; similarly, a pinch of powdered pure red pigment, although very intense and bright at close range, would become semi-transparent and pale when diluted with water.

Such definitions and theories lead to a consideration of a particular quality of color as an idea and not in relation to its practical application. The artist who is concerned to reproduce exact colors must take care when purchasing pigments, because these theories only work if the pigments are pure. Artists' colors, particularly cheap ones, are often impure and, when mixed with others, may produce unexpected or slightly muddied results.

Presuming that the paint is reasonably pure and can be controlled, any one color is capable of taking on different aspects depending of how it is placed in relation to others. In pre-Renaissance paintings, when the number of available pigments was severely limited, one color might have been given two or three different values by careful placing or layering. As well as being aware of the value of complementaries, it is vital to notice the warmth or coolness of colors. Orange and red are usually considered to be warm in comparison with a light blue, for example, but such generalizations can easily be rendered meaningless by the actual activity of one particular shade next to or over another. By placing a warm color such as red transparently over a blue, the cool color might be affected in such a way that it appears to be warm. The greatest advantage of oil paint is its natural transparency which enables artists to render these color differences optically rather than just physically by mixing.

MEDIA

The boundaries of portraiture are almost indefinable, and the methods and techniques by which they may be created can no longer be defined in the rigorous terms of previous centuries. The fact that oil paint dominates the history of portraiture does not preclude the use of other, more immediate methods of painting.

Experiments in Watercolors and Gouache

Watercolor and water-based gouache paints are suitable for quick color studies and the limitations of such techniques in portraiture are compensated by their advantages. The importance attached to oil paint is mostly due to its imitative abilities. It is not possible to paint skin with such accuracy in watercolors but their transparency is suited to experiment, and to coming to terms with paint generally. An awareness of the fluid nature of handling

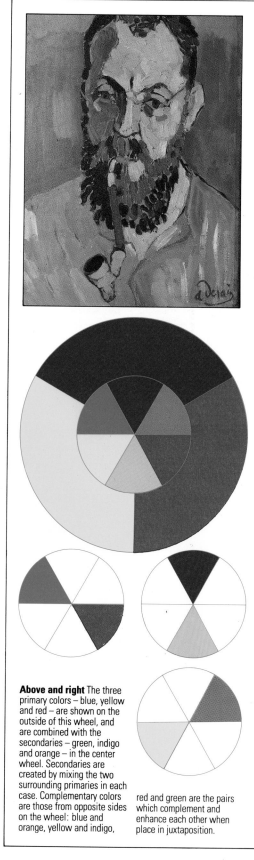

Above and right The three primary colors – blue, yellow and red – are shown on the outside of this wheel, and are combined with the secondaries – green, indigo and orange – in the center wheel. Secondaries are created by mixing the two surrounding primaries in each case. Complementary colors are those from opposite sides on the wheel: blue and orange, yellow and indigo, red and green are the pairs which complement and enhance each other when place in juxtaposition.

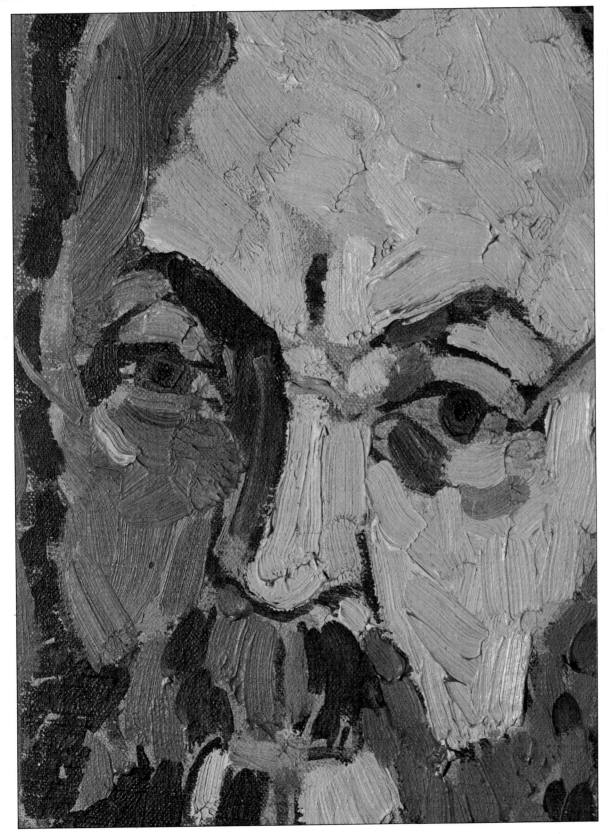

Far left *Portrait of Matisse,* André Derain (1880-1954). Derain was a member of the Fauve group of artists which included Matisse, Rouault (1871-1958) and Vlaminck (1876-1958). They were all interested in the use of pure color to express emotion; sometimes they used it arbitrarily or for decorative effects, but otherwise to create volume, as Cézanne and van Gogh had done before. Here, Derain exploited intense colors to mold the shape of Matisse's face seen in a strong light.

Left This detail shows how the artist worked *alla prima,* applying all the paint in the same stage, working "wet into wet" on the beige ground which is left bare in places. The thick paint and obvious brushstrokes provide a heavily textured result which matches the boldness of the color. Reds are set against dark greens, and blues against oranges.

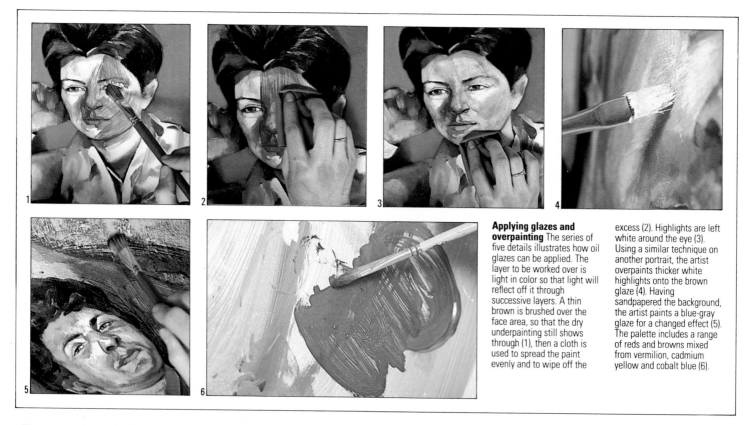

Applying glazes and overpainting The series of five details illustrates how oil glazes can be applied. The layer to be worked over is light in color so that light will reflect off it through successive layers. A thin brown is brushed over the face area, so that the dry underpainting still shows through (1), then a cloth is used to spread the paint evenly and to wipe off the excess (2). Highlights are left white around the eye (3). Using a similar technique on another portrait, the artist overpaints thicker white highlights onto the brown glaze (4). Having sandpapered the background, the artist paints a blue-gray glaze for a changed effect (5). The palette includes a range of reds and browns mixed from vermilion, cadmium yellow and cobalt blue (6).

will prepare the artist for the more daunting prospect of painting in oils or acrylics. The opaque quality of gouache, which has white added, is useful for practising working up to the lights, with pure watercolor used for shadows and mid-tones.

Another advantage to experimenting with water-based paints is the relatively inexpensive support that is required for the purpose. Although watercolor paper is preferable, any fairly substantial paper will suffice and this may be pinned to a board or soaked in water and attached to the board with lengths of paper tape around each edge. Once the paper is glued to the board in this way it will shrink when dry and be stretched taut enough to absorb the wet pigment without the surface wrinkling.

The Use of Acrylics

The most significant development in recent pictorial techniques is the invention of acrylic paint. The properties of this versatile medium are often underestimated and they possess many of the characteristics of both oil and watercolor. Unlike both, acrylic paint dries in distinct layers and is therefore well suited for glazing. With watercolor, the subsequent additions of paint to the same area of paper dissolve and mix with the preceding ones, except at the edges of dry areas. The problem in oil painting is that the length of time necessary for an area to dry conditions any

further applications of paint to the same area. Acrylic paint's most distinctive advantage is its ability to dry quickly and permanently. This allows the artist considerable freedom and allows constant changes to occur throughout the procedure. Acrylics may be used on paper, cardboard, masonite and canvas with equal success. When used on paper the properties of acrylic are similar to those of other water-based paints: when they are used on canvas their properties are not dissimilar to those of oil paints.

One of the most interesting and useful qualities of acrylic paint is that it can be employed in conjunction with, or instead of, oils. Rather than working directly into a white ground with oil paint, the initial stages of the work may be indicated with washes of acrylics. Because of their quick-drying qualities, they are suitable for spontaneously and creatively establishing the main forms of a portrait.

Often the most daunting yet enjoyable aspect of painting involves coming to terms with the untouched surface of the canvas. For the painting to progress, it is necessary to cover the areas of white primer. By using acrylic paint the whole surface may be covered with a thin wash of color, or alternatively different colored washes for different parts of the painting. This may be particularly helpful when the subject is situated against a light-colored surface such as

an interior wall. If the artist attempts to paint something of light tonality onto a white ground, the color may appear to be lifeless. By first painting the area in a mid-tone or a neutral gray, the final color will appear to have more body. By using acrylic paint for this purpose the painting may involve several layers of quickly applied color which, if they were in oil paint, would take a considerable time to dry. It should be remembered that it is not possible to paint with acrylics over oil paints.

The choice of technique is obviously a personal matter and may depend on the time available or the size of the painting in question. Using acrylic the portrait painter will be able to paint the initial washes of transparent color in the same sitting as the oil paint. This kind of technique is considered by many to be indispensable when approaching the difficulties of painting human skin. Although some painters since the time of the Impressionists have favored the technique involving the direct application of opaque paint onto a white surface, this is not suited to conveying the subtlety of human skin. Prior to the nineteenth century, painters realized that fair skin often changes in color depending on reflected light and the color of the surrounding objects. It was also realized that the tone of the skin appears to be cooler in some parts of the body, especially where the bone structure is more visible. By using a cool

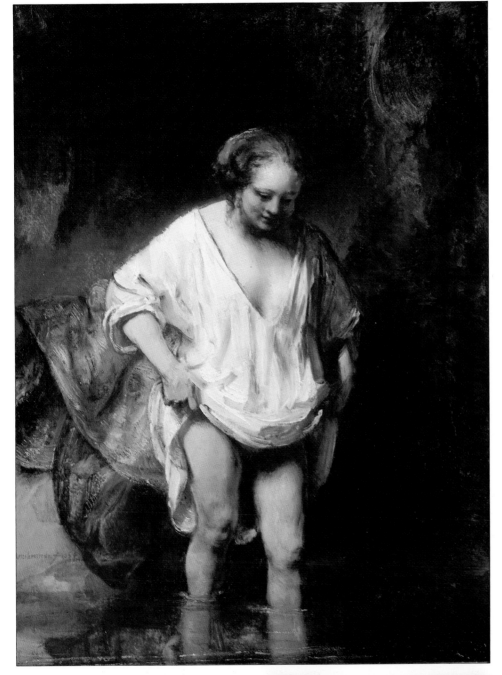

underpainting of blues and greens, thinly applied flesh tones will give this impression; the skin at certain points on the forehead, for instance, can be made to look thinner than the skin of other parts of the body.

Oils

If the artist chooses to use oil paints, any preparatory application of paint, unless left to dry, will mix physically with the subsequent paint applications. Oil paint is a remarkably versatile and flexible medium, and many artists have capitalized on its slow-drying quality by moving the paint about on the surface for the duration of the painting. The technique of *alla prima,* or painting the complete picture in full color in one session, has gained popularity since the nineteenth century. This usually involves working directly onto a ground with wet paint and adding color without gaps for drying. The spontaneity of such an approach can be more immediately creative, and painters who prefer this method rarely resort to any preparatory stages on the canvas itself. However, the activity of painting "wet into wet" can sometimes lead to an uncomfortable build-up of paint which, because of its opacity renders the ground color or priming useless. The physical thickness of the paint itself can clog the surface to such a degree that further application is hindered, and in this situation it is sometimes as well to scrape off the excess paint.

Occasionally, however, this kind of necessity provides interesting results that could not otherwise have been anticipated. A close examination of some of Degas' paintings reveals that he used this kind of accidental effect to advantage. His creative nature was often not satisfied by the results of orthodox painting procedures and sometimes while painting a figure he would feel that the head was being overpainted. He would then wipe away the excess paint and in the course of so doing reveal a more interesting paint quality closer to his intentions. Rather than wiping out the image completely, Degas would keep the remaining thin paint or stain which suggested a particular quality or mood that the more logical paint application hindered. Although he was interested in traditional methods of oil painting, his personal technique did not rely on such means of describing visual appearance. Even a cursory glimpse at his paintings reveals quite different techniques varying from thin transparent washes to thick opaque paint. Sometimes he applied the paint in short strokes or hatchings, sometimes in carefully modulated areas. In some parts of the painting the grain or tooth of the canvas would be evident and yet an adjoining area would reveal a history of color changes.

Above *Woman Bathing in a Stream,* Rembrandt van Rijn. The woman's skin is painted quite thickly in the highlights and with great tonal subtlety to give an impression of solid flesh in a diffused light.

Right Detail of *Two Ladies of the Lake Family,* Sir Peter Lely. Blended tones and precise attention to detail are exploited to achieve the smoothness of flesh. Green underpainting and the weave of the canvas show through in shadows while the highlights on the cheeks, nose and earring display fine modelling. Thin strands of hair add to the finesse.

Surfaces

Before any painting can begin, the artist must first select the medium and then prepare the painting surface and the palette. If acrylic or oil is accepted, then it will be preferable to prepare a canvas or a panel. Different kinds of wood may be used for panels but the cheapest and most convenient is masonite. It is available in large sizes: these provide expansive work surfaces without needing to join the pieces together. First of all, it is preferable to wipe the masonite surface free from grease with gas or denatured alcohol and then, if a gesso ground is required, the panel should be sized on both sides with a preparation of rabbit-skin glue to prevent warping. The glue may be obtained from an artists' suppliers, or an equivalent from interior decorators may be used called anti-fungal decorating size. The granules are dissolved in water until soluble and then, with the addition of more water, heated gently in a double boiler. Although the size should not be boiled, it should be applied to the panel while it is still hot. The same preparation may be used on canvas.

When the glue is dry a further preparation made from one part glue size solution, one part whiting (made from French chalk or precipitated chalk) and one part zinc oxide powder is applied while it is still warm. On drying, further coats may be applied. It is always preferable to use the smooth side of masonite, which may be roughened slightly with some fine sandpaper to give the primers something to grip to, and several thin coats are preferable to a thick coat.

If a canvas support is required it will be necessary to stretch the canvas over a wooden frame known as a stretcher. These may be bought ready-prepared from art shops or alternatively made especially for the purpose. The obvious expense of buying commercially prepared stretchers has resulted in many artists preparing their own. Most art students make them with lengths of 3 × 1in (8 × 3cm) wood: each side of the stretcher is lap-jointed or mitred and then glued and screwed. If the stretcher is to be larger than 3ft (1m) square, it may be necessary to add lap-jointed cross-bars for extra support. It must be remembered that once the canvas has been stretched and sized, it will shrink and exert considerable stress on the stretcher, while it is drying. Unless the wood is sufficiently supported or strengthened it will warp; the larger the painting the more cross-bars will be required. In a stretcher of moderate size, for example about 5 × 4ft (1.5 × 1.2m), one cross-bar will probably suffice.

The quality of different canvases varies considerably. They are usually available in materials such as cotton, linen, hemp and jute, and also in different weights. The important thing is that the weave is close and

free of knots and flaws. The easiest method of stretching canvas is to use a staple gun. Although tacks were originally used, the ease with which staples may be applied makes this concession to the twentieth century an invaluable time-saver. Roughly staple the canvas in its approximate place with the weave parallel to the sides, using one or two staples at each corner. Continuing from the center of one of the longest sides and on the side directly opposite, apply the staples either to the back of the stretcher or the outside edge. Moving to one of the shorter sides and then to its opposite, add a few more staples. When each side is firmly attached by three or four staples in the center, check that the weave has remained parallel to the sides of the stretcher. Work out from the center of each side by adding half a dozen staples or so and then turning the stretcher around so that each side progresses evenly to the corners. By

Right A particular canvas may be chosen for the size of its weave, for its roughness or smoothness, for its imperviousness or for the way it absorbs the paint. Canvases are made from linen, cotton, a linen-cotton mix and jute. Unbleached calico is a cheap cotton weave (1). A good quality cotton canvas feels as fine as linen when it is well primed (2). Jute is coarse and needs effective priming if a smooth effect is required (3). Linen (4 and 5) is generally available in several sizes of weave, the most expensive being closely woven. Linen primed with acrylic is multi-purpose (6).

Above left Detail of Te Rerioa, Paul Gauguin. Taken from one of his Tahitian paintings, this details shows a woman's eye which was painted on rough, unprimed jute. The coarseness of the canvas expresses a primitive quality in the painting, which matches the content of much of his work. Painting on such a canvas was not, however, so much a matter of choice as necessity, as he lived in conditions of poverty in the South Sea Islands. Being unprimed, the canvas absorbed the paint as it was applied, with the result that the colors seem dull and muted, an effect which is emphasized by the darkness of the jute.

Above right Detail of Mr. and Mrs. Clark and Percy, David Hockney. Compared with Gauguin's canvas, Hockney's is finely woven. The plain weave heavy cotton canvas, primed with a thin, white acrylic gesso, is just visible beneath the acrylic overpainting, which is applied thickly in the highlights and also to emphasize the effect of mascara. Hockney used the fine canvas for a deliberately smooth total effect in this painting. Even on the finest support, however, the threads which are woven over the others will catch the paint while a brush will pass over the hollows.

Left *Portrait of Jean Muir* (1979), Anthony Green (b1939). The artist has exploited the unlimited potential of shapes in much of his work. The resulting picture makes the spectator feel privileged with a private view into a section of the subject's house.

unless the artist is intent on painting into a ground of brown tonality it is unnecessary. The main idea of a palette is that it enables the artist to mix color on a surface of a similar color to that of the underpainting or ground. The easiest way to achieve palettes of the chosen colors is to acquire a rectangular sheet of glass and position colored paper underneath it. As the painting surface changes, the paper may be substituted so that the colors can be mixed in relation to the surface.

It may be useful at first to limit the range of paint colors, and rather than clutter the palette with numerous tints, choose a few key ones from which many others may be mixed. Personal preference and experience will eventually prompt the artist to choose only the colors that are suited to the particular purpose. Although many artists prefer not to use black paint, white paint will certainly be essential in larger quantities than any other colour. A fairly strong yellow will be useful, either cadmium yellow or cadmium yellow pale; also a yellow ocher and possibly raw umber. Various kinds of red pigment are easily available, and again the choice is based on personal preference. A strong crimson is sometimes selected but greater quantities of vermilion, light red or Indian red may be more useful. Added to this will be a blue, either cobalt or ultramarine, and also a green, perhaps terre verte.

Joshua Reynolds advocated the use of a limited palette of white, black, Indian red, and raw umber. Although the omission of blue may seem surprising, the colors chosen provided three muted primary colors which through optical mixing would provide the warmth and coolness of their primary equivalents. The brightness of color is not necessarily due to its purity of hue but to the way it is related with the other colors in the picture. Edgar Degas once expressed his contempt for the seemingly arbitrary excesses of some of his Impressionist contemporaries in their use of bright color. He remarked that he could paint a picture that would appear to be full of color using only varying shades of mud-colored paint because they are both warm and cool.

Paints are available in loose pigment form or otherwise commercially prepared in cans or tubes. In this form they are packaged in different quantities and also in different strengths depending on whether they are extended, as in "students' colors" or concentrated as in "artists' colors."

As well as plenty of newspaper and rags for wiping brushes, it will be also necessary to acquire some jars for cleaning brushes and containing the painting medium. Pure turpentine is essential for mixing color – it binds the pigment but has the advantage of being much thinner than oil – and turpentine

working in this way a check may be kept on the tautness of the canvas.

The next step is to select a ground before priming the support. If an oil-based primer is selected, then a coating of rabbit-skin glue will be essential in order to seal the canvas and make it nonabsorbent. There are many recipes available for making grounds but they are not all for use on canvas. Canvas continues to be the most popular painting surface because of its flexibility, but this advantage renders certain preparations useless. During the course of painting, the canvas will be continually stretching and springing back into shape. Atmospheric conditions will also affect the surface by causing it to expand and contract, and so a ground will be required that is nonabsorbent but also durable and flexible. This immediately eliminates many interior decorators' preparations and also the gesso

grounds which are too brittle to bear constant movement. A simple homemade ground consisting of flake white, linseed oil and genuine turpentine provides an adequate base for oil painting, but to save time oil-based primers are also available ready-made from artists' suppliers. They are made especially for the purpose and because they are available in cans may be stored and used without waste. Alternatively, an acrylic-based primer is commercially available and equally suitable for oil and acrylic painting. If this is preferred it will not be necessary to size the canvas as it will seal and prime at the same time.

Palettes

The choice of palette is an important decision. It is a good idea to choose a mixing surface of the same color as the primer. The use of brown varnished wooden palettes has become something of a cliché in recent years, and

substitute or benzine will be needed for cleaning brushes during the process of painting. After each painting session the jars of turpentine may be left, and the next day the pigment will have settled, allowing the clear turps to be poured off and used again. Purified linseed oil may be used as a mixing medium in conjunction with a siccative or drying agent, but this must be added sparingly as cracking may occur if the drying is accelerated.

Many kinds of painting media are commercially available for use in oil painting. They include copal oil medium of different grades, wax medium, stand linseed oil, retouching varnish and many other equivalents sold under different trade names. For oil or acrylic painting a good selection of bristle brushes is needed. The selection may be extended with the addition of decorators' brushes which, although coarse in quality, are excellent for covering larger areas of the painting. Palette knives may be used not only for mixing but as an alternative to the brush.

SELECTION AND COMPOSITION

The process of selection involved in drawing or painting a portrait is of paramount importance to the artist, and as well as selecting the particular medium it is important that the artist is able to select the most essential qualities of pose and structure and present them in terms of a pictorial composition. However complex the posture of the figure may appear at first glance, it can always be simplified in relation to the relative positions of the individual forms. In attempting to draw the face it is important to consider the angle of the neck and shoulders even if they will not be evident in the final picture. At every point of articulation the axis changes direction and it is necessary to understand these changes and how they affect the distribution of weight in the figure as a whole.

Before beginning to draw or paint a portrait a position should be established and the board or canvas placed to allow an easy view of both the surface and the model without too much

unnecessary movement. In art schools students often sit astride a wooden seat known as a "donkey." This comprises a wooden support for both the artist and the drawing board or canvas. A chair or easel may be used but if a table is preferred it is important that the support is not resting horizontally or distortion will occur due to the shortened angle of the paper. If the artist is seated with the board or canvas just resting and easily moved, the horizontal edge of the surface may be related to any parallel equivalents in the subject. This system only works, however, if the board or canvas is positioned directly in front of the artist in such a way that, to the artist, the developing image appears to be directly below his or her view of the model. If the model is seated on a chair against a wall an indication of the floor level at the base of the wall can be established as a horizontal line. If this appears to be parallel to the top edge of the board or canvas, then a vertical axis can also be established and a constant movement

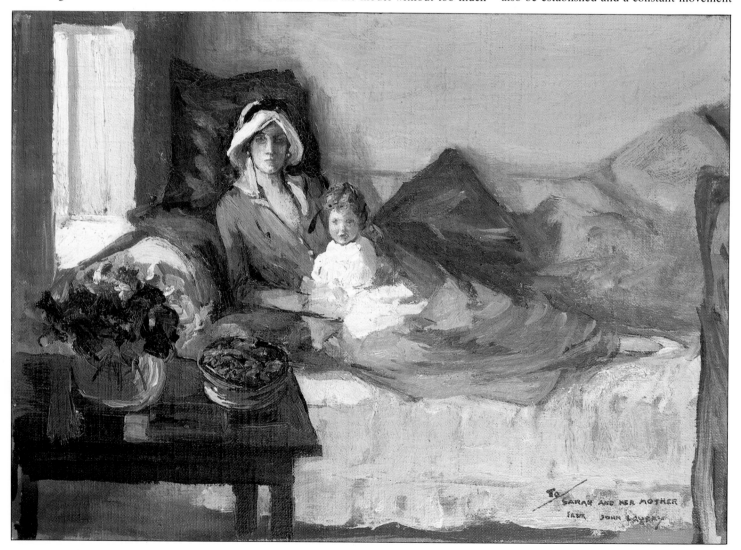

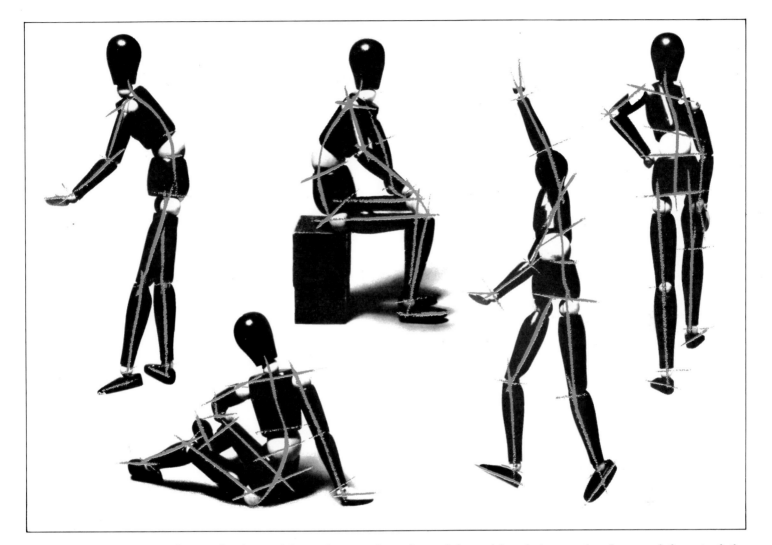

Left *Clementine Ogilvy, Lady Spencer-Churchill,* Sir John Lavery (1856-1941). This charming picture is thought to have been painted while the artist was staying with the Churchills at Hoe Farm, Godalming, in about 1915. It is interesting to consider how the paint would have looked without the foreground table and the objects on it, as they provide this composition with the necessary solidity of a right angle. The whole picture forms an elongated right-angled triangle, the top of the window and Lady Spencer-Churchill's feet forming the other angles. Her body provides an elegant curve within the main shape, while the vertical points of the cushions and the child's head add interest to the surface picture.

Above The human figure is capable of an infinite number of movements, and when composing a portrait it is worth considering not only how to pose the subject but how to place the pose within the shape of the paper, board or canvas. The whole figure could be included, or just a section. The figure could be placed centrally or to one side, with some of it outside the frame. While selecting and planning in this way, the artist should be considering the emotional responses of the spectator to particular poses and to resulting surface structures.

of the eye between the surface and the model will enable the artist to establish the structure quite easily. Many artists use a plumb line as a vertical measure. Personal preference dictates to what degree these devices are employed.

In many instances the subject will not include obvious geometric divisions and it is then useful to situate the model in such a way that some architectural element is visible. This could be a window frame or a doorway or even a table, allowing the artist to observe negative shapes between the form of the figure and the surrounding space. Many attempts at drawing and painting do not consider the figure in relation to its immediate environment, and a common misconception arises whereby the figure is considered to be as important as the surroundings are unimportant. Once aware of the use of relating the figure to the background, the idea of composition becomes increasingly evident.

The idea of drawing as design, which includes the idea of drawing with a brush, involves the ability to consider the image in

relation to the shape and format of the surface. During the Renaissance, paintings were often incorporated into architectural settings and predetermined shapes affected the pictorial design. The use of a rectangular support for painting and drawing has a long tradition and is still popular because it is convenient. The shape will affect the nature of the image: if the subject involves any horizontal or vertical divisions they can be related to the boundaries of the paper and so provide a form of visual echo which will give the drawing a stability and unity. Circular, square or irregularly shaped surfaces demand different compositional considerations, but can be used to good effect.

A common method of planning the structure of a work involves subdividing a sheet of paper into smaller rectangles and making quick drawings. In this way many different compositional structures may be found within a seemingly limited subject. By contemplating the various pictorial options, the artist will be able to exercise control and

eliminate the arbitrary arrangement that would probably be the result of a lack of consideration. The acknowledgement of negative shapes will become second nature if they are considered from the start. Although there is a natural temptation to focus on the face, a pictorial unity will only emerge through a more general awareness of the space occupied by and around the figure.

One of the easier ways to consider the organisation of material can be to cut a rectangle out of a piece of card and view the subject through it. By moving it horizontally and vertically the figure may be considered in different positions within the rectangle. By moving the card nearer to the figure the area of space around the figure decreases and eventually the face will appear to fill the whole frame. Although the window frame idea may be dispensed with, the activity of looking and selecting will at some point involve making a mental note of the imaginary boundaries of the sheet of paper, or to the intended boundaries within the sheet. It is common practice to position the portrait in the center of the paper and proceed outward from the center, and yet a more interesting configuration may result by considering other, more unusual positions within the rectangle. The ease with which many great artists have used compositional devices is deceptively subtle and, needless to say, such deception is the product of considerable knowledge and experience. The idea of composition has so far been considered in formal terms but an awareness of compositional structure can also affect the mood of the drawing by the psychological implications of the positioning of the figure.

During the Renaissance compositional organization provided the foundation for all artistic concerns, and the rediscovery of a means of establishing ideal proportions resulted in a general belief in the importance of the golden section. This term is applied to the aesthetic harmony of proportion produced

Right *A Memory/Our Dear Stan* (1976), Anthony Green. The charm of this portrait is that the artist has treated an ordinary-looking subject and setting with a care and consideration that betrays his feelings. Although the man is viewed mowing his lawn in a setting which thousands recognize as similar to their own home, the shape of the canvas is unique and only allows the man's house and garden to be described, as if he exists in a world of his own.

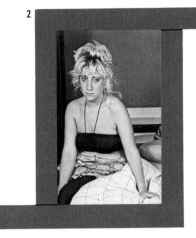

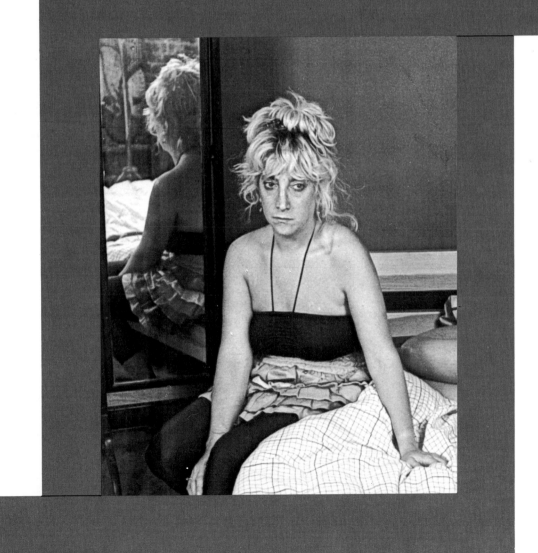

Framing
The artist can select the frame best suited to the composition and the desired effect by using two L-shaped pieces of paper or cardboard and moving them to extend or shorten the edges. Using an instant photograph to help in composing the picture, the whole shot of this intended scene shows some empty floor space, an expanse of door and the arm of another model across the bed (1). Treated in a vertical format the girl's face seems longer (2). It is possible to concentrate on the face by ignoring all surrounding objects and details, leaving the background empty and making the face fill the frame (3), but the figure and the mirror behind are finally included in the chosen frame to add interest (4). Mirrors can be used effectively in portraits as they automatically show two sides of the subject and allow the spectator to glimpse something of the rest of the artist's view.

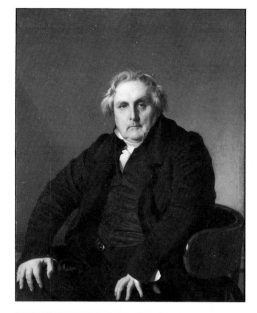

Above Ingres' masterful exploitation of the canvas surface can be seen in this line drawing taken from *Monsieur Bertin*. The bulkiness of the figure, the way the head sinks into the shoulders and the heavy, round back of the chair all give an impression of solidity, which is enhanced by the low placement of the half-figure within the frame. It is a strong, triangular composition, designed to express something of the subject's character and to force the viewer's response.

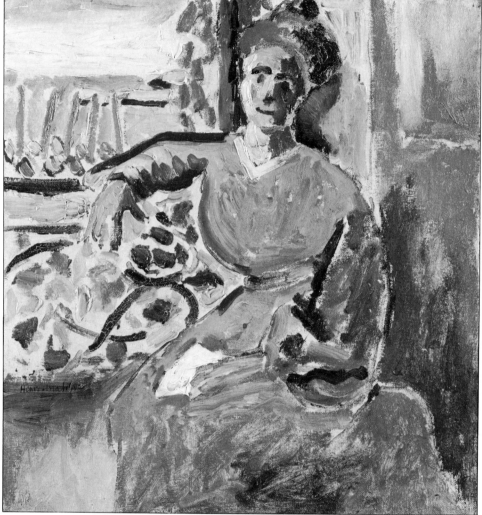

when a line is divided in such a way that the smaller division relates to the larger just as the larger relates to the whole. By geometric application, a rectangle can also be constructed in such a way that subdivisions within the rectangle will accord with this harmonious relationship. Although some painters have put this theoretical concern into strict practice, many others have applied it in an intuitive manner. Triangles and pyramids have also been employed as a means of establishing a stable and powerful structure, one especially evident in religious compositions. With experience, painters have taken more liberties with pictorial organization, and it may not be evident that any one geometric form dominates compositional structure through the centuries.

When Ingres drew or painted a male figure he invariably used an upright and alert posture, and the conscious positioning was often echoed by the positions of surrounding objects or by patterns. Similarly, when drawing or painting a portrait of a woman he would accentuate the curvature of the body in the surrounding clothing and drapery. The compositional organization of his portraits reflects the respective roles of men and women in society.

In the twentieth century Henri Matisse explored this kind of pictorial association to such a degree that the repetition of curves in his compositions become a dominant feature of his work. Both Ingres and Matisse were aware that hard angular forms evoke strength and severity while the repetition of curves often evokes the quite different sensations of sensuality or gentleness.

One of Ingres' most successful male portraits is *Monsieur Bertin*. The huge bulk of the man's body provides a formidable appearance, and although the composition cannot be equated to any single geometric form, its underlying structure forms a triangle. The feeling of weight pressing on the thighs by the hands is accentuated by their being at the

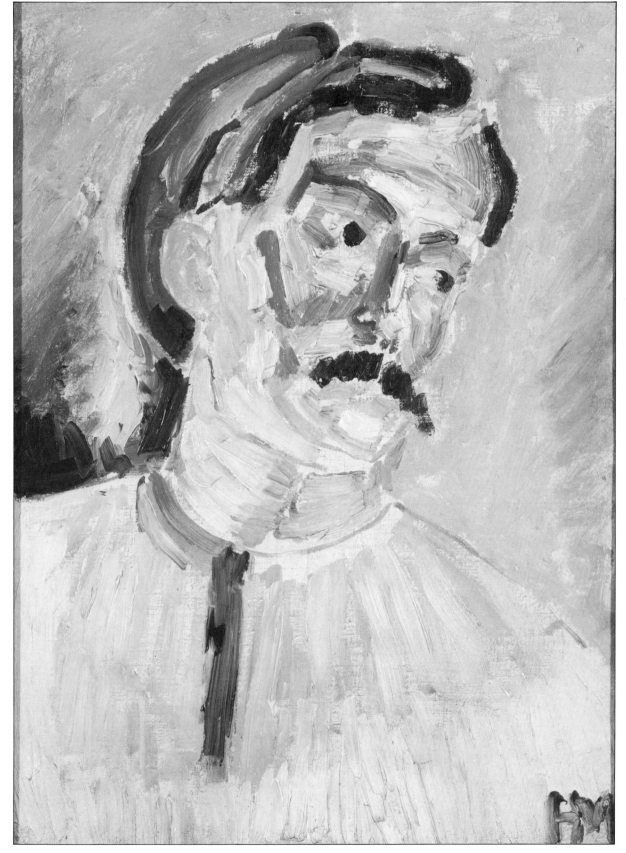

Contrasting viewpoints.
Matisse, a member of the
Fauves group of painters, is
famous for his bright,
emotive use of color, which
he often exploited for strong,
decorative effects. These two
portraits, *Study of Madame
Matisse* (**far left**), and *Portrait
of Derain* (**left**), look quite
different from their originals
when seen in black-and-
white reproduction because
the color is essential to their
feeling of vibrancy and
liveliness; without the
distraction of Matisse's
color, however, they usefully
illustrate the artist's
deliberate exploitation of
space. For his wife's portrait,
he chose to stand at a
distance to allow a view of
her whole figure and her
surroundings, so adding an
aura of domesticity and
comfort, while the beauty of
the scene outside, bathed in
sunlight, is also imparted.
These things provide reasons
for, and enhance, her obvious
enjoyment of the situation.
For Derain, Matisse wanted
an uncluttered view, and a
strong and direct portrait is
the result.

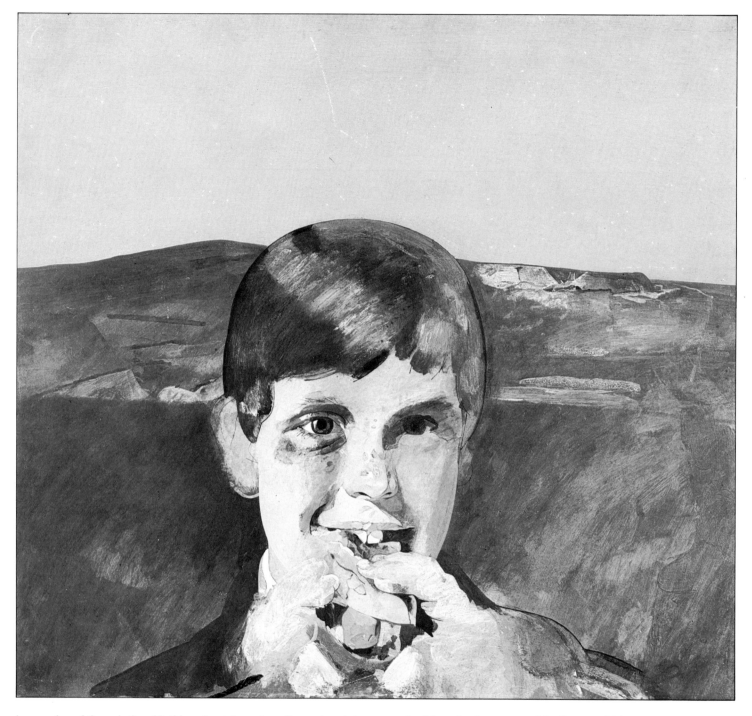

lower edge of the painting. Nothing about the composition is arbitrary; the calculated area of space above the head provides a contrast to the tightly compact volume of the lower portion of the picture. At first glance it might be assumed that the powerful image is due to the facial expression but, like many powerful portraits, the feeling of human presence is accentuated by the thoughtful pictorial structure.

Composition has been considered so far in two-dimensional terms and although the surface structure is crucial to the success of a picture, it prompts a further consideration of structure in a three-dimensional sense. In *Monsieur Bertin*, it is evident that the bulk of the figure can be considered in relation to its depth. Several existing studies for this picture reveal how Ingres considered alternative postures and had originally intended the figure to be standing. Had Ingres incorporated the whole figure within the picture, the powerful effect would have been diminished. The positioning of the figure in relation to the perimeter of the canvas is crucial.

Lucian Freud is a contemporary painter who has exploited the psychological tensions made possible through pictorial organization. The results are often inventive and surprising, and few recent painters have been able to produce such striking images within an orthodox format. In the portrait of Francis Bacon the intensity of the image is due partly

to the microscopic attention to detail and partly to the simple compositional compactness. Nothing interferes with the frank description of the face and yet the choice of such a small area of space around the head suggests an awareness of the positive effect it would have. The tension in this picture occurs because of the relationship between the tangible volume of the face, which seems to expand outward, and the abrupt perimeter of the rectangle which presses inward and contains the image.

Before considering the activity of painting it is worth emphasizing that the compositional structure in a drawing or painting involves selecting the positions of certain objects or features which may be considered in terms of lines, and shapes within the whole. In order to find those shapes it is first necessary to select the objects or props required. In both the above examples the human form is the focus of interest. Both Ingres and Lucian Freud chose to isolate their subjects by carefully considering and limiting the area of surface not occupied by the figure. In many other instances Lucian Freud juxtaposes his figure with either an animal, a plant or some aspect of a domestic interior. Ingres, on the other hand, presented his subjects with certain attributes of social status and went to great lengths to find the right accessories for his portraits; he also placed an emphasis on clothing and jewelry. From this, it would be reasonable to assume that he spent a considerable amount of time selecting and organizing his subjects in terms of color and texture, as well as shape.

By looking at any portrait painter of any period it will be apparent that each one found a personal way of selecting from the numerous possibilities evident in reality. It is often easier to start with a simple format of one figure situated against a simple background. With experience it may be possible to gradually involve other objects that reveal clues about the identity of the sitter. These may take the form of a direct reference to the sitter's occupation or personal interest; alternatively they may simply suggest an interior space, for example, a domestic environment. Many painters have used landscape backgrounds for portraits or a combination of both interior and exterior by the use of a window. The possibilities are endless and yet every given situation demands a similar understanding of the relationship between the shape of the figure and the surroundings. The more complex subjects probably involve more preparatory work and it is often necessary to draw the various components of the subject separately having considered the whole. Written notes on color and lighting may be useful when it comes to translating the image into a painting; photographs can also be used

Above left *Boy Eating a Hot Dog* (1960-65), Peter Blake. In this portrait, Blake seems to be summing up the transience not only of movement but of youth. The boy obviously relishes the hot dog; Blake painted it with emphasis and placed it in the center foreground but, surrounded by teeth and about to be consumed, the existence of the hot dog makes a direct play on the fleeting qualities of energy and life, and dramatically points out the conflict between the fact that paintings last while situations do not.

Above *Francis Bacon,* Lucian Freud. The confrontation between subject and spectator has been forced by the fact that the face takes up the entire surface of this picture. The meticulous detail of the features, skin and hair matches the close viewpoint, but the subject is looking down as if to retain a certain privacy. There is a sympathy between the subject and the artist, expressed in the gentleness of expression.

to provide the information that cannot always be gained during the limited time available with a model.

Any appraisal of the elements of compositional structure would be incomplete without some comment on the work of Edgar Degas. His ability to depict figures in natural and unforced poses has rarely been equalled. Degas managed to push the boundaries of portraiture further than any previous artist, and his inventive results are the product of a lifelong fascination with the problems of pictorial organization. The influence of photography and the Japanese print directly affected Degas' attitude to composition. He realized that in reality a figure or group rarely occupies a position that would be consistent with the commonly accepted poses in orthodox portraiture. In order to convey a more convincing posture Degas would deliberately choose odd angles for his viewpoint. By looking from above, the figure would adopt more unusual shapes in relation to the rectangle. By positioning the figure close to the edge of the canvas and emphasizing the large areas of empty space, Degas was able to suggest a degree of informality almost unprecedented in Western art.

Below *The Meeting* or *Good Day Monsieur Courbet* (1854), Gustave Courbet. The supposed position of the spectator is below the subjects of this group portrait and also to one side; in fact he or she would be standing on the grass border. Courbet in this way makes the spectator feel apart from the situation, like an onlooker, a *voyeur*. This technique indicates Courbet's arrogance.

Right *Portrait of Diego Martelli*, Edgar Degas. Influenced by the unusual perspective of Japanese prints, Degas approached this portrait from above, exploiting the viewpoint to emphasize the squatness of the man's figure. To place the figure deliberately to one side of the picture and to include a large expanse of tabletop was considered almost revolutionary in the mid-nineteenth century.

JANE IN TURBAN
acrylic on canvas

The properties of acrylic paint enable the artist to alter a painting radically, to a greater extent than would be possible even with oils. If, during the course of a painting, the artist feels that the picture has begun badly, rather than proceed reluctantly it is better to reconsider the compositional organization, pose, tonal structure and scale; acrylic allows this type of change. A canvas support, primed with acrylic primer, makes an ideal base. Acrylic is water-soluble and may be thinned with water during the early stages; later, undiluted, it will give more body.

The model was originally seated on the arm of a couch, wearing a black dress and dark turban (1). The artist chose to depict the subject so that both arms were clearly visible and the head positioned at the top left of the canvas. After establishing the figure, the artist felt that more time and space should be devoted to the head and less to the background (2).

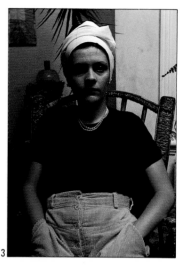

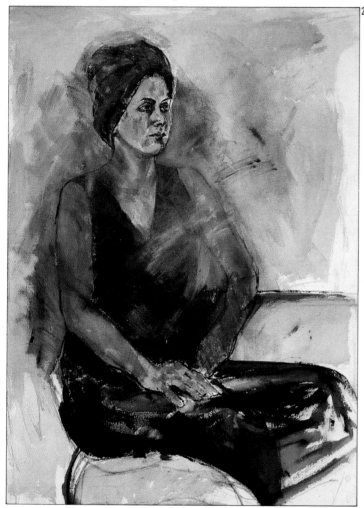

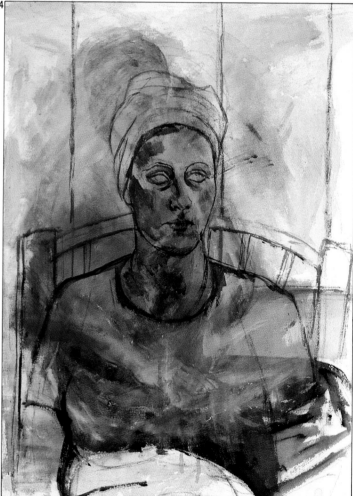

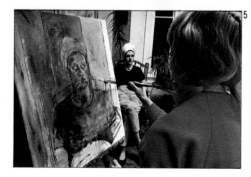

In the second pose the light is coming from the opposite direction. A white turban is substituted to provide more contrast with the shaded background (3). A thin wash partially obscures the first attempt but the canvas is not reprimed so that the first image is clearly visible while the second is being painted (4). The second pose is almost symmetrical, the simple vertical divisions of the background providing three distinct changes of tone. The darkest gives the head and turban emphasis (5).

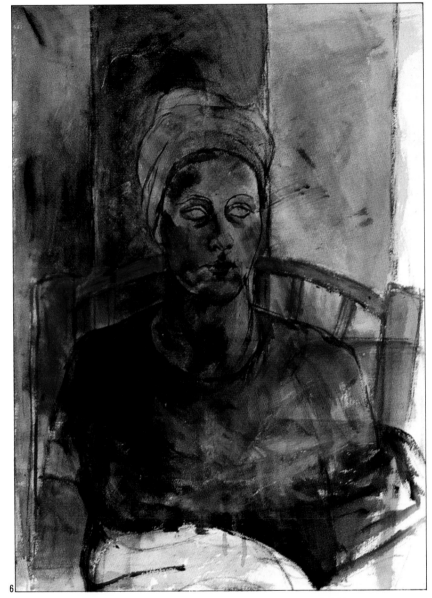

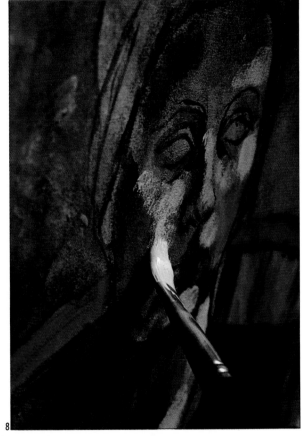

Another advantage of not repriming the canvas is to allow the first attempt to function as a type of underpainting for the second image. The dark blue, previously used to indicate the dress of the subject, now provides a foundation for the flesh tones that will follow (6). Although acrylic is water-soluble, it can also be mixed with acrylic medium in later stages of the work for more body (7). Flesh tones are applied, using fairly thick paint in cream and pink tints. Because this paint is less fluid than the underpainting, the grain of the canvas picks up the paint as it is lightly dragged over the surface. Acrylic is not water-soluble once it has dried – subsequent layers will not disturb the paint beneath and the technique of application is similar to oil (8).

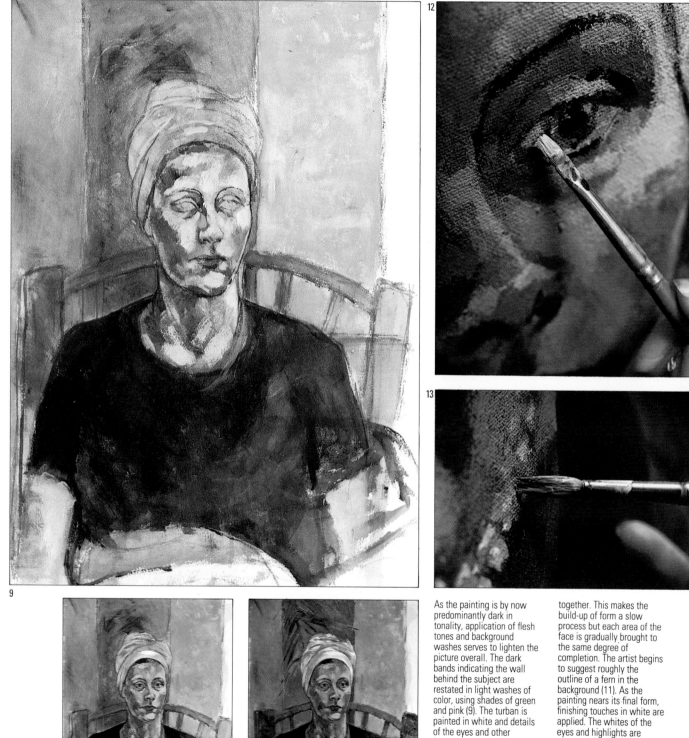

9

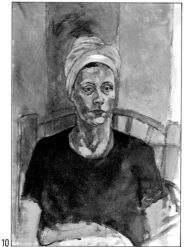

10

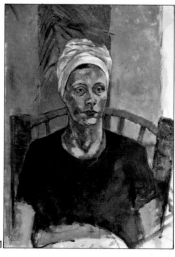

11

12

13

As the painting is by now predominantly dark in tonality, application of flesh tones and background washes serves to lighten the picture overall. The dark bands indicating the wall behind the subject are restated in light washes of color, using shades of green and pink (9). The turban is painted in white and details of the eyes and other features are more clearly defined (10). Each color on the face is applied as a separate patch, with no attempt to model the color together. This makes the build-up of form a slow process but each area of the face is gradually brought to the same degree of completion. The artist begins to suggest roughly the outline of a fern in the background (11). As the painting nears its final form, finishing touches in white are applied. The whites of the eyes and highlights are painted (12). A white pearl necklace is added at the last moment, using a simple stipple technique with the point of a brush (13).

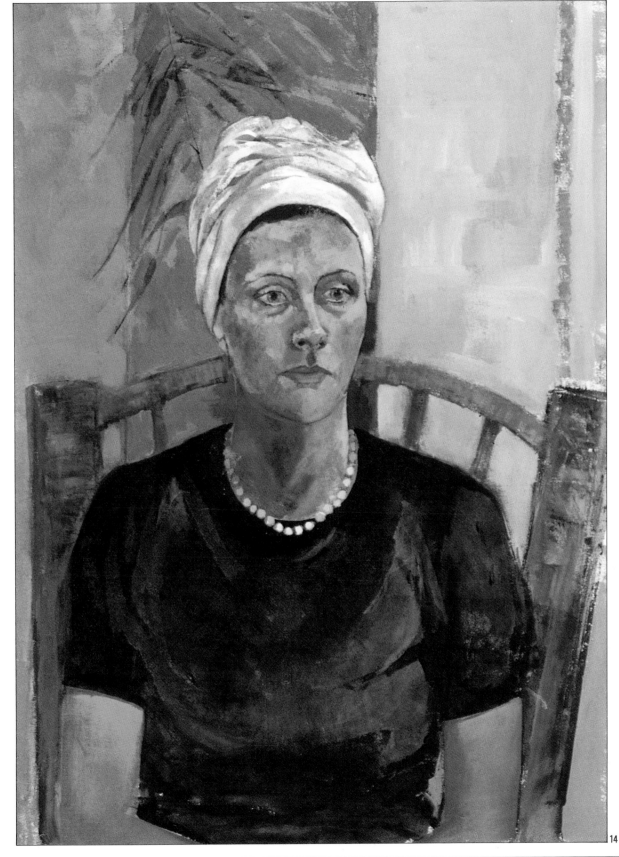

In the final painting the last-minute additions of the fern and necklace have served to provide points of focus around the head and alleviate the simpler compositional divisions of the picture. Although the figure is placed squarely on the canvas and fills the picture space, too rigid a symmetry is avoided by placing the fern off-center at the top. The gentle arc of the chair back and its warm color serve to complement the curve of the bare arms. Similarly, the pearl necklace echoes in form and color the white turban framing the face (14).

14

JOANNA
oil and acrylic on canvas

Although some painters favor working "wet into wet," there are many advantages to making an underpainting. An acrylic underpainting, in particular, may be useful as a means of establishing the image prior to the application of oil. In this portrait, the dominant color is red; by painting the background first in green, the complementary of red, and then applying red, the final color has an added vibrancy. Much of the figure is also underpainted in green, in anticipation of the warm skin tones to follow. An artificial light source was chosen to illuminate the subject and provide a compositional unity.

The chaise longue allows the model to pose more naturally than would be possible in a straight-backed chair. A folding red screen is chosen for the background, its uniform color to dominate the tones of the painting and the simple vertical divisions to form an important compositional structure. The spotlight situated to the right of the model lends an element of drama to a straightforward portrait (1).

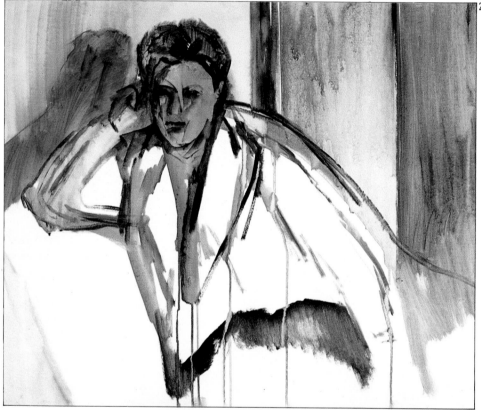

Using washes of green-blue acrylic paint, the artist roughs out the basic structure of the painting, paying little attention to detail but considering the overall design in terms of the abstract relationship of one form to another (2). Lighter shades of green are mixed on the palette (3). These are applied primarily to the face, establishing mid-tones and areas of highlight. The quick-drying property of acrylic paint makes it ideally suited for underpainting; subsequent layers of oil can be applied without hindrance (4 and 5).

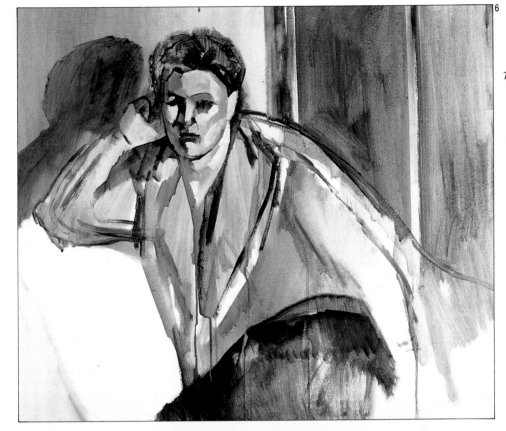

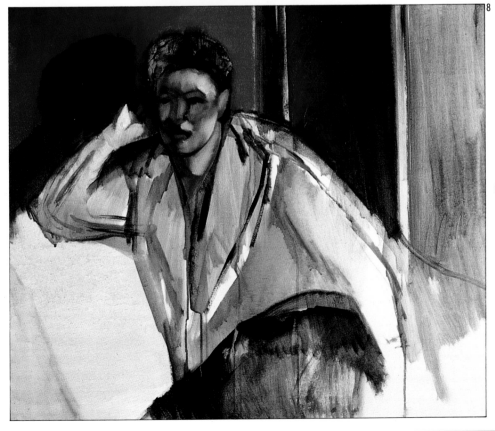

Gradually more information about the volume of the form is indicated and the underpainting is left to dry (6). The next stage is to begin painting in oil. Flesh tints are mixed on the palette (7). The skin tones are applied thinly at first to allow the underpainting to show through. The strong light source accentuates the volume of the face (8). The shadow falling across the screen, which defines the space between the subject and background, is darkened (9).

The process of painting should always be able to accommodate change and alteration. Working constantly from the model, the artist revises and refines the angles of the pose (10).

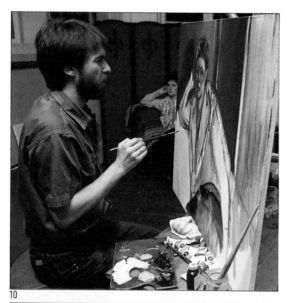

10

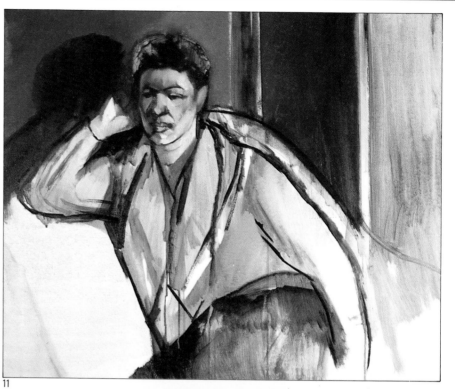

11

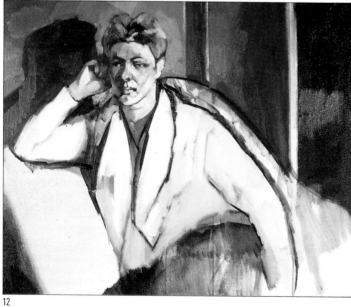

12

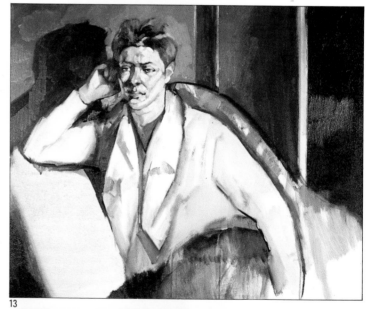

13

An attempt is made to simplify the effect of light on the face so that the painting progresses consistently throughout (11). A soft pink tone is added over the green underpainting of the sweater (12). Detail of the pattern on the scarf is roughed in (13). More attention is paid to the face, particularly the eyes (14).

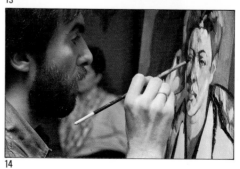

14

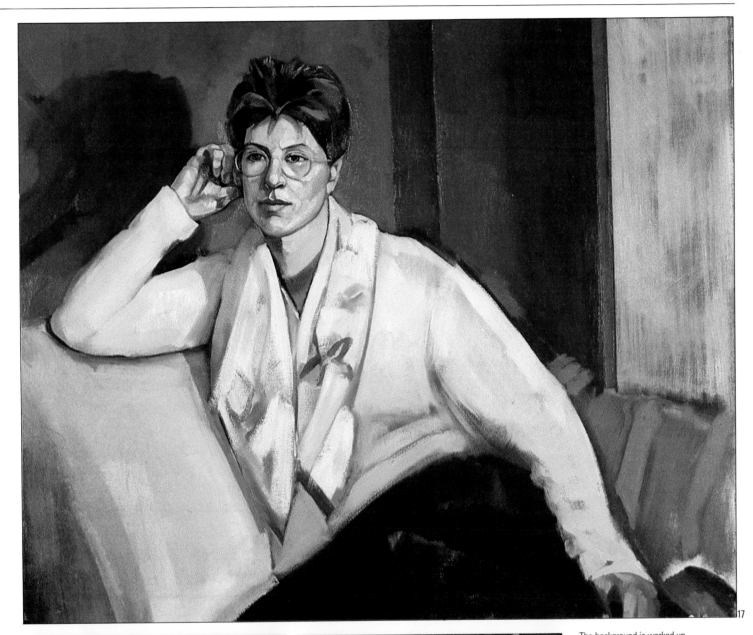

The background is worked up more fully (15). Substantial changes are then made to the face, which becomes more smoothly modelled, and the suggestion of the sofa in the background is painted out, simplifying the composition. The scarf is also reworked (16). In the final version, details such as the glasses and scarf pattern are added. It is always important to consider the negative shapes as positive elements, rather than empty space, to make a strong and unified composition (17).

HUGH SEATED
oil on canvas

The use of oil paint for this portrait enabled the artist to build up layers of paint gradually, incorporating both thick and thin paint. During the early stages of the painting, the figure was positioned against a simple, uniformly colored backdrop; later on, it was felt that the introduction of another image might accentuate the main subject's pose. To accomplish this, a second figure was introduced, into the background, echoing the leaning posture of the subject. The figure in the background does not necessarily provide an illusion of depth or indicate recession in space, but has a flatter, more two-dimensional appearance. This intentional ambiguity suggests a painting of a painting directly behind the subject. This artistic device is often used for emphasis or balance; it is notable in the work of Vermeer and Degas.

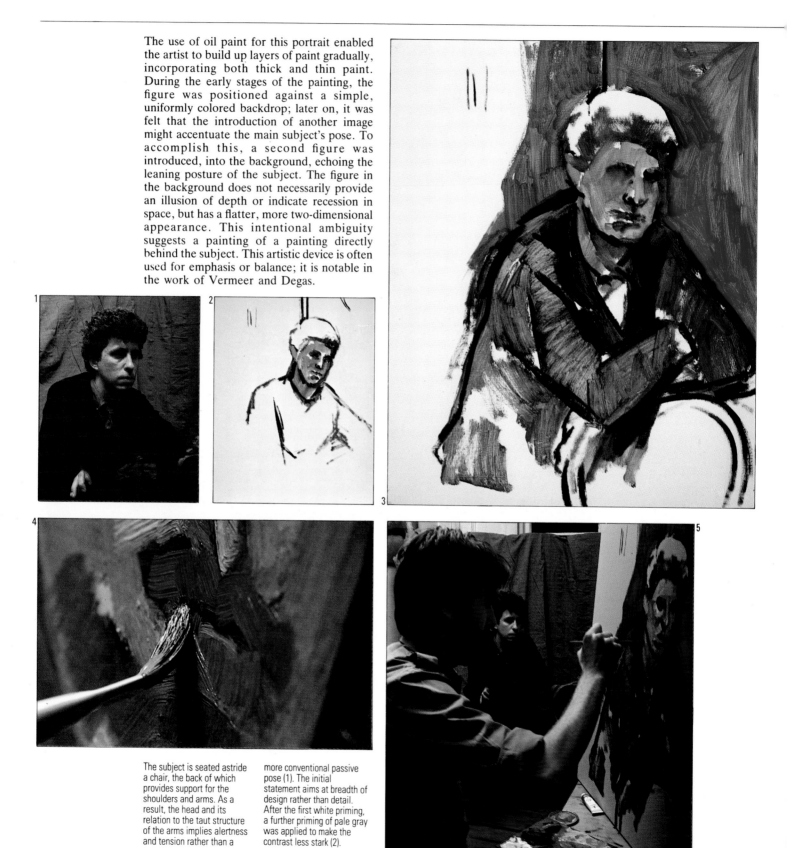

The subject is seated astride a chair, the back of which provides support for the shoulders and arms. As a result, the head and its relation to the taut structure of the arms implies alertness and tension rather than a more conventional passive pose (1). The initial statement aims at breadth of design rather than detail. After the first white priming, a further priming of pale gray was applied to make the contrast less stark (2).

270

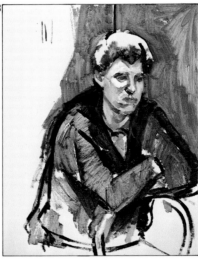

Working with a limited range of colors, the artist begins by establishing the approximate position of the figure and chair in relation to the shape of the canvas, using paint thinned with turpentine (3). As the model relaxes from the initial pose, more attention can be paid to specific features (4 and 5). Detail is added to the area around the eyes (6). In an attempt to produce a vibrant blue-green background, this area has been underpainted in red. Once the basic forms have been laid in, the picture is left to dry (7). When the painting has dried, small adjustments are made to the shadow areas and contours of the face (8). The blue-green background is applied and further adjustments made to the figure, particularly to the shoulders (9).

More detail is worked into the face, with highlights being applied with a fine brush on the cheeks (10). A fairly strong artificial light source helps to emphasize the form of the face. This is painted in blocks or patches of pigment that are not modelled but are connected as a series of planes. By building the form in this way and continually adapting it, an attempt is made to simplify what in reality is extremely complex (11). The tones of the face are subdued to harmonize with the background color (12).

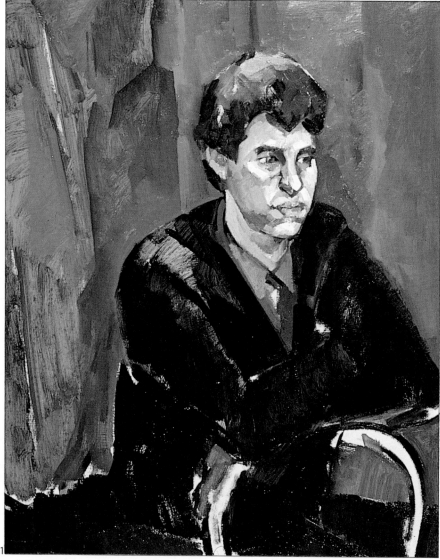

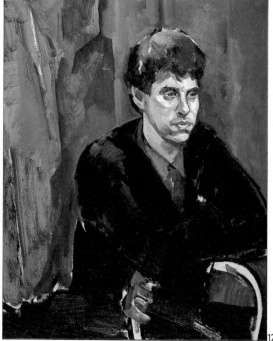

A further interpretation of the background is attempted. The properties of oil paint are such that many revisions are possible (13). The asymmetrical position of the figure seems to demand a more complex background and these elements are roughed out in paint (14). By the final stage, the "picture within the picture" is established in the background and the painting as a whole shows more uniformity of treatment. During the course of the work, considerable alteration has been made to the contours of the head and description of the face (15).

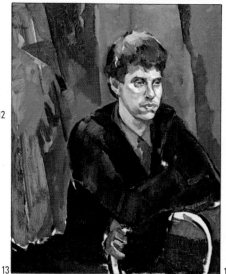

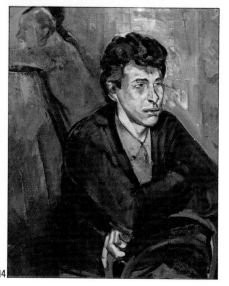

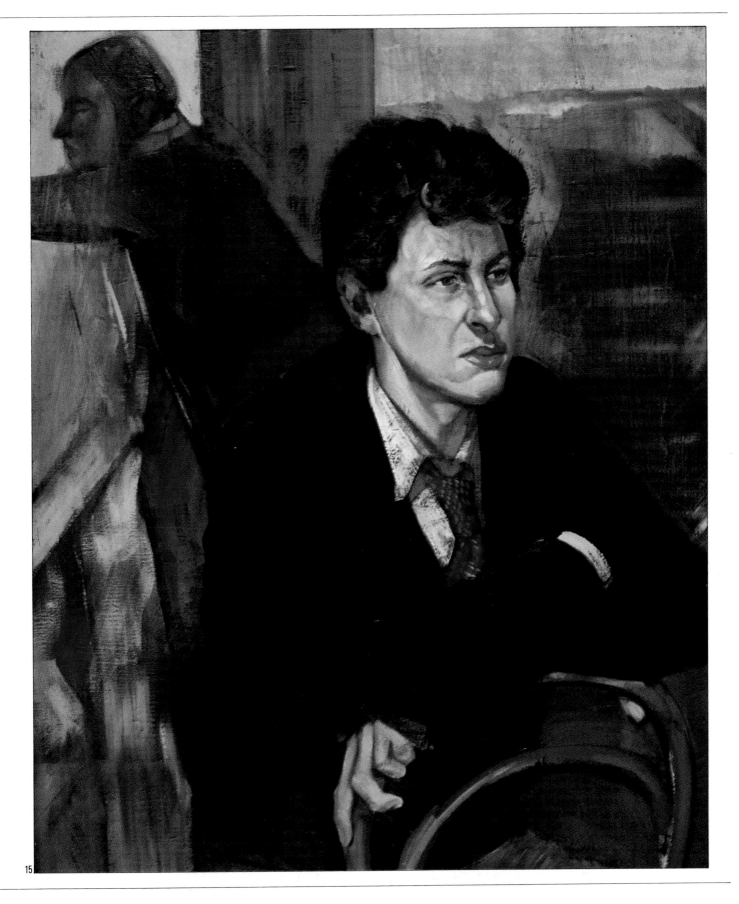

15

YOUNG GIRL
watercolour on paper

Watercolors are used effectively to capture the casual informality of this portrait. Many artists treat watercolors as a way of sketching faces and preparing for later oil paintings, but this picture displays a subtle and detailed use of tones and overlaid colors. The medium is well suited to the representation of a child's smooth, unwrinkled skin and wispy hair. Moreover, the layers of quick-drying paint can rapidly be laid one over the other before the subject becomes bored. The thicker, opaque quality of the shirt is created using a dry-brush technique and the result contrasts with the luminosity of the skin.

The outlines of the girl are first drawn in pencil; then details of the shape of the eyes and slight shadows around the mouth are painted in gray and burnt umber in thin strokes, the areas left white being as important as those painted. Strands of hair are then added; the brush can usefully be exploited to describe the way the hair moves (1). Well diluted light red and gray shadows under the chin are added, and the shirt filled in with flat gray and blue (2). The paper wrinkles slightly where the washes are well diluted in water to cover the shirt, but this is unimportant as the paper will shrink again as it dries and in any case the wrinkling adds to the texture of the material.

Using the thin, pointed end of a round, sable watercolor brush, the lips are painted with precise outlines, partly to emphasize, by contrast, the highlighted area of the upper lip, which is left white (3). Flesh tones are painted in the shadowed areas, reinforcing the eyes, nostrils and chin, while gray is used for darker shadows. The hair is thickened with further layers of paint over the previously dried layers (4).

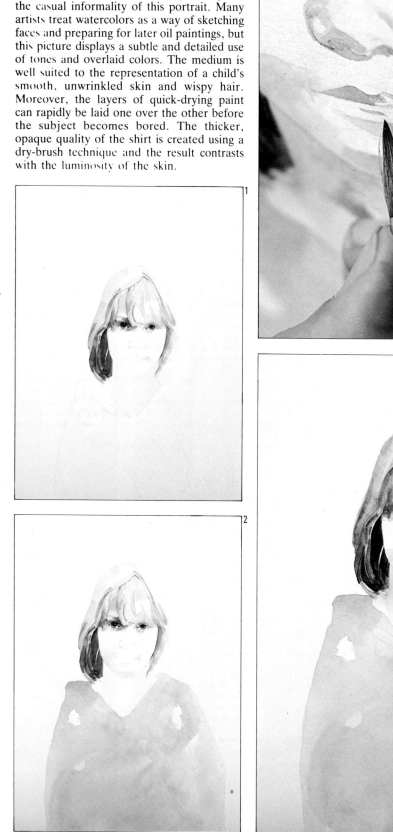

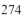

5

6

8

7

The face and hair are continuously built up with thin layers of brown and gray on dry paint, with highlights on the cheeks left white. Folds in the material are described with strong dark gray lines of shadow, and shadows of the neck also added (5). With attention to detail on the shirt, the artist adds gray paint to show the position of the arms and the creases in the collar, and two thin lines for the lines of stitching (6). When the painting is dry, a brush loaded with dry paint is splayed and drawn across the shirt area to add texture (7). Bright red flowers are painted onto the dried layers of the shirt yoke, and a layer of flesh tones over the lighter cheek finally added, still leaving small patches white for highlights (8).

WOMAN IN DOTTED DRESS
acrylic on canvas

Acrylic is a versatile medium and well suited to the beginner and experienced artist alike. It is particularly useful because it covers well, and if any mistakes are made they can be corrected almost immediately without fear of muddying the colors, or of the mistake showing through. The colors are opaque and vivid, and retain these characteristics for a long time. However, if acrylic paint is applied thinly or is well diluted, it behaves like watercolor, and the color beneath or the color of the canvas can in this way be made to show through. This characteristic is valuable when painting flesh, as the translucency associated with skin is usually achieved in paint by layering tones or by allowing a pale ground to show through successive, darker tones.

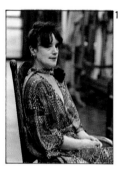

The subject is seated at a sideways angle to the artist, with her head turned and her eyes looking down (1). On a primed and stretched heavy cotton canvas, the artist first sketches in the main contours of the semi-profile, the eyes, nose, chin, jaw, ear and hair, then adds streaks of thin color and blocks in the hair (2). Concentrating on the face, light flesh tones are filled in over the cheeks, chin, nose and forehead, and small shadows indicate creases of the flesh (3). Rich reds and browns are added to the high cheek area and the forehead, while the area immediately under her eye is left light to show that the light is from above. The lips are given a precise shape and some areas of the chin lightened again with pale opaque yellow and pinks (4). Gray is laid over the background and the dress filled in with a thin, uniform black wash, so that the red shows through from underneath. The skin of the chest is painted in thin browns and the white priming shows through, giving it a luminous quality (5).

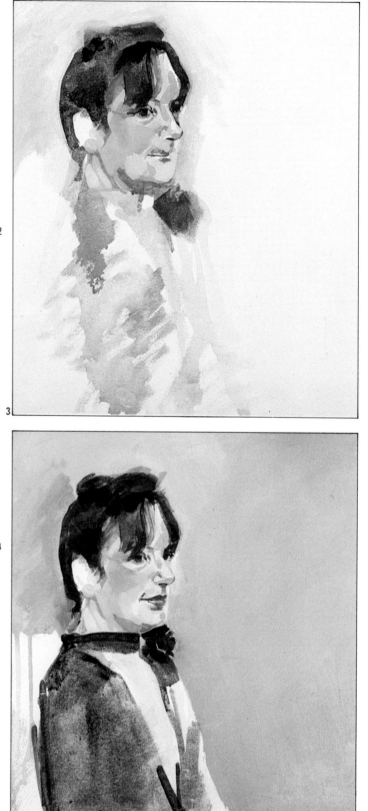

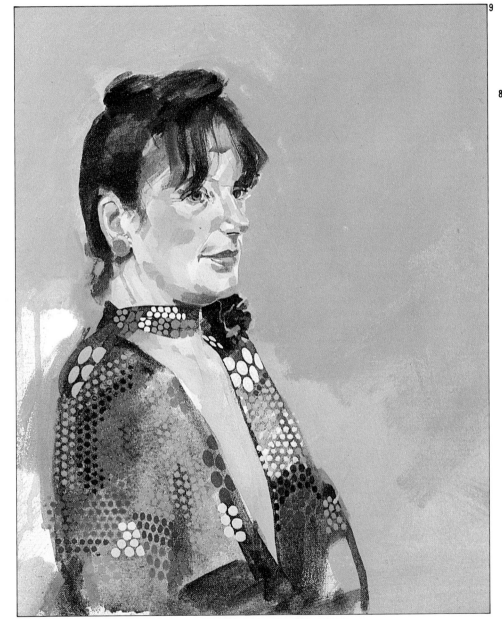

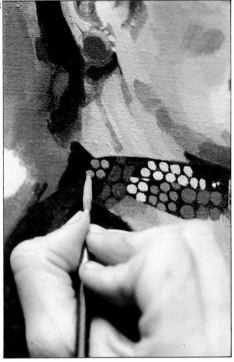

The dress is built up with further strokes of thin black paint applied with a broad brush and the basic shadows of the arm and shoulder are added. Further flesh tones are painted on the neck and chest to describe the shape of the collarbones and the ear is filled with shadows using a thin brush. White, yellow and red dots are stencilled over the black in thick, opaque paint (6). Rows of dots are applied with a thin brush using stencils of different sizes. Sometimes the artist encroaches into the background, but this abstract quality adds interest to the painting (7). Some of the dots are built up freehand (8). The dress is covered with these dots at different angles and in different colors (9).

ADDIE
gouache on paper

The fluidity of water-based paints such as gouache means that they are ideally suited for making either color studies, in preparation for larger oil paintings, or quick, complete pictures when time is limited. This type of paint is usually regarded, however, as better suited to landscape subjects than faces and some experimentation will be necessary when attempting to render the solidity of the human figure and the precise values of skin tones.

Water-soluble paints are best applied to stretched paper to prevent the paint wrinkling the paper as it dries. The paper should be prepared by wetting it thoroughly on both sides and then attaching it to drawing board with strips of paper tape around the perimeter. When the paper dries it will shrink slightly; subsequently it is ready for the application of paint.

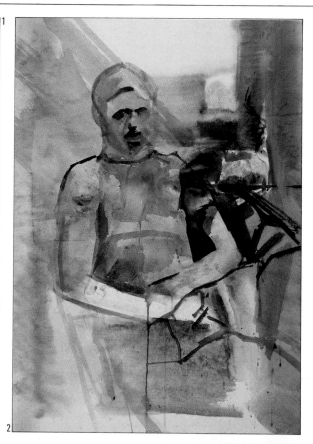

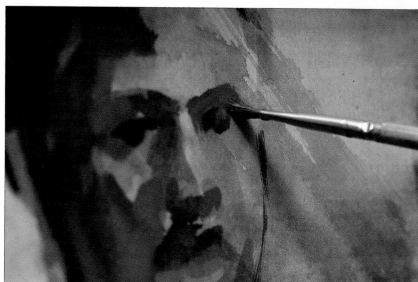

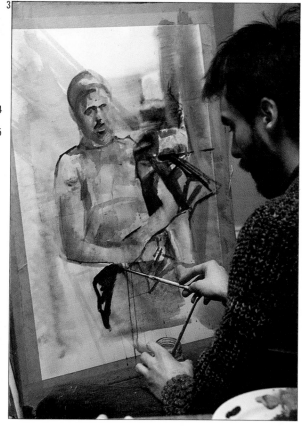

The pose of the model, although symmetrical from the front, appears slightly turned to one side when seen from the artist's viewpoint. Natural light from a window to the right of the model illuminates the form (1). The artist begins by drawing with the brush rather than making a preliminary pencil sketch (2 and 3). This method allows more freedom to convey the effects of light, especially on the face (4). The painting grows out of the drawing rather than being considered as a separate activity from the initial statement. The paint is kept as fluid as possible (5).

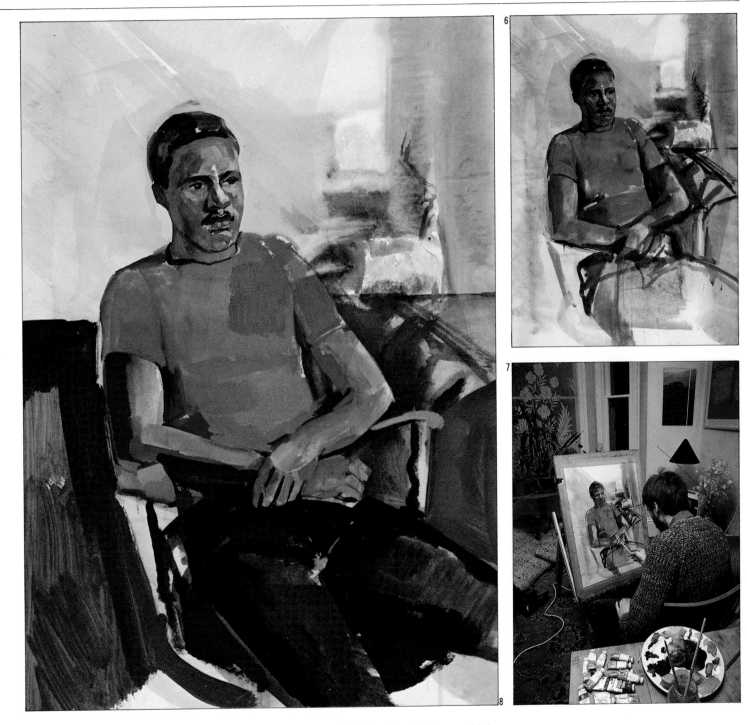

Gouache always remains water-soluble, unlike acrylic paint which is also water-based. The application of wet paint over dry may disturb and mix with the preceding color. This need not be a disadvantage, if a fluid result is required. Here the area surrounding the figure is conveyed by overlapping washes of color (6). The bulk of the figure is indicated in a broad painterly treatment. The positions of areas of paint are considered with respect to their abstract qualities within the rectangle of the surface as well as their more obvious representational associations (7). The structure of the head is continually assessed and reassessed during the course of the work. By the final stage, the earlier, more approximate statement has been subtly altered. More time is spent painting the face – the focus of interest for the portraitist – than any other part of the picture (8).

DRAWING AND
PAINTING
LANDSCAPES

ADRIAN BARTLETT

ART AND THE NATURAL WORLD

Painters from most civilizations have expressed their delight in the natural world. On the walls of Egyptian tombs are innumerable images of birds, animals and flowers, painted or carved with great sympathy and displaying the result of keen observation. However, the intention of these pictures was to represent the activities and interests of man as the conqueror of nature; the plants and animals were seen as a decorative backdrop to man's presence. Although they depicted individual elements of nature in a straightforward way, Egyptian artists would never have tried to bring these elements together as a picture in the way we understand the term. They were not employed to express their own personalities, but to use colors and shapes already chosen and endowed with a particular religious meaning. The skin of men, for example, had to be red ocher, and women were always a paler shade. Backgrounds were generally white or yellow. Everything had a religious significance, so birds or plants may well have been included for symbolic reasons, even though they were painted naturalistically with strong decorative effect.

The same is true of ancient Greek paintings which were influenced, both in style and technique, by the Egyptian artist-craftsmen through the Minoan civilization. In what little painting survives, from Greece, Rome and Byzantium, there is a continuing appreciation of the decorative value of natural forms, but to most people at that time, nature must have represented sheer physical hard work, rather than an object of intrinsic beauty.

In medieval art, nature takes on a greater symbolic value and is represented less realistically. Artists worked in the service of Christianity, a religion which in its early centuries scorned sensuality. There was a considerable fear of nature, of dark forests, storms and other natural hazards, perhaps reflecting a fear of man's own nature. In paintings of this period, a single stylized tree might be used to represent the whole Garden of Eden.

Gradually, however, nature was seen to be tamed in the monastery gardens, and even eventually associated with enjoyment. Later medieval poetry extrolled pleasures which were decidedly un-Christian in the sense of the earlier religious teachings, and these ideas later found a pictorial expression in the work of the Italian Renaissance. There is little vegetation in evidence in the great pioneering frescoes of Giotto (1267-1337), but wonderful glimpses of the natural world can be seen in the paintings of the later Sienese school – particularly in *Good and Bad Government* by Ambrogio Lorenzetti (1319-1398) and some works by Simone Martini, who was a friend of the poet Petrarch (1304-74).

The landscape played an increasingly important role in painting, albeit with strong human associations, and by the time of Piero della Francesca (1410/20-92) the figures are inseparable from their natural surroundings. A good example of this is a small work by this artist in the Accademia in Venice, *St. Jerome and a Devotee.* It shows an interesting use of color which conveys a strong bond between man and his environment. The landscape is painted in soft greens and umbers. The figure of St. Jerome, a wooden crucifix and the town behind are painted in a similar, but lighter range of color. The effect of this is to establish immediately a relationship between the saint and the landscape where he is evidently at home. The devotee, however, is clearly a visitor, as expressed by the isolated cool red of his cloak, its color making a delicate balance with the complementary greens behind. The painting has a Christian theme, and nature is no longer treated symbolically but is represented as a cultivated and unthreatening setting.

This and other paintings demonstrate that Piero had a profound feeling for geometry and a developed appreciation for the laws of perspective. He also made extensive use of a canon of geometric proportion derived from Pythagoras and known today as the Golden Section. Commonly applied in classical Greek architecture, it is based on the idea that certain relationships of shapes are especially satisfying to the eye. Its laws are derived from forms in nature, such as the spirals found in sea shells and the way seeds are placed in sunflower heads, and the rectangle based on such forms has been used by many artists during and since the Renaissance. Good examples of Piero's use of the Golden Section are the *Flagellation* (1456/7) in Urbino and the *Baptism* (usually considered one of his earliest works) in the National Gallery, London. The latter picture is still not a "pure" landscape, as the figures are the most significant elements, but from the flowers in the foreground to the fields on the horizon, all is closely and objectively observed. There are no strong contrasts of light and shade, no apparent literary overtones, a carefully considered use of color (note how the eye is led into the background by the alternate colored and monochromatic figures); all conspiring to give the utmost clarity.

Another example of straightforward observation of landscape, a little later in the fifteenth century, is the work of Giovanni Bellini (1430/40-1516). His paintings show a greater interest in light and shade, while there is an attempt to convey the feeling of a particular time of day, which did not seem to interest Piero della Francesca so much. In many ways, the work of these two painters can be seen as examples of a tradition of landscape painting (a cool, direct and

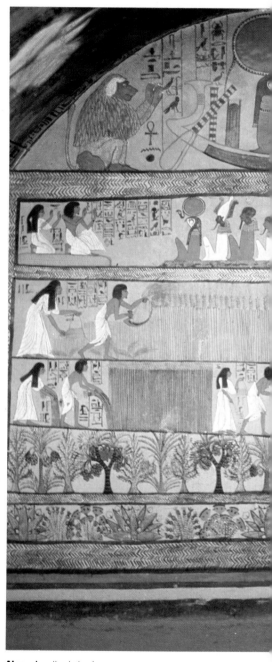

Above A wall painting from the tomb of Semmejem, Egypt. Dating from the time of the New Kingdom (1580-1085 BC), it depicts the agricultural products of the river Nile and shows an awareness of the rich decorative value of natural forms. One of the purposes of such paintings was to ensure the deceased was supplied with adequate provisions for the afterlife, demonstrating a remarkable belief in the power of visual imagery. The artists who were entrusted with this task could clearly not resist the opportunity to exploit the decorative potential of the trees, the grain and the patterned animal. The water, too, is expressed as a decorative surround.

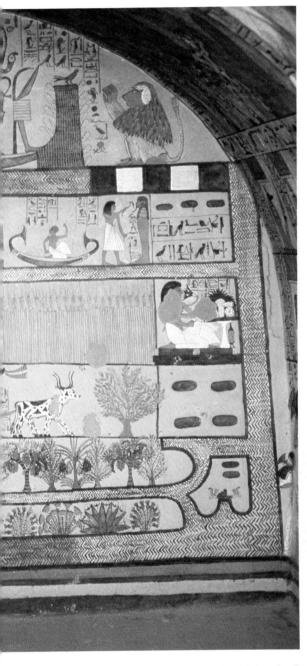

Left A detail of a hunting scene from the tomb of Nakht painted early in the New Kingdom. It shows cats climbing papyrus plants to find birds' eggs. At this period artists were achieving a new freedom. Birds, for example, previously perched like hieroglyphs, were allowed to spread their wings and fly.

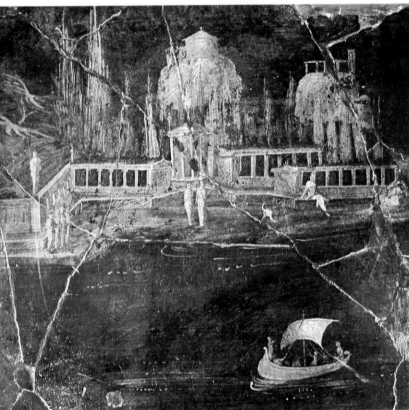

uncluttered observation of the world) which was later continued by such painters as Bruegel, members of the Dutch school and, to some extent, by the Italian painter Canaletto.

A different tradition of landscape painting began with Italian painters such as Giorgione (1475-1510). Together with the Renaissance interest in classical sculpture, there existed an equal interest in the Latin poetry of Ovid and Virgil, who had themselves been influenced by the Greek writers Theocritus and Hesiod. The idea of a Golden Age of pastoral bliss, decribed anew in a work called *Arcadia* (1504) by Jacopo Sannazaro increasingly appealed to

the Renaissance artists. Many branches of the arts have been influenced, directly or indirectly, by this work – Shakespeare's *As You Like It*, for example – but most of all, landscape painters. The word Arcadia is still used to evoke an earthly paradise.

Giorgione's *Fête Champêtre* (c1510) is a visual expression of this ideal landscape. The composition is again dominated by figures but the countryside is more than a background. The effect of the picture is very dependent on the way in which nature is represented. The light and shade in the trees, the delicate foliage, the distant glimpse of the sea, all

Above A wall painting from Pompeii, the Roman city buried by the ash of a volcano on 24 August, AD 79. This surviving scene may have been part of a large panel set on the wall of a house. It is painted in light colors on a black ground, and depicts a sanctuary by the sea in an idealized setting. Many Roman paintings contained a religious or ritualistic symbolism, but this suggests a positive sense of enjoyment of natural surroundings.

Left A drawing by a monk, (c1066). The tree forms betray little interest in objective observation, but serve as a general symbol of nature. In much medieval art there are stong patterns derived from flora and fauna but the landscape as a whole was not seen as a fit subject for the artist.

reinforce the lyrical mood of the lovers. This picture is not just an ideal landscape, it also suggests an ideal climate in which the arts can flourish.

Some 35 years after Giorgione's death, one of the greatest landscape painters was working in northern Europe: Pieter Bruegel (1525-1569). His pictures follow the more naturalistic tradition of Piero della Francesca rather than the poetic idealism of Giorgione and Titian. He does refer to classical literature in *The Fall of Icarus* (c1558), but even in this picture, the figure of Icarus falling into the sea plays a very small part in the composition, which is a wonderful panoramic landscape. Bruegel chose to paint this scene as an illustration of the German proverb "no plough comes to a standstill because a man dies" – a down-to-earth expression summing up human indifference. His treatment of the theme shows his preoccupation with everyday life.

Among Bruegel's other landscapes are a series depicting the four seasons. They do not have the geometric balance that can be seen in Piero's work but their composition is by no means haphazard. In *The Hunters in the Snow* (c1565) a line of trees is placed in a perfect row down the hillside, creating a strong link between the returning hunters in the foreground and the skaters below. This downward movement is again emphasized by the diagonals of the hunters' spears, the steep roofs on the left and the swooping bird. In *The Corn Harvest* there is again much repetition of shapes. The eye is led from the standing corn in the foreground to the fields in the distance, by a broad sweep which continues back along

a cart track to the left of the picture. The conical forms of the women's hats mirror the shocks of corn, and the brace of partridge to the left are echoed by the figures behind them carrying sheaves.

Bruegel's use of color is interesting, too, helping to achieve the overall clarity to be observed in Piero della Francesca's paintings. The group of peasants having their midday meal at the foot of the tree demonstrates how color is used to augment form. The colors of the clothing match the peasants' gestures of eating and drinking, and their sense of fulfilment. The quality of the bread which the woman with her back to us is eating is conveyed in the color of her blouse and hat, a color which is derived from the surrounding grain. The man at the back must be drinking wine, judging by the color of his shirt. We can feel his thirst in this color. The position of white in the clothing of the other figures reinforces the ways they are eating their white broth. The prostrate man on the left has obviously had his fill of both broth and wine, as conveyed by his white shirt and the wine-colored cloth under his head. This use of local color is a subtle way of portraying atmosphere and temperature.

The traditions founded by Giorgione were continued in Italy by Claude Lorraine (1600-82), born in France, but an Italian painter by adoption. He first went to Rome as a pastry cook, but went on to study painting there and his idealized scenes of antiquity have been an enduring influence on landscape artists. Although Claude, like Bruegel, has been described as a simple man, his work suggests

otherwise. Claude's compatriot and near-contemporary, Nicolas Poussin (1594-1665), who also lived in Rome where the two artists went out painting together, was certainly more educated and his paintings have a more obvious intellectual content. Both painters took up the theme of Arcadia, Claude more exclusively in terms of the ideal landscape, Poussin hinting at nature's darker side. A characteristic work by Poussin, copied from Guercino (1591-1666), is *Et in Arcadia Ego*, meaning "Even in Arcadia I (death) am found." Romantics were later to misinterpret this as "I too, have tasted Paradise," but Poussin's message was less simple.

Claude often worked directly from nature, and, although his themes were classical, his real interest was light. He is known for his magnificent sunsets and also for effects of light at all times of the day. Where other landscape painters observed the effects of the different seasons on the countryside, he portrayed the changing light from dawn to dusk. His drawings show great freshness and immediacy, although his finished paintings seem to follow a formula in their composition. There is generally a dark foreground, a large clump of trees or group of buildings on one side, a smaller one on the other side, a paler middle distance and then a glorious sky full of infinite nuances of light. His eye for subtle changes of tone enabled him to present vast areas of sky and immense distances, often without using particularly bright colors. As a result his work unfortunately does not reproduce very well.

Claude and Poussin made an enormous impression on the eighteenth-century English painters Constable, Girtin and Turner. One of Claude's greatest and most influential paintings was *Psyche at the Palace of Cupid* (c1664), an idea taken from a tale in *The Golden Ass*, written by the late Roman writer Apuleius (b AD 125). The painting is full of poetry and has quite understandably been known as *The Enchanted Castle*, a classic example of the Arcadian theme. Turner said of one of Claude's paintings that he was both pleased and unhappy when he viewed it – it seemed to be beyond the power of imitation. But Poussin, with his rigorous use of geometry and the Golden Section, with strong right-angles and frontal compositions, was less popular with the English. Poussin was more the precursor of the strongly structured landscapes of Cézanne.

Well before Claude's death in 1682, pure landscape had come to be seen as a fit subject by artists all over Europe. There was already a wealth of naturalistic painting in Holland – Jan van Goyen (1596-1656), Jacob van Ruisdael (1628/9-82), Adraien van de Velde (1636-72), Meindert Hobbema (1638-1709), not to mention Rubens (1577-1640) and

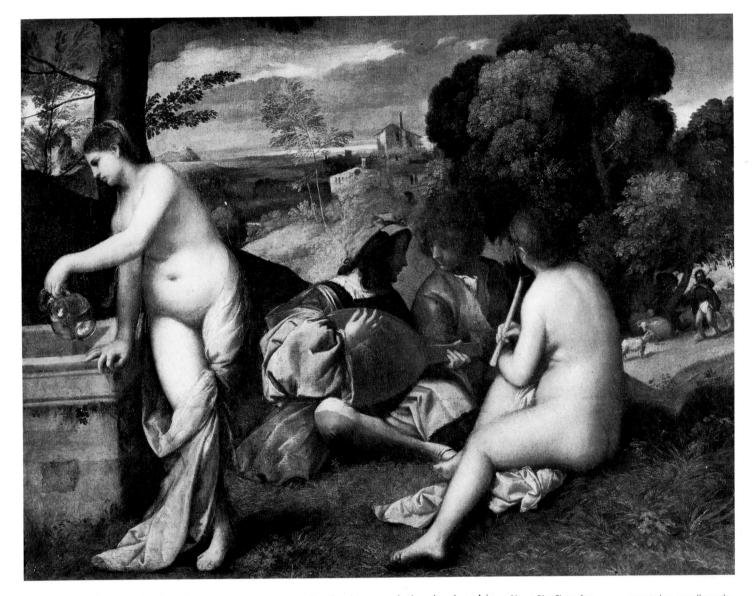

Rembrandt (1606-69). Landscape was, however, subordinate to Rubens' flamboyant historical and mythological subjects and Rembrandt's profound humanitarian vision, although Rembrandt's unsurpasssed skill as a draftsman can be seen in innumerable landscape etchings and drawings. One painting by Rembrandt which does treat landscape as a major theme is the *Landscape with an Obelisk*, a dramatic, imaginative work about the forces of nature.

Jacob van Ruisdael, who died the same year as Claude, stands out as one of the greatest painters of the realistic northern school. His output was enormous, and his later work shows a more romantic vein than others of this period, with large skies and sweeping clouds casting deep shadows across the fields. He was much admired by Constable.

It was not until the middle of the eighteenth century that landscape painting developed in England into something more than topographical views of country estates. In 1746, Canaletto (1697-1768) came to England from Venice in search of more patronage. He is best known for his views of Venice painted to sell to gentlemen on the Grand Tour, mostly English, but when he seems to have been painting more for himself, as in *The Stonebreaker's Yard* and *The View of Whitehall Looking North*, he displayed his full powers of observation.

Canaletto made some use of a *camera obscura*, which had been invented in the sixteenth century although the basic principle was noted by Aristotle. The *camera obscura* is a box with a lens at the front, an inclined mirror inside and a glass screen on top, over which is placed a sheet of thin paper. If the scene is sufficiently bright it will be projected

Above *Fête Champêtre,* (c1510), Giorgione. His life was short and barely a dozen works survive. Giorgione was a Venetian, a pupil of Giovanni Bellini, and this work shows him as one of the first painters to express a mood by means of a landscape. He was also one of the first Venetians to paint pictures for private collectors, which were executed on a smaller scale than work intended for churches. It was not unusual at the time for works which were left unfinished to be completed by another artist. It is thought that Titian finished this one when Giorgione died of the plague. It expresses the youthful hopes of the Renaissance itself.

Right *The Baptism of Christ,* Piero della Francesca. There are few paintings which have so fully captured the calm, impersonal beauty which is often associated with the best classical sculpture. This unemotional view of the world owes much to Piero's love of geometry. The principal lines in the composition follow harmonic proportions based on the Golden Section.

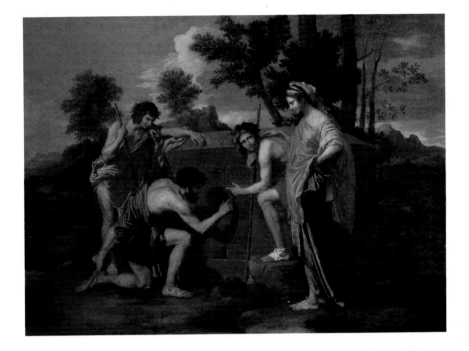

Left *Et in Arcadia Ego* (1639-40), Nicholas Poussin; one of two copies Poussin made of a painting of the same title by Guercino. The inevitability of death was a constant theme in classical Greek and Roman literature. This theme is used here ironically by Poussin, with his reference to Arcadia on the tomb, and the idealized landscape setting.

Below *The Corn Harvest* (*c*1565), Pieter Bruegel; one of a series of five paintings depicting the seasons of the year. In all these pictures he expresses his love of the countryside and the close relationship between man and his surroundings. All of them contain figures of country people, whose labors he celebrates, but the important features of the composition are always dominated by the landscape. Although he may seem to have romanticized rural life, he did not seek the lyrical mood to be found in Giorgione's *Fête Champêtre*. Rather, he appears to be satisfying his curiosity and delight in agricultural practices. With Breugel the realistic landscape emerges as a noble theme.

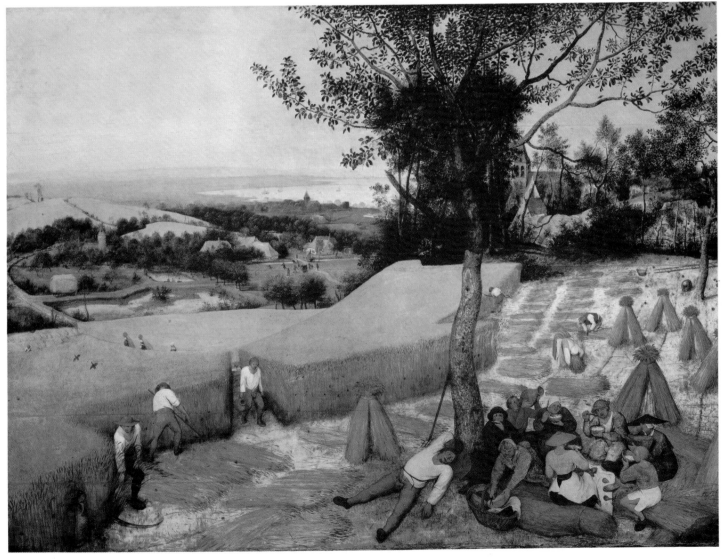

onto the paper and can then be traced. In the early days of its use, when lenses were of relatively poor quality, the image was distorted at the edges, and not all artists who used it as a drawing aid thought to correct this distortion. Among English painters to have used it are the Sandbys, Paul (1725/6-1809) and Thomas (1721-98), de Loutherbourg (1740-1812), Thomas Girtin (1775-1802) and John Crome (1768-1821). Sir Joshua Reynolds (1723-92) had a folding model, bound to look like a book on ancient history.

Another curious optical toy which should have a brief mention in the history of landscape painting is the "Claude glass," more for its indication of the influence of Claude on the English than for any practical usefulness it might have had. The Claude glass was a curved, tinted mirror which was supposed to turn a reflection of a hilly landscape at sunset into a Claude painting. The reflection subdued colors so that the subject was seen in light and shade. These glasses were very

Above left *Psyche at the Palace of Cupid,* Claude Lorraine; an idealized landscape but nevertheless the result of innumerable studies direct from nature. The figure plays an insignificant part in the compositional structure of the work, despite its importance for the content.

Above *Wheatfields* (c1650), Jacob van Ruisdael. This artist was a contemporary of Claude, but had more sympathy for the tradition of realism. Where Claude's art was lyrical and Mediterranean, with literary associations, Ruisdael's was realistic and Northern. Despite an enormous output, Ruisdael is said to have been a dour man who never painted a clear and sunny day. Nevertheless, his paintings are not entirely lacking in romanticism.

Left *Landscape with an Obelisk* (c1638), Rembrandt. This is one of the few paintings by this master with landscape the dominant theme. The scale of the figures serves to intensify the drama and storminess of the landscape.

popular with travellers and romantic poets.

Canaletto's move to England was typical of a general trend among Italian artists looking for wealthier clients, The flourishing of the arts has always been closely linked with, if not entirely dependent on, the existence of rich patrons. While England's wealth was increasing, Italy's was declining, although there was an element of exchange between the countries. An interest in classical values in art was an important reason why a rich young Englishman's education was not considered complete in the eighteenth century until he had made a Grand Tour of Europe, the climax of which was a prolonged stay in Italy. So the great flowering of landscape painting in England was backed by a growing prosperity, from the industrial revolution, and an extensive knowledge of earlier European traditions.

As already suggested, Claude was a major influence, but English painters added a quality of their own – a more personal, less academic response to the countryside. Richard Wilson (1714-82), Sir Joshua Reynolds, George Stubbs (1724-1806), Joseph Wright (1734-97) and John Cozens (1752-97) all made the pilgrimage to Italy, although they did not embrace its influence to the same degree. Stubbs and Wright refused to acknowledge the authority of the academic doctrines of the past, as did Thomas Gainsborough (1727-88) who never left his native country. The determination of these artists to take a fresh look at nature introduced an important element into the art of the period, resulting in

a complex interaction between the academic approach and a more spontaneous response to the visual world.

Gainsborough made a very individual and unorthodox contribution with freely drawn and rather emotional evocations of landscapes. He painted portraits for a living, but wrote to a friend, "I'm sick of portraits, and wish very much to take my Viol da Gamba and walk off to some sweet village where I can paint landscapes and enjoy the fag end of life in quietness and ease." This wishful thinking recalls Giorgione's *Fête Champêtre.* The influence of classical art and literature, the beginning of industrialization in the cities, all gave impetus to the image of Arcadian release.

Toward the end of the eighteenth century three artists were born within a year of each other: Thomas Girtin, William Turner (1775-1851) and John Constable (1776-1837); the latter two becoming the greatest English landscape painters. Girtin is best known for his watercolors, a medium in which he made considerable innovations, using richer, more direct application. He died in his late twenties; Turner said, "If Tom Girtin had lived I should have starved." Turner worked in a great variety of media and tackled an enormous range of themes, whereas Constable devoted himself almost exclusively to an honest, naturalistic observation of the English countryside.

Both Turner and Constable were admirers of Claude, and in Constable's work this influence was finally assimilated with the equally strong influence of the Dutch painter Ruisdael. Constable concentrated on the particular sensations received from a particular scene in nature, where Claude had taken elements from different places and welded them into an imaginative composition. Some comparisons can also be made between Constable and the poet Wordsworth. Each loved the familiar and never turned their back on the countryside where they grew up. Both were important figures in the Romantic movement which took place between about 1750 and 1850, and much of Wordsworth's poetry could be describing Constable's painting, as this example from *Tintern Abbey*:

I have learned
To look on Nature, not as in the
Hour of thoughtless youth; but hearing
 oftentimes
The still, sad music of humanity.

There was certainly an element of sadness, even pessimism, in Constable's later work, and there may well have been an element of nostalgia, for by the 1820s there was much unemployment and poverty in country life which he would not have been affected by as a child. But it was his interest in the familiar which gave his work its strength. He would

Left *View of Whitehall Looking North* (c1730), Antonio Canaletto. Canaletto is probably best known for his views of the canals and buildings of Venice. He often painted at great speed for the tourist market. He was certainly skillful and, at his best, a thoughful and objective observer in a realistic tradition. His earlier Venetian scenes were painted on the spot, which was unusual at the time, but he later worked both from drawings and with a *camera obscura* in the studio. He worked in England for about 10 years in the mid-eighteenth century.

work extensively from the same view before attempting the finished canvas. First he made rapid pencil drawings in notebooks, followed by rapid paintings in oil, then more detailed drawings and larger paintings. One of his many qualities was an ability to hold on to his original conception of the work and develop and refine it by constant study. He even made full-sized paintings for himself before proceeding to the finished version to be exhibited. Perhaps he felt a need to conform to the contemporary notion of what constituted a "finished" picture, but the immediacy of his preparatory work is often more appealing now. It is interesting to look at the finished *View of Hampstead Heath* beside the study for that work. The latter is painted much more freely with quick broad brushstrokes. In some of his more highly finished works he did gain additional richness from the inclusion of greater details, but sometimes overdid it by putting little flecks of light on almost every leaf. This does not detract from his achievements. His paintings were about the countryside, but also about enjoying being there. Most importantly, they were the result of a direct relationship with what he saw before him.

Where Constable concentrated his attention on familiar landscapes, Turner had much wider interests in terms of subject matter. He started his career using watercolors, working alongside Thomas Girtin on fairly traditional landscapes, and although he later painted a lot with oils, he contrived to use this medium throughout his life. It could be said that his oil paintings were influenced by this understanding of watercolor, a medium well suited to his interest in high-key effects of light. Watercolor does not give a tonal range at all comparable with oil paint, and Turner's oil paintings mostly employed the brighter part of the spectrum, often in conjunction with pure white, giving a similar effect to watercolor paper. This love of brightness was not fully expressed in his work until he eventually went to Italy at the age of 44, by which time he had established a controversial reputation for himself with the bold "unfinished" look of his pictures.

Turner's taste for the romantic and dramatic can be seen in his grand themes. In *Snow Storm, Hannibal Crossing the Alps,* and in most of the storm and shipwreck pictures, the violence of nature is the real theme. In *Hannibal* the soldiers display no heroics but crouch sensibly behind rocks. The composition of the painting is similarly unclassical with its diagonal sweeps and the absence of vertical and horizontal lines; nature is presented in disorder. Dark, pessimistic, streaks in his character were challenging the

more serene classical influences Turner had admired as a young man. His delight on arriving in Venice for the first time was not so much due to the magnificent architecture and pictures, but was an appreciation of the glare of the sky and the reflections in the lagoon.

Conventional taste had found trends in Turner's work difficult to appreciate earlier, and it was to be increasingly perplexed. His works had already been labelled by contemporary critics as "pictures of nothing and very like." Another quip – "tinted steam"

– was probably generally accepted as fair comment. Turner did, however, have a champion in the writer John Ruskin (1819-1900), who extolled the art of landscape painting, particularly Turner's. Unfortunately, Ruskin got carried away by his belief in Turner as the greatest of landscape painters and is thought to have destroyed, on Turner's death, a number of figure drawings which Ruskin considered pornographic and harmful to Turner's reputation. The breadth of Turner's vision was misunderstood even by

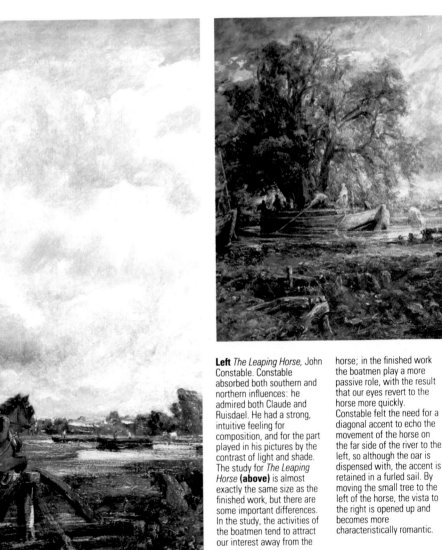

Left *The Leaping Horse,* John Constable. Constable absorbed both southern and northern influences: he admired both Claude and Ruisdael. He had a strong, intuitive feeling for composition, and for the part played in his pictures by the contrast of light and shade. The study for *The Leaping Horse* **(above)** is almost exactly the same size as the finished work, but there are some important differences. In the study, the activities of the boatmen tend to attract our interest away from the horse; in the finished work the boatmen play a more passive role, with the result that our eyes revert to the horse more quickly. Constable felt the need for a diagonal accent to echo the movement of the horse on the far side of the river to the left, so although the oar is dispensed with, the accent is retained in a furled sail. By moving the small tree to the left of the horse, the vista to the right is opened up and becomes more characteristically romantic.

the person who did most to advance him.

Turner did not actually settle in Venice for any length of time but made hundreds of watercolor studies there, painting in oil on his return to England.

There is little recognizable form in the paintings, the composition depending entirely on the juxtaposition of colors. He was not really attempting to paint the effect of light, but to paint light itself.

Well before Turner's death in 1815, it had become accepted for a landscape painter to work directly from the subject, rather than make studies outside and then compose a picture from them in the studio. A school more or less devoted to the outdoor approach developed in Norwich. This part of England had strong trade links with Holland and many Dutch paintings had found their way into East Anglian collections. It was natural that artists here should absorb the influence of Ruisdael, Hobbema and Aelbert Cuyp (1620-91), all the more so as the countryside was similarly flat. The principal figures of the Norwich school were John Crome and John Sell Cotman (1782-1842). They painted landscapes in watercolor and oil with great freshness, following the Dutch tradition of enjoyment of the familiar scene.

The hundred years preceding Turner's death in 1851 had seen great developments. At the beginning of this period, the creative energy was in part the result of the successes of England as a country, and these successes saw the growth of a middle class which could afford paintings. A painter could survive without the patronage of an aristocracy educated on the classics. Both Constable and Turner had been nurtured on Claude but subsequently developed individual styles. However, neither was immensely popular at his death. Constable was born relatively poor and died in a similar condition, his work not fully appreciated in his own country. Turner enjoyed worldly success – he was a shrewder man – but his later work had no immediate influence.

Although he had little following in England, Constable was much admired in France, where he had exhibited *The Hay Wain* and the *View on the Stour* in 1824. The romantic painters, Géricault (1791-1824) and Eugène Delacroix (1798-1863), travelled to England where they welcomed the change from the classical traditions still prevalent in their own country. It was Constable's free handling of paint that impressed Delacroix, rather than his subject matter, but both of these aspects were later to have an influence on Jean François Millet (1814-75), Diaz de la Peña (1807-76) and Theodore Rousseau (1812-67). These three formed a group of landscape painters at Barbizon, in the country south of Paris. In common with Constable, their work was based on the direct obser-

vation of rural life. Millet at his best had a wonderful eye for color in which he anticipated Impressionism. The group as a whole upheld the dignity of peasant labor, but tended to sentimentalize.

It was not only the influences from England at this time that produced great landscape artists. Jean Baptiste Camille Corot (1796-1875) showed little interest in either Constable or the Romantic movement in general. He was born in Paris and made a late start in painting as his father wanted him to go into the family cloth business. He was a generous, ingenuous man, always charitable to other artists, and ready to help and learn from the young. This openness is seen in his painting, through his ability to simplify and rationalize forms without generalizing them. Combined with this was a natural gift for the very accurate observations of tonal values. He often used a full tonal range, from very dark to very light, with intermediate colors

Above *Venice* (1840), J.M.W. Turner, This is one of Turner's more elaborate compositions in praise of the rich effects of light which he found so compelling in the city. Compared with his later paintings of Venice, this contains a wealth of detail; this was subsequently to dissolve into the bright mists of the lagoon in later works.

Right *Appledore,* Thomas Girtin. In this watercolor of a river estuary very few colors are used and none of them are very bright; it is Girtin's extensive use of very watery paint which gives the work its expressive quality.

carefully evaluated within the overall tonal structure. In many of his landscapes, he chose a time of day when shadows are deep and the sunlight only picks out a few areas brightly, often making these few light shapes the focus of our interest. A particularly good example is *The Lake of Geneva: The Quai des Paquis* where it seems he has made an early decision in its composition about which few shapes will be the brightest.

Corot's training was classical, following in Claude's and Poussin's footsteps to Rome. As was now common practice, he made small paintings from nature with the intention of using them for larger works to be completed during the winter months. In these small studies he displayed a sure sense of composition, and an accurate eye for tone and color. In other words, his studies were complete works on their own, and they remain his best work. Where he went on to enlarge one of these little paintings into an exhibition piece he frequently failed, simply because the initial quality of his on-the-spot observation was the real core of his work: in these studies, he wanted to capture precise moments of the day when the tonal structure was of critical importance. He said, "Never leave anything uncertain in whatever you do. Paint the picture part by part, as fully as possible at the first try, so that very little remains to be done after everything has been covered with paint. I have observed that something done at the first attempt is more direct, more attractive, and that it is often possible to take advantage of accidents; whereas if one does a thing over, one often loses the original color harmony."

Constable's landscapes expressed an underlying philosophy about man's relationship with nature, but Corot's were the result of a more direct, less literary response. Yet it could be claimed that both painters were important forerunners of Impressionism because their best work was done while they were actually looking at the motif – the physiological eye was playing a greater role in the construction of the picture. Looking back to the painting of Claude, Bruegel or Piero della Francesca, it is apparent that their grand and ambitious themes could never have been achieved without painstaking studio preparation. It would be unfair to Corot to say that he was less ambitious in his work than these masters, for *his* visual explorations were in relatively new territory. He could have pointed out quite correctly that the Umbrian sun would never have cast such pale and delicate shadows as those we see under Piero's trees. Both Corot and Constable shared a part in the trend toward visual realism.

By the middle of the nineteenth century Europe was no longer the only place where Western landscape traditions were emerging

Below *Snow Storm:
Hannibal and his Army
Crossing the Alps* (1812),
J.M.W. Turner. This
imaginative composition
shows a mixture of
romanticism and worldliness.
The dramas of nature form
the real subject, and Turner
no doubt enjoyed the irony
that the soldiers survived the
passage only to suffer a
more tedious defeat in Italy.

Bottom *Golden Summer*
(1888), David Davis. Davis
was one of the Australian
artists who were indirectly
influenced by the Barbizon
school in France. He took part
in an exhibition held in
Melbourne in 1889, called
the 9 × 5 exhibition because
all the works were painted
on wooden cigar box lids of
those dimensions. Many of
the paintings were of the
countryside around
Melbourne.

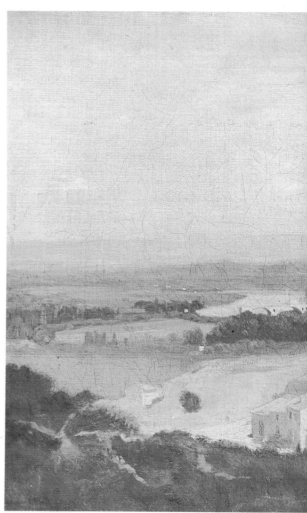

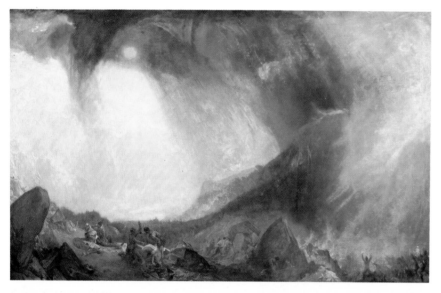

Above *Avignon: View from
Villeneuve* (1835), Jean-
Baptiste Camille Corot. This
is one of many small
landscapes painted out of
doors by Corot during his
summer travels. He kept it in
his own collection all his life.
He may well have considered
it as a study for a larger work
to be completed in the winter
months, but the composition
is so satisfactory that it is
hard to imagine how a
different scale might improve
it. There is a close
relationship between the
way in which an artist makes
his observations and the
scale whereby he translates
them into paint.

and being adapted. In America, Washington Allston (1779-1843) and Thomas Cole (1801-48), the most important painters of the Hudson River school, had imported a Claudian approach, which they both developed into a more extravagantly romantic style, similar to their English contemporary John ("Mad") Martin (1789-1854). Cole had grown up in England and, after emigrating to America, continued to travel in the West Indies and Europe throughout his life. When in Italy he rented the studio which was thought to have belonged to Claude.

The continuing admiration of Claude was also manifest in the work of early Australian painters, John Glover (1767-1849), for example. However, at this time the Australian population was still tiny, in part composed of people who were there against their will. It was not until the Swiss painter Louis Burelot arrived in 1864, bringing with him the open-air techniques of the Barbizon school, that an important Australian movement got under way.

It was in France that the greatest changes were taking place, accelerating the progress of natural realism, a trend anticipated by the preceding generation of artists. Gustave Courbet (1819-77) condemned romanticism along with classicism, reacting against the idealization of nature which was current teaching in the art schools and considerably debased. Only the familiar was worth the artist's attention: "Nature offers a beauty superior to any artistic convention." His work was uneven in quality, but his fierce stand against academism set an example for the Impressionists, who spent a large part of their lives as poor and unpopular as Courbet.

The main figures of the Impressionist movement, Camille Pissarro (1831-1903), Edouard Manet (1832-83), Edgar Degas (1834-1917), Paul Cézanne (1839-1906), Alfred Sisley (1839-99), Claude Monet (1840-1926) and Auguste Renoir (1841-1919) were all born between 1831 and 1841. Of these, Manet and Degas were neither landscape painters, nor entirely Impressionist in their own work, but must be mentioned for their influence and support for the group. Cézanne and Renoir also developed away from the movement after its initial achievements, but for a time the paintings of all of them represented an explosive reaction to the increasingly dry and colorless work of the academic school. Pissarro, Sisley and Monet took natural realism to an ultimate point, excluding any element which was not informed by the visual impression received by the eye. Paintings were executed in front of the subject, often a familiar landscape, a street or a river scene, pitched in a high key, with bright colors discovered even in the deepest shadows.

One of the Impressionists' most durable achievements was to show that anything can be a fit subject for painting; the importance lay not with what was painted but how it was perceived. Monet, starting from the direct influence of Corot and the very indirect influence of Constable, went on to choose the formal facades of cathedrals and the almost formless shapes of haystacks to demonstrate this point.

Renoir was a close associate of Monet for a while, but after some success with portrait paintings, he travelled around Europe, studying in museums, and became increasingly dissatisfied with the limitations of Monet's exclusively visual approach. Sisley, like Monet, remained true to the ideals of

Impressionism, but somehow with less conviction and his later paintings suffered as a result. Pissarro, in his old age, began to introduce into his work a more conscious structure than we see in the very freely composed waterlily paintings of Monet; indeed both of them, by the 1890s, were debating to what extent they should feel committed to the immediate impression. Pissarro was coming round to the view that the unity which the human spirit gives to vision can only be found in the studio. "It is there that our impressions – previously scattered – are coordinated, and give each other their reciprocal value, in order to create the true poem of the countryside."

Cézanne associated himself with Impressionism during its great decade, the 1870s, but it was an uneasy alliance. He was not happy with a painting being so dependent on the light of a specific moment of the day. He was not temperamentally suited to making rapid statements, which the outdoor technique demanded. Although he liked his subject in front of him as he painted and he used the bright palette of the Impressionists, he wanted to build forms with color without being committed to particular effects of light. While Cézanne wholeheartedly endorsed the need to look at nature afresh, he was also drawn to the grand formal compositions of Poussin and stated that he wanted to paint similar works, but directly from nature.

Cézanne's early work was not greatly appreciated by his fellow artists, still less by the public. He decided to return to his native Provence where with the help of family money he was able to settle down to many years of singleminded industry. One advantage of this move was the more settled climate of the south. It is said that he sometimes deliberated for up to 20 minutes in between brush strokes; certainly he spent a month on some paintings.

A lesson from Cézanne's Impressionist days was that where there is color at all, the whole scale is called into existence; where he might use blue to give the effect of recession, there is also a complementary orange to reaffirm the surface. His important achievement was to present a complete world where objects are seen as form in space, as a two-dimensional pattern and in terms of color harmony. The color harmony helps to achieve both form and pattern in such a way that each augment the other. His method was akin to that of a sculptor carving a relief – always being aware of the surface and yet conjuring up immense space from a relatively shallow incision. Cézanne's chisel was clean cool color.

Cézanne declared a preference among painters of the past for the great colorists: Titian (c1487-1576), Tintoretto (1518-94), Veronese (1528-88) and Rubens, and his early work had an almost baroque character. Later,

he used his powers to intellectualize the art of painting. He moved away from the naturalism of Constable, Pissarro and Monet, giving less importance to the purely visual function of the eye. "Monet is only an eye," he said (adding, "But what an eye!"). He gave form a greater identity than the atmospheric approach of Impressionism allowed, unwittingly following Piero della Francesca with his use of local color and simple continuous outlines, minimizing shadows and reflected color, applying paint thinly, not imitating textures with either brush or pigment, but letting color determine texture. Impressionism could so easily degenerate into a mere copying of nature. Cézanne reinstated classical structure, with a tension of composition which had begun to disappear. He wanted us to see with the inner, not the physiological, eye.

By the end of the century Cézanne was a lonely and suspicious man, almost a recluse, although he travelled to Paris regularly. In 1895, Pissarro suggested to Monet and Renoir that they encourage the young dealer Vollard to see what their friend from earlier days had been doing. The result was an exhibition of over 100 of Cézanne's paintings; Cézanne's friends, Degas included, bought as much as they could afford. He died in 1906 amid a growing interest in his work but after the years of isolated innovation, he never believed his paintings were properly understood.

Above *La Montagne Sainte-Victoire* (1905), Paul Cézanne. This is a later version of the many paintings Cézanne made of this mountain. By taking some of the colors from the foreground and using them in the sky Cézanne was trying to make us aware of the flat surface of the canvas. Although the sky and the mountain are painted strongly, there is no doubt about the recession across the ground away from the spectator to the base of the mountain. Every tiny part of the canvas is treated with great intensity.

Right *The Breakaway* (1891), Tom Roberts. Born in England, Tom Roberts went to Australia at the age of 13, but later returned to London to study. The almost photographic realism in this picture, imported from Victorian England, is employed to express the artist's excitement at the brightness of the light. It was this strong light that determined the characteristic blue and gold palette of subsequent schools of Australian landscape painters.

While Cézanne was working in Provence, Impressionism was being developed in a parallel but different way by Georges Seurat (1859-91), a painter who saw himself more as scientist. The Impressionists had already broken their painted surfaces down into the colors of the spectrum, and had maintained that black did not exist in nature. Seurat took this idea further by using only the three primary colors, mixed with nothing but white. In his experiments with optical mixtures and color theory he applied the primaries as hundreds of little dots over the surface of the canvas (popularly called Pointillism, but he preferred the term Divisionism). A green shape, for example, would be made up of

yellow and blue dots. He also took a great interest in geometry and the Golden Section, and admired Piero della Francesca. Naturally, working as he did, his large paintings had to be executed in the studio. Like Cézanne, Seurat achieved great monumentality without sacrificing any of the new luminosity in painting gained by the Impressionists.

The bolder use of color during the second half of the nineteenth century had been almost universally welcomed by artists, but Cézanne and Seurat were not alone in wanting to achieve more than a purely visual representation of nature. Paul Gauguin (1848-1903), Vincent van Gogh (1853-90) and Henri Matisse (1859-1954), were all important as

generators of different non-naturalistic schools of painting in the twentieth century. To a greater or lesser extent, they all joined in the increasing interest in artistic traditions and cultures outside Western civilization: Islamic, Moorish, Oriental and primitive.

Gauguin rejected European ideas in general, and naturalistic representation in particular, countering Seurat's Divisionism with a style known as Synthetism. This involved the use of large areas of flat, strong color which were juxtaposed to evoke moods and emotions – a source of much abstract art today.

Van Gogh's eventual difficulty with the Impressionist idiom, and consequent essays in

both Seurat's and Gauguin's styles, was more closely connected with his own temperament than with any theorizing. As is well known, he led a life increasingly interrupted by periods of insanity, culminating in suicide, but not without moments of joy, as on his first discovery of the south of France. His problem as a painter was that he had learned from the Impressionists and Seurat how to express delight, but not despair. Later he felt a need to say more about his own personal sensibilities and developed an agitated brush-work to animate his subjects. He made calculated distortions in perspective for particular purposes; an isolated figure on a road, which disappears into the distance with

Above *Landscape at Collioure* (1906), Matisse. Although Matisse tried for a short while to make his color schemes conform to the theories of some of his Post-Impressionist contemporaries, his exuberant approach expressed itself more easily by intuition. The freedom with which he applied color to the canvas is deceptive; he composed his pictures with great care.

Center right *Drought-Stricken Area* (1934), Alexander Hogue. This landscape is composed almost entirely of hard lines and angles, used to suggest the disappointments experienced by many Dustbowl farmers during the American Depression. The cow's ribs, echoed by the broken machine and the dry, ribbed sand, are the focus of the desolate isolation of the scene.

Above *Waterlilies* (1916-22), Claude Monet. This painting also hovers on the verge of abstraction, but within a different tradition. The many pictures of waterlilies made by Monet in his last years are often hailed as one of the starting points of abstract art, particularly Abstract Expressionism, but it would be more accurate to see them as a logical development of Monet's commitment to total naturalism and to recording the eye's sensations.

Right *Primrose Hill* (1961), Frank Auerbach. Auerbach is a painter who uses color as a tool for drawing the forms of the landscape, but never in a descriptive or naturalistic way. The result is a strong feeling of physical presence. The thickness of the paint is not the result of any interest in surface texture.

Right *Farm at Duivendrecht* (1907) Piet Mondrian (1872-1944). There is always some fascination in seeing the early work of an artist who has subsequently become associated with a particular style. Mondrian's later work is uncompromisingly abstract, mostly based on a black grid filled in with rectangles of color. This early work, a romantic and stylized landscape, shows how radical a change he made.

Above *Trees and Barns* (1917), Charles Demuth (1833-1939). Demuth was an American artist who studied in Paris, and the influence of both Cézanne and the Cubists is manifest in this taut, elegant composition. The geometric shapes of the barns are used to intensify the organic twisting forms of the branches.

an exaggerated perspective, expresses loneliness and alienation. He also used simplified outlines and strong color for emotional effect. Van Gogh and Gauguin were the prime influence on the Norwegian Edvard Munch (1863-1944) and a subsequent school of Expressionist painting.

In 1905, a questionnaire devised by a journalist was sent to a large number of painters in France, asking for their views on trends in painting at the time. It was generally agreed that the freedoms gained by Impressionism had been of lasting value, but that greater content was sought. Gauguin and Cézanne were praised, the one for his rich and decorative color, the other for his use of color to create space and structure. Some answers to the questionnaire also suggested that artists should put more of their own personality into their work. Whatever measure of agreement was reached in their answers, artists at that time were working in a greater variety of directions than ever before, and have continued to do so.

At the turn of the century, the painter who emerged as the most able to assimilate these diverse forces was Henri Matisse. Never associating himself with any particular school. Matisse responded to many in a personal way, learning from Gauguin, Seurat and Cézanne, and from different cultures throughout the world. Matisse was able to combine decoration and structure in a unique way and his pictures, however free they seem at first glance, were always composed with rigorous care. In 1944 he gave an explanation of his approach: "The vertical is present in my mind; it helps me to define the direction of the other lines . . . I never draw a curve, for example a

branch in a landscape, without bearing in mind its relation to the vertical." By implication, drawing and composition, the placing of shapes in relation to the edges of the paper or canvas, were inseparable. Nothing should be drawn without reference to its part in the whole.

Matisse's lifetime covered a period which saw not only rapid changes in the way artists treated their subjects, but also the disappearance of the subject altogether. Although the development of abstract art does not fall within the scope of this book, it is interesting to note that there have been many painters, such as Nicholas de Staël (1914-55), who have taken landscape as a starting point for abstract painting. Other artists have reacted against abstraction, some by looking back to Cézanne, others by responding to the type of realism expressed by photographs.

Today, our knowledge and understanding of foreign traditions brings home the power that artists have always exerted over our manner of looking at nature. Travellers to China, who are familiar with Chinese paintings, inevitably see the landscape through the eyes of its interpreters whereas, for the first painters who went from Europe to Australia where there was no tradition of landscape painting, it took along time before they stopped seeing a European landscape in the Australian bush. We can now look back with amusement on those romantic poets, who were so conditioned by a tradition of landscape painting that they used a piece of tinted glass to force the English countryside to conform to their vision of a pastoral paradise.

This has only been a brief survey of the history of landscape painting in Western art.

It would have been possible, especially for the earlier centuries, to write an alternative account, using quite different paintings as examples. The artists discussed here have been chosen not only for the interest and beauty of their work, but also for their individual contributions to the development of landscape as a subject and their influence on other artists.

OBSERVING AND RECORDING NATURE

Painting from nature is almost invariably the result of an artist combining many images and impressions collected over a length of time; it is a synthesis of his visual experiences. However, when the painter represents a varied collection of three-dimensional forms in space on the flat surface of his canvas he cannot avoid distorting what he has seen. Perspective is one convention which he can decide to employ in order to form these many images into a coherent entity. Perspective has its own laws, but these are not laws of painting as a whole, and many artists choose not to use them. To choose to use them involves understanding the idea of a picture plane.

USING PERSPECTIVE
The Picture Plane

Imagine holding up an empty frame or a sheet of glass squarely between you and the scene you are painting. It must be at right angles to your line of vision and stay in the same position because it establishes a particular viewpoint in relation to the motif. If this viewpoint is altered during the course of the painting, it leads to inconsistencies in perspective.

To explain the reason for this, imagine sitting in the middle of a plowed field. If you look at the field in one direction, the lines of the furrows will cross horizontally from one side to the other. If you make a right-angled turn, these lines will be going away toward the horizon. If you look to a corner of the field, they will be rising diagonally toward a point out of sight. If you extend your line of vision and include the landscape beyond the plowed field, looking directly across the furrows you will have horizontal lines across the foreground. If you include a wide vista, which involves looking from one side to another, consider what would happen to these horizontal furrows if you are altering the position of the picture plane. Looking through the picture frame toward a clump of trees at the righthand corner of the field, the furrows would appear to fall away to the left; swinging the frame round toward the lefthand corner, the furrows would fall away to the right. To do the same for the intermediate points, and combine the views, would produce a gradual curve for the edge of the field. Assuming that the field is relatively flat, this is clearly a distortion; it is only by accepting a fixed position for the picture plane that the edge of the field can be represented as a straight line.

It is also useful to check the angles which lines observed in the landscape make with the verticals and horizontals formed by the edges of the frame, and therefore the painting. This can easily be done by holding a paintbrush first vertically and then horizontally, and gauging the angle of the observed line against it. If the painter makes use of the principle of

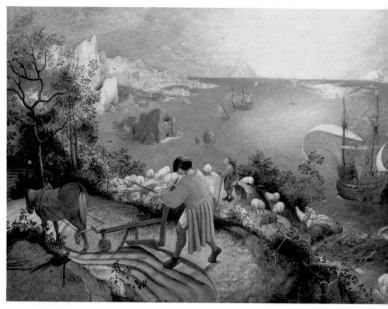

Right *The Avenue at Middelharnis (1689).* Meindert Hobbema (1638-1709). Hobbema was a pupil of Ruisdael, and many of his works are very similar in style to those of his master. This one, however, has a quiet, peaceful atmosphere, whereas Ruisdael's often hint at a certain conflict between man and nature. What the paintings of the two artists certainly have in common is the emphasis given to large skies. Hobbema gave up painting in his early 30s and spent the next 40 years of his life as a wine taster.

Left *The Fall of Icarus,* Pieter Bruegel. Although Bruegel painted many scenes of Biblical stories and of folk customs, this is his only reference to classical mythology. His treatment of the theme shows his preoccupation with everyday life, and a sympathy for the farmers whose labors are unaffected by dramatic events.

Right *Crossing the Ganges,* Akbar. This Persian painting shows a tradition that is completely different from that found in Western art. Some recession is achieved by the overlapping of forms, even though the most imposing figure, furthest away from us, is larger than the others. The decorative value of the figures, animals and the water clearly takes precedence over an attempt at the spatial organization which is so important in Western art.

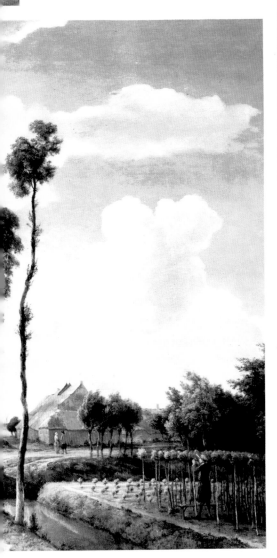

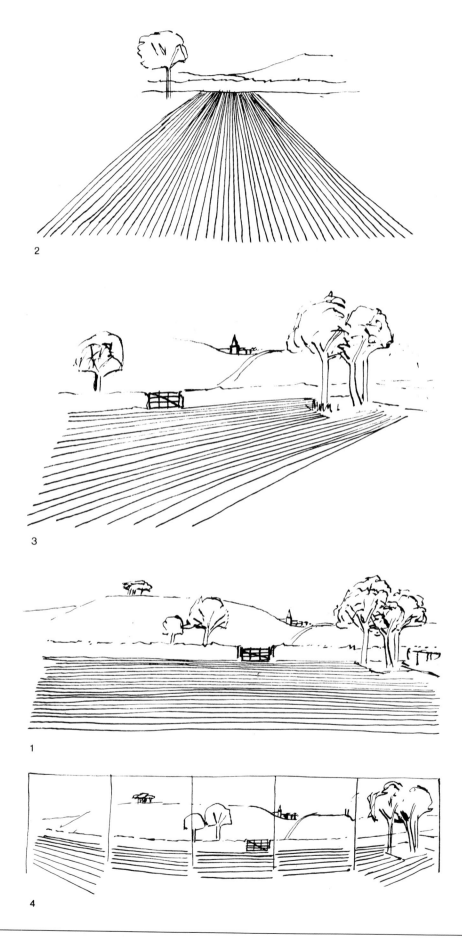

the picture plane and then looks for the variations, he will be better equipped to make sense of the space he is representing in his composition.

The Vanishing Point

The next important step is to establish the eye level. If you now turn 90 degrees you see furrows going away toward the horizon. The angle the furrows make against other furrows will change according to your own height from the ground. When standing, your imaginary eye-level line will be the same distance from the ground as your eyes; if you can discern another person on the horizon you will know exactly where it is. The parallel furrows, if extended to the horizon, will appear to meet at a point on this level, which is called the vanishing point.

This point can be within the picture or outside it, depending on whether the furrows are parallel to your line of vision. If you are looking diagonally across the furrows to the corner of the field, they will have a vanishing point off the edge of the picture, but it will always be somewhere along the eye level.

If there is a hollow in the field, lines will converge below the eye level where they dip downward and above it where they rise up again, although the vanishing point will stay on the same vertical axis. In this situation, most artists prefer to trust their own powers of observation.

Linear Perspective

Perspective operates in all dimensions. An avenue of trees, for example, will recede according to the same laws. If the trees are planted in a straight line and are the same height, both the bases and the tops of the trees will form lines which will converge at the same point. *The Avenue at Middelharnis* by Hobbema (1638-1709), which shows a view of a country lane running through an avenue of trees, where the vanishing point is at the level of the painter's eye above the ground in the middle of the lane, is a fine illustration of this. It does not, however, look like a picture from a textbook on perspective, because the artist has carefully observed all the variations that occur in nature. The trees are all different, the spaces between them are irregular, and the strong verticals which they make are offset by the horizontal accent of the lane turning away to the right, by the angles of the farm buildings and by the interest in the figures.

The angles that walls of buildings make with the picture plane is also important. If Hobbema's lines of trees had rows of houses behind them, the sides of the houses looking onto the road would be at right angles to the picture plane, and their bases and tops would therefore conform to the same vanishing point as the trees. If, on the other hand, you were

Linear perspective
1. In this view looking across a plowed field, the pictorial convention, if the ground is flat, is to make the lines representing the furrows straight and parallel to each other.
2. Taking the same example, if a right-angled turn is made, the furrows appear to converge.
3. Looking to one corner of the field, the previous effects are combined.
4. The wide-angle view, including the edge of the field, shows that we do not really perceive lines as being straight.
5. The vanishing point can be within the picture or outside it, but it remains on the eye level if the ground is flat.
6. If there is a hollow in the ground, the vanishing point changes its height according to the deviation in the surface.
7. A square church tower viewed from a distance appears to have vertical sides.
8. A closer view of the same tower, looking up, makes the sides appear to converge.
9. Looking down, the sides appear to come together.
10. If the church tower is viewed from an angle, each side will conform to its own vanishing point.

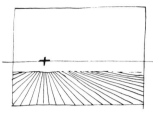

5

6

7

8

9

10

Above and right Two views of Venice by Antonio Canaletto: *North East Corner of Piazza San Marco* (**above**) and *View of Piazza San Marco, Facing the Basilica* (**right**). Canaletto embraced wholeheartedly the perspective systems pioneered earlier in Italy by Alberti, Uccello and Piero della Francesa. He was a highly skilled draftsman but appreciated the value of the *camera obscura* as an aid to the drawing of complicated architectural detail. The *camera obscura* was a device which projected an upside-down reflection of a scene onto thin paper or glass, which could then be traced by the artist. Canaletto would have seen it as a useful time-saving gadget; he made hundreds of drawings and paintings of Venetian scenes which he sold to travellers on the Grand Tour.

looking straight onto a wall of a building, a square church tower for example, this wall would be parallel to the picture plane, its base and top horizontal, and its sides vertical. If you were very close to this wall and wanted to express its height, its sides would appear to converge on a vanishing point, even though they are built vertically from the ground. (The depth of a large hole could be expressed by the same means.) If the walls of the church tower were seen neither frontally nor at right angles to the picture plane, they would have vanishing points at different points on the eye level. Natural phenomena such as clouds can also be seen to conform to the laws of perspective.

Atmospheric Perspective
Another spatial dimension is added by the use of tone and color. All colors are observed through the atmosphere, which will affect our perception of them in accordance with their distance from the eye. For example, there will be more blue in a green field which is further away.

A tree trunk which has sunlight playing on one side will have a dark side where the sun does not strike it. The greater the distance from which it is viewed, the less the contrast between the lighter and darker side. From a distance the darker side seems to become lighter because the atmosphere is itself illuminated; the shadow on the tree trunk will seem progressively lighter the further it is away. The lighter side will become very slightly darker according to the density of atmosphere, but to a lesser extent than the shadow gets lighter.

In paintings, strong contrasts of tone or color make objects appear closer. It is important for a painter to be able to compare the tonal values in what he sees. A good exercise is to compare objects of different color and try to discern which is lighter or darker in tone than the other. In composing a painting it often helps to pick out the lightest and the darkest tones in the scene, and place everything in its appropriate place within this tonal scale. Experience will dictate how closely to stick to these literal observations when it comes to mixing colors and actually putting them on the canvas.

The accurate observation of tonal values is an important skill to develop and is closely linked with observation of color. In terms of aerial perspective, colors are also subject to enormous variation according to prevailing conditions of light and atmosphere, and, as a general rule, they become less intense at a distance. There are lesser contrasts of colors in the more humid atmospheric conditions of northern Europe than in the drier climates of the Mediterranean or the Southwest. This partly explains the greater concern with aerial perspective shown by Dutch, English, and northern French painters such as the Impressionists.

If the aim of the painter is to create space on a flat surface, it might seem a simpler matter to make things recede by making them bluer and paler, but, as with linear perspective, each separate picture has its own compositional demands. Distance is not the same thing as pictorial space, which only comes to life where there is an interplay or a tension between space and the flat pattern of the picture's surface.

COMPOSITION

It is not possible to separate an artist's use of either aerial or linear perspective from the way he approaches composition as a whole. If

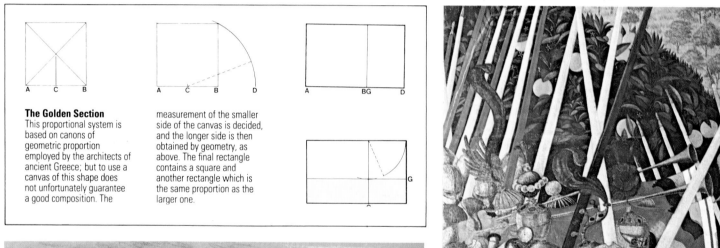

The Golden Section
This proportional system is based on canons of geometric proportion employed by the architects of ancient Greece; but to use a canvas of this shape does not unfortunately guarantee a good composition. The measurement of the smaller side of the canvas is decided, and the longer side is then obtained by geometry, as above. The final rectangle contains a square and another rectangle which is the same proportion as the larger one.

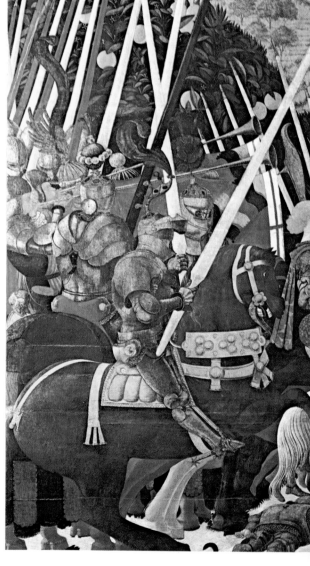

Above *Jetty*, J.M.W. Turner. This chalk drawing is from Turner's sketchbook, and shows the artist's intuitive approach to drawing. The proportions of the figures compared with the jetty and boats are not necessarily accurate in terms of classical perspective. This was not Turner's concern; he was far more interested in the conditions of light, here achieved with the use of light chalk on dark paper.

it is accepted that a picture aims to create its own world, then the eye of the spectator must be guided to read it as such. If a landscape painting depicts a large vista, the spectator's eye must be led around it from one point to another, in such a way that the painting can be understood as a complete entity. This constitutes movement in a painting. The painting is static; the eye of the spectator is not.

There are no rules about what makes a good composition because there are so many variables: color, tone, intensity of color, strength of lines, paint texture, quality of brushstrokes, and so on. Nevertheless, there have been many theories on the subject. One school of thought maintained that the painter should imagine an oval within the rectangle of the canvas and ensure nothing important was

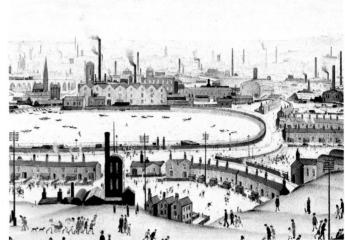

Below *The Battle of San Romano,* Paolo Uccello. This is one of the earliest paintings where pictorial space is expressed by linear perspective. The foreshortened figure of the dead soldier and some of the broken lances have fallen most conveniently to the ground at right angles to the picture plane.
Right *The Pond,* L.S. Lowry. This artist, along with many twentieth-century painters, has evolved his own personal approach to perspective. In this case, the aerial view distances the spectator from the scene and enables him to embrace a wide panorama. There is no real focal point which would lead us to any center of activity.

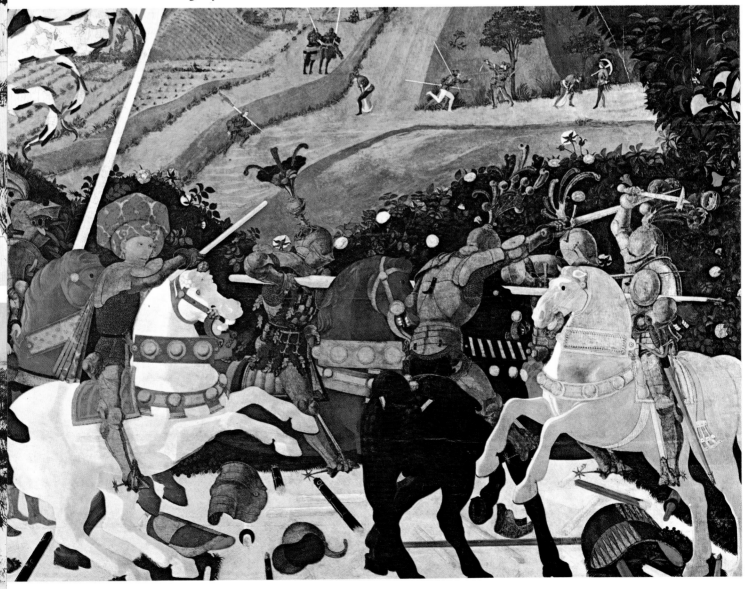

Above *Salisbury Cathedral,* John Constable. Constable used here a compositional device which creates, to some extent, a picture within a picture. The cathedral is set in space by positioning it so we see it through the frame of trees in the foreground. Constable has also used the old leaning trees to offset the gothic perpendiculars of the architecture.

Right A common way of enlarging a sketch or preparatory drawing for a painting is to rule a fine grid of lines over the drawing and then do the same on a larger scale on the canvas. If this method is to be of any real value, the grid must be drawn accurately, because small errors of measurement on the drawing will be magnified.

Right *Pines Near the Mediterranean.* This shows a vigorous use of pastel which expresses the character and rhythm of the pine trees with swiftly executed strokes of color. The trunks at either side are dark, placed so as to frame the glimpse of bright blue sea and sky beyond, with the pinks and pale yellows of the middle distance contrasting with the dark blue-greens of the trees' shadows. These colors give us a strong feeling of heat.

working drawings and notes in a sketchbook, and complete the work at home.

Monet, who was interested in the effects of light above all else, seldom worked on the same picture for more than two hours at a time in a day. Within two hours, color values can change considerably. The ideal arrangement for a painting of any size is to work for a short period over several days, or weeks if necessary. If this is not possible the size of the picture must be considered accordingly.

Artists have different feelings about the extent to which they need the subject in front of them as they paint. For some, it is essential all the time, the direct visual response being painting's prime concern. If there is limited time, the picture may then have to be small. For other artists, possibly endowed with good visual memories, color notes supported by a drawing are sufficient to sustain even a large work away from the subject. The only way to find out what is individually appropriate is to try both. It is a good thing anyway to complete an occasional painting on the spot, with nothing invented or guessed at, even if it is tiny and the forms simplified.

Having decided on the size, the shape might also seem a problem to the inexperienced, and experienced artists occasionally change their minds about this even when the work is under way. In practice it is not a critical choice. If it is not excessively long and narrow, one of the challenges of the painting will be to make the composition work within the available rectangle, although to an experienced eye there will be subjects which appear to demand particular proportions. The shapes of canvases are often referred to as either "landscape" or "portrait," which means no more than that the painting is either horizontal or vertical. A landscape can be painted on a "portrait" canvas and vice versa. A sensible beginning could be a canvas of about 18 × 24 inches (45 × 60cm), or smaller or larger in the same proportion. (The vertical measurement of a picture is always given first.) The time available and the medium chosen will influence the actual size.

Left *Hillside in Shadow.* This landscape is executed on a portrait-shaped canvas. The composition is given stability by the roof in the foreground, which also contrasts manmade shapes with the trees on the slopes behind. The artist has been attracted by the clarity of the lit parts of the landscape and their almost total disappearance into the mysterious shadow above.

PREPARATORY SKETCHES

Preparatory, even small and sketchy, drawings are always helpful because they stimulate the act of objective observation and help to sort out the feel of the composition, its stronger accents and the placing of lines and masses. Some artists choose to do this on the canvas itself, and others feel more confident making an initial drawing on paper. If there is a desire to keep the eventual colors bright and transparent, the less overpainting on the canvas the better.

As an aid to this planning, you can make a window out of a small piece of card or stiff paper, through which the basic proportions of the landscape can be assessed in relation to the proportions of the canvas. The outside measurements of the card are not important. In the middle of the card, cut a hole of the same proportions as the canvas. This window can then be held at a distance from the eye so that the features across the landscape that you

wish to include are visible, and you will be able to see how much of the foreground or sky will fit into that proportion. Conversely, if you definitely want to include certain features in the foreground at the bottom of the canvas and a certain amount of sky above the horizon at the top, you will be able to see how much will fit on either side, and you may decide as a result of this experiment to turn the canvas round, so that the vertical side is the longer. A refinement is to tape two pieces of thread vertically and horizontally across the exact middle of the window so that the central point of the view can be established. This will facilitate the subsequent judgement of distances and their placing on the canvas. If such devices are to be used, they must be made accurately and held squarely before the eye, as the window represents the "picture plane;" otherwise they are useless.

In the familiar image of the artist at work, he is not using his pencil for drawing, but

holding it up in front of a screwed-up eye and measuring a length on it with his thumbnail. This is another way of calculating intervals. The horizontal distance between trees, for example, can be measured off by the eye along the length of the pencil, or any straight edge, and then compared with the height of a tree by turning the pencil upright. But, if this method is not used carefully, the results will be inaccurate. First, the pencil must be held at exactly the same distance from the eye all the time; errors here are greatly magnified over the larger distances of the landscape. Second, it must be held still. Third, any position of the pencil must be at right angles to the line of vision because it is representing the imaginary surface of the picture plane. There are painters who are particularly interested in the mechanics of vision inherent in this approach, and for greater accuracy would use a plumb line to be sure of having a true vertical. The inexperienced, however, should start by

Sketches
This selection of sketches shows the diversity of approaches – from simple notes on form and composition to full detailed drawings. In the sketch of a hillside with houses **(above)**, the artist has roughed out a suggestion of shapes in pencil. In contrast, the pen and ink drawing of a farm **(center)** is a complete work in its own right. The drawing has been reinforced with ink washes, strengthening the trees and adding to the form of the buildings by selectively applying tone. White gouache was added in places. The detailed drawing of the old tin mine **(above right)** is an example of the sort of work which is best carried out in a fairly large bound sketchbook, so the drawings can be carried across two pages. The information such drawings provide is excellent reference for later work in the studio. The rapid but strong pencil drawing of the aqueduct **(below right)** was also made in a sketchbook. The forms of the trees have been expressed by the shapes of the shaded areas, the artist having selected what would give a sense of strong light. The aqueduct, seen against the light, with the diminishing perspective of its arches, has given the artist the opportunity to encompass a large expanse of space.

Left A wide variety of sketchbooks are available, ranging in size from small pocket types to larger ones more suitable for detailed work. Sketchbooks also come either in portrait (upright) or landscape (oblong) formats. Some have spiral bindings or perforated pages; others are bound in book form so it is possible to work across two pages. Sketchbooks can be improvised – from blank diaries as in the example shown here – or made up to the artist's specifications. The medium chosen for sketching depends very much on personal preference, but it is important to remember that charcoal and pastel will smudge unless fixed.

training the eye to judge true distances.

REPRESENTING LIGHT AND COLOR

Whether mathematics or intuition have been employed in the planning of the composition, no one element in painting can be isolated from the others, and there are immediately other factors to be taken into account. Light, strong or subdued, should immediately be influencing the marks made on the canvas. In a strong light, the compositon should not probably be based on the topographical layout of the landscape because the strength of contrasts created by the sun and the shapes and colors of shadows may well create a pattern demanding a particular placing on the flat surface. Many artists start by blocking in the main dark areas, for the pattern of light and dark is what gives a picture its intitial impact, and it is a good idea to start seeing the work in terms of shapes from an early stage. The only disadvantage of this is that the dark

Right This example demonstrates how to achieve combinations of color and tone by identifying the range of colors and building up an overall effect with small dabs of color. This type of pointillist approach is very effective from the point of view of paint surface, but is not a means of precise representation. It is possible to float colors into each other, by adjusting the proportions of one color to another in different parts of the painting, but this is not effective if the colors are not allowed to mix freely or if one color or group becomes isolated or overbalanced.

Below right *An Afternoon at La Grande Jatte,* Georges Seurat. Seurat brought a scientific approach to his perception of color, from which he evolved a method which he called "divisionism." The shadows are made up of colors which are complementary to the colors in the adjacent areas of light. For example, where the local color of grass is made up of green and yellow, the nearby shadow will contain red and blue. The timeless, static quality of his paintings is a result of his interest in compositional theories derived from the use of the Golden Section.

Above right *Dido Building Carthage* (detail), J.M.W. Turner. In his early years, Turner painted nothing but watercolors, and when he started using oil he made much use of the glazing techniques employed by watercolorists. In this painting, the luminosity of the sky is achieved in this way. Turner was a great admirer of Claude, who had painted skies at all times of the day. This painting anticipates Turner's later preoccupation with skies.

Far right *Waterlilies; Harmony in Green,* Claude Monet. Painted in the ornamental garden which Monet created for himself toward the end of his life, this is just one of many paintings on the theme of waterlilies. He often worked on several different pictures during the same day, leaving one aside as the light changed.

colors used to represent these dark masses could be too much of a generalization. On the other hand, a too-detailed linear drawing on the canvas, however accurate as a drawing, can obstruct the observations which will express a sense of light, observations which are often of very subtle changes in color and tone.

The painter, excited by a visual idea, is faced with the problem of getting it onto canvas as quickly as possible, whether that means three hours or three months. He wants the picture to be complete as soon as it is started. For this reason he should try to keep the work complete from the first moment, so that, in a sense it is finished at any stage, whether it is just a note about color relationships or a much fuller statement about forms in space. Of course, changes will be made as the picture develops; it may start as just a few patches of color and then grow into something much more detailed and complex.

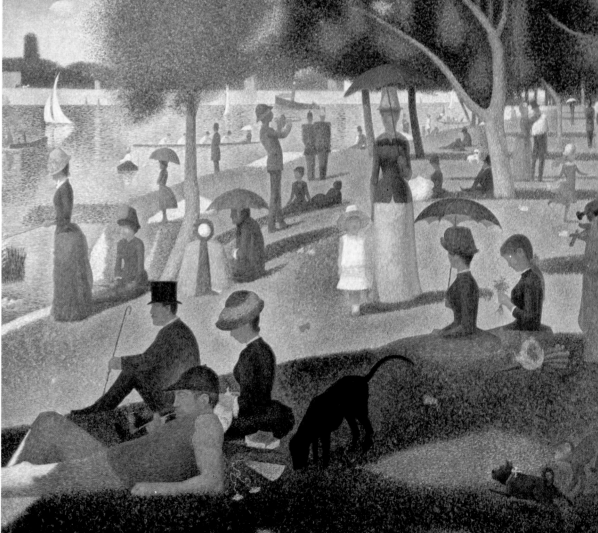

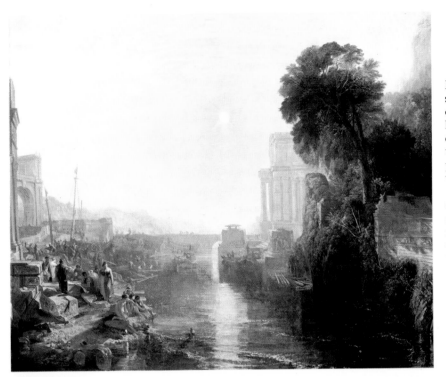

But these early patches of color can and should have a unity because they have been observed in relationship to each other. It is of limited value to put only one color onto the canvas. The patches will probably be no more than an abstraction of the colors seen in a particular place at a particular time, but they will have a significance.

As far as possible, it is best to avoid putting anything on the canvas which will obviously need subsequent alteration but there are many different ways in which the same subject can be painted and deferring a decision will probably only multiply the problems of selection. Suggestions of colors should be introduced at the earliest possible stage, giving an idea of their potential impact.

No two people perceive color in exactly the same way. Also, it is impossible to see one color on its own, and its translation into paint will lead to further differences of interpretation. This is leaving aside any

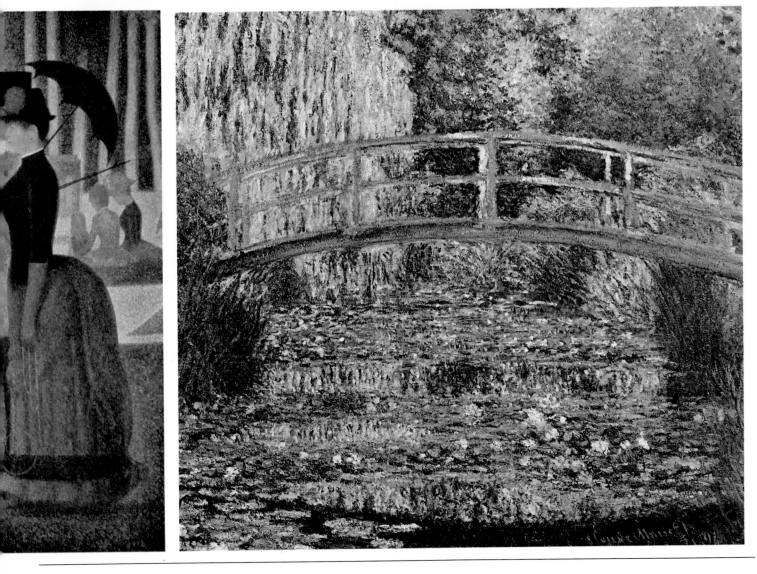

Above These two watercolor studies illustrate the specific problems of reflection. The first is a purely graphic representation of patterns in water and is a combination of hard-edged shapes, linear qualities and fuzzy color. Color in water depends on the surroundings. The second study is of a heavy rain cloud over water. As with water, clouds and sky cannot be studied enough. Although it is tempting to use photographs to freeze an effect, it is important to capture the sense of movement and space, making frequent studies so the effects of color, light and form can be fully understood. It is also important to achieve some transparency when painting skies. Wet paint applied to wet areas gives fuzzy edges which are useful for showing thin clouds. Blotting with a tissue lifts color so different tones can be achieved.

Right This ink and watercolor wash drawing is a study of direct reflection – in this case of two trees. The relected image should not be an exact mirror of the object, especially if there is movement in the water. If a more graphic approach is desired, it is possible to formalize general tendencies of reflected patterns, as David Hockney has done in his swimming pool paintings.
Far right *Dedham,* John Constable. Constable always made many studies on the spot, both simple and elaborate, and in a variety of media. This pen and wash drawing concentrates on the contrast of light and shade and includes nothing which is not relevant to this theme. The spontaneity of the brushstrokes contributes a lively directness which is characteristic of Constable's outdoors sketches.

degree of color blindness that might affect an individual. It may be generally agreed that a particular barn door is brown, but this "brown-ness" cannot be conveyed on the canvas with any accuracy without putting it into the context of the surrounding colors. If the barn walls are made of warm-colored boards, the door may appear a cool brown; if they are made of gray boards it may appear warmer, and so on. And both door and walls will be seen in the context of the whole landscape – the blue of the sky, the green of the fields or whatever surrounds them. There are no absolutes in color, only relationships.

The brown will be altered again by conditions of light and atmosphere. The actual brown of the wood it is made of, or the color it is painted, is its "local" color. This local color will be modified: if the sun strikes it, it will become warmer; if it is in shadow it will become cooler because it is influenced by the blue of the sky. Imagine the whole barn, built of gray boards, illuminated by the sun on one wall, with the wall where the door is in shadow. The three-dimensional aspect of the barn can be expressed by the contrast between its lit and unlit sides, by warm and cool color respectively. The brighter the light, the greater this contrast will be; the wall in shadow will lose its local color increasingly in relation to the brightness of the other wall, and become submerged in the colors chosen to express the shaded areas.

As the eye is presented with such a variety of colors in nature, it might seem sensible when representing nature with paint to acquire as many different tubes or sticks of color as are manufactured, in preparation for any conditions. In practice the reverse is true. To endow a picture with any degree of subtlety or richness it is essential to be able to mix colors, so that each hue can be rendered in its full range of tone and intensity. When familiar with minute tonal differences, an artist may notice that a particular picture demands the use of a certain green, for example, and if it cannot be made from the blue and yellow already available, only then may it be necessary to increase the range of pigments.

The painter now has to make a decision about how much he wants to express the feeling of light. The Impressionists, who had brightened the painter's palette and used strong colors for their shadows, tended to give precedence to the effects of light, letting the formal aspect of objects, their precise shape and local color, take second place. The brown of the barn door will be affected, even lost, by being in the shade; similarly bright light will detract from the force and variety of local colors, rather than enhancing them as might be expected. There is a point where the door would lose its unique brownness altogether.

These two possible approaches to representing form in color provoked Cézanne to ask, "To yield to the atmosphere or to resist it?" His own answer was: "To yield is to deny the 'localities,' to resist is to give them their force and variety." He tended to give objects their local color and pay less attention to atmospheric conditions.

If there is no direct sunlight, the color of the two walls of the barn will probably be much the same, their local color more apparent. The painter may have to look hard to be able to represent different tones for the side and end walls to express the change of plane at the corner of the building. If he can see no difference, the expression of this right angle may depend entirely on his observation of the angles of the roof. An error in drawing here might turn the form inside out. He might, however, find that one wall is slightly cooler than the other, because they will reflect what

light there is in different ways, being set at different angles. This raises an important aspect of color which is of especial use to the painter – its temperature. It is difficult to think of a single painting where forms in space are successfully represented without making use of the interplay of warm and cool colors. Even where strong local colors are used, a sense of light cannot exist without this variation of temperature. Warm colors tend to come forward while cooler colors recede.

Having placed objects in coherent spatial relationships, a painter may want to say something about the material nature of these objects. It is a temptation which should probably be resisted until the more important problems of space, light and composition have been solved; some would argue that it should be resisted altogether. However, it cannot be denied that the quality of a surface conditions its observed color, and objects reflect light

according to the hardness of their surface; the surface cannot be entirely ignored. A black woollen garment will be very little affected by its surroundings, whereas a polished steel surface will be altered dramatically, In fact polished steel sometimes appears to have no local color, its surface being nothing but reflections. This would present another situation where the artist must choose between representing the local color of an object or the way the color is modified by the environment. There may be a temptation to show the shiny surface of an apple by adding the tiny reflection of light coming in through a window, but if this is slightly overdone the three-dimensional form of the apple will be destroyed. At all stages, the painter is presented with a whole range of decisions which, if deferred, could lead to chaos.

Right This painting of a garden was worked entirely in gouache. The intention was to give an overall impression of light and color. The spindly forms of the roses in the foreground help to give definition to the space.

318

Left This study of clouds was executed in pencil with a cobalt blue watercolor wash. Clouds are constantly changing; rapid studies over a period of time give the opportunity to practice rendering the effects of light and form.

Below This is a mixed media work in watercolor, pastel and gouache. The texture of the drawing is not really intended to represent movement but there was a vibrant effect of light in the orchard through the branches and blossom which the artist chose to render by using layers of paint washes and scribbled pastel marks. This is an impression of light and color, not a portrait of the scene.

Color studies: paint
These paint mixtures are a number of grays and browns obtained by mixing pairs of complementary colors. In each (1,2, and 3) the vertical center row is a mixture of equal parts of the complementaries: pure at the top and with white added in two proportions below and center. On the left and right of each center row are the effects of overbalancing toward one color or another. To compare the types of gray, a simple black/white scale (4) is provided.

Color studies: pencil
These studies show the range of tones possible by building up with overlapping layers of colored pencil.
1. Basic green overlaid with bright green, brown, blue, yellow, red.
2. Yellow and green crosshatching overlaid with grainy shading in the same green.
3. Blue overlaid with brown, and green overlaid with brown.

WORKING INDOORS

So far the problems considered have been related to working directly from nature; given time and good weather this is usually the most satisfactory, despite difficulties. It is important not to give up too easily, because the freshness gained in the painting can more than compensate for the problems encountered in achieving it. The advantages of having your subject before you are obvious, but anyone who has stood in a field with a large canvas on a windy day with mosquitoes and rainclouds on the horizon, will acknowledge the attractions of working at home.

Other reasons that may make it desirable to work away from the motif include the increased opportunities to plan the composition and the proportions of the canvas, which can be much larger. Sketches and notes made in the field need to be extensive. A painting started on the spot may consist of just a few tentative strokes, which will give a basic planning of the flat surface, but a preparatory drawing can be made to explore precise spatial relationships. However accurate, it may not be sufficient if it is only linear. It should have a feeling for the strength of light and, the exact positions of shadows.

The best way of approaching such a drawing may be to consider what enables you to see objects as three-dimensional forms, and why you perceive the spatial relationships between them. For example, why do you observe a group of buildings in the distance as more than just a series of flat shapes? Is it because some of the buildings are receding in accordance with the laws of linear perspective? Or, if they are too far away to see tiny changes of direction, is it because the angle of light shows up the receding planes? If a band of trees appear as a flat shape, then an outline may be enough for the drawing, but a note about its

Above For this pencil and watercolor drawing of a headland, the artist used photographs of the same scene as reference. Several pictures were taken of the cliff from different angles; the photographs were then cropped and pasted together to give a composite picture, with a wider angle of view. The interest in this scene was the folded rocks and lines of vegetation; in making the drawing the artist chose to exaggerate this aspect by drawing the scene at low tide. Photographs are useful sources of information when a drawing cannot be made on the spot, but, as in this example, it is important to adapt the reference to your own requirements rather than simply copy what the camera has recorded.

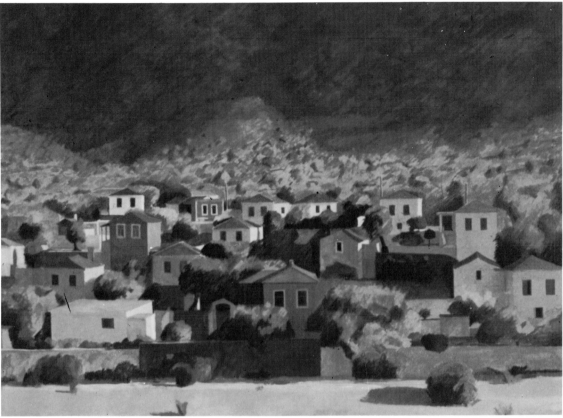

Right *Village in Southern Greece.* In hot climates the sun can overwhelm the colors of a landscape for much of the day, but in the morning or evening light, as here, color assumes more force. One of the aims of this painting was to avoid using a particular focal point, so that the spectator's eye is encouraged to explore for itself the angles and corners of the houses, to find its own point of interest.

Left *Trees and Undergrowth.* This watercolor places us in the middle of a tangle of plants and branches. The artist has decided that what expresses this density is variety, of form and color. A wide range of greens has been used together with transparent and opaque washes and a variety of color mixtures has been explored. There is also observation of the individual character of different branches: straight and slender, heavy and bowed, light and spidery, all contributing to the general feeling of profusion.

Above In this cloud study a watercolor wash was combined with gouache. A thin wash of cobalt blue was applied and then wet white gouache was dropped in and allowed to spread. When using thick opaque paint to suggest heavier clouds, the tones will need to be adjusted and will often need to be lighter than appears at first.

color will be needed to establish its position in space.

A painter develops his own language for making written notes about color. To start with it may be plainly descriptive such as "very pale blue-green," but with experience of using a certain range of colors these descriptions may develop into references to particular pigments.

Photographs or color transparencies can help with some details, but they have limitations. The camera's eye only records what it sees for a fraction of a second. It does not register an understanding of form, and cannot accumulate the experiences of looking over a period of time. There are also technical problems: only the experienced photographer knows exactly which film to put into the camera and which filters to use in any given condition of light, to approach accuracy of color. On the whole, transparencies still give more reliable color than prints, mostly because the processing is more direct, and they can be useful when, for one reason or another, it is impossible to make an adequate drawing. They can be projected onto a canvas to establish positions, but distortions are possible. The projector must be level and the canvas vertical; the canvas must be exactly at right angles to the center of the projected image. This can be checked by making sure the distances from each side of the canvas to the projector's lens are the same. In a

darkened room, the image on the canvas can be lightly marked in, but this must not be confused with drawing. The camera cannot capture perspective according to our pictorial conventions; so, where we might make the side of a building vertical, and parallel with the sides of the canvas, the camera will demonstrate the operation of linear perspective in every dimension, and the building will become narrower as it gets further away from the lens. The camera will also demonstrate that landscape is a section of a circular globe, and will not obligingly straighten lines which we have chosen to see straight for pictorial purposes. Sophisticated lenses devised to keep straight lines straight are, unfortunately, expensive.

It is important to understand that these distortions are taking place so that the photographic image is not taken too literally. Although a good transparency provides clues about tonal relationships and two-dimensional proportions, it cannot offer that unique perception of the physical relationship between the artist or the spectator and the world, which distinguishes a good painting.

We are aware at times of the physical strangeness of the world; this is the experience an artist seeks when he works. With what sense of wonder must a sixteenth-century Dutch painter, travelling to Italy from the flat landscapes of his homeland, have arrived in the Alps. More mundanely, you can provoke this sensation of extraordinariness by bending over to look for a few moments at a strange, new world. The forms, the spatial intervals, the colors, all have a new three-dimensional vividness. In the same way, when you wake in a strange room, ordinary objects in unfamiliar juxtaposition can acquire a new richness. The aim of the artist must be to represent this sensation.

Far left *April Evening.* A freely executed oil painting made from a much more precise watercolor study **(left)** which was painted on the spot. The study, while in itself a finished picture, contains enough important information to give the artist confidence to handle the paint vigorously and with freedom. There has been no attempt to copy the study in a literal way; even the proportions have been changed.

Left *Gates in Normandy.* In contrast to the above painting, this was made from a transparency which the artist took himself, having felt sufficiently interested in the subject to make a painting, but not having any more time than it takes to focus a camera. The nature of the subject naturally demanded precise information, particularly as the sun was in a position where it just touched the top of the palm trees and the ridge of the roof.

Left *Venice Moonshine.* Hercules Brabazon. A gouache study which has been made freely and rapidly, with solid color laid over both wet and dry areas of wash. Despite the sketchiness of some parts, such as the reflections, the trees have been observed and established with considerable accuracy.
Far left This pair of studies shows how local color, that is the actual color of an object, can be dramatically altered by bright sunlight. The difference of warm and cool colors enables the painter to establish the solidity of the barn in the top study, but in the sunless conditions **(below)** where both visible walls are closer in color, the end wall has been made cooler to express the change of plane.

DRAWING LANDSCAPES

Almost everyone can make a great variety of marks on a piece of paper – when people bemoan the fact that they "cannot draw" they really mean that they have not learned how to observe. The quality of a drawing depends more on the artist's ability to observe, than on any special skill with pen or pencil. The ideal drawing medium for each artist is the one which expresses his observations most directly. When an artist chooses a medium to draw with, he looks for the one which will become an expressive extension of his fingers, so that his hand and eye can work together with as little impediment as possible. Naturally this choice will be influenced by the nature of his observations: it would be difficult to say much about a delicate cloud formation with a laundry marker.

The great advantage of an ordinary pencil, provided it is not too hard, is that the strength of the mark it makes is open to considerable variation, from light to heavy. Pen and ink may seem less flexible by comparison, but a pen drawing by a great master such as Rembrandt is a reminder that it is not so much the nature of marks made on the paper which is important, as the quality of the observation which has informed them.

Provided that it is used to express form, almost any drawing medium can come to life. It can be instructive to draw the same object using as many different materials as possible, in order to find out which one is most successful for conveying space and volume. If the object is drawn as an outline, using a medium which gives too even a line will make the drawing seem flat and formless. It would be more appropriate to draw the outline with a soft pencil or some other marker which has

variable strengths and tones. If there are strong contrasts of light and shade in the object, with large dark areas, then charcoal might be the most suitable medium. It is important, however, to be aware of each medium's limitations; it fact, the particular discipline imposed by any medium can act as a stimulus.

It is also important not be be influenced by color when making a monochromatic drawing. Although colors contribute to the understanding of a form, we have to force ourselves to look for other signposts when drawing. Only where a color change is also a change of plane will it interest the draftsman; expressing a change of color by shading may mistakenly indicate a change of plane. A sense of light, on the other hand, is important from the outset.

Drawings, normally made by dark marks on a pale, if not white, surface, depend on tonal variation and contrast, but to become exclusively preoccupied with light and shade can prevent artists from discovering the pencil's ability to make expressive lines, immediate responses to observation. It is often when the artist is working quickly that he produces his best drawings; when there is no time to be self-conscious about the nature of the marks he is making and his pencil becomes a part of his hand. Students in some art schools are encouraged to alternate long, thoughtful studies with very rapid ones to achieve a command of drawing. Eventually, quick two-minute sketches can be progressively prolonged to become fuller and more thorough drawings without losing the immediacy and expressiveness.

It is easy to start a drawing without thinking

Right *A Path Bordered by Trees*, Peter Paul Rubens. Rubens is best known for his grand Baroque paintings, but it is always refreshing to have a glimpse of his more intimate studies. The handling of the trees is both free and delicate. It is undoubtedly only a study for a small part of a much larger composition, yet Rubens has achieved much more than a mere working drawing.

Below centre *Harbor on the Schelde*, Albrecht Dürer. This very fine line drawing is precise yet economical. The solidity of the forms is realized with sparing touches. Each shape is related most carefully to all the others in such a way that the whole image acquires a unity which is more than a sum of parts. Dürer was the main transmitter of Italian Renaissance ideas to northern Europe.

Right *Behind the Trees.* The artist has begun this drawing with an open mind as to which medium will best express feelings about the subject. Pencil and two colored chalks have been used alternately to build up the image in a very free and direct manner. The wild tangle of the trees' branches has been simplified by the use of black and red chalk, with firmer statements in pencil where appropriate.

Left *View of Wivenhoe Park,* John Constable. Constable demonstrates here how much can be achieved with the pencil alone. The forms of the landscape are firmly established in space, but also the quality and texture of each part is given due weight. The cornfield in the foreground has its own character defined with the simplest of means, and the delicate treatment of the sky is equally sensitive to light and texture.

about how it will place on the paper, but the spatial implications of this placing should not be ignored. Often the illusion of space is destroyed when an object is drawn in the middle of a large sheet of paper with no suggestion of surroundings. A drawing is, after all, often exploratory work for painting, and composition and drawing should be seen as inseparable. It is simple enough to pencil a frame around a drawing. If the frame is drawn in alternative positions, the effect it can have on our feelings for the subject, its dynamics and priorities, will be obvious.

PAPER

Paper is all too often taken for granted, but it can discolor and even disintegrate; so it is sensible to have some understanding of how to look after it. As paper is made of organic material, it is sensitive to light, temperature, humidity and other atmospheric factors. A good sheet of paper can be very expensive, and artists who use a lot of high-quality paper are advised to treat it with a great deal of care. The surface of a thin cheap paper might be preferred for some types of work, and will need even more care.

A combination of light and acidity is paper's main enemy. Both before and after use, paper should be stored wrapped in acid-free paper (not in plastic bags which would prevent it from breathing). Paper should also be kept in a room which is not subject to great changes in temperature or humidity. If paper is constantly absorbing moisture from the air and then drying out again, it will soon become wrinkled and consequently more difficult to use. The pages in a sketchbook will generally survive quite well, even if the paper is of poor quality.

If a drawing is framed, the glass should not be allowed to come in contact with the paper, as changes in humidity will stimulate the growth of bacteria, causing brown spots, or "foxing," to appear. (It is better to use glass in frames rather than plastic, which is slightly porous and scratches easily.) To hold the drawing away from the glass it is necessary to use a mount. This must be made from acid-free card, sometimes called museum board, and if a glue to secure the drawing to the mount is used it should be a water-soluble type, such as gum arabic. Masking tape, clear tape and similar adhesives should be avoided;

Right *Row Houses.* In this subject, the interest lies in the hanging patterns of brickwork and the details of the facades. For a drawing which demands precision and a subtle differentiation of textures, pencil is the ideal medium. A 2B or 3B pencil can make fine lines and is soft enough to give a range of tones. Softer grades can be used to block in black areas. The appeal of this type of work rests on minute observation and the patience to record detail faithfully.

Making paper
1. Shred scraps of waste paper, barely cover them with water and leave to soak overnight. Make a note of the weight of paper used.

2. Put the soaked paper into a blender. Add just enough water to ensure that the machine works smoothly. Blend the paper until it forms a pulpy mass.

3. Pour the pulp into a plastic bucket or other suitable container.

4. Measure out a quantity of pulp and pour it into a large vat of water. The proportion of water to fiber should be 99½:½ so it is important to have kept note of the weight at each stage of the process.

5. Stir the water in the vat to distribute the pulp. Plunge the paper mold in the vat and immerse it in the solution.

7. Hold the mold at one end of a piece of felt, drop it down flat to release the paper and pull it up quickly from the felt at the other end.

8. Lay another sheet of damp felt over the paper. Repeat the process if more than one sheet of paper is being prepared.

9. Put the felt sheets containing the paper into a press and apply heavy, even pressure to squeeze out the surplus water.

10. Take the flat sheets out of the press. Roll back the top layer to expose the sheet of paper.

11. Hold the paper by the top corners and peel it gently away from the felt. The paper will still be damp but it is quite strong at this stage.

Right *Tall Tree*. A thoughtful and concentrated pencil study of a solitary tree. As a result of careful observation of the directions of the branches, the tree creates its own space around it. A good artist can always be recognized by the ability to avoid any sort of generalization, endowing everything with its own individuality.

6. Bring the mold out of the vat in a horizontal position so that the water drains away, leaving an even layer of pulp in the mold. The process of filling the mold should be done in one smooth, quick action.

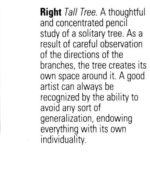

12. Lay the paper on a sheet of blotting paper and make sure it is completely flat. Allow to dry naturally. Alternatively, dry the paper in a small photographic print drier. Finally, coat the paper with size.

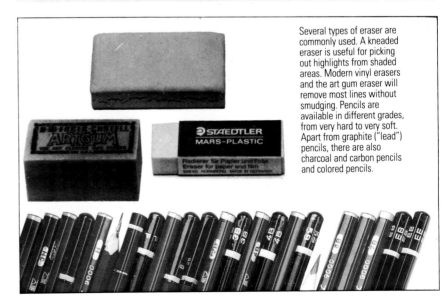

Several types of eraser are commonly used. A kneaded eraser is useful for picking out highlights from shaded areas. Modern vinyl erasers and the art gum eraser will remove most lines without smudging. Pencils are available in different grades, from very hard to very soft. Apart from graphite ("lead") pencils, there are also charcoal and carbon pencils and colored pencils.

they will destroy the paper. Finally, the framed drawing should not be hung in a position where is it exposed to bright light.

Paper has a front and a back. It is important to use the right side, particularly with soft chalk or pastel, because the mechanical texture which distinguishes the back, although not immediately obvious, will show up if lightly drawn over with chalk. This fine mechanical texture, which is impressed by the wire mesh of the mold on which it was made, is not always easy to identify, but if the sheet is held at an angle to the light it will appear in relief. The front may look rougher on many papers, but it lacks this grain.

Artists develop preferences about which papers to use by experiment, and there is a

large range of weights and degrees of smoothness from which to choose. A rougher surface tends to be more suitable for chalk and charcoal, as the "nap" or "tooth" on the surface holds these materials better. Pen and ink is less sympathetic on such a paper, however, as the nib will damage the surface; if the paper is absorbent, the ink will "bleed" and produce a fuzzy line.

The surfaces of good papers are divided into three main categories: Rough, Not and Hot Pressed. Rough is paper with a natural untreated surface, just as it comes off the mold. Not is smoothed a certain amount under pressure, and Hot Pressed (HP) is the smoothest of all. Each of these categories also varies according to the degree of glue size that has been added to the paper. Size controls the absorbency of the paper; the more size the greater its resistance to water. A completely unsized paper is called water-leaf. It is almost as absorbent as blotting paper, has a delicate surface and should be handled gently.

Rather than buying sheets of expensive handmade paper, a good quality drawing paper is adequate for many types of drawing. There are also other possibilities. Mold-made paper, for example, is made from the same quality materials as handmade, but on a machine and is consequently cheaper.

A sensible choice for outdoor work is paper bound as a sketchbook. A sketchbook is not as cheap as single sheets, but if it is bound in hard covers and has detachable pages it offers great advantages. It is portable and provides a

simple solution to the problem of storage. Although sketchbooks would not be appropriate for delicate work such as pastel, they are good for pen or pencil drawings. Art suppliers should have a choice of sketchbooks containing a variety of different papers.

DRAWING MEDIA
Pencil

Pencils offer the most direct means of making marks on paper; most people have been familiar with them in some form or another from their earliest years. The artist is primarily concerned with a pencil's degree of softness. There is normally a choice of 12 grades, from very hard (6H) to very soft (6B). Although fairly hard pencils may be used for fine and delicate work on occasion, they have certain disadvantages. They can only make pale lines of limited variation in strength, and the strongest line will involve exerting a fair amount of pressure, which will indent the surface of the paper. Such a line is impossible to erase completely. The softest pencils, on the other hand, while they are capable of smooth dark lines, have the minor disadvantages of needing frequent sharpening, and also tend to smudge easily. A 2B or 3B pencil is a good balance, but many people prefer something softer, Pencils with thick leads, which are particularly suitable for filling in dark areas, are also available in different grades.

Far right The horizontal strokes of the pencil lines in this drawing provide an interesting contrast with the strong vertical format. 2B and 4B pencils were used, and the highlight areas were erased out with a kneaded eraser.
Below *Palm Trees.* The quality of colored pencils has improved in recent years, and an increasing range of colors is now available. Colored pencils have consequently become both a useful means of making preparatory drawings and an interesting medium in their own right.
Below right In this

sketchbook drawing of a waterfront street in Charleston, South Carolina, the artist has used several different grades of pencil from 2H to 2B. A rough outline was drawn first to check positioning and then the outline was drawn more firmly in a grade H pencil. Shading was then done in soft and hard pencils. The softest, 2B, was reserved for the small dark areas of the windows, which provide effective contrast with the white clapboard house fronts. The result is a detailed drawing which nevertheless retains a lively and spontaneous feeling

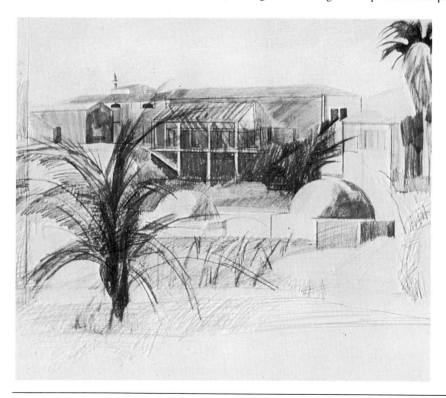

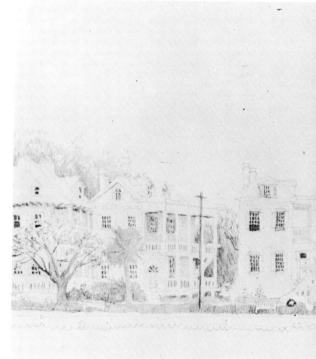

1

2

3

4

5

6

Pencil effects Using different grades of pencil on different types of paper gives a wide variety of effects.
1. A soft pencil (4B) is useful for making a graduated tone on fairly smooth paper.
2. A 4B pencil on rough paper gives a rougher result.
3. If the reverse end of a pencil is used to make indentations on the paper, the marks will show up when

drawn over.
4. Erasers can be used in a positive way not just to remove errors. They are particularly effective for creating highlights.
5. China markers, such as Berol, reveal the texture of the paper.
6. A dense black or gray tone can be made by smudging soft pencil dust with the fingers.

Pencil grades
Eight different grades of pencil were shaded across a piece of paper in varying tones to show the differences between grades. The pencils were (**top to bottom**): 10H, 7H, 3H, 2H, HB, 3B, 6B and EE.

It is not really fruitful to make general statements about how to begin drawing, because often the most lively and also most personal work results from not thinking too hard about the exact nature of the marks you are making. However, it is usually better to begin with tentative lines. These can always be made more emphatic, and it is often interesting to see where an artist has changed his mind as his observations have consolidated. To make too much use of an eraser if lines seem wrong can interrupt the directness of expression which the pencil can achieve so well. It could also be argued that to erase a mistake so that it is no longer visible, is not going to increase one's chances of getting it right next time. A better approach would be to see every mark as part of the whole process of exploration.

Silverpoint, rarely used today, is a method of drawing made with a piece of silver on paper which has been coated with an opaque white pigment. The line produced is ineradicable, and consequently this type of drawing demands greater deliberation.

Some varieties of colored pencil are also useful to the artist, particularly the Derwent range, as they are water soluble. They can be used for straightforward colored drawings, or brushed over with water to obtain washes. The pencils themselves can be moistened to produce a softer line. They are naturally harder than true watercolor pigments so they are not a rival to that medium, but they can be

Right *Storm 3.* This evocative ink drawing exploits the dramatic theme of stormy weather by using the full contrast of black Chinese ink and the white of the paper. The artist used a brush, together with other improvised drawing materials, such as a rag and a twig, to achieve this atmospheric result.

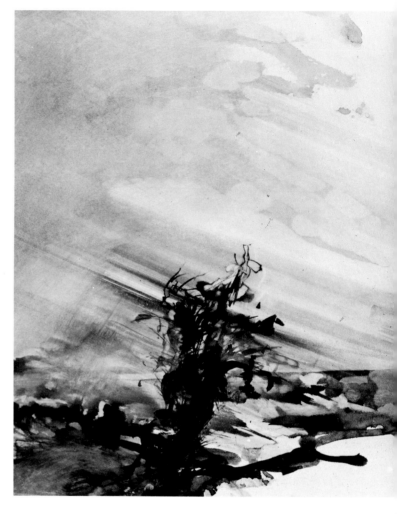

Below left Almost any type of pen can be used for drawing, although the traditional dip pens, where the nib fits into a separate handle, will always retain their appeal for the artist.

used for similar effects on a small scale.

Pen and Ink
The lines made by pen have a much more incisive quality than those of any other drawing medium. None of the more recently developed tips made of fiber, for example, however fine, can match the clean sharpness given by the metal nib. It is becoming more and more difficult to find an extensive selection of nibs of the sort which fit into a separate handle, made specifically for artists, but this difficulty is offset to some extent by the increasing number of complete pens now on the market. For those who prefer but cannot obtain the more traditional variety, a fountain pen with an italic nib is quite a good substitute for the dip pen. The thickness of the line can be varied by the angle of the nib, as with dip pens, and these pens do give a more even flow of ink. Even so, fitting a new nib into its handle, dipping it into a pot of ink and carefully blotting does have a certain appeal. It also imposes a discipline and rhythm which is both stimulating and technically satisfying.

Care must be taken when buying ink to check its permanence. Even reputable manufacturers sell inks, especially colored ones, which can fade surprisingly quickly. They are

not usually sold with any grading, and should be considered "fugitive" unless otherwise labelled. This is a common problem with most ink found in felt-tipped pens, which also tend to run out surprisingly quickly, but there are exceptions. Some pens made for designers contain permanent inks and give precise control over the thickness of line.

An extension of pen and ink drawing is to use a brush to spread the ink out into either solid dark masses or paler washes. Inks or watercolors can be used. Sable brushes are generally the best for this purpose; they retain their shape well and have a firm but springy quality which gives good control. They must be washed out very thoroughly after use, as dried ink at the base of the hairs will cause them to splay.

Charcoal and Chalk

Both chalk and charcoal are much softer than the softest pencil and are more suitable for work on a larger scale. A black chalk or charcoal can give areas of a rich, velvety nature, but since the medium is so soft it must be held onto the paper with fixative. The tenuous bond between charcoal and paper before it is fixed means that the eraser can be used in a positive way to take out darkened areas to get back to white.

Chalk and charcoal are well suited to the creation of light and dark masses, rather than the more linear compositions for which a pen or pencil is better. As soon as the paper

Below Pen and ink is particularly effective for representing the bleak landscape of winter. In this drawing of a farm building the ink lines are softened with a wash.

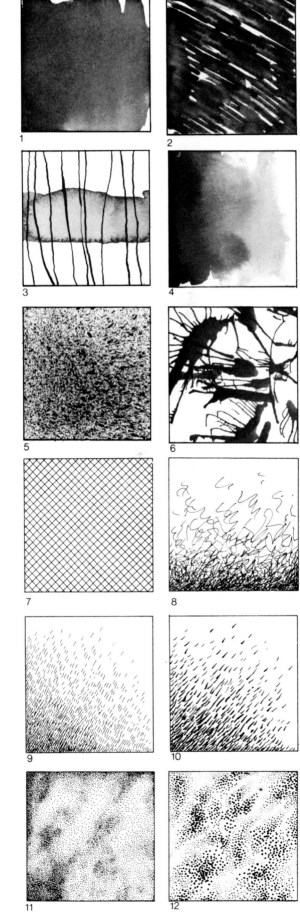

Right Pen and ink effects
1. An ink wash and brush can be used for graduated tones.
2. A wet paintbrush drawn through thick ink lines gives a blurred effect.
3. A combination of wash and line can be created by drawing a wet brush over ink lines.
4. A graduated wash can be made by laying a block of tone and feathering it out with a wet brush.
5. Ink can be splattered with a toothbrush. A softer effect will be achieved if the ink is then blotted.
6. Wet ink can be blown across the paper using a straw, to give spidery marks.
Technical pen effects
7. A crisscross pattern drawn with a technical pen is even.
8. Scribbles can be effective.
9. Use a fine nib for these dashes.
10. A thicker nib gives a heavier pattern.
11. Dotting with a fine nib is one way of creating a varied tone.
12. This effect is achieved by dotting with different nibs.

331

becomes broken up into dark and white shapes it becomes much more important to consider the drawing in relation to the whole area and proportion of the paper, and to see the whiteness of the paper positively rather than merely as a background. This white can be thought of as another tone at the artist's disposal, and its shapes considered as carefully as the shapes made by the charcoal. The effect can also be achieved by using white chalk, but it is more rewarding to try to make the white paper itself function as a color.

Charcoal can be obtained in sticks of various diameters, from very thin to the much thicker pieces used by scene painters. The most popular charcoal stick is made from willow. One of the characteristics of charcoal is that it is extremely brittle, so it must be handled very gently. There have been attempts to make charcoal pencils, bound in wood, but these are on the whole unsatisfactory as the charcoal has to be compressed and consquently loses its particular quality. Chalk or crayon, on the other hand, being a manufactured medium, is pleasing and easy to use in this form. Chalks are available in varying degrees of hardness, so some experiment is advisable. A good type is Conté, which comes in black, brown or red. A strong paper should be used and the surface should not be too smooth or the chalk will skid. Fixative must always be carried, for use as soon as the work is finished. It is particularly important to remember this point when using charcoal for sketchbook drawings on location. Fixative is available in aerosol cans or bottles with pumps from art suppliers.

Right *Mother's Roses.* This image used the full richness of the velvety black that charcoal can give. One of the strengths of the composition is that as the artist has related the forms of the plants to each other, they have also been related from the beginning to the whole area of the paper. The vitality of the surface is due, too, to the use of black and white as positive and negative in turn; in some places black shapes are seen against a white ground and in other places this is reversed. In the process, the forms have shed their more literal meaning but gained in form.

Below
The effects of charcoal vary according to the type used and the surface of the paper. Here a range of charcoal sticks was drawn across a variety of surfaces, from rough-textured handmade paper to smooth drawing paper. Charcoal is available in pencil form or sticks. Sticks come in varying widths and all types of charcoal are available in soft, medium and hard.

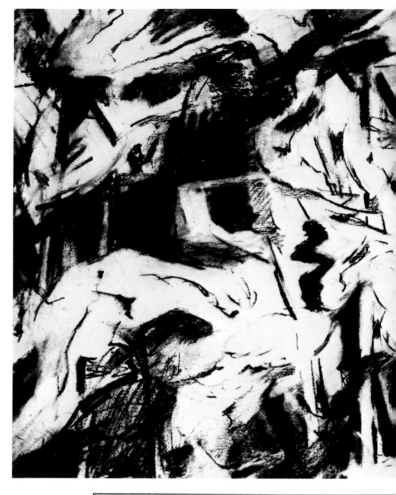

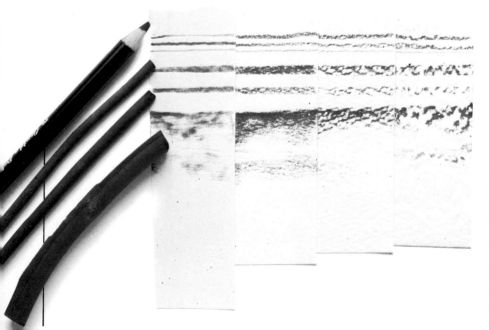

Charcoal effects
1. Fine hatched lines build up an area of tone. Work in one direction.

2. Loose crosshatching is useful for indicating texture.

8. To make an erased texture, first draw a thick black line.

9. Work the black line into a pattern using a kneaded eraser. Do not erase the line completely.

Left *Boxted.* The artist has here used charcoal for its softer tones of gray. The drawing is firm but with a minimal use of line – the shapes being given a tonal value to establish their relationship with others. It is impossible to separate the appeal of an image from the means with which it was made. Here the artist's observation of gentle variations of tone in the landscape is ideally suited to the medium employed.

3. Broad areas of tone, revealing the texture of the paper, can be made with the side of the charcoal stick.

4. Working in line over the top of a broad area of tone creates a richer texture.

5. A softer effect can be achieved by smudging charcoal dust with the fingers.

6. A soft kneaded eraser can be used to erase or work in extra texture.

7. A vinyl eraser is useful for creating highlights of fine lines.

10. To make a charcoal wash, first complete the drawing in line and tone.

11. Apply a wash with a moistened brush, spreading the tonal areas.

12. Allow the wash to dry before further work.

13. White chalk or pastel is effective to highlight on tinted paper.

14. Fixative is essential to prevent the drawing from smudging. Spray lightly.

Pastel

Pastel is a medium which hovers finely between painting and drawing. It offers the most direct way of getting pure colored pigment onto a surface. The pigment is bound tightly with gum arabic, or occasionally tragacanth, and then molded into sticks, but so lightly that it crumbles onto the surface with the minimum of pressure. It is this delicacy which gives pastel both its beauty and its numerous technical problems. The softness of the pastel requires great care from the moment it is first picked up until after the work has been framed.

Left There is a wide range of pastels on the market; Grumbacher and Rembrandt are two well-known brands. Although many manufacturers produce box sets, it is not always advisable to buy pastels this way. It is often better to choose pastels separately, even from different manufacturers if necessary, and aim to build up an extensive collection of shades in the colors that most appeal to you. Because pastels are not easy to mix

and they are so light and compact, it is easy enough to carry a wide range of colors.

Below Keeping families of colors in separate boxes is a good way of ensuring that pastels remain clean. Because pastels are so soft they pick up dirt easily.

One of the aims of the pastellist is to use the pigment in its purest and most direct form, and this must influence his approach to color. Although it is quite possible to mix colors, the desired freshness and directness can suffer; in any case, there is less need to mix since pastels are light and compact, and more can be carried than tubes of oil paint. Where the painter will mix his own colors from a relatively small number of tubes, the pastellist can select appropriate colors from an enormous range to suit the demands of a particular work. It may well be that only a dozen pigments are employed for one picture, no more than the painter has on his palette, but another subject may suggest an entirely different set of pastels. Where the painter would make different mixtures from the same basic palette the pastellist is better advised to carry a wider variety of colors.

There are hundreds of colors available in pastel, often only barely discernible from one another, and a choice may well seem impossible when seeing the full range on display. (Ten different whites are available.) However difficult the choice, it is probably not worth buying a box of pastels as these selections tend to contain too many bright strong colors at the expense of intermediate ones. Whether some bright colors are used or not, it is the indeterminate grays, soft greens and ochers which are eventually the most useful. For landscape and nature subjects, it should almost be a policy to buy those very colors which are most difficult to describe, those pearly blue-grays, warm silvery pinks and pepper and salt colors, which we find so beguiling in nature. It is best to acquire an assortment of such colors gradually and have a more sparing collection of the bright primaries.

As with any other medium which involves the use of color, it is important to aim for a good balance of warm and cool colors, for this dimension of color is the one which can best express the play of light on the landscape. A tonal variety is also necessary, but pastel is a medium where the value of a color change can be most telling. Because of the powdery, granular nature of the pigment, it cannot attain quite the same tonal range as an oil painting.

There are several makes of pastel which can be highly recommended; Grumbacher and Rembrandt are both good choices. Pastels are very fragile, and it is worth developing a storage system. Because a painter has relatively few tubes of paint to organize, these can be thrown into a box without suffering any damage, but the pastellist works with a far greater number of delicate colors, which also must be kept clean. A good system is to collect a large quantity of small cardboard

boxes, preferably with linings of corrugated paper to hold the pastels in place. A foam rubber padding will prevent the pastels from jolting and getting broken when they are carried around, and the box should be secured with a rubber band.

There is also the problem of keeping the pastels clean, as they are so soft they can both rub off on one another and also pick up dirt from elsewhere. Dusting them with flour is often recommended, but there is a tendency for the flour to cling to the pigment too much. A better suggestion is to sprinkle a little rice, well-known for its absorbency, into each box.

Whether such refinements are employed or not, it is a good idea to divide the pastels into groups of color, each with its own box. Each box should contain a family of colors; cool whites, warm whites, blue-grays, green-grays, pink-grays, violets, reds, blues, yellows, sand colors, browns and so on.

An important part of these decisions about color is the choice of paper. It is rare to use a white; there is a particular satisfaction to be derived from using a color which is itself part of the whole color scheme. Areas of the paper can be left untouched, thus contributing to the overall harmony. It is possible to buy paper in

quite a good range of colors, preferably warm grays, cool grays and green-grays; again, the soft colors which are hard to describe. The paper must be of good quality, mold-made if not handmade. It should be sized and fairly thick. Too soft a surface will get damaged and not permit alterations. It is particularly important to establish which is the front side of the paper, as the mechanical texture of the back will soon appear when the pastels are applied. Ingres and Canson are two makes of paper which are very suitable; there are also papers sold specifically for pastel and charcoal drawing use. These have a hard granular surface, which is too hard for some tastes. An ordinary Not or Rough surface is normally satisfactory; Hot Pressed can be a little too smooth. It is important for the paper to have enough "tooth" to rasp off the pastel.

Due to the difficulties of covering one color with another, it is necessary to develop ways of removing pastel from the paper's surface. A painter using oil paint will have his brush in one hand and a rag in the other, so that the construction of the painting is a constant process of addition and subtraction. The same applies to pastel, but a rag alone is not always adequate. A clean dry rag can be used to flick

Above Some notion of the range of colors available can be gained from this display. Pastels are also made in three grades: soft, medium and hard. Manufacturers usually label pastels with the name of the color and a number to indicate the relative lightness or darkness of tone. There is no standard system, but a scale of 0 to 8 is often used, with 0 being the lightest shade.

Left *Sketchbook Study,* J.M.W. Turner. Turner was an artist who constantly switched from one medium to another. He loved to experiment and paid no great attention to the conventions of his time in matter of either technique or subject. Here we can see the boldness with which he used pastel: he sometimes turned to this medium in the evenings when the light became too subdued for him to work with watercolor. He frequently favored working on dark paper. As light was one of his major preoccupations he liked it to be present in his work as the result of a positive statement with brush or chalk.

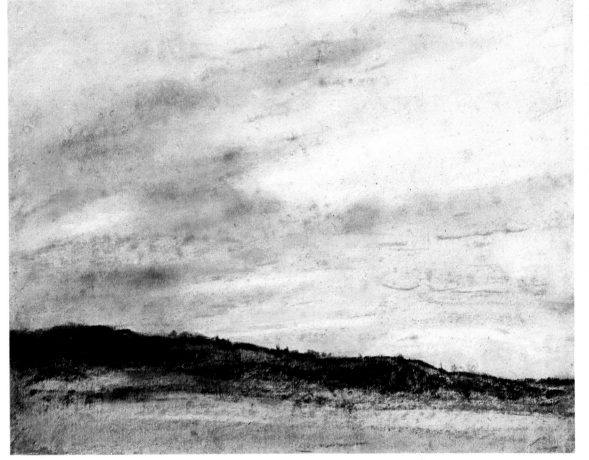

Pastel techniques
1. Press firmly using the side of the pastel to obtain broad, diagonal strokes.

2. Rubbing lines with the fingertips gives a hazy look to pastel hatching.

3. To achieve crisp fine lines, use the side of the pastel and apply light pressure.

4. Another set of fine lines, worked in the opposite direction, gives crosshatching.

5. Broad areas can be worked by using the blunt end of the pastel. Work in one direction only, applying firm, even pressure.

6. To lay a broad, grainy area, peel away the protective paper and use the long side of the pastel.

7. A kneaded eraser, kneaded to a point, can be used to lift the pastel and create highlights.

8. A stippled effect can be obtained by using the blunt end of the pastel to make brisk strokes across the paper.

Above A number of different papers are suitable for pastel work. Paper must have enough "tooth" to rasp off the pastel as it is drawn across the surface. Tinted paper is particularly effective, as some areas can be left to provide an additional color. Ingres papers are reliable colored papers. Fabriano *(1)* Swedish Tumba *(2)* and Canson *(3)* are specially textured Ingres papers, available in a range of colors. Glass paper *(4)* is a soft, fine paper with a sandpaper surface. Vellum *(5,6)* is good for a delicate, detailed approach.

Right *Wooded Landscape,* Thomas Gainsborough. Gainsborough's techniques were considered somewhat unorthodox by his contemporaries but his work had a freshness which gained him many admirers. This freshness he managed to bring even to the landscapes he drew or painted in the studio. He had a major place as a portrait painter but his real love was landscape, which he composed and invented in a variety of media. He anticipated Constable in his portrayal of the everyday rural scene, but possibly because he spent less time working on the spot than Constable was to do, his later landscapes tended toward the picturesque.

pastel off the paper but it is helpful to have a few other means of erasing. A good quality eraser, is essential, and, for finer adjustments, an eraser in stick form. Also useful is a piece of synthetic sponge, and because the pigment is dry and is not actually absorbed by the paper it can be brushed off with a paintbrush. This should have fairly stiff bristles such as hog bristle, which have been worn down.

At all stages, the fragility of the medium must be remembered. When the work is finished, it is desirable to put it in a card mount of some sort so that the surface will be protected. The prospect of mounting the finished work may affect the earlier planning of the composition: if the edges of the paper are going to be lost anyway, the proportions of the work need not correspond exactly with the proportions of the paper. Allowing for a border means that the paper may be held with clips onto a drawing board and the edge can be used for trying out colors. The border may be an equal distance in from the edge of the

paper all around, but if the proportions of the picture are to be materially different from that of the paper this should be established at an early stage. If necessary, draw the border lightly onto the paper as the composition is worked out. With almost any medium, there can be a temptation to start a picture as a vignette – that is, an image with undefined borders – but this should be resisted. Working on colored paper, the pastellist may find this tendency more pronounced; the feelings of space and light have to be created by the color, where on a white surface they may be implicit.

With pastel, a tentative drawing may be made on the paper with a neutral color Conté crayon, but the decisions about which colors to use simply cannot be deferred. If a color is wrong it is best to remove it altogether, which may well be advisable with paint too, but the pastellist has much less latitude. A color can never be totally obliterated by another.

Where a painter starts by putting little dabs

of the main colors to be used on the canvas, the pastellist tries out the colors with each other on the edge of the paper. He must make a selection from the many different colors at his disposal to meet the demands of each separate subject, and it is very unlikely that he will use anything like as many as his full collection. At this stage, it is useful to have a few empty boxes at hand so that the pastels tried out and chosen are easily available.

Once a pastel has been chosen and is identifiable from the mark on the edge of the paper, it can then be unwrapped and used on its side if need be. It is not practicable to sharpen pastels. If a finer line is needed, the pastel can be broken in two to give a sharp corner to work with.

It is possible to mix colors to some extent by working one color into another which has already been applied to the paper. If this is done too much, however, there is a danger of the colors losing their brilliance. One of the main reasons for working in pastel is that it is

Above The use of fixative alters the appearance of pastel drawings, making the colors appear darker. However, not all colors are darkened to the same degree and relationships between colors can therefore be affected. Some fixing is necessary, however, or a great deal of pigment will be lost from the surface.

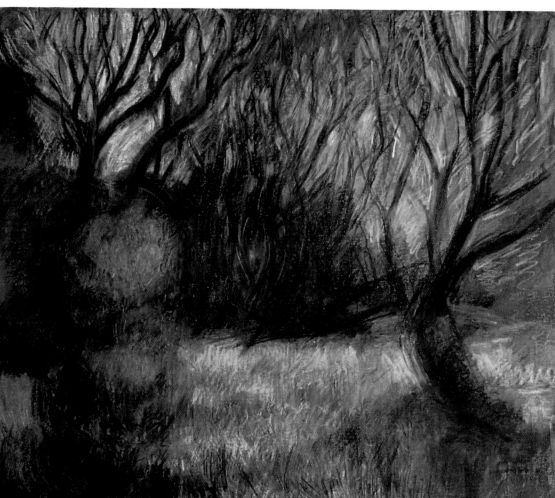

Right *Trees,* Lawrence Toynbee. Oil pastels are not yet manufactured in such a wide range of colors as the more traditional pastels bound with gum. This need not be a disadvantage as the building of form is always more important than copying the colors we see. Lawrence Toynbee is perhaps best known for his sporting pictures, but he has also made many fine landscapes in paint and pastel.

one of the most direct ways of applying pigment; so it is worth considering other methods which will reduce the need to rub colors together. For an area which one feels has elements of several different colors, pastel is well suited to a divisionist approach, that is, breaking up the area into its different component colors in minute juxtaposition, without rubbing them all together. The subsequent color will be mixed in the eye rather than on the paper. This technique need not be quite so methodical as Seurat's

Pointillism, where each dot of color was carefully calculated in size, and the whole was intended to be viewed from a specific distance. Used in a free fashion, it can often bring an area to life and give it more sparkle than an area of flat color, especially if the color of the paper is also contributing.

Changing media can give artists new insights, and the switch from paint to pastel, and the other way round, could be instructive in the area of color mixing. With pastel, there is a wide range of color to be picked up and

applied. With paint, the color has to be made on the palette. Both ways of working are difficult, but attempting the two different approaches can teach a great deal about color in general.

Some controversy exists among pastel artists over the use of fixative, a thin varnish suspended in a fast-evaporating carrier which holds the pastel to the paper. It is generally acknowledged that some fixing is necessary, although the purist would keep this to an absolute minimum, with the good reason that

it has a dulling effect on the surface. Before the pastel is fixed, the tiny particles of pigment lie at different angles, reflecting light from every direction. When they are sprayed with the varnish, these particles seem to subside and lie more evenly, no longer displaying that original sparkle. The other reason for resisting the use of fixative is that it darkens the color. This would be slightly more acceptable if all colors were darkened to the same degree, but some pigments change just a little, others much more dramatically. This can radically alter relationships between colors which have been carefully established. However, without fixative, even a light jolt can cause a fair quantity of pigment to fall off the surface. Manet once made a pastel drawing on canvas, which, being a more flexible support than mounted paper, soon shed almost the entire work.

One compromise solution is to fix the work lightly in stages as it progresses. This has a double advantage. It enables the artist to assess the degree to which his colors will darken before the work is finished so he can make the necessary adjustment as he goes along, and also it permits a more vigorous restating of lines or masses without reducing the colors to an indeterminate mess. Some freshness will be sacrificed by this method, but a richness can be gained.

Those who use pastel more as a drawing medium, especially if they work vigorously and are constantly making alterations without erasing what is already on the paper, are forced to make more use of fixative. Edgar Degas experimented continually with such technical problems. Not only did he test the advantages and disadvantages of fixing the pastel at various stages, he also tried soaking his paper in turpentine before working on it. His work is very well preserved.

It is worth experimenting both with different methods of fixing pastels and with different fixative preparations. Fixative can be applied with a spray, or atomizer, or from an aerosol can. The paper must be laid down on a flat surface, and it is important not to get the point of the sprayer too close.

Fixative is basically a form of shellac dissolved in alcohol or methylated spirits. Clear shellac can be put in a small muslin bag which is suspended in pure grain alcohol. The shellac will dissolve and sink to the bottom of the container, leaving the shellac in the bag in contact with fresh alcohol. It will take a matter of days for all the shellac to dissolve; then the solution is filtered to remove impurities and sealed in a bottle. The proportion of shellac to alcohol is one part shellac to ten parts alcohol. To increase the permanence of the fixative, copal resin can be added to the above mixture in the following proportions: ⅜ oz (5g) clear shellac, ⅜ oz (5g) powdered copal resin and 16 ounces (.6l) alcohol. A cheaper version is to mix white shellac varnish in equal parts with methylated spirits.

An alternative to shellacs and resins is the casein from milk; some people simply use milk. An old method of ensuring the permanence of documents written in pencil was to dip the paper in skimmed milk, but a pastel could not be treated in this way. A recommended recipe based on casein is: ¾ oz (10g) casein, ³⁄₂₀ oz (2g) borax, 12 ounces (.4l) water, and 4 ounces (.12l) pure grain alcohol.

First, a little of the water is added to the casein and borax. After a few hours this mixture will turn to syrup, which is then diluted with the remaining water. The alcohol is then added and the solution is left to stand and clarify. It is then decanted and bottled.

It is advisable to mount a pastel as soon as it is finished and fixed. The mount must be made of acid-free card, or museum board, and should be as thick as possible. The pastel should be fixed onto a solid piece of backing card, with the window mount hinged to form the front. The firm backing will protect the back of the work and keep the paper as flat and rigid as possible. No part of the front of the paper need be glued. The glue used to secure the paper to the backing card should be water-soluble, such as gum arabic. Clear tape and masking tape should be avoided at all costs, but other types of tape made with a harmless adhesive are available. Experiment with different sizes and colors of mounting board. Usually, a color which enhances one of the pastel colors is most suitable, although white can set off a tinted paper.

Right Oil pastels are quite different from pure "true" pastels. They are stronger and less brittle, and because they are harder, can be sharpened to a point with a knife. Oil pastels are usually available in a set – a typical medium-sized selection is shown here. They are useful for sketches, for the preparatory work in oil painting, and can also be combined with watercolor washes to give an interesting effect.

RICHMOND DAM
charcoal on paper 20×26 inches (51×66 cm)

The attraction of this image for the artist was that the eye, having first been drawn by the white foaming water tumbling down from the dam, is then directed further back in space by the equally bright, but absolutely smooth surface of the river above the dam. Charcoal was chosen because the idea was a specifically tonal one. Charcoal also provides an excellent means of covering large areas with tone very quickly; this is important when working out of doors in uncertain weather.

The dam itself has been simplified as a silhouette, and the sky has been made darker than was literally the case, in both instances to intensify the whiteness of the water. The composition has been organized so that we get some feeling for the space between ourselves and the dam. This intention can often lead to rather large expanses of foreground, but in this case the swirling water provided another contrast with the absolutely flat surface of the river beyond the dam.

Charcoal is a bold medium, best suited to emphatic lines and heavy areas of tone. Because it is powdery and unstable it can be difficult to control at first, but with practice it will be found most rewarding, especially for large drawings or quick sketches showing a scene in terms of light and shade. A thin charcoal stick is first used lightly to sketch out the basic lines of the composition *(1,2)* showing simple shapes and the main directionals across the picture plane. The dark tones of bridge and background detail are then loosely blocked in with vigorous hatching. The structure of the composition is developed with heavy linear marks along the horizon line, reinforced with patches of tone laid in with the tip and side of the charcoal stick *(3,4)*. The shapes are gradually elaborated.

3

1

2

7

4

The advantage of the crumbly, loose character of a charcoal stick is that an eraser can be used freely as a means of developing the drawing, rather than just to eliminate mistakes. To build up the tones the black powdery material can be spread lightly with a rag or fingers and white areas reclaimed with the eraser *(5)*. This technique is used here to indicate the broad sweep of water in front of the dam. The background is built up with a combination of lines and flourishes representing trees and bushes interwoven with grainy, scribbled marks and dense patches of tone, laid with the long side of the stick. The dam is described in greater detail, contrasting the sharp lines of the man-made structure with the heavy mass of trees behind. As the drawing progresses the shapes are reworked and darkened to emphasize tonal constrasts in the image *(6)*. This also gives a variety of textures in the drawing. Parts become almost black while an uneven, grainy gray fills the sky and is echoed lightly in the water. Drawing materials such as charcoal and pencil are essentially linear and this quality is apparent even in areas of heavy shading, giving a complex network of interacting marks which must become cohesive in the final image *(7)*.

5

6

WOODS
pencil on paper 20×26 inches (51×66 cm)

A 2B pencil is used here which is soft enough for shading in areas of tone but can be used with some precision to establish the linear basis of the composition *(1)* and in developing detail. The main vertical and horizontal lines are put in, linked by curving shapes noted briefly at first. Light hatching establishes some tonal depth *(2)*.

2

3

One of the artist's objectives here has been to define the forms of the trees and undergrowth without them becoming too subordinate to the effects of light, which comes from an unseen source. The light, however, is an important part of the image; the path leads out of the woods and we are intended to follow it in our imagination. The artist has had to seek a balance between expressing the theme of darkness within the woods, and at the same time giving the trees and plants sufficient solidity to establish their positions in space. Consequently, the lines which delineate some of the tree trunks in the foreground, and the broad leaves on the ground, are given more weight than if they had been seen in an exclusively tonal manner. The flexibility of the marks made by a fairly soft pencil has been exploited to this end, outlines being legible within broad areas of shading.

1

342

4

5

In the final stages those parts of the image which define the overall structure should be reinforced and details sharpened to provide focal points in the drawing. A detail of the foreground (6) shows how certain lines are reworked to draw out a particular form from the vigorous mass of marks. A heavy black pencil with a thick point may be used in addition to the 2B to vary the tone and texture of the marks.

In a pencil drawing such as this, where the subject contains a dense mass of forms and details, it is best to work across the whole composition at each stage, developing the relationships of line and tone. When a rough impression of the whole image is established (3) with broad areas of light hatching, the lines are reinforced to bring up the shapes of individual elements and new lines are added (4) to fill out the composition and describe the complexity of the heavy mass of trees. To develop the feeling of depth and emphasize the receding lines of path and trees heavier areas of shadow are hatched in among the vertical lines (5). Criss-cross marks and short, emphatic lines are put in to show grass and plants around the base of the trees in the foreground. Working across the image strengthening the marks or redefining particular shapes allows control of the overall view so the forms of trees, bushes and plants emerge gradually and the drawing has a continual harmony. Each layer of tone should be carefully placed to clarify the three-dimensional nature of the forms and suggest surface texture and the fall of light.

6

343

THE BRIDGE
pencil on paper 15×20 inches (38×51 cm)

An architectural subject can present a simple, almost abstract composition, for example in the smooth lines and flat surfaces of modern buildings, or a random, complex arrangement of pattern, tone and color. This may be as intricate as anything found in nature, although fixed within a basic geometric structure. A wealth of visual stimuli is provided for the artist in the contrast of old and new buildings, smooth stone or glass walls against aging bricks and ironwork, and the natural earth colors of traditional building materials interrupted by brightly painted doors, street signs or advertising billboards. A drawing in pencil or charcoal, as here, may deal with the linear emphasis, broad planes and heavy shadows while a painting is obviously more suitable if interest lies mainly in the rich colors seen under summer light or the subtlety of wintry grays and neutral tones. Rules of perspective may be found useful in this type of work, but close observation of the network of shapes and the way the elements interlock is fundamentally more valuable. Much of the pleasure in such a subject lies in unexpected effects, caused by the differences in height and structure among the buildings, heavy cast shadows touched by rays of light striking between roofs or walls, and decorative devices incorporated in the shapes, whether by accident or design as the site has evolved and developed.

3

4

1

An architectural subject should be carefully planned and there is no harm in using a ruler to trace out the basic composition. When firm guidelines have been established *(1)*, the drawing can be continued freehand as too much reliance on a ruler will lead to a rigid, lifeless drawing. A 2B pencil is used here on soft paper with a fairly heavy grain so that broad areas of dense tone can be built up.

2

5

8

7

The jumble of urban landscape produces interesting combinations of tone and pattern within a basically geometric structure. The basic outline establishes this composition and areas of tone are blocked in directly. Patterns such as brickwork and the iron bridge are lightly drawn in line and shaded, loosely at first and then more strongly to build up a range of grays and blacks, for example in the dark windows of the central building (2). A range of tones is established in this central area within the pencil grid (3) and the darkest tone is then put in to establish a key. This is the heavy black band of the bridge which cuts through the image (4). Grays in the background are added, completing the horizontal and vertical lines of the bridge (5). Details of the buildings below are strengthened, using an eraser where necessary to clean up white shapes (6). As the drawing progresses the tones are unified by further work, showing the pattern of bricks and heavy shadows on the walls to the left of the image (7). Another dark patch of tone showing a doorway on the righthand side is broken up with detail (8) and also serves to balance the dominant shapes in the bridge.

OLIVE GROVE
pen and ink on paper 8×12 inches (20×30 cm)

The particular character of some landscapes will often prompt the use of a particular medium. The twisted and spiky quality of the olive trees has led the artist to exploit the type of spiky marks possible with pen and ink. He has used the trunks of the trees and their shadows on the ground to create a sort of broken grid as a way of defining the spatial extent of the grove. The sparse shadows almost directly under the trees have been used to express the position of the sun, and the rather leisurely figure of the shepherd to express the heat.

Pen and ink invites an economical statement, but the silhouetted leaves and branches at the top were made by letting generous drops of ink fall onto the paper. These were then dispersed with rapid movements of the pen.

3

It is difficult to correct an ink drawing successfully, so the medium requires a confident and disciplined approach. The subject must necessarily be one which can be broken down in terms of line, pattern and texture but although the marks made with pen and ink are characteristically linear, a great deal of variation can be achieved between thick and thin, fluid or crisp lines. A useful way to start is to draw in a loose outline of a central object, for example the spreading tree in this image *(1)* and put in a few lines to show the layout of the drawing as a whole. Building on this the form can be elaborated to identify the rhythmic structure of the composition *(2)*. Although the approach is direct nothing should be put in at this stage which eliminates areas of further development in the image. The detail *(3)* shows how the composition progresses from left to right in a sketchy, open manner.

1

2

5

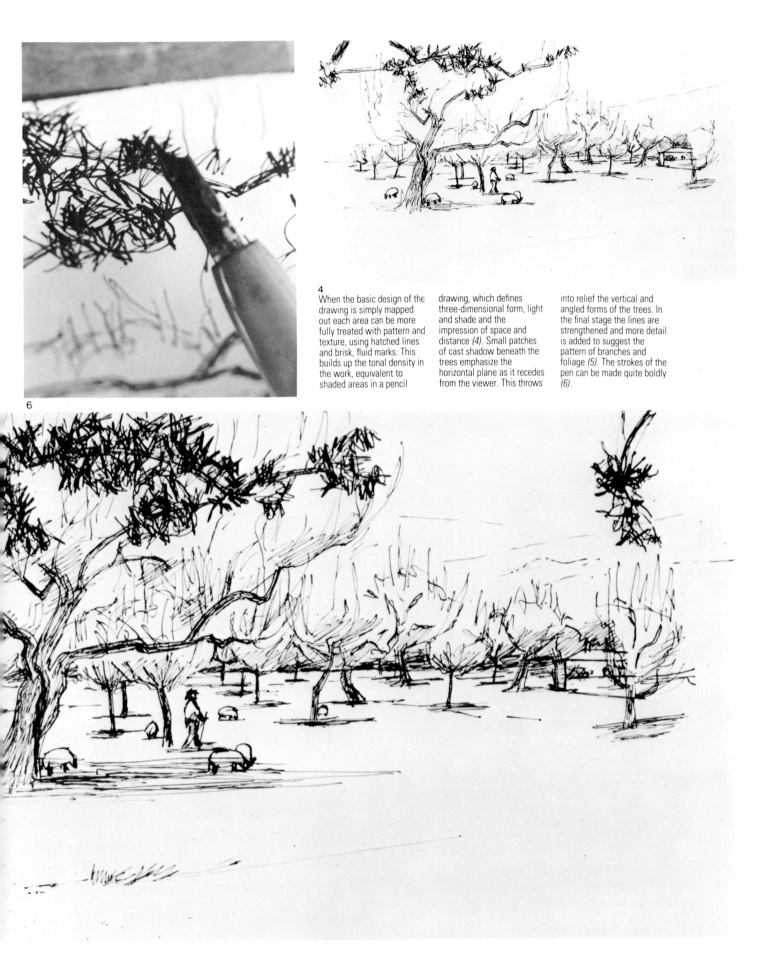

4
When the basic design of the drawing is simply mapped out each area can be more fully treated with pattern and texture, using hatched lines and brisk, fluid marks. This builds up the tonal density in the work, equivalent to shaded areas in a pencil drawing, which defines three-dimensional form, light and shade and the impression of space and distance *(4)*. Small patches of cast shadow beneath the trees emphasize the horizontal plane as it recedes from the viewer. This throws into relief the vertical and angled forms of the trees. In the final stage the lines are strengthened and more detail is added to suggest the pattern of branches and foliage *(5)*. The strokes of the pen can be made quite boldly *(6)*.

POPPIES IN HAUTE PROVENCE
pastel on paper 6×4 inches (15×10 cm)

Pastels offer the qualities of both drawing and painting media – they can be used for linear results or directly applied in shapes of color. This work shows a very painterly approach; all the drawing has been done with delicate touches of pigment. The treatment of the chosen motif is quiet, almost intimate, and its qualities are dependent on the subtle juxtaposition of colors. There has been no attempt to give the landscape more drama than the color itself conveys. The composition is based on an intuitive feeling for the placing of one color next to another, rather than any formal geometric or linear scheme.

This composition is a good example of an artist having decided exactly what it is in the scene which has promoted a response, then keeping that idea as the predominant guiding factor throughout the work. There is no feeling that he has introduced any element which is not intrinsic to the enjoyment of the poppies' color. The blue-greens of the hills behind complement the warm reds of the flowers, as the mauvish elements of the background complement the warm greens of the grass in the foreground. The flicker of light enlivens the whole landscape.

1

A pastel drawing may be made on tinted paper so that traces of the paper which show through the finished work provide a middle tone. In the initial stages establish the composition by showing the broad bands of sky, horizon, middle ground and foreground. Make loose, sketchy marks in colors appropriate to elements in the drawing and then gradually make them more descriptive. *(1).*
Strokes of yellow and sage green are used to create the structure in the foliage and are linked with the colors of the sky. Small marks of pink and red indicate the flowers and the middle ground is loosely blocked in. At first, identify the darkest tones and most vivid colors. Here the rhythms in the landscape are put in with olive green, black and touches of red which show the poppies. The sky is blocked in with grainy masses of cobalt and cerulean blue and a warm, light mauve.

Colors

cobalt blue	light olive green	red
cerulean blue	dark olive green	deep rose pink
light pink	yellow	salmon pink
light mauve	raw sienna	
blue-gray	brown	

The drawing must be allowed to build up slowly or the powdery colors will mix and become unmanageable. Avoid resting the hand on the paper or the drawing will be smudged. Alterations can be made by lifting the color with a stiff, dry brush and a small eraser. As the image is filled out with colors worked one over another, check the overall balance of tones. Be wary of heavy accents of light and dark which may appear exaggerated. Place bright colors and highlights carefully. For example, the red of the poppies dominates the foreground but crisp touches of pure color are offset against hazy patches of pink and red emerging through the green foliage. Establish a sense of distance by reducing the distinctions between one element and another at the horizon line. This has been achieved here (2) by overlaying dark colors with a light pink.

2

EVENING LIGHT, GRAND CANAL
pastel on paper 8½×5½ inches (21×14 cm)

The buildings and canals of Venice have held the attention of artists since the Renaissance, and the quality of light that pervades this water-bound city must be one of its most consistent attractions. Here the artist concentrated on a cool mood; the buildings have lost the warm colors of midday and acquired a range of silvery qualities.

The principal features of the composition were established with some firm drawing and subsequently built upon with gentle changes of tone. The poles with red stripes in the foreground give a scale both in terms of space and of color to which the other buildings relate. They form a starting point from which the eye is taken by means of alternating light and dark, and warm and cool colors, toward the domes of the church seen above the rooftops. It is a picture which expresses enjoyment of an unfamiliar view of these domes, so often featured in paintings of Venice, and gives a sense of having turned a corner to discover the unexpected.

Right A composition which includes complex architectural detail must be carefully planned and the initial drawing must be quite elaborate, even though some of the detail may be lost when the work is completed in color. It is not always possible to work on a full drawing with the subject immediately in view and in this case drawings and notes made in a sketchbook will prove invaluable. A hardback sketchbook with high-quality paper provides a firm, smooth surface for pencil drawings made on the spot. These should include as much detail as possible and written notes can be added to record effects of color and light. Take down all the information about line, color and tone so you can select particular aspects later.

1

Details of the drawing shown in full on the following pages emphasize the importance of a well-observed linear structure as the basis of the composition. The colors are built up with a network of small marks following the basic outlines of form and decoration *(1)*. A contrast between warm pink and brown tones and cool blues in varying shades is employed to capture the effect of evening light on the buildings. The intense, light tone of the sky is put in at an early stage, providing a key to highlights and shadows in the rest of the image. Note how the pastel is held at an angle to the paper with the hand hovering just above the surface *(2)*, so that the marks can be placed precisely without disturbing previous work. The overall tone of the blue-gray paper provides an underlying harmony to the drawing.

2

To draw a linear composition finely, it may be convenient to use a chalk or pastel pencil, the type with a wooden casing, which can be sharpened to a point. Make sure it is not greasy or it will be impossible to work freely over the outlines. The image here is drawn in brown on blue-gray paper *(1)*. Cool tones are established first, using light ultramarine and cerulean blue. The lightest part of the sky, directly behind the buildings, is emphasized with pure white to give a cold, clear tone. These colors are extended through the image *(2)* and offset with warm pink and two shades of brown. The broad masses of buildings and water are built up in simple form, using heavy patches of color against brief strokes loosely woven into the outlines. As soon as the architectural features are placed the balance of tone and color can be fully developed.

1

2

Colors

ultramarine	light cerulean blue	light red
light ultramarine	light gray	burnt umber
white	light pink	light burnt sienna

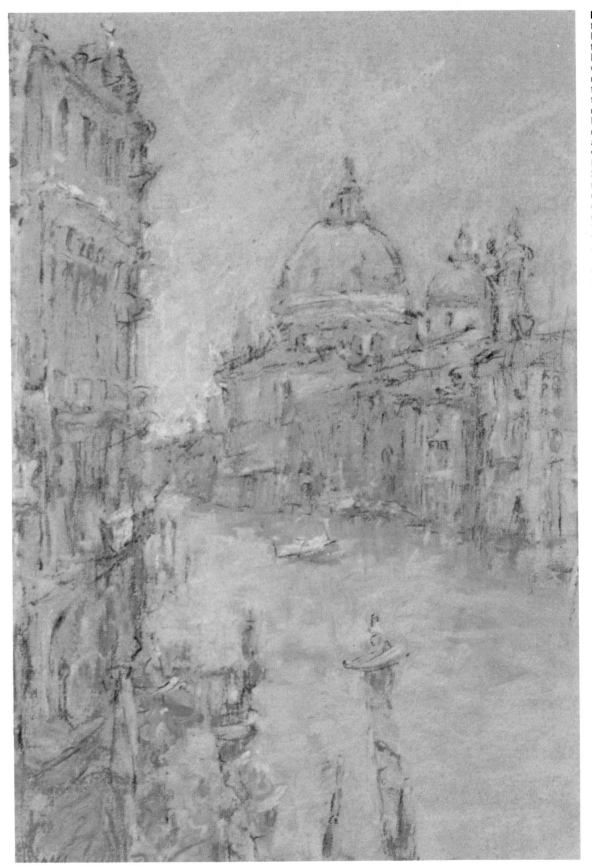

Left An important aspect of this image is the effect of light over the local colors of the buildings, giving a luminous pearly tone to the warm colors. A limited range of colors is used and the tones are linked throughout the different areas of the composition. Pink is used liberally to suggest the delicate color of stone in the architecture. This is modified with a warm beige in the lefthand side of the drawing. Some distinction is maintained between the blue of sky and canal and the darker tone used to shadow details in the buildings. The foreground is stressed with the heavy shadow to the left and strong detail in bright red, laid in with small, decorative flourishes, showing the boats and landing posts. The directions of the pastel marks help to create a particular form and define the space and structure in the subject generally. The separate tones are gradually merged to harmonize the colors and suggest that the view is given a shimmering, vibrant effect by the evening light.

PUYMERAS: OVERGROWN VINES
pastel on paper 7×4¾ inches (18×12 cm)

Athough this pastel contains no strong tonal contrasts, it is nonetheless primarily concerned with light. The shapes of the buildings in the hilltop town are seen over the tangle of vines in the foreground, and the forms of each part of the composition enhance each other by their differences. This does not cut the work in half, as it might have done, because of the bright light which has been observed very consistently as it strikes houses and vegetation alike. It is a high-key light, which conveys heat and unifies the whole. The picture is also unified by touches of the warm pink of the buildings appearing in between the foreground vines.

The artist demonstrates well, in this and her other works, the importance of finding the warm and cool elements in all the colors she uses. The little strokes of warm and cool color, extended over the whole surface, even in the bright sky, serve to create a mesh which captures the light.

The picture also shows how an artist's interests operate on different levels at the same time. This picture is of vines and buildings, but equally important is the strong sunlight, which strikes all objects with complete impartiality.

The first stage of this drawing consists of a fairly detailed analysis of the linear structure of the composition *(1)*. The cluster of buildings on the horizon is carefully drawn to give a sound basis for the solid forms. The tangled vines and undergrowth in the foreground are suggested with delicately traced lines and heavier accents which mark the directions and interplay of branches and foliage. The paper is again gray, with a blue-green tinge suitable to the main areas of color which will be added. A few notes at the bottom of the page draw attention to particular aspects of color and tone to be developed in the drawing. The basic sketch is completed in a neutral tone before local color is added *(2)*.

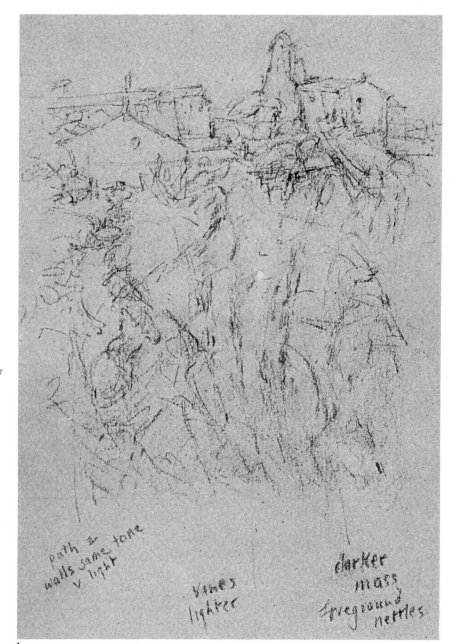

1

2

3

Over the initial drawing the local color is added and light tones are brought out in the sky, buildings and pathway. White, mauve and a light flesh tone are used for this, with a vivid light blue for the sky (3). The foreground area is loosely blocked in with pale green and then developed with light strokes of blue, mauve and yellow ocher. At this stage the work is kept simple, showing only brief touches of shadow and highlight. The masses of color are then built up and elaborated (4) to break down broad areas into a more detailed network of shape and color. The pastel strokes correspond to the interwoven foliage in the foreground. When an overall impression of form and color emerges the buildings are blocked in more solidly with light tones (5) to emphasize the contrast between the stone surfaces reflecting light and the more complex organic forms below.

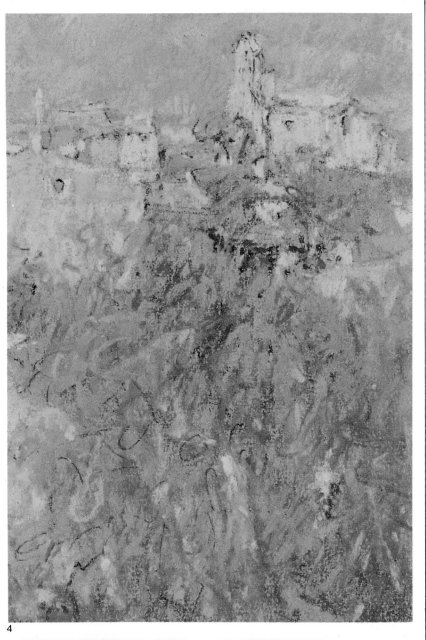

4

5

355

PAINTING LANDSCAPES

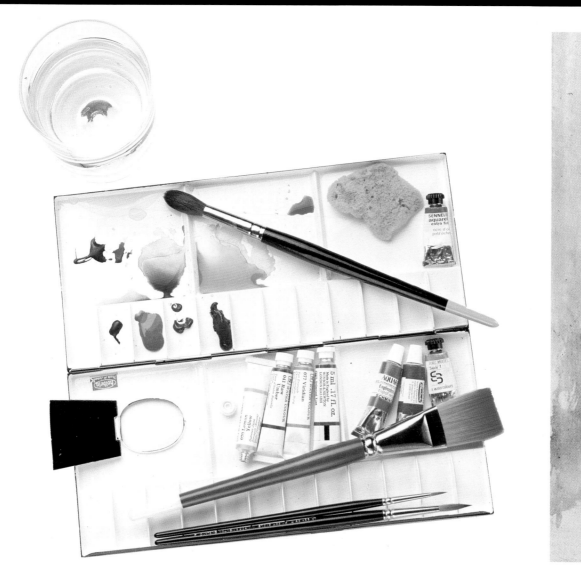

WATERCOLOR

The term "watercolor" is used in two senses, one of which is more specific than the other. In its broader sense, it simply refers to colors which have been ground up with a water-soluble medium. More specifically, it has come to refer to a way of using such colors so as to exploit their transparent nature. This method, developed primarily by English artists in the eighteenth century, uses the white of the paper on which the painting is done to give colors luminosity. White as a pigment is not used at all. Colors are lightened by further diluting them with water so that they become increasingly transparent, which allows more light to reflect off the white of the paper underneath. This dilution is commonly called a "wash." Where this transparency is not considered desirable, a white pigment can be added, generally Chinese white, which makes the colors more opaque; this is called "body color."

Watercolor has been used both with and without the addition of white for many hundreds of years. The decoration of medi-eval manuscripts was done with both transparent and opaque watercolor, the latter preferred for greater richness in conjunction with gold leaf. Only the purist English school of watercolorists made a hard and fast distinction between the use of added white or "body color," and the transparent form which they preferred, and even among this school there was much unorthodox experiment. Turner, for example, frequently used body color and scratched into the paint with a knife – uses of the medium which the purist would find unacceptable.

Water is a vital element in the process which is often taken for granted. Very hard water often has the effect of precipitating the particles of pigment in the paint; so if the local tap water is hard it is better to collect some rainwater or, best of all, use distilled water. It is a good idea to have two jars of water, one for mixing with the color and the other for cleaning brushes.

The medium with which the pigments are manufactured is gum arabic. This is a misnomer today, as all the acacia trees in the Middle East from which the gum was taken have now died, the water springs which fed them having dried up. Most of the gum now comes from Senegal and South America.

Because of the different climates of West Africa and Arabia, where the acacia trees were subjected to high temperatures in a dry atmosphere, their water supply being subter-ranean, there have been some difficulties of manufacture, and the Senegalese gum has to be given an artificial heat treatment.

Water is often the only medium necessary when painting, but sometimes an artist may wish to give the paint more body without changing its color; this can be achieved by dissolving a little extra gum arabic into the water. This will also increase the adherence of the pigment to the paper.

Different pigments are manufactured with different amounts of gum arabic, and behave differently when they are being applied. It is useful to have some gum on hand, so it can be added when needed. Only the experienced watercolorist will notice the minute dif-

Far left For making watercolors outdoors, a travelling palette is useful. Separate wells for mixing are essential, so that colors do not flow together. Traditional watercolor palettes are white, usually made of ceramic or enamelled metal. A white palette will enable you to judge the strength of a wash before applying it to the paper.

Left *Venice from the Giudecca,* J.M.W. Turner. In contrast to the vigorous style of many of Turner's works, this watercolor has been executed with great delicacy and economy. He has used a limited palette and made very transparent wet washes in a carefully considered and deliberate manner. Fine accents of opaque color have been added to establish form.

Above All good papers for watercolor have a right and a wrong side. The correct side to use has been coated with size.
Right Watercolor papers vary in weight and texture, and these characteristics will affect the final result. It is wise to buy the best paper that you can afford. Experiment with different surfaces for different effects. Handmade paper is favored by watercolorists, but tends to be rather expensive.

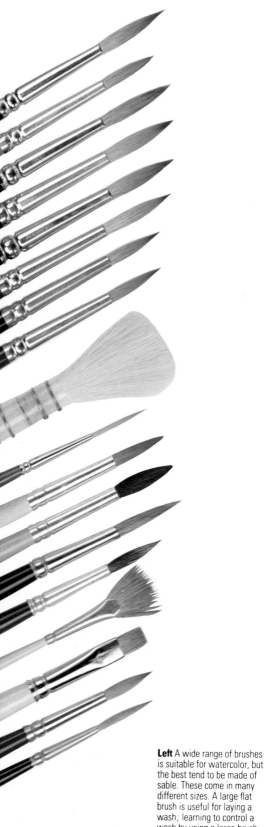

ferences between colors mixed with smaller or larger amounts of gum, or gum of different qualities, but recognition of them can stimulate experiment. Small quantities of sugar or glycerine can be added to give the paint more body and to delay the drying time. A variety of gums, which all behave slightly differently, can be used.

Gum tragacanth This must be ground to a very fine powder and then dissolved in a tiny amount of pure grain alcohol, or possibly vodka if the alcohol is difficult to obtain. This is best kept in a bottle or jar with a top, so that it can be shaken at intervals.

Corn starch Add 1¾ oz (50 g) of powdered starch to just enough cold water to make a paste. Add the water a little at a time, stirring it to the consistency of cream, and than add this mixture to about a cup (8 oz or 300 cc) of boiling, preferably distilled, water.

Sarcocolla This is a gum resin which has been used for at least 2,000 years. It is much harder than gum arabic and becomes virtually insoluble when dry. Alcohol is the best solvent, but then it cannot be varnished with an alcohol-based varnish. Unlike other watercolor media, it can be used on top of oil paint and can give brilliant glazes.

Levulose An extract from honey, levulose is made by exposing stiff pale honey to the air until it hardens and becomes crystallized. It is then dissolved in alcohol, shaken vigorously and allowed to stand for several hours, shaken again at intervals, and finally filtered.

Glycerine This is a colorless extract from fats, and is easily obtainable.

Brushes

The best brushes for watercolor are made of sable or camel hair, but a large flat hog's-bristle is also useful for washes. Generally a brush is chosen because it can hold water, yet has enough spring in its hairs to retain its shape, and is capable of forming a fine point. The tendency over the years has been for artists to use smaller brushes, but this may be a way of avoiding the difficult skills which have given watercolor its appeal, namely the control of a brush charged with a lot of water to give direct and luminous washes. It is worth trying to handle as large a brush as possible, a size 14 or even larger, provided it has a good point. Smaller ones to accompany this could be sizes 8 and 4, which should be adequate to begin with, even if smaller or intermediate sizes are eventually needed.

Other useful equipment includes a small sponge, linen or cotton rags, and blotting paper.

Left A wide range of brushes is suitable for watercolor, but the best tend to be made of sable. These come in many different sizes. A large flat brush is useful for laying a wash; learning to control a wash by using a large brush is an important watercolor skill.

Paper

The quality of paper used by watercolorists is bound to have an important and direct influence on the nature of the work. A heavy, sized, handmade paper is best for watercolor because it holds water well, but a beginner may choose to practice on a good quality drawing paper, which is cheaper. However, too poor a paper will give discouraging results. A paper's characteristics, its roughness, absorbency and so on, are very important; every artist becomes increasingly aware of what sort of paper is going to suit his own needs. David Cox (1783-1859), in 1836, found his own ideal in a rough, tinted paper which absorbed his washes well. It was actually made as a cheap wrapping paper but, subsequent to his own use of it, was sold specifically for artists. Unfortunately wrapping papers are no longer made from cotton pulp, and there is no good cheap paper available yet. It is wise to accept from the beginning that the quality of paper is just as important as the quality of paint and brushes.

Left *The White House, Chelsea* (1800), Thomas Girtin. Girtin's work, and particularly this one, was greatly admired by Turner. Girtin was a pioneer of watercolor and extended the medium to new depths and subtleties. This example, painted with a limited range of pigments on buff paper, displays his fine sense of composition and sure eye for tone and color. It also shows a great sensitivity to the mood and atmosphere of a particular time of day.

The final choice which each artist makes about paper will depend on the sort of imagery which interests him. It will have to be thick and strong if he is going to scratch and scrub it as Turner did, and have a smooth surface if very fine detail is required. Only experiment will provide the answer. It is best to avoid paper sold in blocks or pads, because, for a medium where water can be used in great quantities, the glue which holds the sheets together round the edge is seldom strong enough to keep the paper flat.

To ensure a flat surface, paper can be stretched on a drawing board. When the correct side of the paper has been established, it is dampened evenly all over with a sponge. It need not be flooded with water; the paper should absorb the water without leaving any excess lying in pools on the surface. The paper is then stuck down onto the board all the way round the edge with paper tape, and allowed to dry naturally, not in the sun or with artificial heat. The surface must of course be kept clean and free of grease.

When a watercolor has been completed and is to be framed behind glass, it is important to ensure that the picture's surface in not in contact with the glass because of the problems of condensation.

Colors

Watercolor paint can be bought either as small, hard cakes or in tubes. The tubes are marginally easier to use especially if working on a larger scale, but, although it can be kept moist by the addition of sugar, honey or glycerine, the paint dries quickly on the palette, and using it becomes similar to using the cakes. Many boxes of paint have lids in the form of a palette, which are usually white enamel; alternatively, a few small white saucers can be used. It is important that they are white so that the exact strength of a wash can be assessed before it is put on the paper. It is also helpful to have a few spare scraps of paper for testing colors.

Paints are graded "permanent," "normally permanent" or "durable," "moderately permanent" and "fugitive." An artist may have to settle for less than permanent if he needs a particular color, but it is best only to buy permanent colors. Although there are a good 60 different colours easily available, it is advisable to start with less than ten. No two artists use exactly the same palette all the time, so there are many variations on the basic palette.

Here are suggestions for a palette containing only completely permanent colors: lemon yellow, yellow ocher, light red, Indian red, raw umber, terre verte, viridian and cobalt blue. Note that neither white nor black is included. It is better, while developing a feeling for the medium, to use the paper as the white; this is a time-honored tradition. A pure black suggests a total absence of light, which is a rare phenomenon, and near-black can easily be made from a mixture of the blue and raw umber. At some stage a stronger yellow may be needed and this could be cadmium. A brighter red could be alizarin crimson or cadmium again, and other useful additions are

raw and burnt sienna, French ultramarine and Hooker's green. It is surprising what a range can be achieved with a few basic pigments, and it is both instructive and enjoyable to mix these colors with each of the others in turn, with varying quantities of water, in order to find different ways of making intermediate shades. Some simple color-mixing exercises can be especially valuable for the discovery of grays, which can be produced from unlikely combinations.

Techniques

One of the first techniques to learn is how to lay a wash, that is, an even, transparent tone which will be illuminated by the paper underneath. It is worth trying this both with the paper dry and with it lightly dampened with a sponge. The quality and texture of the paper will affect the result, an even wash being easier to achieve on a very rough surface, for example, if the paper is damp. Similar to dampening the paper for stretching, it is not necessary to use a lot of water as the fibers can only absorb a certain amount. It should not be possible to see any water glistening on the surface, which occurs if too much has been applied; excess can always be sponged off. Use as large a brush as possible and fill it with the appropriate mixture of pigment and water. The board should be slightly tilted so that the paint will run. Lay the wash as quickly as possible, with broad strokes across the paper, starting at the top and working down. Try this also on a dry paper, with different quantities of water in the brush. If the paper has a very rough surface the color may not penetrate all the pits in the surface, which result is called a "broken

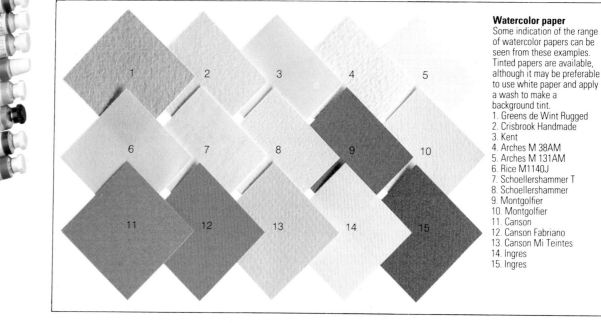

Watercolor paper
Some indication of the range of watercolor papers can be seen from these examples. Tinted papers are available, although it may be preferable to use white paper and apply a wash to make a background tint.
1. Greens de Wint Rugged
2. Crisbrook Handmade
3. Kent
4. Arches M 38AM
5. Arches M 131AM
6. Rice M1140J
7. Schoellershammer T
8. Schoellershammer
9. Montgolfier
10. Montgolfier
11. Canson
12. Canson Fabriano
13. Canson Mi Teintes
14. Ingres
15. Ingres

Left *The Mine* This is an example of the use of watercolor without body color. The white road markings and the left side of the building where it catches the light are areas of uncolored paper. The right side of the building is represented by a very pale gray wash.

wash". When experimental washes have become controlled and even, the next step is to practise graduating them from top to bottom, and vice versa. The color of a sky often changes very gradually toward the horizon. Blurred effects can be explored further by using more water than for a normal wash and floating color onto it, or introducing a color into an area of a different one before the first is dry. These soft effects have been much used in the treatment of skies.

The watercolorist, if he seeks to keep the painting as translucent as possible, works from light to dark. It is clearly important to make an early decision about the areas to be left absolutely white. If there are none at all then the color closest in tone to white is established and this can be the first wash. If it is very pale it can be applied over the whole surface. The next darkest color is then established and overlaid, and so on, until the very darkest at the end. One way of building up dark areas is to lay a wash over a color which has already dried, but too many layers

will eventually become dull. Turner and his contemporary, Thomas Girtin, adopted one method of expressing the shaded part of an object – painting the whole form with a pale wash, and then overpainting the dry shaded area with a darker mixture of the same color.

The difficulties of working from light to dark will soon make themselves apparent. Some of the palest areas might be no more then tiny, intricate shapes, such as a cluster of leaves in bright sunlight, which will have to be carefully avoided when the darker surrounding washes are applied. If the colors are to remain transparent, it is not possible to make them lighter again if the brush should accidentally slip. This is a problem inherent in the purist use of watercolor, which demands that as few corrections be made as possible.

The French called this approach the English method, but there have been many English watercolorists, including Paul Sandby, De Wint (1784-1849), Samuel Palmer (1805-81) and Turner, who used body color as a way of making dark areas light again. The

translucency prized by the purist is sacrificed, but greater freedom is gained. Without white paint, the only way of making dark areas light is actually to remove the color from the paper. There are several ways of doing this. Thomas Girtin wetted the offending color again with a brush and then lifted it off with blotting paper. John Sell Cotman used dry bread. Others have scratched it off with a knife, but this can only be done when the paper is thick and strong. A more ingenious method of achieving light patches within a dark area, but one which requires forethought, is to make up a mixture of beeswax and turpentine with some flake white pigment, and paint it onto the light areas at the beginning. The darker wash can then be laid all over, the beeswax resisting the water in the wash. When the color is dry the wax mixture is removed with turpentine, exposing the white paper underneath. The advantage of this is that the light areas can be painted as positive shapes, rather than having to work round them carefully with the darker color.

Most watercolorists would accept it is desirable to use the white of the paper as far as possible, keeping a little white pigment in reserve which may be used only for tiny touches at the end. Other additions can be made with pen and ink. As there are limited opportunities for making radical alterations to a watercolor, an artist may turn in this way to other media, to rescue a work which might otherwise be considered to have failed. This medium can usefully be combined with chalk, pastel or with oil pastel to create different effects.

Pure watercolor is often at its best when completed swiftly and spontaneously. If serious mistakes are made early on it can be abandoned and started afresh on a clean piece of paper, and even the most skilful painter may attempt the same image several times before being satisfied. The other recourse is to let it develop into a gouache.

GOUACHE AND TEMPERA

Gouache is simply watercolor paint which has white added. Where watercolor is transparent, gouache is opaque. It can be bought in tubes or in jars, and is sometimes called "poster" color. As the white of the paper is not used to lighten colors, it can be applied much more thickly. A larger range of brushes can be used as the pigment has more body than watercolor. With gouache the texture of the paint is important, but like watercolor it can be used in a very liquid state. To prevent the colors running together the drawing board should be fairly flat. As the color dries it becomes lighter, and, if lighter than intended, it can be overpainted when the first color is absolutely dry. The dry paint is very absorbent and can pick up dirt easily; so if fine detail is being added it is sensible to rest the painting hand on a clean piece of paper.

The qualities of gouache, its thick color, opacity and its visible texture, are quite different from watercolor. When both are used together in the same picture, these differences can be exploited.

Tempera is another form of watercolor, but instead of gum arabic either all or part of an egg was originally used to bind the pigment, and the paint called egg tempera. It was universally used for easel painting until the fourteenth and fifteenth centuries when it was combined with, and eventually superseded by, oil painting. It has been revived from time to time since then, and it is now possible to buy ready-made tempera colors. These colors are no longer made exclusively with egg, so the term tempera has come to cover emulsions of various sorts.

Tempera is an exacting medium, as the colors dry immediately and become paler. It is also very durable; the paint does not crack, discolor or deteriorate with changes of temperature or humidity. The oil in oil paint can attack and destroy the surface it is painted on, but tempera actually protects its support.

As with watercolor, tempera can be painted directly onto paper, but wood and canvas can also be used without a priming. Colors should be mixed on a non-absorbent palette similar to the watercolor palette; small china saucers or dishes are ideal. All sorts of brushes are suitable, but they should be washed frequently as the color dries quickly.

This fast drying means that there is little scope for working the paint on the surface to create gradations. It has to be done instead by building up a gradual change of color with tiny strokes of the brush, or cross-hatching. It is possible to buy preparations which retard the drying of the paint, but if these are used excessively it could be argued that they degrade the medium by depriving it of its own particular disciplines. However, such retarders have always been used; Filippo Lippi (c1457-1504) used honey for this purpose.

To make the traditional egg tempera, mix powdered pigment thoroughly with egg yolk and allow it to dry. If scraped with a knife when dry it should have the consistency of candle wax. If it flakes, more pigment is needed. This is then moistened with water on a brush and applied to the paper or canvas.

Right Tempera is usually produced by combining powdered pigments with an egg solution. The egg solution serves to bind the pigment to the surface. A limited range of colors is available ready mixed in the tube form, but these do not dry as readily as the handmade paint.

Making tempera
Tempera is a combination of egg binder and a pigment.
1. Crack an egg in half.

2. Separate the yolk from the white, allowing the white to drain away into a bowl.

3. Pick the yolk up very carefully, without breaking the sac.

Colors can be made more transparent by including some white of egg.

If is not necessary to prime the canvas, but if a white surface is preferred, the primer can be made in the same way with white pigment, yolk of egg and water. To give the surface of a tempera painting a light gloss when it is finished it can be polished with silk, but the paint must be completely dry.

Above *Quay* This gouache explores the qualities of the medium with a great variety of grays. These have been enriched by areas of underpainting, made with transparent and semi- transparent washes of warm color. In places these warm colors have been allowed to show through. The decorative qualities of the stones have been fully exploited.

4. Hold the yolk over a jar, slash the sac with a scalpel and let the yolk drain into the jar.

5. Add water to the yolk, a small amount at a time. The amount of water needed varies.

6. Make the pigment paste by first filling a small glass jar with pigment.

7. Add water to the pigment until it forms a thick paste. The amount required depends on the absorbency of the pigment.

8. Put the top on the jar and shake vigorously. Mix binder and paste together when required.

GARDEN IN RICHMOND
watercolor on paper 20×23 inches (51×58 cm)

Although watercolor is a medium which can be used very quickly and spontaneously, there are occasions when the composition has to be carefully planned. In this example, the white of the paper is used for part of a sharply defined architectural detail, and it is important for the nature of the image that this shape remain a pure white. Before any color was applied, the areas to be left white were covered with a masking fluid which could later be removed. This is a modern version of the beeswax and turpentine method used in the eighteenth century.

The white shapes where sunlight strikes the ornamental urn are the parts of the picture which initially hold our attention, but which subsequently lead us to the door in the wall behind. The link between the urn and the door is made by the asssociation of architectural shapes, placed as they are among freely handled areas of trees and grass. Despite the prominence of the urn, the door is the real center of attention. The color of the door is the warmest color in the painting, and the artist's intention is purely to play on our natural curiosity about what might lie on the other side of the wall.

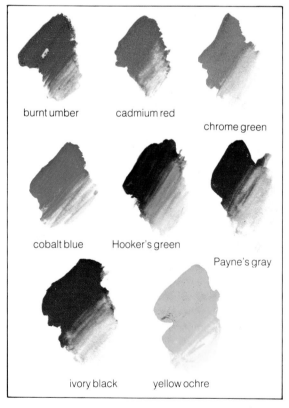

burnt umber cadmium red

chrome green

cobalt blue Hooker's green

Payne's gray

ivory black yellow ochre

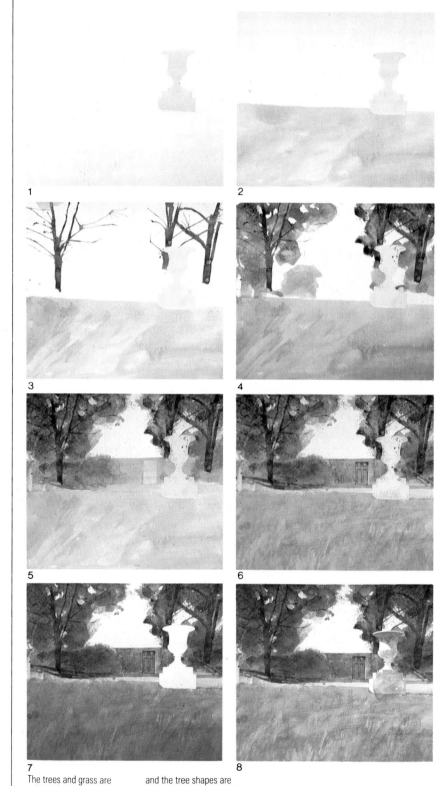

1 2

3 4

5 6

7 8

The trees and grass are painted freely here, using several techniques which cannot be fully controlled. To preserve the clean shape of the garden urn it is first painted with masking fluid which protects the paper (1). Broad washes of cobalt blue and chrome green establish the sky and foreground (2) and the tree shapes are painted and blown to make spiky lines (3). The foliage is loosely washed in (4) and developed with blotted and spattered paint (5,6) as the rigid shape of the walls is added. The mask is rubbed away and the urn drawn (7,8).

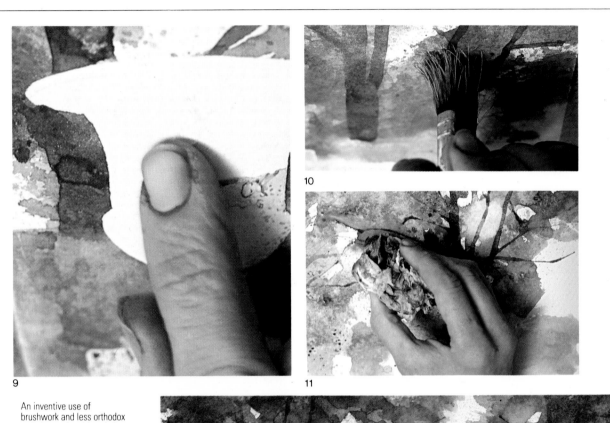

9

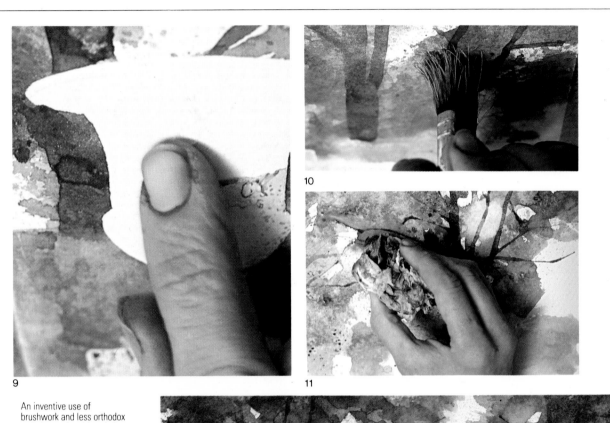

10

11

An inventive use of brushwork and less orthodox techniques give this painting a vibrant, textural quality enhanced by the emphatic highlight *(9)*. The techniques fully exploit the transparency of watercolor. The texture of the foliage is made by adding loosely brushed and spattered color, flicked from the end of the brush *(10)* to pools of green made by rolling a well-loaded brush over the paper. Crumpled tissue paper dabbed into wet paint *(11)* simulates a complex leafy pattern. All this can be freely applied over masking fluid, which is rubbed away to reveal the clean shape of the urn when the paint dries *(12)*.

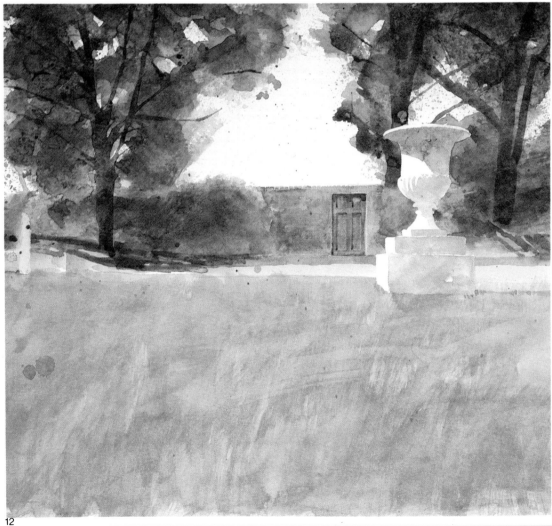

12

A GLASTONBURY ROMANCE
watercolor on paper 20×12 inches (51×30 cm)

A broad sweep of landscape has an almost universal appeal. Most of us will go out of our way to enjoy a good view. City dwellers often find particular exhilaration in looking at wide open spaces and valleys such as the scene the artist has portrayed here. The complete absence of detail in the immediate foreground implies similar open spaces in the directions we cannot see, behind and to either side, as though we were alone in rolling countryside. All signs of human activity have been excluded from view, the scale of the valley and surrounding hills being given by the relative sizes of the trees as they diminish toward the distance. The considerable recession is achieved by using the very palest of colors for the hills on the horizon, with an alternation of warm and cool to take our eye back across the valley. It is a romantic view of nature, in the tradition of many English watercolorists since the eighteenth century.

1

This painting demonstrates the classical watercolor technique of building from light to dark using thin washes of color *(1)*. Heavy white paper is used as the support, stretched on a board so that it continues to dry flat as successive layers of wet paint are applied. The texture is varied by the use of various shapes and sizes of brushes, and by working wet into wet *(3)* or laying fresh color over dried paint. As can be seen from the detail *(2)*, small dabs of paint dropped into a wet wash spread to give a fuzzy texture while hard-edged shapes are contrived by waiting until the broad areas are dry before detail is added.

3

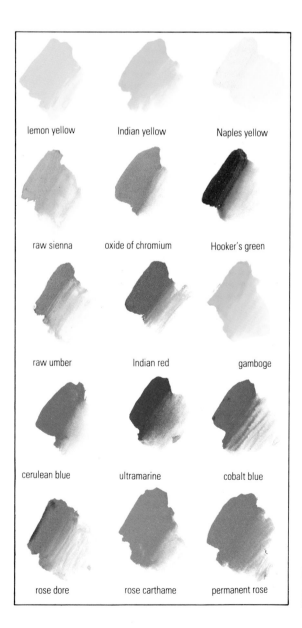

lemon yellow

Indian yellow

Naples yellow

raw sienna

oxide of chromium

Hooker's green

raw umber

Indian red

gamboge

cerulean blue

ultramarine

cobalt blue

rose dore

rose carthame

permanent rose

4

366

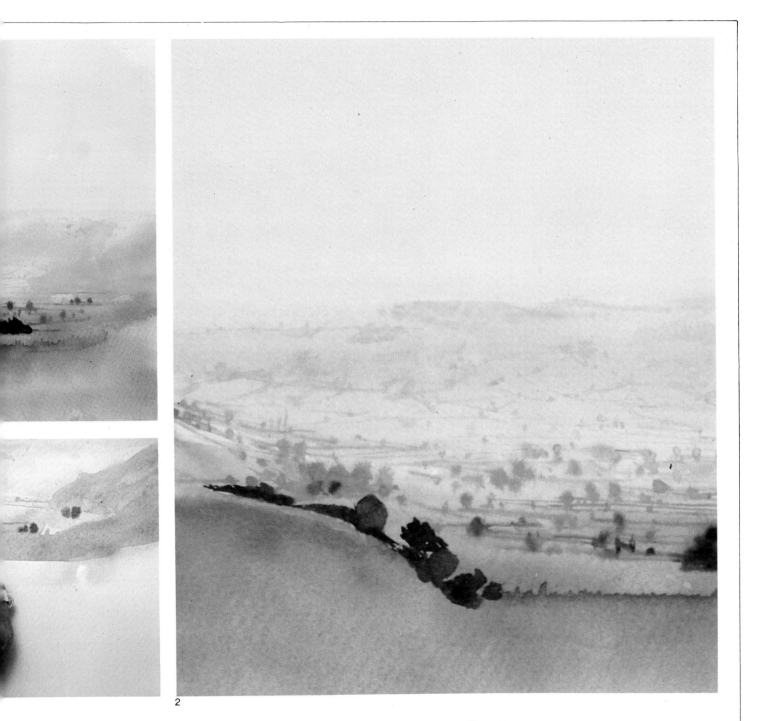

2

The combination of wet washes of color and small shapes which provide detail must be carefully controlled. Watercolor stains the paper and is not easily corrected. The choice of brush is important at each stage and a preference will gradually be found. A wide bristle brush *(5)* is useful for laying in heavy washes while round sable or pointed Chinese brushes are more suitable for details *(4)*.

5

Watercolors are best mixed in a plastic or ceramic dish which must be white so the strength of the color can be seen. As the colors lighten in drying the washes should be more intense than may appear necessary. This is a matter of judgement which develops finely with practice. In the first stage broad areas of color are laid in to define different elements of land and sky *(1)*. Here a central division of the picture plane is made with a line of green over a basic wash of cerulean blue, raw umber and indigo. The color is laid very thinly. Wet colors are brushed into the wash and allowed to spread on either side of the center line, giving the rough shape of the valley. As the paint dries the areas are given more emphasis *(2)*, making use of the fuzziness of spreading colors and the runnels forming in the paper in which heavier tones collect. This can be useful in landscape painting, echoing the natural undulations of hills and valleys. As the basic forms emerge small dabs and strokes of raw umber, ultramarine and a mixture of the two are put in to show the lines of trees and hedges in the middle ground *(3)*.

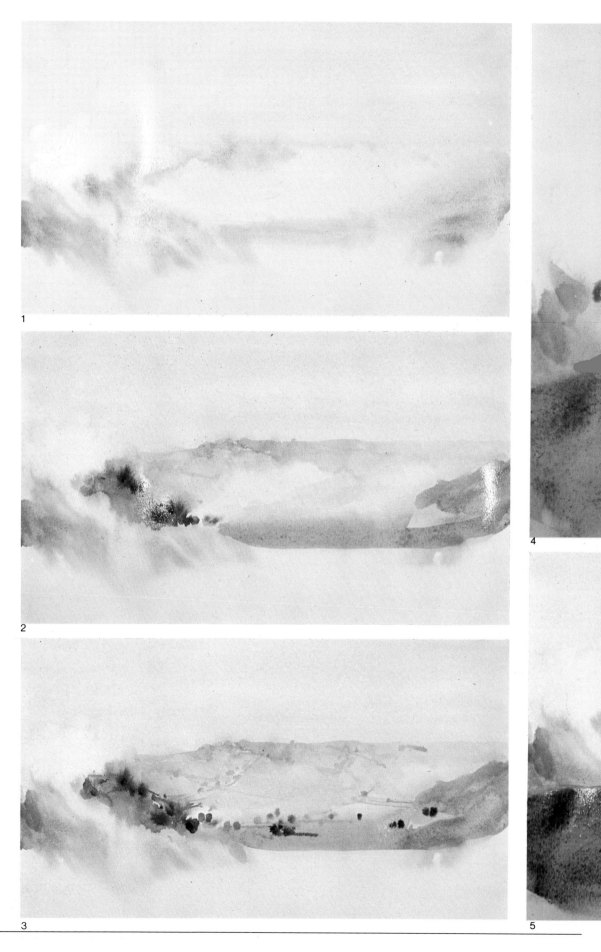

1

2

3

4

5

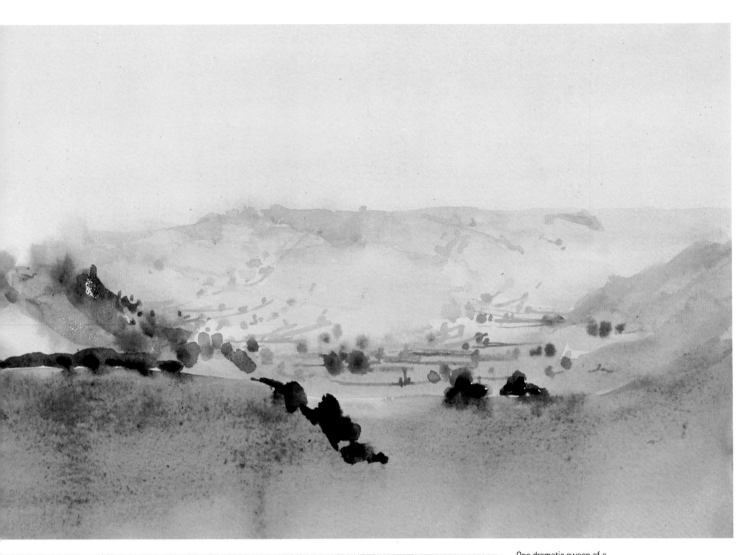

One dramatic sweep of a large bristle brush, well loaded with a mixture of Hooker's green and raw sienna, fills the foreground *(4)*. The previous washes should be nearly dry so the line between foreground and middle ground is well defined, with a fairly hard edge. This largely alters the character of the work and gives a strong tone against which the other details can be emphasized. The horizon and sky are given a lighter tone by lifting paint with clean water and a sponge or dry brush. This must be done carefully or the paper surface may be damaged. Heavy tonal details are added to strengthen the hills in the middle distance on either side and a line of dark trees is put in to define the recession in the foreground *(5)*. If the painting is allowed to dry the true tonal relationships can be seen and adjusted as necessary in the final stage.

IRISH HILLS
watercolor on paper 5×7 inches (13×18cm)

Watercolor is a medium which is ideal for achieving very soft and gradual changes of tone and color combined with a direct and spontaneous technique. Consequently, it is well suited to representing changing weather conditions, when clouds alter from one moment to the next; above all it is very suitable for rendering the watery skies of northern Europe. This painting exploits the appropriateness of the medium for the subject, evoking those days when dark rain clouds alternate with sudden and brief bursts of sunshine. It also shows the effectiveness of using a large brush loaded with water. This technique produces unique drying marks, wholly consistent with the nature of the subject, when the water is absorbed by the paper.

The artist has made the weather and its effect on the landscape the main theme here, allowing the merging of sky and hills to fuse mysteriously. The pictorial space is created to some extent by the decreasing size of trees and fields, but more by atmospheric perspective, with warm colors in the foreground receding to cool blues and grays in the distance.

lemon yellow Indian yellow Naples yellow

raw sienna oxide of chromium Hooker's green

raw umber Indian red gamboge

cerulean blue ultramarine cobalt blue

rose dore rose carthame permanent rose

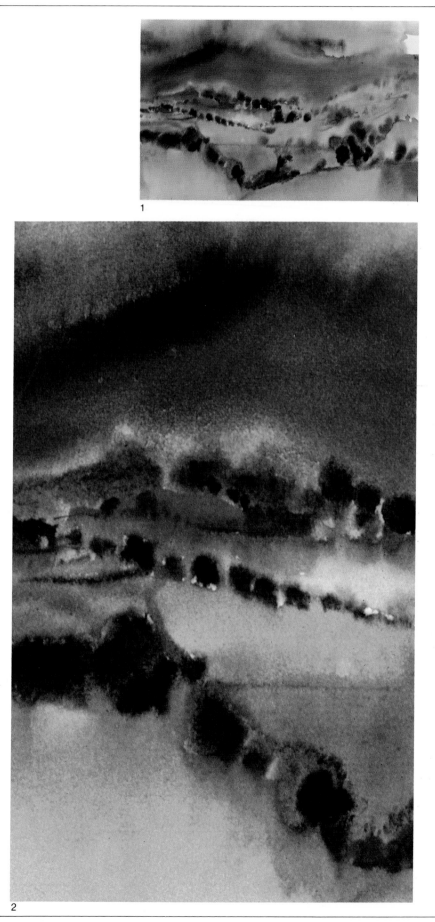

1

2

3

A sharp contrast of tone and color is conveyed through a technique in which the blurring and soft interaction of wet watercolor washes suggest the forms *(1,2)*. The painting is atmospheric rather than fully descriptive and is created on a small scale which gives a certain vigor and tension to the marks. A soft Chinese brush is used *(3)* which has a thick base of hairs tapering to a very fine point.

4

5

Details of the painting show how fluid brushstrokes encourage the natural flow of the watery paint. Broad sweeps of color laid with a round, soft brush melt together *(4)* and spread more readily if the paper is already dampened with clean water. Extra color less heavily diluted can be dropped into the wash to vary the tonal qualities.

6

The color can be lightly controlled or lifted by dabbing gently with an absorbent sponge or pad of tissue *(5)*. This alters the tone and texture of the paint and also speeds up the painting process by removing excess moisture so colors can be overlaid more quickly. A medium-sized sable brush *(6)* is a good alternative to Chinese brushes for adding small details and precise shapes. It is vital to judge the drying time correctly so the color diffuses just the right amount.

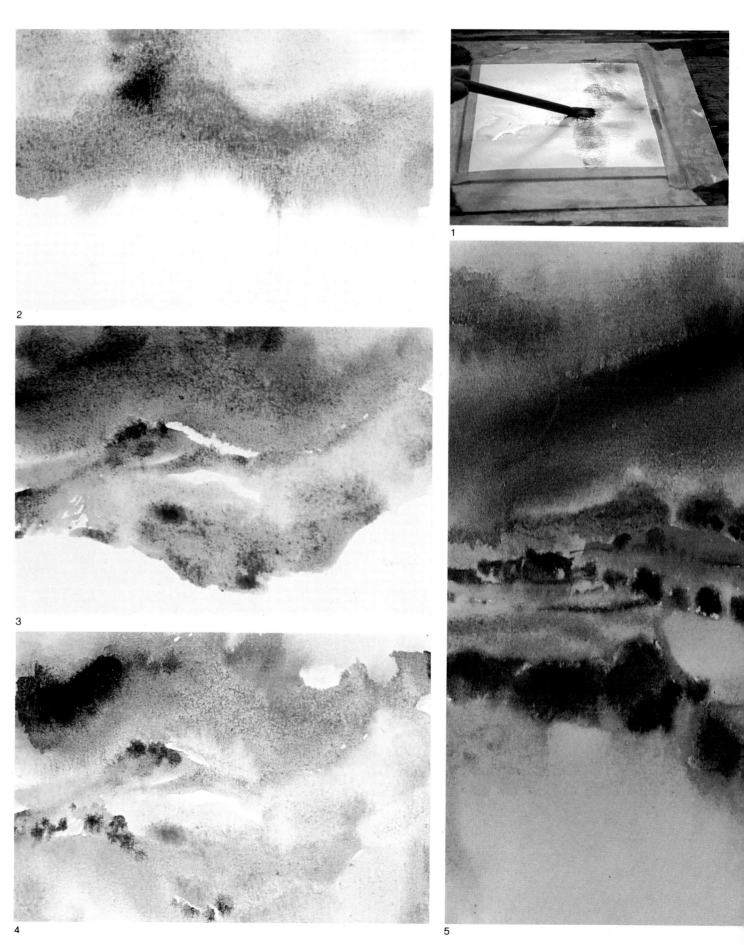

2

3

4

1

5

The painting has a well-defined color scheme, divided between the heavy blue of the mountain and the yellow tones in the foreground, linked by warm pink and gray washes and the dark lines of trees and bushes. The dark band of blue is established immediately (1), merging gently into a wash of blue and rose suggesting the sky . These colors are put down with plenty of water (2) so the blue spreads and flows naturally, drying without harsh lines at either edge.

The mauve-pink is extended into the foreground (3) and small patches of strong green and yellow are laid in which follow the rhythm of the gently curving landscape below the mountain. The colors are mixed to form subtle grays which shade and deepen the brighter hues. Well-judged control of the moisture is essential. The painting need not dry out completely at any stage but if it is too wet the colors will simply mix and become muddy. Details of the trees

are gradually developed with dark green and raw umber (4) carefully placed in small dabs and patches. The tones are extended and enriched throughout the image. Contrasts are built up more heavily in the final stage (5) with the colors brushed in and blotted to create form and space. To give a misty effect around the mountains and sky a little white is dropped into the color washes, making the paint slightly opaque.

Above *Trees in Spring*. A fresh and spontaneous watercolor which exploits the white of the paper to express bright sunshine. The large trees in the background are seen against the light, which enables the artist to contrast the variety of tones found in the smaller tree in front of them. The different types of trees and plants are expressively and economically conveyed by a variety of brushstrokes.

SUMMER PAINTING
watercolor on paper 9½×13 inches (24×33 cm)

1

In this work the artist was interested in the ways in which a landscape changes, sometimes dramatically, from season to season and under different weather conditions. Although the fields and hills are firmly established in space, it is not the artist's intention that we should see them separately from the low clouds that transform them. The transparency of watercolor has been used in varying degrees to achieve this.

The spontaneity which is so effective in this medium imposes considerable disciplines on the artist. To capture transitory cloud effects, in the manner we see here, involves working at great speed while judging the correct proportions of pigment and water, and getting it right first time. There are some ways that mistakes can be rectified, but for pale and delicate passages, such as thin watery clouds, the work can quickly look labored and lack freshness if not applied swiftly and confidently.

Here the artist has observed the soft and subtle gradation of tone that gives the scene its atmosphere. The stronger greens in the foreground ensure that we appreciate the scale of the whole landscape.

To capture the effect of light with brush and pigment is an extremely difficult task. In this subject *(1)* there is a combination of the brightness of summer light and the heavy atmosphere created in a passing shower. Watercolor is the perfect medium for this task as its rich, translucent hues and subtle tonal mixtures have the delicacy necessary for an effective rendering. Again the basic areas of color are built up in broad washes of thin paint *(2)* and details added with accurately placed patches of tone and color *(3)*.

2

3

As the landscape takes shape the brushstrokes become all-important, especially in the final stages where broad bands of gray are laid over the colors to create the atmospheric effect of the rain clouds. This layering technique suggests the shroud of mist and rain through which the summer light still breaks.

375

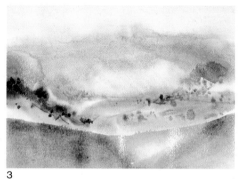

1

2

3

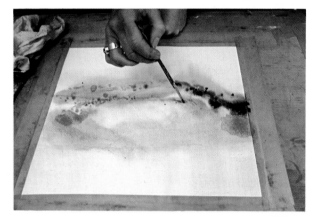

In the early stages the colors are deliberately allowed to blur and merge together, mixing into subtle tones which suggest the division between sky and land. The paper is wetted with clean water and blue, green and yellow washes laid in, with a slighly darker emphasis added in raw umber on the lefthand side (1). As the colors dry a warm pink tone is brushed into the sky and touches of blue in the middle ground (2). The foreground is blocked in with a broad bristle brush, the paint still wet so that it dries in a mass of uneven tone (3). More detail is added in the middle ground with green and brown mixtures. The sky is given a yellow cast to represent light breaking through the cloud and this is overlaid with diagonal strokes of blue-gray (4). These are made more emphatic and merged into the blues in the landscape (5). Colors in the foreground are strengthened (6) and the stormy sky given an opaque gray cast by adding a little white to the paint (7).

The work is laid flat **(above)** to prevent the colors from running uncontrollably and to give free access to the painting. The brushwork should be loose and confident, giving a vigorous rhythm to the washes of color and lines of detail. As the tones gradually build up the diffused colors form a web of shapes and hues which are drawn out by adding definition with the point of the brush **(right)**. Many colors are allowed to mix on the paper to achieve the full effect.

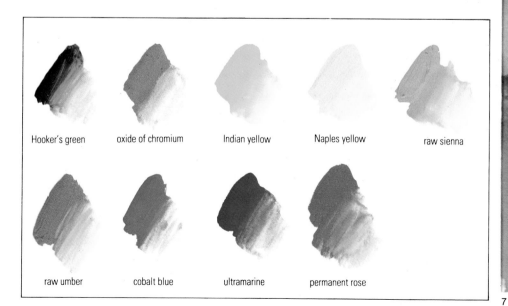

Hooker's green oxide of chromium Indian yellow Naples yellow raw sienna

raw umber cobalt blue ultramarine permanent rose

7

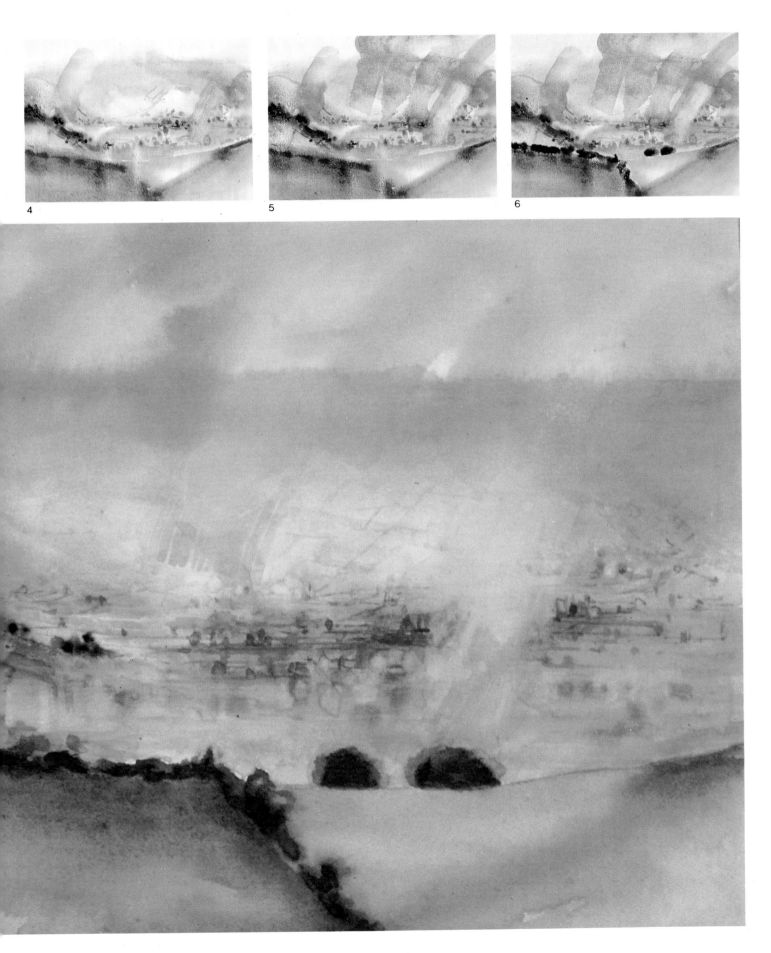

4

5

6

OIL AND ACRYLIC

The use of pigments ground with vegetable oils has ancient origins, but was not adopted and developed by artists until the beginning of the fifteenth century. Most large-scale pictures and decorations before then were executed in mosaic or fresco, but these techniques demanded the cooperation of a team of craftsmen and their apprentices. Smaller works were done with various forms of watercolor and egg tempera, none of which permitted much reworking. The limitations of these techniques prompted the development of a freer, more flexible painting medium.

Oil had earlier been used as a final glaze on tempera, which always dries quickly and becomes lighter as it dries. These glazes gave the tempera surface an added richness and helped to unify the colours. This practice continued up to the time of Rubens, when many painters were adopting oil as the dominant medium. Jan and Hubert van Eyck, fifteenth-century painters who lived in Bruges, and Giovanni Bellini (c1430/40-1516) from Venice, are commonly acknowledged to have made the most important innovations in oil painting techniques, although south of the Alps the change from tempera was more gradual. The paintings by the van Eyck family are well preserved because they took great pains in the preparation of their materials.

There have been technical developments since the innovatory period but these have mostly been concerned with making the handling of oil paint as free as possible. While this freedom from the disciplines imposed by tempera, watercolor, fresco, pastel or mosaic makes oil easier to use in some ways, it also demands a great number of difficult choices and decisions. Most shops selling artists' materials have overwhelming displays of colors, brushes, solvents, canvases, boards, varnishes, and primers. Restraint should be practiced from the start; much can be achieved with the simplest equipment. Tempera and watercolor impose inherent disciplines, but oil requires the artist to impose his own.

The oil used in the manufacture of oil paint is either linseed or, particularly in France, poppy. It is now rare for an artist to make his own oil paints, but when this was common practice there was an opportunity to control the qualities of each color. Different pigments absorb different amounts of oil, just as different quantities of gum arabic are needed in the preparation of watercolors. Oil colors are now bought in tubes, and unfortunately manufacturers must consider such problems as the shelf-life of their product, which sometimes results in the addition of more oil than necessary. The control which is now possible is only the result of long experience of each color's drying time, transparency, permanence and viscosity, and its reaction to further additions of oil. A faithful copy of a painting made before the introduction of paint in tubes would now be impossible, as we no longer have the degree of control over the medium as the artists who made up their own pigments for a specific requirement.

A technical point which is easy to overlook when working, is that if a color is painted on top of another, the first coat should be absolutely dry. There is a danger of the paint eventually cracking if this is not observed. It is even more important if there is more oil in the first color than in the second. If the artist likes to paint with more oil than a color contains in the tube, he can add more, but it is safer to reserve this practice for the latter stages of the picture. The paint needs to be looser or more liquid early on, this should be achieved by adding turpentine rather than oil. A hazard of using too much oil, at any stage, is a tendency for the surface to wrinkle when it

Above Mixing basic oil paint with oil or a thinner such as turpentine allows the artist to control certain properties: thickness of the paint, drying time and texture are among the variables.

Left Oil paints are best bought individually. To begin with, it is wise to use a small range of colors; other colors can be made by mixing. A good basic palette for a beginner would be: titanium white; a yellow, such as yellow ocher, lemon yellow or Naples yellow; cadmium orange; baryta green (emerald); viridian green or terre verte; cerulean and cobalt blue and ultramarine; a red, such as alizarin crimson, cadmium red or Venetian red; a brown, such as burnt umber, raw umber or burnt sienna; cobalt violet or mars violet; ivory black, lamp or vine black.

Right There are many oil painting sets on the market. Look for one with a good selection of colors and good quality brushes. This kit contains a palette, palette knife, oil, varnish and turpentine.

Making oil paint
1. Spoon powdered pigment onto a glass slab and pour enough oil onto it to make a thick mixture.

2. Blend the oil and pigment using a spatula.

3. Mix the pigment with the oil using a glass muller. Press down firmly and move the muller in circles.

4. Store the paint in a glass jar. Cover with a little water if it is to be kept for long.

dries. This is because the oil expands as it is exposed to air. There is no way to avoid this except by using it with moderation. It is always advisable to keep the extra oil stored in the light, because in the dark the oil becomes dark.

There are few painters who use nothing but oil to dilute and liquify their colors. Most use turpentine, often to the exclusion of additional oil altogether. Genuine turpentine should be used, rather than substitutes such as mineral spirit, which may be used for cleaning brushes and palettes but is not suitable as a paint thinner.

Colors

The properties of oil colors, their permanence and their ability to mix with others, are constantly under research. It is sad to see traditional pigments becoming rare and expensive, but new and often more stable alternatives appear all the time. Artists' colors are made from a wide range of materials, varying from dead beetles and the urine of yaks fed on mangoes, to complicated chemical mixtures. There is no need to know the origins of a pigment, but it is a good idea to acertain its permanence and mixing ability.

The beginner will learn most by confining himself to as small a palette as possible. A basic palette might consist of titanium white, yellow ocher, light red, cobalt blue and black. Other colors can be made by mixing; in this way, the beginner learns the potentialities of each pigment. The only exception to this rule is when an artist places brilliance of color above all else, as a color made by mixing several will be slightly denser, and less light will reflect through it from the white surface on which is is laid. A palette can always be extended later.

A toxic label should not deter the use of certain pigments, as this would eliminate too many essential colors. Normal precautions should be taken, such as keeping paints away from young children and not chewing on brushes in moments of stress.

It is worth remembering that one of the greatest colorists, Titian, used a very limited palette. He is reported to have said that only three colors are necessary. In theory, any color should be obtainable from the three primary colors, red, yellow and blue, but in practice this only works with absolutely pure pigments which are not available as artists' paints. Titian did not even have the use of a bright yellow, a pigment developed well after his time, and he made do with yellow ocher; but he did have genuine ultramarine and madder, with the additions of a few earth colors.

Rather than using black it is nearly always worth mixing dark colors, as they stimulate the eye to perceive the real nature of shadows.

Very dark grays can be obtained by mixing blue with either raw umber or burnt sienna; black should only be used as a last resort if these mixtures are still not dark enough. It is easy to make a color darker by simply adding black, but if this is done too much the result will be dull. Reasons such as this will be found to justify extending the suggested five-color palette. Here is a possible nine-color palette: flake white, lemon yellow, yellow ocher, cadmium red, Indian red, raw umber, burnt sienna, viridian green and cobalt blue. This selection provides the potential for many variations.

Flake white can be replaced by, or used in addition to, titanium white. The latter is denser and occasionally necessary for its ability to cover a darker color. The yellows, reds and browns are included as warm and cool counterparts. Cadmium yellow, pale, vivid or deep, could replace the lemon. Yellow ocher is always useful. A brighter cool red could be alizarin crimson or rose madder. Burnt umber could be added as a warm version of raw umber. Ultramarine is a useful additional blue.

Before starting to paint from nature, it is useful to experiment with mixing pigments. Rather than assuming that gray is simply a combination of black and white, it is better to try combinations like white, viridian and Indian red, or cobalt and raw umber, or ultramarine and burnt sienna. Different combinations of blues and yellows produce a wide range of greens. Landscape painters often also need to use a variety of soft, delicate tones.

Supports

The support is the name given to the material onto which the paints are applied. It can be wood, paper, masonite, canvas or even metal. For oil painting, canvas or masonite are most commonly used. Wooden panels must be well seasoned, which is now rare, and their weight makes them less suitable for the landscape painter. A good quality paper is a possibility, but it needs to be clipped to a similarly awkward board and, if the paint is applied thickly, it would probably need permanent reinforcement at the back. Cardboard is a better support, but has the disadvantage of being made of poor quality materials which become brittle with time. There are various cards and boards made specially for artists, but these are sold with prepared surfaces which make them expensive. Masonite is a firm, strong, durable material but the back has a coarser surface with a deep grain imposed by the machine on which it was made. It is ugly and mechanical and should never be used for painting. The front is more suitable, but it needs to be rubbed with a medium sandpaper to remove the shine.

Canvas certainly has the most advantages.

Right *Hampshire Lane.* The composition is arranged so that the spectator's eye will follow the twist and dip in the country road. There is a concentration of small shapes where the shadows of tree trunks fall across the road, leading the eye to the white fence in the middle distance.

Below *The Grounds of the Château Noir,* Cézanne. Where the Impressionists concentrated on visual sensations of light, Cézanne's priority was the structural content of his motif. This painting owes its strength to the fine tension between the structure of the trees' forms and the carefully composed pattern on the surface on the canvas.

It is light, it can be bought in a great variety of weaves, and is universally available either in its natural state or already prepared for painting. It can be rolled up when the painting is finished and dry. Linen makes the best canvas. Cotton is not strong enough and is too elastic. Those who wish to buy unprepared canvas should first stretch it. If time is available, this gives the artist an opportunity to obtain the particular sort of surface he likes best. The nature of the surface is often the most important factor in the choice of support.

Wooden stretchers for canvas can be bought in almost any length and have ends which are mitred and slotted, which enable the artist to tighten the canvas if it stretches and sags. When slotting two sides together make sure that all the bevels are at the front, to prevent the wood from touching the canvas when in use, causing ridges. The four corners should be knocked tightly together, forming perfect right angles. This is best done by measuring the diagonals of the rectangle until they are the same. If the canvas is large, there should be an extra crosspiece between the longest two sides, to support them when the canvas shrinks during preparation. A shrinking canvas exerts a surprising force. Any size larger than about 30 × 40 inches (approximately 80 × 100 cm) should have this strut if the canvas is not primed.

When the stretcher has been fitted together and forms a perfect rectangle, lay it onto the canvas, which should extend 2 inches (5 cm), with the bevelled edges down. The canvas weave should be parallel to the stretcher sides. Fold the canvas round to the back and fasten it in the middle of one side with a large-headed tack or staple; then pull the canvas taut across and fasten it directly opposite on the other side. Do the same on the other two sides, then, pulling the canvas tight, move along toward each corner, fixing at opposite sides as you go. It is better to work evenly out to the corners, keeping each side in step with the others, rather than fastening the canvas completely on one side before doing the next, as this stretches the canvas unevenly. When all the sides are fixed, lift up the corners of the canvas and lay them on the line of the mitre, leaving two loose pockets at either side to be tucked in as neatly as possible. Take care not to put a tack through the ends of the stretchers, which makes it impossible to tighten the canvas later on. Tightening is achieved with small wooden wedges which should be supplied with the stretcher. They fit

Below left *Yuba County.*
This English painter's view of northern California shows his enjoyment of a relatively new range of landscape colors, but it is interesting that this has not prompted him to buy tubes of color that he does not normally use. Instead, he has made new mixtures from his customary palette, which is surprisingly limited, considering the great variety of soft greens, ochers and umbers with which he has composed this picture.

Below Types of canvas
1. Unbleached calico is inexpensive.
2. Cotton canvas is a cheaper alternative to linen.
3. Jute is coarse.
4, 5. Linen makes the best canvas and comes in different weaves.
6. Primed linen is suitable for most purposes.

into slots on the inside of each corner, and should be used as equally as possible at each corner or the canvas will cease to be rectangular. It is not always necessary to use them, especially on small works, but a canvas will stretch with the constant action of the brush. The wedges enable the artist to keep the canvas taut.

Grounds

Whatever material is used for the support, its surface must be prepared with a ground or primer. The preparation of canvas for oil painting should achieve two aims. The first is to protect it from the oil in the paint. Oil will oxidize in time and become acid, and when this happens the canvas cannot survive for long. The second is to provide a surface which the painter finds most suitable for working on. The absorbency of this surface can vary according to taste. It does not have to be white, but white will minimize any tendency of the colors to darken over long periods.

Preparation of the canvas is easier when it is already on the stretcher, but is important to allow for the shrinkage which will take place by not having the canvas too taut. Fingers are normally strong enough for tightening the canvas on the stretcher; canvas pliers are available but generally unnecessary. Preferably, however, the canvas is prepared before it is stretched, to avoid any distortion of the stretcher or the canvas as it shrinks.

The first stage of priming, or laying a ground on a canvas, is to apply a thin coat of glue size, preferably rabbit-skin glue. Size, bought in small thin sheets or crystals, should be dissolved in enough water to cover the canvas. It is difficult to give exact measures, but if it is in crystal form use about one tablespoon to 8 ounces (.31) of water. Heat the water in a pan and stir in the size until completely dissolved. The water must not be allowed to boil. One way of testing the strength is to put a drop of warm size on a finger and as it cools press the finger and thumb together. It should become sticky but not too sticky. The size must not be too strong or it will eventually crack when painted over.

Apply the warm size with a large flat decorator's brush, covering even the edges. Surfaces other than canvas may be more absorbent and require two thin coats. It should be left to dry overnight.

The next stage is the white priming. Recently, paint manufacturers have produced an efficient ready-to-use primer based on titanium oxide. This is a dense white which is very stable. It can be used on all surfaces which have been sized, and is suitable for both oil and acrylic painting. Some painters prefer to make their own grounds so they can control the absorbency. There are many recipes, but a simple general-purpose ground can be made

by mixing zinc white with yolk of egg and water. It dries very quickly and subsequent coats can be applied without too long a delay. This is clearly less convenient than the ready-made grounds, which are worth trying out before making one's own. Their only disadvantage seems to be that they become hard if kept in a shop too long. It is wise to open a tin before buying it to make sure it is still liquid, and buy no more than is needed. If necessary, it can be diluted a little with turpentine.

All grounds should be applied in at least two coats. Each coat should be thin, and thoroughly dry before the next is laid. Again a large flat brush is used and each coat applied as evenly as possible. The roughness or "tooth", of the surface can be controlled to some extent when the final layer of the ground is applied. For a rough surface the primer can be lightly stippled with the end of the brush as it begins to dry. A smooth surface can be obtained by rubbing the last coat gently with fine sandpaper. This should be done without rubbing through to the canvas.

Many will prefer to buy canvas or board which is already stretched and primed. This can be expensive and, although different qualities are generally available, ready primed canvas is not absorbent enough for some tastes. Little can be done to remedy this. If on the other hand a ground is too absorbent, whether bought or prepared by the artist himself, the surface can be covered with a thin coat of retouching varnish. Always make sure, throughout the preparation of a canvas, that each coat is completely dry before any subsequent coat is applied, and before the painting is started.

Stretching a canvas
1. You will need a ruler, knife, staple gun and staples and a pair of canvas pliers.

2. Fit the corners of the stretcher together. Tap each corner with a hammer to make sure that they fit securely.

3. Measure the diagonals to make sure that the stretcher is perfectly square.

Left *Early morning, San Francisco.* The magnificent sunrises and sunsets of Turner and Claude have inhibited many artists from approaching these subjects, but thoughtful observation puts nothing out of bounds. There has been no exaggeration here of the colors we normally associate with sunrise, and no over-dramatization. The artist has concentrated on the organization of this composition so that we can understand the spaces he has chosen to depict, rather than making any more of the sky and its limitless distance than we can actually see. The link of orange between the sky and the foreground directs us to observe the effects of light on the immediate environment at this time of day.

Equipment

Brushes Brushes come in so many shapes and sizes that it is difficult to make any positive recommendations except to say that they must be of the best quality. The shape and size to suit each artist can only be discovered by trial and error. Brushes are normally made either of hog's bristle or of sable. Hog's bristle brushes have a stiff bristle and can be bought in larger sizes than sable. They are more suitable if the paint is to be applied thickly, or if the paint is used straight from the tube without being thinned with turpentine. Sables are more appropriate if the paint surface is to be kept smooth, and when very fine detail is required. Both hog's bristle and sable brushes are made in three main shapes: flat, which has bristles of the same length and a square end; filbert, which is flat with the bristles arranged to form a rounded end; and round, with bristles set in a tubular ferrule tapering to a rounded end. Four different sizes of "rounds" made of hog's bristle between No. 1 (the smallest) and No. 8 would be quite sufficient to start with, perhaps adding a small sable for very fine detail. Brushes for oil painting have longer handles than watercolor brushes, which permit the painter to hold them in different ways and to work at a greater distance from his canvas. This is often desirable when a canvas is large.

Some brushes, particularly hog's bristle, wear down quickly, and grounds with much tooth tend to accelerate the wear; so it is worth buying brushes with long bristles. After use they should be cleaned every day before the paint has hardened, or the bristles will splay into a useless shape. The most thorough way to clean them is with soapy water in the palm of the hand, making sure that the paint is removed up to the ferrule. When clean they should be patted back into shape. While you are painting they can be cleaned, preferably with mineral spirit as turpentine is oily and can gum the bristles together.

The paintbox This is a useful item for the landscape painter, although not indi-

4. Allow about 1½ inches (3.5cm) overlap all around. Cut the canvas using a knife and ruler.

5. Place the stretcher on the canvas. Pull the canvas around at one end and staple on the outer edge of the stretcher.

6. Pull the canvas taut at the opposite end and staple. Repeat for the other two sides.

7. Staple at intervals of 3 inches (7.5 cm), up to 2 inches (5 cm) at the corners. Fold in the corners.

8. Secure the corners with two staples each.

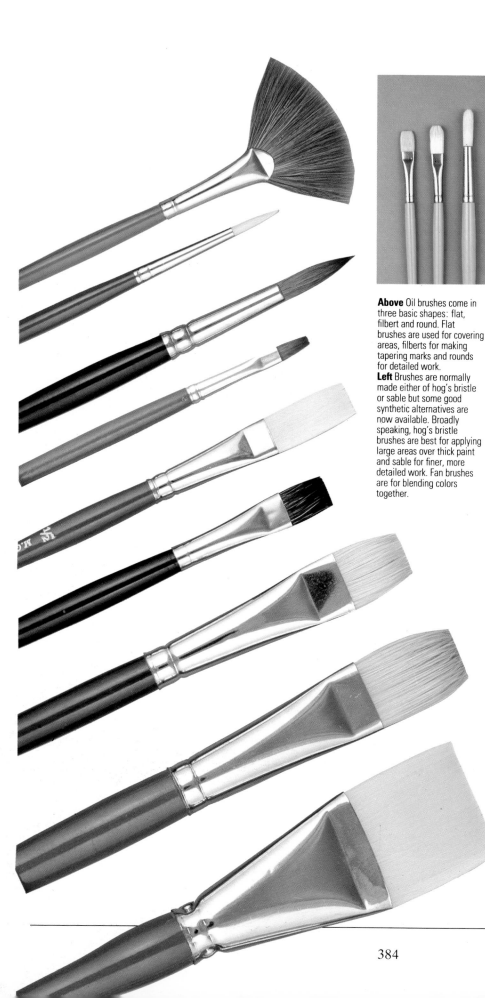

Above Oil brushes come in three basic shapes: flat, filbert and round. Flat brushes are used for covering areas, filberts for making tapering marks and rounds for detailed work.
Left Brushes are normally made either of hog's bristle or sable but some good synthetic alternatives are now available. Broadly speaking, hog's bristle brushes are best for applying large areas over thick paint and sable for finer, more detailed work. Fan brushes are for blending colors together.

spensable. It should be no larger than necessary, but it is best to have one which will hold as much of the equipment as possible. The most suitable boxes are divided into compartments which hold the contents in place. There should be a separate compartment, the length of the box, for brushes. Make sure that this is long enough to hold the longest brush; it is annoying to buy a brush and find it has to be carried separately. There should be room for bottles of oil, turpentine and possibly mineral spirit. A palette cup, a metal container for oil or turpentine, is also useful. The best cups have a screw top which keeps the medium in good condition when not actually being used. (Turpentine should not be exposed to light and air longer than necessary.) An extra cup should be carried for cleaning the brushes. Varnishes need not be carried as it is unlikely that a painting will be dry enough before it is brought home for varnish to be applied.

A paintbox large enough to hold all this equipment will also be able to hold a palette of a reasonable size. Many boxes are made to hold a rectangular palette in the lid. The palette can be plastic, or wooden, which would be easy to make. Plywood is adequate, but the surface must be treated to reduce its absorbency by rubbing it with beeswax dissolved in turpentine until it has a good, smooth finish. A palette knife is useful for scraping unwanted paint from the palette, and for mixing colors in large quantities. Any spare space in the box should be filled with cotton rags which are essential for cleaning brushes and the palette while working, and also for wiping paint off the canvas.

The easel The only other piece of essential equipment is the easel. There are many on the market which are light and fold into a small space. Some are flimsy, and some can hold only small canvases. Strength and stability are important, although a strong wind can capsize even the sturdiest. In this situation, the strength of an easel would enable the painter to suspend stones or pieces of wood from a central point, so anchoring it in position.

Few portable easels are made with sufficiently long legs to permit the artist to work standing up. This is unfortunate for those who like to stand back from their work at frequent intervals. A collapsible stool will also be needed.

An alternative to carrying a separate paintbox and easel is a contrivance which combines both. This has the advantage of being easier to carry, and means that the easel itself will be sturdier.

Techniques
When painting directly from nature, it is worth remembering not to attempt too much detail, and to concentrate on the accurate

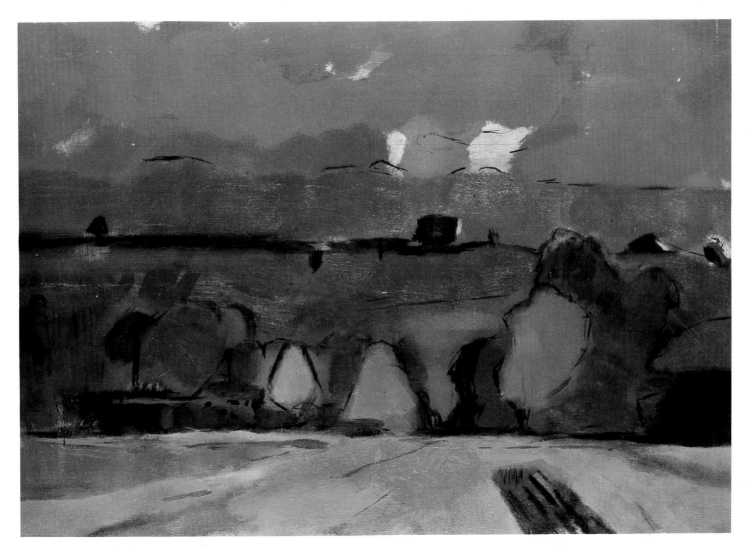

Above *Evening, Clodmore Hill.* This painting evokes the emotive value of large areas of bright color earlier explored by Gauguin. It is also in line with a more specifically English tradition which stems from the early pastoral landscapes of Samuel Palmer, which were very romantic and mystical.

Left *Greek Landscape.* A symmetrical placing in the foreground of the house and two olive trees creates a firm composition which is given more point by the touches of light catching the jagged cliffs behind. There is also a fine balance between the use of local colors and the way they are modified by the evening light.

observation of color relationships. It is easy to make bright colors too bright, and not consider how they are modified by the prevailing light. This is generally the result of looking at a color in isolation. It is helpful, when beginning a painting, to put as many of the observed colors on the canvas as quickly as possible, so that the value of each can be assessed in relation to the others.

The early marks on the canvas should be kept as thin as possible. As layers are painted one on another, they can be increasingly oily, but an oily first layer will cause the paint to crack. The brushmarks may look ugly if later painted over with a thinner color, and sometimes even contradict the purpose of the second color.

An alternative to modifying a color by repainting is to apply a second color with broken brushstrokes, so that the first color shows through. This is called "scumbling" and is also used by pastellists, who cannot mix their pigments to the same extent as painters. Another technique for modifying an existing color is "glazing." This is the application of a layer of paint which has been considerably thinned with oil over a more opaque one. It is

Right Acrylic paints, like oils, are available in sets from a number of manufacturers. Basic equipment should include a selection of colors similar to the range for oils, a palette, mixing dishes and several brushes. The best brushes for acrylic paints are the synthetic ones specially developed for this use. Sable or hog's bristle brushes can also be used. Because acrylic paint is extremely quick-drying, all painting equipment must be cleaned immediately after use. This is particularly important for brushes.

more properly a studio technique as it involves waiting for layers to dry, but it can produce rich effects.

If the paint is worked a lot, and many alterations are made, some areas of the painting will go dead and colors will lose their natural value and brilliance. Retouching varnish can be used to restore a color's brilliance by reducing its absorbency. It is a quick-drying varnish, which must only be used when the "dead" paint is dry. It should be applied as thinly as possible; just enough to fill the pores in the paint. Some artists prefer to mix a little ordinary varnish with their oil or turpentine at the outset, to make such retouching unnecessary and to accelerate the drying of the paint. There are three main varieties available, copal, mastic and damar, but it is better to keep the painting fresh without taking such measures.

Even when the painting is finished, it is not essential to varnish it, but there may be some slightly duller parts which were not retouched while the work was in progress. In this case a thin film of retouching varnish can be applied all over the painting, or one of the above can be applied if an increased brilliance or a heavier protection is thought necessary. Mastic or damar are considered safer than copal, which is virtually impossible to remove should this ever be necessary.

Liquid varnishes should be applied with the painting laid flat, with a soft brush, in a dry, dust-free atmosphere, as swiftly and evenly as possible, without going over the same place twice. If a high gloss is not desirable, there are some efficient wax varnishes available, which bring out the colors, provide ample protection, and can either be left with a mat surface or polished to give a little shine.

Acrylic

Acrylic paints have been shown to be a sound and flexible new development. They use water as a medium rather than oil. They dry extremely quickly, so there are none of the worries about overpainting which concern the oil painter, and they provide a suitable medium for working at great speed. They can be thinned with plenty of water and blown onto the canvas with a spray. The surface on which they are applied can be cut up and molded with no risk of the paint cracking, unless it is very thick, which makes them suitable for collage. It is also possible to use them as a thin, quick-drying undercoat for oil painting, although they cannot be put on top.

Despite their flexibility, acrylics do have some disadvantages. Brushes must be washed thoroughly in lots of water at frequent intervals, and there is a danger of paint drying on the palette before it is even used. For this reason the less absorbent the palette the better. A plastic one, or even a piece of glass,

is preferable to a wooden palette. The paints can also darken noticeably as they dry, especially if thinned with water. The technology of acrylic paint has only been developed in the last two decades, and there are enormous differences between different makes, the less good ones drying more quickly than the better. It is a good idea to keep tubes of acrylic paint in a tightly sealed plastic box in order to minimize this drying. There are an increasing number of additives which give greater control, such as drying retarders and "tension breakers" which alter their viscosity.

Acrylic paints have less body than oil paints, and are well suited to smooth flat areas. Their opacity is very similar from one color to another, unlike the variations found in oil pigments. Some would consider this an advantage and others the loss of an appealing dimension. One undeniable advantage of acrylics is that they can be applied to any surface without priming.

Above *A Haystack* (1978-79) William Delafield Cook. This Australian painter uses photography for his work in a deliberate and sophisticated way. He takes photographs of his chosen motif, making sure to achieve a high technical quality. These photographs are a series of prints of every small section of the scene, so that he has the maximum amount of detailed information. All the prints are then joined together to cover the whole area included in the compositions. The painting is then built up in many stages, using very fine brushwork. The rapid drying time of acrylics enables the artist to develop an area with an infinite number of tiny strokes.

Right Acrylic paint is available in tubes or in pots. Various media can be added to acrylic paint to increase the range of effects and techniques. These include gloss, texture paste and poylmer medium to add body. It is best to use these with care.

THE TRACK: AUTUMN
oil on canvas 30×30 inches (76×76 cm)

This study of a landscape in late autumn and the snow scene on the following pages were both painted from approximately the same position. A comparison of the two shows how an artist might approach the same subject in a variety of ways according to exactly what his eye is presented with on each occasion. The colors in a landscape and the way in which the light affects them may change radically, and this happens not only from one season to another but also at different times of the same day. An accent of color visible at one time may attract the eye as a natural focal point and consequently prompt a composition which will exploit this feature. At other times this accent may seem unimportant.

The autumn landscape was painted in overcast weather, with a heavy dull sky and no direct sunlight. These conditions tend to make colors flat. The artist chose to concentrate on a small section of the scene so that the composition arose more from the angles and directions found in the forms of the landscape than from, for example, a pattern of shadows. One result of this decision was that distant features, such as the cottage among the trees, were in danger of seeming closer than they were in reality, so the track in the foreground assumed a particular importance as a means of establishing the space between the spectator and the middle distance. The track also creates large triangles in the foreground which offset the verticals of the trees and the horizontals of the middle distance.

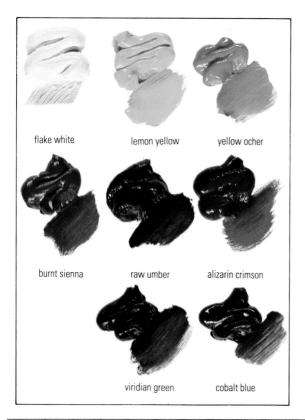

flake white lemon yellow yellow ocher

burnt sienna raw umber alizarin crimson

viridian green cobalt blue

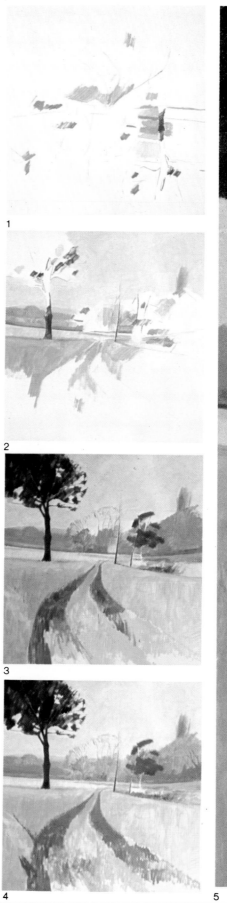

1

2

3

4

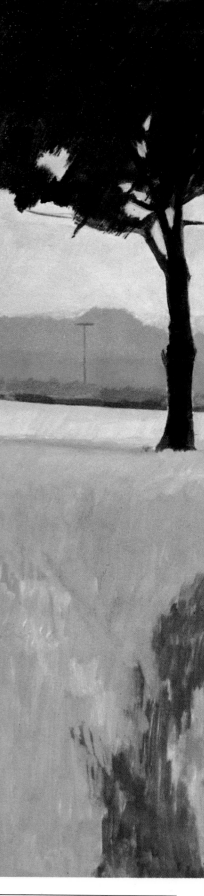

5

388

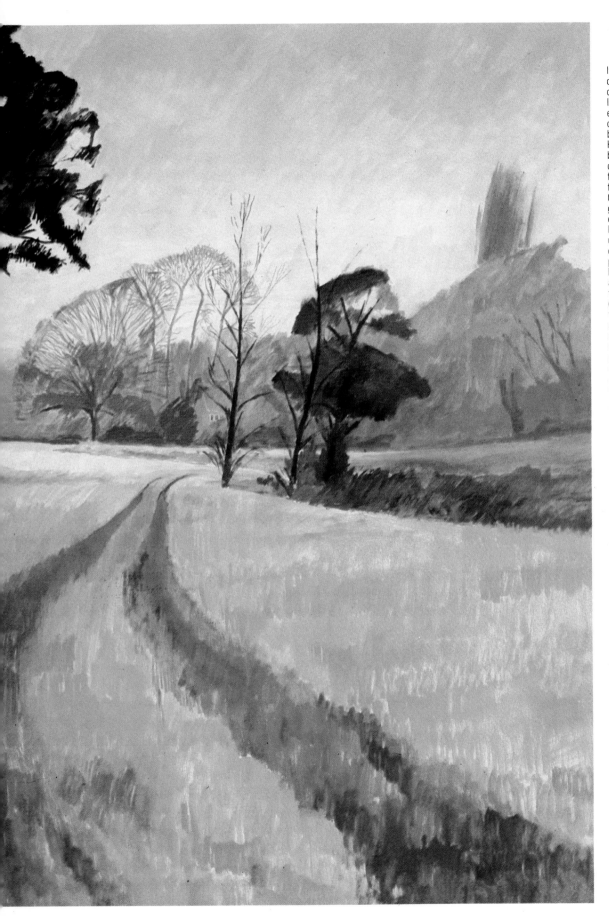

It is not always necessary to draw up a composition in detail before painting. In landscape particularly, the effect often depends upon colors and masses which are best approached directly. However, a few lines brushed in lightly with a gray or neutral tone are valuable for establishing the main features of the landscape *(1)*. Continuing with brown and gray tones small areas of easily identifiable color are loosely brushed in. It is useful to block in broad areas of color as quickly as possible *(2)* which lay the basis for a more detailed analysis of the shapes and tones. Here the warm (brown) and cool (blue-gray) tones are blocked in. These are developed with the addition of local color *(3)*, such as the green of the grassy track and the heavy shape of the dark brown tree. At the same time the linear design of the composition is emphasized in more detail, with fine brushmarks describing the distant trees. As color and texture are built up the sense of distance is preserved by using the richest colors in the foreground and reworking the misty blue and mauve tones of the horizon line *(4)*. In the finished work *(5)* the focal points are brought out with tonal contrasts and detailed drawing with the brush.

THE TRACK: WINTER
oil on canvas 20×28 inches (51×71 cm)

In this snow scene, an extremely different perspective was adopted. The forms of the landscape were defined almost solely by the blue shadows. In the autumn picture, the track was made into an important element in the composition because it led the eye into the landscape at the same time as providing a strong color change between the stubble of the field and the green grass where tractors had driven. But after a heavy fall of snow the only indications of the track's position were the small shadows cast by the furrows left by the last wheels that went along it. The local color of the grass has been replaced by a surface reflecting chance conditions of light.

One of the artist's aims in this painting was to convey the extreme brightness of the snow, so the colors were kept in a high key. In conditions of bright sunlight on snow, local colors are almost entirely absent, so the balance between light and dark, and sunlight and shade, is of critical importance. If the shadows are made too dark there is a danger of distorting the surface of the field. If too light, the brightness of the illuminated areas will lose its force.

A landscape covered with snow offers an artist a unique opportunity to observe its forms in a truly sculptural way, without the attractions and distractions that the normal colors may provide. At the same time, this absence of a variety of color means that the smallest clues which suggest the shape of the landscape must be exploited to the full. A tree's shadow may be the only way of defining the ground underneath it.

1

This painting *(1)* shows a more distant view of the scene in the previous image, the exact relationship being apparent from the marked picture *(4)*. The other major difference is that it is seen in a different season and many changes will occur in a wooded landscape as the trees lose their leaves and the landscape is reduced to a skeletal structure covered in snow. The quality of light is extremely important: the shadows are harsh and cool in tone against the brilliant white of the areas which reflect light fully. The basis of these aspects of the composition is established immediately in the drawing, made with a round hog's bristle brush and blue-gray paint well diluted with turpentine.

4

2

3

titanium white yellow ocher burnt sienna

cobalt blue raw umber

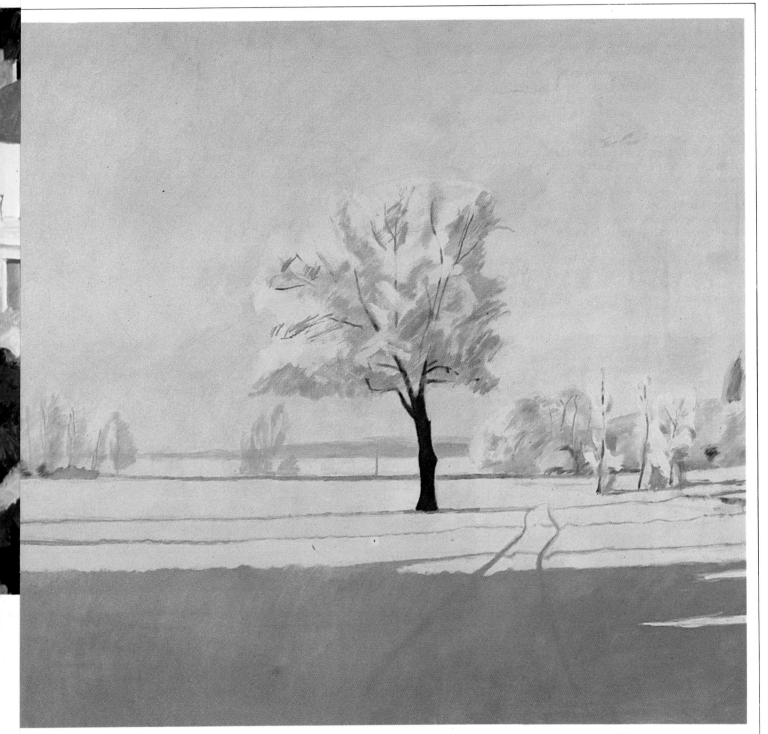

A broad wash of blue across the foreground represents the heavy shadows *(2)*. By contrast, the elements of warmer tone are added using raw umber for the dark tree trunk and touches of burnt sienna thinly washed in or mixed with white in the line of trees across the background. Horizontal lines clearly establish the receding plane from foreground to background *(3)*. The stark nature of the view is emphasized in this way, unlike the previous composition where the foliage, although sparse, gives density to the landscapes. In the final stage the trees are given more definite form with heavy brushmarks in warm and cool grays and pure white. On the horizontal plane the blue shadow is strengthened but remains as an unmodified contrast to the white. Against this fairly plain ground detail is provided by the trees, put in with loose, vigorous brushstrokes. The composition *(4)* is carefully balanced by the combination of colors, tones and surface texture.

In the early stages of an oil painting the color can be blocked in quickly, filling the basic areas of tone *(1)* before the paint texture and color relationships are refined. At first the paint should be applied thinly, diluted with turpentine, and the canvas weave can be seen through the paint which forms a stain of color on the surface *(2)* rather than a thick skin. In this way the whole canvas is gradually covered and forms can be developed in more detail. It is a matter of preference which type of brush is used, but on a medium or large canvas bristle brushes are most convenient for blocking in as they are resilient and can be handled freely *(3)*. Although it is important to recreate the subject faithfully a painting can become dull if the materials are not also considered with equal attention. The thickness and texture of the paint and qualities of the brushmarks add vitality *(4)*.

To emphasize an atmosphere of heat and light the warm tones are put in with yellow ocher, white, Naples yellow and burnt sienna *(5)*. Alizarin crimson added to the blue-grays gives them a warm cast in shadow areas. The trees and hedge are built up more solidly with tones of green and more detail is drawn in the house *(6)*. In the finished painting *(7)* the colors and tones have been more fully balanced, setting up the contrasts of light and dark, warm and cool which give a vibrant effect to the colors. As thicker paint is added the brushmarks are carefully judged and made to describe the general form and direction of each element, whether organic or manmade. The blue-gray tones offset light, warm yellows and the rich greens of trees and hedge, while the cluster of plants on the balcony adds a splash of color in the predominant white of the brightly lit building. The blue, yellow and pink clothes of the figures also provide tiny color keys in the painting which lead the eye across the composition toward the focal point of the central villa.

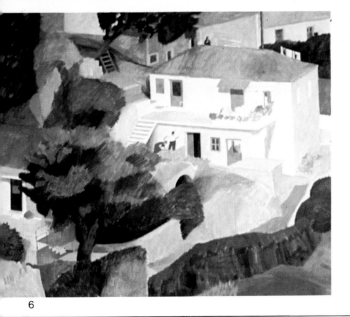

6

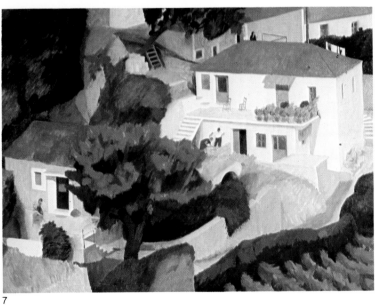

7

THE CLIFF AT BEACHY HEAD

acylic on canvasboard 20×24 inches (51×61 cm)

One of the most frequent problems of painting dramatic, natural formations is how best to give the spectator a feeling of their awe-inspiring scale. Early painters of the English landscape, such as Philip James de Loutherbourg (1740-1812) and Joseph Wright (1734-97), who both painted the rocky landscape of Derbyshire, almost invariably included in their works some small manmade feature, figures or animals, in order to impart this sense of scale. Here the foreshortened view of the lighthouse serves this purpose. It also contributes, with its shadow on the water, to establish the flatness of the sea. This flat surface in turn offsets the rugged, precipitous cliff face, almost inducing a feeling of vertigo. The texture of the chalk cliff is enhanced by the gently modulated surface of the water as it recedes toward the horizon.

The feeling for the exact quality of surfaces is an important element in this painting. It is achieved to some extent by the brushwork appropriate to each area but also by the careful observation of cast shadows. The hard, dark shadow in the foreground intensifies the dense, chalky white where the sun strikes the cliff face. The small shadow of the lighthouse provides the artist with an opportunity to imply the translucency of the surrounding water. The result is a painting of contrasts; horizontal with vertical, cool with warm. These effects depend heavily on the particular position of the sun. The artist has built the composition around the configuration of shapes at a particular time.

1

2

light green Hooker's green

yellow ocher cadmium yellow

ultramarine Payne's grey

phthalo blue raw umber

black cadmium red

3

Acrylics are opaque and quick-drying so colors must be blended quickly or overlaid in thin washes of paint well diluted with water. The sky and sea are first blocked in with graded tones of blue-gray (2). Hooker's green is the basic color of the grassy clifftop. Details of the

rock formation are brushed in (3) emphasizing the tone contrast of heavy shadows and the reflective white surface. The texture is then roughened by spattering thin paint (4) and this is set against a smooth reworking of sky and sea. Details are refined in the last stage (6)

and the lighthouse painted with a small sable brush. The sky and sea are painted with a mixture of Payne's gray, ultramarine and white with a little yellow oxide added to give a greenish tinge to the sea. Mix acrylic colors in roughly the quantity needed at each stage (1) as

unused paint will quickly dry on the palette. The initial blocking in may be done with a broad hog's bristle brush to spread the color quickly, but a No. 6 sable gives more precision in following outlines on the cliff and lighthouse (5).

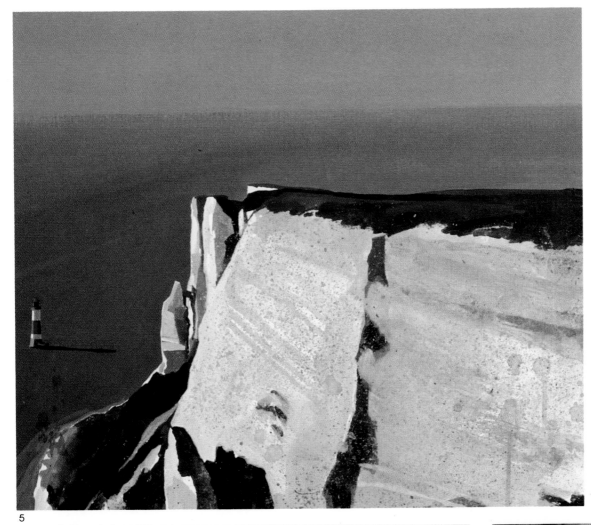

5

Below Spattering is a simple technique which adds to the variety of texture in the painting. A torn piece of newspaper is placed on the painting to mask off the areas of sea and sky. This also provides a rough edge to the spattering, defining the shapes on the cliff face. A broad bristle brush is loaded with well-diluted paint and held over the painting. Flicking the bristles with finger and thumb causes drips and blots of color to fall onto the paint surface. The technique cannot be precisely controlled but the texture can be modified by overpainting.

6

BRIDGE AT RICHMOND
acrylic on canvas 20×26 inches (51×66 cm)

The forms and shapes of particular bridges observed by painters over the centuries constitute a recurrent theme in the history of landscape painting. Corot, Monet, van Gogh, Whistler, Cézanne and Matisse are just a few of the artists who have made the arches of a bridge an important part, if not actually the main theme, of some of their pictures. In some cases it is the view framed by the bridge, a picture within a picture, which gives the subject its fascination. Or, as with Cézanne, it is the simple geometric value of a Roman arch.

In the painting here, the artist was absorbed by the intricate decorative detail of an iron bridge over the Thames, but at the same time used each arch to form a series of small glimpses within the larger framework of the composition. The whole bridge is given its position in space by the extended foreground, and by the fact that we can see the tops of the distant trees appearing above the bridge. The details of the architecture itself and the intricacies of the lock gates seen through the righthand arch contrast with the simplified treatment of the river bank and the groups of trees in the distance. A further contrast to the architectural shapes is provided by the freer handling of the nearest river bank on the right. The bridge itself, being the main subject for the artist, is placed so that one of its arches sits centrally in the canvas, but as this is not the central arch an over-symmetrical arrangement is avoided.

Acrylic paint is well suited to work which demands areas of flat color, and also where clean, hard-edged shapes are needed. Both the sky and the patterns made by the architecture of the bridge take advantage of this quality.

Above The painting is executed on cotton duck primed with white acrylic emulsion. This has a slight tooth which grips the paint but does not interfere with the texture. The first wash of color is a light blue-gray applied with a bristle brush. The paint is applied thinly and built up in successive layers to modify color and tone.

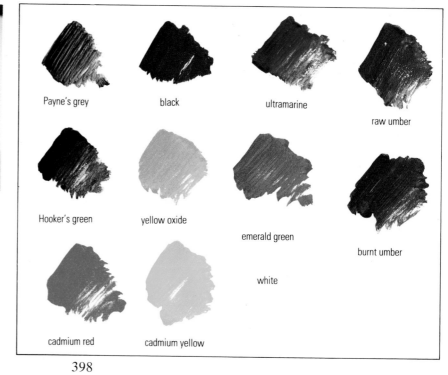

Payne's grey

black

ultramarine

raw umber

Hooker's green

yellow oxide

emerald green

burnt umber

white

cadmium red

cadmium yellow

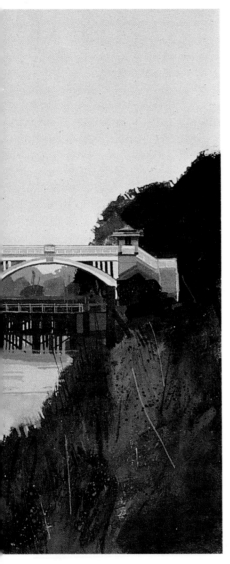

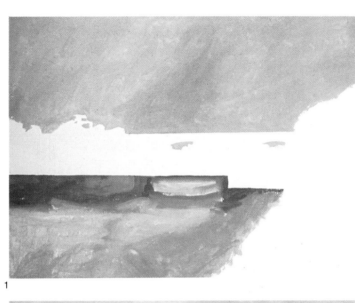

1

The basic structure of this composition is quite simple but the bridge itself contains much intricate detail. The shapes are first lightly sketched on the canvas in pencil and the broad areas of sky and water brushed in with gray-blue *(1)*. Trees behind the bridge are put in with a darker gray and the bank and foliage loosely described with raw umber *(2)*. Initially the shapes are not precise so form and color are gradually developed and modified as the work progresses *(3)*. Flat hog's bristle brushes are used to cover the canvas with color while a medium round sable brush has a fine point suitable for drawing details of the bridge.

2

Below Acrylics can be overpainted quite rapidly to develop the relationships of color and tone, but it may be as well to put in the shapes quite precisely from the start. The arch of the bridge is followed with a fine sable brush **(below)** while broad areas of flat color are applied with a broad bristle brush **(bottom)** in long strokes.

3

4

5

6

7

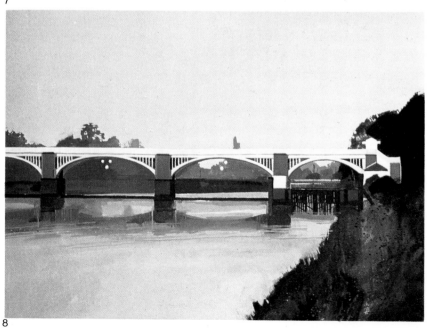

8

When the basic shapes are established the tones can be adjusted to add definition to various elements in the image. The river is reworked with a lighter color (4) to emphasize the dark reflection of the bridge. The riverbank is overlaid with Hooker's green and a broad yellow strip is painted across the top of the bridge (5). To paint the horizontal lines accurately the brush is guided along a plastic ruler, held at a slight angle from the surface of the canvas (6).

The structure of the bridge is more carefully defined (7). Light and dark tones of gray, mixed with raw umber and yellow oxide, are used to establish the basic three-dimensional forms. At the same time the bank and reflections in the river are developed. Following this, colors are put in which imitate the paintwork of the bridge (8).

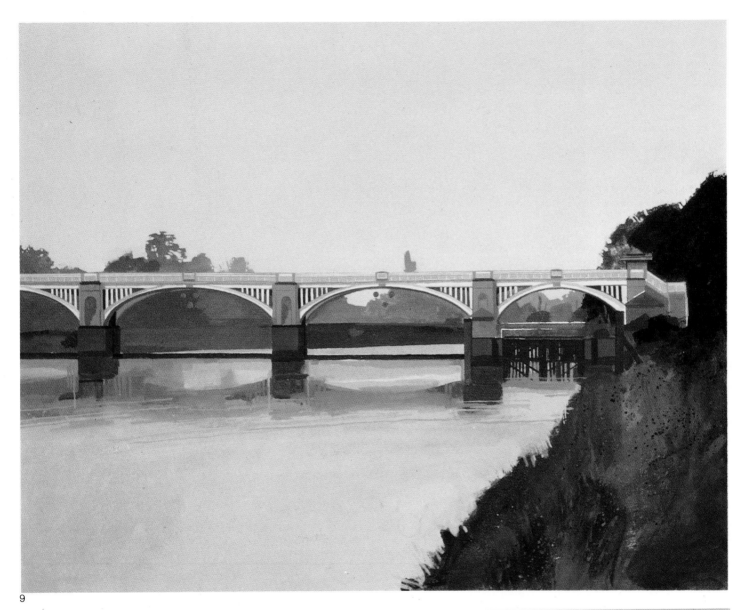

9

10

11

Detailed work on the bridge is added with a fine sable brush, each shape described with great precision and paying careful attention to color and tone *(9)*. Emerald green, Hooker's green, white and yellow oxide are mixed to form the appropriate colors, shaded with raw umber. Finally the grassy bank is described by drawing lightly with the brush *(10)*. A watercolor sketch for the painting *(11)* shows the different effect of the more delicate medium compared to acrylic.

A primed masonite support is used here, which does not grip the paint evenly at first, so a variety of textural effects can be made. The foreground and sky are loosely put in with a broad bristle brush *(1,7)*. The green in the foreground is brushed with water and blotted with a rag *(6)* to show up the brushmarks. This is contrasted with a flatter area at the horizon *(5)* put in with a flat synthetic bristle brush. When the landscape is blocked in the basic tones of the walls and house are established *(2)*. Black, raw umber, white, yellow ocher and Payne's gray are the colors used. The fields behind the house are given variety of tone. The sky is gradually reworked with blended color and the foreground given more depth with a wash of dark green and light spatterings of color *(3)*. At the same time detrails of the house and its surroundings are gradually developed *(4,8)*.

4

1

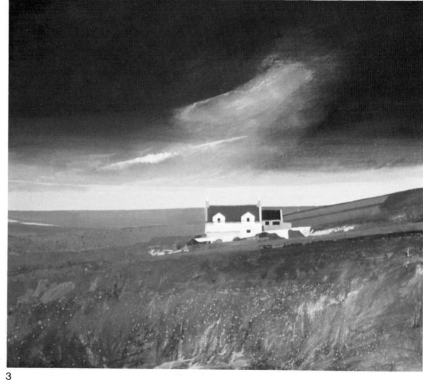

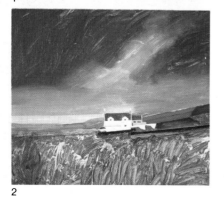

2

3

HEAVY WEATHER
acrylic on masonite 24×27 inches (61×69 cm)

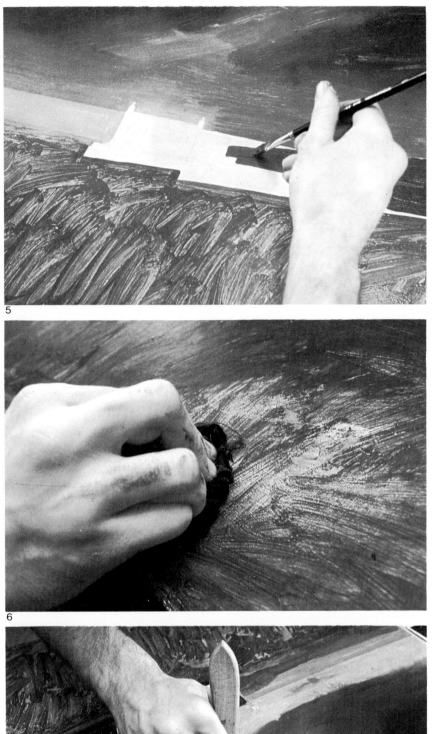

5

6

This picture is, as the title suggests, primarily concerned with the menace of the elements; however, such sensations can seldom be achieved by simply making the sky dark. Here the white sheets drying on the clothes line contribute as much to the final effect as the color of the threatening clouds above. Firstly they are the lightest shapes in the painting, and the contrast of their whiteness with the predominately dark, surrounding areas gives the color of the sky more force. Secondly, their foreshortened shapes, as they billow out in the wind in the direction of the spectator, express the force of the wind. These jagged shapes are also related to the regular geometric architectural shapes of the house behind. The house provides an element of stability in the composition, both with its clean vertical and horizontal lines and its placing in relation to the horizon. The line of its roof is an important part of the broad sweep of the horizon itself, despite not being exactly in line. This stability serves to set off the diagonals and irregular shapes elsewhere in the painting: the sheets on the line, the lighted accents in the sky and a similar accent repeated in the grass in the right foreground.

The painting of a foreground in a landscape can often present particular problems. Sometimes the individual shapes of blades of grass or leaves on a tree can be easily discernible, but at a slightly greater distance the artist is forced to make a decision between the elaborate portrayal of minute detail and a way of making a more generalized statement. The best solution is often to start with fairly large masses of color and then see if more detailed treatment is appropriate as the painting progresses. Here the artist has overlaid a broad area of green with a very free splattering of paint in keeping with the overall feel of the subject. This splattering also serves to introduce a feeling of movement.

7

8

DRAWING AND
PAINTING
STILL LIFE

HAZEL HARRISON

THE STILL LIFE TRADITION

The term still life comes from the Dutch *still-leven,* which came to be used in the seventeenth century, and simply describes any painting of inanimate objects such as fruit, flowers or kitchen utensils. The French term *nature morte* means exactly the same, but was coined in the 18th century, probably in a spirit of disparagement since the French art establishment regarded it as an inferior branch of painting. Still life thus encompasses flower painting, but there is another branch of flower painting that has little to do with still life and springs from a different tradition, namely botanical illustration. A careful drawing or painting of a flower or plant whose purpose is to record each minute detail of its structure and shape is not a still life; it is an object seen in isolation, independent of environment. A drawing or painting of a single bloom placed in a vase and seen in the context of an interior is, however detailed and precise, a still life.

Botanical illustration, however, does have some bearing on the development of still life, and flower painting in particular, since many of the early flower painters were primarily artists who saw their task as the precise and accurate description of botanical specimens. Without this tradition the course of flower painting in Flanders and the Netherlands might have been very different; so it is relevant to examine it briefly here.

BOTANICAL ILLUSTRATION

As early as the Middle Ages in Europe scientists began to analyze and catalogue various types of flora and fauna, with particular emphasis on the various herbs and plants and their medicinal properties. A host of illustrated books began to appear, most of them based on a Greek prototype, the five-volume herbal of the first century AD by Dioscorides. Most of these early herbals, which contained home-grown remedies for diseases and ailments, were crudely and inaccurately illustrated. Two notable exceptions, however, were a book of medicinal plants called *Liber de Simplicibus* compiled in southern Italy and a herbal of 1397 by Francesco Carrara illustrated by an anonymous artist who appears to have worked directly from nature, so realistic and convincing are the specimens portrayed. This work was followed by many others from Italy and Germany, in the latter case illustrated with woodcuts, often hand-colored, and in 1597 the famous *Herball or Generall Historie of Plantes* by John Gerard appeared in England. By this time, however, botany was becoming a recognized subject, independent of medical study. The days of the herbal were over, and illustrators were to come into their own as artists.

By the sixteenth century botany had been established as a serious branch of science;

botanical gardens had been opened, notably at Pisa and Padua, and well-to-do scholars and dilettantes were amassing collections of plants and minerals in the increasing search for knowledge of the natural world. The demand for good illustrators to describe these accurately and sensitively was constantly growing, and artists such as Jan "Velvet" Bruegel the Elder (1568-1625), who specialized in flowers and was to become influential in the Flemish school of flower painting, produced marvellous works which are faithful botanical descriptions as well as paintings in their own right. These pieces were produced for patrons with considerable knowledge of botany, and the artist went to great lengths to procure the particular specimens requested.

In the eighteenth and early nineteenth centuries there were several great names in botanical illustration, among them a woman, Maria Sybilla Merian, whose natural-history books show her to have been a superb flower painter. The greatest purely scientific flower painter was undoubtedly Georg Dionysius Ehret, who illustrated a book called *Hortus Cliffortianus,* compiled by the botanist Linnaeus and based on the garden of his patron, George Clifford.

But the most famous of all today, well known to us through prints of his work, was the Frenchman Pierre-Joseph Redouté (1759-1840), who usurped Ehret's popularity a generation later, and became official artist first to Marie Antoinette and then to the Empress Josephine, who employed him to illustrate the plants in the gardens of Malmaison. Redouté painted flower pieces and the occasional still life of fruit as well as illustrations, and thus bridges the gap between the two traditions. He also invented his own process of stipple engraving, which allowed his work to be widely disseminated without any loss of quality.

STILL LIFE: EARLY BEGINNINGS

Still life subjects had little place in ancient art, which was mainly concerned with religion in its various aspects. However, there were occasional examples in Hellenistic Greece, where an artist called Zeuxis apparently did well financially from painting "foodstuffs." These have not survived, and we only have written documentation for them, but it seems likely that the examples of Roman still life which do still exist, mainly in the form of mosaics, and the wall paintings at Pompeii of the first century AD, were based on Greek originals. Still life appears to have become quite common at this time; Vitruvius mentions pictures of food, which were called *xenis,* almost certainly inspired by the custom of sending edible gifts to prestigious visitors.

The all-pervading Christian ethos of the medieval world left no room for still life, or indeed for naturalistic art of any kind, but during the Gothic period painters and sculptors became more interested in the observation and portrayal of the natural world. Many wonderfully carved capitals and other architectural details showing foliage, flowers, and well-observed human faces testify to this, and during the thirteenth and fourteenth centuries elements from nature

Right Gentian from *Choix des plus Belles Fleures* (1827-33), Pierre-Joseph Redouté. Redouté's wonderfully accurate and well-observed flower studies brought him considerable wealth and success, and he invented his own stipple engraving process. This allowed his works to be widely disseminated, and they have remained popular to the present day.

Left "The Superb Lily," a page from *Temple of Flowers* (1799-1807), R.J. Thornton. This mezzotint, showing a single splendid bloom against a mountain landscape, was deservedly one of the most popular illustrations in the book.

and the "real world" begin to appear in paintings also. Giotto (1266/7-1337), often regarded as the father of modern painting, tried to give his figures a solidity and realism previously unknown and unconsidered. He was praised by Boccaccio for his skill in rendering any detail or object in such a way as to deceive the eye, and in the Arena Chapel at Padua, where he painted his greatest fresco masterpieces, there are some *trompe l'oeil* niches which have been claimed as the first true examples of still life.

This new spirit of realism was particularly strong in Flemish art, and many fifteenth century Flemish religious paintings include "mini still lifes," such as a table of shelf piled with bibles and scrolls, or a cupboard displaying musical and scientific intruments, all observed with the same degree of loving care and attention to detail given to the figures themselves. These, although always related to the theme of the subject and clearly used to tell a story, rather in the way that Van Gogh's still lifes were to do, show the growing desire of artists to paint what they saw, celebrating in paint not only the glory of God and the piety of the saints, but the intrinsic fascination of the world around them.

Initially, the more intellectual painters of the Italian Renaissance had little regard for this kind of episodic realism, and the occasional venture in this direction was seen as simply an exercise in paint handling, on a level with the masterly perspective drawings produced by such artists as Paolo Uccello (1396/7-1475). However, the Flemish devotion to realism had a considerable impact on later Renaissance painters such as Vittore Carpaccio (c1450/5-1523/6), whose paintings are full of touching and delightful details.

THE SIXTEENTH CENTURY

The first known, true still life from Italy, a *Still Life with Partridge and Iron Gauntlets*, a painting of still life objects on their own rather than as a painting within a painting, was produced in 1504 by Jacopo de' Barbari. From this time on naturalistic elements became more important in Italian painting, though usually still subjugated to a religious or historical theme. By now the style known as Mannerism had replaced the strict classicism of the Renaissance, and one of its characteristics was the introduction of realistic detail into grand conceptions that were in the main intellectual rather than based on direct observation.

Two distinct threads can be traced in the development of still life painting at this time, the first being the new awareness of the natural world and the second being a form of symbolism, particularly where flowers were the subject. There is a painting by the Flemish artist Hans Memling (c1440-94) which sheds interesting light on this, although it belongs to an earlier period. This portrait painting has a vase of flowers painted on the reverse of the canvas – perhaps the first true still life to exist from Flemist art. Decorating the backs of portraits, usually with heraldic or symbolic subjects, was quite a common practice at the time and it is probable that the flowers may have had a symbolic relationship to the sitter's family history or character. Flowers in paintings were often used as symbols; the lilies in Annunciation scenes, for example, represent the purity of the Virgin.

Throughout the sixteenth century and into the seventeenth still life in general, or at least one type of still life, assumed an allegorical significance. Flowers set beside a skull were used to signify the inevitable triumph of death. More subtly, a candle burning down or a single petal falling from a flower symbolized the transience of both beauty and life itself. This type of painting was known as a *vanitas,* and became an art form in its own right with its own centers of production. Many such paintings, usually showing a skull resting on a book flanked by a candle and an hourglass, were produced for the religious orders and for the homes of the pious. These paintings, although limited in subject matter, gave a religious justification to still life, which very probably contributed to its emergence as an independent genre.

THE SPECIALIST PAINTERS

Perhaps the most important factor in the emergence of this art form which was to flower so dramatically in the seventeenth century was the shift in artistic patronage after the Reformation. Ecclesiastical patronage had now all but ceased, and artists found their patrons in a new breed of men – dealers, collectors, and wealthy merchants. In the Netherlands particularly, painting became a business of specialization, with some artists becoming known for their landscapes, others for their portraits, and yet others for still lifes or flower pieces. All these artists would pass on their skills to apprentices and pupils, so that, just as in the production of pottery or silverware, certain places became associated with certain types of painting.

Among these artists were several who gained renown for their skill in rendering inanimate objects. One such was the Dutch painter Pieter Aertsen (c1508-75), who painted ostensibly religious subjects, but with the figures in the background, the foregrounds being dominated with still life subjects such as baskets of vegetables, plates of fruit, copper cooking utensils and so on. Paintings such as *Christ in the House of Martha and Mary* provide a fascinating insight into the changing tastes of the times – the religious theme is still present, but the real point of the painting is the still life. Aertsen also painted *genre* (secular) scenes of somewhat idealized peasants in kitchens surrounded by vast cornucopias of food. Since he trained many apprentices his influence was considerable, and his work was admired not only in Holland but also in Italy and Spain, where it was probably known to both Caravaggio and Velasquez.

Another Italian artist who must have seen the work of Aertsen or one of his followers was Vincenzo Campi (1536-91), who lived and worked in Cremona. The influence is apparent in his canvases of poultry, fish and fruit sellers, which are really still lifes with a figure in the background to provide a rationale for the lavish displays of produce. These paintings, like Aertsen's, were very popular, and were much imitated, notably by a Bolognese painter called Bartolomeo Passarotti (1529-92), and his influence can also be seen in the work of Annibale Carracci (1560-1609), particularly *The Butcher's Shop* in Christ Church, Oxford. These *genre* scenes continued to be produced in Holland, Italy and in Spain (where they are called *bodegones*) and some of Velasquez' early work is in the same tradition.

CARAVAGGIO

The new realism was given considerable impetus by the work and ideas of Michelango Merisi da Caravaggio (c1571-1610) in Rome. His influence was to be a far-reaching one, and the Italian still life tradition was firmly rooted in his revolutionary approach to painting. He himself thought highly of still life painting, and said in a letter to one Teodoro Amideni that "it required as much craftsman-

Left *Still life with Gun,* Pieter van Steenwyck. In this seventeenth-century Dutch *vanitas* the artist has used the traditional elements, the skull and flowers, strengthening the message of death's inevitable triumph with the gun on the table.

Above *The Supper at Emmaus*, Caravaggio. Paintings such as this, in which a lovingly depicted still life group forms a central part of the composition, became common in Italy, Spain and the Netherlands throughout the sixteenth and seventeenth centuries. Caravaggio may have begun his career as a still life painter, and these "set pieces" are to be found in many of his works.

ship to paint a good picture of flowers as of figures."

Caravaggio was trained by Simone Peterzano, a somewhat undistinguished Milanese artist, and went to Rome around 1592, possibly as a still life painter. His early works were mainly small canvases, including half-length figures of boys in which still life, of fruit or flowers, formed an important element, as in the *Boy with Fruit* in the Borghese Gallery, Rome. There were also some musical scenes, with beautifully painted musical intruments, and the superb *Basket of Fruit* in the Pinacoteca Ambrosiana, Milan. This is an important painting both in the history of still life and in the history of art in general, although it may not have been painted as an independent still life but have been cut down from a larger painting. At any rate it is a model of the truth and realism Caravaggio

sought in his art, a demonstration of his belief that painting should present unidealized subjects instead of the manufactured ones the Mannerist style had made popular, dominated by theatricality and false grandeur.

In his later religious paintings Caravaggio completely broke away from the standard practices, working directly from the model (often models picked up from the streets) with no preliminary underpainting on the canvas. He was endlessly inventive, constantly experimenting with ideas and techniques, and his influence on other artists of his time and later was profound, particularly in his dramatic use of lighting, known as *chiaroscuro,* and his emphasis on what he called "dramatic realism."

By now, as we have seen, painting had become specialized, and still lifes were very much in demand. Various centers of production sprang up in Italy, one such being the "academy" of Giovanni Crescenzi in Rome, who taught the art of Caravaggist still life to many other artists. He was a skilled artist himself, and one of his followers wrote of a particular painting of his: "He made . . . an extremely beautiful display of glassware, diversely represented; some glasses dimmed by frost, others with fruit in water; wineglasses and glasses of different shapes."

The fashion soon spread from Rome to Lombardy, where a center grew up in Caravaggio's native Bergamo, and then to Naples, at that time under Spanish domination. In Bergamo the most important exponent was Evaristo Bachenis (1617-77), who painted still lifes with musical instruments reminiscent of those being produced at the same time by Zurbarán in Spain. The work of the Neapolitan school has an even stronger similarity to the Spanish, for obvious reasons, and one of the most interesting painters was Giuseppe Recco (1634-95), who was a flower painter before changing direction to specialize in rather Baroque-style paintings of fish. These, although evidently done from dead specimens and therefore just qualifying as still lifes, also feature underwater rocks and seaplants, and their bright, glowing colors make them appear almost as though painted on the seabed itself.

SIXTEENTH-CENTURY SPAIN

The *genre* paintings and still lifes produced in Italy and the Netherlands in the sixteenth and early seventeenth centuries were certainly of a high artistic standard, but few of them can be claimed as great art. It was left to Spain, a country where the new realism mingled with an austere religious tradition and a

background of economic depression, to produce two artists who elevated the form to something really fine.

These two were Juan Sánchez Cotán (1561-1627), born near Toledo and trained by another still life painter, Blas de Prado, and Francisco Zurbarán (1598-1664). Toledo was at the time a center of intellectual activity, and Sánchez Cotán, before he forsook the world to become a monk, studied mathematics and architecture with El Greco and was a member of the city's intellectual circles. He admired El Greco, and owned some of his paintings, but this had no effect on his own style. He painted about 11 truly marvellous still lifes of everyday subjects which are quite different from anything seen before – quiet and calm, with a wonderful understanding of spatial values and color harmonies. The subject matter of these paintings is moving in itself, and reflects Sánchez Cotán's piety and frugality. He painted only the humblest of foods, such as would be found on the table of a peasant; here are no great glistening hams or exotic fruit, but ordinary vegetables, watermelons and simple loaves of bread. Some of these paintings are almost abstract in their use of bold geometric shapes – such as a window frame – with the smaller shapes of the vegetables imposed on them, and might easily have been painted in our own century, not the sixteenth.

Zurbarán, born near Bádajoz, settled and worked in Seville, where he was apprenticed to a painter of devotional images. By 1629 he had become official painter to the town, and remained so for some 30 years. He painted a great many religious subjects as well as a *Siege of Cadiz* for the king's palace in Madrid, but among his most admired works today are the powerful single figures of saints and monks in prayer or meditation, monumental figures which express a deep feeling of piety. His still lifes have something of the same quality, of careful control combined with minutely observed and faithful realism. Zurbarán made realism almost a religion of its own, admitting no place for the imagination in his art, and relying on exact perception to provide the impression of space, form and recession, rather than any intellectual theories. Paradoxically, those painters who claim to simply "copy nature" often seem to produce the most moving and poetic works, as though arriving at art in spite of themselves.

Velasquez (1599-1660) is often mentioned in the context of still life painting and, although he painted no "pure" still lifes, his early *bodegones* are in the direct tradition of Pieter Aertsen. In the *Kitchen Scene with Christ* the objects in the foreground are treated with just as much care as the figures, and the colors and textures are rendered with total clarity and faithfulness.

Right *Kitchen Scene with Christ*, Diego Rodriguez de Silva Velasquez. Paintings like this one are a continuation of the tradition begun by Pieter Aertsen, in which an ostensibly religious subject is dominated by a still life group in the foreground. Here the group of three figures, with Christ on the left, seen through the hatch window, occupies only a small part of the painting, and is treated almost as an "inset." The real subject is the still life and figure of the kitchen maid, whose challenging gaze seems to assert the importance of her domestic domain.

THE NETHERLANDS

Flemish still life painting, although in the central tradition of minute observation and faithful attention to detail, was given its artistic form by the great artist Peter Paul Rubens (1577-1640), the almost single-handed creator of the Baroque style of painting that was soon to spread all over Europe. The still lifes and flower pieces of this period, exuberant and unashamedly materialistic, were designed for the homes of the wealthy merchant classes, and are quite unlike the much more restrained paintings of the Dutch school, which reflected the more sober pre-occupations of a strict Protestant society.

It is uncertain whether Rubens himself ever painted still life, but his influence was strong enough to be felt by artists in all fields, and a brilliant interpreter of his style, as applied to still life painting, was Frans Snyders (1579-1657), painter of fruit and the trophies of the hunt, whose work was widely disseminated throughout Europe. Snyders was a pupil of Pieter Bruegel the Younger (c1564-1638), and he worked with Rubens on the still life and animal parts of several of his paintings.

Other notable Flemish still life painters were Paul de Vos, Jan Fyt, who was much influenced by French and Spanish art, Pieter Boel, who exported Fyt's style to Paris, David de Coninck, who took it to Rome, Cornelis Schut, Jan van der Hoecke, and Jan Bruegel the Elder, the father of Flemish flower painting.

Jan Bruegel (1568-1625), the brother of Pieter Bruegel the Younger, had also worked with Rubens, and painted landscapes as well as flower pieces, both in the same highly detailed and polished style. His work was much admired by his contemporaries, and his flower pieces, often consisting of great garlands with literally hundreds of different blooms, each one painted with great delicacy and in minute detail, were in constant demand. He had many followers, among whom were Ambrosius Bosshaert and Roelandt Savery, who introduced flower painting into Holland.

The Dutch still life school combined several related but separate traditions, each one with its own center of production, but flower painting became popular all over the country and grew more and more elaborate in the hands of such artists as Abraham Mignon (1640-79), Jan Davidsz de Heem (1606-84) – who turned to flower pieces from the *vanitas* still lifes fashionable at Leiden – and, slightly later, Justus van Huysum (1659-1716) and Rachel Ruysch (1664-1750). These last two artists brought the art of flower painting to quite unparalleled heights: the flowers were selected and arranged with painstaking care, and watercolor sketches were made before the final painting began so that blooms from different seasons could be used in combinaion. In the finished works, each tiny drop of water, each leaf vein or curl of a petal, is described with astounding skill and accuracy, and sometimes tiny insects can even be seen among the foliage.

The major center for production for flower paintings was the city of Utrecht, the home of many refugees from Flanders, so they constitute a direct continuation of the Flemish tradition. The Hague, a rich market town, had a preference for the still lifes of Abraham van Beyeren (c1620-90), many of which feature displays of fish or tables laden with various kinds of food and show much of the exuberant spirit of Flemish painting. This "spread table" theme was a recurring one in both Flemish and Dutch still life; sometimes the table would be quite frugal and at other times lavish, often with symbolic overtones. Many of the most lavish were the work of Willem Kalf (1622-93), in whose elegant and highly organized compositions reflections and transparent surfaces are often contrasted with dense textures and glowing colors under Rembrandt-type lighting.

Left *Still Life with Basket of Grapes*, Frans Snyders. Snyders' specialties were fruit and the trophies of the hunt, and he worked with Rubens on parts of the latter's paintings. This exuberant still life typifies the Baroque painting style, and the skill with which it is painted is quite breathtaking: the viewer can almost feel the different textures of the Persian rug, the gold chalice and the cool, damp grapes.

Yet another subdivision of this type of still life is that formed by the much more restrained group of paintings sometimes referred to as "breakfast pieces," which were popular in the wealthy town of Haarlem. Their originators were Pieter Claesz (1596/7-1661) and Willem Claesz Heda (1594-1682), and they are characterized by the grouping together of objects with many different textures, such as porcelain, glass, cloth, various sorts of food and so on, with each one being given its precise tonal value and the color kept very muted, almost monochromatic.

FRANCE

France presented a rather different climate for art from that of the Netherlands, since after the mid-seventeenth century the country's artistic standards were dominated by the Academy, originally set up in 1648 and reorganized in 1663 as an intrument of control. The Academy frowned on the

Above *Still Life of Flowers*, Rachel Ruysch. Ruysch and her contemporary Justus van Huysum brought the art of flower painting in Holland to new heights. Here each bloom is depicted in faithful detail, and yet the whole composition is full of liveliness and movement, with the dramatic lighting serving to "spotlight" the central section of the arrangement. Such paintings were the result of many months' careful observation and drawing.

Left *Still Life of Roses, Tulips and Other Flowers*, Roelandt Savery. Savery, one of the followers of Jan "Velvet" Bruegel, was the artist who introduced flower painting into Holland. The flower pieces of this period were not done from life but from separate preliminary studies of each flower, thus allowing the artist to combine blooms which appear at widely separated times of the year.

painters of the Venetian school for paying too much attention to color, and despised the realism and petty subjects of the Netherlands artists; religious, historical or literary subjects were deemed to be the only ones suitable for a serious artist.

However, in the early part of the century a flourishing school of still life painting arose, mainly because so many artists from the troubled Netherlands had settled in Paris. Even before the establishment of the Academy painting in France was divided into strict categories, with still life firmly at the bottom as a lesser kind of art, pretty but unimportant. However, the Netherlands style evidently appealed to the French buyers if not to the arbiters of taste, and it survived in France for considerably longer than it did elsewhere.

The most important of these painters were Lubin Baugin, François Garnier (active *c*1627-58), his stepdaughter Louise Moillon (1609/10-96), Jacques Linard (c 1600-45), René Nourisson (active 1644-50), Pierre Dupuis (1610-82) and Sebastien Stoskopff (1597-1657). Although they were all working in the Netherlands tradition, their paintings were in general simpler and less flamboyant. Baugin's *Dessert with Wafers*, for example, is relatively austere, and Stoskopff's *Pâté and Basket of Glasses*, although showing the same delight in different textures as the Flemish and Dutch painters, is much less cluttered in composition.

France's really great still life painter, however, belongs to the eighteenth century, and his story is a surprising one of success and public acclaim. Jean-Baptiste Chardin (1699-1779) was unlike most artists of his time in that his father, a cabinetmaker, regarded painting as a craft, and insisted on his son training at a craft guild rather than at the Academy itself. The Academy was not only far more prestigious, it also gave artists a good background in the humanities, very necessary for painting the then fashionable history pieces. Chardin does not seem to have trained in drawing as rigorously as most artists of the time either, and he chose still life as his speciality partly because he felt his training had been inadequate and partly because he had not the funds to finance large-scale works.

Chardin was an exact contemporary of François Boucher, who epitomized the current popular style, the flowery, ornate and somewhat shallow Rococo. However, in spite of producing paintings which seemed totally contrary to the tastes of the times Chardin was an immediate success, and he was received into the Academy in 1729 following an exhibition of his paintings at an open-air show in the Place Dauphine the previous year.

Chardin's paintings, although they have a surface realism which ties them to the Dutch tradition, also have great depth and a kind of simple truth that has been an inspiration to still life painters ever since. His technique, too, although apparently simple and direct, was very refined, and he achieved extremely subtle gradations of tone through different densities of white, with thick, rich impastos. Diderot, who was one of his many admirers, wrote of his work: "It is difficult to comprehend this kind of magic. Thick layers of colors are applied one upon another and seem to melt together. At other times one would say that a vapor or a light foam had breathed on the canvas. . . Draw near and everything flattens out and disappears; step back and all the forms are recreated."

THE NINETEENTH CENTURY

Still lifes continued to be produced through the eighteenth and early nineteenth centuries. The golden age, in terms of schools of still life, was over, but it had now become an art form that no longer needed a school or center of production in order to validate it, and from the nineteenth century onward countless artists have turned to still life and flower pieces to produce some of the world's finest works of art. This once humble art form had become respectable, just as landscape painting had, and it could now be viewed by artists as just one of the options open to them.

In France toward the middle of the nineteenth century the power and prestige of the Academy were challenged by artists who were concerned with the more realistic and less grandiose themes of landscape and the everyday world. Eugène Delacroix (1798-1863), Camille Corot (1796-1875) and Gustave Courbet (1819-77) all adopted in various ways the traditional themes and motifs of Flemish and Dutch still life, and naturalism began to take a hold once again. The scene was gradually being set for the emergence of one of the most revolutionary of all art movements, Impressionism, which was to completely change the face of the art world.

However, one of the most important painters in terms of still life was Henri Fantin-Latour (1836-1904), who was not actually a member of the Impressionist group though he was of the same generation. He attended the academy of Charles Gleyre in Paris, where he met such painters as Edgar Degas (1834-1917) and Alphonse Legros, and he later travelled to London, where he exhibited at the Royal Academy and became a friend of James Abbott McNeill Whistler. He painted sensitive figure groups, which were much admired in France, but in England he is best known and admired for his lovely, glowing still lifes and flower pieces very much in the tradition of Chardin.

Henri Fantin-Latour, although acquainted with Manet and his circle, was basically an old-fashioned painter working in a conventional tradition, unlike the Impressionists themselves, who were to break away completely from the old styles in their work. Hitherto, the modelling of form through tonalities had been seen as the most basic part of a painting, but the Impressionists were concerned with light and color, and with the attempt to capture fleeting moments by means of a very direct painting method. Because of

Left *White Narcissi*, Henri Fantin-Latour. Fantin-Latour, although of the same generation as the Impressionists, was essentially a traditional painter working in an established tradition. He worked in England as well as France, was friendly with Whistler, and exhibited at the Royal Academy. His flower pieces were much admired in England, while in France his reputation rested more on his sensitive figure groups.

Right *Still Life with Brioche*, Edouard Manet. Manet although best known for paintings such as *Olympia* and *Le Dejeuner sur l'Herbe*, painted a great many still lifes, usually of humble, ordinary subjects such as loaves of bread and other food, very much in the tradition of Chardin.

their preoccupation with the changing patterns of light, the body of the Impressionists' work is landscape, usually painted on the spot, but Auguste Renoir (1841-1919) painted several lovely flower pieces, as did Camille Pissarro (1831-1903). Edouard Manet (1832-83), on the other hand, painted a great many still lifes, mainly of very simple subjects, such as a ham and a loaf of bread, or two fish on a table. Manet, although often regarded as the "father" of Impressionism, was not actually a member of the group, and he did not share their devotion to outdoor landscape painting. He was much influenced by Japanese prints, which were being imported into France in large numbers at this time. His work shows a new emphasis on pattern formed by the opposition of lights and darks, with the minimum use of half-tones, though later in his life he adopted the lighter palette of the Impressionists and abandoned the use of black.

Three artists also associated with the Impressionists but with very different aims were Vincent van Gogh (1853-90), Paul Gauguin (1848-1903) and Paul Cézanne (1839-1906), all of whom painted still lifes and flower pieces which rank among the world's finest art. Van Gogh's still lifes are in many ways firmly within the Dutch realistic tradition, that of portraying everyday objects in a truthful manner, but they have an extra dimension in that they both tell a story and express and idea. His famous *Chair and Pipe* in the Tate Gallery, London, for example, says more about his own humble way of life than any portrait or photograph could; the deeply moving painting he did early in his career of a pair of worn boots describes to perfection the life of their owner; while his still lifes of piles of books on a table tell us how important books were to him – he was extremely well read. The *Sunflowers,* a series of which were painted as decorations for the room he had made ready for Gauguin at his house in Arles, were intended, as he said himself, "to express an idea of gratitude," and the color yellow, his favorite, associated with the life-giving qualities of the sun, obviously carried symbolic overtones.

Gauguin too painted several still lifes, mainly with flowers, and those done toward the end of his life show great exuberance and a powerful, dramatic use of color as well as the bold flattening of perspective to create pattern which was one of the hallmarks of his painting.

Cézanne was possibly the greatest still life painter ever to have lived, and his ideas, as expressed in his paintings, had far-reaching effects on the subsequent history of art. His concern, unlike the Impressionists, was with the underlying structures of nature, not with light and atmosphere; "deal with nature by

means of the cylinder, the sphere and the cone," he said. He used still life as a vehicle for working out his intellectual ideas about form and space, taking endless pains – sometimes whole days – to arrange the separate elements of his groups in a way that matched his preconceptions. He was a superb colorist, and the reason that his still lifes – and his landscapes – glow with such amazing vibrance is that each brushstroke was placed with great deliberation to give maximum control and modulation of color and tone. Like everything that is done superlatively well, they look easy and spontaneous, but this was far from being the case.

Above *Van Gogh's Chair with His Pipe,* Vincent Van Gogh. Van Gogh's still lifes, although very much in the central tradition of Dutch realism, constitute a form of visual autobiography, telling us much about the artist's interests and way of life. This painting, like that of his bedroom in Arles, done at the same period, illustrate the simplicity of his chosen lifestyle.

CUBIST STILL LIFE

Cézanne's ideas were taken several steps further by the two main founders of the Cubist movement, Pablo Picasso (1881-1973) and Georges Braque (1882-1963). The main development of Cubism was from 1907 to about 1914, though it went through several stages in succeeding years, and it arose to some extent as a reaction against the Romantic tradition of Delacroix and the apparently "easy" appeal of Impressionism. The Cubists rejected the intrinsic interest in either themes or emotions, and represented objects and landscapes as many-sided, or many-faceted, solid forms. Their still life took its subject matter from a very limited range, and the objects themselves were represented without light or space, thus denying them a physical context and the emotions and associations inherent therein. The Cubists also employed a very restricted color range, as

near to monochrome as possible, since color was also seen as a strong forger of emotional links. The reality, the Cubists believed, lay in the artists' conception of the subject not in the subject itself, and it was thus valid to construct it from different aspects, seen at different times.

Picasso did several Cubist still lifes before moving on to other pastures, but Braque did almost nothing else, and it was he who pioneered the technique of collage, in which pieces of paper, cloth or other materials were stuck down onto the paint surface. Braque's work had a lasting influence on other abstract and semi-abstract painters, and his still lifes, in spite of the avowed non-emotionalism of the Cubists' aims, have a strangely haunting, peaceful beauty.

Another important artist in the Cubist movement was the Spaniard Juan Gris (1887-1927), who left Spain to take up residence in

Paris. Gris also painted still lifes, in the style known as Synthetic Cubism. This allowed for the return of elements such as color and texture, disapproved of in the earlier phase, Analytical Cubism, and Gris' paintings make great use of textures such as wood grain and paper, often done by means of collage.

Cubism was the first abstract art movement, and it later spawned others, while several unrelated movements such as Expressionism, Surrealism, Futurism, Dadaism and so on grew up alongside it. Since this time there have been too many art movements to enumerate, some abstract and others representational. In general, however, art is now moving away from abstraction, and individual artists are finding their own paths. Both realistic and interpretative representations of the "real world" – landscape, figure painting and still life – are once again being allowed into the artist's repertoire of subject matter.

Left *Still Life: Apples, Bottle and Chairback*, Paul Cézanne. Cézanne's still lifes are among the finest works ever to have been produced in this branch of painting, superbly composed and glowing with rich color. Cézanne saw still life as a vehicle for exploring his ideas about form and space and the underlying structures of nature, ideas which were to be taken further by the Cubist painters in the years after his death.

Right *Still Life (The Violin)*, Juan Gris. Gris has been described as the most refined and classical of the Cubist masters. His still lifes, painted in the style known as Synthetic Cubism, reintroduced color and texture, frowned upon by the earlier phase of Cubism pioneered by Picasso and Braques. In this still life painted entirely in oils, the color and texture of the wood panelling and pink patterned wallpaper contrast with the flat, monochrome areas.

CHOOSING AND ARRANGING A STILL LIFE

THE CHOICE OF SUBJECT

When you embark on a still life project the first decision to be made is what kind of a still life you intend to paint. This decision will obviously be influenced by your personal interests, for instance, one person may find the shapes of manmade objects such as kitchenware or antique plates and vases suggest a painting, while others find more inspiration in natural forms such as fruit, vegetables, flowers or fish. You can also approach the subject from another angle and decide on a theme, after which you can look for a selection of objects to "illustrate" it. A successful still life should always have some kind of theme: this can be purely visual, with objects related to one another by virtue of similar sizes, colors and textures, or it can be more "literary," a grouping of objects with similar associations such as kitchen utensils and vegetables or a violin and a bust of Beethoven. Still lifes can be symbolic – those painted in the Netherlands in the seventeenth century often showed a skull with flowers as a reminder of the transience of life and beauty – or they can tell a story. Van Gogh's still lifes, such as his famous *Yellow Chair* and several paintings of groups of books piled on a table, are almost a form of autobiography, pictorial descriptions of his interests and way of life.

Objects which are too dissimilar in appearance or which have no obvious associations usually create an unpleasing painting, as they set up instant discords in the viewer's mind. For instance, a vase of flowers will look perfectly logical when placed on a table with crockery or silverware, but if a pair of boots were placed in the same group the effect would be bizarre and disturbing. Surrealist paintings are, of course, based on just such odd juxtapositions, but Surrealist still life is a rather special case.

When you have decided on a theme, visual or otherwise, the next step is to decide what you want to say in your painting in purely artistic terms. Is color the most important element or is it the shapes themselves which attracted you to the objects? In a still life of bottles, for example, one person may be preoccupied with the solidity of the forms and the way in which they interact with each other, while another may see exactly the same group in terms of flat pattern, with areas of bright color and very little form. The seventeenth century still life painters were fascinated by the different textures of glass, fabric and various foodstuffs, while many later painters were more interested in the geometric shapes formed by the objects than in the objects themselves. In the bright, exuberant painting of the aspidistra *(above right)* color is the dominant factor, while in the *Still Life with Tea Caddy (opposite above)* a quiet, tranquil mood is conveyed through the use of

the cool, harmonious colors and the repeated vertical and horizontal lines.

SETTING UP THE GROUP

The great beauty of still life painting is that you can choose the objects that interest you and arrange them in any way you want, which allows you to express your ideas quite freely and in an individual manner, unlike portrait painting, in which you are much more tied to a specific subject. You can also arrange the lighting so that it shows the group to its best advantage. But first it is necessary to find a suitable place for the set-up, where it can remain undisturbed for the duration of the painting. The corner of a room can be a good choice, as this enables you to control the background by using either plain walls or drapes and to arrange an artificial lighting system that will not change as you work. If

Above *Still life with Aspidistra*, James Nairne. For this painting, the artist's starting point has been color, and he has assembled objects whose strong, clear colors complement one another. Composition is not neglected: notice how the folds of the blue cloth lead the eye into and around the painting, and how the verticals in the righthand foreground balance those in the background.

you opt for natural light, with the group placed near a window or on a window sill, bear in mind that you will only be able to work for a limited period each day because the tonal values and the shadows will alter drastically from one part of the day to another.

Once you have gathered together the objects you intend to paint, the next step is to set them up in an arrangement, and it is worth taking some time over this. Always try to think of your intentions toward the painting,

Left *Still Life with Tea Caddy*, Lincoln Seligman. This painting is almost monochromatic by comparison with the one opposite. The mood of tranquillity set by the color scheme of cool blues with touches of warmer pinkish-beige is enhanced by the repeated vertical and horizontal lines which form a framework for the curves of the tea caddy and bowl.

Below *Three Fish on an Oval Plate*, Stan Smith. Here the artist has been fascinated, not only by the rich colors of the fish themselves, but by the geometric possibilities of the composition. He has chosen a high viewpoint, which has given him a simple composition of three diagonals intersecting an oval, all enclosed within the rectangle formed by the table top.

of how you want it to look and what you are trying to express. If color is your main theme make sure that you have achieved a good balance in the set-up, with a pattern of lights and darks, and colors which enhance one another. If form is your primary concern pay particular attention to the lighting so that you have a clear transition of tones on each object, defining their shapes. Arrange the objects in several different ways until you are quite sure the composition is one that will make a good painting; it is much easier to change the set-up than to change the painting. It is often helpful to make a few quick thumbnail sketches of different groupings, and to look at the arrangement through a viewfinder made of a piece of cardboard with a rectangular aperture cut in it. This acts as a frame for the group, isolating it from any distracting background and giving you an idea of how the objects relate to one another and how they will fit within the painting surface. It is only too easy to set up a group which leaves either too little or too much background, or to place one large object in such a way that it diminishes or devalues any smaller ones. Beware, too, of over-cluttering a still life group, as too many objects in different colors or textures will create an over-busy, restless impression. Still life should aim at creating harmony, not discord.

Backgrounds themselves are a very important element in still life groups, as are shadows, and should always be given careful consideration. In the fourth painting by Giorgio Morandi *(see over)* the background forms its own geometric shapes, which are balanced by the shadows, while in the drawing of onions the spaces between the rounded forms are just as important as the forms themselves. This drawing, although very simple, is a a good example of a deliberate and careful arrangement, with the background and foreground divided into unequal horizontal rectangles by the line of the table top, and the left-hand onion, placed slightly apart, leading the eye into the center of the picture.

Another important factor to consider is viewpoint – a group can be totally altered by your angle of vision. If you stand above a low table the objects will be foreshortened and you will see all the table top and little or no background, while if your group is at eye-level you will see some of the front of the table and a great deal of background. In this case you may want to include some extra compositional device such as a window frame, the edge of a curtain or a chair. The still life of fish on a plate *(left)* shows a high viewpoint, and the artist's main interest was evidently in the placing of the elliptical circle, with its diagonals formed by the fish, on the rectangle of the table top.

1

3

2

The Italian artist Giorgio Morandi painted mainly still lifes using only a small range of colors and tones. This selection of paintings shows his concentration on strong, simple shapes in uncomplicated settings: The influence of the ideas of de Chirico can be seen in the juxtaposition and formal qualities of the picture space in Morandi's 1919 *Still Life* **(2)**. This contrasts with his later work **(1)** where the artist has treated the strong simple shapes of the vases and other containers in a more realistic way. The still life of 1915 **(3)** shows a Cubist influence in the geometric treatment of the shapes in the composition. The long vertical strokes emphasize the vertical axis of the painting.

The background in the still life of 1918 **(4)** is more prominent than in the other pictures. The geometric shapes of the background are balanced by the strength of the shadows. In all still life painting, it is important to work out what kind of balance you wish to achieve between the subject and its setting. In this picture, it is clear that the objects are standing on a table, while in many of the others the background is less obvious. If your subject is on a table, how should you position it best – in the center; or, as in this example, to one side? Before starting to paint, examine your subject from several angles and even do a number of quick studies in pencil or charcoal to work out the pros and cons of various arrangements.

4

5

This picture **(5)** was painted in 1926 and is therefore the latest in this sequence. In order to help you with your own still life painting, compare these five examples and give some attention to how the artist's approach and style have changed in treating very similar groups of objects.

A still life consisting of a single vase of flowers, or one in which a vase of flowers forms the main subject, can present special compositional problems. Nothing seems to invite painting more readily than this kind of subject, which is not only colorful and attractive, but looks simple to handle. In fact it presents an almost immediate problem – that of how to arrange it on the painting surface without leaving too much dull and featureless space around it. You can, of course, place it centrally and symmetrically against a dark or pale background, and this can work quite well if the vase or bowl is reasonably rounded and weighty, but a tall vase containing long-stemmed flowers such as lilies does not naturally fit very well into the usual rectangular picture format. Thus it is often necessary either to decide on an asymmetrical arrangement, possibly with the vase placed to one side and the flowers themselves leaning toward the center of the picture or to allow the flowers to "bust" the frame, that is, to go out of the picture.

Another solution to the problem is to make more of the foreground or background, by using a patterned tablecloth, drapery or some extra element to balance the composition.

The Dutch painters often used some fallen petals by the side of the vase, a bloom taken from the main arrangement, or a separate subject such as a bowl of fruit. In the watercolor of the cyclamen (below) a patterned cloth has been used on the table, and the table itself is angled to provide a set of diagonal lines in the foreground. This prevents the picture from looking dull and empty, which it might otherwise have done. In fact the artist had originally drawn the cyclamen head on, with the back of the table providing a horizontal line across the picture, but changed it in the final stages. In the painting of forsythia (right) the flowers have been allowed to "bust" the frame at the top, and a double shadow, from two separate light sources, has been used to provide balance and interest in the foreground. The painting of irises (far right) shows yet another approach, in which the vase of flowers, although the focal point of the painting, actually takes up quite a small part of the total picture area. The shadows, and the horizontals and verticals formed by the shelf and the walls behind make a pleasing, rather austere, pattern, brought to life by the delicate shapes of the flowers themselves.

Left *Still Life with Cyclamen,* Marc Winer. The flower in its pot is placed centrally, but monotony has been avoided by the angle of the table top, which has provided three diagonals, and by the checked pattern on the tablecloth, giving foreground interest.

Left *Jug of Forsythia*, Charles Inge. Here balance and interest are provided by the double shadow in the foreground, which also suggests the horizontal plane on which the jug is resting.

Right *Irises in a Green Vase*, Ian Sidaway. The artist has used three-quarter lighting so that the vase of flowers has thrown an interesting shadow on the white wall. This is a good example of the use of shadow as an integral part of a painting, and the rest of the composition has been planned with equal care. The picture has been divided into three rectangular shapes by the shelf and the side of an alcove, with the vase placed in such a way that it interacts with the rectangles.

Left *Interior with Sunlight*. In this painting the pattern of light forms the basis of the whole composition, and the strong tapering rectangles of light on dark lead the viewer's eye into the picture. Effects like this need to be captured very quickly; the artist probably worked from preliminary studies.

LIGHTING

The way the light falls on an object defines both its form and its color, so it goes without saying that lighting is vital to a still life or flower piece. As any portrait photographer knows, lighting can be a complex subject, but for painting the wisest course is to keep it as simple as possible.

If you are using natural light, try to restrict it to one main source, and overcome the problem of moving shadows by deciding where you want them at the outset. In the painting of the interior *(left)* the light coming in through the window is the key to the whole painting, its shape underlining the arrangement of various objects as well as taking the eye into the picture. Obviously this pattern would not remain unchanged for long, so the artist blocked it in quickly at the start of the painting, leaving the more detailed work until a later stage.

When using artificial light, be careful not to set yourself impossible problems by, for example, training a strong light on highly polished or reflective surfaces. Reflections and highlights are very appealing, and if used in moderation they can give life and sparkle to a painting, but too many can create a fragmented pattern which may both destroy the form of the objects and make it difficult to unify the picture. Experiment with indirect lighting, either by placing a screen between the light source and the set-up or by bouncing the light off a reflector, such as a piece of white cardboard or a mirror.

Lighting is particularly important for flower paintings, as patches of light and shade can throw the shape of a stem, leaf or petal into relief, thus defining the form and character. In general, three-quarter lighting – that is, using a light source between the side and the front of the subject – is the best. This gives good, clear shadows which describe the shapes well, while direct frontal lighting tends to flatten everything out, just as the noon sun does in a landscape. Back lighting can often be very effective: a flower piece placed against a window on a sunny day can be very dramatic, as the foreground flowers and the vase will appear as dark shapes with the occasional leaf or petal standing out in vivid color as the light shines through their delicate surface.

DRAWING AND PAINTING TECHNIQUES

PAINTING MEDIA

Some branches of painting are commonly associated with a particular medium. For instance, people tend to think of landscapes and flowers in connection with watercolor, while the phrase still life may conjure up a vibrant oil painting by Cézanne. However, more and more still lifes are now being done in watercolor, which is becoming increasingly popular with both amateurs and professional artists, and the potentialities of paints such as gouache and acrylic are being explored as alternatives to the more traditional oils.

Oil and Acrylic

Oils, however, remain one of the most versatile of all painting media, and are particularly well suited to the rather considered, deliberate approach demanded of still life subjects. The great beauty of oils is that they can be used in so many different ways, from thick impastos built up with a painting knife to thin, transparent glazes laid one over another, which was the method used by the Renaissance painters. Both approaches can be used effectively to create very different effects and atmospheres.

Acrylics are sometimes regarded by novices as a substitute for oils, but in fact they are quite unlike any other paints, being made from synthetic resins, and require completely different techniques. Acrylics are very fast-drying and cannot be moved around and manipulated on the support as oils can, although they can be used with a retarder, made of glycerine, which allows for some alteration to be made. Like oils, acrylics are basically opaque, but they can be diluted with water and used in transparent layers, which has made them popular with many flower painters. Altogether, they are a challenging and exciting medium with great potentialities, but they are certainly less easy to use than oils and considerable practice is needed to establish a personal technique.

Acrylic paints can also be used as an underpainting for an oil painting. Many artists begin a still life or flower piece with either a monochrome underpainting, in which the main pattern of lights and darks is established before any color is put on, or a colored underpainting, which is a simpler version of the finished work and provides a key for the more detailed application of colors. The problem with this method is that oil paint, even when diluted with turpentine as is usual in the early stages of a painting, takes a fairly long time to dry, but if acrylic is used instead the next stage of the painting can proceed almost immediately as it dries so rapidly. It is quite safe to use acrylic in this way since it does not affect the oil paint laid on top, but acrylic cannot be used on top of oils.

Canvases and Boards

The most commonly used support for oil painting is canvas (or cotton) stretched over wooden frames and then primed, that is, prepared with some form of grounding which prevents the oil paint soaking into the canvas. Canvases can be bought ready stretched and primed, but it is much less expensive to prepare your own by buying stretchers by the pair and buying canvas by the foot. Traditionally, canvases have always been primed first with glue size and then with a white oil-based paint, which can be bought in art shops. However, the sizing stage can be cut out by using acrylic primer, which is applied directly to the canvas with no layer of size. This makes an excellent ground for both oil and acrylic paintings.

Most art shops sell canvas boards, which are an inexpensive alternative to canvases. These are usually primed with acrylic primer and thus are suitable for both media. Virtually any hard surface can be used as a support: masonite is a popular and inexpensive choice, and plywood, chipboard and cardboard can also be used. All these should be primed before use or the oil will sink into them and the paint will eventually crack.

Acrylic can be used on any of the supports mentioned above, as long as they are primed with acrylic, not oil primer. They can also be used on paper of virtually any kind, but if they are being diluted with water the paper should be stretched first, as for watercolor painting.

Watercolor and Gouache

Watercolor and gouache paints are both made in the same way, from pigment mixed with gum arabic, but gouache is made opaque by the addition of white pigment and extender. They are often used in combination, with opaque paint being used in certain areas of a painting to contrast with the transparent washes of watercolor, but gouache paints can, of course, also be used on their own. They are rather tricky to use successfully, since when a layer of wet paint is laid over a previous layer the paint below tends to become stirred up, resulting in a muddy, rather unpleasing effect. However, many artists do use them effectively, and they have the advantage that, because they are opaque, light can be worked over dark. With pure watercolor, light areas must be "reserved," which means that corrections are less easy to make.

When using watercolor the important thing to remember is that dark shades must be built up gradually and light areas created by leaving white paper or paper with a a pale wash laid over it. This means that, although small corrections can be made as the work progresses, major ones cannot, except by the rather drastic method of washing the whole painting off by immersing it in a bath of water.

An accurate preliminary drawing is thus more important in watercolor than in the opaque media; so when setting up a still life or flower piece make sure that the composition is satisfactorily planned before starting to paint. It is advisable to make a few rough sketches first to work out the main lines and balance of the shapes and to establish which areas are to be reserved.

DRAWING MEDIA

Drawing is not often associated with still life and flower pieces, which are usually regarded as subjects for paintings, most often in oils. This is mainly because all the most famous and notable works in this branch of art, such as the rich and glowing still lifes by the Dutch artists of the seventeenth and eighteenth centuries and the equally rich and colorful paintings of Cézanne in the late nineteenth century were in oils, and it is these that come to mind when the phrase still life is mentioned. However, the term "drawing" nowadays covers a much wider range of media than it did in the past, and drawing does not necessarily have to be in monochrome. As well as the conventional pencils, charcoal and pen-and-ink, drawing media now include a wide variety of different colored pencils and chalks, as well as soft pastels and oil pastels, both of which combine drawing and painting techniques. Lovely, painterly effects can be created with pastels and crayons, both of which are well suited to still life subjects. The more traditional drawing media, such as pencils, pen and ink, and pen and wash are still much favored for capturing the delicacy of flowers and plants, as are the more recent inventions such as the technical pen, which gives the very fine and meticulous lines some artists find suit their particular style.

Still life, because its subject matter and arrangement can be closely controlled by the artist, is often regarded as a useful exercise in working out tonal balances and compositions as well as a way of gaining practice in drawing and painting techniques. This is not intended to imply that still lifes cannot be works of art in their own right; of course they can, and often are. But there is no better way to familiarize yourself with the various drawing media than to set up a simple still life or flower piece and try out various different treatments, starting with monochrome studies in charcoal, pencil or pen and ink, and moving on to color, using pastel, oil pastel or colored pencils. A pen and ink drawing may be simply a piece of drapery arranged on a stand, yet it provides the artist with a real challenge in terms of exploring shapes and forms. In this way you will find out which medium suits your particular style and way of working; you may be attracted to the broad sweep of charcoal or

Above *A Bowl of Mixed Flowers*, Dietrich Eckert. Pastel is an ideal medium for flower pieces as the pigment is extremely vivid. The artist has worked on a neutral-colored paper with a surface coarse enough to accept heavily applied color and has used 24 different pastel sticks. He began by sketching out the position of the vase and flowers in black, and then applied the colors one at a time, working from the light tones to the dark. When complete, the work was fixed to prevent smudging.

pastels if you like to work on a large scale, or you may prefer small, tightly worked areas of cross-hatching in pen and ink or colored pencils.

Types of Paper

The most commonly used paper for drawing is drawing paper, which is made in various different grades and weights. It is a tough, resilient surface, well suited to monochrome work in charcoal, pencil, Conté crayon, or pen and ink, and so on. It is also a good surface for crayon and colored pencil work, provided texture is not to be a particular feature of the drawing, but it is not suitable for pastel or for any work in which a quantity of water is used with the medium, for instance, watercolor pastels or watercolor pencils used with a wet wash.

Pastel particles need to be held securely by the paper or they will simply fall off the surface. So the paper made for pastels has considerably more "tooth" than drawing paper, that is, its surface is rougher. Pastel paper comes in a variety of finishes to suit different methods of working; these include a soft type of sandpaper on which colors can be built up quite thickly, and a soft, flock velour paper which has an attractive sheen. Watercolor paper can also be used for pastel if a rougher surface is required.

Watercolor paper should be used for any water-based drawing media and, of course, for watercolor painting. Watercolor paper is made in three basic finishes, Hot Pressed, which is very smooth, Cold Pressed (or Not surface), which is between smooth and very rough and is the most popular paper, and Rough, which is very grainy, as its name implies. It is also made in a variety of weights, expressed in pounds for the weight of each ream of paper. As a general guide, a 70-lb. paper is quite thin, while a 300-lb. paper is very thick, almost like cardboard. The thinner papers – any below 200 lbs. – need to be stretched before use for any work in which large areas of washes are to be applied or it will buckle and be hard to work on. This is not difficult, but the paper must be soaked and takes some time to dry out thoroughly, so it needs to be done some time in advance. Cut the paper to the required size, soak it flat in a tub or large tray of water, shake off the excess moisture and then lay the paper right side up on a drawing board. Tape all around all four edges with brown paper tape (gumstrip) and make secure by putting a drawing pin in each corner.

Using colored or toned papers can be a considerable advantage even for mono chrome work, particularly where white chalk is used with charcoal or Conté crayon to build up broad areas of tone, as it can provide a middle tone against which to key the lights and darks. They are not, of course, suitable for all drawings; for instance a delicate pencil drawing of a flower in which the quality of the line is the most important factor would not be enhanced by a mid-blue or mid-gray paper. However, they are excellent for any drawing in which the relationship of the tones is important, and provide a rather more "friendly" surface than a sheet of glaring white paper.

For pastel work colored papers are used much more frequently than white ones, but in this case the color of the paper must be chosen carefully with the finished work in mind. For example, if you have made a simple and dramatic arrangement of glass bottles or pale-colored flowers against a dark background you could choose a paper which provides the background color, thus enabling most of the pastel to be used for the subject itself. In the flower piece illustrated here a gray paper has been used, which allows the white foreground and brightly colored flowers to show up very well. Sometimes a particular color is chosen in order to unify the general color scheme. For instance a soft yellow-brown paper will impart a warmth and glow to the whole picture. Pastels, unless they are used very thickly, seldom entirely cover the paper, and patches are often deliberately left showing; so choosing the right color and tone is particularly important.

PORTRAIT BUST AND DRAPERY
charcoal on paper

This picture illustrates how willow charcoal, although a fragile medium, can create a very dramatic finished drawing. The drawing process was one of working up dark areas and then modifying them with a kneaded eraser to achieve a balance between light and shadow. There is a constant movement between the building up of dark areas, lightening them, and then working back into the shadow areas – and then repeating the entire process.

In all drawing media, and particularly with charcoal, it is to your advantage to experiment with the various textures and tones the medium is capable of producing. From a very fine, fluid line to a heavy and dense black, charcoal is flexible enough to fulfill every creative need. Because it is so easily erased, artists feel comfortable with willow charcoal. Where it can be difficult to lay down strong paint colors, with charcoal the artist can let his imagination run free without fear of spoiling a picture, as any mistake is easily corrected or altered.

1. The artist has roughed in the main shapes with the end of a piece of light charcoal. He then began to block in the shadow areas using the side of the stick.

2. The charcoal was thoroughly blended and then the features were drawn in and the outlines strengthened.

3. A kneaded eraser was used to highlight areas in the cast and the drapery. A kneaded eraser can be used almost as a drawing tool in itself; it is much more than just an implement for correcting mistakes.

4. Medium charcoal was used to give depth and definition to the shadow areas.

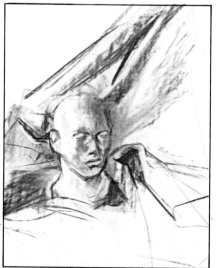

5. The side of a piece of light charcoal gave further subtlety to the features, and was blended with a rag.

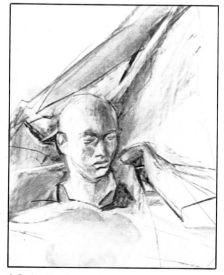

6. Further blending was done on the background, giving a much more three-dimensioned look, after which the shadows were lightened by drawing the eraser gently across the surface.

The attractive qualities of using willow charcoal are shown in the finished picture. By a skillful handling of tone and texture, the artist has produced an unusual still life Note in particular the combination of different textures and shapes to add visual interest.

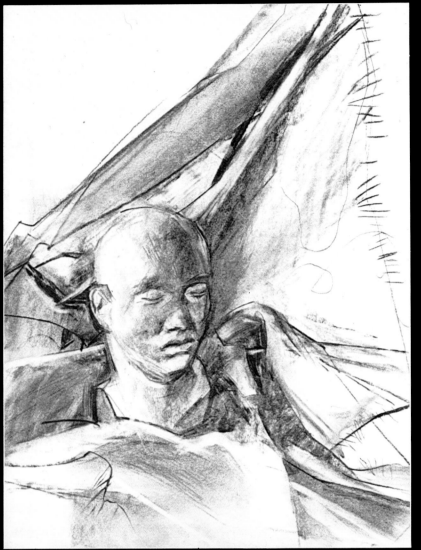

Here the artist puts in dark facial details using the tip of the charcoal.

By using a kneaded eraser, the artist can erase back through the charcoal layer to create highlights and subtle tones of gray.

HAT
colored pencil on paper

A still life arrangement can be an excellent vehicle for the study of color, shape, and structure. The still life may take any form from the traditional subject of fruit and flowers to a jumble of objects randomly selected from whatever is at hand. Choose objects which offer an interesting pattern of forms; develop contrasts and harmonies in the range of colors and between geometric and irregular shapes.

The final effect of this drawing is created by successive overlaying of lines in different colors, woven together to create a range of subtle hues. Each layer is described by lightly hatching and cross-hatching to gradually build up the overall effect. Blue and purple form rich, deep shadows in the yellows; a light layer of red over yellow warms up the basic color without overpowering its character.

The finished picture (right) illustrates how colored pencil may be used to create a subtle, atmospheric image. The combination of soft tones with a strong composition creates a balanced and interesting image.

Subtle color tones are created by overlaying light strokes of color. Here the artist works over a shadow area with a light yellow pencil.

Small detail areas are described with a dark pencil. This is sharpened to a fine point.

1. The first step was to lay in a block of light blue behind the hat. The direction of the pencil strokes was varied, and the same blue used for the shadows on and around the hat.

2. The background color was intensified, the details of the hat were suggested, and the shape of the boxes was drawn in with a yellow pencil.

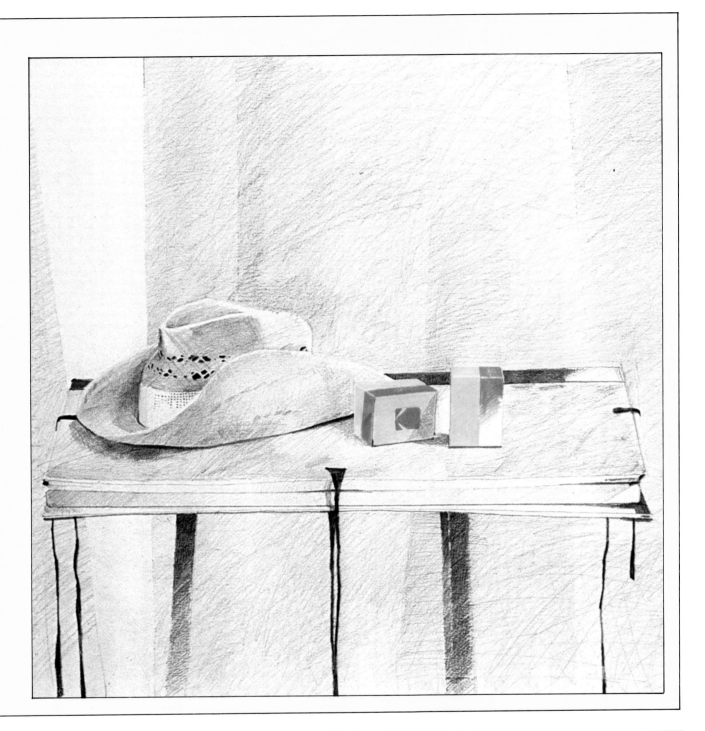

3. The colors were built up, using stronger tonal contrasts. Purple was used for the shadows under the hat, together with darker blue, which makes the objects stand out from the background.

4. The portfolio and sketchbook were outlined in black and the colors of the boxes strengthened.

5. The tones were strengthened further by heavy reworking in places, with details built up in black and yellow ocher.

DAHLIAS
pastel on paper

In terms of color, shape, and gesture, the subject for this picture is well suited to a pastel drawing as bold colors and sharp, gestural strokes are a few of the many potential uses of pastel. Of course the technique used will determine the end result; if this picture had been executed with heavy blending, smudging and subtle colors the results would be quite different.

The colors used are basically complementary: red, orange and pink; blue, purple and green. It is worth remembering that color is created by light, and color will always reflect and bounce off neighbouring colors. The artist has exploited this by using a complementary color within a predominant color area. Thus there are touches of red in the purple flowers, and touches of purple in the red and orange flowers. The dark blue used to describe the stems and shadow areas works as a contrast to both the purple, blue and red, intensifying and adding depth to the overall picture.

The composition was purposely arranged to give a feeling of closeness. The white of the paper works in stark contrast to the densely clustered stems and flowers in the bottom left corner and the directional strokes serve to lead the eye upward and across the page.

1. After roughing in the shapes with charcoal, the flowers were lightly sketched in pink, red, and purple and the stems in light and dark greens.

2. The colors were then blended with a small piece of tissue, and the petals of the blue flowers were drawn in with sharp, directional strokes.

A method of blending is to use a small piece of tissue. Unlike a finger, the tissue will both blend colors and pick up the pastel, thus lightening the tone.

Pastel marks can either be left as clean strokes or blended into subtle gradations of tone and color. Here the artist is blending within the flowers, mixing the orange and pink.

Using the tip of a pastel, the artist describes stem and leaf shapes with a quick, loose motion.

430

3. Thicker, brighter pastel was laid on to build up the vivid colors of the flowers.

4. A heavy layer of purple was put on the base of the blue flowers, and the leaves and stems were crisply defined with the corner of the pastel stick.

5. The tones were built up with quite a heavy pressure so that none of the paper surface showed through the thick pastel.

To finish the picture the artist continued to develop strong dark areas with blue. As a final step, a tissue was used to pick up loose color and blend into the righthand corner.

431

GERANIUM
watercolor on stretched paper

Watercolor uses transparency to create both color and tone. For this reason white is not normally a part of the water-colorist's palette and thus the artist must rely on the various techniques and color mixes to achieve a successful picture. In this painting the variety of techniques illustrates the flexibility of the medium, as well as the skill required to use it to its best potential.

The demands of using watercolor require that the artist be able to antici-pate what will happen in advance of put-ting the paint on the surface. This can be a hit-or-miss effort, especially when applying loose washes of color or letting colors bleed into one another. The artist has a certain amount of control over where and how the paint is applied, but once the brush touches the paper there is much that can happen which the artist will not be able to predict.

In this case, while care was taken to capture a true representation of the subject, the background was described in a more or less ad hoc manner, allowing paint and water to mix with no attempt to control its movement on the surface.

1. The shapes were blocked in quickly using diluted paint applied with a No. 6 sable brush. No underdrawing was done in this case, but most artists would have made some preliminary pencil lines to place the main elements of the composition.

2. The flower was darkened by mixing a little cerulean blue and applying it over the pink, to create a purplish tone. A mixture of sap green and yellow ocher was used for the darker parts of the leaves.

432

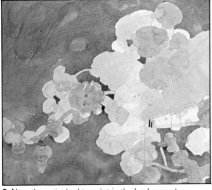

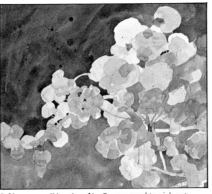

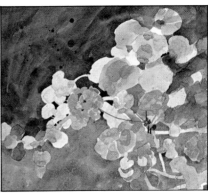

3. Now the artist had to paint in the background, as without it the final tones and colors could not be judged. He used a mixture of Payne's gray and cerulean blue, applied loosely and freely with a large brush.

4. Now a small brush, a No. 2, was used to pick out the finer shadows on the leaves. The Payne's gray of the background was mixed with sap green for these.

5. Pure Payne's gray was used for the fine details such as the stems and veins.

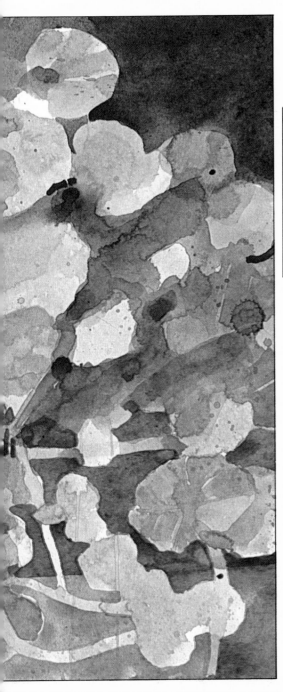

To bring the picture together and make it more interesting, in the final stages the artist concentrated on darkening and strengthening the overall image. The background was brought down to describe the foreground plane, and leaves and flowers were touched up with stronger tones.

With a very wet wash of water and green, the artist describes the general leaf shapes. The wet paint is pulled out of these areas in thin strands to create the stems of the leaves.

With a small sable brush the artist is here touching in areas of deep red over the lighter underpainting. From a distance, this will give the flowers depth and texture.

VASE OF HONESTY
oil on canvasboard

A predominantly white painting will exercise all of the painter's skills. Preconceived ideas of the effects of color and light must be abandoned in favor of careful and thorough observation. This is thus an excellent way of training your eyes to see the many subtle tones and shades of color which exist in what is commonly believed to be a "noncolor."

One way of confronting the problem is to look at the subject in terms of warm and cool color areas. In this painting the white and gray tones are roughly divided between those created from the addition of blue – the cool tones – and those created by the addition of yellow – the warm tones. Until the middle steps of the painting, these warm and cool tones are exaggerated to allow the artist to correct or revise the tones as needed. In the last steps, the entire painting is gradually lightened to allow the subtle color variations to be revealed.

A wide range of marks is achieved by the confident handling of the bristle brushes. The artist has used both the tip and length of the brushes to vary the strokes and textures of the painting.

1, 2. Since this subject was intended as an exercise in a very limited color range it was important to work out the balance of lights and darks carefully at the outset. The artist accordingly began with a monochrome

underpainting in a blue-gray, which is the predominant color in the finished work. The paint was very much thinned with turpentine so that it was easy to handle and dried quickly.

3. With the paint still used quite thin, the artist began to add areas of warmer color across the image.

4. More colors were added, the paint being used now slightly more thickly. Notice how the solid block of yellow brown on the table top, repeated in the vertical window frame, has brought the picture to life and provided a foil for the blue-grays.

5. Now the blue of the background is strengthened and the range of tones throughout the painting is widened and given more impact. The colors remain subtle and muted, but far from dull or muddy.

6. The tip of a No. 3 bristle brush was used to draw into the shapes, emphasizing the linear structure.

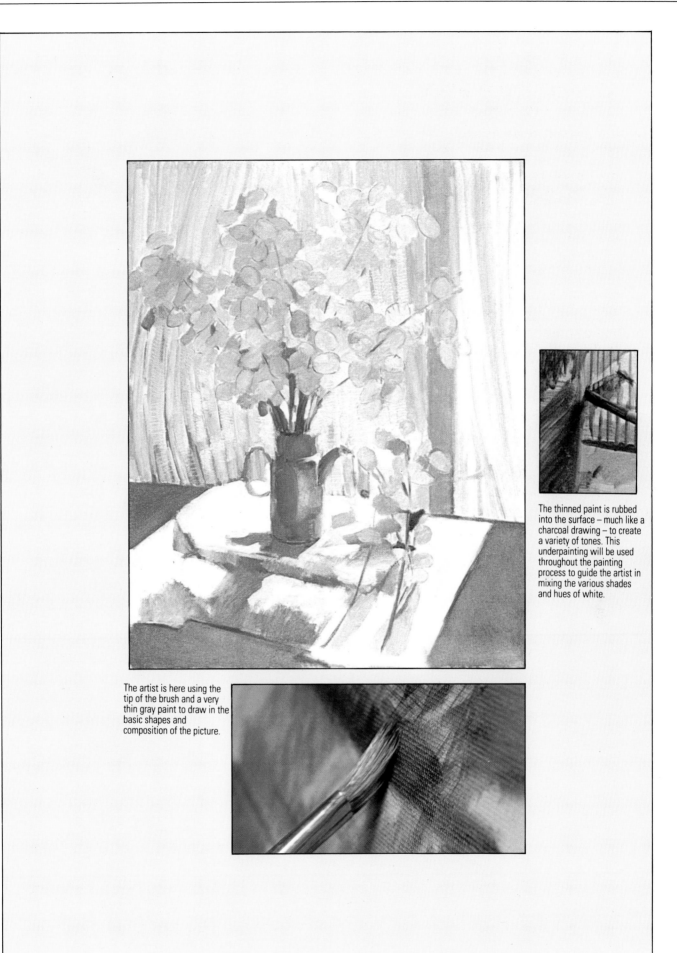

The thinned paint is rubbed into the surface – much like a charcoal drawing – to create a variety of tones. This underpainting will be used throughout the painting process to guide the artist in mixing the various shades and hues of white.

The artist is here using the tip of the brush and a very thin gray paint to draw in the basic shapes and composition of the picture.

VEGETABLES AND WINE
acrylic on paper

Of the many media and mixed media available to the artist, a prime factor should be which media will most successfully capture the subject. If the painting illustrated were executed in watercolor or pastel rather than acrylic paint, the final effect would be much different. In this case, acrylics were chosen because of the bold color scheme of the subject. Unlike other painting media, acrylics have an inherent brilliance and brightness which makes them particularly well suited for describing subjects which demand a bold use of color.

In this painting, the aim of the artist was to create a composition using the classical triangle with the wine bottle as a focal point. One the demands of the still life is that the various objects be arranged in such a way as to avoid flatness in the painting. A mixtue of different sizes, shapes, and textures ensures that the finished painting will successfully avoid this problem.

1. Using raw and burnt sienna, orange and red, shapes were blocked in with a No. 6 bristle brush.

5. A small amount of yellow was added to the mixture to vary the tone of the green.

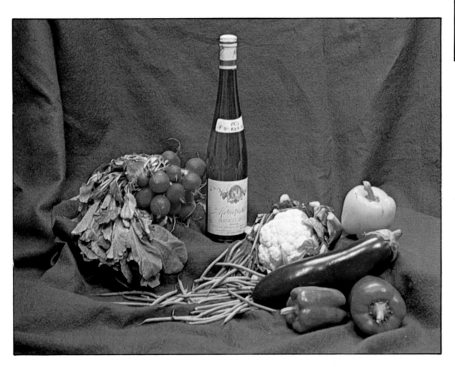

For its painting the consistency of the paint was kept fairly thick and juicy. By adding a matt or gloss medium, the texture may be further altered.

2. Hooker's green and pthalo green were used in combination, with added white for the paler tones.

3. Pure white was applied with a No. 6 watercolor brush for the label and highlights.

4. The background, pthalo green and white, was applied with a bristle brush.

6. Using Hooker's green and a No. 4 brush, the dark green shadow areas of the background were put in, keeping the paint fairly wet.

7. A small amount of burnt sienna was added to the Hooker's green for the shadow areas of foreground.

8. Pthalo green was mixed with more white for the lighter areas of the cloth.

Shapes of the objects are described with a thinnish mixture of paint and water.

The shape of the eggplant is initially described with broad strokes of light and dark tone.

Once the underpainting has dried thoroughly, a thick layer of paint is laid down.

Highlights within the bunch
of radishes are created by
using a strong red.

A juicy mixture of white and
yellow ocher is used to
describe cauliflower florets.

9. Areas of the background cloth were lightened to create a pattern of sharp-edged folds.

10. A No. 2 brush and Hooker's green were used for the dark shadow areas of the green vegetables.

11. The cauliflower florets were painted with pure white and the No. 2 brush, as were the highlights on the bottle.

12. Fluid even strokes were used to paint the beans with the same small brush.

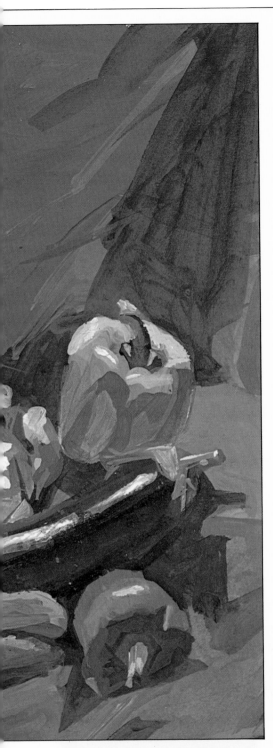

Using a pale green tone similar to that in the background the artist here puts in the finishing touches on the eggplant.

Highlights can be created by using pure white paint directly from the tube.

CONTRIBUTING ARTISTS

Diana Armfield: 348–9, 350–3, 354–5. **Adrian Bartlett:** 311, 321(t), 340–1, 342–3, 346–7, 380(t), 388–9, 390–1, 392–5. **Victoria Bartlett:** 310(b), 312, 312–3, 313(b). **John Brewer:** 323. **Oliver Campion:** 381, 382–3. **Mark Churchill:** 434–5. **Terence Clark:** 220–1. **Margaret Clarke:** 218–9, 222–3, 262–5. **Moira Clinch:** 313(c), 327(t), 328–9. **Roger Coleman:** 124(t). **William Delafield Cook:** 387. **Anthea Cullen:** 52, 53(tl). **Bill Dare:** 41(tc). **John Devane:** 35, 41(tr), 56–9, 88–9, 106–9, 114–7, 130(b), 130–1, 184–5, 204, 216–7, 228–9, 266–9, 270–3, 278–9, 253(b), 328. **Dietrich Eckert:** 425. **Aldous Everleigh:** 60–1, 98, 104, 110–3. **Victoria Funk:** 430–1. **Tim Gibbs:** 385(t). **Maggi Hambling:** 327(r), 330–1(t). **Clive Howard:** 226–7. **Charles Inge:** 422–3. **Jane Joseph:** 332–3(t). **Judith Lang:** 320–1, 322(t), 323(t), 324, 333, 334. **James Marks:** 320(tl), (bl). **Judy Martin:** 314(t), 318, 319, 321(b). **Philip Morsberger:** 85(t). **James Nairne:** 418. **Frances Parker:** 316(l), 317, 344–5. **John Raynes:** 309. **Lincoln Seligman:** 419(t). **Ian Sidaway:** 274–5, 276–7, 364–5, 396–7, 398–401, 402–3, 423, 428–9, 432–3. **Stan Smith:** 41(tl), (bl), (br), 53(b), 54–5, 82–3, 84, 84–5, 85(b), 86–7, 95, 96(t), 98, 99, 100, 101, 104(r), 105, 129(b), 133, 134, 135–7, 138–41, 199(t), 203(r), 208, 209, 361, 363, 419(t). **Lawrence Toynbee:** 338. **Ann Verney:** 366–9, 370–3, 375–7. **Mark Wickham:** 330–1(b), 385(b). **Mark Winer:** 197(r), 329(t), 422.

ACKNOWLEDGEMENTS

Accademia, Venice (Scala): 17, 39(r). Albertina, Vienna: 76, 188, 325(bl). Andrews Reddwill Collection, Surrey (Scala): 64. Art Gallery of South Australia: 297. Arts Council of Great Britain: 202, 258. Baltimore Museum of Art, Cone Collection: 96(b). John Bellamy: 97(t). Biblioteca Marucelliana, Florence: 199(l). Birmingham Museums and Art Gallery: 51(b), 243. Borghese Gallery, Rome (Scala): 20–21. Bridgeman Art Library: 128, 407(b), 413(b), 414(l). British Library: 284. British Museum, London: 37, 305, 335(b) (John Freeman); 149(b), 189(r), 201, 207, 230(l), 357(t). Chicago Art Institute: 211, 314(b). Chiesa S Felicita, Florence (Scala): 123(l). Christies, London (Bridgeman Art Library): 8, 50(t), 412, 413(t), 414(r). Richard Cole: 215(tr). Courtauld Institute Galleries, London, Home House Trustees: 68(b), 149(t), 250(cl), 293, 416. Dallas Museum of Fine Arts: 299(c). Delphi

Museum (Scala): 14(t). Duke of Buccleuch and Queensberry, Bowhill Collection: 290. E T Archive: 406, 407(t). Faber and Faber, London: 215(br). Féderation Mutualiste Parisienne, Paris (Giraudon): 28(bl), 66(b). Michael ffolkes, *Punch* Magazine: 215(tl). Fitzwilliam Museum, Cambridge: 325(t). Fogg Art Museum, Harvard University, Bequest of Grenville L Winthrop: 305(b). Fotomas Index: 14(b), 31, 34, 48, 77, 64(b), 92. Frans Halsmuseum, Haarlem: 44–5 (Tom Haartsen); 166. Gemäldegalerie, Staatliche Museen Preussischer Kulturbesitz, W Berlin: 42–3, 152. Gemeentemuseum, The Hague, Collection Haags (© SPADEM): 17(l), 300–1. Glasgow Museums and Art Galleries, the Burrell Collection: 210. G.L.C. for Iveagh Bequest, Kenwood House: 147(r). Anthony Green: 251, 254. Johnny van Haeften Gallery, London (Bridgeman): 408. Reproduced by gracious permission of Her Majesty the Queen: 22(l), 73, 186, 200, 305(t). Hermitage, Leningrad (Bridgeman Art Library): 50–1, 78(b), 298. Coll. Jesi, Milan (Scala): 420(b). Jeu de Paume, Paris: 174(b); 8–9 (Scala) 26 (Josse). Kunstsammlung Nordrhein-Westfalen, Düsseldorf: 28(bl), 417. Kunstmuseum, Basel (Hans Hinz): 42. Louvre, Paris: 47, 74–5, 126(l); 157, 158, 161, 173, 205, 232(tl), 242(tr), (br), 285, 287(t); 24(b), 24–5, 28(t), 63, 126(b), 127(r) (Scala); 174(t) (Bridgeman Art Library); 315(b) (Snark). Lugano, Thyssen Collection (Scala): 48–9, 51(t), 71. Mansell Collection: 66(t) (from *The Rape of the Lock* 1986). Marborough Fine Art, London: 213, 245(t), 299(b). Mauritshuis, The Hague: 168. Metropolitan Museum of Art, New York: 10–11, 287(b) [Rogers Fund 1919 (Eric Pollitzer)]; 38 (Bequest of Joseph Pulitzer, 1924); 159 (Robert Lehman Collection, 1975); 162, 163 (Bequest of Mrs H O Havemeyer, 1929); 179 (Bequest of Gertrude Stein, 1946 © SPADEM); 289(t) (Bequest of Benjamin Altman, 1913). Milan Gallery of Modern Art: 420(t). Musée Départmental des Vosges, Epinal (Bridgeman Art Library): 62. Musée Fabre, Montpellier: 260. Musée Toulouse-Lautrec (Scala): 49. Musées Royaux des Beaux-Arts, Brussels: 171(r), 190–1, 302. Museum of Modern Art, Venice (Bridgeman Art Library): 9(l). National Gallery, London: 22–3, 66–7, 144, 145, 146, 147(l), 153, 160, 164, 167, 169, 170, 171(l), 172(r), 176, 187, 192, 193, 232(bl), (r), 233, 234, 236(l), (r), 237, 239(r), 240(l), (r), 241, 249(tl), (tr), 286, 288(t), 294–5, 299(t), 302–3, 306–7, 315(t), 380(b), 409, 410–1. National Gallery of

Art, Washington: 26–7, 156; 16(r), 230(r) (Mellon Collection); 92–3 (Rosenwald Collection), National Gallery of Canada, Ottawa: 125. National Gallery of Scotland, Edinburgh (Bridgeman Art Library): 9(r), 261. National Gallery of Victoria, Felton Bequest, 1937: 294(b). National Museum, Naples (Scala): 16(l). National Portrait Gallery, London: 189(l), 214, 215(bl), 242(tl), 244(l), 252. Desterreichisches Museum, Vienna (Bridgeman Art Library): 29. Coll. Dr Orombelli, Milan (Scala): 421(t). Nigel Osbourne: 150(b). Palatina Gallery, Florence (Scala): 12. Sir Roland Penrose Collection (The Bridgeman Art Library): 70–1. Petersburg Press © David Hockney 1973: 180(t), 198, 212. Philadelphia Museum of Art (Bridgeman Art Library): 79. Phillips Collection, Washington: 296. Prado, Madrid: 12–13, 13, 46(b), 148, 165; 100–1 (Scala). Private collections: 206(l), 322(r) (London © SPADEM); 256 (Switzerland © SPADEM); 420–1 (Milan – Scala). QED Publishing: 30, 118, 119, 124(r), (b), 126(c), 127(l), 327(b), 329(t), 330(l), 331, 332–3(b), 335(t), 336, 362–3, 378(b), 379(b), 381(r), 383(b), 384(l), 386. Quarto Publishing: 32, 33, 36, 94(b), 129(t), 310(c). Coll. della Ragione, Florence (Scala): 421(b). Redfern Gallery/Art International: 387(l). Rijksmuseum, Amsterdam (Bridgeman Art Library): 23. Royal Academy, London: 290–1. San Marco Museum, Florence (Scala): 122(b). S Maria Novella, Florence (Scala): 20(t). Scala: 122(t). Ronald Sheridan Photo Library: 14–15, 18, 18–19, 90, 120, 150(t), 282, 283. Sistine Chapel, Vatican (Hans Hinz): 123(r). Isabel Stewart Gardner Museum, Boston: 288(b). Tate Gallery, London: 11, 50(b), 65, 68(t) (© artist), 69, 70, 78(t), 78–9, 80, 180(b), 206(r), 242(bl), 249(b), 259, 294(t), 307, 359, 415; 46(t) (V Sivitar Smith); 181 (© Waddington Galleries); 203(l), 247 (© ADAGP); 245(b) (© Anthony D'Offray Gallery); 250(cr) (© David Hockney, 1970); 257 (© SPADEM). Uffizi, Florence: 151, 154, 155, 231, 235; 19, 20(b), 44, 72–3 (Scala); 24(t), 75 (Bridgeman Art Library). Victoria & Albert Museum, London: 80–1, 291, 292–3, 303, 309(b), 310(t), 316–7, 325(br), 327. Walker Art Gallery, Liverpool: 244(r). Wallace Collection: 172(l). Wellington Museum, London: 239(l). Williams College Museum of Art, Williamstown: 300. Yale University Art Gallery: 97(b).

Key: (t) = top; (b) = bottom; (l) = left; (r) = right; (c) = center